The Collector's Guide to

Vintage

Cigarette Packs

Joe Giesenhagen

Schiffer Publishing Ltd

4880 Lower Valley Road, Atglen, PA 19310 USA

Acknowledgments

I would like to give special thanks to three people which, without their help and understanding, this book could not have been put together. First is my wife, JoAnn, who put up with me buying cigarette displays, lighters, and other miscellaneous items when times were very, very lean for us. Thanks, JoAnn.

Second, I would like to give a special thanks to Krista Burton for helping me cross the "T's" and dot the "I's". Third is a special thanks to Carl H. Clawson, Jr. for his many years of hard work in putting most of this information together. Carl started to collect cigarette packs and labels in 1942 when he found an empty pack of Lucky Strike "green" and several other older packs behind the desk of his father's auto repair shop in Beaver City, Nebraska. Carl now lives in Rockville, Maryland. He has collected both full packs and wrappers, but he mostly collects wrappers. Thanks again Carl, for all of your hard work, research, and input. Without you, I could never have made this book so interesting.

Copyright © 1999 by Joe Giesenhagen
Library of Congress Catalog Card Number: 99-63736

Book Design by Anne Davidsen
Photography by Molly Higgins
Type set in Americana/ Goudy

ISBN: 0-7643-0930-7

Printed in China
1 2 3 4

Published by Schiffer Publishing Ltd.
4880 Lower Valley Road
Atglen, PA 19310
Phone: (610) 593-1777; Fax: (610) 593-2002
E-mail: Schifferbk@aol.com
Please visit our web site catalog at
www.schifferbooks.com

This book may be purchased from the publisher.
Include $3.95 for shipping.
Please try your bookstore first.
We are interested in hearing from authors
with book ideas on related subjects.
You may write for a free catalog.

In Europe, Schiffer books are distributed by
Bushwood Books
6 Marksbury Rd.
Kew Gardens
Surrey TW9 4JF England
Phone: 44 (0)181 392-8585; Fax: 44 (0)181 392-9876
E-mail: Bushwd@aol.com

Table of Contents

Introduction

It all started in the spring of 1962 when I went to work for P. Lorillard tobacco company. While I worked for them, they came out with a couple of new brands of cigarettes, York and Spring, which I thought were very interesting. I never thought about collecting cigarette packs until one of the accounts I serviced asked me if he could get a credit on a couple of old packs of cigarettes that he had. I saw that they were Space Cigarettes. I told him that my company could not give him credit for the packs, but I would buy them from him.

On February 15, 1965 at exactly 12:00 p.m., I decided to quit smoking. When I had the craving for a cigarette, I would buy a pack of cigarettes that I did not like and put them in my pocket, promising myself I would have a smoke later. I would throw them in a box I had with me in the truck I was driving. It was not long before I had two apple boxes full of cigarettes, all different kinds from all over the world. Eventually I would buy packs whenever I saw something new. Most of the antique shops did not know what cigarette packs were worth so I could buy them at a reasonable price. Some of my accounts would buy cigarettes for me when they went on vacation.

By the summer of 1996, I had collected over 4,500 packs, including duplicates, and I decided to buy some older collections to put in a museum. When John Lofgren of Minneapolis, Minnesota put his collection on the market, I bought it. Then John told me that Chuck Hynes of Minnetonka, Minnesota had his for sale and I bought his large collection as well. At this time I would like to thank John Lofgren, and Chuck Hynes for working with me, and helping my collection grow to over 15,000 packs. After six months of organizing I have ended up with 8,532 different kinds of cigarettes. I have 4,205 different kinds of American brands, 267 different kinds of samples, and 4,060 different kinds of foreign brands from 114 countries—and my collection continues to grow! I also have a couple thousand miscellaneous items which I hope to display in a tobacco museum that I am planning to build in Clinton, Missouri within the next couple of years.

In the Beginning

Paper soft packs and boxes often come to mind whenever cigarette packs are mentioned. They outnumber by far any other type of cigarette wrappers. However, there has been a huge variety of cigarette containers produced through the years. In addition to an astronomical number of paper containers in a wide variety of sizes, shapes and styles, cigarettes have also been packaged in metal, glass, cloth, foil, wood, plastic, tissue, and other materials.

The first cigarette wrappers, from the late 1840s and 1850s, were more than likely tissue similar to that used to wrap fancy individual fruits. A handful of cigarettes were rolled up in the tissue with the ends of the tissue twisted. Later the twisted ends were clipped, and a round seal glued to each end of the bundle. I know of no one who claims to have any such old packs or wrappers, except Carl Clawson, Jr., who bought two tissue-wrapped packages of Santa Justa cigarettes in the Azores Islands in the early 1950s. Certainly, given the extremely fragile nature of both wrapper and contents, such wrappers would be exceedingly rare in any condition.

Soft packs, something akin to present day soft packs, were probably used in the

1860s and 1870s but they were apparently more square than rectangular. The wrapper also apparently folded over both ends of the cigarettes and had no inner wrap or outer cover. This was a logical follower of the tissue wrapper. So very few specimens have survived, so it would be difficult to make a judgment of their worth. Even the ads that I have seen are inconclusive. In the early 1880s, Duke introduced the "slide and shell" boxes, also known as "hull and shell", and distributed them most widely in England. Later, "clam shell" boxes also came into use. An informal packaging protocol seems to have developed. Soft paper packs were for "red-blooded" Americans, who smoked cigarettes blended with burley and bright tobaccos. Boxes appealed to "dudes" and foreign cigarette fanciers, who smoked Turkish and Latikia-based cigarettes.

Both types of boxes were much better adapted to hand packing than almost any other container, saving possibly a drawstring cloth bag like the one used for Satin Straight Cut by William S. Kimball Company in the 1880s. Eventually W. Duke Sons & Company, as well as Ginter and Kenney, packaged the majority of their smokes in slide and shell boxes. The surviving Pinhead, Cross-cut and other packs of the time are examples.

During the 1880s and 1890s, tin, glass, wood, and other containers also became popular, particularly for vending containers of 50, 100, or more cigarettes and remained very popular until the early 1930s and even later.

There were some soft packs in the 1890s, but very few have survived. The majority of the early surviving examples of soft packs are from 1910 to 1920, in the form of Mecca, Camel, and later, Lucky Strike, although these also came in boxes. Some of these early soft packs were square with eight, ten, or twelve cigarettes rather than rectangular. Perfection is one example.

From about 1920 on, the number of soft packs increased as the boxes declined. The early soft packs were seldom wrapped in anything except the printed wrapper with a paper inner wrapper. Some were occasionally wrapped like boxes in translucent onion skin or similar paper. A 1916 Mogul ad of a clam shell box of ten cites "protective inner foil and outer linen wrapper." "Linen" in this case means a type of paper instead of cloth. A Camel soft pack depicted in a 1915 advertisement looks surprisingly like today's pack except that it has no outer cellophane, and the corners are slightly more rounded. The few soft packs from this period that did survive could be in good shape.

In the early 1930s soft packs wrapped in cellophane appeared. The clear wrap served two primary purposes: First, it made the packs much more attractive, and (theoretically) kept the tobacco fresher. Regardless of its advantages, it did a cruel disservice to later pack collectors.

Made of cellulose, cellophane absorbs moisture from the air and when it dries, it shrinks. Over long years, the cyclic absorption and drying severly distorted many of the surviving soft packs from the 1930s and 1940s. During the war years, from about 1942 through 1946, cellophane went to war and few packs had an outer wrap. These non-cellophane-wrapped WWII packs have survived in better shape than earlier or later cellophane-wrapped ones.

In the late 1940s and early 1950s, glassine, which is non-cellulose based, replaced cellophane and shrinkage became less of a problem, although it was not entirely eliminated. In other words, if you see a 1930s vintage pack that looks too good to be true, look very closely, it's probably a fake.

Glassine overwraps appear to be fairly stable, so many of the packs from the 1950s and 1960s remain in relatively good shape. A combination of excessive moisture and warmth, such as storage in a garage which gets hot in the summer and cold in the winter, seems to cause shrinkage so even packs wrapped in glassine should be protected from extremes. I have noticed that after a few

years, the glassine becomes brittle and the pack covering tends to tear easily, particularly the area around the tear strip.

During WWII, the type of cardboard used for cigarette boxes was in very short supply and some of the makers converted their box brands to soft packs during the latter part of the war. Many of the boxed brands were discontinued slightly before, during, or shortly after WWII. This was probably because the makers were putting all of their resources into their regular brands, which were in very short supply. After WWII, into the early 1950s, the overwhelming majority of brands sold were soft packs.

In the late 1950s and early 60s, both the familiar flip-top and the short-lived molded plastic box by PMC appeared with many king size smokes. Plastic, the wave of the future, bombed and disappeared, but the flip-top box captured a significant following, particularly during the 1960s when it proved to be a handy depository for a few sticks of Mary Jane, and remains a good seller to date.

Today, in any fair size market or drug store, three or four dozen different brand names are available. Most are offered in six to as many as fourteen different flavors, as well as sizes, and pack or box styles. In 1947, consumers had their choice of one size of Lucky Strike, Pall Mall, Camel, Chesterfield, Philip Morris, Old Gold, two Raleighs, Kool, and one or two types of several other lesser known brands, like Fleetwood and Cavalier. There was no Winston, Salem, Virginia Slims, or Capri. Marlboro was a sissy 70mm pack with red-tipped cigarettes, although there was also a white-tipped type. Collecting was much easier and much less expensive then!

Brand Names

Even the first hand-rolled cigarettes prepared for commercial consumption on a local scale probably had brand names.

Some early brand names we know of are Scalping Knife and Battle Ax, makers unknown, but which probably pre-date Sultana, Moscows, and Opera by the Bedrossian Brothers from as early as 1862. The Bedrossians offered as many as seventeen different brand names by 1967 and probably others, which have gone unrecorded. Early 1850s and 1860s registration of brand names was sporadic. Land borrowing of brand names occurred on occasion. The 1978 June-July issue of Brandstand shows a page from Connorton's Tobacco Brand Name Directory. Listed are brand names from "O", Opera Puff by Allen & Ginter, to "Y", Yenidje by W.S. Kimble & Company. Seventy-four names are listed. Reverting back to "A", we can assume that well over 140 names were listed in total. Connorton has missed many of the localized brand names.

For my fellow collectors, I would like to correct a commonly held myth about the Connorton's Directories. Whereas they contain a lot of interesting information, they do not claim to represent anything even vaguely approaching complete lists of the various brands manufactured. In the 1880s less than half the brands of cigarettes and manufactured tobacco were recorded. During the height of tobacco trust days, as the industries consolidated, that figure rose to only eighty percent.

We might assume then that there were upwards of 200 or more brand names in use by very early account of the rise of cigarettes.

Around 1850 the proper thing for a wealthy American was to send his sons to Paris to put the finishing touches on their education. While in Europe, they usually learned to twist a pinch of tobacco in a film of paper and turn it into a smoke. When they returned to America they brought cigarette papers with them, and used them much to the astonishment of their friends. For some years after this, until about 1855, a cigarette smoker who rolled tobacco in white paper was an unusual sight. Not everyone could roll them, however; there was a knack to it, a delicate

twist of the thumbs and fingers that required some practice. It took so much time and trouble to roll these cigarettes, the wonder is that among busy Americans the practice did not die out, but instead lived and grew.

A few years later Spaniards in Cuba made an improvement by putting up packages of cigarettes requiring only the final roll. These were brought over to America and they soon took the place of the old papers and pouches. For twenty years, those of us who smoked cigarettes at all smoked these Cubans. Then Yankee ingenuity stepped in.

The Cuban cigarette is about a thimbleful of granulated tobacco loosely rolled in a piece of paper almost as thick as newspaper. The ends of the paper are tucked in and the cigarettes are done up in bundles. To smoke one, you must smooth out the folds and reroll the cigarette, for it is not prepared for smoking when it leaves the factory. Then, when you have rolled it, you must keep it continuously between your thumb and finger or it will come apart. This rerolling and holding was too tedious a process for lively Americans, and the distinctive American cigarette was invented. Its peculiarity was, and still is, that when it leaves the factory it is ready to be smoked. It requires no more rolling. The tobacco in it is as solid as a cigar and the ends of the paper are fastened together with an infinitesimal touch of paste. It struck the public, in a minute, this new form of cigarette. Made by machinery, more tobacco could be pressed into these cigarettes than there was in the Cuban handmade cigarettes. Above all, it required no labor before the smoker was ready for a puff. The style of manufacture was perfected, and it soon had many admirers. This style of cigarette excelled the Cuban cigarette in everything but quality. Ten or fifteen years earlier, 1866 to 1871, half a dozen firms were making cigarettes in limited production in this country. They were made of the well-known Perique tobacco, from Louisiana. The tobacco was very strong, black as ink, and the wrapper was much larger and heavier than necessary. They were neatly wrapped in tin foil packages and soon demand, and consequently production, grew. Such was their strength and soothing properties that it was commonly believed they contained small quanities of opium. This was not the case. Perique tobacco is strong enough in itself without any adulteration, and no manufacturer was likely to adulterate cheap tobacco with expensive opium. With these first of the American cigarettes came in the custom of giving each peculiar brand its own name. Now we have hundreds of brands, each made of a different tobacco or of different combinations. This strong old Sweet Caporal cigarette, the pioneer of American brands, is still in use, and from this point cigarettes went down through several levels of strength until they reached a blend the manufacturers wanted. These were made by Kinney Brothers in Richmond, "so mild a baby might smoke a package of them without scenting its breath".

In the 1880s, the Bedrossians were still active in New York, Kenney in Maryland, Allen & Ginter in Richmond, Duke in Durham and Liggett & Myers in St. Louis. Goodwin in New York, Kimball in Rochester and other lesser plants were also rolling smokes. The prevailing philosophy might have been "if they wanna get their name in the paper, they gotta buy an ad".

Given the fragile nature of the cigarette wrappers of the time, probably a significant number of brand names have disappeared without a trace into the mists of time, but an impressive number remain. We will never list them all, but as with collecting them, it is fun to try.

Dating Cigarette Packs

One or a combination of the following indicators may be used to determine more or less precisely when a pack was manufactured. Other minor indicators, discussed later, may also help.

Internal Revenue Stamps

Internal revenue stamps were used from December 1, 1868 to June 24, 1959. This is probably the best single indicator of a cigarette pack's age, if present. The stamps varied over the years:

- The first form of the "Manufacturer's Notice" concerning re-use of the pack or box and destroying the tax stamp appeared on cigarettes from 1868 to April 30, 1879.
- The second form of the "Manufacturer's Notice" from May 1, 1879 to June 24, 1954. The three different forms of the notice are specified and dated later in this discussion.
- Companies put a "factory number" on the pack from 1868 to June 24, 1954.
- The third form of the "Manufacturer's Notice" was used from June 25, 1954 to June 25, 1959.
- Nothing was required on packs from June 25, 1959 to October 8, 1960.
- The Manufacturer's city, state, and permit number or approved symbol has been required since October 9, 1960 to date.
- Zip codes came into use in 1963, and appeared with manufacturer's address on pack by 1965.
- "Caution" appeared on packages from July 1, 1966 to September 30, 1970.
- "Warning" appeared from October 1, 1970 to October 12, 1985.
- "Universal Bar Code" was used from 1970 through 1974.
- "Surgeon General's Warning" began October 16, 1985 and appears to date.

From mid-1955, when the requirement for the factory number on the package was dropped, until 1959, when the tax stamps were discontinued, some makers printed a "C" for cigarette on packages or "TP" for tobacco permit number identifying the maker. Others did not. "C" and "TP" numbers have since been used on generic and on some export packs. These numbers are included in the list of factory numbers in Appendix C. The revenue law for the 1955 to 1960 period required a permit number or an "approved" symbol on the pack. I have no idea what an approved symbol might be other than a registered brand name or trademark.

Reading the Cigarette Revenue Stamps

The earliest cigarette revenue tax stamps were used in 1868. Cigarettes were first taxed in 1864 to help finance the Civil War. From 1868 through 1878 large stamps were used on whole cartons and not on individual packs. The first individual pack tax stamps were issued and used in 1879. I do not know of any sure way to date packs before that time, except by learning when the various manufacturers were active. From 1879 on, the tax stamps may be used to date packs by use of the series numbers on the tax stamp, or, in some cases, by lack of a series number.

The series of US cigarette tax stamps on which the series year is an inscribed part of the stamp design rather than overprinted seperately are as follows:

- Series of 1879: 1879 through 1882
- Series of 1883: 1883 through 1886
- Series of 1887: 1887 through 1897
- Series of 1898: 1898 through 1900
- Series of 1901: 1901 through 1908
- Series of 1909: 1909 only
- Series of 1910: 1910 through 1916
- Series of 1917: 1917 through 1920

The Series of 1917 stamps for ten cigarettes did not have a dates on them. They simply said "Ten" across the bottom. The sixteen- and twenty-cigarette stamp are different from each other but both say "Act" or a series number they used through 1931.

Some tax stamps, 1878 through 1931, and perhaps even later, had the year and/or a factory number overprinted on the stamp. This is one way to instantly date a pack.

As noted above, from 1918 through 1931 tax stamps with no intrinsic date and no series number were used. They were sometimes overprinted with "Series of 1922", "Series of 1926", and so on. Like the earlier stamps, they were occasionally also overprinted with a date and/or a factory number. If the pack has no date or series, it probably dates from 1918 through 1931.

Starting in 1932, the tax stamps were given a new series number yearly, starting with series 102 for 1932. From 1932 through 1954 (Series 124), the "Add 30" rule dates the pack. Simply add thirty to the series number to learn the year the pack was sold. For example, stamp series 114 plus 30 equals 1944. The series number is in very fine print on series 102 through series 125.

Series 125 tax stamps were used from 1955 through 1959, when the tax stamps were discontinued. The series 125 stamps used in 1955, as with previous stamps, are one inch wide. From 1956 or 1957 through June 1959, the stamps are only three-quarters of an inch wide, obviously more narrow and easy to see. The tax stamps used on the few Class B cigarettes, like Gray's by BEH, are more green than blue, and usually have a series number overprinted in black ink. Class B cigarettes are obviously larger and heavier cigarettes and are taxed at a different rate than are Class A cigarettes. Some series 125 stamps may be overprinted with a year, although I can't recall having seen any.

Tax stamps for package amounts other than twenty, such as eight, twelve, eighteen or forty, from 1920 through 1959, do not apparently carry a series number. Most of them that I have seen have a series year overprinted from 1932 through 1959, such as "Series 117" for 1947. As with the common twenty stamps, the odd number stamps from 1956 or 1957 through 1959 are only three-quarters of an inch wide.

A legible tax stamp on a pack may allow a consumer to date the pack from within an eleven year period, 1920 to 1931, to the precise year, 1909, 1930s, and 1940s. An occasional overprint may allow precise dating to almost any year up to 1959.

A detailed rundown of the many cigarette revenue stamps may be found in any edition of Springer's Handbook of North American Cinderella Stamps.

Perhaps from the first tax stamps in 1868 until at least the 1940s, if not later, regular tax stamps were required on most, if not all, exported cigarette packages, but the manufacturer's notice and factory number were not. If you have a pack with a series 105 stamp on it and no factory number or manufacturer's notice, you have a pack that was exported about 1935, sold, and brought back into the country. Many, if not most, of the brand names listed have been exported at one time or another even if this is not noted on the brand name listing. Likewise, some of the brand names listed may be imports, even if they are not so listed. All imported cigarettes were also required to have the proper tobacco tax stamp affixed, but will not have the notice or factory number.

The Manufacturer's Notice and Factory Numbers

In the 1860s and 1870s small shops were preparing hand-rolled cigarettes, mostly for a local clientele, which provided almost one hundred percent of the few cigarettes marketed. These shops had to buy the federal tax stamps and apply them to each package. Most of the wrappers of the time were flimsy cardboard, with slide and shell boxes predominating. In many cases, as most of us know, these early stamps were placed flat on the box rather than over the end where they would be

torn when the box was opened. Some of the small shop owners were not above hiring neighborhood lads to collect discarded boxes (stamps included) to be reused, or the stamps would be removed from the packs and applied to new packs. This led to the requirement for the manufacturer's notice and that the manufacturer be identified on the stamp, for example, an overprinted factory number, district, and state.

The manufacturer's notice was required on packs from 1868 through June 1959. Factory numbers were also required on packs from 1868 until June 1954. There were, in fact, factory numbers printed on packs, or on the tax stamp on the pack as early as the 1870s. I have a few packs with no factory number or notice. I would say trust the tax stamps but be wary of too much reliance on factory numbers and notices around the turn of the century.

Three differently worded manufacturer's notices have been required by the various changes in the law, as follows:

From December 1869 to April 30, 1879:

"Notice, the manufacturer of the cigarettes herein contained has complied with all of the requirements of the law. Every person is cautioned under penalties of law, not to use this package for cigarettes again."

From May 1, 1879 to June 24, 1954:

"The manufacturer of the cigarettes herein contained has complied with all of the requirements of the law. Every person is cautioned not to use this package for cigarettes again, or the stamp thereon again, nor to remove the contents of this package without destroying said stamp, under penalties provided by law in such cases."

From June 25, 1954 until June 24, 1959:

"Law forbids the reuse of the federal stamp hereon and requires the person who empties this package to destroy such stamp when the package is emptied."

Carl Clawson, Jr. has in his collection a 1956 red and white 70mm Philip Morris wrapper from F24-KY, the old Axton-Fisher plant, with a unique rendering of the third notice. It reads: "The contents of this package are subject to federal tax. The federal law forbids the reuse of any label or stamp hereon to evidence federal tax and requires the person who empty this pack to destroy any such label or stamp."

In June 1954, the factory number became history although the tax stamps and third notice remained on packs for another five years until mid-1959. If you know when certain cigarette factories were opened or closed down, the factory number can help in dating packs. For instance, if you have an Old Gold pack or tin from Factory No. 8, Fifth District of New Jersey and the tax stamp is illegible or missing, you know it was made sometime before Lorillard shut down their New Jersey plant, probably around the mid 1950s.

The "Dead" Period: 1959 to 1960

From June 1959 through October 1960 there was no requirement for a tax stamp, notice, factory number, or anything else on packs except, perhaps, the manufacturer's name. I am not even sure that was required. I have some packs from this period, which do have the company name and city of the manufacturer.

The Zip Code: 1963

The US Postal Service launched zip codes in 1963. The cigarette makers who put an address on the pack did not apparently begin using zip codes until at least late 1965, and, probably sometime in 1966. In mid 1966, the "Caution" began to appear on packs. So, if you have a pack with a zip code and no caution message, date it between late 1965 and mid-1966.

The Health Warnings

The duration of the "Caution" and "Warning" is cut and dried, however the "Surgeon General's Warning" is still in use. Few other general clues exist to more precisely date packs during these periods. It is, however, the fairly recent past and many of us have accurately dated our packs or wrappers over this period.

The Bar Code

The bar code for inventory and pricing came into use about 1971 or 1972. It first showed up on cigarette packs no earlier than 1975. The bar code was first mentioned in the August 1976 issue of Smoke Signals. In a column called "The Pack Rat" by Frank Hogan of Detroit, Michigan, it was noted that more and more packs were being redesigned to accommodate the bar code. Different manufacturers adopted bar codes at different times, and it was not found on all packs for several years. A "warning" pack without a bar code would date from late 1970 to early or mid-1975. There are, however, even at this late date, American packs being produced without the bar code. Carl Clawson, Jr. has a pack of Jackpot Junction made by TP-22-VA (Star Tobacco Company) in 1994 for the lower Sioux Indian Community that has no bar code.

"Trust" Era Packs

A brief sketch of the timing of events during the trust years from 1890 through 1911 may help in dating some packs during this period. The chronology listed below is not intended as a detailed history but may make things a little less confusing.

In 1881 W. Duke Sons & Company began to make and market hand rolled cigarettes. Pinhead and Cameo were two of their leading brands. The Dukes marketed aggressively and also persisted in improving the Bonsack cigarette making machine. They succeeded and by the end of 1886 had fifteen Bonsack machines in two factories, Factory 42 in Durham and Factory 30 in New York City. More importantly, J.B. Duke had a secret contract with the Bonsack maker and gave him preferred status in royalty charges for cigarettes made on the Bonsack. By the end of the 1880s the Dukes were seriously hurting the sales of the other major cigarette makers, including Kenney, Allen & Ginter, and others.

In January 1890, Duke, Allen & Ginter, Kenney, Goodwin, and Kimble formally merged to become the American Tobacco Company with J.B. Duke as president and Ginter of Allen & Ginter as Vice President. The founding companies each received stock in the new company in the ratio of: Duke, three; Allen & Ginter, three; Kenney, two; Goodwin, one; and Kimball, one. The American Tobacco Company proceeded to undersell and eventually absorb or bankrupt many small cigarette makers.

In 1898, the American Tobacco Company established the Continental Tobacco Company with the primary goal of buying out or undercutting plug tobacco makers. J.B. Duke was also president of Continental, but Continental was only loosely controlled by American. By 1899 Continental had acquired R.J. Reynolds, P. Lorillard, and the Drummond Tobacco Company of St. Louis, among others. In acquiring companies, Continental also amassed a number of cigarette brand names. I do not know whether the Continental Tobacco Company became independent with the break up of the trust in 1911, nor do I know what relationship it had with the later Continental of West Virginia or Continental of South Carolina.

The same year, a group of independent financiers formed the Union Tobacco Company to operate independently of and in competition with the American Tobacco Company Union. This group also acquired Liggett and Myers of St. Louis, Blackwell's Durham Tobacco Works and the National Cigarette Company of New

York City, among others. By the end of 1898 Union was also a subsidiary of American. As with Continental, Union had acquired many cigarette brand names and produced cigarettes through the end of the trust years as a subsidiary of the American Tobacco Company until sometime in the 1930s.

In 1900, American created the American Snuff Company which also acquired cigarette brand names in the process of buying out snuff dealers. The following year, American also created the American Cigar Company and acquired, along with many cigar brands, more cigarette brand names, including many from United Cigar in Whalen.

J.B. Duke created the Consolidated Tobacco company in 1901, which included the American Tobacco Company and Continental Tobacco. In theory, if not in practice, the American Tobacco Company was only a subsidiary. Consolidated tobacco lasted until 1904 when Duke again broke it into the American Tobacco Company and Continental.

1902—Duke engineered the creation of the British-American Tobacco Company in England.

In 1911, the American Tobacco Trust dissolved with cigarette brand names going to the new American Tobacco Company, Liggett and Myers, and P. Lorillard. R.J. Reynolds was awarded snuff, chewing tobacco, and smoking tobacco brand names.

During the American Tobacco Trust years many other noted names in cigarette history were either absorbed by the trust or driven out of business. These included Cameron & Cameron, Irby, S.F. Hess, Monople, Leopold Miller, the Felgners of New York, and Chicago, Falk, Bohls, and Bollman in California.

All of these companies were apparently producing cigarettes independently as late as 1898, along with about four hundred other makers. Although the cigarettes of the original five members of the American Tobacco Company all carried the American name in addition to their own, it is not at all clear how many of the brands of other assimilated company carried the American name. My pack of Consols simples says Consolidated Tobacco Company, with no hint of American. I am not sure, incidentally, that Duke "created" the Consolidated Tobacco Company. I believe that a company by this name may have already existed and been taken over by Duke, my reason being that my pack of Consols has a tax stamp which would have been in use in the late 1880s or early 1890s.

Taking Care of Your Packs and Wrappers

Paper soft packs, boxes, and wrappers are inherently fragile and vulnerable items. Light, heat, moisture, varmints, and airborne contaminants such as cigarette smoke and cooking fumes can all damage, dull, or even destroy them. Cyclic variations in atmospheric humidity and air pressure contribute to slow deterioration. In addition, alternating atmospheric pressure also contributes to the disfigurement of packs, particularly soft packs, by allowing tobacco crumbs to migrate outside the printed wrapper but inside the sealed glassine cover as the packs expand and contract like a bellows. Frequent moving, including mailings of the packs, also contributes to loose crumbs. Cigarette tobacco is hydroscopic, absorbing moisture rapidly under humid conditions, even when apparently sealed in cellophane or glassine. This accumulated moisture will eventually carry the tobacco stain to the paper wrapper, discoloring it.

More damaging to packs is the chemical reaction which occurs between the inner foil wrap and the outer wrapper. The combination of moisture and paper is acidic, the wrapper disintegrates the foil causing it to stick to and stain the outer wrapper and eventually destroy it. You are condemning your packs to a slow death when you store them in an unheated garage, attic, or humid basement.

Almost all paper, certainly including cigarette pack and box paper, is born to lose. By nature of its manufacturing process, it is acidic and self destructive. It can be made nonacidic but the process is expensive. Insofar as the cigarette makers are concerned there is no motive to go for nonacidic paper. Packs are in production one week, and in the pipeline the next. One week on the shelf, one day in the smoker's pocket, and in the trash the next day unless they end up in a collection, which is of no concern to the maker.

The acids in the paper slowly, or swiftly, depending on the paper, react with both the moisture in the air and the air itself. The process is slow, but inexorable. The deterioration is hastened by exposure to light, particularly sunlight. The ink may, or may not, fade, but the paper slowly grows more brittle and may discolor. Eventually, it will disintegrate. As I said, paper is born to lose. The process can never be completely stopped, but it can be slowed down. I have found, in older packs, that the paper on the cigarettes also deteriorates. It erodes swiftly around the brand logo. Apparently the acid in the paper reacts with elements in the ink. Sunlight which covers the paper is a print and paper killer, but even artificial light over a long period of time will do a number on your packs. If you show your packs under a fluorescent light fixture for five or six weeks it fades most, if not all, inks, but also attacks many papers. It will accentuate the effect of the acids in the paper. It can be a tough choice for those of us who like to exhibit our packs in our homes or elsewhere, but day in and day out exposure of packs will eventually fade them out, even if the paper doesn't get old and brittle, which it probably will if kept in the light.

Ideally, paper items should be stored in a sealed, opaque, humidity controlled container charged with inert gas. This is obviously impractical for a home collection if the collection is to be seen and enjoyed. Just a few simple precautions can extend the life of your packs by many years.

Hints

- Seal your packs neatly in clear plastic or glassine, even to the point of putting a second wrap over the pack if it still has the original glassine wrapper. Insulate them from the air as much as possible.
- Keep your packs in the dark as much as possible.
- Avoid handling your packs as much as possible.
- Avoid storing your packs in extremes of heat, cold, humidity, and dryness, although a couple of weeks in a freezer probably won't hurt them as described below.
- If you have older soft packs which are being distorted by shrinking cellophane, strip the cellophane as soon as possible. A shapely pack without cellophane beats a warped pack with cellophane. The distortion will only get worse if you do not act and wrap the pack in plastic.

The above hints apply to both the clam shell, slide and shell boxes, as well as soft packs. Wrappers are best kept in the loose leaf document protectors sold in office supply stores. Specifically, I am talking about the black, plastic covered sheets, open at the top and bottom, for placement in a three-ring binder. Your wrappers may be reviewed whenever the urge hits, and may be removed or replaced easily. They generally stay in place nicely without the use of tape or adhesive, and are in the dark the rest of the time. Also, the document protectors may act to counteract paper acids. Their efficiency in acid protection probably varies in direct ratio to their price. The more expensive the protector, the better the protection but even the cheap ones are better than having your wrappers tucked into an envelope.

Weevils, which hatch out from larva carried in tobacco, can attack from the inside of the packs, both old and new. I bought a very small collection, sight unseen, and when I picked them up they were full of weevil holes. In the collection was a full carton of Chesterfield's from the 1934 era and the weevils had come completely through the carton. Even other nondiscriminant bugs can attack from outside. The weevils go through foil as well as paper, leaving ugly little holes in their wake. Cockroaches and silverfish will munch on packs at times, as will mice and rats.

I have put all of my collection through the freezer test for six to eight weeks and I have been watching them very closely. I haven't had any new holes in the packs that I purchased with weevil holes in them, so I think I have killed off all of the unhatched weevil larva or presumably, the weevils themselves.

Fending off the other "varmints" is more difficult. When I build the frames for the museum, I will allow space for moth balls or flakes to be placed periodically. If you have your packs in frames or packed in boxes, it shouldn't be difficult to periodically place a few moth balls or flakes inside your frames or boxes, particularly if you are displaying an empty pack or box. The flakes or moth balls will eventually disappear by evaporation and require replacement. This should discourage the silverfish and roaches who will find even a tiny opening into your frames. If you store your packs in the open, such as on shelves or ledges, they will be vulnerable.

I would be preaching to the choir if I had tried to tell tin collectors how to take care of their goodies. I can only note again that light and humidity are the enemies. The light will fade colors, including lithographed colors, and the humidity will rust the metal.

My approach would be to tuck in a slica gel cell, available at florists. This absorbs moisture. Put the gel cell into each tin and tuck the tin in a plastic freezer bag. I would also try to expose printed or lithographed tins to as little light as possible within reason.

"Rebuilt" Packs

One cannot collect very seriously for any length of time without being exposed to "rebuilt" packs. These can be very discouraging. I have put quotation marks around "rebuilt" because the term covers several different sins, some of which are described below.

Authentic unused older wrappers obtained from the factory are used to wrap an inner foil package of new cigarettes. Lucky Strike 70mm seems to be a favorite. The recovered pack is then inserted into the glassine outer wrapper previously removed from the newer package. Sometimes a color copy of the authentic older wrapper is used, adding insult to injury.

A glassine wrapper on a newer package of the appropriate size is carefully cut around the bottom and fitted over an authentic older package from which the cellophane has been removed or is missing.

A clam shell or shell and slide box which has been flattened out is reshaped using glue or tape on the inside and given a new glassine covering with later cigarettes inside. In some cases, older tax stamps are used. In other cases, newer closure strips are used even though the authentic pack should have had a tax stamp. I am not convinced that the person who rebuilt the pack necessarily meant to deceive. These packs do tend to change hands and the original innocent intent may get lost.

Some collectors build or rebuild packs for their own collections or for friends. There is no fault with this. A rebuilt pack is just as interesting to most people as the authentic pack would be, and most people would never know the difference. Other collectors build up packs and offer them for sale with full notification that they are rebuilt. Again, I cannot fault this. Then there are the con-artists out to make a buck, which I can fault. The price of a rebuilt pack is about the same as a

label. In most cases, the authentic pack is worth three to four times as much as a rebuilt pack. I know collectors relatively new to the hobby who have invested a good sum of money in some nice packs only to find, sometimes after admiring them for several days or weeks, that they are not original. All I can do is commiserate with them. We learn from our mistakes.

The rebuilding process goes something like this: The rebuilder finds labels of old, discontinued brands. He carefully cuts around three sides of the glassine on the bottom on one of the new packs and slips the pack out of the glassine. He removes the wrapper from the pack, leaving only the foil inner wrapper. He then carefully wraps the old label around the foil pack using glue or double sided tape to secure it in place. He puts a tax stamp, or a closing strip in lieu of a tax stamp, on the new pack. He then slips it back in to the original glassine and seals the glassine to the bottom of the pack with double sided tape, et voila! An authentic-looking old pack.

Some rebuilders are more skilled and painstaking than others, but some of the following hints should enable you to determine if a pack is rebuilt. Look at and feel the glassine around the bottom of the pack. You should be able to feel and see where it has been cut. This is a dead giveaway.

Check the series number on the tax stamp. A 1930s pack should not have a 1920s tax stamp with no series number and a late 1940s tax stamp on it. Also, be aware that some pack designs spanned these eras with minimal change. This will be a judgment call.

A 1930s wrapper with a closure strip rather than a tax stamp is an obvious rebuilt pack. An authentic 1930s or 1940s package will have a tax stamp with a series number on it.

Check the state tax stamp(s) on the package. If they are more than two or three cents, the wrapper is probably from a newer pack, although some states will be exceptions. Also, does the pack have a colored tear strip? Colored tear strips were seldom or almost never used before the 1940s.

It also helps to know who you are buying from. A little correspondence, during which you express your distaste for rebuilts before you buy, will probably help at least part of the time. Don't hesitate to exaggerate your expertise at spotting rebuilts.

If you flatten your wrapper you can rebuild it by soaking them in lukewarm water. Almost all of the major manufacturers use water solulable glue and the packs came apart very nicely. The ink on the packs also did not run in the water. Flattening the rebuilt wrappers is another story. The glue used by rebuilders in unpredictable. Some is water solulable, and some will soften with lighter fluid or acetone. In some cases, I simply had to carefully peel the pack apart, hoping for the best.

The double-sided tape used by rebuilders will come off, with care, after being soaked for a few minutes in lighter fluid. The lighter fluid will not discolor the pack paper, or cause the ink to run. After the tape is peeled off, the adhesive can be cleaned off of the wrapper by rubbing it, sometimes not too gently, with a paper towel moistened with lighter fluid. Keep working at it, it will come off.

One problem with soaking wrappers in water to separate them is that the closure strip also falls off and must be refastened to the wrapper if you like to include them with the wrapper. Some people in the past used scotch tape to do this. After a few years the scotch tape adhesive will discolor the pack all the way through until is is obvious from the front. While the scotch tape can be removed, again using lighter fluid, the stain is apparently there to stay. I have tried lighter fluid, acetone, methanol, even methyl-ethylketone or MEK. Nothing has worked. I do not believe the newer invisible scotch tape will discolor a pack like this, but I cannot be sure.

All of this may help you to salvage the wrapper from a rebuilt pack if you collect wrappers. Make sure you read the above hints again and look very closely before you buy!

In Addition...

The prize packs sought by most collectors are packs that date prior to and during the tobacco trust years. The trust was formalized as the American Tobacco Company in January 1890. The charter members herded into line by James Buchanan "Buck" Duke of Duke Sons & Company were Duke, Allen & Ginter, Kenney, Goodwin, and Kimball. Fortunately for collectors, Buck Duke did not work at eliminating brand names. Many of the charter members' brand names were rolled out for several years after the consolidation, although Duke did shut down plants. Goodwin, for instance, was shut down soon after the establishment of the trust, but Goodwin's brand names continued in production, in the original design with the ATC name added, at the Kenney and Allen & Ginter plants, as well as others for several years.

I have given the American Tobacco Company two designations: ATC for the period from 1911 when the "trust" was dissolved until the present; and ATD, an arbitrary designation to indicate the trust years from 1891 to 1911. The brand name list will show the brand name under ATD during the trust years and ATC during the following years, provided that ATC was awarded the brand name at the breakup or acquired the brand names at some later time.

LAM, LOR, and RJR existed before the trust, were in the trust, and became independent entities after the trust dissolution. In most cases their older brand names will be listed under ATD during the trust years, with the original vendor listed in the vendor column.

The United States Tobacco Company may also be a source of confusion. There were two different companies who used this name, and both made cigarettes. The United States Tobacco Company of Virginia, in Richmond, made cigarettes from around the late 1890s until 1921 or 1922 with brand names such as Albernarle Pippins and Capital. If the United States Tobacco Company Virginia plant was F1-VA, and I have no packs to show that it was, then it was part of the American Tobacco Trust. I have seen smoking tobacco of that era with the American Tobacco name made in F1-VA. In any case, this early United States Tobacco Company of Virginia is designated USV in my lists. In 1922 USV was bought by a consortium of other tobacco companies formed after the breakup of the trust. Most, if not all, of the companies provided tobacco products other than cigarettes, such as snuff. After buying USV in 1924, the new company chose to be known as the United States Tobacco Company of New Jersey, designated as USJ in my lists. USJ produced a few brands of cigarettes from the time USV was acquired in 1922, such as North Pole and Polly, but I do not know what factory number they used or even what state the plant was in.

USJ eventually ended up with offices in Connecticut, and a tobacco plant in Richmond, Virginia. USJ cigarettes, from at least 1951 to 1955, are from F1-VA, later from TP-3-VA or C-3-VA. In the past few years, I have seen no cigarettes from USJ. I believe that they may have dropped cigarettes to concentrate on smokeless tobacco.

Many brand names have a built-in confusion factor, for example, The Pet, by Allen & Ginter. Registered about 1881, this cigarette was simply called The Pet. At some time between then and 1890 to 1891, at which time Allen & Ginter joined the trust, the word "the" was dropped and *The Pet* became just *Pet*. To make matters more complicated, an illustration of an approximate 1895 pack in the June/July 1978 issue of "Brandstand" reads down the front of the pack: "The Pet Cigarettes Ponies Straight Cut Virginia." This later pack is by Allen & Ginter, the American Tobacco Company successor. This has apparently led to listing of the Pet Ponies as a brand name. In fact, the word "Ponies" in the name is describes the cigarettes, akin to "Lights" or "Kings". When Liggett & Myers was given the brand name in 1911, it was still "The Pet", but may have been shortened to "Pet" or "Pets" later. In any case, as far as I can tell, the only Pet Ponies brand is the one cited above. Many other brands have the same confusion factor.

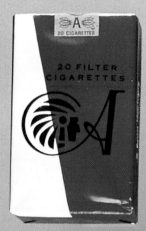

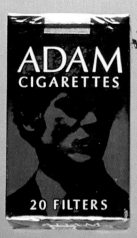

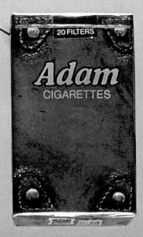

A, 1985, Trademark, $25-35

Adam, 1971-72, Face, $8-12

Adam, 1972-73, Leather, $8-12

Actron, 1971, Trademark, $25-35

Afternoon Egyptian, 1923, $60-85

After Dinner, 1898, $90-135

Airline, 1940, Plane facing left, $40-55

Airflow, 1942, Milder fuller flavored, $55-65

Airflow, 1956, No Stamp, $25-35

Airline, 1976, Test Market, $25-35

Airline, 1941, Plane facing right, $55-65

Alamo, 1960,
Trademark, $25-35

Alduna, 1955, $40-55

Alligator, 1946, $40-55

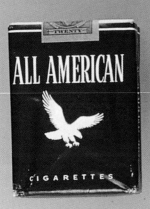

All American, 1942-44,
Buy U.S. war bonds, $55-65

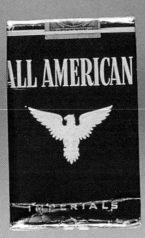

All American, 1941-44,
24-Pack, $55-65

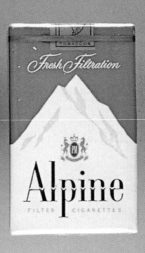

Alpine, 1958, $25-35

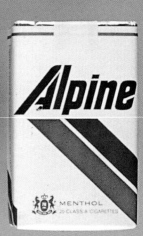

Alpine, 1971,
Trademark, $25-35

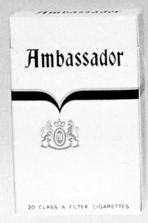

Ambassador, 1967,
Trademark, $25-35

American, 1959, $25-35

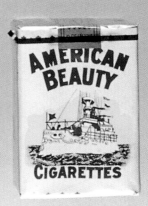

American Beauty,
1952, $40-55

American Spirit, 1985,
All natural, $6-9

American Ovals, 1969,
Test market, $25-35

Andover, 1980,
Trademark $25-35

American Lights, 1976-82,
Test market, $7-9

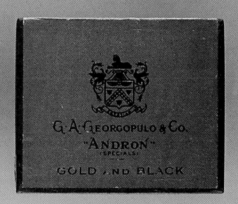

Andron Special, 1967, $8-12

Andron Black & Gold, 1959, $25-35

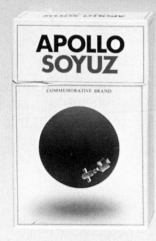

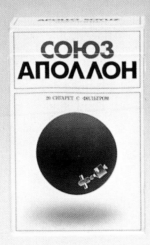

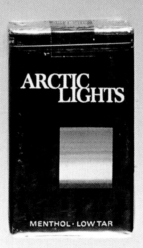

Apollo Soyuz, 1975,
Joint US/USSR space
mission, $40-55

Back of Apollo pack,
1975, $40-55

Arctic lights,
1979-81, $7-9

Arden, 1964,
Test market, $25-35

Astron, 1901, 10 count, $90-135

Aspen, 1979-81,
Trademark, $25-35

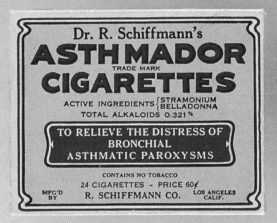

Asthmador, 1892-1980, Non-tobacco, $55-65

Back of Asthmador pack

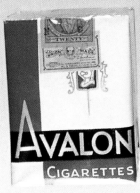

Avalon, 1936,
No pennies, $55-65

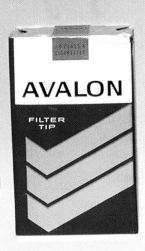

Avalon, 1982,
Trademark, $25-35

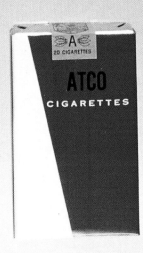

Atco, 1967,
Trademark, $25-35

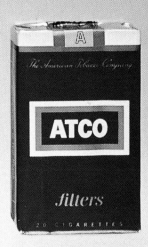

Atco, 1968,
Trademark, $25-35

Austin, 1963, Trademark, $25-35

Axton's Vintage Special, 1942, $55-65

Aztecas, 1924, $60-85

Bankers Club of America,
1937, $55-65

Banquets (120), 1956. Individually
packaged in glass tubes, $55-65

Barclay, 1966,
Trademark, $25-35

Barclay, 1968, New
multicel filter, $8-12

Barking Dog,
1934, $55-65

Barracuda, 1966,
Trademark, $25-35

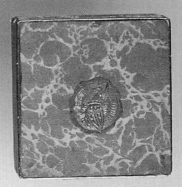

Batt Bros, 1909, $200-325

Basic, 1974, Test mkt, $7-9

Basic, 1972, $7-9

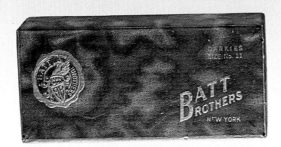

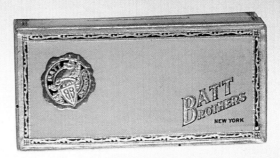

Batt Bros, 1923, $60-85

Batt Bros, 1923, $60-85

Beech-Nut,
1921, $60-85

Beacon, 1964, Trademark, $25-35

Beech-Nut, 1940,
RKR, $55-65

Beech-Nut, 1965,
Plain end, $8-12

Benaderet's Harem
Beauties, 1930, $60-85

Benaderet's Straight
Habanas, 1933, $60-85

Belair, 1993, $3-5

Belair, 1959-65, $25-35

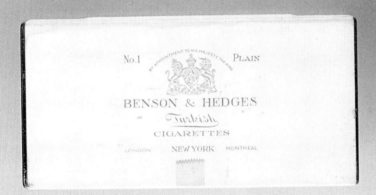

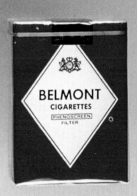

Benson & Hedges No.1, 1930, $200-225

Belmont, 1962,
Trademark, $25-35

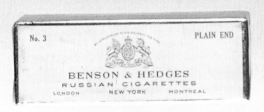

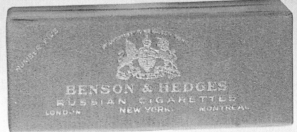

Benson & Hedges, 1932,
20 count, $90-135

Benson & Hedges, 1938, $150-190

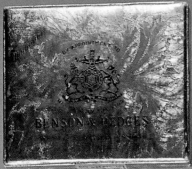

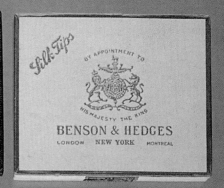

Benson & Hedges, 1941, $60-85 Benson & Hedges, 1938, $60-85 Benson & Hedges, 1938,
Silk tips, $75-115

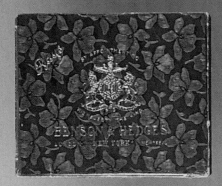

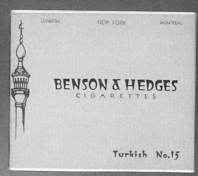

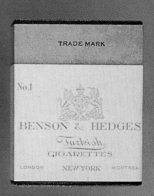

Benson & Hedges, 1935, $75-115 Benson & Hedges, 1938, $75-115 Benson & Hedges,
1927, $90-135

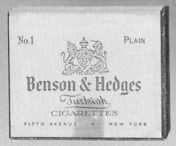

Benson & Hedges No. 1,
1932, $95-150

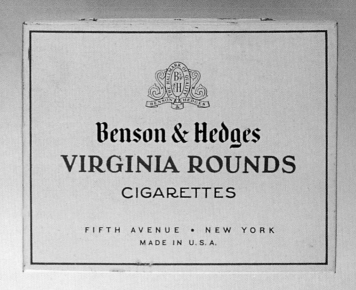

Benson & Hedges,
1913, $200-325

Benson & Hedges Rounds, 1946, 50 count, $150-225

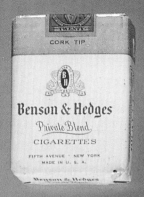
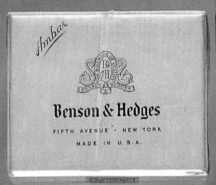
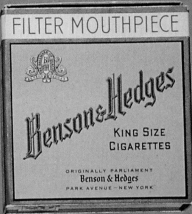

Benson & Hedges,
1955, $40-55

Benson & Hedges
Amber, 1927, $95-150

Benson & Hedges,
1956, $25-35

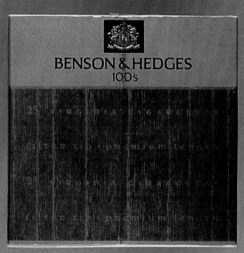

Benson & Hedges, 1977, $7-9

Benson & Hedges, 1977, $7-9

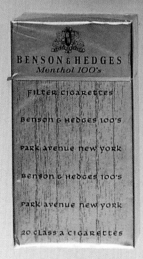
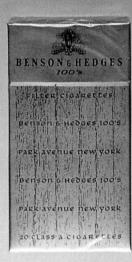
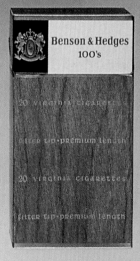

Benson & Hedges,
1982, $7-9

Benson & Hedges,
1982, $7-9

Benson & Hedges,
1992, $3-6

Best, 1977, Trademark, $25-35

Best Buy, 1981, First series, $7-9

Between the Acts, 1883, $200-250

Billups, 1961, "Lite-up with Billups...your friend, $25-35

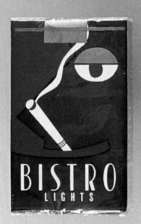

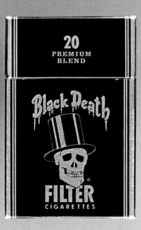

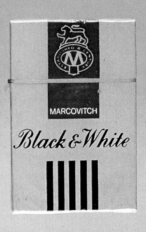

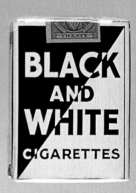

Black And White, 1934, $55-65

Bistro, 1981, test market, $25-35

Black Death, 1991, $7-9

Black & White, 1972, $7-9

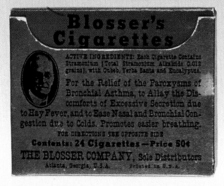

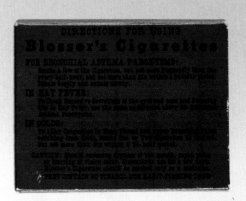

Blosser's, 1874-?, Medicinal cigarette, $200-250

Back of Blosser's pack: Get well or get high?

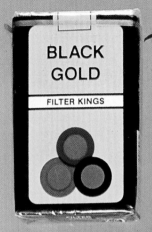

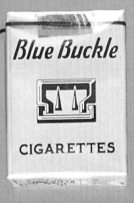

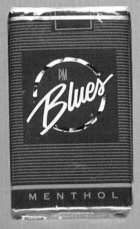

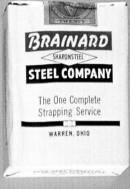

Black Gold, 1984,
House brand, $7-9

Blue Buckle, 1950,
Trademark, $40-55

Blues, 1995, $4-6

Brainard Steel Co.
1951, Your Name
Cigarette co. $60-85

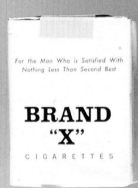

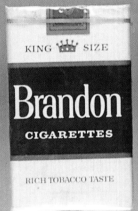

Brand X, 1960, $25-35

Brandon, 1961-68, $7-9

Bravo, 1978,
Non-tobacco, $8-12

Back of Bravo pack

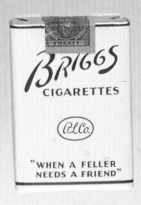

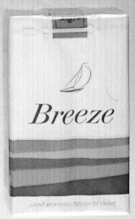

Brennig's Own,
1958, $40-55

Briggs, 1930, Pipe
tobacco, $60-85

Bravo, 1964, Lettuce,
non-tobacco, $55-65

Breeze, 1959, $25-35

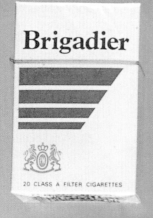

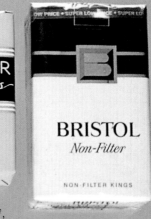

Brigadier, 1979,
Trademark, $25-35

Bright Star, 1928-37,
Nothing but the very
best, $60-85

Bristol, 1966,
Trademark, $25-35

Brighton Convertible,
1968, $7-9

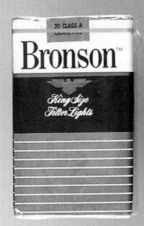

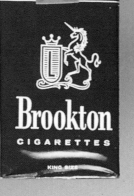

Bronson, 1983, $7-9 Brookton, 1958, $40-55 Brookwood,
1979-81, $25-35

Brownies, 1938, Tobacco
leaf center, $55-65

Buckingham,
1934, $60-85

Buffalo Athletic Club, 1948, $55-65

Buffalo Spirit,
1990, $8-12

Bogart, 1964,
Non-tobacco, $25-35

Born Free, 1995, $2-4

Boro, 1971, Trademark,
$25-35

Boultbee & Colby, 1922, $90-135

Bounty, 1978,
Trademark, $25-35

Bull Durham, 1966, $8-12

Bull Durham, 1978, $7-9

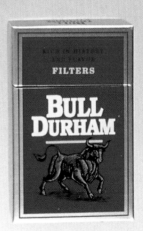

Bull Durham, 1978, $7-9

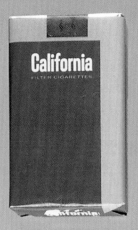

California, 1972,
Trademark, $25-35

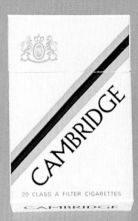

Cambridge, 1966,
Trademark, $25-35

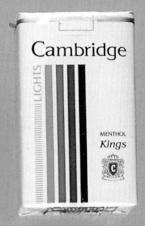

Cambridge,
1970, $8-12

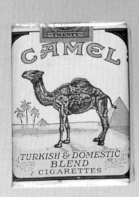

Camel, 1933, $55-65

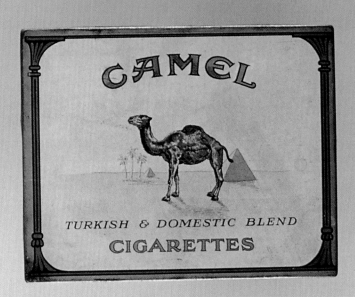

Camel, 1933, 50 count, $150-190

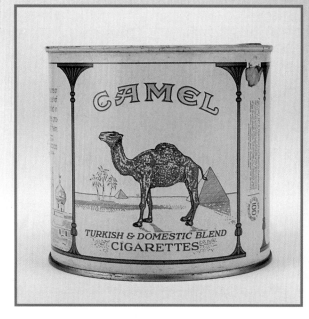

Camel, 1940s, 100 ct. $180-225

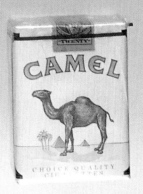

Camel, 1958, Cleaned-up pack,
off market by Nov. 1958, $55-65

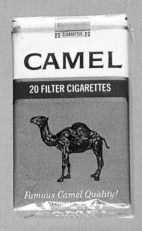

Camel, 1965, $25-35

Camel, 1966-68, Test market $25-35

Camel Lights, 1972, $7-9

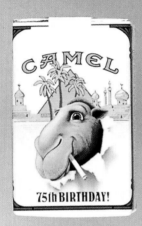

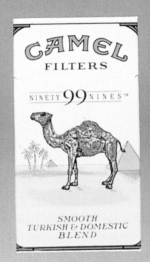

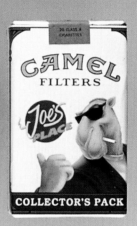

Camel, 1988, 75th birthday, $55-65

Camel, 1991, 99mm, $25-35

Camel, 1994, One of Joe's collector pack series, $55-65

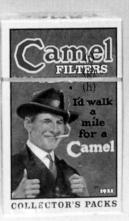

Camel, 1994, One of States series, $55-65

Camel, 1995, One of Joe's packs, $55-65

Camel, 1995, One of Old ads series, $55-65

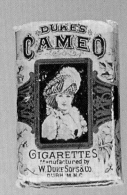
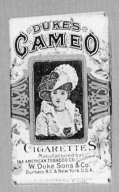
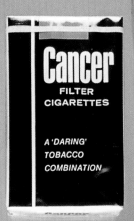

Duke's Cameo, 1878, first production, $180-225

Duke's Cameo 1887, From updated machine, $150-190

Cancer, 1966, $8-12

Capri, 1975, Trademark, $25-35

Cardinal, 1992, $4-6

Carl Henry, 1926, $55-65

Carlton, 1961, $25-35

Carlton, 1971, $7-9

Carmen, 1929, First design, $60-85

Carmen, 1932, Second design, $60-85

Carmen, 1971, Trademark, $25-35

Carnival, 1968,
Trademark, $25-35

Carriage Trade, 1976,
Trademark, $25-35

Cascade, 1964-70, SB
coupons, $25-35

Casinos, 1967, $25-35

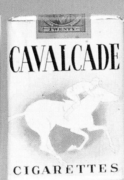

Cavalcade,
1935-44, $55-65

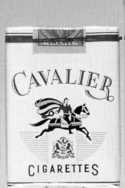

Cavalier,
1939, $55-65

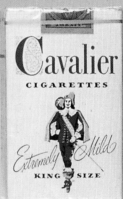

Cavalier,
1954, $40-55

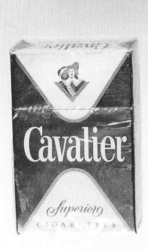

Cavalier, 1955, $40-55

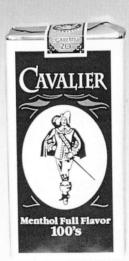

Cavalier, 1992,
$4-6

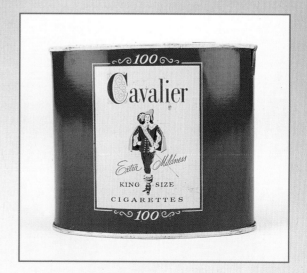

Cavalier, 1950, 100 ct. oval tin, $180-225

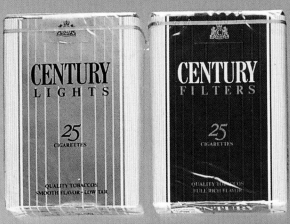

Century 25s,
1987, $4-6

Century 25s,
1987, $4-6

Century 100s,
1968, $8-12

Charing Cross,
1937, $55-65

Chasers, 1975, $25–35

Chelsea, 1943, $55-65

Chesterfield, 1887,
Cards inside, $180-225

Chesterfield,
1932, $70-95

Chesterfield Kings,
1962, $8-12

Chesterfield, 1911-44, 50 ct. 3 designs, $90-135

Chesterfield, 1985, $8-12 Chesterfield 101s, Chesterfield, Chesterfield,
 1964, $40-55 1968, $40-55 1968, $40-55

Chesterfield, 1980, $8-12

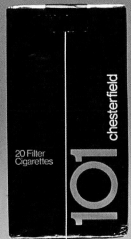
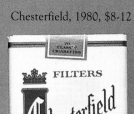

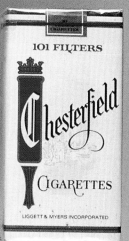

Chesterfield, Chesterfield
1967-69, $25-35 101s, 1980-85,
 $30-35

Chesterfield 101s,
1973, $25-35

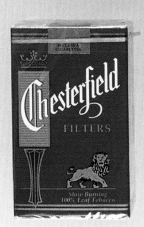
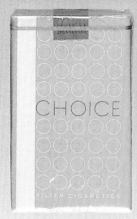
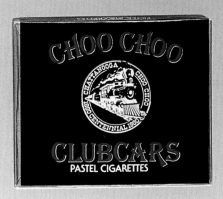

Choo Choo Club Cars, 1980, $8-12

Chesterfield, 1989, $4-6 Choice, 1974,
 Trademark, $25-35

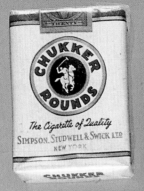

Chukker Rounds,
1940, $55-65

Chukker Rounds,
1936, $55-65

Chukkers, 1932, $70-95

Churchhill,
1940, $40-55

Cigarette Time, 1934,
Produced one year,
$70-95

Cimarron, 1993, $4-6

Cindy, 1935, $55-65

 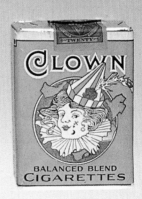

Class A, 1987, $4-6

Clipper, 1941, $55-65

Clown, 1920-38, Big
seller in 20's & 30's,
$70-95

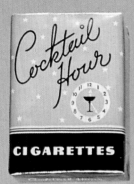

Cocktail Hour,
1935, $55-65

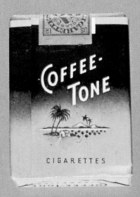

Coffee Tone, 1941,
Wartime wrapper, $55-65

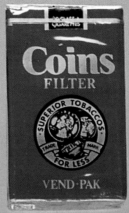

Coins, 1985, Made for
vending machine, $7-9

Coins, 1985, $7-9

Cold Harbor, 1966,
Test market, Ohio, $25-35

Colleen, 1967,
Trademark, $25-35

Colony,
1964, $8-12

Colorado, 1968,
Trademark, $25-35

Combo, 1967,
Trademark, $25-35

Combo, 1969,
Trademark, $25-35

Commander, 1959,
Test market, $25-35

Compac, 1961,
Test market, $25-35

Compass, 1965,
Trademark, $25-35

Competidora,
1979, $7-9

Condax, 1901, Self-closing box,
$180-225

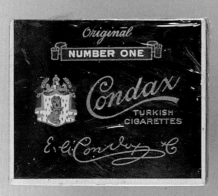
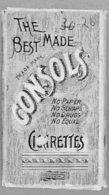
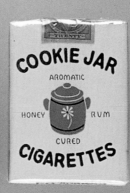
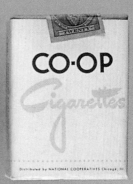

Condax No. 1, 1928, $60-85

Consols, 1872-96,
$180-225

Cookie Jar,
1947, $40-55

Co-op, 1948,
$40-55

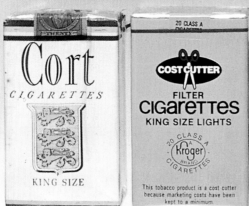

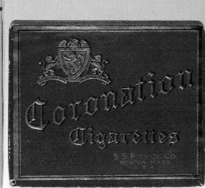
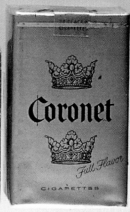

Cort, 1940, lead foil
inner liner, $55-65

Cost Cutter,
1981, $7-9

Coronation, 1930, $55-65

Coronet, 1962, $25-35

Cougar, 1969,
Trademark, $25-35

Coupon, 1911-68,
$60-85

Cowboy, 1972,
Trademark, $25-35

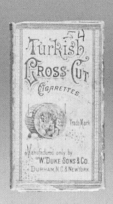
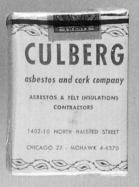

Cross-Cut, 1887,
$200-250

Cross Cut, 1880,
Medicated cigarette,
$250-325

Culberg, 1951, Your
Name Cigarette Co.
$40-55

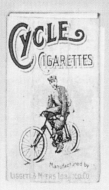
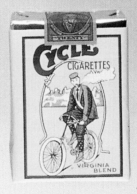

Cycle, 1911, 10 ct.
$75-115

Cycle, 1928, 20 ct.,
$40-55

Dale, 1964, Trademark, $25-35

Dallas, 1978, Trademark, $7-9

Darkies, 1942, 10 count, $60-85

Daytona, 1971, Trademark, $25-35

Debs, 1939, "It's very smart", $55-65

Decade, 1976, $8-12

Dawn, 1975, Test Market, $25-35

Deities, 1938, $55-65

Delta, 1985, $7-9

Denictor, 1941, $55-65

Denver, 1973, Trademark, $25-35

Devon, 1962-68, Test market, $25-35

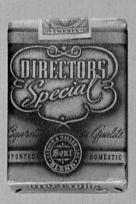

Director's Special, 1942, Two types, $55-65

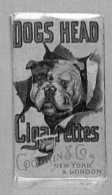

Dogs Head, 1892-95, $180-225

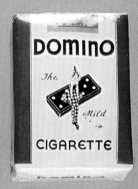

Domino, 1931-59, $55-65

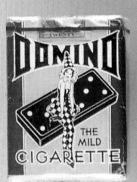

Domino, 1933, $55-65

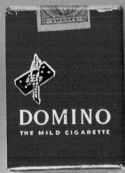

Domino, 1956, $40-55

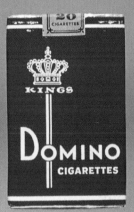

Domino, 1954, $40-55

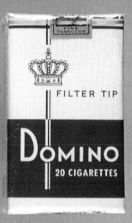

Domino, 1959-76, $8-12

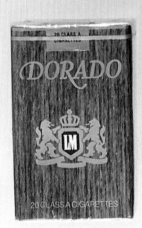

Dorado, 1977-85, $7-9

Dorado, 1962, Trademark, $25-35

Doral, 1967, $8-12

Doral II, 1978, $7-9

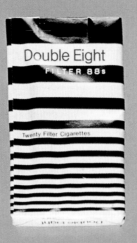

Dorchester, 1950,
Trademark, $40-55

Double Eight, 1968,
Trademark, 88mm,
$25-35

Doublets, 1941-44, $75-95

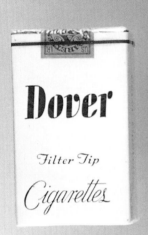

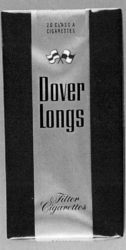

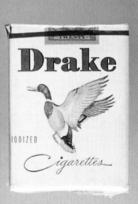

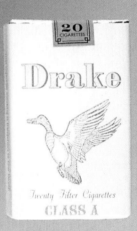

Dover, 1959,
Trademark, $25-35

Dover Longs,
1967, $8-12

Drake, 1946-59, Low
nicotine, $40-55

Drake, 1973, $7-9

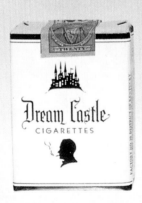

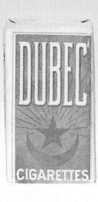

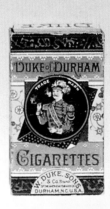

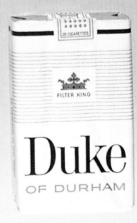

Dream Castle, 1936,
$55-65

Dubec, 1891-1911,
$150-190

Duke of Durham,
1890-1911,
$200-275

Duke of Durham,
1956-70, $25-35

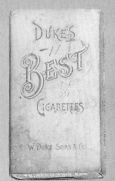
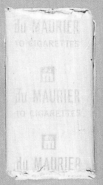
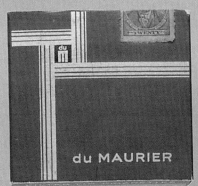
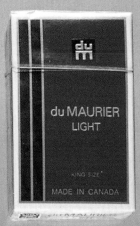

Duke's Best, 1884, $180-225

duMaurier, 1912, Hand rolled, $180-225

duMaurier, 1955-? $40-55

duMaurier, 1975, $7-9

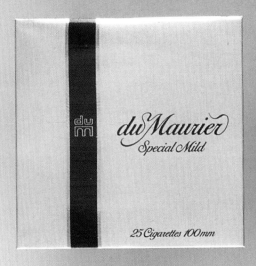
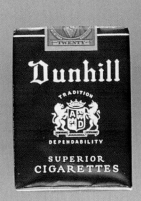
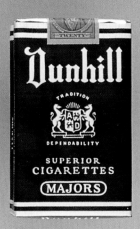

duMaurier, 1965, $25-35

Dunhill, 1938, $55-65

Dunhill, 1940-52, $40-55

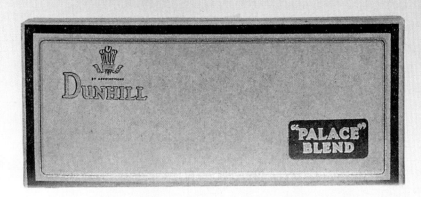

Dunhill, 1938, Palace Blend, $90-135

Dunhill, 1952, $40-55

Dunhill International,
1978, $7-9

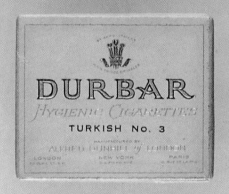

Durbar No. 3, 1902, $90-135

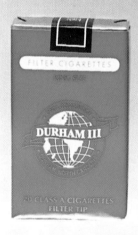

Durham III, 1996,
$15-25

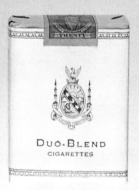

Duo-Blend, 1948,
$60-85

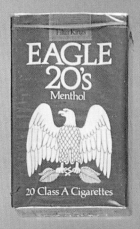

Eagle 20s, 1975, $15-25 Eagle 20s, 1993, $4-6 Early Virginia,
1935, $55-65

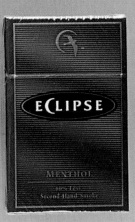

Echo, 1939, $55-65 Eclipse, 1995, Cigarette Eclipse, 1996, Still
flavor with no smoke, on test market as of
$15-25 1999, $7-9

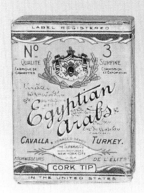
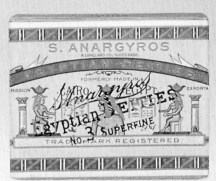
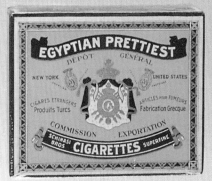

Egyptian Arabs No. 3, Egyptian Deities No. 3, Egyptian Prettiest,
1909, $75-115 1911, $75-115 1930, $70-95

Egyptienne Luxury,
1905-11, $90-135

Egyptienne Luxury, 1911,
20 count, $90-135

Egyptienne Straight,
1913, $90-115

Egyptienne Straight, 1943, $40-55

Eli Cutter, 1984, $8-12 each.

El Cuño, 1963, Finest
cigar tobacco, $25-35

Elliott, 1996,
$15-25

Embassy, 1947,
$40-55

Embra, 1969-70,
$25-35

Encore, 1955, Custom fashioned mouthpiece, $40-55

Encore, 1963, Recessed filter, $25-35

English, 1920, $70-95

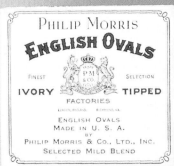

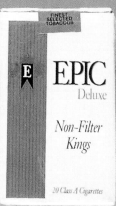
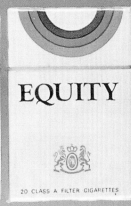

English ovals, 1914-present, Check price guide, $4-350

Epic, 1975, Trademark, $25-35

Equity, 1968, Trademark, $25-35

Esquire, 1937, $55-65

Eve, 1968, $8-12

Eve, 1973, $7-9

Eve, 1990, $4-6

Explorer, 1960, Trademark, $25-35

F & D, 1974, $4-6

F and D, 1936-38, Fine and Dandy, $70-95

Fact, 1974, $25-35

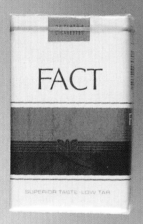

Fact, 1977, $7-9

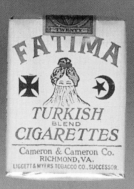

Fatima, 1887-1996,
Check price guide, $4-190

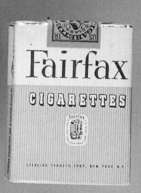

Fairfax, 1950,
Chlorophyll, $40-55

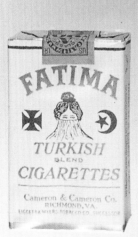

Fatima, 1887-1996,
Check price guide, $4-190

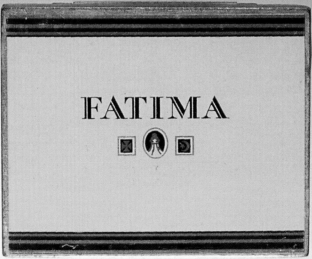

Fatima, 1911-date, $200-250

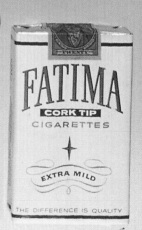

Fatima, 1954,
Cork tip, $40-55

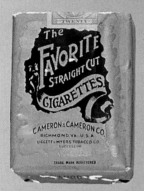

Favorite Straight Cut,
1894-1911, $90-135

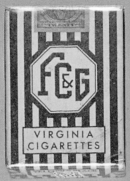

FC&G, 1928,
Same as Yellow and
Black, $60-85

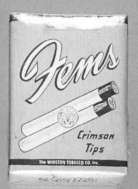

Fems, 1940-1944,
Crimson tips, $55-65

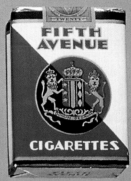

Fifth Ave,
1935, $55-65

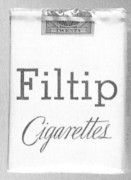

Filtip, 1950,
Trademark, $55-65

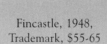

Fincastle, 1948,
Trademark, $55-65

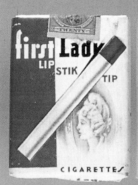

First Lady, 1939,
Lipstik tip, $55-65

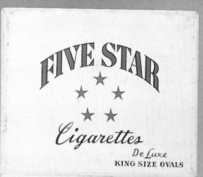

Five Star, 1945, $75-115

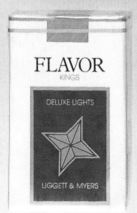

Flavor, 1981, $7-9

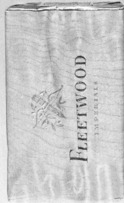

Fleetwood, 1941-44,
$40-55

Flair, 1968, $8-12

Focus, 1988,
Trademark, $25-35

Formal, 1942, $55-65

Frappé, 1960-74,
Mint green menthol,
$8-12

Free, 1979, non-tobacco,
$15-25

Free, 1984, non-tobacco,
$8-12

Full House, 1928, $60-85

Frontier, 1969,
Trademark, $25-35

G-D, 1954, $55-65

Galaxy, 1960-1985,
$8-12

Gatlin Burlier
Smokies, 1978, $8-12

Gatlin-Burlier Smokies,
1981, $8-12

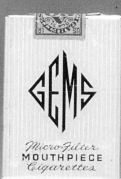

Gems, 1932-58,
$60-85

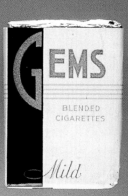

Gems, 1934, $60-85

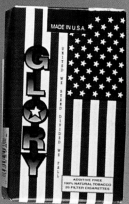

Glory, 1996,
Two kinds, $7-9

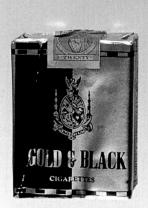

Gold and Black,
1955, $55-65

Golden Lights,
1978, $7-9

Golden Lion, 1874,
Trademark, $25-35

Golden Rule,
1934, $60-85

Golden State,
1935, $55-65

Gold Falcon,
1972, $7-9

Gold Stripe, 1967,
Trademark, $25-35

Gordon Buchannan
1955, $55-65?

Gordon Buchannan, 1932, $70-95

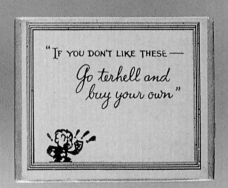

"Go terhell & buy your own", 1931, $60-85

Go To Hell!,
1987, $7-9

GPC, 1980, $8-12

GPC, 1989, $4-6

Grand Prix, 1994, $4-6

Green Mist, 1975,
Trademark, $25-35

Gridlock, 1988, $4-6

Gunsmoke, 1994, $8-12

Gunsmoke, 1994, $8-12

Gunsmoke, 1995, $3-6

Gus' Smoke Shop, 1976, $25-35

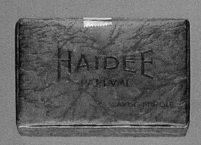
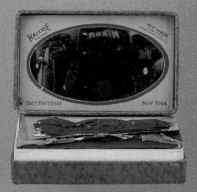

H.D. 1933,
"Union Made",
$55-65

Haidee, 1883, Mirror
inside, $325-425

Haidee, 1883, 10 ct. $325-425

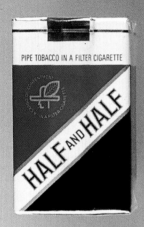
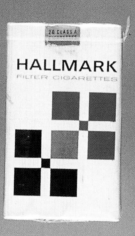

Half and Half, 1954-85,
Pipe tobacco, $25-35

Hallmark, 1965,
Trademark, $25-35

Hallmark, 1977, $7-9

Happy Hit,
1935, $55-65

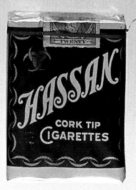
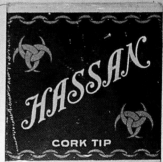

Harley-Davidson,
1988, $40-55

Harley-Davidson,
1988, $40-55

Hassan, 1911, $200-250

Hassan, 1945, $60-85

Havana, 1938, $55-65

Havana No. 38, 1966, $8-12

Havana No. 38, 1966, $8-12

Havana Ovals, 1968, $8-12

Havana Vega, 1956, $25-35

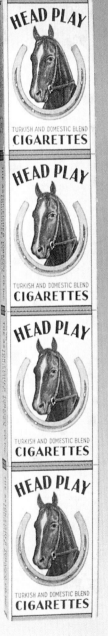

Hawk, 1970,
Trademark, $25-35

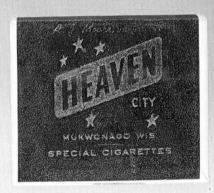

Heaven, 1955, $40-55

Head Play, 1933, longest
cigarette made, $150-190

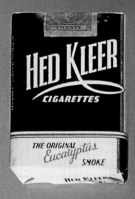

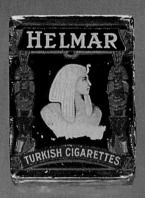

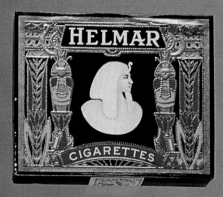

Hed Kleer, 1935-36,
$75-115

Helmar, 1938,
$90-135

Helmar, 1947, $55-65

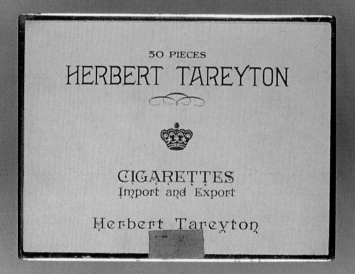

Herbert Tareyton, 1929, $225-300

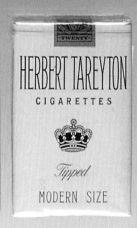

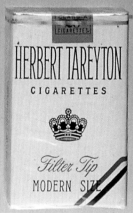

Herbert Tareyton,
1913-23, $75-115

Herbert Tareyton,
1941, $55-65

Herbert Tareyton,
1957, $25-35

Herbert Tareyton,
1954, $40-55

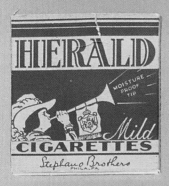

Herald, 1931, 8 count, $75-115

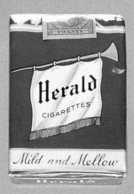

Herald, 1955, $60-85

Herald, 1989, $7-9

Here, 1975,
Trademark, $25-35

Heritage, 1972, $25-35

Heritage, 1990, $7-9

High Admiral, 1893-1896,
$250-$375

High Grade, 1883,
$225-350

High Score, 1950,
$40-55

Highway, 1992, $4-6

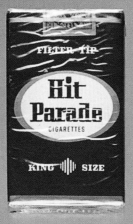

Hit Parade, 1955, $40-55

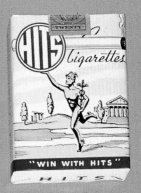

Hits, 1936, $40-55

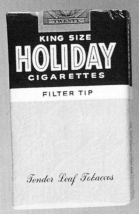

Holiday, 1948-69,
$25-35

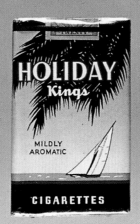

Holiday, 1948-69, $40-55

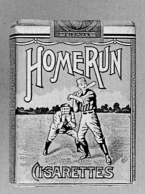

Home Run, 1944,
$40-55

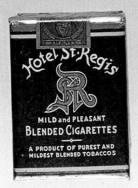

Hotel St. Regis,
1948, $40-55

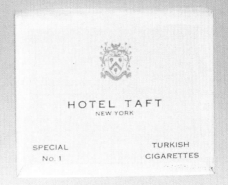

Hotel Taft, 1955, $40-55

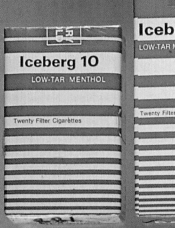
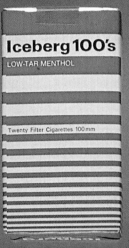
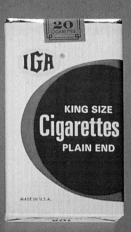

Iceburg 10,
1971-74, $7-9

Iceburg 100s,
1973-85, $7-9

IGA, 1967, For food
marts, $25-35

IGA, 1968, For food
marts, $25-35

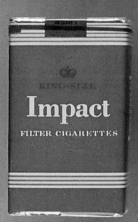

Impact, 1978,
Trademark, $25-35

Imperiales, 1930,
$60-85

In, 1973, Trademark,
$25-35

Island Longs, 1968, unusual slide
and shell box, 101mm, $25-35

Ivanoff Russian, 1901,
$90-135

Ivory tipped, 1974,
Trademark, $25-35

Jacks, 1992, $3-5

Jaguar Longs,
1952, $60-85

Jasmine Slims,
1993, $7-9

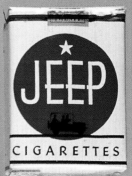
Jeep, 1941, $55-65

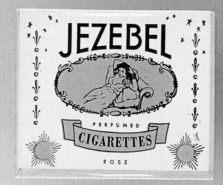
Jezebel, 1955, Perfumed, $55-65

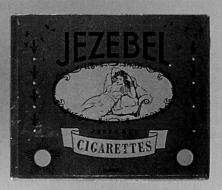
Jezebel, 1955, Perfumed, $55-65

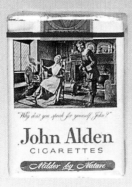
John Alden, 1947,
$55-65

John Alden, 1952,
$55-65

John Metaxas,
1944-47, $60-85

Johnnie Walker,
1935, $55-65

Johnnie Walker,
1938, $55-65

Jubilee, 1965, Trademark, $25-35

Julep, 1928, "Hint of mint",
$60-85

Jumbo, 1932, $55-65

Jupiter, 1965,
Trademark, $25-35

Jumbo, 1945, 'V.M.J." cigar box. $180-225

Karnak, 1910-1911,
$75-115

Kelly, 1986,
Trademark, $25-35

Kensitas, 1936, $70-95

Kent, 1957,
"micronite filter",
$25-35

Kent, 1952,
"micronite filter",
$40-55

Kent Golden Lights,
1984, $7-9

Kent III, 1978, $8-12

Kent International,
1994, $3-6

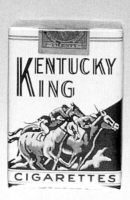

Kentucky King, 1934, Two
different pictures, $55-65

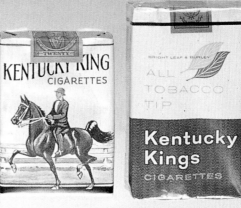

Kentucky Kings,
1956, Tobacco Filter,
$25-35

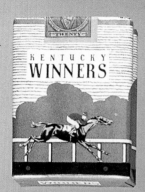

Kentucky Winners,
1934, Horse going right,
$55-65

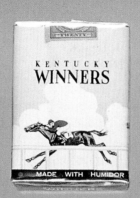

Kentucky Winners,
1938, Horse going left,
$55-65

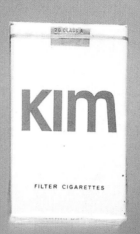

Kim, 1971,
Trademark, $25-35

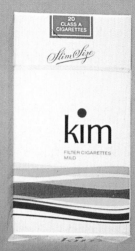

Kim Slims, 1987, $7-9

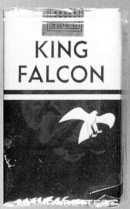

King Falcon,
1972, $7-9

King Sano,
1953 $40-55

King Sano,
1966, $8-12

Kingsley, 1939, $55-65

Knightsbridge,
1985, $7-9

Kool, 1937,
$40-55

Kool, 1933, 50 count $180-225

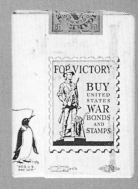

Kool, 1944, 50 count $150-190

Kool, 1933, $60-65

Kool, 1942, Buy Bonds,
$60-85

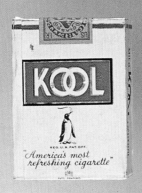

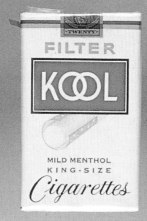

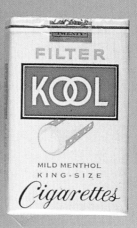

Kool, 1955, 4-line verse
on back, $55-65

Kool, 1956, 2-line verse
on back, $25-35

Kool, 1963, $8-12

Kool Naturals, 1976,
Test market Arkansas,
$25-35

Kool International, 1978, $7-9

L&M, 1953,
70mm filters, $40-55

L&M, 1954,
Filter Kings, $40-55

L&M, 1959,
70mm filters, $25-35

L&M, 1959,
Filter Kings, $25-35

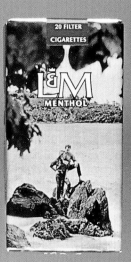

L&M, 1968, $40-55

L&M, 1972, $40-55

L&M, 1972, $40-55

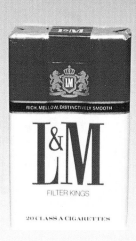

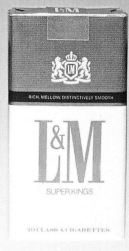

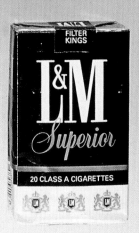

L&M, 1974, $7-9

L&M, 1987, $7-9

L&M Longs,
1974, $7-9

L&M Superior,
1978, $7-9

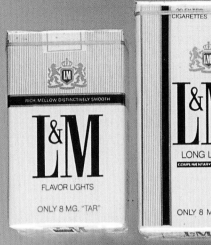

L&M, 1976, $7-9 L&M, 1976, $7-9 L&M, 1987, 30 count, L.T. Brown, 1975,
$25-35 $7-9

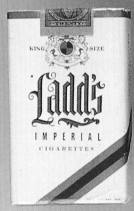
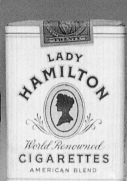
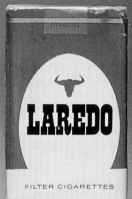
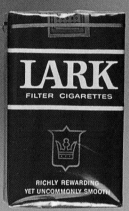

Ladd's Imperial, Lady Hamilton, Laredo, 1968, $8-12 Lark, 1963, $25-35
1940-1944, "Unquestionably 1919-1946, $55-65
a finer cigarette". $55-65

Lark, 1969, Lark II 1977, Las Vegas, 1983, Las Vegas, 1969,
$8-12 $8-12 $8-12 $8-12

Legend,
1993, $4-7

Leighton,
1948, $40-55

Leighton, 1936, $70-95

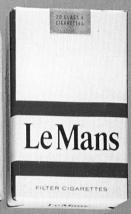

LeMans, 1972,
Trademark by BAW,
$25-35

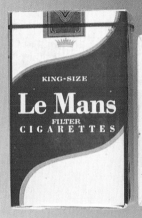

LeMans, 1973,
Trademark by RJR,
$25-35

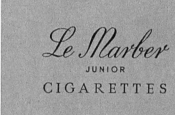

Le Marber, Junior, 1939, $70-95

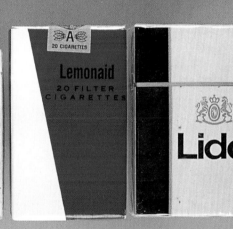

Lemonaid, 1974,
Trademark, $25-35

Lido, 1957,
Trademark, $25-35

Less, 1974,
Trademark, $25-35

Life, 1948, Wet Proof
Paper, $40-55

Life, 1952, $40-55

Life, 1963-71,
"Millicel" $8-12

Life, 1977, $7-9 Limelight, 1964, Lion, 1928, war paper, Listerine, 1927,
 Trademark, $25-35 $60-85 $60-85

Little King, Logic, 1962, London Life, London Lords,
1953, $25-35 Trademark, $25-35 1922, $90-135 1968, $8-12

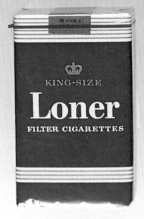
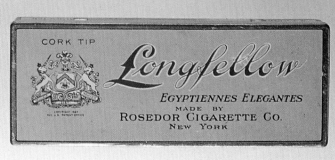

Longfellow, 1923-36, $150-190

Loner, 1973, Trademark,
 $25-35

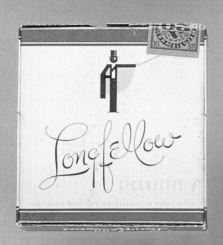

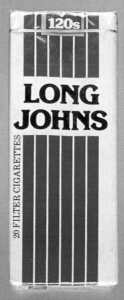

Longfellow, 1943, $40-55

Long Johns, 1975,
$7-9

Lord Mansfield, 1968,
Trademark, $25-35

Lords, 1952, Low nicotine, $55-65

Lord Salisbury, 1935, $55-65

Louisiana World Expo.
1984 (World's Fair),
$25-35

LSD, 1967, 1 of 10 spoof
packs, $60-85

Lotus Club, 1955, $40-55

Lucky Charm, 1925,
$60-70

Lucky Strike, 1930, $150-225

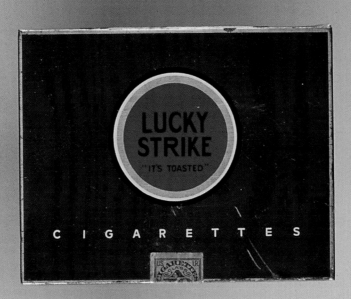

Lucky Strike, 1935, $150-225

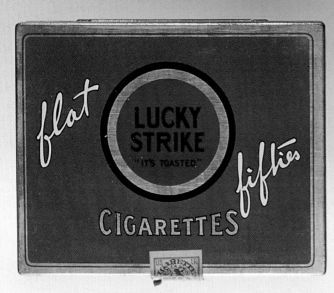

Lucky Strike, $150-190

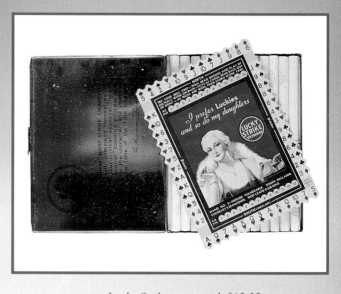

Lucky Strike game card, $15-25

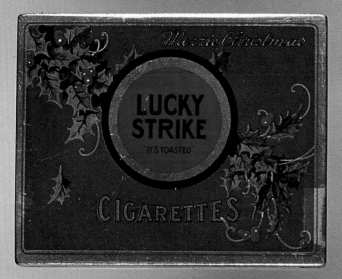

Lucky Strike Christmas, $225-325

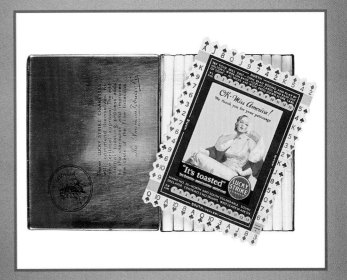

Lucky Strike game card, $15-25

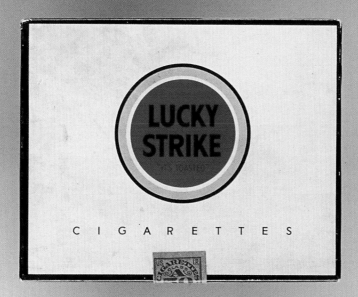

Lucky Strike (White) $150-225

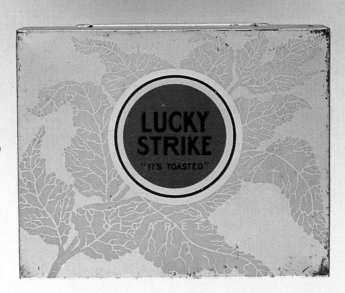

Lucky Strike (Gold Leaf)
$150-225

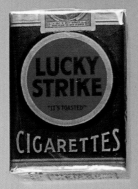
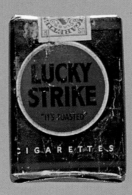
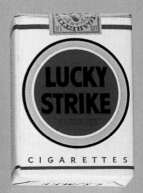

Lucky Strike
(green),1916-1941
$75-115

Lucky Strike (blue),
S-105, No record,
$75-115

Lucky Strike (white)
1942, $65-85

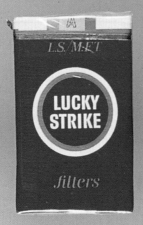
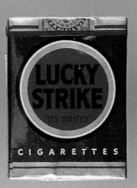

Lucky Strike,
1972, $7-9

Lucky Strike, (green)
1936, $75-115

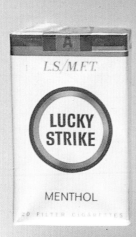
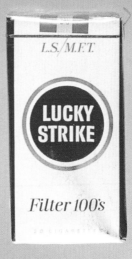
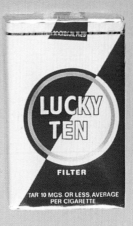

Lucky Strike, 1967, $8-12

Lucky Strike,
1970, $8-12

Lucky Ten, 1971, $25-35

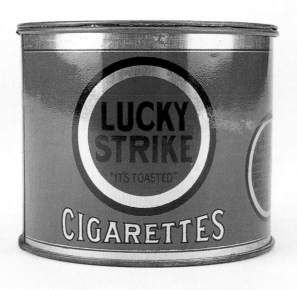

Lucky Strike, 1939, 100 ct. tin, $250-325

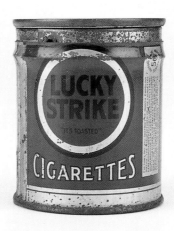

Lucky Strike, 1940, 50 ct. $180-225

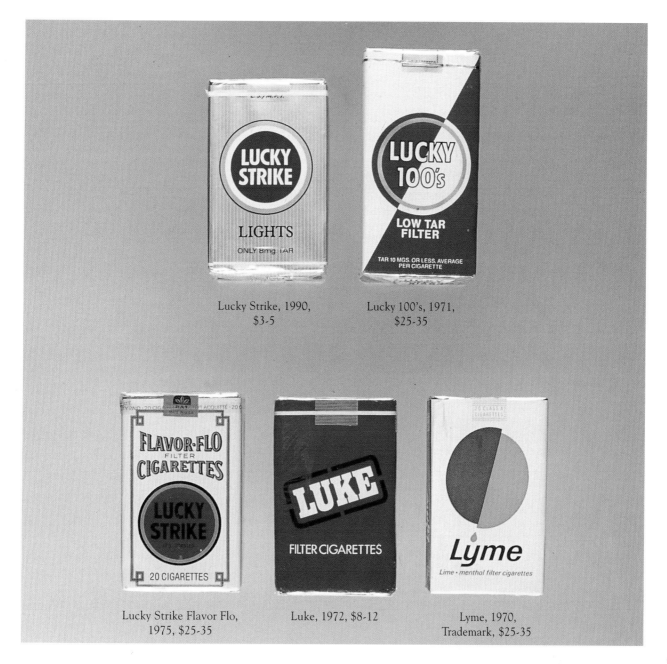

Lucky Strike, 1990,
$3-5

Lucky 100's, 1971,
$25-35

Lucky Strike Flavor Flo,
1975, $25-35

Luke, 1972, $8-12

Lyme, 1970,
Trademark, $25-35

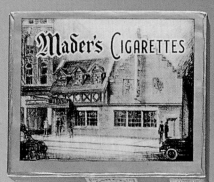
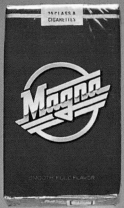

Mader's, 1955, $40-55 Magna, 1987, $8-12 Major, 1986, $4-6 Makaroff, 1939, $55-65

Makaroff, 1909,
$150-190

Malibu, 1987,
$4-6

Mallard, 1973,
$8-12

Manchester, 1994,
$3-6

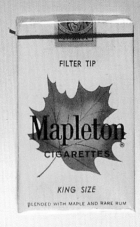
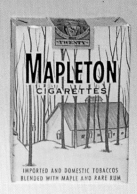

Mapleton, 1937,
$60-85

Mapleton, 1948,
$55-65

Mapleton, 1955,
$25-35

Mapleton, 1954,
$25-35

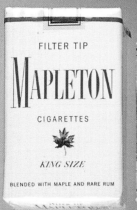

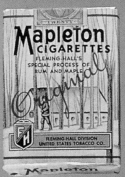

Mapleton, 1955,
$25-35

Mapleton, 1952,
$55-65

Marcovitch, 1967,
Trademark, $25-35

Marker, 1992, $3-5

Mark Ten, 1980,
Trademark, $25-35

Marlboro (tin), 1935, $250-325

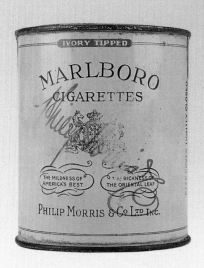

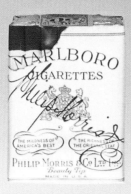

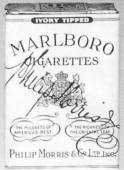

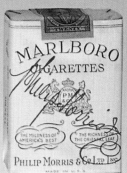

Marlboro (tin), 1935,
$300-425

Marlboro, 1936-55,
red tipped, $60-85

Marlboro, 1924-36,
Known as a "sissy"
cigarette! $60-85

Marlboro, 1930-55,
$60-85

Marlboro, 1954, $40-55

Marlboro, 1961, $25-35

Marlboro Menthol,
1966, $8-12

Marlboro, 1967, $8-12

Marlboro Country,
1972, 70mm Trademark,
$25-35

Marlboro, 1985, $7-9

Marlboro Lights,
1971, $7-9

Marlboro 25's, 1991, $3-5

Marlboro Medium,
1992, $3-5

La Marquise,
1974, Trademark,
$25-35

Marshall's
(Cubebs), 1938,
$60-85

Martini, 1936-44,
$55-65

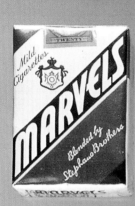
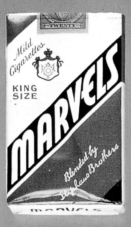
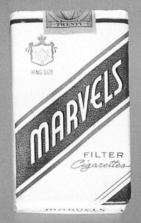
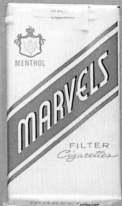

Marvels, 1931-58,
$55-65

Marvels, 1955,
$25-35

Marvels, 1960-75,
$25-35

Marvels, 1964-75,
$15-25

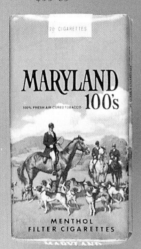
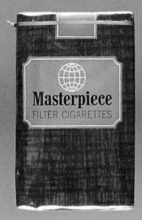
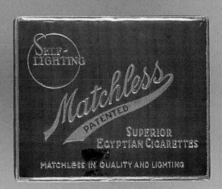

Maryland, 1966,
Riding with the
hounds, $25-35

Masterpiece, 1964,
$25-35

Matchless, 1930, $70-95

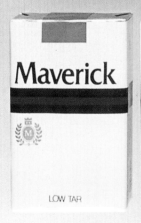
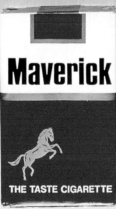

Maverick, 1978,
$25-35

Maverick, 1971,
2 Var. $7-9

Maverick, 1997,
$3-5

Maverick, 1997,
$3-5

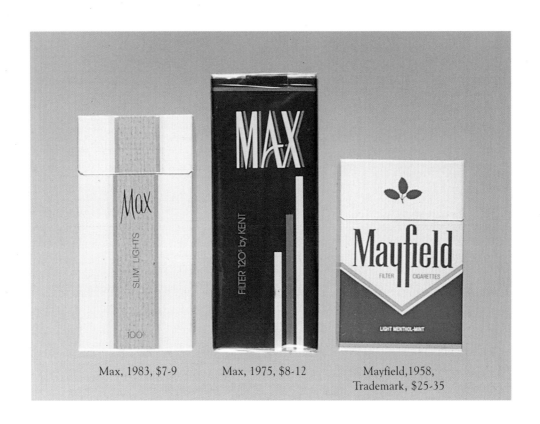

Max, 1983, $7-9 Max, 1975, $8-12 Mayfield,1958,
Trademark, $25-35

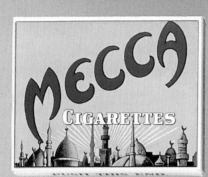

Mecca, 1911, $75-115

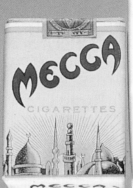

Mecca, 1945,
$40-55

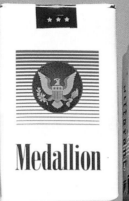

Medallion, 1994, $3-5

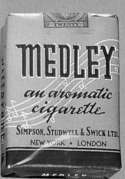

Medley, 1939, $55-65

Medley, 1946, $40-55

Melachrino, 1884, $180-225

Melachrino, 1912,
100 count, $200-250

Melachrino, 1912, 50 count, $180-225

Melachrino, 1959, $25-35

Melachrino, 1959, $25-35

Melowick, 1943, Unusual filter—white cardboard, $60-85

Mercury, 1938, $55-65

Meridian, 1993, $4-6

Merit, 1968, Trademark, $25-35

Merit, 1975, $7-9

Merit, 1989, $3-6

Mermaid, 1967, $8-12

Meteora, date unknown. Approx. $90-135

Metere, 1976, Trademark, $25-35

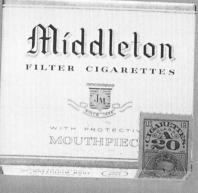

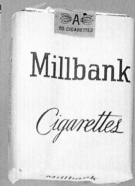

MGM Grand-Reno, 1978, $8-12 Middleton, 1955, $55-65 Millbank, 1948, $40-55

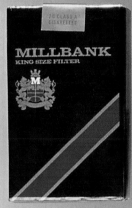

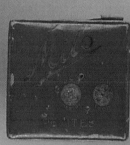

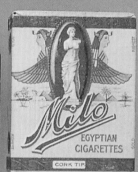

Millbank, 1978, $8-12 Milo Violets, 1930, $55-65 Milo, 1899, 40mm, $90-135 Milo,1924, $60-85

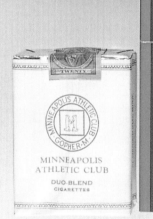

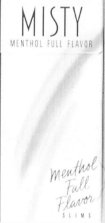

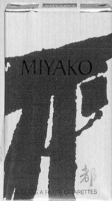

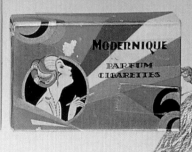

Minneapolis Athletic Club, 1954, $40-55 Misty,1991, $4-6 Miyako, 1974, $8-12 Modernique, 1921, $180-225

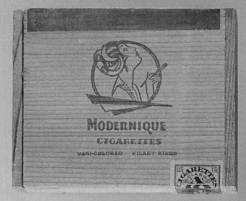

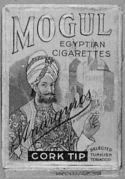

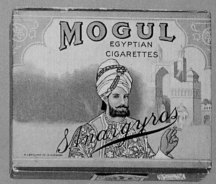

Modernique, 1955, Redwood
box of 50, $150-190

Mogul, 1892,
$180-225

Mogul, 1911, $150-190

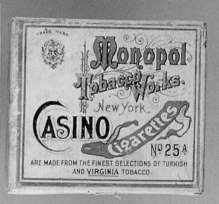

Monaco,1992,
$3-5

Monarch, 1992,
$3-6

Money, 1990
Trademark, $25-35

Monopol Casino,
1884, $150-190

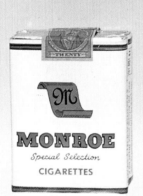

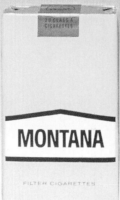

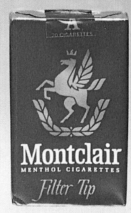

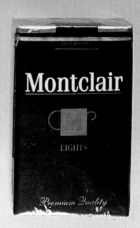

Monroe, 1952,
$40-55

Montana, 1971,
Trademark, $25-35

Montclair, 1970,
$8-12

Montclair, 1989,
$3-6

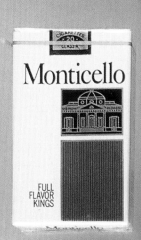
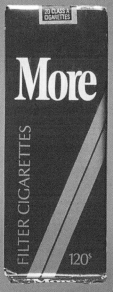
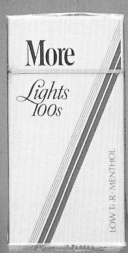

Monticello, 1984,
$3-6

More,1974, $8-12

More, 1983, $7-9

More, 1987, $3-6

Motor, 1897-1938,
S-108, $55-65

Mr. Menthol, 1970-71,
Test market, $25-35

Mr.Slims, 1970,
Trademark, $25-35

Ms, 1972, Trademark,
$25-35

Ms, 1972, Trademark,
$25-35

Multifilter, 1967,
Plastic pack, $25-35

Multifilter, 1973,
$7-9

Multifilter, 1973,
$7-9

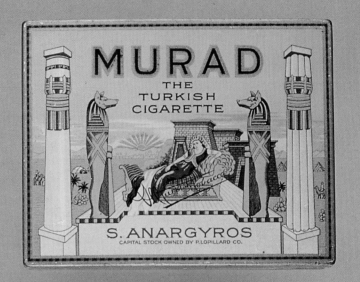

Multifilter, 1976, $7-9

Murad, 1904, $250-325

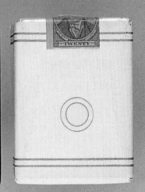

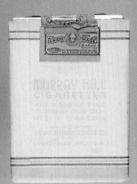

Murad, 1905,
$75-115

Murad, 1971, $7-9

Murray Hill, 1936-44,
$55-65

Back of pack of
Murray Hill

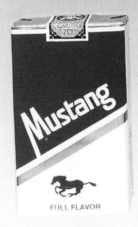

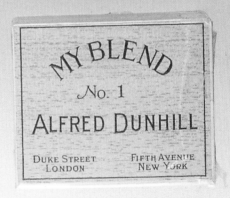

Mustang, 1994, $3-6

My Blend, 1940, Made for
A. Dunhill, $90-135

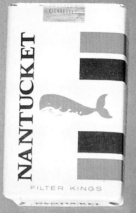
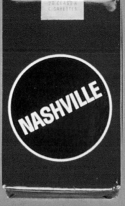
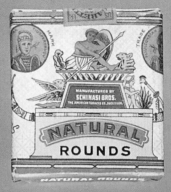

Nantucket, 1984,
$7-9

Nashville, 1971,
$25-35

Natural Rounds, 1930,
$75-115

Natural, 1915,
$75-115

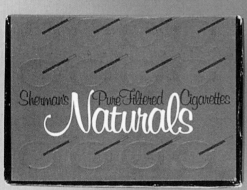
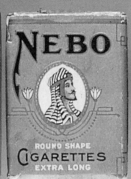
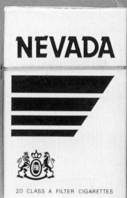
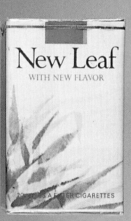

Naturals, 1942, $60-85

Nebo, 1911,
$75-115

Nevada, 1968,
Trademark, $25-35

New Leaf, 1970-1980,
2 variety's, $8-12

Newport, 1956,
Mint, $40-55

Newport, 1967,
Mint, $8-12

Newport, 1970,
Mint, $7-9

Newport, 1985,
Mint, $3-6

Newport, 1975, mint, $7-9

Newport, 1978,
Non-menthol, $8-12

Newport 25's, 1994,
mint, $3-5

Newport Slims, 1992,
Mint, $3-5

Newport Stripes, 1990,
Mint, $3-5

Newport Ice, 1996,
Mint, $3-5

Next, 1978,
Trademark, $25-35

Niagara No. 10,
1939, $55-65

Niagara, 1978,
Trademark, $25-35

No Name, 1950,
Trademark,$40-55

Northwind, 1980, $7-9

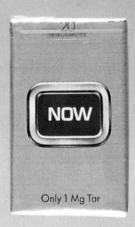

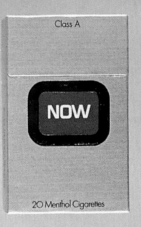

Nova, 1967,
Trademark, $25-35

Now, 1976, $7-9

Now, 1976, $7-9

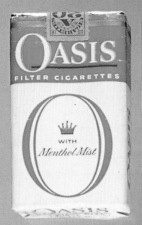
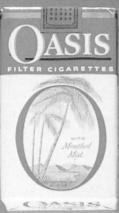
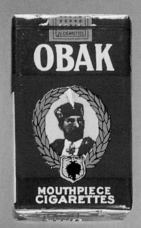
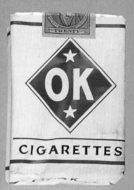

Oasis, 1963-80
With menthol mist,
$25-35

Oasis, 1963-80,
With menthol mist,
$25-35

Obak, 1977,
Re-issue, $7-9

OK, 1950, $40-55

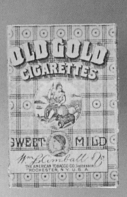
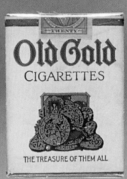
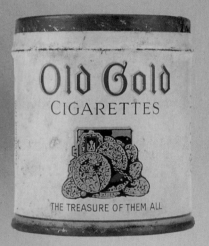

Old Gold, 1884,
$250-325

Old Gold, 1887,
$200-250

Old Gold, 1923,
$60-85

Old Gold, 1948, 50 ct. $225-325

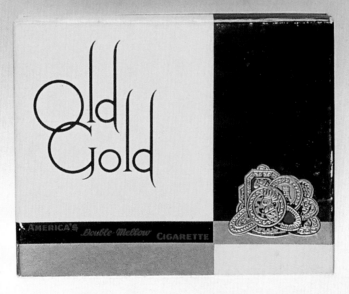

Old Gold, 50 count, $225-325

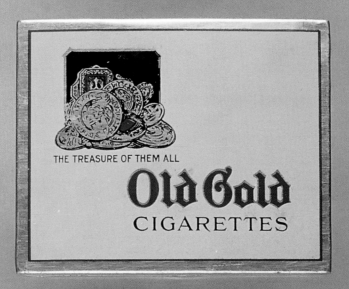

Old Gold, 50 count, $225-325

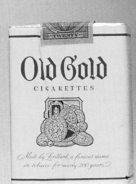

Old Gold, 1943,
$70-95

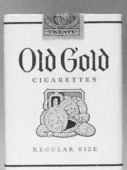

Old Gold, 1955,
$40-55

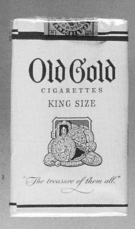

Old Gold, 1952,
$40-55

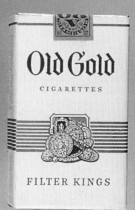

Old Gold, 1954,
Filter, $40-55

Old Gold, 1956,
Filter, $40-55

Old Gold, 1958, Spin
Filter, $35-45

Old Gold Straight,
1957, $40-55

Old Gold Straight,
1960, $40-55

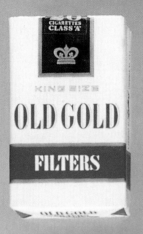
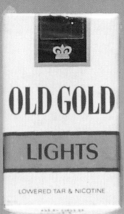
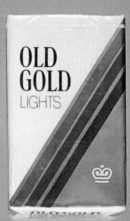
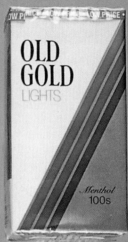

Old Gold, 1967,
$8-12

Old Gold Lights,
1972, $7-9

Old Gold Lights,
1985, $3-6

Old Gold Lights,
1990, $3-6

Old Mill, 1911,
Series 1910, $75-115

Old '76, 113 mm, 1918, $70-95

Omar, 1911-1950s,
$60-85

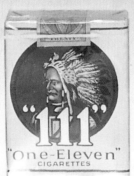
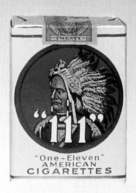
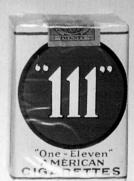

Omni, 1983, $7-9

"111", 1926, $60-85

"111", 1934, $55-65

"111", 1938, $55-65

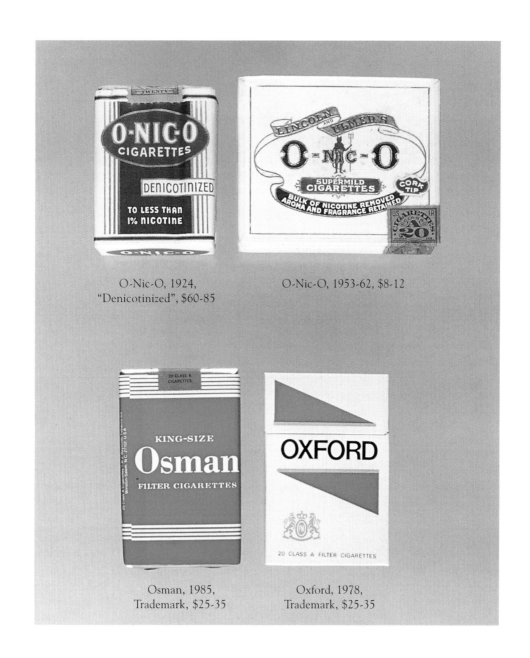

O-Nic-O, 1924,
"Denicotinized", $60-85

O-Nic-O, 1953-62, $8-12

Osman, 1985,
Trademark, $25-35

Oxford, 1978,
Trademark, $25-35

P&Q, 1981, $7-9 Pace, 1995, $3-5 Pacific, 1966, Page boy, 1965,
 $25-35 $25-35

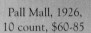
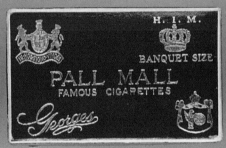
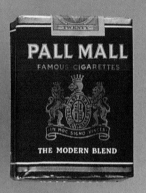

Pall Mall, 1926, Pall Mall, 1926, 20 count, $60-85 Pall Mall, 1930,
10 count, $60-85 $60-85

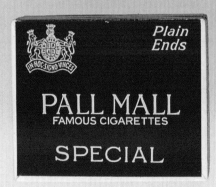
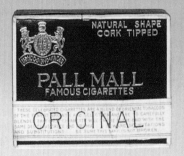
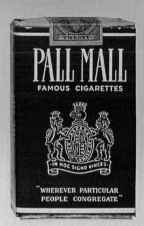

Pall Mall, 1922, $75-115 Pall Mall, 1920s, Pall Mall, 1939,
 $75-115 $55-65

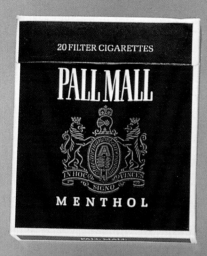
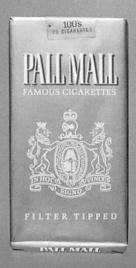
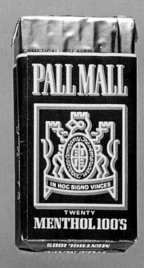

Pall Mall, 1966, $8-12 Pall Mall, 1971, $8-12 Pall Mall, 1976, $8-12

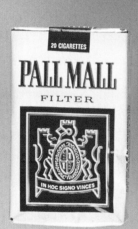
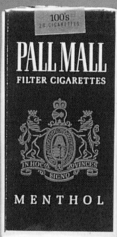
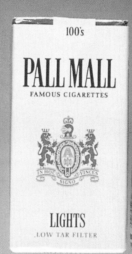
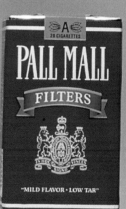

Pall Mall, 1980, Pall Mall, 1976, Pall Mall, 1977, Pall Mall, 1986,
 $7-9 $8-12 $8-12 $5-7

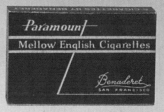

Paons, 1929, 54mm, Paramont, 1936, $60-85
 $90-135

Inside of Paons box.

Par 5, 1967, $25-35

Parkway, 1962,
Trademark, $25-35

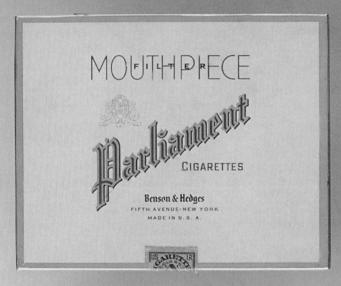

Parliament, 1930, 50 count, $200-275

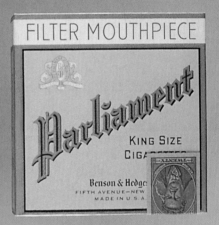

Parliament, 1931, $55-65

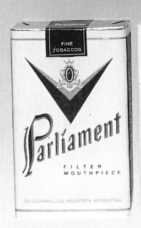

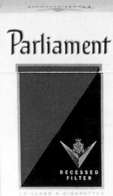

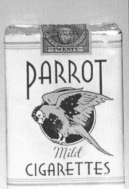

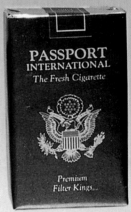

Parliament, 1953,
$40-55

Parliament, 1978,
$7-9

Parrot, 1932, "They
speak for themselves",
$55-65

Passport, 1992,
$4-6

Pastelle, 1954, $40-55

Paul Jones, 1927,
$60-85

Paul Revere, 1973,
$7-9

Paxton, 1963-66,
plastic pack, $40-55

Paxton, 1963-66,
plastic pack, $40-55

Paxton, 1966,
box, $8-12

Peachey, 1920,
$60-85

Penbarry, 1927,
$60-85

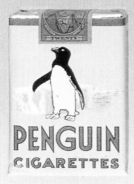

Penguin, 1929,
Early Menthol,
$60-85

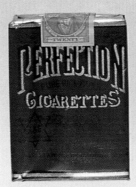

Perfection, 1912,
$75-115

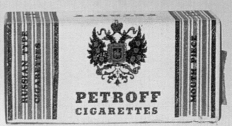

Petroff, 1945, $60-85

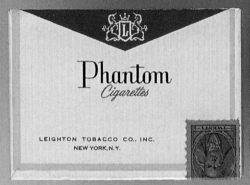

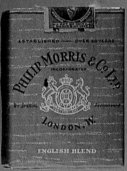

Phantom, 1955, $40-55 Phantom, 1940, $60-85 Philip Morris, 1913, $75-115

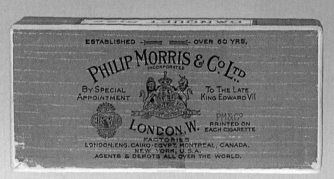

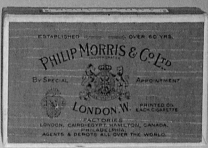

Philip Morris, 1922, 50 count, $225-375 Philip Morris, 1920s, $75-115

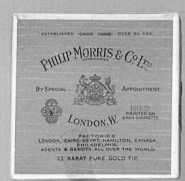
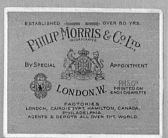
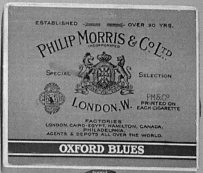

Philip Morris London W.
1922, $225-275

Philip Morris London W.
1922, $225-275

Philip Morris Oxford Blues,
1934, $60-85

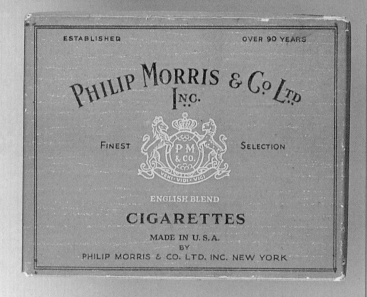
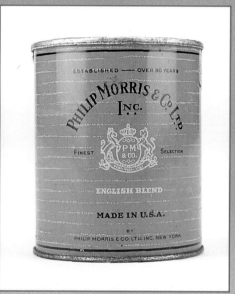

Philip Morris 1934, $225-375

Philip Morris, 1950, 50 ct. $225-325

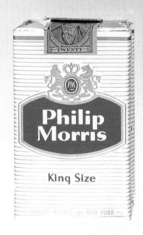
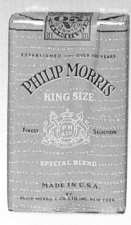
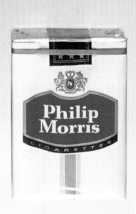
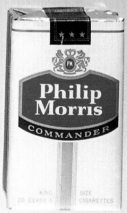

Philip Morris, 1963,
$35-45

Philip Morris, 1955,
$55-65

Philip Morris,
1963-1970s, $25-35

Philip Morris,
1963-1970s, $25-35

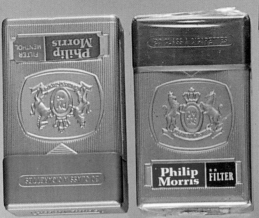

Philip Morris, 1963-66,
Plastic, $40-55

Philip Morris, 1963-66,
Plastic, $40-55

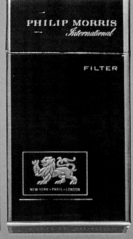

Philip Morris,
1973, $7-9

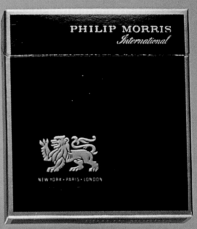

Philip Morris, 1973, $7-9

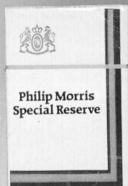

Philip Morris,
1967, Trademark,
$25-35

Philip Morris, 1972,
Trademark, $25-35

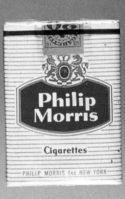

Philip Morris, 1955,
$40-55

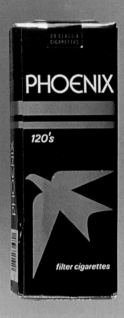

Phoenix, 1975,
$7-9

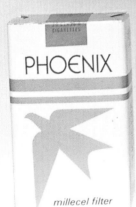

Phoenix, 1978, $7-9

Picayune, 1911-57,
No Series, $75-115

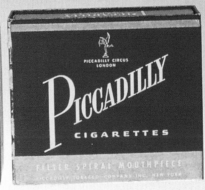

Piccadilly 1920-53, $75-115

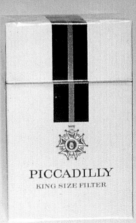

Piccadilly, 1952,
$55-65

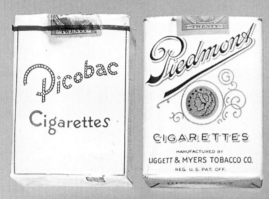

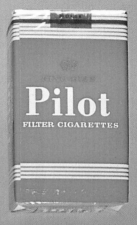

Picobac, 1950,
$55-65

Piedmont, 1929,
$60-85

Piedmont, 1893-1911,
$75-135

Pilot, 1964, Trademark,
$25-35

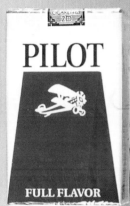

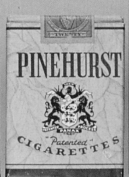

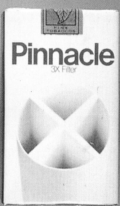

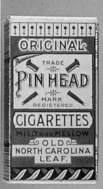

Pilot, 1992, $3-6

Pinehurst, 1945,
$40-55

Pinehurst, 1939-44,
$60-85

Pinnacle, 1970,
$8-12

Pinhead, 1882,
one of Duke's
first, $275-375

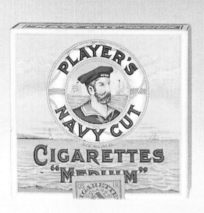

Players Navy Cut, 1938,
$55-65

Players, 1938, 50 count, $250-325

Players, 1983, $7-9

Players, 1984,$7-9

Plus, 1975, Trademark,
$25-35

Plymouth, 1951,
$40-55

Polar, 1930-44,
$55-65

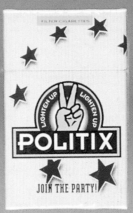

Politix, 1995, $4-6

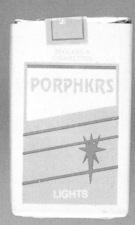

Porphkrs, 1990,
3 types, $4-6

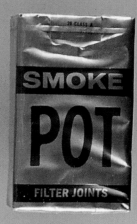

POT, 1967, 1 of 10
"spoof" packs, $60-85

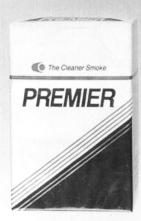

Premier, 1987, $25-35

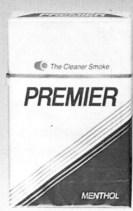

Premier, 1987, $25-35

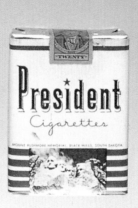

President, 1952,
$55-65

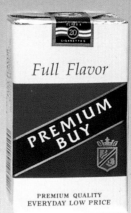

Premium Buy,
1992, $4-6

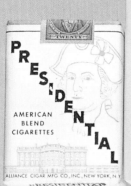

Presidential, 1945, wartime pack, $40-55

Price Breaker, 1982, $7-9

Prime, 1995, $4-6

Princeton, 1969, Trademark, $25-35

Puffies, 1928, $60-85

Puppies, 1945, $60-85

Pure, 1995, Two varieties, $4-6

Pure Virginia, 1953, $40-55

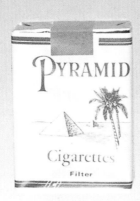
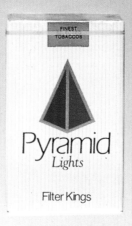
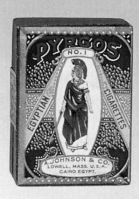

Puritan, 1964, plastic "humidor" box, $40-55

Pyramid, 1985, made for & by imates, $25-35

Pyramid, 1988, $3-5

Pyrgos No.1, 1910, "Egyptian" $90-135

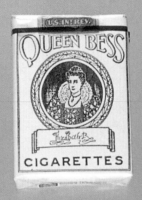

Queen Bess,
1950, $40-55

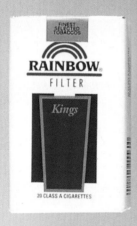

Rainbow, 1987,
$3-5

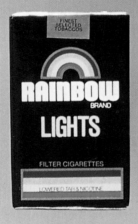

Rainbow, 1993,
$3-5

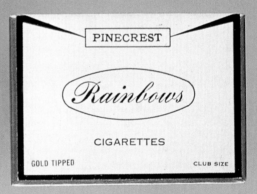

Rainbow (Pinecrest), 1973, $7-9

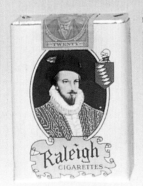

Raleigh, 1928,
$60-85

Raleigh, 1944, war
bond ad on back,
$70-95

Raleigh, 1948,
$60-85

Raleigh, 1952,
$60-85

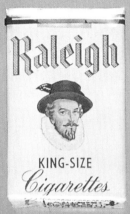
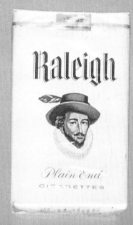
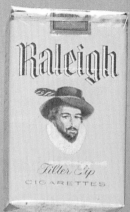

Raleigh, 1953,
$40-55

Raleigh, 1954,
$40-55

Raleigh, 1957,
$25-35

Raleigh, 1958,
$25-35

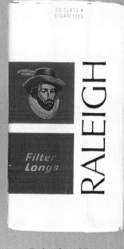

Raleigh, 1967,
$8-12

Raleigh, 1968,
$8-12

Raleigh, 1974,
$7-9

Rameses II, 1895-1958,
$25-190

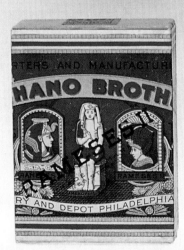
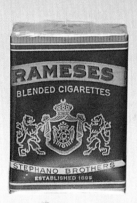
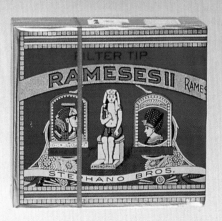

Rameses II, 1932, $55-65

Rameses, 1895-1958,
$25-190

Rameses II, 1895-1958, $25-190

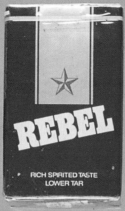

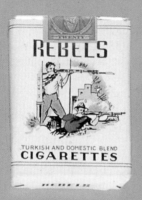

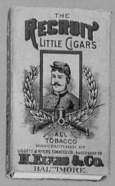

Real, 1977-1980, $8-12

Rebel, 1971, $7-9

Rebels, 1937, $55-65

Recruit, 1888, $180-225

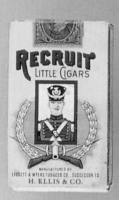

Recruit, 1889, $150-190

Red Crown, 1940, war paper inner wrap, $55-65

Redford, 1970, Test market, $25-35

Red Sun, 1973, Reissue by LAM, $7-9

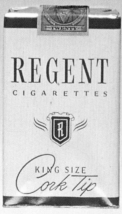

Regent, 1937-50, "buy bonds" $55-65

Regent, 1937-50, $55-65

Regent, 1955, $25-35

Regent, 1954, $25-35

Relu, 1912, $75-115

R1, 1966, $8-12

Reyno, 1957-1970s,
$40-55

Reyno, 1913-1947,
$90-135

Ricardo, 1975,
$7-9

Rich, 1977,
$7-9

Richfield, 1971,
Trademark, $25-35

Richland, 25-pack,
1983, $7-9

Richmond High Class,
1898, $150-190

Richmond Preferred,
1973, Trademark,
$25-35

Richmond Straight Cut,
1911, $225-300

Ritz, 1993, $4-6

Rivalo, 1935,
$55-65

Riviera, 1959,
$25-35

Riviera, 1959,
Trademark, $25-35

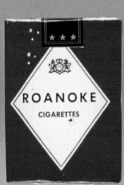

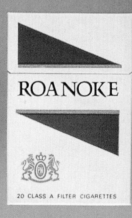

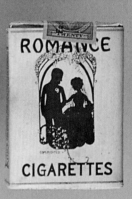

Riviera, 1991, $4-6

Roanoke, 1957,
Trademark, $40-55

Roanoke, 1961,
Trademark, $25-35

Romance, 1928,
$60-85

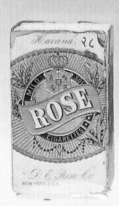

Rose, 1887,
$180-225

Roy, 1937-44,
$55-65

Roy, 1964,
Trademark, $25-35

Roy, 1973,
Trademark, $25-35

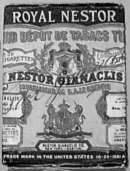
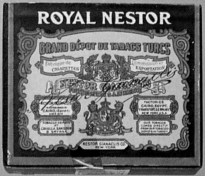
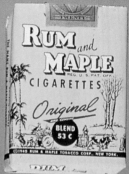

Royal, 1976,
Trademark, $25-35

Royal Nestor, 1915,
10 count, $75-115

Royal Nestor, 1915,
20 count, $75-115

Rum And Maple,
1937-53,
blend 53c, $55-65

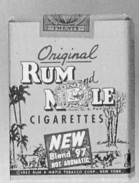
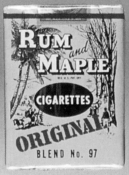
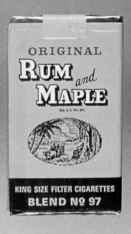

Rum And Maple,
1937-53, blend 97,
$55-65

Rum And Maple,
1937-53, Original,
$55-65

Rum And Maple,
1937-53, Original,
$55-65

Rum And Maple, 1973,
Trademark, $25-35

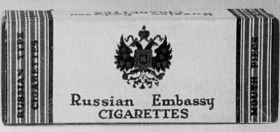

Russian Embassy, 1934, No. 35, $60-85

Russian Embassy, 1934, $60-85

S.P.Q.R., 1939, Small
Profit Quick Return,
$180-225

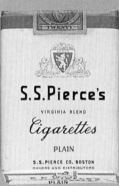

S.S. Pierce's,
1950, $40-55

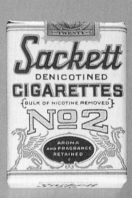

Sackett, 1928,
De-Nicotined,
$60-85

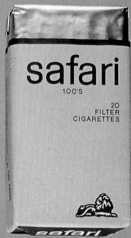

Safari, 1957, $25-35

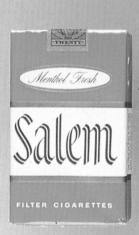

Salem, 1956, $25-35

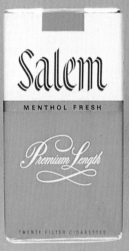

Salem, 1963-72,
$8-12

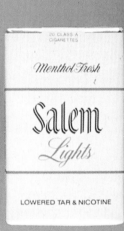

Salem Lights,
1975, $7-9

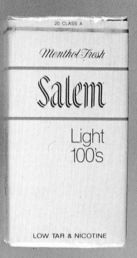

Salem Light
100's, 1970, $7-9

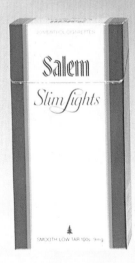

Salem Slim Lights,
1993, $3-6

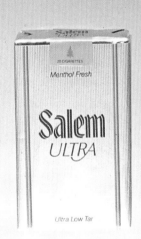

Salem Ultra,
1980, $8-10

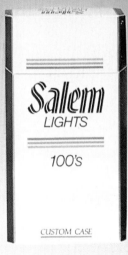

Salem Lights 100's,
1989, $3-6

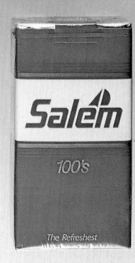

Salem 100's,
1993, $3-6

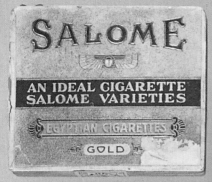
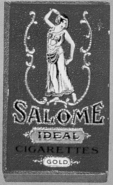
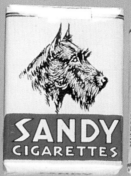

Salome Egyptian Varieties,
1923, $70-95

Salome Ideal,1935,
$55-65

Sandy, 1937-44,
$55-65

Sano, 1953,
$40-55

Sano, 1944,
$55-65

Sano, 1955, $40-55

Sano, 1955, $40-55

Sano, 1958,
$25-35

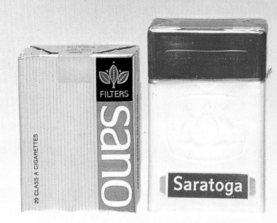

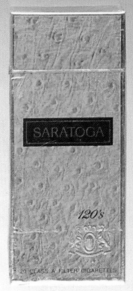

Sano, 1959, $25-35

Saratoga, 1962,
Plastic, $40-55

Saratoga, 1975,
$7-9

Satin, 1982, $7-9

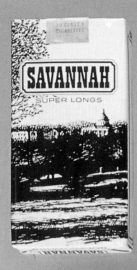

Savannah, 1976,
$7-9

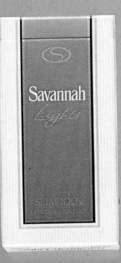

Savannah, 1987,
$3-6

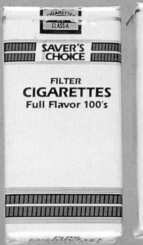

Saver's Choice,
1980, $7-9

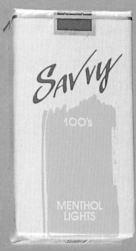

Savvy, 1988, $7-9

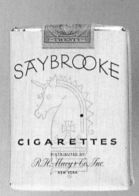

Saybrooke, 1941,
$55-65

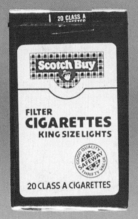

Scotch Buy, 1981,
$3-6

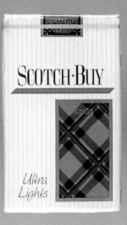

Scotch Buy, 1993,
$3-6

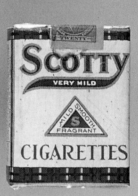

Scotty, 1931,
$60-85

Sebring, 1988,
$3-6

Sedona Lights, 1995,
$3-6

Sensation, 1938-43,
$55-65

Seven Island Club,
1937-44, $55-65

1776, 1990, $7-9

Seventy 70, 1976, $25-35

Sheffield English Type 5, 1946, "Mild and Delectable" $40-55

Sheffield English Type 5, 1952, $40-55

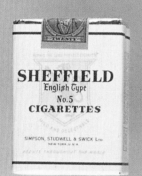
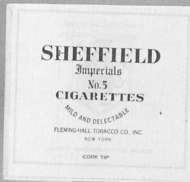
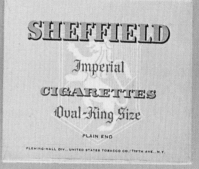

Sheffield English Type 5, 1930, "Mild and Delectable" $60-85

Sheffield English Type 5, 1941, $55-65

Sheffield English Type 5, 1942, Sheffield on bottom, $55-65

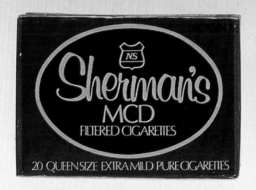

Sherman's MCD, 1975, $8-12

Shenandoah, 1963 Trademark, $25-35

Shenandoah, 1966, Trademark, $25-35

Shenandoah, 1993, $3-6

Shirley, 1935, $55-65

Sierra, 1968, $8-12

Silhouette, 1928, $60-85

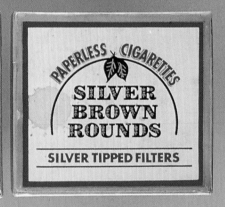

Silva Thins, 1987, $4-6

Silver Brown Rounds, 1973, $8-12

Silver Brown Rounds, 1973, $8-12

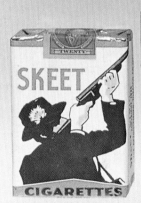

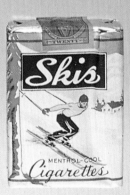

Skeet, 1936, $55-65

Ski, 1975, Trademark, $25-35

Skis, 1940, $55-65

Skis, 1961, $25-35

Slim Price, 1993,
$3-6

Smiles, 1923,
$60-85

Smokes, 1992,
$3-6

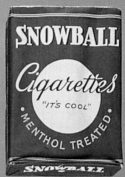

Snowballs, 1933,
$60-85

Solo, 1982,
$25-35

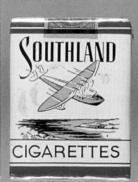

Southland,1935,
$55-65

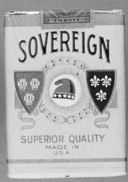

Sovereign, 1950,
$40-55

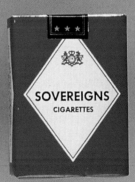

Sovereigns, 1965,
Trademark, $25-35

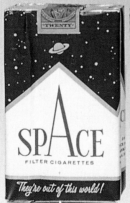

Space, 1956, the start of
my collection! $40-55

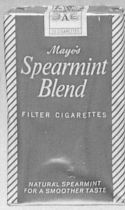

Spearmint Blend,
1966, $25-35

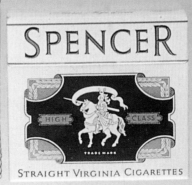

Spencer, 1919, $75-115

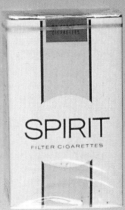

Spirit, 1971,
Trademark, $25-35

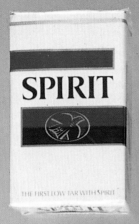

Spirit, 1978, $7-9

Spotlite, 1954,
Self lighting, $70-95

Spree, 1970,
Trademark, $25-35

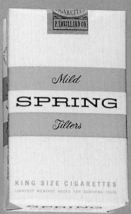

Spring, 1959,
$25-35

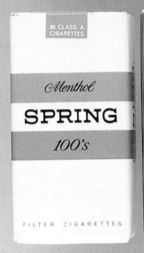

Spring, 1967, $8-12

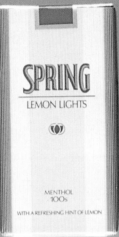

Spring, 1989, $3-6

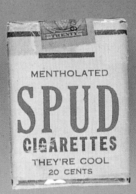

Spud, 1924-26,
$75-115

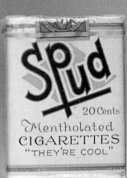

Spud, 1926,
$70-95

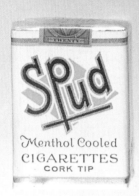

Spud, 1932,
$55-65

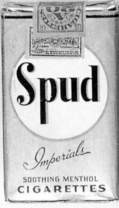

Spud, 1940-44,
$55-65

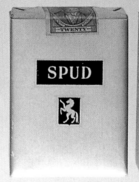

Spud, 1956, $25-35

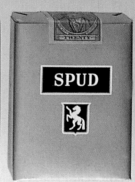

Spud, 1956, $25-35

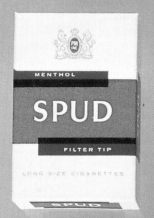

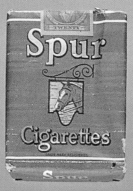

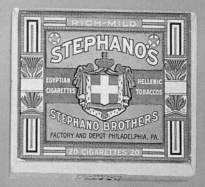

Spud, 1976, Trademark,
$25-35

Spur, 1939,
$55-65

Stephano's, 1921, $70-95

Stephano's Five Star, 1931, $60-85

Stephano's Rich & Mild, $60-85

Sterling, 1994, $3-6

Sterling, 1990,
$4-7

Sincere, 1950,
$40-55

St. James Court,
1974, $7-9

St. Moritz, 1972, $7-9

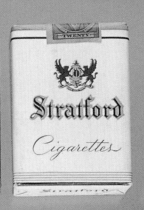

Stockton, 1995,
$3-6

Straight Cut, 1950,
$60-85

Stratford, 1945,
$40-55

Signature, 1995,
$3-6

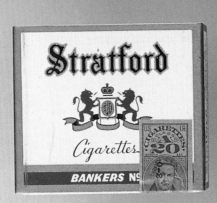
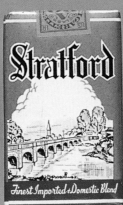
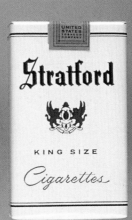
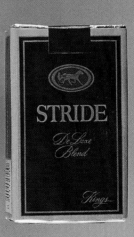

Stratford, 1940, $55-65

Stratford, 1945,
$40-55

Stratford, 1955, $40-55

Stride, 1975, $8-12

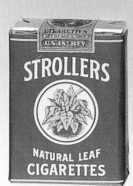
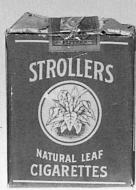

Strollers, 1922,
movie star cards,
$200-275

Strollers, 1916,
"Natural Leaf"
$90-135

Style, 1975,
Trademark, $25-35

Style, 1991, $3-6

Sub-Rosa, 1885,
$180-225

Suedes, 1975,
Test Market,
$25-35

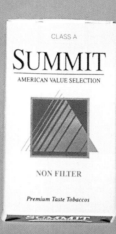

Summit, 1993,
$3-6

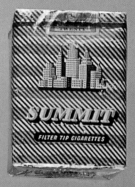

Summit, 1952,
$40-55

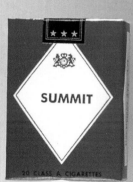

Summit, 1971,
Trademark, $25-35

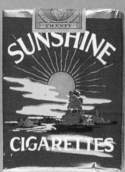

Sunshine, 1935,
$55-65

Superior,, 1988,
$3-6

Super M, 1974,
$7-9

Super Valu, 1962,
$25-35

Svoboda, 1910, $75-115

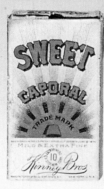

Sweet Caporal,
1911-69, 10 ct.
Longtime bestseller
for ATC. $150-190

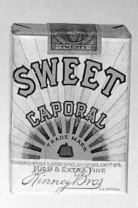

Sweet Caporal, 1911-69,
20 ct. $6-55

Sweet Caporal, 1985,
Trademark, $25-35

Tall, 1975, $7-9

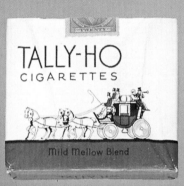

Tally-Ho, 1911-50, $40-85

Tango, 1969,
Trademark, $25-35

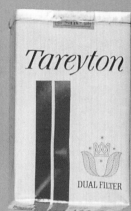

Tareyton, 1993,
$3-6

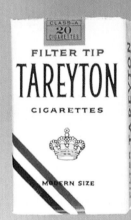

Tareyton, 1975,
$7-9

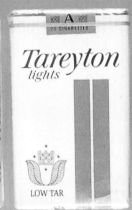

Tareyton, 1978,
$7-9

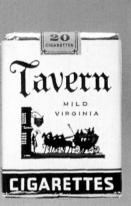

Tavern, 1939,
$55-65

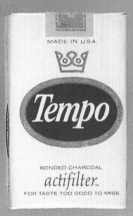

Tempo, 1963,
$25-35

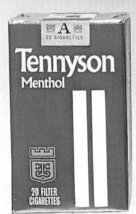

Tennyson, 1966,
$8-12

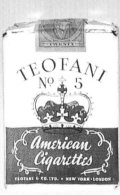

Teofani No. 5,
1915, $75-115

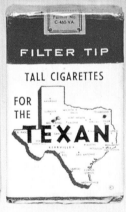

(Tall Cigarettes for the)
Texan, 1957, $25-35

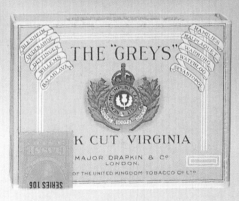

The Greys, 1930, $60-85

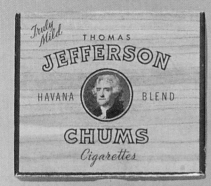

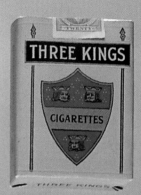

Thomas Jefferson, 1945, $55-65 The Three Castles, 1926, $60-85 Three Kings, 1938, $55-65

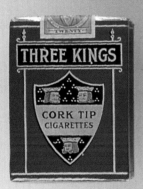

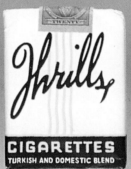

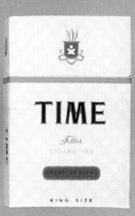

Three Kings, 1895-1911, $150-190 Thrills, 1936-44, $60-85 Time, 1930, $60-85 Time, 1968, $8-12

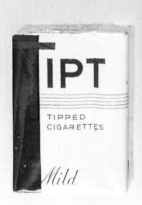

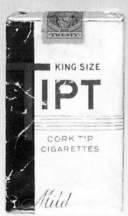

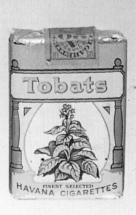

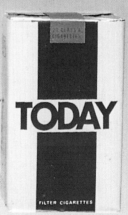

Tipt, 1932, $55-65 Tipt, 1932, $55-65 Tobats, 1937, $55-65 Today, 1970, $8-12

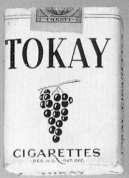
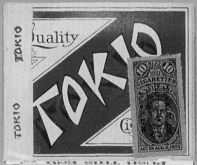
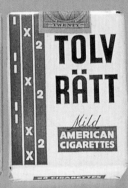
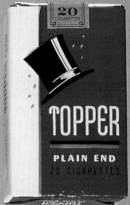

Tokay, 1936-44,
$55-65

Tokio, 1901, $90-135

Tolv Rätt, 1945,
$40-55

Topper, 1957,
$25-35

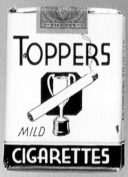

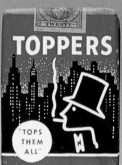

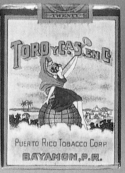
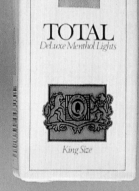

Toppers, 1920,
$70-95

Toppers, 1935,
$55-65

Toro Y Ca. S.en,
1936, $55-65

Total, 1975, $7-9

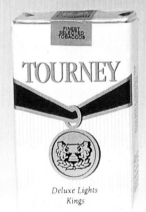
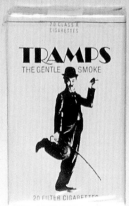
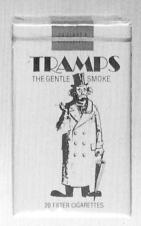
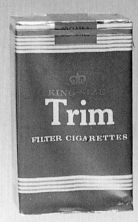

Tourney, 1989,
$7-9

Tramps, 1974,
$8-12

Tramps, 1977,
$8-12

Trim, 1966,
Trademark, $25-35

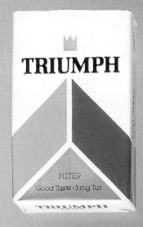

Trumph, 1983, $7-9 Trumph, 1985, $3-6 True, 1966, $25-35 True, 1974, $7-9

True, Gold, 1987, Tryon, 1967, $8-12 Tune, 1976, Turkish Delight, 1904, $90-135
$3-6 Trademark, $25-35

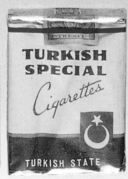
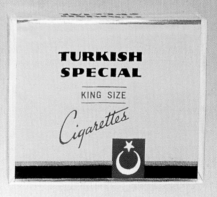

Turkish Ovals, 1966, $25-35 Turkish Special, 1949, Turkish Special, 1950, $55-65
$40-55

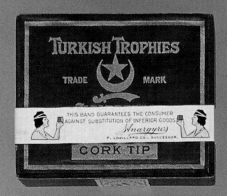

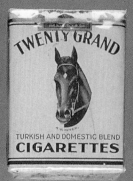

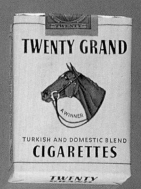

Turkish Trophies, 1892-1905, $150-190

Twenty Grand,
1931-44, $60-85

Twenty Grand,
1931-44, $60-85

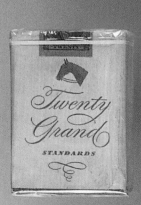

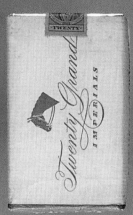

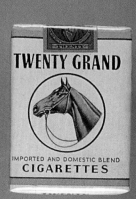

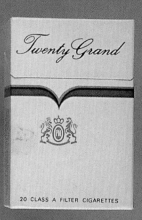

Twenty Grand Imperials,
1942-44, $60-85

Twenty Grand
Standard, 1936,
$60-85

Twenty Grand,
1931-44, $60-85

Twenty Grand, 1962,
Trademark, $25-35

Twist, 1973-80, $7-9

Two Lions, 1956, $40-55

Twenty Turks, 1968, $25-35

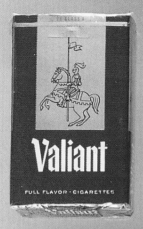

Valiant, 1963,
$25-35

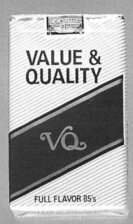

Value & Quality,
1990, $3-5

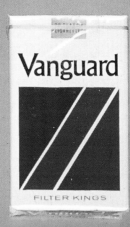

Vanguard, 1975,
$7-9

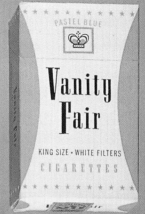

Vanity Fair, 1957,
$25-35

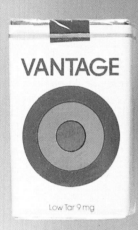

Vantage, 1964,
$25-35

Vantage, 1970,
$7-9

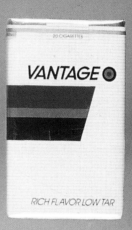

Vantage, 1990,
$3-6

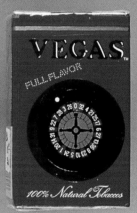

Vegas, 1987, 3 Types,
$4-6

Vello, 1975, Test Market
in Springfield Mo.,
$25-35

Venture, 1968,
$8-12

Vernon, 1940,
$55-65

Vernon, 1935, $55-65

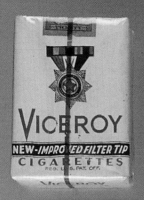
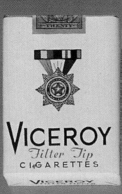
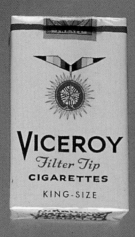
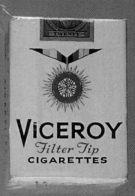

Viceroy, 1935,
$55-65

Viceroy, 1936,
$55-65

Viceroy, 1953,
$40-55

Viceroy, 1936,
$55-65

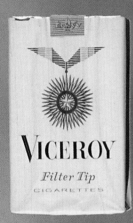
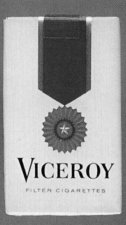
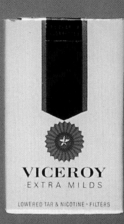
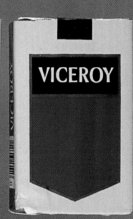

Viceroy, 1956,
$25-35

Viceroy, 1967,
$8-12

Viceroy, 1970,
$7-9

Viceroy, 1978,
$4-6

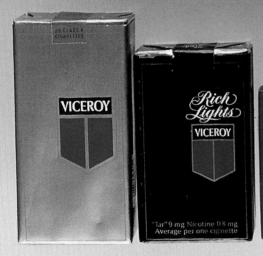

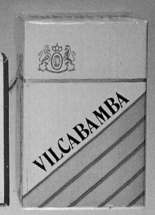

Viceroy, 1980, $4-6

Viceroy Rich Lights,
1979, $4-6

Viceroy, 1935, $200-250

Vilcabama, 1974,
Trademark, $25-35

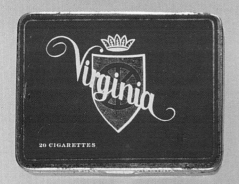

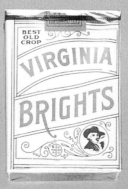

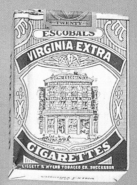

Virginia, 1948, $40-55

Virginia Brights,
1911, $90-135

Virginia Extra, 1912,
$90-135

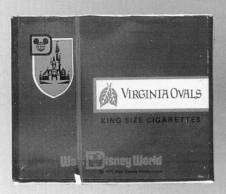

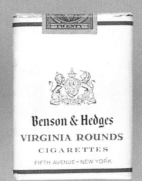

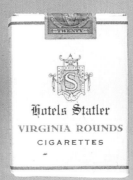

Virginia Ovals, 1971, made for
Disney World, $25-35

Virginia Rounds,
1931, $55-65

Virginia Rounds, 1937,
"Hotel Statler" $55-65

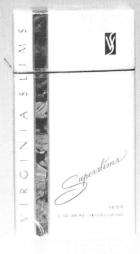

Virginia Slims, 1968,
$8-12

Virginia Slims, 1989,
$4-6

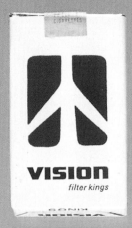

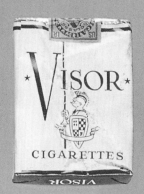

Vision, 1975,
Trademark, $25-35

Visor, 1950, $40-55

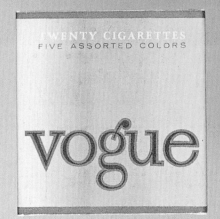

Vogue, 1955, $55-65

Vogue, 1955, $55-65

Waldorf-Astoria,
1955, $40-55

Wall Street, 1927, $60-85

Walnut, 1938,
$55-65

Waterford, 1965,
Drop of water in
filter, $25-35

Wave, 1987, $4-6

Wellington, 1927,
$60-85

West, 1989, $7-9

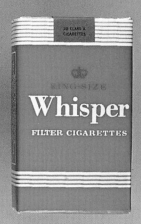

Whisper, 1976,
Trademark, $25-35

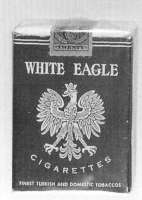

White Eagle, 1941,
$55-65

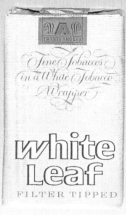

White Leaf, 1967,
Test market in
Wichita, Kansas.
$25-35

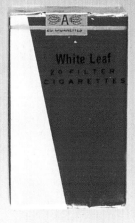

White Leaf, 1966,
Trademark, $25-35

White Rolls, 1935,
$55-65

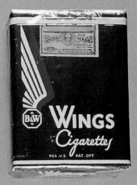

Williamsburg, 1960, Trademark, $25-35

Winchester, 1930, Trademark, $70-90

Winchester, 1970, Trademark, $25-35

Wings, 1929, $60-86

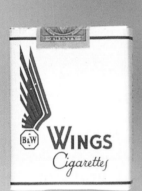
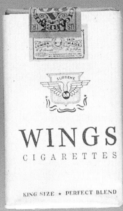
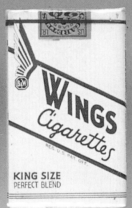

Wings, 1934, $55-65

Wings, 1940, First 85 mm, $55-65

Wings, 1948, $40-55

Wings, 1955, $25-35

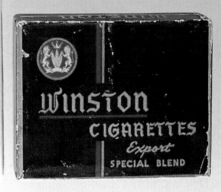

Wings, 1966, $25-35

Wings, 1966, $25-35

Wings, 1967, Trademark, $25-35

Winston, 1939, $60-85

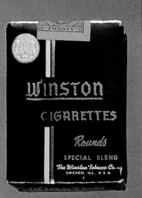

Winston, 1939,
$60-85

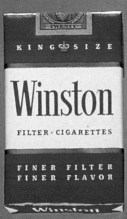

Winston, 1954,
$55-65

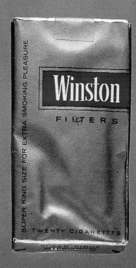

Winston, 1974-
1980, $7-9

Winston, 1975,
$7-9

Winston International,
1976, $7-9

Winston Ultra,
1983, $4-6

Winston Select,
1997, $3-5

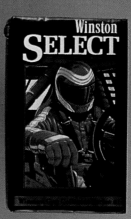

Winston Nascar,
1995, $15-25

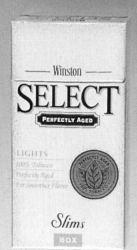

Winston Select,
1997, $3-6

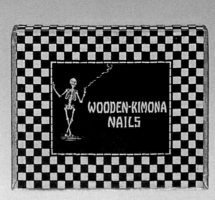

Wooden Kimona Nails,
1923, $60-85

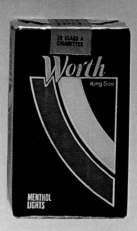

Worth, 1983, $3-6

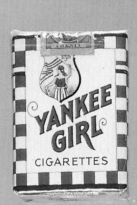

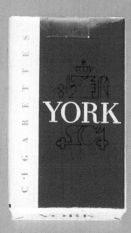

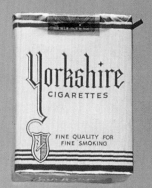

Yankee Girl, 1921,
$60-85

York, 1955,
$40-55

Yorkshire, 1952,
$40-55

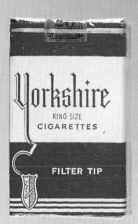

Yorkshire, 1967,
$25-35

Yorktown, 1927,
$60-85

Yours, 1983, $7-9

Yukon, 1959, $25-35

Zack, 1974, $7-9

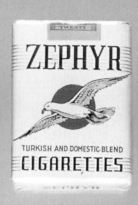

Zephyr, 1930-44,
$55-65

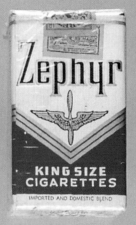

Zephyr, 1944,
About the time
Zephyr trains,
$45-55

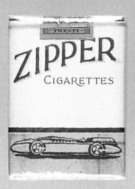

Zipper, 1940, $55-65

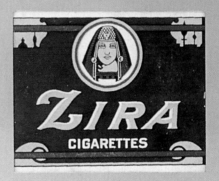

Zira, 1909, $90-135

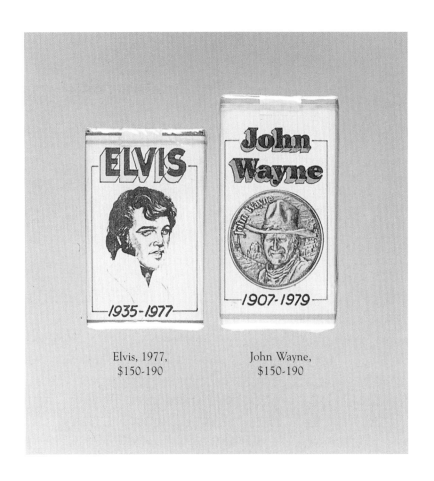

Elvis, 1977,
$150-190

John Wayne,
$150-190

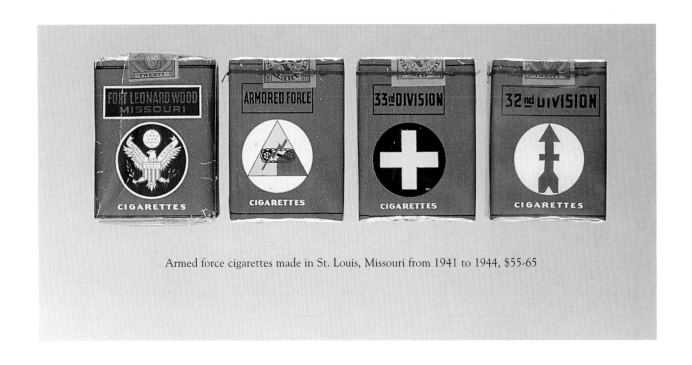

Armed force cigarettes made in St. Louis, Missouri from 1941 to 1944, $55-65

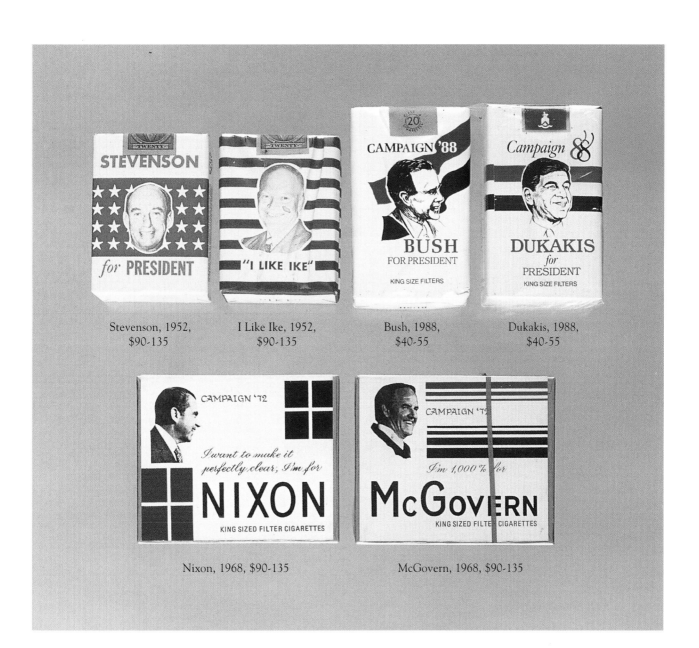

Stevenson, 1952,
$90-135

I Like Ike, 1952,
$90-135

Bush, 1988,
$40-55

Dukakis, 1988,
$40-55

Nixon, 1968, $90-135

McGovern, 1968, $90-135

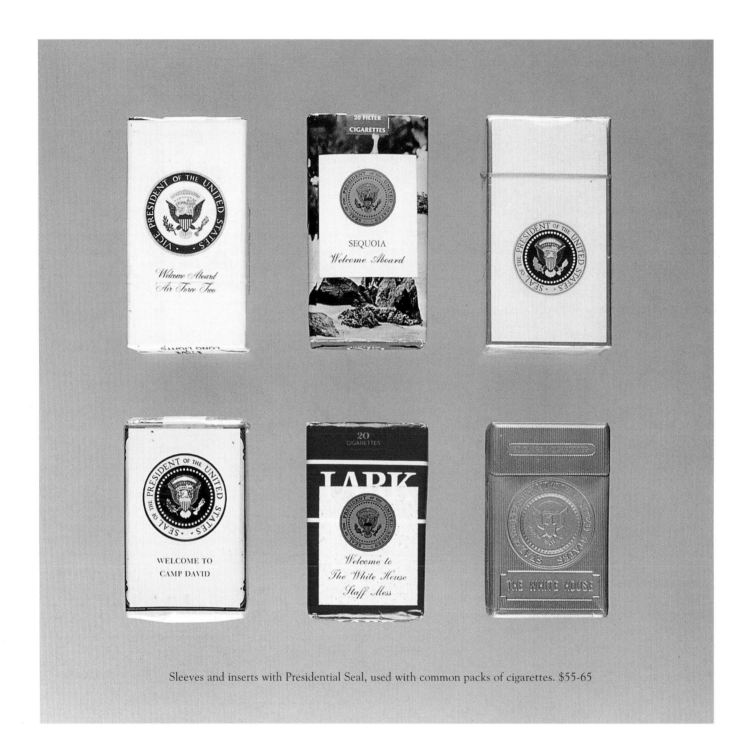

Sleeves and inserts with Presidential Seal, used with common packs of cigarettes. $55-65

SAMPLES

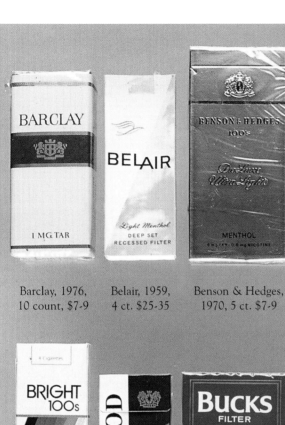
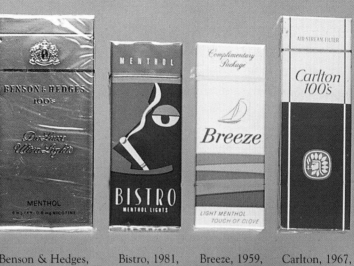

Barclay, 1976, 10 count, $7-9

Belair, 1959, 4 ct. $25-35

Benson & Hedges, 1970, 5 ct. $7-9

Bistro, 1981, 4 ct. $7-9

Breeze, 1959, 4 ct. $25-35

Carlton, 1967, 4 ct.$7-9

Bright, 1976, 4 ct. $7-9

Brookwood, 1970, 4 ct. $7-9

Bucks, 1994, 6 ct. $4-6

Carlton, 1967, 4 ct. $7-9

Cambridge, 1976, 4 ct. $7-9

Camel, 1940, 3 ct. Blue letters, $40-55

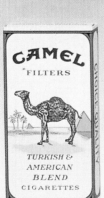

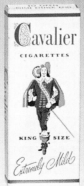

Camel, 1964, 4 ct. $25-35

Camel Lights,1978, 4 ct. $8-12

Camel, 1964, 4 ct. $25-35

Cavalier, 1967, 4 ct. $25-35

Cavalier, 1957, 4 ct. $40-55

Chesterfield, 1940, 4 ct. $55-65

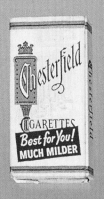
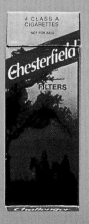
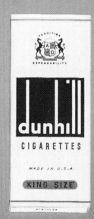
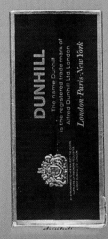
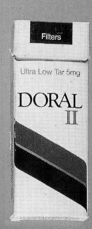

Chesterfield,
1940s, 9 ct.
$180-225

Chesterfield,
1950, 4 ct.
$25-35

Chesterfield,
1970, 4 ct.
$25-35

Dunhill,
1952, 4 ct.
$40-55

Dunhill, 1965,
5 ct. $8-12

Doral II, 1976,
4 ct. $7-9

Embassy,
1956, 2 ct.
$40-55

Favor, 1985,
5 ct.$4-6

Fleetwood,
1944, 4 ct.
$55-65

Galaxy,
1960, 4 ct.
$25-35

Gunston, 196?,
5 ct. $8-12

Hit Parade,
1955, 5 ct.
$40-55

Iceburg 100's,
4 ct. $8-12

Iceburg 10,
4 ct. $8-12

Kent, 1976,
4 ct. $7-9

Kent Golden
Lights, 1976,
4 ct. $7-9

Kent, 1955,
5 ct. $40-55

Kent III,
1976, 4 ct.
$7-9

Kentucky King, 1964, 4 ct. $8-12

Kool, 1970s, 4 ct. $7-9

L&M 100's, 1976, 4 ct.$7-9

L&M, 1976, 4 ct. $7-9

L&M, 1967, 4 ct.$25-35

Lark, 1976, 4 ct.$7-9

Life, 1957, 4 ct. $25-35

Lucky Strike, 1940, 3 ct, $60-85

Lucky Strike, 1930's, 9 ct. $180-225

Lucky Strike, 1930's 3 ct. $40-55

Lucky Strike 1955, 5 ct. $25-35

Lucky Strike, 1950. 2 ct. $30-35

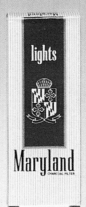
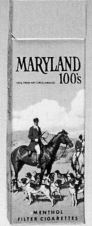

Lucky 100s, 1971, 4 ct, $25-35

Marlboro, 1954, 4 ct. $40-55

Marlboro, 1963, 4 ct. $25-35

Maryland, 1984, 4 ct. $8-12

Maryland 100's, 1976, 4 ct. $8-12

Max 120's, 1975, 4 ct. $7-9

Max 120's
1975, 4 ct.
$7-9

Merit, 1976,
4 ct. $7-9

Newport,
1960, 4 ct.
$25-35

Newport,
1983, 4 ct.
$8-12

Newport, 1976,
4 ct.$7-9

Northwind, 1980,
6 ct.$25-35

Old Gold,
1930s, 2 ct.
$60-85

Old Gold,
1950, 5 ct.
$40-55

Old Gold,
1930s 5 ct.
$60-85

Old Gold,
1957, 4 ct.
$40-55

Old Gold, 1960,
5 ct.$25-35

Old Gold,
1967, 4 ct.
$8-12

Old Gold,
1980, 4 ct.
$7-9

Pall Mall,
1939, 5 ct.
$60-85

Pall Mall,
1954, 4 ct.
$40-55

Pall Mall,
1967, 4 ct.
$8-12

Pall Mall,
1970, 4 ct.
$7-9

 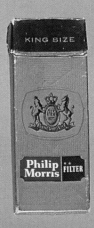

Philip Morris, 1920s, 2 ct. $75-115

Philip Morris, 1930s 4 ct. $55-65

Philip Morris, 1950s 4 ct. $60-85

Philip Morris, Early 1950s, 4 ct., $60-85

Philip Morris, 1960s 4 ct. $25-35

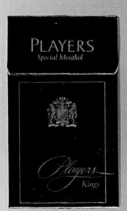 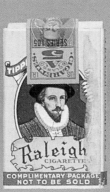

Players, 1976, 6 ct. $7-9

Raleigh, 1935, 5 ct. $60-85

Raleigh, 1964, 4 ct. $25-35

Real, 1976, 4 ct. $7-9

Reef's, 4 ct. $8-12

 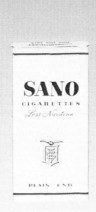

Salem, 1956, 4 ct. $40-55

Salem, 1976, 4 ct. $7-9

Sano, 1952, 4 ct. $55-65

Sensation, 1938, 2 ct. $60-85

Silva Thins, 1964, 4 ct. $25-35

Stuyvesant,
1976, 4 ct. $8-12

Tareyton, 1976,
4 ct. $7-9

Tempo, 1963,
4 ct. $25-35

Triumph, 1979.
4 ct. $7-9

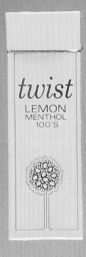
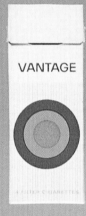
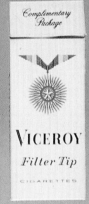
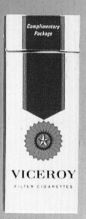

True, 1976,
4 ct. $7-9

Twist,
1979, 4 ct.
$8-12

Vantage, 1976,
4 ct.$7-9

Viceroy,
1958, 4 ct.
$25-35

Viceroy,
1967, 4 ct.
$8-12

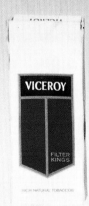
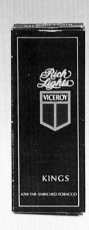
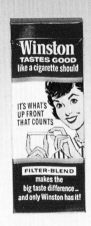

Viceroy,
1975, 4 ct.
$7-9

Viceroy Rich
Lights, 1975,
4 ct. $7-9

Winston,
1954, 4 ct.
$40-55

Virgina
Slims, 1976,
4 ct. $7-9

York,
1962, 4 ct.
$40-55

Cigarette Facts and Anecdotes

Pall Mall: Wherever Particular People Congregate

Carl H. Clawson Jr.

Pall Mall is a respected old English brand first produced in the USA in the 1890s by ATC. It was one of James B. Duke's prize brands, and by 1898 an ATC subsidiary, Butler & Butler of NYC, had prime responsibility for producing the brand. They continued on the job through the trust dissolution in 1911 until about the 1920s, perhaps even the early 30s. Pall Mall was a fancy Turkish smoke in a fancy red box with many variations, and ATC continued to sell it until at least the 1940s.

Around 1935 George Hill, the CEO of ATC, revamped the Pall Mall blend, producing an American cigarette a la Lucky Strike, wrapped it in a red 70mm soft pack, and created a classic. It did well enough, despite the depression, that he created a new subsidiary, The American Cigarette & Cigar Co., Inc. (ACC, F60-NC Durham) to produce Pall Malls. I know of no other smokes with the ACC name.

The first Pall Mall soft pack (no. 1) may be the original from 1935. It was red, white print, with a gold stripe top and bottom, gold crest and gold highlighting of the white Pall Mall lettering, which was a quarter-inch high. By 1939 (no. 2) the gold on Pall Mall, which had grown to 3/8 tall, had been dropped, although the gold crest and stripes were retained. In 1939 or 1940, Pall Mall (no. 3) became king size (85mm), with "Pall Mall" a scant 5/8 tall (it still is), and the 70mm pack was dropped. The gold crest and stripes remained (no. 4) until late 1942 to early 1943. No. 4, first to sport the WWII "V" for victory, was also first to wear the slogan "Wherever Particular People Congregate". This slogan is still on every pack and pre-dates L.S./M.F.T. by a few months, probably making it the second longest running U.S. cigarette slogan (after the "Famous Cigarettes" which appears under "Pall Mall" on the pack).

In 1943 the all-red with white print pack (no. 5), with the second V appeared. The basic design remains unchanged to date. *In Hoc Signo Vinces* (with this sign we conquer) says the crest, and Pall Mall did. *Per Aspera Ad Astra* (through adversity to the stars), another slogan, is a little further afield. I believe that the other two V blurbs, 5-A and 5-B, complete the WWII set for Pall Mall, to make 5 packs with the "V" on the back. I have never seen any others.

The ACC name was still on Pall Mall in the early 1950s, (no. 6) but in small print it was identified as an ATC subsidiary. By 1954 (no. 7) The American Tobacco Company name was on the pack, and they were being made in Louisville. The 1956 pack carried a four-line notice about destroying the stamp. By 1959, the notice (although it had the same wording) had shrunk to 3 lines (no. 8). The 1965 pack (no. 9), just prior to the Caution requirment, carried the least writing of all the red Pall Mall packages and is one of the most attractive when spread out as a wrapper, it was made in Richmond.

The first take-off on the red pack was in 1959 (no. 16) when the pack was bordered in gold. This hung on for a few years although I do not have one with the Caution, which dates from July 1, 1966. The classic red continued in production during this test.

As far as I know, all Pall Malls after July 1, 1966 carried the caution in a box (no. 10). By 1969 (no. 11) ATC was marked on the pack as a division of American Brands. The first "warning" notice was required on October 1, 1970. At that time Pall Malls (no. 12) were still made in Durham (the former ACC site) as well as Richmond and Reidsville. The Louisville site was apparently shut down. In 1976 (no. 15), the universal bar code showed up on the side of the pack. The first zip code was introduced in 1969 (no. 11), although the zip code had gone into general use in 1963.

The classic red expanded to accomodate 25 cigarettes in 1984 (no. 17), just in time to catch the old warning. I believe they are still being produced. About 1989 another take-off on the classic red hung a blue banner on the pack reading "Filters" (no. 18). The crest was modified and for the first time 100mm size was offered. I seldom see these in my area but they may still be in production. No. 19 is a similar take-off with a yellow banner reading "Unfiltered Lights". This brand was tested in New England, and never made it. I found this pack in a K-Mart near Providence, Rhode Island. Although I had the store's tobacco manager tearing the place up, it was the only pack in the store. Likewise, a pack that had "Lights" on a yellow banner (No. 20), was another test run that didn't make it. Although the gold-framed pack from 1959 (No. 16), stuck with the "Particular People" slogan, these three late take-offs all carried different wording. All four of them should be called quasiclassic red.

Classic red Pall Malls have been produced at F60-NC (Durham), F30-KY (Louisville), F30-NC (Reidsville) and F130-VA (Richmond). There are, of course, many other Pall Mall packs—white, gold, green, hermetically sealed, continental boxes, flip-top boxes, sample packs, etc.—but you could make a hobby of collecting the variations of the classic red alone. I have over 60 or 70 major and minor variations of the pack, but if you show only the pack's face in your collection, one pack of Pall Malls is all you need, and it can be from 1943, 1953, 1963, 1973, 1983, or 1993. In other words, it hasn't changed since I started collecting cigarette packs...and, incidentally, it is a fine smoke.

Rum and Maple: Mapleton Wars

Carl H. Clawson, Jr.

In 1937 the Rum & Maple Tobacco Corporation of New York, with the aid of the Tobacco Blending Corporation, sauced up some pipe tobacco with rum and maple syrup and produced Rum & Maple cigarettes. Meanwhile, same year, in Louisville, Fleming-Hall, with help from Axton-Fisher, sauced up some pipe tobacco with rum and maple syrup and gave us Mapleton cigarettes.

1937 was too early to be aware of the coming cigarette shortage of World War II; cigarette companies were taking all the tobacco they could to make cigarettes. During the war, cigarettes were not flavored, so apparently these flavorful cigarettes were aimed at pipe smokers. Apparently each company sold enough to sustain production, and WWII certainly gave them a new lease on life.

It would be nice to know which brand came first, since they both branded the word "original" on their early packs. The first three Rum & Maple packs introduced in 1941, 1943 and 1951, respectively, all differ in detail. To my sorrow, I do not have a copy of the original 1937 pack, which features "Blend 53C". By 1944, (no. 2) we have "New Blend 97", but by 1951 (no. 3) it became "Original Blend 97". To make things more interesting, on pack no. 4, (1967) by Larus or House of Edgeworth for Rum & Maple we are back to Blend no. 53. The words "Rum & Maple" may be found in eight different places on the first two packs. I have seen no packs from either Rum & Maple or Fleming-Hall dating later than 1967. Rum & Maple did put their name on other brands, such as Little King, 1953, Larus/Hoe, Hayward, Presidential, and St. Moritz.

Mapleton's first three packs were identical except for a change in wording on the side panel. Then they changed in 1939, 1944, 1946. All of those are from Axton-Fisher (F24-KY). PMC bought Axton-Fisher in 1944, including about 15 or 20 of their brand names.

U. S. Tobacco (F1-VA) produced Mapleton from 1953 through 1968. I also have an identical pack with the warning bought in 1972. I have seen none since. Flemming-Hall repeatedly used the rum and maple theme on the Mapleton packs, as well as the word "original". I have no idea whether any lawsuits were filed, but by the mid-1950s Mapleton packs mentioned only "maple and rare rum", not "Rum & Maple".

About Trademark Protection Packs: TMs

Carl Clawson, Jr.

Many cigarette pack collectors show little or no interest in trademark protection packs, otherwise known as "TMs". There are several reasons—TMs are relatively difficult to find (although wrappers are not), the packs of some TMs are relatively dull and vary little in appearance, and they do not reflect mainstream product packaging trends. I have found them interesting and unduly neglected in the pages of *Brandstand*, except for occasional ads. In fact, I do not recall having seen a reproduction of an ATC TM pack in *Brandstand* in the 10 years I have been reading it. But TMs are interesting and in some cases, I believe, a real asset to a collection.

I believe that trademarks and logos are issued for a 20-year period, and (like patents) may be renewed for an additional 20 years. If the brand name is regularly offered for sale to the public, there is no question that it is protected; if it is not placed for sale the trademark could be usurped. Accordingly, the companies place one or more cartons of TM-style cigarettes with apparently randomly chosen retail vendors on occasion for public sale.

I have come across TMs on the counter very rarely. The last time I saw a TM for sale locally was in December 1991, when I came across PMC's Skyline and Americana series of 5 different TMs in a unique set. Such PMC TMs as California, Park Drive, Greenport and Fairmont were included. These five packs were also vended by Georgopulo/Andron at the time. Other TMs I have found on local shelves

in the past 10 years include Bryant Park and Pilot by RJR, New Yorker by PMC and ATCO by ATC. For most of us collectors, except, perhaps, those who work for tobacco companies, obtaining a large collection of TM packs is difficult and costly.

It's difficult to judge when the first TM packs were sold. I have some which appear to date back at least to the 1930s. Then, in the late 1800s, before national distribution of brand names, many, if not most, brand names were not registered. For instance, in 1887 both W. S. Kimball & Co. of Rochester, N.Y. and Monopole Tobacco Works of N. Y. City were simultaneously producing a brand called Casino). There are many other such cases. The first TMs probably appeared after 1900, but I cannot substantiate this.

I have seen no TMs by Benson & Hedges (before they merged with PMC), Stephano, Georgopulo, Laurus & Bros., U.S. Tobacco Co., Axton-Fisher, Christian Peper, or any other minor makers, although some of their packs were scarcely more elaborate than some TM packs. Also I find it odd that I have not a single TM pack with a caution on it, although I am sure they exist. The caution lasted 5 years (1/66-1/71), too long for them not to have been issued.

I have never found a name on a cigarette from a TM pack. Logic would suggest that, because relatively few TM packs of each brand name are required, when a TM production run is scheduled several different brand names are run off—all with the same cigarettes. Older TMs were 70mm unfiltered. From the 50s or 60s on, most or all have been king-size (85mm) filters. Insofar as I can tell, the tobacco in TMs is generally of the same quality as in name brands. This holds true for most generics also.

Early ATC TMs such as Lone Eagle and De Mauduit probably date from the 1930s. Lone Eagle 70mm unfiltered was printed in black or white, De Mauduit in red ink or white. From the early 1970s (if not earlier) the standard ATC TM was all red with a white wedge, with black and white words. Dakota is an example. I know that RJR came out with Dakota in 1990. Stephano registered Dakota in 1964, made Dakota filter 70mm in 1964 and Dakota filter 85mm in 66. Georgopulo/Andron may also have had a Dakota. Navy (Gail & Ax) is another example of ATC's TM and, incidentally, my nominee for the most unusual brand name of the decade, if not of the century. Only Blue Horse Pills comes close! I include Fifty Fifty in my TM collection because it is not as finished as an earlier Fifty Fifty test market pack (from 1967, with the caution). I'm not even sure the company could always unequivocally identify a given pack as a TM or not. As with the other TMs, I hold no PMC TMs prior to the "warning" era. Since the 1970s, however, PMC has had, by far, the most collectible of the TM packs. All are king-size flip-top boxes, filter tipped and a unique design for each brand. Each design is colorful, entertaining, unpredictable, and, for the most part, a nice conversation piece. Any sizeable collection of PMC TMs should be an attention getter.

From at least the early 1970s, B&W TMs have featured the square bullseye in blue and yellow. Avalon and Eli Cutter are examples. Occasionally a pack comes along with the bullseye in black and orange, which really stands out, like the Lear package. All are 85mm filter. On some packs the date of the copyright is given, as on Avalon. Avalon was a popular seller for B&W back in the thirties so I don't know if this is a renewal, or a new copyright. Top Score (orange red on white) and Dorchester (black on white), both 70mm unfiltered, probably date from the 1940s or earlier. Coronet (dark blue on white, 85mm filter) dates from the 50s. B&W, as mentioned in an issue of *Brandstand*, issued about 75 different brands of cigarettes in the 1980s marketed by special order. At the same time, apparently, they were issuing the square bullseye TMs of many, if not all, of these same brands.

L&M is a respected old-timer in marketing cigarettes but I do not have, nor have I seen, any L&M TMs prior to the old warning (1971). This doesn't mean

they don't exist, but they must be pretty tightly held. Their TMs during the warning and SGW years are very basic black print on white with a minimum of detail. The sole exception to black and white in my collection is Gulf—maroon on white, but still very basic. In the case of Bogart, from the blurb on the pack, one would assume that the trademark was held by Dallas Cigarette Co., rather than L&M.

Lorillard TMs are hard to find. In fifty years of collecting I have picked up only six different Lorillard TMs in three different styles and I am not sure about one of them; in other words, I haven't seen enough samples to support any generalities about them. True Gold has black and white printing on a solid orange wrapper. I have 3 of this type, all with the old warning. AAAHHH is black on white; I have two, both with the Surgeon General's Warning. I include Mustang because it is not up to Lorillard standards for their mass- or test-market brands and may or may not be intended as a TM protection brand. Although Lorillard has marketed many brands over many years, such as Beech Nut, Deities, Drawing Room, Egyptienne Luxuries, Harem Beauties, Helmar (and Ramleh), Sensation and Turkey Red among many others, which have been discontinued, I have never seen a Lorillard TM for any of these old timers. As with L&M, I can't say that they don't exist, but they are rare.

R.J. Reynolds likes blue packs. All their TMs are in blue, the majority like T.J. Fats, with a few like Beret. All are 85mm filter with white wording. I believe that there are very few or no older (pre-1960) RJR TMs because RJR had only one brand of cigarettes—Camel. With the introduction of filtered Winston in the late 50s, RJR made up for lost time, having registered over 250 brand names since then. In fact they have even abandoned several brand names. But I have been unable to find any RJR TMs prior to the warning.

I know that there are collectors with over 1,000 different TMs. There are also many collectors who are or have been directly associated with the tobacco companies. There are even more collectors who live in tobacco country. Many of us would appreciate any further information any of you can add to this little opus on TMs, including correcting any errors I may have backed into.

Cigarette Vending Machine Packs

Within the past few years, a brand called Coins was produced for sale in vending machines. Two prize items in my collection are vending machine packs of Coins that date back to the 1930s.

Among the very early vending machines were cigarette machines. While we may purchase everything from combs to toothpaste form vending machines today, the early machines could not handle non-uniform sized items. The Paul A. Werner Company of New York City came up with an idea to package an oddly-sized vending machine convenience and sell cigarettes at the same time. They produced a brand called Long, which took its name from the fact that the cigarettes were 75mm, instead of 70mm. Under the cellophane of each pack was a double-edged razor blade. Thus, the traveling salesman could purchase his daily pack of cigarettes from a vending machine and get his daily razor blade at the same time. Vending machines in nearly every train station and bus depot in the country carried them. The pack I have has a series 105 tax stamp on it and it is still full, unopened and the razor blade is still there.

When the price of cigarettes went up in 1942, the old 10-cent brands were raised to 12 cents. Vending machines were made to accept a single dime or a dime and a nickel for the major brands. There were no mechanical means available to make change for these new prices, so Avalon cigarettes, which originally were sold for 10 cents, were packaged with three pennies on the side of the pack. They were loaded into the 15-cent slots of the vending machines and now for a dime and a nickel, you got your pack of Avalons along with 3 cents change.

Lucky Strike Green Goes To War

There is a story behind the story of why Lucky Strike Green went to war. It is true that both titanium and bronze saved from the green and gold inks contributed to the war effort. Chesterfield contributed as well, by dropping their gold ink during the war. In addition, other brands dropped the lead foil used to preserve moisture. It seems the entire tobacco industry made a contribution to the war effort, not only Lucky Strike.

But the real story of why American Tobacco Company made the change has never been publicized. According to Chuck Hynes' brother-in-law, who was a leading art designer in this country, the story goes like this:

In late 1939 or early 1940, American Tobacco Company conducted extensive market research in an effort to increase sales. At about that time, it was becoming more fashionable for women to smoke. They found that Camel was the man's brand, and Chesterfield was preferred by women over both Camels and Luckies. They found that women liked the taste of Luckies, but hated the green, red and gold package. It was not feminine.

When they discovered that the two metals used in the ink were being used in sufficient quantity to make a valid contribution to the war effort, their advertising department developed the famous slogan "Lucky Strike Green has gone to war". Riding on the coat tails of the patriotic movement that developed, they quickly made the change to red and white, the colors their marketing department had already determined were acceptable to women. By becoming Patriotic they not only contributed to the war effort, but also increased sales by 38% in a year!

Head Play: Collector's Classic

Perhaps the most famous cigarette pack of them all is Axton-Fisher's classic brand Head Play. It first appeared on retailers' shelves on December 11, 1933.

It seems that in writing the tax laws concerning tobacco products, the government had stipulated that cigarettes be taxed according to the number in each pack. At the height of the depression, a few pennies saved could mean a lot; furthermore, more than half the price of a pack of cigarettes was represented by taxes.

Axton Fisher Tobacco Company saw the loophole in the tax laws and introduced Head Play to slip through that hole. The 11-inch slide and shell box was designed in such a way as to make in obvious to the consumer that he could get twenty smokes out of a pack of Head Play while paying taxes on the five 11-inch long cigarettes. Axton-Fisher did everything but print instructions on the side of the box. Although the brand lasted less than a year, it was so unique that it is remembered more than forty years later by smokers and non-smokers alike. To a depression-weary public, smoking an uncut 11-inch Head Play became an amusing challenge. Head Play continued in production only until May 20, 1934, when the government closed the loop-hole in the tax laws.

Philip Morris: Over 145 Years

Carl H. Clawson. Jr.

I recently bought a rather beat-up brown Philip Morris 70mm wrapper. At first look I was unimpressed, then took another look. Small lettering across the front reads "Established—over 60 years". I checked my other brown PM wrappers and a couple on flat 50 boxes. They said Established over 80, over 90 or over 100 years. Since several of them are dated, it wasn't difficult to establish that the 80 years message was used 1932-1942, 90 years was used 1942-1952 and 100 years was used 1952-1955, at which time the brown pack became a red and white pack. By extrapolation then, the "over 60 years" on my new wrapper says it was sold between 1912-1922.

But there is a problem here. I have a 10-page copy of a typewritten Philip Morris History given to me by the company in 1968. (The final entry in it is: Sep 13, 1967-Marlboro 100s introduced in flip-top box.) The first entry reads: Philip Morris, an Englishman, began manufacturing cigarettes in the late 1850s. If the company was established over 100 years before 1952, PM must have been putting out smoking tobacco or something similar for a few years before they started rolling cigarettes. I am pretty sure that 1952, give or take a year, was the beginning of the "over 100 years" mark. And I am also pretty sure that over 60 years is from 1912-22.

However, another entry in the Phillip Morris history reads "1933–Introduction of new Philip Morris English Blend—brown pack." I have always taken this to mean that the brown pack started in 1933, but I now have one from 10 or 15 years earlier. I guess the key word in the 1933 quote is "new". While the teens pack and 1930s packs are similar, there are differences. "London, W." is in different size letters on the two packs, and the teens pack is distinctly lighter in color. I can pin down the date of the teens pack more precisely. The pack says Philip Morris & Co. Ltd., Incorporated. In another entry, The history says, "1919-New firm incorporated in Virginia under name Philip Morris & Co., Ltd., Inc." Phillip Morris originally set up shop in New York in 1902 (according to another entry) and I believe they were known only as Philip Morris & Co., Ltd. until 1919.

In any case, there is just enough to the revenue stamp left on the wrapper to determine that it is the type first used in 1918-19 (and up through 1931—with no series number) As far as I am concerned, my wrapper dates between 1919 and 1922, and at 74 years old isn't too shabby at all.

While Philip Morris, in the early years, probably had a shop or factory where hand-rolled cigarettes were made. I do not believe they had an effective mass-production facility until 1934, when they bought the Continental Tobacco Company. The American Tobacco Comapany (trust) founded Continental in 1898 as a subsidiary. It apparently was separated from American during the trust dissolution in 1911 or sometime thereafter. Continental also apparently had a connection of some type with Phillip Morris early on after 1911. One of my old packs says F21-VA on the side. This is the Continental plant, so, in effect, Philip Morris (and other Phillip Morris brands) were made for the company by Continental. F21-VA continues to show up on the packs until 1955. In addition, F7-VA began to show up on packs in the mid- to late 1930s. Phillip Morris also bought the old Axton-Fisher plant in Louisville in 1944 and both brown and red/white packs with F24-KY were sold until 1955, when factory numbers were dropped.

There were several relatively minor changes to the brown pack in the 1940s. About 1943, "London W." was no longer on the packs and the indecipherable center of the pack face seal, or coat of arms, became PM&Co. In 1948 England Blend became Special Blend. The brown pack was replaced by a red/white pack in 1955, but not until after a king size brown pack was rolled out. I suspect that brown packs may have been made and shipped to sales hot spots for several more years.

As a matter of interest, Phillip Morris was the sales agent for Stephano Bros. (Stephonos, Rameses II) from 1924 to 1929, and Stephano made cigarettes for PMC. I also have an Oxford Blues box, among others with the PMC name made at the Stephano Bros. plant (F2032-PA) during WW-II.

Benson & Hedges: Cigarettes for the Elite

Carl H. Clawson Jr.

Richard Benson & William Hedges opened their tobacco shop at 5 Bond Street, London—a rather tony address—in 1873. Twenty-six years later in 1899, they set up an outpost in the colonies, in New York City, to be specific. Their forte at the time was pipe tobacco, snuff, etc. Cigarettes were essentially a sideline although they apparently sold a few brands from the time they set up the New York shop. Some of their very early brands were: Alma Mater (1901), London No. 1, Turkish No. 1, Plain No. 3, and No. 15, and Russian No. 4.

During the WW I era, they made Tubarette (with a mouthpiece that looked like a straw as an integral part of the cigarette) and Old Gubek. Other early brand names were La Yerba Habana, My Lady Dainty, London Blend, His Majesty's Virginia Oval, and Royal Albert. In the 1920s they expanded with Magnolia, Ambar, Plain No. 15, Russian Nymphs, Silk Tips, The Greys, Straight Cut, SPQR, Parliament and others, including Turkish Crown Gold, a dainty gold-tipped 60mm cigarette about as big around as a small soda straw in a dainty box of ten.

Almost all of their brands were vended in primarily clam shell type boxes, although the Greys and a few others were in slide and shell (or hull) boxes. In the late 1930s or early 1940s, several brands were sold in soft packs, including Virginia Rounds and Private Blend.

Benson & Hedges' pack designs were not exactly cutting edge. These conservative packs do not liven up the collection, although I must admit that some of them have a certain understated elegance. There were also some exceptions. Deb's Rose Tips (another of the few soft packs) in bright red and white, with red-tipped cigarettes pictured on the pack, stood out like Santa Claus at a nudist colony when you walked into the Benson & Hedges Fifth Avenue showroom. Debs were a later B&H introduction, probably in the late 1930s.

Philip Morris, looking to jump on the filter bandwagon, decided that Parliament might be a shortcut to getting there. To get the brand name, they had to buy the Benson & Hedges company, so they did in 1954. Benson & Hedges ceased to exist as an independent, although in the next few years, Philip Morris carried the name nationwide, not only with Parliament in the white and blue pack and box, but with classy Benson & Hedges packs and eventually Virginia Slims. In the meantime, to placate the customers who craved their Parliament Mouthpiece filter smokes in the slide and shell box, Philip Morris produced Benson & Hedges Mouthpiece Filter in an almost identical box, with Benson & Hedges replacing Parliament diagonally across the front ot the box. I do not know what happened to the many other specialty brands from Benson & Hedges. I have seen none of them since the 1950s, nor have I heard anything about them, so I presume that they were dropped.

Appendix A:
LIST OF CIGARETTE MERCHANTS

Included in this list are all the companies and/or individuals whose names are known to have appeared on a cigarette package, either as a cigarette maker, vendor, or both. With many older cigarettes it is difficult to know whether the name on the package is the actual maker of the cigarettes. Up to June 1955, most of the major cigarette makers may be identified by factory number, and later, sometimes, by permit number. Identifying maker and vendor for the minor companies is more problematic, even with factory numbers. Therefore the "Merchant" (first column) may be either a maker or vendor. 1,534 merchants are listed.

The Identification Code (column two) is a three-letter code unique to each merchant. This code is also used in the Brand Name and Factory Number Listings to identify the merchants. The codes are defined in Appendix B in alphabetical order to assist identification of a merchant.

The Year column indicates the general time frame when the merchant was known to be active.

The Brand Name column lists a factory number associated with the given merchant, and usually (but not always) with the listed brand name. This does not mean that the listed "Merchant" necessarily made cigarettes, only that cigarettes with his name on them were made in this factory.

Appendix A:
LIST OF CIGARETTE MERCHANTS

MERCHANT	ID	YEAR	BRAND NAME	FACTORY	REMARKS
A and P, NYC.	GAP	1986	P&Q	TP-555-2NY	See Great Atlantic&Pacific Tea Co (Export), By Star Tob.
A.C.E., NYC.	ACN	1997	Marilyn	TP-22-VA	
Abdulla & Co.	ABD	1905	Abdulla		
Abraham,F. & Sons Boston, MA.	AFS	1898	Knights of Columbus		Listed in Connorton's Directory 1898.
Abramowitz, Jos., NYC.	ABR	1894	The Home		Listed in Connorton's Directory 1898.
Acker Merrall & Condit, NYC.	ACK	1898	Elegancia La		Listed in Connorton's Directory 1898.
Adams, F E & C.	ADA		Peerless		
Adams-Powell	ADP	1922	Indian Girl		Probably by McElwee Tob. Co.
Adriatic Group	ADR		Gemini		
Advanced Tob. Products, TX.	ADT	1985	Favor 86		
Advertising Cig. Distributors	ADC	1937	Petit Amour		
Ahrens, M. J., & Co., NY.	AHR	1901	Egyptian Fancies No.4		
Albertsons, Inc., Boise, ID.	ALB	1988	Generic		Un-named Generic by LAM.
Albrecht, Otto &Co., Davenport. IA.	ALR	1898	Cuba Pickings	TP-42-NC	Listed in Connorton's Directory 1898.
Aldeo, Domingo, NYC.	AEO	1898	Spanish Puros		Listed in Connorton's Directory 1898.
Alexandre, S.	ALX	1923	Alexandre		
Alexiou, John Wilkes Barre, Pa.	ALE	1955	Salome	F22-12PA	Assoc w/Lee Tob. (LTC),& Penn Tob.
All American Brands	ALA		All American		
Allen & Co., NYC.	ALL		Cheroots		See Allen Tob. Co. Later ALG.
Allen & Dunning	ALD		Call Chewing		
Allen & Ginter Tob. Co. Richmond VA, New York City	ALG	1875-	Richmond	F25-VA	In American Tob. Trust in 1891.
Allen & Marshall Philadelphia, Pa.	ALM	1891	Gem	F25-2VA	Also F42-4NC.
Allen, J. F. Co., Richmond Va.	ALT	1898	Liberty Place		Listed in Connorton's Directory 1898.
Alliance Cigar Mfg. Co., NYC.	ALC	1874	Allenetes	F20-14NY	May also be listed as Allen (ALL)
Alliance Tob. Co., NYC.	ACM	1924	Puppies	F24-14NY	Alliance Tob Co.or Alliance Cigar Co.
Allied Tob. Products	ALI	1945	Presidential	F20-14NY	Alliance Tob.Co.or Alliance Cigar Co. Mfg.
Allison Brothers Co. Rochester, NY	ATP	1880	Carteret		
Allones, R. & Havana Cig Co.(LA)	ABC	1910	Lawn Tennis		
Alpha Beta Co., La Habra, CA.	ALO	1987	Econo Buy	TP-42-NC	Store Brand by LAM or American Strs
Alsfelder, Fred, Cincinnati, OH.	ALP	1898	Three Doses		Listed in Connorton's Directory 1898.
Alternative Cig. Inc. Buffalo, NY.	ALS	1996	Pure	TP-168-NY	On Tuscarora Indian Res, See TAI.
Alvarez, Oscar Augusto Leon	ACI	1914	Galled		
Alzanne Cig. Co.	ALV	1948	Alzanne		
Ambassador East	ALZ		Pump Room	F5-2NY	By BAH.
American Brands	AME		Margharita		
American Cig. & Cigar Co. Inc.	AMB	1939	Pall Mall	F130-NC	Subsid of ATC to produce Pall Mall
American Cigar Co.	ACC	1923	Lady Churchill		
American Cig. Co., Durham, NC.	ACG	1886	Little Sweetheart	F30-NC	
American Leisure Concepts	AMC	1971	Pet		
American News Co., NYC.	ACO	1879	Marquis De Lorne	F2032-2PA	First Cigarette Card.
American Store	AMN	1932	Gems	TP-42-NC	By STP
American Stores Buying Co. UT.	AMS	1990	Econo Buy	F30-NC	By LAM,Prev. Alpha Beta Co. Ca.
American Tob. Co. (1911-1955) (See also ATD)	ATC	1911-1955	Lucky Strike	F42-NC	Same assoc. Company's S. Anargyros, Kinney, Lommed Bros. Also F60-NC, F3-LA, & F619-1NY.
American Tob Co., (Trust) (1890-1911) Also ATC,BAT)	ATD	1890		F7-3NY F8-5NJ F30-2NY	Later name for ATC W. Duke & Sons (DUK) W/Kinney, Allen/Ginter, Kimble & Goodwin. In Trust 1900 Master Brands to LOR in 1911, Also F21-NY and F7-NY.
Amster, Henry, Cleveland OH.	AMT	1890	Pen Head		Listed in Connorton's Directory 1898.
Amster, Max	AMR	1911	Tiptoe		Listed in Connorton's Directory 1898.
Anagrosti, Willy	ANA	1898	Honey Clover		
Anargyros, S. Co. NYC. Oakland Ca.	ANR	1912	Arabesca / Murad		
Andremi, M. A.	ANM	1926	Andremi		
Andron, G. A., & Co., Inc., NYC.	AND	1991	Texas Lights	TP-165-NY	Formerly G.A. Georgopulo.
Anglo-Egyptian Cig.& Tob. NYC.	AEC	1900	Anglo-Egyptian # 1	F602-3NY	
Ansor Corp.	ANS	1975	Alhambra		
Antoniedes Cig. Co., NYC.	ANT	1906	Sultan	F174-3NY	
Antonio Co.	ANC	1965	Antonio GO-GO		

MERCHANT	ID	YEAR	BRAND NAME	FACTORY	REMARKS
Apostolides, A., NYC.	APO	1927	Alexandra Special	F245-2NY	
Appleby & Helme, NYC.	APH				
Arabesca Cigarette Co.	ARA		Arabesca		
Arabian Nights Cig. Co., Inc.	ARB	1915	Arabian Nights		
Ararat Tob. Co., Detroit, MI.	ART	1931	Fanny	F225-MI	
Aristypho, T., Co.	ARI	1902	Aristypho No. 1	F467-1PA	
Armand Co.	ARM	1952	King of Kings		
Armstrong Bros., NYC.	ARN	1898	Hunter		Listed in Connorton's Directory 1898.
Arndt, M. B.	AST	1911	Recortes		
Artzt, Richard, Philadelphia, Pa.	ATZ	1898	Artztdale		
Artzt, Simon, Kattenburg, NY.	ARZ		Arzt 20's Egyptian		
Aschner's A., Sons, Brooklyn, NY.	ACR	1898	Brooklyn Dutchess		Listed in Connorton's Directory 1898.
Ascot Tobacco Works, Ltd., NY.	ASC	1901	Royal Ascot		
Ash, Louis & Co. St. Louis. MO.	ASU	1898	Champagne		Listed in Connorton's Directory 1898.
Ash Louis, NYC.	AHL	1898	Mareus Superbus		Listed in Connorton's Directory 1898.
Asheville Tob. Works & Cig. Co.	ASH	1884-	Beauty Bright		
Asheville Tob. Works Ashville, NC.	ATW	1883	Jumalaska		
Aslan Bros. Philadelphia, PA.	ASL	1908	Karam		
Associated Whsl. Gro Inc. KC. KS	ASW	1987	Always Save	TP-42-NC	By LAM. Store Brand.
Ateshian Cig. & Tob. Co., IL.	ATE	1895	Ateshian Turkish		
ATG, Inc. Annandale, VA.	ATG	1992	Benton		
Athos Sob Co.	ATH		Athos	TP-2442-PA	Prev.Robert Gordon Tob. Co. PA.
Atlantic City Cig, Inc PA.	ATL	1982	Atlantic City	TP-762-FL	By Mendez Enterprises.
Auld, C. C.	AUL	1937	New Yorker		
Austin, Nichols & Co., NYC.	AUN	1898	Featherweight		Listed in Connorton's Directory 1898.
Autograph Cig. Co., The NYC	AUO	1942	Demitasse	F156-2NY	
Autolite Mfg. Co. Newark, NJ.	AUT	1903	Autolite		Also F24-14NY, and F750-3NY.
Axton-Fisher Tobacco Co. Louisville, KY.	AFT	1903-1944	Twenty Grand	F24-KY F49-KY	Fact and many brandnames to Philip Morris Co. in 1944
Badger State Tob. Works	BAD		Peerless		For F. E. Adams & Co.
Bagley, John J. & Co., Detroit, MI.	BAG	1923	Bagley's Sweet Tip		Listed in Connorton's Directory 1898.
Bailey Bros., Inc	BAI	1922	Carolina Royales		Maybe F100-NC
Bamberg, H., Columbia, SC.	BMB	1898	College Twisters		Listed in Connorton's Directory 1898.
Bandeni, H., Columbia, SC.	BDZ	1898	Blue Chip		Listed in Connorton's Directory 1898.
Banghart Bros. & Co., Chicago, IL.	BGH	1898	Dandy Cat		Non-Tob Cigarette.
Bankers Club of America	BCA		Bankers Club		
Bantob Products Inc.	BPI	1976	Vanguard		Non-Tob Cigarette.
Barbour, James L. & Son, DC.	BBJ	1898	Belle of Washington	F100-NH	Listed in Connorton's Directory 1898.
Barkmahn Co.	BAR	1915	Barkmahn		Merged W/Philip Morris Co.
Barlow, Rogers & Co. NY.	BRC	1898	Anotta		Listed in Connorton's Directory 1898.
Baron & Co. Baltimore MD.	BAC	1885	Capsule		Listed in Connorton's Directory 1887.
Baron Bros.	BBR	1898	Radames		Listed in Connorton's Directory 1898.
Baron, Benj., NYC.	BBE	1898	Lafayette		
Barrington Tob Co.	BAN	1913	Barrington		
Barson, A. N.	BSN	1900	Natural		
Bartec Corp.	BTC		Affair		
Bateholder Bros., Philadelphia PA.	BTH	1898	Dot and Kit		Listed in Connorton's Directory 1898.
Bates, Jacob, NYC.	BAJ	1898	Good Luck		Listed in Connorton's Directory 1898.
Batt Bros. Tob. Co., NYC.	BAB	1923	Modernique	F551-2NY	Also F551-3NY, Sold to GAG, 1951!
Bauer, J.	BAU	1934	Puff Slenderline		Agent for GAG.
Baum, Edward, Co., Lynn MA.	BAM	1950	Statler Tissues	F407-2NY	
Bayler, Chas. A., York PA.	BAY	1898	Confederate BattleFlag		Listed in Connorton's Directory 1898.
Beck, W. M., Richmond VA.	BCK	1898	Ahead of the Times		Listed in Connorton's Directory 1898.
Becker, Chas. R., Baltimore, MD.	BKE	1898	Baltimore Fives		Listed in Connorton's Directory 1898.
Bedrossian Bros.	BED	1867	Sultana		Also Turkish Elegantes in 1862
Beechwald Bros., Ida Grove, LA.	BEE	1898	Ozark Fruits		Listed in Connorton's Directory 1898.
Beerman & Co., Atlanta GA.	BEM	1898	Scorcher		Listed in Connorton's Directory 1898.
Beleske, J.	BEL	1887	Morocco Moorish		Listed in Connorton's Directory 1898.

Top table:

MERCHANT	ID	YEAR	BRAND NAME	FACTORY	REMARKS
British American Tob. Co., Ltd.	BAT	1920	Ace or Eagle Bird		Formed 1901, Co-existed with ATD-1901-1911, Parent Co. of BAW.
Broadway Drugs	BRW	1931	Golden Gift		By Riggio Tob. Co.
Bromall & Wogan, Philadelphia, PA	BML	1898	Pennsy		Listed in Connorton's Directory 1898.
Brooks, T.E.	BRO	1969	Las Vegas		
Brothers Tob. Co.	BRT	1946	Mallard		
Brown & Ackerman	BRN		Baronet		
Brown & Williamson Tob Corp KY.	BAW	1926-Date	Raleigh	F36-KY F35-VA	Also TP-16-GA, TP-35-VA, F15-KY, C36-KY and TP-36-KY.
Brown Bros. Co. Winston, NC.	BRB	1885-	Gold Leaf	F460-VA	Listed in Connorton's Directory 1898.
Brun, Adrian	BUN		Victoire		
Bruzard & Kohlman, NYC.	BRZ	1945	Czarovitz, le		
Bryden, Geo. A. NYC.	BRY	1898	Topo, El		Listed in Connorton's Directory 1898.
Buchanan & Lyall, Brooklyn, NY.	BUL	1898	Amorita		Listed in Connorton's Directory 1898.
Bucher & Bucher Co., Dayton, OH.	BCB	1898	Drifter's Club, The		Listed in Connorton's Directory 1898.
Bucher, D., & Co., NYC.	BCH	1886	Imperiales		Listed in Connorton's Directory 1887.
Bud Cig. Co., Inc., NYC.	BUD	1915	Bud		
Budner, Louis, Buffalo, NY.	BDN	1898	Living Shield	F410-2NY	Listed in Connorton's Directory 1898.
Burton, Edward	BUR		Eton		
Burton-Marshall	Bum		Carioca Rums		
Busnitz, S., & Co., Richmond VA.	BUS	1880	Scotch Cap		Subsid. of ATC, Also made Pall Mall, ca. 1905
Butler, Wm. K.	BUT	1903	At the Foundation		
Butler-Butler, NYC.	BUB	1905	Sovereign	F2153-3NY	
Burtniz, S.	BUZ	1885	Old Burley		
Byedavco Inc., Washington DC.	BYE	1992	Friendship (export)	TP-3-VA	Export brand, by USJ.
C. W. Distributors, Chariton, IA.	CWD	1992	Lots of Value	TP-22-VA	By Star Tob. Co. (SAR) Named Gnrc.
C.A.D.O.Co.	CAD	1913	Fifty Six		
C.D.E. Inc.Twinsburg OH.	CDE	1988	gENERIC	TP-42-NC	No-Name Gnrc. By LAM.
Cable Bellpurch	CBC	1943	Bells California	F94-1NY	By LEI.
California Tob. Co.	CAL		California		
Calixto Lopez Co.	CLX	1903	Morro Castle		
Camber-Turkish Tob. Co.	CAB		Camber Rubies		
Cambridge Tob. Co., The NYC.	CDG	1938	Ardsley	F24-KY	By AFT.
Cambyses Co., The	CMB	1913	Ramly		In Trust.
Cameron & Cameron	CAM	1885	Fatima	F25-2VA	
Cameron & Sizer	CAS	1889	Purity Paper		
Cameron, A. & G.	CRN	1889	Cameron's Entire		
Camp Importation Co. NYC	CIC	1880	Camp	F697-3NY	
Cambell, Geo., & Co., Richmond	CBL	1908	The Three Cities		
Campus, Cesare	CPS		Campus		
Cannon & Waller, Inc., Toledo, OH.	CAN	1945	Director's Special	F1-100H	
Canton Cigar Co, Canton, PA.	CGC	1898	Darktown Fire Brigade		Listed in Connorton's Directory 1898.
Capital Drug Co.Inc. Augusta, ME.	CAP	1937	Kinsman's Asthmatc		
Caresso, M.	CAR		Princess Rosa		
Carl Henry, Inc. NYC.	CAH	1915	Carl Henry	F460-VA	House Brand by LAB Picadilly T. C.
Carlen Tobacco Co., NYC.	CLC	1905	Carlen's American	TP-622-NC	Subsid. of LOR, Exp. to Japan.
Carolina Cig. Co, Greensboro NC.	CCO	1993	Harley-Davidson	F7-VA	By PMC.
Carreras Limited, London Eng.	CRR		Craven A		
Carroll & Greenstone, VA.	CLG	1880	My Sweetheart		
Carroll, Wm. S., Lynchburg, VA.	CLL	1875	Lone Fisherman		
Carsey-McEwen Tob Co., TN.	CRY	1898	Belle Meade		Listed in Connorton's Directory 1898.
Castritsky, Geo. P	CTY	1923	Valentino		
Central Tob. Co., NYC.	CEN	1941	White Eagle	F27-2NY	In Coop W/Polish Nat. Tob. Monoply.
Certified Grocers of Florida FL.	CER	1988	Monticello	TP-42-NC	House brand by LAM.
Chalkiadi, Inc.	CHA	1884	Haidee	F551-3NY	Has mirror inside of pack of 10.
Challenger Industries Ltd. NJ.	CHL		Bravo		
Chaparral tob. Co., Inc., PA.	CHP	1988	Chaparral	TP-2442-PA	By GOR.
Chaparral Tob. Co., CA.	CHT	1993	Chaparral	TP-2442-CA	
Charciel Corp.	CRL	1924	Kismet		
Charlie's cig. Land, NC	CCL	1995	Charlie's Cig. Land	TP-2442-PA	
Chemex Corp.	CHM		Consulate	F42-NC	By LAM.
Cherokee Nation Inc.	CHN	1898	Comanche		Listed in Connorton's Directory 1898.
Chesterfield Cig Co. Durham, NC.	CHE	1992	Chesterfield	TP-42-NC	Subsid of LAM/The Liggett Group
Choice Tobacco Inc.,??	CBY	1997	CBY	TP-22-VA	By star (Export?)
Christian Dior	CHD		Christian Dior		
Christian Peper Tob. Co.	CHR	1934	Gordon Buchanan	F11-1MO F15-1MO	Early Co. brands went to Wisert TC. Also F12-WV.
Churchill Tob. Co.	CHU	1940	Churchill Kings	F42-NC	
Cigarette Pack Collector's Assn.	CPC	1996	Durham III		For Durham III meet.
Clerke & Co. Boston MA.	CLR	1898	City Bouquet	TP-2442-PA	Listed in Connorton's Directory 1898.

Bottom table:

MERCHANT	ID	YEAR	BRAND NAME	FACTORY	REMARKS
Belfield & Brooks, Philadelphia PA.	BLF	1898	Prince Albert		Listed in Connorton's Directory 1898.
Below, S.S. Amesbury, MA.	BEW	1898	Carriage Centre		Listed in Connorton's Directory 1898.
Ben-Asher Co.	BEA	1976	Taste		
Benaderet,S. Inc.	BEN	1915-1980	Paramount	F213-1CA	40 Different Brand Names + Bendheim
Bros. & Co. NYC.	BNB	1898	Angels		Listed in Connorton's Directory 1898.
Benicia Co.	BEC	1990	F & L	TP-7-VA	House Brand by Philip Morris Co.
Bennett Tob. Co.	BNT				
Bensen International, CA.	BES	1899-1954	Imports	F1-2NY	Distinguished Tob. Importers. Also F5A-NY, & F936-3NY, Made mny brnds. before merger w/PMC, in 1954.
Benson & Hedges Tob. Co. NYC.	BEH		Old Gubek	F5-2NY	
Bentley, C. E.	BEY	1927	Garrison		
Berberian Bros., Boston, MA.	BER	1927	Wall St. Special	F122-MA	Merged W/Leighton Tob Co.
Berg, Isadore, NYC.	BRG	1898	American Exchange		Listed in Connorton's Directory 1898.
Berkman, Coe & Levin, NYC.	BEK	1886	Liberty Bell		Listed in Connorton's Directory 1898.
Bethke, H. R.	BET	1933	Silver Bell		Listed in Connorton's Directory 1898.
Bevan & Co. Martinsville, W.V.	BEV	1898	Old Bob Ridley		Listed in Connorton's Directory 1898.
Biershatsky, B., NYC.	BSH	1898	Sweet Bride		Listed in Connorton's Directory 1898.
Billor, David, NYC.	BRD	1898	Full Moon		Listed in Connorton's Directory 1898.
Billor, S., NYC.	BLE	1898	Blue Guard		Listed in Connorton's Directory 1898.
Billups Oil Co.	BIL	1962	Billups	F460-VA	House Brand by LAB
Bing, D., NYC	BGD	1898	Our Tony		Listed in Connorton's Directory 1898.
Bissell, J. M. Hartford, CN	BSS	1898	Rosabacco, La.		Listed in Connorton's Directory 1898.
Black Death, U.S.A.Beverly Hill CA	BLD	1993	Black Death		Imported from/EEC.
Black Tob. Co., Miami, FL.	BLC	1963	Centrofinos Cigarettes	TP-45-VA	By HOE
Blackwell & Co. Durham, NC	BLA	1878	Golden Belt		
Blackwell's Durham Tob. Co.	BLY	1875	Margarita Segarette	F417-28NY	Listed in Connorton's Directory 1887.
Blakely, John Segarette Co. NYC.	BLR	1876	Bull Moose		
Blaser, Ike	BLO	1919	Wizard	F12-WV F20-11MO	Also F916-NY, Absorbed Many small Cig. makers or vendors.
Bloch Bros. Tob. Co., The					
Blosser Co.	BLS		Blosser' s		
Blossom Marketers	BLM		Dividend		
Blue Knight Enterprises	BLK	1964	Kiss of Death		
Blue Network Breakfast Club, (Don McNeill)	BLN	1945	No		
Blue Peter Cig. Co., NYC.	BLP	1914	Blue Peter	F59-2NY	
Bluestein, Tobiad, Inc.,Chicago IL.	BST	1915	Boulevard	F358-1IL	
Blumenberg, Simon, NYC.	BLB	1898	Mary Powell		Listed in Connorton's Directory 1898.
Bock & Co., NYC.	BKC	1898	Valley Girl		Listed in Connorton's Directory 1898.
Bock & Stauffer	BOK		Standard		
Bock y Ca	BOC	1908	Bock y CA.		
Boeger, H. A. Cleveland, OH.	BOE	1898	Tryphena		Listed in Connorton's Directory 1898.
Boguslavsky, T.	BOG	1921	Cerise		
Bohls, H. & Co. Tob Works CA.	BOH	1888	Calmade		
Bollman, John & Co.CA.	BOL	1896	Obak	F171-1CA	Forced to Close by ATD 1894 Into Trust, 1902, then to LAM
Bonded Oil Co.	BOO		Bonded	F460-VA	House Brand by LAB
Bonded Tob. Co.	BON	1943	Denictor	F137-5NJ	See H. Sackett Bonded Tob Co.(SAC)
Bonnell			Bonnell Blend		
Booker Tob. Co. Inc.	BKR	1913	Sweet Briar		
Booker, W. L. Cigar Co.	BOT	1913	SweetBriar		
Borowsky, J. W.	BOR	1898	Coronia		Listed in Connorton's Directory 1898.
Borsook, Mary, Brooklyn, NY.	BRK	1898	Cuban Hero	F35-2NY	Listed in Connorton's Directory 1898.
Boultbee & Colby	BOU	1925	Egyptian Idols		Factory also used by Contopoula Bros
Bouquet-Cohen Co.	BOQ	1908	Nebo		Was bought out by LOR.
Bovee & Adams, New Orleans, LA	BAA	1983	Pocahontas		
Bowie & Wilson Richmond VA.	BOW	1898	Climax		Listed in Connorton's Directory 1898.
Boyce, Joseph P.Cigar Co., MA.	BOY	1898	Axminster		Listed in Connorton's Directory 1898.
Bramas Trading Co., NYC.	BRM	1946	Cherie	F460-VA	LAM Export
Brand Marketing Co., Portland Or, San Francisco, CA.	BRA	1988	Generic	TP-42-NC	None name Generic by LAM.
Brand X Enterprises	BRX		Brand X		By GAG.
Braunman, Robert, Jersey City NJ.	BNN	1898	Alex and George		Listed in Connorton's Directory 1898.
Bravo Labs, Ltd.	BRL	1968	Bravo		A no nicotine Cigarette.
Bravo Smokes, Inc., Hereford TX.	BRV		Bravo		
Breitweiser, H. &J., Tob Mfg'rs NYC.	BWS	1916	Ivory		
Brennig's Own Inc. NYC.	BRE	1935	Brennig's Own Yacht Club	F10-KY	By TBC.
Brewer, Clark, & Sons	BRR	1867	Whiffs		
Brewster, H. P, Rochester, NY.	BRS	1898	London Lords		Listed in Connorton's Directory 1898.
Briki Tob. Co.	BRI	1968			Became Superior Products Co.
Brilles, M. & Co. Allegheny, PA.	BLL	1898	Blue and Gold		Listed in Connorton's Directory 1898.

MERCHANT	ID	YEAR	BRAND NAME	FACTORY	REMARKS
Clover Tob. Co. | CLO | 1948 | Moby Dick | | Could be Glover.
Club 45 Tob. Co. NYC. | CLT | | Club 45 (Export) | |
Club Imports, Inc. | CLI | 1985 | Original American Spirit | | By GAG.
CM Products, Inc., Sacramento, CA. | CMP | 1988 | Best Buy | TP-42-NC | House brand by LAM, Later PMC.
Coast Tob. Co. | | | | TP-16-GA | MAJOR BRAND by BAW. TP-7-VA.
Cocabaco Tob. Co., MO. | COA | | Brownies | |
Cocktail Hour Cig Co. | CBA | 1884 | Cocarettes | |
Cohan, Joseph, NYC. | COC | | Cocktail Hour | F30-NC | By ATC.
Cohn, M. & M. & Co. Chicago, IL. | COJ | 1898 | King Leah | | Listed in Connorton's Directory 1898.
Cohn, M. L., & Co. Chicago, IL | COM | 1898 | Army | |
Cohn, S. Chicago, IL. | COH | 1879 | Sweet Stephania | | Sweet Stephania Pat. Prep catarrh Cig
Collins Cigar Co. Pittsburg, PA. | CHS | 1898 | Bospora | | Listed in Connorton's Directory 1898.
Collins, J. W. & Co. Richmond VA | CLS | 1898 | Blue Royal | | Listed in Connorton's Directory 1898.
Colonial Tob.Co. | CLN | 1898 | Sporting | |
Columbia Tob. Co., NYC. | COL | 1900 | First Lady | F11-MO | Probably by Tuckett.
Columbus. F, Cigar Co. | COU | 1939 | Du Maurier | F15-KY | Probably by BAW. du Maurier also made by PMC. F248-3NY.
Columa Bros's & Co., NYC | CLM | 1929 | Zebra | F327-2NY |
Commercial Tob. Corp., CA. | CBS | 1899 | Miss Charmion's | |
Commercial Union Cigar & Cig Co. | COM | 1954 | Spotlite | C305-CA |
Commonwealth Brands, Inc KY. | CUC | 1895 | Tuxedo | |
Compania Industrial | CBI | 1995 | Raven/Maui | TP-42-KY |
Compass Foods Inc. NJ, | CMI | 1902 | Pitire | |
Condax, E. A. & Co., Inc. | CFI | 1986 | Generic | TP-42-NC | No-Name Generic by LAM, A&P Groc. Also F320-3NY, Subsid. of LAM.
Condossis, A. D. | CDX | 1914 | Condax | F320-1NY / F320-2NY |
Condossis, A. D. | CON | 1938 | King Condossis | F59-2NY / F394-3NY | Connoisseur TC, & Blue Peter Tob. Co
Congress Cigar Co. | COG | 1925 | Paolina | | See also the Consolidated Cigar Co.
Connoisseur Tob Co. | COS | 1934 | Blue Peter | F59-2NY | See also Blue Peter Cig. Cc. and A. D. Condossis at the same factory
Connor, W. Y., Philadelphia, PA. | CNR | 1898 | Damiana | |
Conrad & Lander, CA. | CND | 1898 | Injunction | |
Conrad, Frank C. | CRD | 1917 | Chiropractor | | Listed in Connorton's Directory 1898.
Consolidated Assets | CDA | 1930 | Patsy Puff | |
Consolidated Cigar Co.or Tob. Co. | CCC | 1917 | Cycle | |
Consolidated Cagar Co. NYC. | CTC | 1872 | Havana Straights | F7-VA | Same brands made by Congress Cigar Company.
Consolidated Cigar Co., VA. | CDR | 1898 | Juba | F12-VA | Or Consolidated Tob. Co., in Trust
Consolidated Cig. Co. NYC. | CCG | 1883 | Jack Rose | F35-2NY | Listed in Connorton's Directory 1898.
Constantine Tob. Co. | COT | 1920 | Vita-Vim | |
Continental Bristol Corp. | COB | 1966 | Palmer | |
Continental Cigar Co. | CNC | 1959 | Bat | |
Continental Concepts, Inc., GA. | CCI | 1992 | Way (Export) | F401-2NY |
Continental Tob. Co./So. Carolina | CNS | 1868 | De Menthe | |
Continental Tob. Co.of W. Virginia | CNW | 1968 | Ascot | TP-14-GA | Also Royal Crest and 4 Kings, Export.
Continental Tob Co. Inc NC. | CNT | 1898-1934 | Cigarette Time | F7-VA / F12-VA | LTC. Continental formed as subsid. to ADT, F21-VA.
Contopoulo Bros. | COP | 1910 | Lepton | F35-2NY |
Convenient Food Mart Inc. IL. | COV | 1989 | CFM | TP-42-NC | House brand by LAM.
Coon, Abraham, NY. or CN. | COO | 1898 | Bonny Brook | | Listed in Connorton's Directory 1898.
Core-Mark Import/Export, CA. | CRM | | London International | | (Import)
Cork tip Cigarette Co. NYC. | COR | 1898 | Pyramid | | Listed in Connorton's Directory 1898.
Cornell Drug Corp. | CDC | 1955 | Trim | F94-NY | A reducing Aid Cig. Made by Riggio Tobacco Co.
Cosmopolitan Tob. Co., Boston MA | CPT | 1910 | American Bud | |
Costakis & Heliotis & Co. | CTK | 1902 | King Seti | |
Costello & Hamilton, NY. | CTH | 1898 | Unnamed | | Listed in Connorton's Directory 1898.
Coulapides, A., Inc. | CUI | 1923 | Egyptian Mysteries | |
Court Cig Co., The | CRT | 1938 | Court | F556-2NY |
Courtinade, F, NYC. | CTD | 1933 | New World | F30-NC | Cigarettes Made by ATC.
Coutoumanos Bros., Chicago, IL. | CTM | 1895 | Athenian | F879-3NY |
Cowie & Co., Ltd. | COW | | Dividends | F1673-1IL |
Craft, Agustus, New Orleans, LA. | CFT | 1898 | Louisiana Tigar | | Listed in Connorton's Directory 1898.
Creagh, John B., Philadelphia, PA. | CGH | 1898 | Cespedes Hall | | Listed in Connorton's Directory 1898.
Creigh, Gudknecht & Co. PA. | CRG | 1898 | Grand Monarch | | Listed in Connorton's Directory 1898.
Crescent Tob. Co., NYC. | CRE | 1890 | In Style | |
Creston Cigar Co., Creston, OH. | CST | 1898 | The Wayne | F587-2NY | Listed in Connorton's Directory 1898.
Crimson Coach, Inc. | CRC | | Crimson Coach | |
Crouse & Co., Reading PA. | CRO | 1898 | American Man | | Listed in Connorton's Directory 1898.

MERCHANT	ID	YEAR	BRAND NAME	FACTORY	REMARKS
Cullivan, Thomas, Syracuse, NY.	CUL	1911	Fireside		From Cigarette Card.
Cunningham, Blake & Co. PA.	CNN	1898	Florida Picking		Listed in Connorton's Directory 1898.
Currie Tob. Co. Louisville, KY.	CUE	1898	Old Tavern		Listed in Connorton's Directory 1898.
Curtis, Harry A.	CUR		Curtis		
Customer Co., The CA.	CUS	1988	F&D	TP-42-NC	F&D (Food & Deli)
			TP-7-VA	Cigarettes made by LAM	
D. M. S., Inc. New Rochelle, NY. | DMS | 1993 | US1 | | Made in Holland for D.M.S.
Dabs Cig. Co. | DAB | 1911 | Dabs | | TP-130-NC
Dakota Indian | DIC | 1993 | Reno | | By LAM
Dallas Cig. Co., Inc., Dallas TX. | DAL | 1993 | Dallas Superlights | TP-42-NC |
Dalton, M. J., Philadelphia, PA. | DLT | 1898 | Tondal | | Listed in Connorton's Directory 1898.
Danville Cig Co., Danville VA. | DAN | 1887 | Souvenir | | In Trust.
Darlington & Co., NYC. | DLG | 1895 | Cameo | | Branch of Virginian T.C. (VGN)
Darragh, J. G. | DAH | 1913 | I.O.U. | TP-7-VA | By PMC (Filter)
Dave's Tob. Co., Concord, NC. | DAV | 1994 | Dave's Original Blend | F24-KY | By AFT.
Dawn Cig., Inc. | DAW | 1930 | Dawn | | Listed in Connorton's Directory 1898.
Dellaneo Cigar Co., NYC. | DEO | 1898 | A Pat Hand | | LTC.
Delux Tob. Co., Portsmount, OH. | DEL | 1922 | Romance | F88-11OH |
Dengler, J. R. | DEG | 1940 | Gateway | |
Denobili Cigar Co., RI. | DEN | 1919 | Royals | |
Deplis, F. A. | DEP | 1899 | Matoaka | |
Derring, Ellis, Co., NYC. | DER | 1898 | Daliska | | Prob by GAG.
Detroit Athletic Club, Detroit, MI. | DAC | 1998 | DAC | |
Deutsch Bros. & Graham NYC. | DEU | 1994 | Bogie Man | |
DFS North America, A Div of | DFS | 1994 | Hole in One | | DFS=Duty-free stores, TM Applied for
DFS Group L. P. Los Angeles, CA. | | | | |
Dibrill & Co., Richmond, VA. | DIB | 1889 | Southern Soldiers Home | | Listed in Connorton's Directory 1887.
Diesel, Henry & Co., Lima Oh | DIE | 1898 | Druggist's Delight | | Listed in Connorton's Directory 1898.
Dill, J. G. | DIL | 1920 | Egyptian Heroes | | Listed in Connorton's Directory 1898.
Dilworth Cigar Co., Lancaster, PA. | DLW | 1898 | Panalette | | Listed in Connorton's Directory 1898.
Dingfelder & Libko, NYC. | DNF | 1898 | Bon Ami | | Listed in Connorton's Directory 1898.
Dingman, Henry C., NYC. | DNG | 1898 | Royal Egyptian | | Listed in Connorton's Directory 1898.
Dock, Mortimer Russell | DOC | 1898 | Egyptian Ebony | | Listed in Connorton's Directory 1898.
Doebelo, F. A., Cincinnati, OH. | DOE | 1898 | Cuban Scrap | | Listed in Connorton's Directory 1898.
Doelman, L. & Co., Buffalo, NY. | DLM | 1898 | Mammoth | | Listed in Connorton's Directory 1898.
Dominguez Bros., Philadelphia, PA | DMZ | 1898 | Altares | | Listed in Connorton's Directory 1898.
Dominion Tob. Works | DTW | 1905 | Stars & Stripes | |
Donohue, T. N. | DON | 1924 | Camile | |
Dosal & Mendez Tob. Corp., FL. | DOM | 1963 | Competidora | TP-43-FL | Ltr. Mendez Enterprises.
Dosal Tob.Corp., Miami, FL. | DOS | 1898 | Gaditana | TP-762-FL | Listed in Connorton's Directory 1898.
Double E. M. Co., Atlanta, GA. | DEM | 1898 | Double E. M. | F266-3MA | Listed in Connorton's Directory 1898.
Douglas, G. Nelson | DOU | 1898 | Makaroff | F622-3MA | See The Makaroff Co. of America.
Dowd, A. J., Chicago, IL. | DWD | 1898 | Flickertails | | Listed in Connorton's Directory 1898.
Drake, A. S., Long Island City NY. | DAK | 1898 | Damgood | | Listed in Connorton's Directory 1898.
Dream Castle Tob. Co., CA. | DRC | 1939 | Dream Castle | F10-KY | TBC made Red Castle for DRC.
Dressner, D., NYC. | DRE | 1887 | Lucky Hit | | In Trust.
Dreyfus Bros., Montgomery, AL. | DRY | 1898 | Black Spots | | Listed in Connorton's Directory 1898.
Drinkhouse, J., Co. CA. | DRK | 1898 | Bear Plug | | Listed in Connorton's Directory 1898.
Drucklieb Bros. | DRL | 1916 | Taper Tip | |
Drucquer & Sons, Ltd., CA. | DRQ | 1934 | Mexican Beauties | F310-1CA / F351-CA | May have also used F130-3NY and F170-3NY.
Drummond Tob. Co. St. Louis MO. | DRU | 1870-1888 | Drum | F100-1MO | To LAM 1888, then into trust.
Dubec Ltd. | DUB | 1886 | Dubec | |
Duckworth Enterprises | DUC | | Grim Reapers | |
Dudley Cheroot & Cigar Co., VA. | DUD | 1898 | Old Powhatan | | Listed in Connorton's Directory 1898.
Duke Co. The | DKE | 1868 | Duke of Durham | F3-VA | Became W. Duke Sons & Co.
Duke, W. Sons & Co. Durham NC. | DUK | 1870-1890 | | F42-4NC | Became American Tobacco Co. (ATD) (Trust) in 1890
Dunhill Ltd. | DUH | | Dunhill | F37-3NY | Made by PMC.
Dunhill, Alfred | DUN | | Shepheards Special | F7-VA / F546-2NY | Sme Fact mde Shepheard's by E. P.
Mesthene | | | | |
Dunlop, David | DUL | 1958 | Record | | Made by BAW.
Dunn, T. J. & Co., PA. | DNN | 1898 | Artie | | Listed in Connorton's Directory 1898.
Dunnsboro Tob. Co. | DNS | 1937 | New Yorker | |
Dupont, (I.E.) de Nemours & Co. | DUP | 1955 | Dupont | |
Durham Tob. Co., Durham, NC. | DUR | 1899 | Two Kings | |
Duval Tob. Co. | DUV | | Duval | | For C. C. Auld.

(Left table)

MERCHANT	ID	YEAR	BRAND NAME	FACTORY	REMARKS
Dycyan & Co., Boston MA.	DYC	1905	Wanda Turkish	F266-MA	
East/West Marketing Co.	EWM	1978	Honey Rose		For the Familiar Herb Co.
Eastern Cig. & Tob. Co.	ECT		A-One		
Eastern Coop Wholesale League	ECW	1943	The Cooperator		
Eastern Cooperative Whls. Inc.	EAC	1948	Co-op Blend 17	F750-5NJ	By Pet?
Eckmeyer & Co. NYC.	ECK	1887	Jocky Club		In trust, 1887 & 1898.
Economy Wholesale Dist. Inc., FL.	EWD	1989	Price Breaker	TP-42-NC	House Brand by LAM
Egyptian Cig. Co. NYC.	EGC	1898	Agnes		Listed in Connorton's Directory 1898.
Egyptian Crown Cig, Co., OH.	EGC	1898	Cuban Patriots		Listed in Connorton's Directory 1898.
Egyptian Deputies Cig. Co. MA.	EGD	1898	Blue Stocking		Listed in Connorton's Directory 1898.
Egyptian Heros Cig. Co.	EGH	1912	Egyptian Heros	F225-1NY F317-2NY	F317-2NY also made Egyptian Heros by I. B. Krinsky.
Egkyptian Ideal Cig. & Tob. Works	EGY	1902	Ramleh		Ramleh, spelled backwards, became Helmar to avoid confusion
Egkyptian Tobacco Co. of America	ETC	1898	Norma		The Camel Factory
Ehrlich, D. P., Boston MA.	EHR	1948	Ehrlich's Blend		
Eitel & Cass?! Louisville, KY.	EIT	1898	Blue Kid	F404-2NY	Listed in Connorton's Directory 1898.
El Paso Cigar Mfg. Co. TX.	ELP	1898	Concert Band, McGinty Club		
Eliot, H. Clay, NYC.	ELI	1898	Monogram		Listed in Connorton's Directory 1898.
Ellinger, Julius & Co., NYC.	ELN	1898	Dreams of Smoke		Listed in connorton's Directory 1898.
Elliot, Charles K.	ELL	1951	Wint-A-Green		
Elliott, Richard, Georgetown, MA.	ELT	1996	Dick Elliott		
Ellis, H. & Co., Baltimore MD.	ELC	1888	The Recruit	TP-2442-PA	For Durham III meet.
Elmer, R., Co. NYC	ELR	1898	Old London Street Co. Exhibition Flips		In trust 1898.
Elmira Tob. Co.	ELM				
Empire Dist. Co., Inc.	EDC	1938	Grand Prize	F24-KY	House Brand by AFT.
Engelberg, A., NYC.	ENB	1898	Savoy		Listed in Connorton's Directory 1898.
Engelhardt, Leopold	ENG	1916	Achoris		
English, Belcher & Co., VA.	EBC	1898	Dental		Listed in Connorton's Directory 1898.
Epstein, J., Bros., NYC.	EPS	1923	Aldea		
Epstein, Morris, Brooklyn, NY.	EPM	1898	Old Fellow		Listed in Connorton's Directory 1898.
Equity Cigar Co., Toledo, OH.	EQU	1898	Little Cricket		Listed in Connorton's Directory 1898.
Erb Tob. Products	ERB		E.R.B.		
Escobal	ESC	1942	Virginia Extra		
Eshrelby, E. C. Tob. Co.	ESH		Shogun Job		
Esposito, J. G.	ESP	1972	Quit		
Ess En Cee Co., Inc.	ESS	1913	Ess En Cee		
Estabrook & Eaton Co.	EST		Earl's Court		
Ettringer & Wilson ETT	ETT	1882	Patti		
Eureka Tob. Co.	EUR		Federal?		
Evans, I. W.	EVN	1937	Mayfair		
Eve Holdings Inc.	EVE	1990	Eve Lights Slim 100's		Subsid. of LAM.
Everette, John, Catawissa, PA.	EVT	1996	John Everette		Duram III meet.
Eversfield, J. C. & Co. MD.	EVR	1887	Peacock	TP-2442-PA	By SAR.
Exotic Tob. Co., Ogden, Ut.	EXO	1994	Buz		By ATC.
Export Tob. Co.	EXT	1925	Gold Flake	F30-NC	House brand by LAM. Lr by PMC.
F & L Products	FDL	1989	F&L	TP-42-VA	FDP Later Known as Benicia Co.
F&D Products, Benicia CA.	FDP	1987	F&D	TP-42-NC	Imports only.
Faber, Coe & Gregg, Inc., NJ	FCR		Imports		
Faber, Coe & Gregg, NYC & IL.	FCG	1928	Yellow & Black	F404-2NY	Cig made by TBC, SSS.
Fairfax Tob. Co.	FAI	1935	London Tops		
Fairlawn Stores	FLS	1936	Name This Cigaret	F24-KY	Contest brand by AFT.
Falk Tob. Co., NYC & Richmond VA.	FAL	1919	Herbert Tarryton	F30-NC F81.2VA F51-NC	
Familiar Herb Co.	FAM		Honey Rose		Herb Cig For E. & W. Marketing Co.
Famous Egyptian Cig Co.	FEC	1902	Notara		
Famous Value Brands, VA.	FVB	1990	Basic	TP-7-VA	PMC market arm for generic's.
Farmer's Co-op Mfg. Group	FCM	1935	Dan River		Cig made by R. L. Swain Tob. Co.
Feder Bros., Cleveland, OH.	FED	1898	Cuban Rebels		Listed in Connorton's Directory 1898.
Federal Cig. & Tob. Co., NYC.	FCT	1920	Federal	F317-2NY	Factory used by I. B. Krinski.
Federal Mining & Mfg Co.	FEM	1952	Federal's Udder Blend	F407-2NY	By GAG via YNC.
Federal Prison Industries	FPI	1950	Still Harbor		Cig. Made w/ by LAM, & for Prison inmates.
Federal Foods, Inc. IL.	FFI	1986	Generic		No-name gnrc. by LAM, & Liggett Gp.
Feifer Co., NYC.	FEF	1898	San Jose		Listed in Connorton's Directory 1898.
Feinberg, Chas. L., Brooklyn, NY.	FEI	1898	National Aroma		Listed in Connorton's Directory 1898.
Feldman, Abe. J, Allentown, PA.	FLM	1882	Flying Jap		Joined Marburg 1887, then to trust.
Felgner, F. W. & Son, MD.	FEL	1882	Shoo Fly		
Fendrich, H. Evansville IN.	FEN	1890	Gems		Listed in Connorton's Directory 1898.

(Right table)

MERCHANT	ID	YEAR	BRAND NAME	FACTORY	REMARKS
Fernandez, S. & Co.	FER	1901-1919	Admiration		Prob. subs of RJR.
Fezzan, T., Co.	FEZ	1883	El Mohada		
Fidell, B.	FID	1938	Worlds Fair		
Field, Alexander, Cig Co., Inc., NC	FLD	1994	Nile		By Riggio Tob. Co.
Fifth Avenue Tob. Co.	FAT	1922	American Queen (Exp)	F94-NY	
Filter Cig. Corp, NYC.	FIL	1959	O-Nic-O		
Finkelstein, L.	FIK	1901	Charmain No. 1	F62-MA	
First Cig Co., The, Boston, MA.	FCC	1933	The First		Full Name of Cig. is (First Consul All Havana. GOR)
First Consul Cig. Co. NYC	FCO	1889	First Consul	TP-2442-PA	By GOR.
First Nation, Indian Reservation	FNA	1995	S Signals		Listed in Connorton's Directory 1898.
Fischedik, H. F.	FIS	1872	Horseshoe		Listed in Connorton's Directory 1898.
Fischer, Max, Allegheny, Pa.	FSC	1898	Yukon		Listed in Connorton's Directory 1898.
Fisher, L. Harry, NYC.	FSH	1898	Annabelle		Listed in Connorton's Directory 1898.
Fitzgerald, John J.	FIZ	1965	Immunity		
Fitzpatrick & Draper, Troy, NY.	FTZ	1898	Pay Off		Listed in Connorton's Directory 1898.
Flagg, John F, NYC.	FLA	1885	Surprise		
Flalaner, G. F. NYC.	FLN	1898	Tioga	F1-1NY	Aka Flemming-Hall Co., Inc.
Flemming-Hall Tob. Co. NYC.	FLH	1939	Mapleton	F1-3NY	Also F404-2NY.
Fletcher, S. J.	FSJ	1929	Eagle (Exp.)		
Flicker Co. The	FLI	1906	Flicker		
Flinchang, S. S. York PA.	FLC	1898	Hopewell, The		
Flora Tob. Co., NYC.	FLO	1898	Lotta Smoke		
Florida Div. of Corrections Industrie	FDC	1986	Florida Division of Corrections Industries		By & for Inmates
FMA International Sales & Service Corp. (ISSCORP) U.S.A. NC.	FMI	1997	Wilson Lights (imp)		From Egypt.
Fmall Herb Co., CA.	FMA		Honeyrose Deluxe Herbal Filter (Import)		
Follard & Stephens	FOL	1905	Albany		
Foods, Inc., Los Angeles, CA.	FOO	1990	Slim Price	TP-42-NC	House brand LAM. Foods, Inc, Formerly VON'S Groceries
Forsyth Tob. products, NC.	FOR	1989	Austin	TP-1-NC	Subsid. of RJR vending gnrc cig.
Fortune Tob. Co.	FOT	1934	Snappy Girl		
Foster Hood & Co.	FOS				
Foster, M. & Co., NYC.	FSM	1898	Madison Sq. Garden		Listed in Connorton's Directory 1898
Fox & Co., Baltimore, MD.	FOX	1885	Pride of Baltimore		Listed in Connorton's Directory 87-89
Fox, H. Newton & Co., PA.	FOH	1898	New Philadelphia Bourse		Listed in Connorton's Directory 1898
Frank, D. M. & Co., NYC.	FDM	1898	Belle of The Rocky Mountains		Listed in Connorton's Directory 1898
Frank, Daniel, Co.	FRN		Dafkah		
Frank, Herman, Bradford, PA.	FNH	1898	W.L. Scott		Listed in Connorton's Directory 1898
Frank, Wally, Co.	FRA	1953	Grey Book		
Frankau, A.	FRU	1921	Empress		
Franklin, H. O., & Co.	FRK		Banker's Special		
Frankson, Adolph, & Co.	FNK	1921	Beau Royal		
Freeman Bros. & Co., Md.	FMN	1898	Baltimore Baseball Champions		
Freeman, S. J. NYC.	FRJ	1898	Bull Terrier		Listed in Connorton's Directory 1898
Freeport Cigar Co., Freeport IL.	FRP	1898	Chicopee		Listed in Connorton's Directory 1898
French Tob. Co.	FRE		French's (Imports)		French Cig. Imports.
French Tobaccos, Inc.	FRH				
Frey, E., NYC.	FEE	1898	Cortland Turkish Mix		Listed in Connorton's Directory 1898
Frey, L. C. & Co., Cincinatti, OH.	FRY	1880	Yara	F295-1OH	
Frishmuth Bro. & Co., Philadelphia, PA.	FRI	1894-1897	Brights		In Trust.
Fritsch & Sons.	FRS	1921	Beechnut		
Frohman, S. & Co. CA.	FRO	1886	L'Egyptienne		Listed in Connorton's Directory 1887.
Fuchs, G. & Co., Reading PA.	FCH	1898	Bell of Glory		Listed in Connorton's Directory 1898.
Fuchs, G., Chicago, IL.	FUH	1898	Flor De Renardo. LA		Listed in Connorton's Directory 1898
Fuchs, Louis, NYC.	FHL	1898	Take One		Listed in Connorton's Directory 1898
Furstenberg, A., NYC.	FUR	1898	American League		Listed in Connorton's Directory 1898
G & B. Tob. Co., TN.	GAB	1980	Choo Choo		See Also Gatlinburlier Tob. Co. (GAT).
G.T.H., Inc., Mt. Pleasant, NJ.	GTH	1987	Club Cars	TP-75-NY	
Gail, G. F Co., Chicago, IL.	GGF	1898	Go To Hell!	TP-75-NY	By GAG.
Gail, G. W., & Ax Tob. Co.	GAX	1896	Little Key West		Listed in Connorton's Directory 1898
Galba Cigaretto Co.	GAL	1926	Little Joker		
Gary Tob. Co.	GAR		Made For Me Quality	TP-42-NC	Subsid of LAM for Generic Cig.
Gatlinburlier Tob. Co., TN.	GAT	1985	Gatlinburlier Smokies	TP-3-VA	By U. S. Tob.

Left Table

MERCHANT	ID	YEAR	BRAND NAME	FACTORY	REMARKS
Gelman	GEL		Acapulco Gold	TP-7-VA	No-name generic by PMC.
Genco Marketing Co., Lincoln NE.	GEN	1992	Generic		Also General Tob Co.
General Cigar Co.	GCC		HCT or H.C.T.	F360-IL	
General Tob. Co., IL. or KY.	GTC	1992	Churchill Downs	TP-7-VA	No-name Generic By PMC. &
Generic Products Associates,, (also GPA Inc.) St. Louis MO.	GPA		Generic	TP-42-NC	Epic, Eagle by LAM
				TP-42-NC	House Brand by LAM, Later by BAW
Generic Products Corp. TX. Ft. Worth TX.	GPC	1987	GPC	TP-16-GA	
Genesee Tob. Works, NY.	GNS	1885	Lawn Tennis		Listed in Connorton's Directory 1887
Genio Market	GNO		Eagle		Listed in Connorton's Directory 1898
Gension, A., NYC.	GSR	1898	Evriesky Vapro		Listed in Connorton's Directory 1898
Georgopulo, G. A. & Co., NYC.	GAG	1905-Date	Andron, (Imports)	TP-75-NY, F407-1NY	Maked Private Brands for Clubs Schools & Frats, F2032-1PA.
Gershuny, N. & Co., NYC.	GRU	1898	The Compass		Listed in Connorton's Directory 1898.
Gialanella, Cesare, Distrib.	GIL	1939	Dante Italo American		
Gianaclis, Nestor Co.	GIA	1906	Royal Nestor	F2100-2NY	F400-3MA, F485-3NY & F2109-1PA.
Giannakis Cigar Co., Chicago, IL.	GNK	1948	John Metaxas		
Gilman & Morrison, Newark, OH.	GMM	1898	Pastel		Listed in Connorton's Directory 1898
Gilmore, Francis T	GIM	1914	Gilmore		
Ginter, Lewis	GIN	1879	Richmond Gems		
Gladstone Tob. Co.	GLA	1945	Jumbo		
Glas, M. & Co., Dayton OH.	GLM	1898	Bowler's Delight		Listed in Connorton's Directory 1898
Glasser Bros., Los Angeles CA.	GLS	1985	Best Buy		House Brand by LAM.
Glencourt, Inc., Walnut Creek CA.	GLE	1990	Scotch Buy		House Brand for Safeway Scores RJR
Glenn, W. B.	GNI		Par		
Global Holding Inc. Westwood, NJ.	GHI	1995	Checkers (Imports)		Mult. from India.
Globe Tob. Co., Detroit, MI.	GLO	1886	Sweet Tokay	TP-42-NC	Listed in Connorton's Directory 87&98.
Grosin, Vladimus F.	GSN	1907	Kremlin	TP-1-NC	
Gold Leaf Cigarette & Tob.	GLC	1928	O-Teen		
Golden Leaf Tob. Co.	GLT	1940	Strike One		
Golden West Tob. Co.	GOL	1931-1934	Azteca		
Goldman, H., NYC.	GOD	1898	Enjoyment Puffs		Listed in Connorton's Directory 1898
Golf Cigarette Co.	GLF	1925	Golf		
Gomler, willis P., Lowell, MA.	GOM	1898	Blizzard		Listed in Connorton's Directory 1898
Gonzalez, Diaz	GON	1898	My Selection		
Good & Johnson	GOJ	1889	Good & Johnson		
Goodman Co.	GOC	1878	Manufacturing Expert for Cigarette		
Goodman, R., Sons & Co., MD.	GDM	1898	After Dinner		Listed in Connorton's Directory 1898
Goodrich A. L., Oneida, NY.	GRH	1898	Merry Maiden	F40-3NY	Listed in Connorton's Directory 1898
Goodwin & Co.	GOO	1885	Gypsy Queen	F26-2NY	In Trust, 1894.
Gordon, Jacob	GRD	1905	J.G. Egyptian	F225-1NY	
Gordon, Powhatan G., NYC.	GOP	1898	George M. Pullman		No-name Generic
Gordon, Robert A. Co., PA.	GOR	1982	Benton	TP-2442-PA	Listed in Connorton's Directory 1898
Gordon, Willis P., Lowell MA.	GDN	1898	Wild Oats		Listed in Connorton's Directory 1898
Goulston Jr., E. S. Boston MA.	GOU	1898	Mono		No-name Generic by PMC, & Epic,
GPA Incorporated St. Louis MO.	GPA	1992	Generic	TP-7-VA, TP-42-NC	Eagle by LAM
Grand Island Cigar Mfg Co., NE.	GIC	1898	Spanish Admiral	TP-42-NC	Listed in Connorton's Directory 1898
Grand Union Co., NJ.	GUC	1988	Generic		House Generic by LAM
Gray, Arthur, NYC.	GRY	1898	Easy Chair		Listed in Connorton's Directory 1898
Great Atlantic & Pacific Tea Co.	GAP	1988	P&Q/Royale	TP-7-VA, TP-42-NC	House Brands, P&Q by LAM, Royale by PMC.
Gredjinski, M. J., Boston MA.	GRJ	1898	Carlton Club	F21-VA	Listed in Connorton's Directory 1898.
Green River Tob. Co., KY.	GRT	1898	Green River		By Continental Tob. Co.
Greenstone, S. F., Lynchburg, VA.	GRS	1887	Yum Yum		
Greenwald, M., NYC.		1898	Spotted Beauties		Listed in Connorton's Directory 1898
Greenwich Village Tob., NY.	GVT	1928	The Blue Horse	F404-2NY	
Grossman, M., NYC.	GMN	1898	X-Races		Listed in Connorton's Directory 1898
Guardian Tob. Co., NYC.	GUA		Denictor	F137-5NJ, F34-2NY	See also H. Sackett (Denictor), and Lincoln & Ulmer (O-Nic-O).
Guild, J. H. Co., Inc., Rupert, VT.	GUI	1882	Dr. Guild's Green Mtn.		
Gumpert Bros., Philadelphia, PA.	GUM	1882	Patriots		Calender Adv. Card.
Gunst, M. A. & Co., CA.	GUN	1880	Gunstoria	F81-VA	
Guttermann, Solomon, NYC.	GTT	1898	Ferdinand La Salle		Listed in Connorton's Directory 1898
H. M. H. Publishing	HMH	1963	Playboy		
H. P. W. Cigarette Co.	HPW	1923	Harvard Club		Merged w/ Philip Morris Tob. Co.
Haan, R. M., NYC.	HAA	1898	Herald Sq. Havanas		Listed in Connorton's Directory 1898
Hack, Francis G.	HAC	1962	Splitz		

Right Table

MERCHANT	ID	YEAR	BRAND NAME	FACTORY	REMARKS
Haddad Bros, NYC.	HDD	1898	Egyptian Pharaohs No. 2 Plain	F657-2NY	See also HAD.
Haddad, Alexander, NYC.	HAD	1911	Egyptian Pharaohs	F647-2NY	Listed in Connorton's Directroy 87&98
Hall & Pierce, Binghamton, NY.	HAP	1898	Daisy		Listed in Connorton's Directory 1898
Hall's Son, Thomas A., NYC.	HAL	1887	Between the Acts		In Trust 1896
Hamburger, Streng, & Co. OH.	HAM	1898	Corn Crib		Listed in Connorton's Directory 1898
Hansen, Julius G., Reading PA.	HSN	1898	Wind Miller		Listed in Connorton's Directory 1898
Hargraft & Sons, Chicago IL.	HAF	1923	Mah Jongg		
Harkert & Goos, Davenport IA.	HAG	1898	Great Smoker		Listed in Connorton's Directory 1898
Harmon, T. H., Lach Haven, PA.	HTH	1898	C.W.S.		Listed in Connorton's Directory 1898
Harralson, Ed., Atlanta, GA.	HRS	1964	Brer Rabbit		
Hartford Project	HRP	1965	HP Milds	C-10-KY	By WTB.
The Hartford Project	HRP		HP Milds	C-10-KY	By TBC or WTB.
Hartman, O. R.	HTM	1921	Shepheard's Special		
Harvey's, Inc.	HAV	1936	Special Hedkleer	F24-KY	By AFT. See aso Hedkleer Tob. Co.
Hasker & Marguse Mfg Co.	HAS	1898	Notara		
Hathaway, E. A., Brooklyn, NY.	HTY	1898	Seymour Club		Listed in Connorton's Directory 1898
Hauseman, Edward C.	HAU	1963	Junior		
Havana Cigar Co., Dallas TX.	HVC	1898	Battleship Texas		Listed in Connorton's Directory 1898
Havemeyer, E. Elmira. N.Y.	HVY	1885	Ideal		
Health Cigar Co., Inc.	HEA	1924	Sano	F404-2NY	By SSS.
Heartland Tob. Co., KY.	HRT	1988	Generics	TP-35-VA	Subsid of BAW for Generics.
Hedkleer Tob. Co.	HED	1938	Hed Kleer	F24-KY	By AFT. See also Harvey's Inc.
Heegard, W. H. & Co., IL.	HEE	1898	Loyal Leaders		Listed in Connorton's Directory 1898
Heere, George E., Reading, PA.	HRE	1898	Two Generals		Listed in Connorton's Directory 1898
Hefter, L., NYC.	HFT	1898	The Knight		Listed in Connorton's Directory 1898
Heinemann Bros., Baltimore, MD.	HNM	1898	Nolens Volens		Listed in Connorton's Directory 1898
Heintzel, R. S. Mfg	HEI	1915	Catareha		
Heitmann Bros., Miamisburg, OH.	HIT	1898	Serpents		Listed in Connorton's Directory 1898
Helme Products Co.	HEP	1923	O. K.		
Helme Tobacco Co.	HLM	1898	Conqueror		Listed in Connorton's Directory 1898
Helme, Geo. W., NY.	HEG	1900	Prince Albert		
Helme, Geo. W., NYC.	HEL	1931	Cigaf		Successor to Appleby & Helme.
Hemboldt, A. & M.	HEM		Exquisitos		
Henry Clay & Bocky. Ca, Ltd., NYC	HCR				See Carl Henry.
Henry, Carl	CAH				
Herbst, S. C., Imp. Co. WI.	HRB	1898	Aberdeen	F460-VA	Listed in Connorton's Directory 1898
Herlan, NYC.	HER	1938	Louisiane		By LAB.
Hernsheim, /s. Bros & Co., LA.	HES	1891	Hiawatha		Listed in Connorton's Directory 1887
Herschhorn, Mack & Co., NYC.	HHH	1898	Tom Moore		Listed in Connorton's Directory 1898
Hersey, A. & Bros, Lancaster, PA.	HSY	1890	Star of the World		From Cigarette Card.
Hess, S. F. & Co. Rochester, NY.	HSS	1886	Gold Clip		Listed in Connorton's Directory 1898
Hetterman Bros Co., KY.	HTT	1898	Green Kid		Listed in Connorton's Directory 1898
Hetzel's, Inc.	HIC		Dream Castle	F44-CA	
Hickey Bros., Inc.,	HIC	1930	The Astor	F407-2NY	For the Astor hotels by GAG.
Higginson, B. M., Inc., NY.	HIG	1898	B.M.H. Inc.	F21-NC	
Highlands, W. R., Ltd., NV.	HGH	1997	Boots (Exp to Mex.)		By Continental via Fred M. Pinkus.
Hill Bros., Binghampton, NY.	HLB	1898	Santee Clair		Listed in Connorton's Directory 1898
Hillier, R. J. Philadelphia, PA.	HLL	1898	Bankers, Puffs		Listed in Connorton's Directory 1898
Hilson Co., NYC.	HLN	1905	Effendina		
Hilton, T. H.	HIL	1898	Wage Scale		
Himrod Mf'g Co. Hoboken, NJ.	HIM	1869	Himrod's Medicinal		By LAB.
Hines, Norman	HIN	1955	Tall Cig. for the Texan	F460-VA	
Hines, W. F., Lexington KY.	HNS	1898	Little Croakers		By LAB.
Hirsch, Ferdinand, NYC.	HIR	1892	Milo		Listed in Connorton's Directory 1898
Hirsch, M., Brooklyn, NY.	HCH	1898	Annex		Listed in Connorton's Directory 1898
Hoffman, E. Co., Chicago, IL.	HOF	1908	Spilman Mixture		Listed in Connorton's Directory 1898
Hofritz, Chas., Dayton OH.	HFR	1898	Spanish Eels		Listed in Connorton's Directory 1898
Hogden, Wm. & Co., NY.	HOG	1898	Minoreas		Listed in Connorton's Directory 1898
Holbrook, S. G.	HOL	1902	Exposition		
Holis, M. G.	HLS		Hes Ra No. 1		
Honkomp & Schmidt, Sedalia MO.	HNK	1898	National Golden Rod		Listed in Connorton's Directory 1898
Hontain, Wm. E. & Co. NY.	HNN	1898	La Belle Ninfa		Listed in Connorton's Directory 1898
Hood, C. L., NYC.	HDC	1898	Champagnettes		Listed in Connorton's Directory 1898
Hood, Foster, & Co.	HOO	1886	Tennyson		Listed in Connorton's Directory 1898
Hood, S. & Co., NYC.	HOS	1898	Cubaneros		Listed in Connorton's Directory 1898
Hoormoozi Bros., NYC	HOB	1923	Hoormoos # 1		Listed in Connorton's Directory 1898
Hooven, Mercantile Co., NYC.	HVN	1898	Duke of Rochester	F263-2NY	Also F263-3NY.
Horenstein, J.	HOR	1939	Tel-Aviv		Listed in Connorton's Directory 1898

MERCHANT	I D 7/1/98	YEAR	BRAND NAME	FACTORY	REMARKS
Horner, James E., NYC.	HON	1880	Marshall's Prepared Cubeb Medicated		
Horwitz, F., & Co., Baltimore MD.	HOZ	1898	A.J.G.		Listed in Connorton's Directory 1898
Hasselman & Otto, St. Mary's OH.	HSL	1898	Sea Gift		Listed in Connorton's Directory 1898
House of Cartier	HOC	1989	Cartier Vendome		Fr. House of Cartier by PMC.
House of Edgeworth	HOE	1968	St. Moritz	TP-45-VA	Formerly Larus & Bros. Co.
House of Vegas, Inc., VA.	HOV	1989	Vegas	TP-2442-PA	By GOR.
Houtain, Wm. E. & Co. NYC.	HOU	1898	Banquet, LA.		Listed in Connorton's Directory 1898
Hovell, Chonponrian & Co., NYC.	HVL	1898	Gentle Sports		Listed in Connorton's Directory 1898
Howe, Thad. H., Chicago, IL.	HOW	1898	Alphil		
Huddle, Ogden	HUL	1957	Seven-Eleven		Durham III.
Hudgins, Joseph, Greensboro NC.	HDG	1966	Joseph Hudgins	TP-2442-PA	
Hudnell, Armstead B.	HUD	1965	F.A.C.T.		
Hughes, Lloyd F.	HUG	1924	Spud	F24-KY	Rights to SPUD menthol process & brand name sold to AFT in 1926.
Huperz, A. A., Detroit, MI.	HPZ	1898	Honest Labor		Listed in Connorton's Directory 1898.
Hupman, J.	HPN	1883	Monopole		
Hurwitz, M., NYC.	HUW	1898	Patrie, LA.		Listed in Connorton's Directory 1898
Hussey Leaf Tob. Co.	HUS		Delphine		See also Virginia Products Corp.
Huston, Tom Peanut Co., OH.	HUP	1932	Toms		
Hyniman, Thom. M., NYC.	HYN	1895	Turf Club		
Ibis Export Import Corp., NYC.	IBS		(Imports)	TP-2442-PA	Imports from countries worldwide.
Ideal Marketing, PA.	IDM	1983	Ideal		House Brand by GOR.
Iiess, S. F., Co.	IIE	1902	Turkish Specials		
Illinois Division of Correction	IDC	1985	Pyramid		Cigarettes by Inmates for Imates.
Imhoff, H. E., Binghampton. NY.	IMH	1898	Shop Girl		Listed in Connorton's Directory 1898.
Imperial Tob. Cig. Co., NYC.	ICC	1898	Battalion		Listed in Connorton's Directory 1898
Imperial Tob. Co.	IMP		du MAURIER		
Imported Tob. Mfg. Co., NYC.	IMT	1908	Red Kamel	F1839-3NY	Went Bankrupt, Sold to S. Ragona.
Independent Grocers Alliance	IGA	1969	I.G.A.	F460-VA	House brand by LAB
Independent Retailers Tob. Assoc.	IRT	1931	Fifth Avenue	F11-1MO	Weisert?
Inter-American Food Inc., OH.	IAF	1991	Cost Cutter	TP-1-NC	By RJR, Prev by LAM fr Kroger Mkts.
International Brands, Inc., OH.	IBI		Made Free		A non-tobacco Cigarette.
International Cig. & Tob. Co., PA.	ICT	1890	Gentleman Jack		From Tobacco Card.
International Cooperation Gp. Ltd.	INC		Double Happiness		(Export)
International Enterprises	INE	1965	OO VII		Could be International Entertainment
International Minerals & Cheical	IMC		Ac'cent		
International Tob. Co. of America	ITC	1938	Afra	F1287-5NJ	In Trust
Irby, W. R., Cigar & Tob. Co., LA.	IRB	1899	Coupon		Listed in Connorton's Directory 1898
Isert, J. Theo., Louisville KY.	ISE	1898	Black Top		Listed in Connorton's Directory 1898.
Istel, I. W. NYC.	IST	1898	Young America		Possibly by ATC.
Italian State Tob. Monopoly	ISM		Macedonia	F649-1NY	
Ives, G. O. Binghampton, NY.	IVE	1898	City 5's		Listed in Connorton's Directory 1898
Iwan Ries & Co.	IWA	1966	Bon Vivantic		
Izen & Grosberg, St. Louis MO.	IZG	1898	Amity		Listed in Connorton's Directory 1898
Jacobs, A. E. Oakland CA.	JCB	1898	Cubanique		Listed in Connorton's Directory 1898
Jacoby, F & Co., NYC.	JAC	1882	Unicum		A Matchless Cig; Hype? or with built-in lighter.
Jacoby, Herman, NYC	JCY	1898	Gold Run		Listed in Connorton's Directory 1898
Jaeger Bros., NYC.	JAE	1898	Aberdia		Listed in Connorton's Directory 1898
Jamison & Searl	JAM	1948	Humps		
Janinda, Harold M.	JAR	1950	Baby Pak		
Jardine, S.			Nugget		
Javelpi, Freres & Cie.	JAY	1914	Javelpi No. 6	F404-2NY	By SSS
Jazz USA, Inc., Menlo Park CA.	JAZ	1980	Jazz (Import)		From Argentina
Jedel, A., Co., NYC.	JED		Jedel's Regelo		
Jeitles, Sulzberger & Jeitles, PA.	JSJ	1898	John Wannamaker		Listed in Connorton's Directory 1898
Jenkins, Henry I., Malden, MA.	JEN	1898	Bell Rock		Listed in Connorton's Directory 1898
Jenkinson, R. & W. Co., PA.	JKN	1898	Lady Fingers		
Jersey City Tob. Co.	JER		Cloud Club		
Jewel Companies, Inc.	JEW	1982	Generic	TP-42-NC	No-name generic by LAM
Jobelmann's Son, Wm. H., NYC.	JOB	1898	Cosmopole		Listed in Connorton's Directory 1898
John Alden Tob. Co.	JAT	1947	John Alden	F10-KY	By TBC.
Johnson Tob. Co.	JTC	1967	Yorkshire		
Johnson. A. & Co.	JOH	1910	Pyrogos # 1	F200-3MA	
Jonas, Max, NYC.	JAS	1898	The Wedding Day		Listed in Connorton's Directory 1898
Jones & Calvi, Brooklyn, NY.	JOC	1880	Iron Duke		
Jones, Arthur	JNS	1935	Sixty Wall Tower		
Jones, Frank, NYC.	JON	1887	Coronet		Listed in Connorton's Directory 1887 by Stamp 12/1882
Jones, W. H., Newark, NJ.	JWH	1898	Senator Barrett		Listed in Connortroy Directory 1898

MERCHANT	I D 7/1/98	YEAR	BRAND NAME	FACTORY	REMARKS
Julep Cig. Co.		1933	Julep	F22-12PA	(Export)
K. A. International, Inc. USA	KAI	1982	U.S. of America		Pfeifer?
Kadee, Charles, Tob. Co. NYC.	KAD	1940	Cornwall	F750-5NY	
Kahan, M., Philadelphia, PA.	KHN	1898	Koscinscky		Listed in Connorton's Directory 1898
Kahn, Jacob L.	KAH	1884	Silver King		
Kahn, Jacob, NYC.	KHJ	1898	Silver King		Listed in Connorton's Directory 1898
Kahner, L. & Co., NYC.	KNR	1898	Life Insurance		Listed in Connorton's Directory 1898
Kaiser, F. E. Cincinnati, OH.	KSR	1898	Commercial Tribune		Listed in Connorton's Directory 1898
Kalimaris, C. D.	KAL	1901	Bouquet		
Kamster, Julius, NYC.	KAM		Kalimaris		
Karp, F., Flushing, L. I. NY.	KAR	1898	Minnarosa		Listed in Connorton's Directory 1898
Kassel, Phillip, NYC.	KAS	1898	Parnassus		Listed in Connorton's Directory 1898
Kaufman, J. S. & Bros., NYC.	KAU	1910	Nile		
Kaufmann, A. L. & A. G., NYC.	KNN	1898	American Babies		Listed in Connorton's Directory 1898
Kaufmann, I., NYC.	KAF	1898	Queen Verra		Listed in Connorton's Directory 1898
Kaufmann, Max G., NYC.	KFM	1898	Seminole		Listed in Connorton's Directory 1898
Keeney, H., Tob. Corp., VA.	KEE	1994	Father Kneipp		(Export)
Kelly, H. R. & Co., Ltd., NYC.	KLY	1898	Spectra		Listed in Connorton's Directory 1898
Kerbs, John & Co., NYC.	KRB	1898	Peter Stuyvesant		Listed in Connorton's Directory 1898
Kerbs, Worthelm & Scheffer, NYC.	KWS	1898	Beefsteak		Listed in Connorton's Directory 1898
Key West Cig. Co., The	KWC		Amidon		
Keyer, Louis W.	KEY	1910	Key West		
Keyes, F. R., Binghampton, NY.	KYS	1898	Plowboy		Listed in Connorton's Directory 1898
Khedivial Co., Le, Chicago, IL.	KHV	1898	United Chief		Listed inConnorton's Directory 1898
Khedivial Tob. Co., The, NYC.	KHE	1896	Brotherhood of Locomotive Engineers		
Khoury Cig. Co., NYC.	KHC	1899	Cabinets	F3-2NY	Also F348-2NY, F279-2NJ,F348-2NY Also El Ahram.
Khoury Tob. Corp.	KHR	1935	Milo	F279-NJ	See also KHO.
Khoury, D. J., & Co., Inc.	KHO	1934	Egyptian Brights	F244-NY	
Kiijian, John, NYC.	KII	1898	Ammon	F266-3NY	
Kimball, Wm. S. & Co., NY.	KIM	1873	Ammon	F266-3NY	Listed in Connorton's Directory 1887,
Kindling, Lonis, Milwaukee, WI.	KID	1887	Imperator		Listed in Connorton's Directory 1887
King Maker Marketing, NJ.	KMM	1996	Three Kings		FTB K, from India.
King-Ferres	KIF		Sioux City Journal		
Kinney Bros. (see Kinney, F. S., Tob. Works NYC.)	KIN		Checkers (Import) / Dot		
Kinney, F. S., Tob. Works, NYC. (aka Kinney Bros)	KIN	1868	Sweet Caporal	F593-MD, F25-2NY, F30-2NY	Listed in Connorton's Directory 1887, 1898, F30-NY, after being taken over by trust, also F30-NC.
Kinsman's	KNS		Kinsman's Asthmatc		
Kirkpatrick, Arthur, Pittsburg. PA.	KRK	1898	Every Day Scrap		Listed in Connorton's Directory 1898
Kismet Cig. Co.	KIS	1925	Kismet		
Kiss Me Cigar Co.	KMC	1919	Kiss Me		
Klee, Robert., Philadelphia, PA.	KLR	1898	Adalinda		Listed in Connorton's Directory 1898
Klein Bros. & Hecht, Paducah, KY.	KLI	1898	Rush Perfecto		
Klein, E. E.	KLE	1904	Hall-Mark		
Kloch, A. R., Springfield, OH.	KLH	1898	X to U		
Knabel, T., Co., Inc.	KNA	1901	Alexander The Great		
Knickerbocker Cig. Co.	KNI	1914	Knickerbocker		Or Knickerbocker Club
Knock, M.	KNO	1918	Yum Yum		
Ko Wah Lum, 763 CA.	KOW	1941	Fook look	F67-1CA	
Koch, A. H., St. Paul MN.	KOC	1898	A Merry Smoke		Listed in Connorton's Directory 1898
Kohlberg Bros., El Paso, TX.	KBG	1898	International La		Listed in Connorton's Directory 1898
Kohlhapp, Wm., Louisville, KY.	KHH	1898	The Gnome		Listed in Connorton's Directory 1898
Kohorn, Henry Von	KOH	1945	Cop	F1-1NY	By Fleming-Hall.
Korn, Sol C.	KOR	1903	Cambridge		
Kramer, Chas.	KRA	1898	Uneeda		Listed in Connorton's Directory 1898
Kraus & Co. Baltimore MD.	KRS	1898	Baron Seal		Listed in Connorton's Directory 1898
Kraus & Lewin /co., NYC.	KLC	1898	Alf and Alf		Listed in Connorton's Directory 1898
Kreider, A. B. & Co., Salunga, PA.	KDE	1898	Fascination		Listed in Connorton's Directory 1898
Kreielsheimer, M., & Co. NYC.	KLS	1898	Angel Food		Listed in Connorton's Directory 1898
Kretek Dist. Inc., Moonpark CA.	KRT	1995	Free Spirit	TP-22-VA	By SAR.
Krinski, I. B. Mfg., NYC.	KRI	1902	Turkish Student	F223-1NY	Also F317-2NY,F255-3NY,F317-1NY, along w/Federal Cig. & Tob. Co. F225-1NY
Krinsky, I. B. (Estate)	KRE	1912	Fifth Avenue Cork Tip	F225-1NY	House brand by LAM Later by RJR.
Kroger Co., The, Cincinatti, OH.	KRO	1988	Cost Cutter	TP-42-NC	
Kuechler, H. C. & Bros., NY.	KCH	1898	Smoke-up	TP-1-NC	Listed in Connorton's Directory 1898

Left table

MERCHANT	ID	YEAR	BRAND NAME	FACTORY	REMARKS
La Honradez T. M. Co., LA.	LAH	1887	La Honradez	F181-CT	Listed in Connorton's Directroy 1887
Labinger, I., Hartford, CN	LBI	1901	Labinger		
Ladis, A.	LAD		Cinclair		
Lady Nic, Inc., NYC.	LNI	1923	Lady Nic		
Lambert Pharmacy Co.	LAP	1927	Listerine	F11-1MO	Prob. by Weisert.
Landfield & Co., Chicago, IL.	LDF	1898	Egyptian Puffs	F248-3NY	Listed in Connorton's Directory 1898 Part of LAB, ca 1952, F244-2NY.
Lane Limited. NYC.	LAN	1946	Lords	F460-VA	
Lane, Robert E., NYC.	LNE	1898	Blocks of Five		Listed in Connorton's Directory 1898
Langrehr	LAG	1872-	Columbia		
Larus & Bro. Co., Inc., VA.	LAB	1978	Chelsia	F460-VA TP-45-VA	LAB became The House of Edgeworth (HOE) about 1978.
Laskaris, M. & Co., Akron, OH.	LAS	1898	Cubeb and Tea		Listed in Connorton's Directory 1898
Laurens, Ed., Inc	LAU	1925	Tanagra		
Lazarakis, J. F, Lowell, MA.	LAZ	1912	Omiros	F7-MA	Also F7-2MA.
Le Febre, S.	LFB	1914	Atlam		
Leavitt & Peirce, Inc., MA.	LEA	1938	Cake Box	F404-2NY	By SSS.
Lee Tobacco Co.	LEE	1937	Le Marber	F64-NY C-1048-1PA	Formerly Leighton Tob. See also Superior Brokerage, C-1048-1PA.
Leefsky, I.	LEF	1932	Volga Boatman		
Lefkowitsch, L. Brooklyn, NY.	LFK	1898	Raymont	F65-2NY	Listed in Connorton's Directory 1898
Leighton Tob. Co., NYC.	LEI	1935	Leighton	F65-NY F64-NY	Made Cig. for Lee Tob. Co. and Superior Brokerage (Le Marber).
Lemlein, A. & Co., NYC.	LML	1898	Lambs		Listed in Connorton's Directory 1898
Leopold & Sons, NYC.	LEO	1898	Aetna		Listed in Connorton's Directory 1898
Leslie & Welch, Buffalo, NY.	LSW	1898	Coffin Nail		Listed in Connorton's Directory 1898
Leslie, Don	LES				
Lewin & Vogel, NYC.	LEV	1898	Blue Jeans	F19-3NY	Listed in Connorton's Directory 1898
Lewis Cigar Mfg. Co.	LWC		Allenetes?		
Lewis, Milton D.	LEW		Diplomat		
Lexington Tob. Co.	LEX		Banker's Special		
Lichtenstein, A., Son & Co., NYC.	LCH	1898	Five senses	F55-6CA	Listed in Connorton's Directory 1898
Lichtet, Mark	LIR	1898	Ritz		
Licker's Egyptian Smoke Shop	LIC	1940	Hollywood Rounds		
Lies, George P. & Co., NYC.	LIE	1885	Red Fox	F42-NC	Listed in Connorton's Directory 1887
Liggett and Meyers Tob. Co.	LAM	1873-Date	Chesterfield	F240-1PA TP-42-NC F42-NC	Also F25-1MO. F64-NY Listed in Connorton's Directory 1898. In trust ca 1900, F25-VA, and F25-2VA. Vice Liggett & Myers Tob. Co.
Liggett & Myers Inc. Durham, NC.	LMI	1978	Argus (TM)	TP-42-NC	
Liggett Group, Inc., The	LIG		See LAM		
Liptert, Seales & Co., Winston NC.	LII	1898	School Boy		Listed in Connorton's Directory 1898
Liptert, W. J. & Co., Winston NC.	LPF	1898	Virginia White Ash		Listed in Connorton's Directory 1898
Lilly-Dungan Co., Inc.MD.	LDC	1950	81 Blended	F1-1NY	By FLH.
Lincoln & Ulmer, Inc.	LIU	1924	O-Nic-O	F137-5NJ	
Lincoln, Seyms & Co., Hartford CT.	LNS	1898	Catch On		Listed in Connorton's Directory 1898
Linton Roscoe R.	LIN	1918	Mule		
List, jack B.	LIS	1963	Taper Off		
Little & Co., Troy NY.	LTL	1898	Liso		Listed in Connorton's Directory 1887
Little King Cigarette Co.	LIK	1958	Little King	F460-VA	By LAB.
Loblaw, Inc.	LOB	1953	Dorset	F460-VA	By LAB.
Loeb, L. L., Philadelphia, PA.	LOE	1898	Ginger Blue		Listed in Connorton's Directory 1898
Lohler-Snyder Co., PA	LOH	1898	Future Prosperity	F32-2NY	Listed in Connorton's Directory 1898
Lommed Bros.	LOM				Successor to Kinney Tob. Works.
Londen Blend Cig. Co., The	LON	1915	The London Blend		
London Tob. Co.	LTO	1943	London Special		
Lone Jack Cig. Co., Lynchburg VA.	LOJ	1887	Bon Ton		Listed in Connorton's Directory 1887
Lopex & Vila. Port, FL	LPZ	1898	Inditos, Los		Listed in Connorton's Directory 1898
Lorillard, Greensboro, NC.	LOC	1969	On Some packs		On packs 1967 - 1968
Lorillard Corp., Louisville KY.	LOD	1967-1968			On packs from 1969 on.
Lorillard, Louisville KY.	LOD	1969			
Lorillard, P. & Co.	LOR	1875-Date	Old Gold	F11-KY C-11-KY TP-11-KY	Also F7-5NY F8-NJ and F8-3NY in U.S. LOR dates from 1760 in U.S. in trust, F1-5NJ, F7-5NY.
Lowenstein, M. W., NYC.	LWN	1898	Captain's Relish	TP-22-VA	Listed in Connorton's Directory 1898
Lwer Sioux Indian Community, MN.	LSX	1994	Jackpot Junction		By SAR. Reservation Casino.
Lowry (no further info).	LOW	1903	Egyptian Cadets		Listed in Connorton's Directory 1887.
Loyd, J. E. & Co., Lynchburg VA. or maybe Lloyd	LOY		Fairy Queen		

Right table

MERCHANT	ID	YEAR	BRAND NAME	FACTORY	REMARKS
Lubliner Palestine Cig.	LUB	1925	Lubliner		Listed in Connorton's Directory 1898
Luchs & Bros., Washington DC.	LUH	1898	Island of Cuba		Listed in Connorton's Directory 1898
Lucke, J. H., & Co., Cincinnati, OH	LUC	1885	Lucke's		
Lyties & Co.	LUY	1915	Dabs		By PMC. Sold at 7-11 Stores Locally.
M&C Products, Inc., Temple TX.	MCP	1992	Premium Buy	TP-7-VA	
M. M.Import Co.	MMP	1922	Lyric		
Maccormack, R.	MCC	1953	Prelungfilter	F179-1CA	
Macedonia Tob. Co.	MAC	1904	Aristocrat		Listed in Connorton's Directory 1898.
Mackler, M., NYC.	MKR	1898	Trumps		
Macklin-Zimmer-McGill Tob. Co.	MCK	1919	Sunny Clime		Listed in Connorton's Directory 1898
Macveagh, F	MAV	1886	Buffo		
MacVeagh, Franklin, & Co., IL.	MCV	1898	Saybrooke	F460-VA	House brand by LAB.
Macy, R. H.(Dept. Store), NYC.	MCI	5/1/98	Madison	TP-2442-PA	By Gor.
Madison Cigarettes Inc., VA.	MDD	1995	Madison	F15-KY	
Madison Tob. Co. Louisville, KY.	MAD	1936	Grads		
Mahn, Godfrey S., Philadelphia, PA.	MHN	1900	Mahnola		Listed in Connorton's Directory 1898.
Mahrt, H. C. Co., Dayton OH.	MRT	1898	Augusta		By USJ.
Mail Pouch Tob. Co.	MPT	1960	PT	TP3-VA	
Makaroff Co. of America, The MA.	MAK	1932	Makaroff Russian	F622-3MA	See also G. Nelson Douglas—President of Makaroff. From a Cigarette Card.
Maller, Oscar, NYC.	MRO	1910	Starlight		
Malone & Hyde	MAL	1963	Hyde Park		
Maloney, Mrs Rene	MLY	1916	M Y Q		
Manchester Cigar Mfg. Co., MD.	MNC	1898	Bar None		Listed in Connorton's Directory 1898
Mandelbaum Bros., Cleeland, OH.	MNB	1898	Moses Cleveland		Listed in Connorton's Directory 1898
Mandelbaum, H., NYC.	MDB	1898	Bayonet		Listed in Connorton's Directory 1898
Manfield & Co.	MNF	1930	Ownitial		
Manhattan Cigarette Co., NYC.	MNH	1898	Full Deck		Listed in Connorton's Directory 1898
Manila Standard Tob.	MAN	1933	Virginia Fads		
Manuel, S. E., Mfg.	MNL	1909	My Own		
Marburg & Felgner Tob. Co., MD.	MRF	1885	Golden Age		
Marburg Bros, Baltimore, MD.	MRB	1880	Lone Fisherman		Listed in Connorton's Directory 1887
Marchosky, S. J.	MAH	1914	Canal		
Marco, Sam, Chicago, IL.	MCO	1898	Red Elephant		Listed in Connorton's Directory 1898.
Marens, Sam., NYC.	MNS	1898	Key Of Cuba		Listed in Connorton's Directory 1898.
Marketing Management, Inc., TX.	MMI	1989	Generic	TP-42-NC	By LAM, also marketed w/LAM
Marketways, Inc.	MKT		Euphoria		
Marmay Mfg. Co., PA.	MRM	1917	Marmay Monogram		
Marrter & Bow, Canton, OH.	MBW	1898	Greater Columbus		Listed in Connorton's Directory 1898
Marsans Bros., NYC.	MRN	1898	Aronia		Listed in Connorton's Directory 1898.
Marshall & Deutch, NY.	MRD	1895	Parlor City		From cigarette card.
Marshall Co., NYC.	MRL	1931	Cordial		
Marshall, Morgan, NYC.	MRH	1898	Red, White and BLue		Listed in Connorton's Directory 1898
Marum, S., NYC.	MUM	1898	Unique		Listed in Connorton's Directory 1898
Marx & Co., St. Cloud, MN.	MRX	1898	Our Fanny	F221-NY	Listed in Connorton's Directory 1898
Maryland-Virginia Tob. Co., Inc.	MDV	1899	Broadway	F214-NY	
Mason, H. M., Boston, MA.	MSN	1898	Voltaire		Listed in Connorton's Directory 1898
Mataoka Tob. Co.	MTK	1923	Gloriette		
Mathues Bros., Inc, NYC.	MAT	1903	Tubarette	F1867-1NY	F1867-3NY
Maureo Tob. Co.	MAU	1900	Maureo		
Mavro Bros.	MVR	1903	Skarabel No. 1		
Mayer, G. A., Brooklyn, NY.	MYG	1898	Tootsies		
Mayer, Sig. C., Philadelphia, PA.	MYE	1898	Bromo Seltzer		Listed in Connorton's Directory 1898
Mayo, Sig. C., Philadelphia, PA.	MYO	1898	Signor, El		Listed in Connorton's Directory 1898
McCann, F J., Packing Corp.	MCU	1929	Dynamite		
McCoul, M., Co., NYC.	MCD	1899	Saturnette		Listed in Connorton's Directory 1898.
McDermod, James M.	MLL	1943	Copley		
McDonnell Co., Philadelphia, PA.	MCW	1927	McDonnell	F65-2NY	By LEI.
McElwee, J. H.	MCE	1922	Indian Girl		Made cig. for Adam-Powell.
McElwee-Martin Tob. Co., NC.	MGL	1898	Indian Girl		Listed in Connorton's Directory 1898
McGlinehy, James J., MA.	MCL	1903	Prince One Peace		
McLean International	MCM		Duncap		
McNamara, J. R., Norwich, CT.	MCM	1885	Old Coon		
Mecann, Geo. M. Co., MO.	MEC	1898	Armenia Oriental		
Medinah Co.	MDH	1898	United Wheelman		Listed in Connorton's Directory 1898
Meiser, R. S. Reading PA.	MSR	1898	Egyptian Miracles		Listed in Connorton's Directory 1898.
Mela, M., & Co.	MEA	1905	Egyptian Miracles	F649-1NY	
Melachrino, M. & Co.	MEL	1895	Melachrino	F1016-3NY	Listed in Connorton's Directroy 1898.
Melikian Cig. Co.	MLK	1925	Lion		

MERCHANT	ID	YEAR	BRAND NAME	FACTORY	REMARKS
Mellek, M, Stapleton, NY.	MEK	1898	Peerless Knight		Listed in Connorton's Directory 1898
Mellor's Worcester, MA.	MLO	1885	Hunter		
Mellow Harvest Tob. Co.	MHT	1938			
Mellzer, S., St. Louis, MO.	MEI	1898	Cuban Bouquets		Listed in Connorton's Directroy 1898
Menashi No. 2 Ck Tip	MSH	1905	Menashi No. 2 Ck Tip	TP-3-VA	
Mendez Enterprises, Inc.., FL.	MEN	1965	El Cuno	TP-762-FL	By U. S. Tob. Co. (USJ), later in Florida.
Menelek Cig. Co., NYC.	MCG	1900	Menelek		
Mentor Co., The Boston, MA.	MTR		Cambyses	F456-3MA	Also made RAMLEY. See also the Cambyses Co.
Mereten Co.	MER	1922	Yum Yum		
Messinger, Chas. R., Toledo, OH.	MES	1886	Virgin Queen		
Messudiah Turkish Tob. Co.	MSD	1913	Messudiah		
Mesthene, E. P., NYC.	MST	1898	Shepheard's	F546-2NY	
Metropolitan Tob. Co., NYC.	MET	1898	London Life		Listed in Connorton's Directory 1898.
Meurer, Chas. & Co., PA.	MEU	1898	Astonisher		Listed in Connorton's Directory 1898
Mexican Cigarette Tob. Co., TX.	MCT	1923	Toreador Mexican	F3-2TX	
Meyer, Henry G. & Son, OH.	MHG	1898	Needmore		Listed in Connorton's Directory 1898
Meyer, Louis	MYR	1905	Haidee		Listed in Connorton's Directory 1898.
Meyer, Max & Co., Omaha, NE.	MEY	1898	Columbia World's Exposition Hummer		
MGAI, Inc., Wheeling, IL.	MGA	1990	Generic	TP-42-NC	by LAM.
Michalitschke Bros. CA.	MLT	1898	Klondike Nugget		Listed in Connorton's Directory 1898.
Michigan State Correctional Inst.	MSC	1986	Northern Lights		
Middleton, John Tob. Co., PA.	MID	1958	Walnut	F30-NC	Priv. brand by ATC & LAB (F460-VA). (Export)
Midwest Tob. Co., NYC.	MIW		Midwest		
Miebis Bros.	MIE	1920	Miebis		
Miller, H. D., NYC.	MHD	1898	Our Pride		Listed in Connorton's Directory 1898.
Miller, L., Chillicothe, OH.	MLR	1898	First Capitol of Ohio		Listed in Connorton's Directory 1898
Miller, Leopold & Sons, NY.	MIL	1883	Le Roy	F2-NY	Listed in Connorton's Directory 1898
Millhiser, Chas, Richmond, VA.	MLH	1898	After Lunch		Listed in Connorton's Directory 1898.
Mills, Harry, Chicago, IL.	MLS	1898	Becket	F1016-3NY	Listed in Connorton's Directory 1898.
Miltiades Melachrino Inc. NYC.	MIM	1923	Miltiades		Different from MEL.
Miltiades.	MLD	1927	Oliver King		
Minassian, David Der H.	MIN		Davros		
Mint Julep Cig. Co.	MIJ	1932	Mint Julep		
Miranda, J.	MIR	1926	Eastern Dream		
Mitchell, A. R. & Co., Boston MA.	MCH	1898	Big Run		Listed in Connorton's Directory 1898
Mitz, Adam, Mansfield, OH.	MTZ	1898	Black Garter		Listed in Connorton's Directory 1898
Mollenhaus, V, NYC.	MOV	1898	Klondike Nuggets		Listed in Connorton's Directory 1898
Monarch Cig. Co., Rochester, NY.	MNR	1887	Monarch		Listed in Connorton's Directory 1887
Monday, S., & Son, Brooklyn NY.	MDY	1913	Raumo	F89-1NY	
Monkiewiez, V. Buffalo, NY.	MKW	1883	Wanda	F30-2NY	
Monopole Tob. Work, NYC.	MON	1887	Petit Canon	F463-3NY	and 1887 in trust, F363-3NY.
Monte Pluma Cigar Co., PA.	MTE	1886	Nickel Plate		Listed in Connorton's Directory 1898
Monticello Tob. Co., NC.	MNT	1939	Monticello		Listed in Connorton's Directory 1898.
Moonlight Tob. Co., NYC.	MTC	1995	Jumbos, City	TP-1-NC	Subsid. Of RJR.
Moorehouse, Stephen Co., NYC.	MOH	1912	Cablegram		From a Cigarette Card.
Morris, G. C. & Co.	MOR	1923	Moriati		
Morofsky, H. S. & Co., NY.	MKY	1898	Rochester Straight Cut		Listed in Connorton's Directory 1898.
Morphides, G., & Co., NY.	MPH	1902	Star of Egypt No. 3		Listed in Connorton's Directory 1898
Morris, A. T., Cincinnati, OH.	MRR	1898	Freckled Squaw		Listed in Connorton's Directory 1898.
Morris, R. F. & Son Mfg Co., NC.	MMF	1898	Silver Chubs		Listed in Connorton's Directory 1898.
Moskowitz, M., Philadelphia, PA.	MSK	1898	Commercial Progress		Listed in Connorton's Directory 1898.
Moss & Lowenhaupt Cigar Co., MO	MOS	1938	Phillip's Own	F11-1MO	Also F404-2NY, By Weisert.
Motley, A. H., Co., NC.	MOT	1898	Alealde		Listed in Connorton's Directory 1898.
Moultouris, James & Son	MOU	1924	Pyramid	F14-MA	F14-3MA
Mt. Vernon Cigar Mfg. Co., PA.	MTV	1898	Clifton Forge		Listed in Connorton's Directory 1898.
Muratti	MUT	1919	Muratti's		
Murison & Co.	MRS	1877	Murison's		
Murray Hill Restaurant	MUR	1937	Jack and Charles'		
Mutual Tob. & Cig. Co., NYC.	MUL	1898	Pioneer		
Myers Bros. Drug Co., MO.	MYB	1898	Yatigan		
Mystic Lake Casino, Indian Res.	MLC	1995	Buffalo Spirit	TP-2442-PA	By GOR.
Nadel, Erwin, Co., Inc.	NAD	1910	Contentnea	F12-4NC	
Nanyang Tob. Co., LTD., NYC.	NNY		Esquire		
Napaindesky, H., NYC.	NAP	1898	Senate		Listed in Connorton's Directory 1898
Nash, M. B, Tob. Co.	NAS	1898	Pdicah' Paducah'		Listed in Connorton's Directory 1898
Nathan, Michael, NYC.	NTN	1898	Grand Regent Bouquet		

MERCHANT	ID	YEAR	BRAND NAME	FACTORY	REMARKS
Nathanson Cigar & Tob. Co.	NTH	1936	Plus Four	F24-KY	By AFT.
National Advertizing Novelties Co.	NAN	1952	Humdinger	F407-2NY	By GAG.
National Brand Sales, IL.	NBS	1993	Better Valu	TP-42-NC	By LAM.
National Cig. & Tob. Co., NYC.	NAT	1893	High Admiral		Taken over by UNI, 1896, ATD, (trust)
National Cigar Stands (or Stores)	NCS		Black and White	F7-VA	By Continental, Later PMC.
National Co-operatives, IL	NCO		Co-op		
National Products Group, OK.	NPG	1988	Bronson	TP-42-NC	By LAM.
National Tobacco Co.	NTC	1925	Nationals		
National Tobacco Products Co.	NTP	1915	Virginia Seal	F930-1NY	
Natrona Tob. Co.	NRA	1919	O Boy		
Near East Tob. Co.	NET	1939	Halutz		
Nector Cigarette Co.	NEC		Arabesca?		
Neuman, Louis E. Co.	NEU		El Arno		
New Directions Film	NDF	1968	Light		Union made, From adv. Card.
New England Tob. Mfg. Co. MA.	NEG	1905	Rex		Listed in Connorton's Directory 1898
New Holland Tob. Co., PA.	NWH	1898	Cafe Chantons	F24-KY	By AFT.
New River Co.	NRT	1936	White Oak		Listed in Connorton's Directory 1898
New York & Key West Cigar CO.	NYK	1898	White Oak	TP-762-FL	
New York Cig. Co., NJ.	NEY	1975	New York		From Cigarette Card.
New York Export & Import Co.	NEI	1895	Top Brand		By LAM.
Newhan Tob. International	NTI	1991	Newhan		
Newman, A. B. Co.	NEW		Eianacles		
Nicholas, G. G., & Son	NIC	1926	Beaver		
Nichols, G. S., NYC.	NCH	1898	Ariston (Import)		Listed in Connorton's Directory 1898
Nickel-In Cigar Co., NYC.	NCK	1898	Nickel-In		Listed in Connorton's Directory 1898.
Niemeyer, Theodorus, Inc.	NIE	1952	I Like Ike		Also Stevenson for President.
Nile Tob. Works, NYC.	NTW	1898	Egyptiennes	F10-KY	Listed in Connorton's Directory 1898.
Noelke, C. D. J., NYC.	NOE	1898	City Club		Listed in Connorton's Directory 1898.
North American Cig. Mfg., Inc. PA.	NAC	1958	Diplomat		
Northeast Tob., Inc.	NOR	1993	Miami Lights		By SAR, See also CBI.
Northern Ohio Cigar Co., OH.	NOC	1898	Celebrated Oak	TP-42-KY	Listed in Connorton's Directory 1898
Notab Products	NOT	1970	Sentry		
Novelty Smoke Shop	NSS	1924	Malta Amber		
O-Nic-O Cigar & Cig. Co.	ONI		O-Nic-O		
O. K. Cigar Store, NYC.	OKC	1898	Upper Ten		Listed in Connorton's Directory 1898
Oblinger Bros. & Co., PA.	OBL	1898	American Messenger		Listed in Connorton's Directory 1898
Odence	ODE		Bacchante		
Oettinger Bros. & Co., MD.	OET	1898	Obahdeo		Listed in Connorton's Directory 1898
Ogden, Chas. Co.	OGD	1949	Flamingo		
One Twenty One Tob. Co., Inc.	OTO	1954	One Twenty One		
Oppenheimer, Fred (or Ferd) NYC?	OPP	1890	National		From Cigarette Card.
Orient Tob. Co.	ORI		Jewel	F108-1CA	
Oriental Cig. Co., Boston MA.	OCC	1898	Orientals		Listed in Connorton's Directory 1898
Oriental Palms Tob. Co.	ORP	1903	Egyptian Palms		
Oriental Tob. Co., MO.	ORT	1914	Victorious Egypt		
Ormont, James & Co.	ORM	1940	New Yorker		
Otting, Frank, Cincinnati, OH.	OTT	1898	Tod Sloane		Listed in Connorton's Directory 1898.
Oussani, Yak, NYC.	OUY	1898	Egyptian King		Listed in Connorton's Directory 1898.
Oussani, Yak, Tob. Co., NYC.	OUS	1898	Egyptian King	F21-2NY	
Oval, Lee T., Co.	OVL		Long Twins		
Owl Cigar Co., NYC.	OWL	1957	Adlai		
Oxford Club, Lynn, MA.	OXF	1898	Oxford Club		Listed in Connorton's Directory 1898.
Pace & Sizer, Richmond VA.	PAC	1887	Straight Web		Listed in Connorton's Directory 1898.
Pace, R. J., Tob. Co., VA.	PCE	1898	Mastiff		Listed in Connorton's Directory 1898.
Pacholder, M. S., Baltimore, MD.	PCH	1884	Sub Rosa		Listed in Connorton's Directory 1898.
Pacific Tob. Co., OR.	PTC	1966	Cancer	TP-75-NY	
Paget & Paget	PAG	1944	Paget & Paget		by GAG.
Pager, Samual, New Haven, CT.	PGT	1898	University		Listed in Connorton's Directory 1898.
Palestine Cig. & Tob. Co., MA.	PLT			F272-MA	
Palestine Tob. Co., Brooklyn, NY.	PAL	1926	Emir	F72-1NY	
Palestine Tob. Corp.	PLS		Balfour		
Pall Mall Electric Association	PAT	1924	Jordana Palest		
Palumbos Lithography & Printery,	PME		Dr. Scotts		
Pan-American Products Corp., NJ.	PLU	1929	Zebra	F24-KY	By AFT.
Pan-American Tob. Co., Inc.	PAP	1937	Pan-Am	F24-KY	By AFT.
Pang, K. F., Co., NYC.	PNM	1994	Texas (Export)	TP-42-NC	By LAM.
	PKF	1912	Pang's Superior Chinese	F120-2NY	
Pantos, Anthony	PAN	1924	Transportation Club	TP-42-NC	By LAM.
Pantry, Inc, The, Sanford, NC.	PTY	1988	Worth		
Paper Cigarette Makers, NYC.	PCM	1898	Relief		Listed in Connorton's Directory 1898.

Left table

MERCHANT	ID	YEAR	BRAND NAME	FACTORY	REMARKS
Pappas tob. Mfg. Co., NYC.	PPP	1915	Kaiser's Strength		Also Pappas Bros.
Pappastratos, Greece	PST		Assos		
Paragon Cigar Mfg. Co., York, PA.	PGN	1898	Huchy Kuchy		Listed in Connorton's Directory 1898.
Paredes, Juan Santalla	PRD	1967	Beck		
Park & Tilford	PAR	1926	P&T Varieties		
Park Avenue Tob. Inc., VA	PAV	1985	Astor		Same Pks Producted in USA and Ger.
Passport Distributors, Inc., PA.	PAS	1992	Passport-1	TP-2442-PA	By GOR.
Passport Marketing, Inc., PA.	PAM	1991	Passport Interm'1	TP-2442-PA	By GOR.
Patterson Bros. Tob. Co., VA.	PBT	1920	Crossword		
Patterson, W. E., Mount Airy, NC.	PRS	1887	Broad Ax		Listed in Connorton's Directory 1887.
Pavlik, A. M.	PAK	1912	Sex Bomb		
Pax Cigarette Co., Danville VT.	PAX	1885	Pax		From Cigarette Card.
Peace Tob. Co.	PEA	1927	Pep		
Peck, Wm., Rutland VT.	PEK	1898	Fox Terrier		Listed in Connorton's Directory 1898
Peer Marketing Associates, NJ.	PMA	1992	Best Choice	TP-1-NC	By RJR.
Peerless Tob. Works.	PEE	1885	Cloth of Gold		
Penn Bros.	PEB	1932	Julep		
Penn Janitor Supply Co., PA.	PJS	1962	Horse Shit		
Penn Tob. Co.	PEN	1934	Longfellow	F624-PA / F22-12PA / F33-4NC	Also Willoughby Taylor; John Alexiou; Julep Co.F624-1PA.F916-NY.
Penn, F. R. Tob. Co.	PNT	1927	Penbarry	F12-12PA	Also F22-12PA, See Penn Tob. Co.
Pennsylvania Tob. Co.	PNS				
Pent Bros. & Coleman, PA.	PBC	1898	Amotah	F4-LA	Listed in Connorton's Directory 1898
People's Tob. Co., LA	PTB	1910	Kotton		To Trust
Peoples Drug Stores	PDS	1986	Peoples		
Pera Cig. Co.	PRA	1914	Pera	F348-2NY	F348-2NY also surbrug (KHEDIVAL).
Perkins, Charles B. & Co., MA	PER	1898	Beacon Hill	F30-NC	
Perkins, George B., Boston MA.	PRK	1898	Nestor Egyptian		Listed in Connorton's Directory 1898.
Peterson Tob. Corp. NYC.	PET	1939	Peterson's	F150-5NJ	Also F365-2NY, & TP-75-NY.
Peyser, Chas., NYC.	PEY	1898	Florida Plantations		Listed in Connorton's Directory 1898.
Pfaff, H. C., Baltimore, MD.	PFF	1898	Battle Monument		Listed in Connorton's Directory 1898
Pfaltzgraff, J. K. & Co. PA.	PFA	1898	Royal Bengal	F750-5NJ	Listed in Connorton's Directory 1898
Pfeiffer, Charles	PFE		Cornwall	F7-2VA	F21-VA—F24-KY—F2032-1PA
Philip Morris & Co's, VA.	PMC	1899-	Philip Morris	TP-7-VA	F100-2NY—F512-NY.
Phillipine Tob. Co.	PHI	Date	Capitol		
Phillips & King Cigar Co., CA.	PHK		Rainbow, Charles Fairmorn (Import)		
Phillips, G, NYC.	PHL	1898	Hogan's Kid		Listed in Connorton's Directory 1898.
Phillipson, L., TX.	PLL	1898	Texas Standard	F562-3NY	Listed in Connorton's Directory 1898.
Photiades, Theo. Co.	PHO				
Piccadilly Cig. Co. (1890)	PCC	1890	Ibis		
Piccadilly Tob. Co., Inc.	PIC	1955	Piccadilly	F137-5NJ	F94-1NY——F137-NJ
Pierce, S. S. Co., Boston MA.	PIE	1915	S. S. Pierce	F460-VA	
Pierce, W. B.	PRC	1886	Sir Isaac Newton		
Pilkinton, E. T.	PIL	1886	Reigning Belles		
Pilkinton, E. T., Co., VA.	PKN	1885	Fruits and Flowers		
Pinecrest, San Francisco, CA.	PNC	1957	Go To Hell And Buy Your Own	C-407-NY	By GAG.
Pinkerton Tob. Co.	PIN	1919	Pay Car	F25-VA	By LAM.
Pinki Bros.	PKI	1883	Mascot	F404-2NY	By SSS.
Pinkus Bros., NYC.	PNK	1918	Pinkus Brothers	F21-NC	F21-NC was Continental T. C. See TNC.
Pinkus, Flora, W.	PKS	1918	Rainbow		
Pinkus, Fred M. Trade Named	PSF	1928	B.M.H. Inc.		
Pinkussohn, J. S. Cig. Co., GA.	PKH		Potpourri	F30-NC	Also F7-VA, By ATC. later PMC.
Plantation Tob. Co.	PLA	1965	Aquarius		
Plat, Rud, Milwaukee, WI.	PLR	1898	Milioki Club		Listed in Connorton's Directory 1898.
Player John, & Sons, Ltd	PLY	1959	Players		Listed in Connorton's Directory 1898.
Pledge Sales Co.	PLE	1959	Pledge		
Plunkett, T. J., NYC.	PTT	1898	Eastern Lights		Listed in Connorton's Directory 1898.
Pogue, W. J., Chattanooga, TN.	POG	1898	Free Nation		Listed in Connorton's Directory 1898
Pohalski, P., NYC.	POL	1898	Barras Memoirs		Listed in Connorton's Directory 1898
Pollacek, Chas, NYC.	PCK	1898	Jester		Listed in Connorton's Directory 1898
Pollak, NYC.	PLK	1890	Marquis		From Cigarette Card.
Ponderosa Tob. Co., CA.	POC	1996	Happy Deluxe		Export
Ponlides, C. N. NYC.	PON	1898	Mignon		Listed in Connorton's Directory 1898.
Porto Rican American Tob. Co. San Juan, PR.	POR	1945	Toro Y Ca	TP-2442-PA	
Postal Cigar Co., Cleveland OH.	POS	1898	Chicago 4's		Listed in Connorton's Directory 1898
Poulides Bros. Tob. Co., NYC.	POU	1897	Bagdad	F355-1NY	Also F365-2NY.

Right table

MERCHANT	ID	YEAR	BRAND NAME	FACTORY	REMARKS
Poulo	PUL		Dervish		
Poynter Products	POY		Philter		
Prager, M. W., NYC.	PRG	1898	Golden Anchor		Listed in Connorton's Directory 1898
Preferred Havana Tob. Co.	PRE	1916	Havana		
Premier Int. Distributing Co., MN	PID	1993	Pierre Cardin International Classic		
Price Cig. Co., Cleveland, OH.	PRI	1936	Lord Nelson, The New		F535-3NY
Prieto, Manuel, NYC.	PTO	1898	Republica, LA		Listed in Connorton's Directory 1898
Pritikin Bros., Chicago, IL.	PTK	1898	Sultan Russian And Turkish		Listed in Connorton's Directory 1898
Product Opinion Laboratory, VA.	POP	1992	Lead. Nat. Brand		By Philip Morris Co.
Prudential Tob. Co.	PRU	1921	Yanks	F30-NC / F649-1NY	F485-2NY—F435-2NY In trust.
Puerto Rico Tob. Corp., PR.	PUE	1938	Rivalo		
Pura Smoke Co., Inc.	PUA	1934	Pura Smoke		Primarily clove Cig. imports from Indonesia.
Purchik	PUR	1920	Muriel		Herbal smokes.
Quintin & Co., Inc., Fairfax, CA.	QUI	1920	Muriel (Imports)		
R and A Adventures, NY.	RAA	1994	Kickum		By AFT.
R. & S. Cigar Co.	RAS	1937	Sandy	F24-KY	
R. J. Reynolds Tob. Co., NC.	RJR	1913	Red Kamel	F24-KY / F1-5NC	Marketing entities: PMA, FOR, MTC. Also TP-1-NC, & F4-NC.
Rack-Rite Distributors, PA.	RRD	1988	Generic	TP-42-NC	By LAM.
Radezky, E., NYC.	RDZ	1898	Tigar		Listed in Connorton's Directory 1898.
Ragland, J. B. & Co., Bedford VA.	RAG	1898	Stoic, LA		Listed in Connorton's Directory 1898
Ralph's Grocery Co., CA.	RGC	1984	Plain Wrap	TP-42-NC	By LAM.
Ramsey, John, Jersey City NJ.	RSY	1898	Jersey Blue		Listed in Connorton's Directory 1898.
Randall-Landfield	RAN	1909	Press Club of Chicago		
Raphael Bros, NYC.	RPH	1898	Gothamettes		Listed in Connorton's Directory 1898.
Raporel Tobacco Co., NYC.	RAR	1945	Raporel Duc D'Alys		By LAB.
Rapoval Tob. Co., NYC.	RAP	1919	Valador		
Rawson & Simpson Co., MA.	RWS	1898	Ben Bolt		Listed in Connorton's Directory 1898
Ray D'Or tobacco Co., NYC.	RAY	1880	Ray D'OR		
Red Cross Tobacco Co., LA.	REC	1912	Red Cross		
Redezky	RED	1895	Tiger	F21-5NJ / F750-NJ	
Redmond Tob. Co., NYC.	RDM	1940	Phi Delta Theta		
Reed Tob. Co., Richmond, VA.	REE	1912	Relu	F460-VA	By LAB.
Rembrandt Tob. Co. (or Corp)	REM	1955	Airflow	F94-NY	By RIG.
Requa Mfg. Co., Inc., NY.	REQ	1891	Cubeb		
Resch, N., NYC.	REH	1898	Renwick		Listed in Connorton's Directory 1898.
Reseska, Helen Maria	RES	1955	Rainbow		
Retailers Cig. Co.	RET	1899	Sweet's		
Rex Cigarette Co., Danville, VA.	REX	1884	Rex		From Cigarette Card.
Reymere & Bros., Pittsburg, PA.	REY	1933	Reymer's	F404-2NY	By SSS.
Reynolds, S. W., Scranton, PA	RSW	1898	Ask For This		Listed in Connorton's Directory 1898.
Rich & Co.	RIC		Carlotina		
Richardson, Denny & Co., NC.	RDD	1885	Monogram		RCH bought by BAW in 1926.
Richardson, Jr., R. P. & Co., NC.	RCH	1924	Old North State		
Richfood, Inc., Richmond, VA.	RHF	1987	Econ	TP-2-VA	By USJ.
Richmond Cheroot Co., The. VA.	RMC	1898	Lee Camp		Listed in Connorton's Directory 1898.
Rieders, M. H. NYC.	RIE	1900	All Tobacco		From Cigarette Card.
Riggio Tob. Corp. of N. Y. Ltd.	RIN	1969	Riggio	F94-NY	
Riggio Tob. Corp., NYC.	RIG	1937	Regent	F94-NY / F94-1NY	F94-NY produced cig, also for Filter Cig. Corp. (O-Nic-O).
Rippen, H.	RIP	1912	Turul	F537-3NY	F537-3NY also made Cigarette for the Royal Turkish Tob. Co.
Ritz Cig. Corp.	RTZ	1940	Ritz	F35-VA	By BAW.
Ritz Hotel Ltd.	RZH	1985	Ritz Hotel		
Ritz-Carleton	RIT	1913	Terwin		
Robbins, Lee J.	ROB	1969	Peace		
Roberts, J. W. & Sons	RBS	1904	Roberts		
Roberts, R. J. ?	RRJ	1881	Parabola		
Robertson-Nettles Tob. Co.	RBR	1898	Date		Listed in Connorton's Directory 1898.
Robinson's California	RBC	1961	Havana, Shermans	C-407-NY	By GAG.
Robinson, A.	RBN	1900	Board Of Trade		
Robinson, Allen	RSN	1935	Mayfair		
Rodriguez, A., NYC.	ROD	1898	Aroma		Listed in Connorton's Directory 1898.
Roever, A. T., Cincinnati, OH.	ROV	1898	Ivory Club		Listed in Connorton's Directory 1898.
Romanoff Cig. Co.	ROM	1919	Romanoff		
Rose, D. E. & Co., NYC.	ROS	1887	Rose		Listed in Connorton's Directory 1898.



MERCHANT	ID	YEAR	BRAND NAME	FACTORY	REMARKS
Rosedor Cig. Co., Brooklyn NY.	RSD	1912	Salome	F22-12PA	F916-NY—F916-1NY—F916-2NY F1048-12PA.
Rosell & Co., NYC.	RLL	1898	Cunning Winks	F439-3NY	Listed in Connorton's Directory 1898.
Rosen Enterprises, Inc.	ROE	1986	Bogart	TP-42-NC	
Rosen, M, NYC.	REN	1898	Grandest Sweep, The		Listed in Connorton's Directory 1898
Rosenberg, Casper, Cleveland OH.	RSC	1898	Cleveland Bars		Listed in Connorton's Directory 1898
Rosenberg, H. Richmond VA.	RSB	1868	Asthmatic		Listed in Connorton's Directory 1887.
Rosenberg, H., Philadelphia, PA.	RSH	1898	American U.S. Havana		Listed in Connorton's Directory 1898
Rosenblatt, C.	RST	1969	Pot		
Rosenblum Bros., NYC.	RBL	1898	Limited Mail		Listed in Connorton's Directory 1898.
Rosenfeld, H., & Co., PA.	RSF	1880	Opera Puffs		
Rosenheimer, A., New Haven CT.	RSR	1898	Old Pump, The		Listed in Connorton's Directory 1898.
Rosenthal, S. M.	RTH	1898	Havana Puffets		Listed in Connorton's Directory 1898.
Ross Tob. Co., Petersburg, VA.	RSL	1899	La Tremona		
Ross, G. Val, Inc, Las Vegas NV.	ROT	1928	Betsy Ross	TP-762-FL	
Roth, Bruner & Feist, OH.	RSI	1985	Las Vegas		
Rothchilds	RBF	1898	Jhubilee		By LAM.
Rothenels, I D., Walton, NY.	ROH		Black & Gold		
Roundup Groceries, Portland OR.	RHN	1898	Generic		Listed in Connorton's Directory 1898
Royal Cig. Co.	RCC	1989	Royal	TP-42-NC	By LAM.
Royal Pearl Cig. Co., NYC.	RCP	1981	Hotel Astor		
Royal Tob. Corp. (or Co.)	RYP	1898	Royal Pearl	F139-3NY	Listed in Connorton's Directory 1898.
Royal Turkish Tob. Co.	RYT	1945	Lion	F537-3NY	
Ruhe Bros. Co., Allentown, PA.	RTT	1907	Garibaldi		
Rum & Maple Cig, Inc.	RUH	1898	Generals Grant & Lee		Listed in Connorton's Directory 1898.
Rum & Maple Tob. Corp.	RUN	1953	Little King	F460-VA	By LAB.
Rush, M. B., NYC.	RUM	1937	Rum & Maple	F10-KY	Also F460-VA, By TBC. & LAB.
Russell James B., Inc., NJ.	RUL	1898	Knights of Pythias (Imports)		Listed in Connorton's Directory 1898. Cig Imprtr based in Eng. JBR by TP-22-VA (STR).
Russell, C. F. Richmond, VA.	RUS	1885	Reigning Beauties		
Russian Turkish Tob. Co., NYC.	RUT	1908	Nazimova		
Russian-American Tube Co.	RNM	1920	Russian American		
S&M Brands, Inc. VA.	SAM	1994	Bailey's	TP-22-VA	By SAR.
Sacconi, Speed, LTD.	SCI	1926	Bell of the Orient		
Sackett, H.	SAC	1928	Sackett / Denicotinized	F137-5NJ	Listed in Connorton's Directory 1887.
Sadler, Mau. & Co., CA.	SAD	1898	Banker's and Merchant's Club		Listed in Connorton's Directory 1898.
Safeway Stores, Inc.	SFS	1981	Scotch Buy, Scotch-Buy	TP-42-NC TP-1-NC	By LAM, RJR.
Safir Smokes	SAF		Bravo		
Sage Cigarette	SAG	1960	Sage		
Salamandia, Tito	SAL	1950	TV		
Salmon Management	SLM	1946	Mereworth		
Santa Fe Natural Tob. Co., NM.	SFN	1996	American Spirit		By GOR.
Sarna's Superette, Minn. MN.	SRS	1914	Sarna's		
Sasso, F. De	SSO	1914	Sasso		
Schadaw, Henry, Brooklyn, NY.	SHW	1898	Brilliantes		Listed in Connorton's Directory 1898.
Scheffey, Lewis C. & Co., NYC.	SFT	1898	Color Guard		Listed in Connorton's Directory 1898.
Scheidnagel, S. B.	SCH	1886	Sweet Caporal		
Schein's Cigar Factory, NYC.	SNC	1898	Golden Chain		Listed in Connorton's Directory 1898.
Schein, M., NYC.	SHM	1898	The World		Listed in Connorton's Directory 1898.
Schendel, Charles & Co., NYC.	SEC	1898	Young League		Listed in Connorton's Directory 1898.
Schenker, I. W., NYC.	SCK	1890	Svoboda/Freiheit	F339-2NY	
Schiffmann, R. & Co., CA.	SCF	1893	Asthmador		
Schinasi Bros., Inc., NYC.	SCS	1893	Egyptian Prettiest	F14-3NY F488-3NY F2109-3NY F174-3NY	F2153-3NYF485-3NY, Also F174-3NY (Rose of Egypt); and F2153-2NY (Natural). Listed in Connorton's Directory 1898.
Schmidt & Co.	SCD	1913	Merak		
Schulte	SCT	1919	Spencer Arms Buds		For a combined group of retailers.
Schulte, NYC.	SLT	1905-1915	Schulte's Own High Grade Turkish		
Schwartz, Harry B., Reading, PA.	SCZ	1898	Cow Bell	F74-2NY	Listed in Connorton's Directory 1898.
Schwartz, Joseph, NYC.	SCJ	1898	Cuban Plantation		Listed in Connorton's Directory 1898.
Schwartz, Peter Paul	SCW	1961	Butties		
Schwartz, Max, NYC.	SWZ	1898	Rays		
Scott Tob. Co.	SCO	1932	Scottie		
Scotten, Daniel & Co., Detroit, MI.	SCN	1898	Cow Bell		Listed in Connorton's Directory 1898.



MERCHANT	ID	YEAR	BRAND NAME	FACTORY	REMARKS
Scotten-Dillon Co., Detroit, MI.	SND	1921	Ramrod	F85-MI	Also F85-1MI.
Scruggs-Vandervoort-Barney Co.,	SVB		The Nasty Pudding		
Sears, Roebuck & Co.	SRO	1955	Yorkshire	F460-VA	Also C-460-VA. House brand by LAB.
Segal, I., NYC.	SGL	1898	Elod		Listed in Connorton's Directory 1898.
Seidenberg, E., Steifel & Co., (or Seidenberg & Steifel) NYC.	SDS	1898	Bluff		Listed in Connorton's Directory 1898
Seidenberg, H., Brooklyn, NY.	SBG	1890	After Lunch		Listed in Connorton's Directory 1887.
Seidenberg, R. J., Co., NYC.	SEI	1898	The Hotel Statler		From Cigarette Card.
Seidenberg, R., Buffalo, NY.	SEB	1898	Ellicot	F5-2NY	By BEH.
Seifert, Rudolf, Chicago, IL.	SEF	1898	Buzz Bee		Listed in Connorton's Directory 1898.
Select Marketing, Richmond, VA.	SEL	1898	Test Pack	TP-7-VA	By PMC.
Selim Milan	SEM	1913	Blue Bells		
Semon, J. S., Philadelphia, PA.	SON	1898	Triple Screws		Listed in Connorton's Directory 1898.
Seneca & Mohawk Tob. Co.	SCM	1992	Seneca Hawk	TP-22-VA	By SAR.
Sentinal Co.	SEN	1969	Sentinal		
Serallian, J. K.	SER	1941	London Pride	F80-6CA	
Seven Island Co.	SEV	1937	Seven Island Club	F24-KY	By AFT.
Shagreen Products	SHG		Eastern Dream?		
Shaw, H. E., Co.	SHA	1942	Tadcaster		
Shaw, Made By, CA.	SMB	1923	Ambra	F141-6CA	By SSS.
Sheffield Tob. Works	STW	1941	Sheffield # 5	F404-2NY	Listed in Connorton's Directory 1898.
Sherick, Daniel, NYC.	SHD	1898	Bergen Beach Bouquet	TP-161-NY	F407-2NY C-407-NY TP-2-PA
Sherman, Nat Co., NYC.	SHE	1898	American Beauties	F65-2NY F407-NY	F26-NJ TP-26-NJ TP-75-NY F404-2NY
Shield, Inc., CA.	SHI		Desert Shield		
Shirk, Joseph G., Lancaster, PA.	SHK	1898	American Federation of Labor		Listed in Connorton's Directory 1898.
Shoemaker, N. C.	SHO	1964	Shorty		
Shop Rite Food Stores, Wakefern Food.	SRF	1961	Shop-Rite	C-1-VA	By USJ.
Shurfine Central Corp., IL.	SRC	1985	Saver's Choice	TP-42-NC	By LAM.
Sidlisky, S., Reading PA.	SDL	1898	Princess Bonnie		Listed in Connorton's Directory 1898.
Siegel, J. M., and D. (or Siegel Bros.)	SIE	1900	Cablegram		
Sigmund Strauss	SIG	1917	Prime Americana		
Silver Rod Sales Co.	SIR	1965	Tweeners		
Silverberg & Co., Baltimore, MD.	SVR	1887	Victoria XXX		Listed in Connorton's Directory 1898,
Silverburg, Chas., NYC.	SLG	1898	Osman Pasha		Listed in Connorton's Directory 1898.
Silverman, Harris, NYC.	SMN	1898	Ladies' Style		Listed in Connorton's Directory 1898.
Silverstone Bros., NYC.	SLV	1898	Colonel, El		Listed in Connorton's Directory 1898.
Simon-Riegel Cigar Co., NYC.	SMR	1898	Afterthought		
Simpson, Max	SMP	1928	Sano		
Simpson, Studwell & Swick, NYC.	SSS	1938	Chukker Rounds	F404-2NY	Also F34-2NY and F406-2NY.
Skillern & Sons, Inc., Dallas TX.	SKI	1937	Rebels	F24-KY	By AFT.
Sklamberg & Abramson, NYC.	SKA	1898	Best Parlor		Listed in Connorton's Directory 1898.
Slade, Geo. E., Chelsea, MA.	SLD	1898	Huh Fine Cut		Listed in Connorton's Directory 1898.
Slameky, Joseph A. & Co.	SLA	1939	ASUF		Listed in Connorton's Directory 1898.
Slutzky, Isaac, NYC.	SLZ	1898	Lubow		Listed in Connorton's Directory 1898.
Smith, C. B. & Bloodgood, Wash., D. C.	SBL	1885	Sweet Capital		
Smith, C. R.	SMT	1917	Sammeas		By AFT.
Smith, Richard D.	SMI	1961	Men Only		
Smith, Thorndike & Brown Co., WI.	STH	1898	Cabinet		Listed in Connorton's Directory 1898.
Smith, W. F. & Sons	SMS	1893	Magnolia		
Smith-Kirkpatrick & Co., NYC.	SMK	1933	White Spot	F13-2NY	Also F13-3NY
Smo-Ko, NYC. Phil, PA.	SKO	1952	Smo-Ko		Medicated Cigarette.
Smoke A Cola Cig. Co.	SMO	1933	S. F.	F94-NY	By RIG.
Smoker Friendly LLC	SFL	1996	Lewiston	TP-42-NC	By LAM.
Smokin Joe's Lewistion, NY.	SMJ	1997	Old Picoon		
Smyth, Woodson & Payne, VA.	SWP	1887			Listed in Connorton's Directory 1887.
Snooty Cig. Co.	SNO	1937	Snooty	F24-KY	By AFT.
Sol C. Korn	KOR				Cambridge Tob. Co., Flemming-Hall Tob. Co.
Sole, Louis C. & Co., PA.	SLE	1898	City of Stamford		Listed in Connorton's Directory 1898.
Somborn, Morris, NYC.	SOM	1898	Beverly		Listed in Connorton's Directory 1898.
Soter, F & E. Tob. Corp., NYC.	SOT	1921	La Turka	F74-2NY	
Soulbrands, Ltd.	SOU	1968	Ebony		
Southern Tob. Products Co., GA.					
Space. Inc.	SPA	1958	Space		
Spaulding, R. Z., Binghampton, NY	SRZ	1898	Sweet Iris		Listed in Connorton's Directory 1898.
Special Tob. Co., NYC.	STC	1935	Duo-Blend	F34-2NY	Also F407-2NY By GAG.

MERCHANT	ID	YEAR	BRAND NAME	FACTORY	REMARKS
Speirs, Albert, Chicago, IL.	SPS	1898	Quaker Gentleman		Listed in Connorton's Directory 1898.
Spier, David, Tob. Co.	SSW	1887	Excellent		
Spiro, Swan & Co.	SPO	1915	Bouyara		
Sprague, Warner & Co., IL.	SPG	1898	The Nile		Listed in Connorton's Directory 1898.
Springfield Co.	SPR	1962	Sweet Life		
Spud Cig. Corp., Wheeling, WV.	SPU	1922	Spud	F12-WV	Lloyd F. Spud Hughes developed process for mentholating Tob.
Squi, Sam	SQU	1902	Jenny Lind		
St. John, W. W., Co.	STJ	1909	Sinjin		
Stacheberg, M., NYC.	SRG	1898	On Change		Listed in Connorton's Directory 1898.
Stade, Amos, Lowell, MA.	STE	1898	Little Canady		Listed in Connorton's Directory 1898.
Stadeker, H. H., Chicago, IL.	SKR	1898	Klondike Pioneers		Listed in Connorton's Directory 1898.
Stahl Jr., Jacob & Co., NYC.	SHL	1898	White Rabbit		Listed in Connorton's Directory 1898.
Stamaloglas, S. E., NYC.	STM	1898	Egyptian Aroma		Listed in Connorton's Directory 1898.
Standard Cigar & Cig. NYC.	SCC	1898	Crown		Listed in Connorton's Directory 1898.
Standard Export Cig. Co.	STD	1919	Standex		
Standard Tob. Co., VA.	STA	1916	Strollers	F81-VA	
Stanley Freres (brothers) IL.	STF	1905	Stanley Freres	F104-1IL	
Stapleton, M. Mullick, NY.	SAN	1898	Good Omen	F460-VA	By LAB.
Star Service Co.	SSC	1936	Star Service		
Star Thompson Tob. Co., FL.	STT	1950	Champ Clark	F157-FL	
Star Tob. Corp., Petersburg, VA.	SAR	1994	Gunsmoke		Incl. TP-22-VA, TP-14-VA, WOR,
Starlight Bros., NYC.	SGT	1898	Starlights	F430-1PA	Listed in Connorton's Directory 1898.
Starr & Reed, Philadelphia, PA.	SRR	1906	Starr & Reed	TP-3-VA	
States Tob. Co., Richmond, VA.	SST	1967	Tryon		By USJ.
Statesville Tob. Works, NC.	STV	1898	Short Off		Listed in Connorton's Directory 1898.
Steane, E. G., & Co., PA.	SEA	1898	Diamond Jubilee		Listed in Connorton's Directory 1898.
Stein & Lethman, NYC.	STL	1898	Hadge Boy		Listed in Connorton's Directory 1898.
Stein, H., Pittsburg, PA.	SNH	1898	Home Stake		Listed in Connorton's Directory 1898.
Stein, Samual, NYC.	SNS	1898	Oriental Queen		Listed in Connorton's Directory 1898.
Stephano Bros.	STP	1921	Rameses	F2032-1PA, TP-3-VA	Also TP-75-NY, By STP, USJ GAG/AND.
Stephen, W., & Son, PA.	SPH	1898	Country King		Listed in Connorton's Directory 1898.
Sterling Tob. Co., NY.	STR	1988	Fairfax	F407-2NY	By GAG/Andron.
Sterling Tob., Boston, MA.	SOB	1924	Ammon		
Stern, Arthur, & Bro., NY.	SRA	1898	Arthur		Listed in Connorton's Directory 1898.
Stern, Jean, & Co., NY.	SRN	1898	Anti Deluvian		Listed in Connorton's Directory 1898.
Sternbaum's Food Marts, Inc.	STN	1948	Julie Marc		
Steuben's Food Co.	STU	1959	Hollywood		
Stewart, W. W., PA.	SWW	1898	City Salesman		By LAB.
Stickney, W. A., Cig. Co.	STI	1908	Town 7 Country		
Stockkebye, Peter, International	STK	1998	Golden Flavors		
Stoddard, L. L. New London CT.	SOD	1997	Handsome Dan		
Stone Hedge Corp., Gilboa, NY.	SGC	1994	Virginians	TP-22-VA	Star Tob. Possible Export.
Stowecroft Brook Dist. Boston MA.	STO		X (in red square)	TP-22-VA	By SAR.
Strand Tob. Co.	SRT	1905	Strand		
Stratford Cig. Co.	SRD	1910	Yvonne		
Straus Brothers & Co., OH.	STS	1955	Private Stock		
Straus, G., NYC.	STG	1898	Sutoca		Listed in Connorton's Directory 1898.
Streng, Hamburger & Co., OH.	SHC	1898	Texaco		Listed in Connorton's Directory 1898.
Strike Axe Trading Co., OK.	SKT	1974	Indiann Smoke	TP-42-NC	By USJ.
Stuyvesant, Peter, of N. Y., Inc.	STY	1973	Peter Stuyvesant	TP-42-NC	By LAB/HOE.
Suares & Crispo	SCR	1936	La Reina Cigarillos	F348-2NY, F279-5NJ	
Sullivan, Powell Tob. Co.	SPC	1902	Oriental		
Sultan-Flore Tob. Co.	SUL	1914	Sultan Flore		
Sun Cigarette Co., NYC.	SUC	1898	Sun		Listed in Connorton's Directory 1898.
Sunfresh Inc., St. Paul MN.	SUN	1988	Generic	TP-42-NC	By LAM.
Super Valu Stores, Inc.	SVM	1950	Super Valu	F460-VA	House brand by LAB.
Sunkperior Brokerage	SUB	1945	Le Marber	F65-2NY	By LEI.
Superior Cigar Co., Buffalo, NY.	SPE	1898	Round and Square		Listed in Connorton's Directory 1898.
Superior Products Co.	SUP	1972	Twenty Turks		
Superior Tob. Co., Inc.	SUR	1920	Happy Smoke		
Supermarket General, Corp., NJ.	SUM	1986	No Frills		By LAM.
Surbrug, John, Co. or TheSurbrukg Co., NYC.	SRB	1899	Milo		
Surrey Ltd, John, Fifth Ave. NY.	SUY	1938	John Surrey's Melody	F10-KY	By TBC.
Sussman, D., NYC.	SUS	1898	Speckled Batch		Listed in Connorton's Directory 1898.
Swain, R. L. Tob. Co., VA.	SWA	1938-	Pensa-Cola	F40-NC, F50-VA	Also F10-KY, TBC, (Pinehurst) and F24-KY, AFT (Pinehurst).
Swedish Tob. Co.	SWT	1947	Blend		
Sweet, J. D. Albany, NY.	SWE	1898	Bicycle Girl		Listed in Connorton's Directory 1898.
Swinging Mothers, Inc., NYC.	SMH	1967	LSD(Like Swing, Daddy)	TP-75-NY	Fun and Games with the Drug culture, by GAG.
Swisher, E. W., Cigar Co., OH.	SWH	1898	Brother Jumbo		Listed in Connorton's Directory 1898.
Swisher, Jno.	SWI	1960	King Edward		
SWR Corp., Knoxville, TN.	SWR	1986	Black Gold	TP-2-VA	By USJ.
Tabard Tob. Co., Ltd.	TAB	1913	Tabard		
Takowefsky, H.	TAK	1903	Sporting Extra		
Tango Mfg. Co.	TNG	1913	Tango		
Tanner, G. W., Providence, RI.	TAN	1887	Honest Deal		Listed in Connorton's Directory 1887.
Taroma, Inc.	TAR	1985	Pierre Cardin Intl.		
Tcharic, Simlah & Co.	TCH	1912	London Life		Camino Real & Te-Amo.
Te-amo Geryl Co., Inc.	TEA		Imports		
Teichman, Isaac, NYC.	TIC	1887	After Dinner		Listed in Connorton's Directory 1887.
Teischmann's Sons, Isaac, NYC.	TEI	1898	Demonstrater		Listed in Connorton's Directory 1898.
Teiser & Pollak, Richmond VA.	TES	1898	Bamboo Tips		Listed in Connorton's Directory 1898.
Tel Aviv Tob. Co.	TEL	1933	Jewel	F108-1CA	
Teller, Frank & Co., PA.	TLL	1898	Golden Smoke		Listed in Connorton's Directory 1898.
Temple, Hummel, Ellis Co., IN.	THL	1898	Chicago Record		Listed in Connorton's Directory 1898.
Teofani & Co., Inc.	TEO	1923	Teofani # 5	F460-VA, F320-3NY	By LAB.
Themelis, Geo., & Co.	THE	1915	Ali Pasha	F265-NY	
Themelis Bros. Co.	THB	1909	Themelis Specials		
Theocaridis, D.	THS		Banker's Special		
Theoraripis	THR		Theoraripis		
Thomas, Cal, Cubana City Cigar Co., Thomasville, GA.	THC	1898	Arkansaw		Listed in Connorton's Directory 1898.
Thomas, John N., Norristown, PA.	THM	1898	Dutch Jake		Listed in Connorton's Directory 1898.
Thompson, Geo. M.	THO	1922	Royal Palm		
Thompson, Geo. M., Chicago, IL.	TGM	1898	Belle of the Lake		Listed in Connorton's Directory 1898.
Thorwart & Roehling, Chicago, IL.	TWR	1898	Cairo 27A		Listed in Connorton's Directory 1898.
Thurber Co., ?? MA.	THU	1895?	Thurber's No. 5	F393-3MA	Listed in Connorton's Directory 1898.
Timayenas, T. T., Boston, MA.	TTT	1898	Canal De Suez		By GAG.
Tint, Harry A.	TIN	1955	Personal Blend	F407-2NY	No Tobacco, Made in England.
Tobacco Alternative, Inc., NY.	TAI	1994	Magic Herbal		By BAW.
Tobacco Brands Corp.	TBR	1945	Melody		Subsid. of ATC.
Tobacco Exporters Internation, Ltd.	TEX	1992	St. Moritz	TP-16-GA	Made cig. for Theodorus Niemeyer, Inc; Dream Castle Tob. Co.
Tobacco Products Corp., NYC.	TPC	1919	Yanks		Also F460-VA By Wiesert, LAB.
Tobacco Products Export Co.	TPE	1919	United States	F10-KY	By AFT.
Tobacco Blending Corp. KY.	TBC	1963	Red Crown		By LAM.
Tobin, R. R. Tob. Co.	TOB	1939	Cookie Jar	F11-1MO	From Cigarette Card.
Tokay Cig. Co.	TOK	1985	Tokay	F24-KY	See Pinkus, Fred M. (PSF).
Topco Associates, Inc., IL.	TOP	1985	Valu Time	TP-42-NC	By GOR.
Toprahinan, M. C.	TOR	1915	Victorious		By GOR.
Toro Y Ca S.en Porto Rico	TOU	1935	Toro Y Ca		
Tourist Cigarette Co., NYC.	TOW	1885	Tourist		
Towne Tobacconists, Inc., NYC.	TNC	1938	Yorkshire	F123-2NY	
Trade Named Cig. Statesville, NC.	TWB	1928	B.M.H. INC.	F21-NC	
Transworld Tob. Ltd. CA.	TWL	1996	Charro	TP-2442-PA	
Transworld Tob. Ltd. CA.	TWT	1994	Gray Wolf	TP-2442-PA	
Transworld Tob. Ltd. DE.	TRC	1996	S Signals	TP-2442-PA	
TRC Co.	TRI	1898	Prince Hamlet	F11-1MO	Listed in Connorton's Directory 1898.
Triumph Smokes, Inc., Dallas TX.	TAW	1898	Triumph		Listed in Connorton's Directory 1898.
Trostal, Geo., Gaston, PA.	TUC	1935	#444		Listed in Connorton's Directory 1898.
Truner, A. W., Macon GA.	TMG	1898	Stud Turner		
Tuckett John E. & Son	TUR	1890	Golden Rule		
Tumbridge, Wm., Brooklyn, NY.	TEC	1898	St. George		
Turco-American Tob. Co., NYC.	TKE	1903	Pall Mall		
Turco-Egyptian Cig. Co., NY.	TRU	1913	Berberin	F308-2NY	Also BUB.
Turco-Egyptian Tob. Co., NYC.			Egyptienne Straights		
Turco-Russian Cig. Co., PA.			Red Kamel	F2153-3NY	(Red Kamel), Bought from S. Ragona, sold to RJR.
Turmac Tob. Co., B. V.	TUM	1958	St. Moritz	C-42-NC	By LAM, St. Moritz also by other makers w/TUM name on pack.
Turney, John E. C., Ltd., LA.	TRN	1898	U.C.V.		Listed in Connorton's Directory 1898.
Tuscarora Reservation Enterprises near Niagara, NY.	TRE	1994	Teka Extra Lights	TP-168-NY	Maybe TAI or ACI.
U.S.A. Cigarettes, Inc., MI.	USM	1992	U.S.A.		(Export), By GOR.
Ullman, Lewis & Co., TX.	ULL	1885	Common Sense		Listed in Connorton's Directory 1887.
Ullmer, Robert & Co., NYC.	ULM	1886	Esmeralda		Non-tob filters.
Ultratech Corp., PA.	ULT	1975	Light-Free		
Union american Cigar Co., PA.	UIO	1898	Greater Beaver Falls		Listed in Connorton's Directory 1898.

MERCHANT	ID	YEAR	BRAND NAME	FACTORY	REMARKS
Union News	UNN		Gateway	F649-1NY	
Union Tob. Co., NYC.	UNI	1892	Three Kings	F2153-2NY, F649-NY	Taken over by ATD, (trust) 1898.
United Cigar Stores	UCS	1919	Beau Brummell	F24-KY	Also Coronet.
United Cigar-Whalen	UCW	1936	Ladd's		By AFT.
United Cigarettes Factories, Pittsburg, PA.	UCF	1915	Cocktail Super		Co. Spelling is correct.
United States Tob. Co. of NJ.	USJ	1922-	Virginia	F1-1NY	Also F1-VA, TP-3-VA, TP-1-VA.
United States Tob. Co. VA.	USV	1895-1921	Mapleton	F1-VA	
United Tob. Works, NYC.	UTW	1898	Idle Hour		Listed in Connorton's Directory 1898.
Universal Tob. Co. (1885-1930) NYC	UTC	1930	La Belle Straight Cut	F535-2NY	
Universal Tobacco Co, NYC.(1990)	UNC	1993	Egyptienne straights	TP-75-NY	
University of Kentucky (Code 1R1)	UKT	1969	Texas		
Upper Ten Cigarette Co.	UPT	1992	Code 1 R 1		
Urtsch & Schmitt, NYC.	URT	1898	Texas		By GAG/AND.
USA Tobacco	USA	1993	USA		
V. 1. Sales, LaVerne, CA.	VIS	1996	Not Guilty	TP-2442-PA	Fm. O. J. Simpson Trial, by GOR.
Vafiadis, Theo & Co.	VAF	1895	Vafiadis	F94-2NY	By SAR?
Vali Cig. Co.	VAL	1917	Vali		
Vallauri, V., NYC.	VLL	1898	Beau Sexe		Listed in Connorton's Directory 1898.
Vallens, Eugene & Co., NYC. & IL.	VLN	1898	Financier		Listed in Connorton's Directory 1898.
Valor Tob. Co., Inc.	VLR	1992	Gallant		(Export)
Value Cig. Co. NYC.	VLC	1898	Big Run		Listed in Connorton's Directory 1898.
Vaughn-Ware Tob. Co., VA.	VAW	1910	Naxima		From silk pennant.
Venable, S. W., & Co., VA.	VEN	1887	Nimrod		Listed in Connorton's Directory 1887.
Verdurin	VER		Greenette		
Vernon Tob. Co.	VRN	1914	Mona Lisa		
Veteran's Tob. Co.	VET	1947	Veteran		
Victory Tob. Co., Inc., WV.	VIC	1936	Blue Crown	F24-KY	By AFT.
Virginia Products Corp.	VPC	1932	Tons	TP-130-NC	Also TP-22-VA, By ATC, Star.
Virginia T.C.	VTC	1993	Good Companion		See also DLG.
Virginian (The) Tob. Co., NYC.	VGN	1895	Eagle		
Vitsas Cig. Co., NYC.	VIT	1940	Cameo	F156-3NY	Also TP-1-NC By LAM. RJR.
Von's Grocery Co., CA.	VON	1983	Polish Golden Tower	TP-1-NC	
Wagner, John B., IN.	WGN	1898	Slim Price		Listed in Connorton's Directory 1898.
Wagner, R. & Co., MI.	WAG	1885	Purdue		Listed in Connorton's Directory 1887.
Wakefern Food Corp.	WAK	1953	Petoskey Chief	F460-VA	Also TP-1-VA, Hse. brnd by LAB-USJ.
Waldorf Astoria International	WAL		Shop-Rite		
Waldorf Astoria, The	WDA		Astor	F30-NC	By ATC.
Walsh's	WSH	1932	Waldorf Astoria		
Walt Disney World	WDW	1971	Walsh's		
Waltenspiel, T. C., UT.	WTS	1898	Walt Disney World		By GAG.
Walwig & Cook, Milwaukee, WI.	WWG	1898	Eagle Gate		Listed in Connorton's Directory 1898.
Wanamaker, J.,Dept. Store, NY.	WAN	1937	Yacht Flag		Listed in Connorton's Directory 1898.
Ward, Wm. P., NYC.	WRD	1898	London Shop	F407-2NY	By GAG.
Ware, F.D., Tob. Co., Inc., VA.	WAD	1913	Idler		Listed in Connorton's Directory 1898.
Warner-Kramer, Norfolk, VA.	WAR	1904	Astor	F56-5VA	
Warner, L.., W., NYC.	WLW	1915	Bare-Kat		
Wartman, M., & Sons.	WTN	1887	White Rolls		
Wassermann, B.	WAS		Cubeb		
Watts, Earl Linzy	WAT		Navy		
Way, E. C., Chicago, IL.	WAY	1898	Old King Kole		Listed in Connorton's Directory 1898.
Webber, Geo, NYC.	WEB	1898	Glamourettes		Listed in Connorton's Directory 1898.
Weiner & Gossage, Inc.	WEN		Motorcycle		
Weis & Co., Baltimore, MD.	WSC	1898	Cicado		Listed in Connorton's Directory 1898.
Weis, Carl, NYC.	WEI	1987	Dean Swift		
Weisert, John Tob. Co.	WEC	1890	Flower of the Nile	TP-42-NC	Also TP-1-NC By LAM, later by RJR.
Weisfeld, D., Chicago, IL.	WES		Generic		
Wells, A. B	WEL	1888	The Vienna Mixture		
Wells-Whitehead Tob. Co.,	WWH	1909	Carmen	F4-1MO	Listed in Connorton's Directory 1898.
Werner, Paul A., Inc. NYC.	WER	1934	High Fashion Turkish		
West Park Tob. Co., VA.	WEP	1992	Magnolia		
Western Family Foods, Inc.	WFF	1984	Carolina Brights	F21-VA	Also F30-NC, By Continental, & RJR.
			Snowball	TP-3-VA	Also TP-22-VA, By USJ, Inr. SAR.
			West	TP-3-VA	By USJ.
			Shur Saving		

MERCHANT	ID	YEAR	BRAND NAME	FACTORY	REMARKS
Western Tob. Co.	WET	1923	Kohar		Listed in Connorton's Directory 1898.
Whaley, C. F., St. Paul MN.	WLY	1898	Como		By TBC.
Whayne, Roy C., Supply Co., KY.	WHA	1947	Roy C. Whayne Co.	F10-KY	Listed in Connorton's Directory 1898.
Wheeler, John T., Brooklyn, NY.	WHR	1898	Manhasset Club		Listed in Connorton's Directory 1898.
Whelan, Geo. J, NY.	WHG	1898	Beau Brummell		Listed in Connorton's Directory 1898.
White, Mrs Anna M.	WHT	1915	White Blend		See also ROE, non-tobacco.
Whitehall Products Inc., NJ.	WHH	1975	Bogart		F1191-3NY (YHP).
Whitelaw, J. & Co., NYC.	WTL	1912	Yale-Harvard-Princeton		
Whiteman, McNamara Tob. Co.	WHN	1898	Nomad		Listed in Connorton's Directory 1898.
Whitlock, P., Richmond VA.	WHL	1895	Old Virginia		
Wicke, Wm. Co., NYC.	WIK	1890	Liberty		
Wiedeman Co.	WIE	1904	31		
Wigdorovitz, L., NYC.	WIG	1898	Lord Bikonsfeld		Listed in Connorton's Directory 1887.
Wildcraft Herbs	WIL		Affaire		
Wilkins, H. & Co., Baltimore MD.	WLK	1883	Airy Fairy		
Willard Hotels, Wash., D.C.	WLH	1929	Collegian		
William Bros. Tob. Co., PA.	WMB	1900	Young Yankee		
Williams, Jno. R. & Co., NJ.	WLC	1887	La Belle Romni		
Williams, R. C. Co., NYC.	WMS	1898	Ten Pins		
Willoughby Taylor, PA.	WTA	1943	Longfellow	F22-12PA	By Penn T. C.
Wims Research Lab.	WIM	1957	Wims		
Winans, R. F	WIM	1975	1776		
Windsor Tobacco Co.	WID	1939	Kingsly	F15-2NY	
Winecke & Doerr, Minn. MN.	WNE	1898	Ball Bearing		Listed in Connorton's Directory 1898.
Winegarden, A., NYC.	WNG	1898	Best Out		Listed in Connorton's Directory 1898.
Winston Tob. Co.	WTC	1940	Fems	F7-1IL	Also F24-KY, By AFT.
Wiseman	WIS	1961	Wild Eleuthero Ginseng		
Witchcraft Herbs	WIT		Silver King		
Witsch & Schmitt, NYC.	WSM	1898	American Lord		Listed in Connorton's Directory 1898.
Wix, J. & Sons	WIX	1885	Wix	F3-NC	
Wohl, Peter & Co., Chicago, IL.	WOH	1898	Cuban Harbor		Listed in Connorton's Directory 1898.
Wolf, B. S., NYC.	WOF	1898	Tosca, La		Listed in Connorton's Directory 1898.
Wolfe & Conti	WOL	1946	Idea		
Wolff & O'Shlag, NYC.	WOS	1898	America's Emblem		Listed in Connorton's Directory 1898.
Wolffe./w. B. Tob. Co.	WLF	1936	Zed		By LEI.
Wolkind, R., Buffalo, NY.	WKD	1898	American Belles	F65-2NY	Listed in Connorton's Directory 1898.
Woodbury, E. F., Portland, ME.	WOD	1898	Russell		Listed in Connorton's Directory 1898.
Wooten, F. W.	WOO	1904	Wooten's		Early month-flavored brand.
Worcester Cigar Co., MA.	WRC	1898	John L.		Listed in Connorton's Directory 1898.
Worch, Albert	WCH	1921	Justrite		
World International Tob. Corp., VA.	WOR	1990	Four Kings	TP-14-VA	Also TP-22-VA, By SAR.
World Tabac Ltd. KY.	WTB	1963	HP Milds	C-10-KY	Previously TBC.
Worldwide Tobacco Inc., USA	WTI	1997	James	TP-22-VA	(Export), by SAR.
Wortheimer Co., The, CA.	WTH	1898	Double Up		Listed in Connorton's Directory 1898.
Wright, Allen H. (OH)	WRI	1926	Cigettes		
Yahn & McDonnell, PA.	YAH	1957	Yahn & McDonnell	F65-2NY	By LEI.
Yerby, G. W., Brooklyn, NY.	YER	1898	Cotton Belt		Listed in Connorton's Directory 1898.
Yorke Drug Co.	YOR	1938	Marshall's Cubeb		
Yorkshire Drug Co., NYC.	YRK	1932	Golden Gift	F916-2NY	
Your Name Cig., Chicago, IL.	YNC	1951	Merry Christmas		By GAG.
Yow Yow Cigar Co., Dayton, OH.	YOW	1898	Yow Yow		Listed in Connorton's Directory 1898.
Zachos, S. G.	ZAC	1925	Pantheon		
Zafiris, A. & Co.	ZAF	1910	Adonis		
Zaphirio, A. & Co., Chicago, IL.	ZAP	1912	Zaphirio	F355-1NY	Also F360-IL.
Zariffe Cig. Co.	ZAR	1910	Zariffe	F44-2NY	
Zeeman, Isidor I.	ZEE	1931	Tel Aviv		
Zehn, Wm., Brooklyn, NY.	ZEH	1898	True Flag		Listed in Connorton's Directory 1898.
Zeiter Tob. Co., Stockton, CA.	ZEI	1992	Union Club		
Zerbe, T. T. & Bros, PA.	ZER	1898	Liver Pills		Listed in Connorton's Directory 1898.
Zesery & Triandafillou	ZET		Bridge Puffs		
Zimmerman, Harris, NYC.	ZIM	1898	The Sea		Listed in Connorton's Directory 1898.
Zippy/Food Bag Markets, PA.	ZIP	1984	Zippy/Food Bag	TP-2442-PA	By GOR.
Zufedi, A. Cig. Co.	ZUF	1895	Zufedi	F562-3NY	See also Theo Photiades (PHO).
Zunder, M. & Sons, CT.	ZUN	1898	Old Pop Smith		Listed in Connorton's Directory 1898.

Appendix B:
CIGARETTE MERCHANT CODE

This is an alphabetical listing of the three-letter cigarette merchant's code for identification of the merchants or makers listed in the brand name or factory number listing. The first column is the three letter code and the second column is the merchant.

Appendix B:
CIGARETTE MERCHANT CODE

ID	CIGARETTE MERCHANT
ABC	Allison Brothers Co., Rochester, NY
ABD	Abdulla and Company
ABR	Abramowitz, Jos., New York City
ACC	American Cigarette & Cigar Co., Inc.
ACG	American Cigar Company
ACI	Alternative Cigarettes, Inc., Buffalo, NY
ACK	Acker Merrall & Condit, NYC
ACM	Alliance Cigareet Mfg. Co., NYC
ACN	A.C.I., NYC
ACO	American Leisure Concepts
ACR	Aschner's A., Sons, Brooklyn, NY
ADA	Adams, F.F. & C.
ADC	Advertising Cigarette Distributors
ADP	Adams-Powell
ADR	Adriatic Group
ADT	Advanced Tobacco Products, TX
AEC	Anglo-Egyptian Cig. & Tob. Co., NYC
AEO	Aldeo, Domingo, NYC
AFS	Abraham, F. & Sons, Boston, MA.
AFT	Axton-Fisher Tob. Co., KY
AHL	Ash, Louis, NYC
AHR	Ahrens, M.J., & Co., NYC
ALA	All American Brands
ALB	Albertsons, Inc. Boise, ID
ALC	Alliance Cigar Mfg. Co., NYC
ALD	Allen & Dunning
ALE	Alexiou, John, Wilkes Barre, PA
ALG	Alletn & Ginter Tob. Co., VA & NYC
ALI	Alliance Tobacco Company, NYC
ALL	Allen & Co., NYC
ALM	Allen & Marshall, Philadelphia, PA
ALO	Allones, R. & Havana Cig. Co., LA
ALP	Alpha Beta Co., CA
ALR	Albrecht, Otto & Co., IA
ALS	Alsfelder, Fred, OH.
ALT	Allen, J.F. Co., VA
ALV	Alvarez, Oscar Augusto Leon
ALX	Alexandre, S.
ALZ	Alzanne Cigarette Company
AMB	American Brands
AMC	American Cigarette Company, NC
AME	Ambassador East
AMN	American News Co., NYC
AMR	Amster, Max
AMS	American Store
AMT	Amster, Henry, OH
ANA	Anagnosti, Willy
ANC	Antonio Company
AND	Andron, G.A., & Co., Inc., NYC
ANM	Andremi, M.A.
ANR	Anargyros, S. & Company, NYC & CA
ANS	Ansor Corporation
ANT	Antoniedes Cigarette Company, NYC & CA
APH	Appleby & Helme, NYC
APO	Apostolides, A., NYC
ARA	Arabesca Cigarette Company
ARB	Arabian Nights Cigarette Co., Inc.
ARI	Aristypho, T., Co.
ARM	Armond Company
ARN	Arndt, M.B.
ART	Ararat Tobacco Company, MI

ID	CIGARETTE MERCHANT
ARZ	Arzt, Simon, NY
ASB	American Stores Buying Co., UT
ASC	Ascot Tobacco Works, Ltd., NY
ASH	Asheville Tobacco Works & Cig. Co.
ASL	Asian Brothers, PA
AST	Armstrong Brothers, NYC
ASU	Ash, Louis & Co., MO
ASW	Associated Wholesale Grocers, Inc., KS
ATC	American Tobacco Co. (See also ATD)
ATD	American Tobacco Co. (See also ATC)
ATE	Ateshian Cigarette & Tob. Co., IL
ATG	ATG, Inc. VA
ATH	Athos Tobacco Company
ATL	Atlantic City Cigarette, Inc. PA
ATP	Allied Tobacco Products
ATW	Ashville Tobacco Works, NC
ATZ	Artzt, Richard PA
AUL	Auld, C.C.
AUN	Austin, Nichols & Co., NYC
AUO	Autograph Cigarette Co., NYC
AUT	Autolite Mfg. Co., NJ
BAA	Bovee & Adams, LA
BAB	Batt Brothers Tobacco Co., NYC
BAC	Baron & Company, MD
BAD	Badger State Tobacco Works
BAG	Bagley, John, J. & Company, MI
BAI	Bailey Brothers, Inc.
BAJ	Bates, Jacob, NYC
BAM	Baum, Edward Company, MA
BAN	Barington Tobacco Company
BAR	Barkmahn Company
BAT	British American Tobacco Company, Ltd.
BAU	Bauer, J.
BAW	Brown & Williamson Tob. Corp., KY
BAY	Bayler, Chas. A., PA
BBE	Baron, Benj., NY
BBJ	Barbour, James L. & Sons, DC
BBR	Baron Brothers
BCA	Bankers Club of America
BCB	Bucher & Bucher Co., OH
BCH	Buchner, D., & Co., NYC
BCK	Beck, W.M., VA
BDN	Budner, Louis, NY
BDZ	Bandenz, H., SC
BEA	Ben-Asher Company
BEC	Benicia Company
BED	Bedrossian Brothers
BEE	Beechwald Brothers, LA
BEH	Benson & Hedges Tobacco Co., NYC
BEK	Berkman, Coe & Levin, NYC
BEL	Beleske, J.
BEM	Beerman & Company, GA
BEN	Benaderet, S., Inc.
BER	Berberian Brothers, MA.
BES	Bensen International, CA.
BET	Bethke, H.R.
BEV	Bevan & Company, W.V.
BEW	Below, S.S., MA.
BEY	Bentley, C.E.
BGD	Bing, D., NYC.
BGH	Banghart Brothers & Co. IL

ID	CIGARETTE MERCHANT
BIL	Billups Oil Company
BKC	Bock & Company, NYC.
BKE	Becker, Chas. R., MD.
BKR	Booker Tobacco Durham
BLA	Blackwell's Durham Tob.Co., NC.
BLB	Blumenberg, Simon, NYC.
BLC	Blackwell & Company, NC.
BLD	Black Death, U.S.A., CA.
BLE	Billor,S., NYC
BLF	Belfield & Brooks, PA
BLK	Blue Knight Enterprises
BLL	Brilles, M. & Company, PA.
BLM	Blossom Marketers
BLN	Blue Network Breakfast Club
BLO	Bloch Brothers Tobacco Company
BLP	Blue Peter Cigarette Company, NYC
BLR	Blaser, Ike
BLS	Blosser Company
BLT	Black Tobacco Company, FL.
BLY	Blakely, Jouh, Segarett Co., NYC
BMB	Bamberg, H., SC.
BML	Bromail & Wogan, PA.
BNB	Bendheim Brothers and Company, NYC.
BND	Bonded Tobacco Company
BNN	Braunman, robert, NJ.
BNT	Bennett Tobacco Company
BOC	Bock y Ca
BOE	Boesger, H.A. OH.
BOG	Bogulslavsky, T.
BOH	Bohls, H. & Co., Tobacco Works, CA.
BOK	Bock & Stauffer
BOL	Bollman, John & Company, CA.
BON	Bonell
BOO	Bonded Oil Company
BOQ	Bouquet-Cohen Company
BOR	Borowsky, J.W.
BOT	Booker, W.L. Cigar Company
BOU	Boultbee & Colby
BOW	Bowie & Wilson, VA.
BOY	Boyee, Joseph P., Cigar Co., MA.
BPI	Bantob Products, Inc.
BRA	Brand Marketing Company, OR., CA.
BRB	Brown Brothers Company, NC.
BRC	Barlow, Rogers & Company, NY.
BRD	Billor, David, NYC.
BRE	Brennig's Own, Inc. NYC.
BRG	Berg, Isadore, NYC.
BRI	Briki Tobacco Company
BRK	Borsook, Mary, NY.
BRL	Bravo Labs, Ltd.
BRM	Brama Trading Corporation, NYC.
BRN	Brown and Ackerman
BRO	Brooks, T.E.
BRR	Brewer, Clark & Sons
BRS	Brewster, H.P, NY.
BRT	Brothers Tobacco Company
BRV	Bravo Smokes, Inc., TX.
BRW	Broadway Drugs
BRX	Brand X Enterprises
BRY	Bryden, Geo. A., NYC.
BRZ	Bruzard & Kohlman, NYC.

ID	CIGARETTE MERCHANT
BSH	Biershatsky, B., NYC.
BSN	Barson, A.N.
BSS	Bissell, J.M., CN.
BST	Bluestein, Tobias, Inc., IL.
BTC	Bartec Corporation
BTH	Bateholder Brothers, PA.
BUB	Butler-Butler, NYC.
BUD	Bud Cigarette Company, Inc., NYC.
BUL	Buchanan & Lyall, NY.
BUM	Burton-Marshall
BUN	Brun, Adrian
BUR	Burton, Edward
BUS	Busnitz, S., & Company, VA.
BUT	Butler, Wm.&.
BUZ	Buznitz, S.
BWS	Breitweiser, H. & J. Tob. Manufacturers
BYE	Byedavco, inc. DC.
CAB	Camber-Turkish Tobacco Company
CAD	C.A.D.O. Company
CAH	Henry, Carl
CAH	Carl Henry, Inc., NYC.
CAL	California Tobacco Company
CAM	Cameron & Cameron
CAN	Cannon & Waller, Inc. OH.
CAP	Capital Drug Company, Inc. ME.
CAR	Careso, M.
CAS	Caeron & Sizer
CBA	Cocabacco Tobacco Co., MO.
CBC	Cable Bellpurch
CBI	Commonwealth Brands, Inc. KY, NC.
CBL	Campbell, Geo., & Company, VA.
CBS	Coluna Brothers & Company, NYC.
CBY	Choice Tobacco, Inc.
CCC	Consolidated Cigar Co. or Tob. Co.
CCG	Consolidated Cigarette Company, NY.
CCI	Continental Concepts, Inc., GA.
CCL	Charlie's Cigarette Land, NC.
CCO	Carolina Cigaret Company, Inc., NC.
CDA	Consolidated Assets
CDC	Cornell Drug Corporation
CDE	C.D.E, Inc., OH.
CDG	Cambridge Tobacco Company, NYC
CDR	Consolidated Cigar Company, VA.
CDX	Condax, E.A. & Company, Inc.
CEN	Central Tobacco Company, NY.
CER	Certified Grocers of Florida, FL.
CFI	Compass Foods, Inc. NJ.
CGC	Canton cigar Company, PA.
CGH	Creagh, John B. PA.
CHA	Chalkiadi, Inc.
CHD	Christian Dior
CHE	Chesterfield Cigarette Company, NC.
CHL	Challenger Industries, Ltd., NJ.
CHM	Chemex Corporation
CHN	Cherokee Nation, Incorporated
CHP	Chaparral Tobacco Co., Inc. PA.
CHR	Christian Peper Tobacco Company
CHS	Coh, S., IL.
CHT	Chaparral Tobacco Company, CA.
CHU	Churchill Tobacco Company
CIC	Camp Importation, Company, NYC.

ID	CIGARETTE MERCHANT
CLC	Carlen Tobacco Company, NYC.
CLG	Carroll & Greenstone, VA.
CLI	Club Imports, Incorporated
CLL	Carroll, William S., VA.
CLM	Columbus, F., Cigar Company
CLN	Collins, J.W. & Company, VA.
CLO	Clover Tobacco Company
CLR	Clerke & Company, MA.
CLS	Collins Cigar Company, PA.
CLT	Club 45 Tobacco Company, NYC.
CLX	Calixto Lopez Company
CMB	Cambyses Company, The
CMI	Compania Industrial
CMM	Cohn, M. & M., NYC.
CMP	CM Products, Inc., CA.
CNC	Continental Cigar Company
CND	Conrad & Lander, CA.
CNN	Cunningham, Blake & Company, PA.
CNR	Connor, W. Y., PA.
CNS	Continental Tobacco Co. of South Carolina
CNT	Continental Tobacco Company, Inc., NC.
CNW	Continental Tobacco Co. of West Virginia
COA	Coast Tobacco Company
COB	Continental Bristol Corporation
COC	Cocktail Hour Cigarette Company
COG	Congress Cigar Company
COH	Cohn, M.L. & Company, IL.
COJ	Cohan, Joseph, NYC.
COL	Colonial Tobacco Company
COM	Commercial Tobacco Corporation, CA.
CON	Condossis, A.D.
COO	Coon, Abraham, NY., or CN.
COP	Contopoulo Brothers
COR	Cork Tip Cigarette Company, NYC.
COS	Connoisseur Tobacco Company
COT	Constantine Tobacco Company
COU	Columbia Tobacco Company, NYC.
COV	Convenient Food Mart, Inc. IL.
COW	Cowie & Company, Ld.
CPC	Cigarette Pck Collector's Assn. MA.
CPS	Campus, Cesare
CPT	Cosmopolitan Tobacco Company, MA.
CRC	Crimson Coach, Inc.
CRD	Conrad, Frank C.
CRE	Crescent Tobacco Company, NYC.
CRG	Creigh, Gudknecht & Company, PA.
CRL	Charcial Corporation
CRM	Core-Mark Import/Export, CA
CRN	Cameron, A. & G.
CRO	Crouse Y Company, PA
CPR	Carrera Limited, England
CRT	Court Cigarette Company, The
CRY	Carsey-McEwen Tobacco Company, TN
CST	Creston Cigar Company, OH
CTC	Consolidated Cigar Company, NYC
CTD	Courtinade, F. NYC
CTH	Costello & Hamilton, NY.
CTK	Costakis & Heliotis & Company
CTM	Coutoumanos Brothers, IL.
CTY	Castritsky, Geo, P.

ID	CIGARETTE MERCHANT
CUC	Commercial Union Cigar & Cigarette Co.
CUE	Currie Tobacco Company, KY.
CUI	Coulapides, A., Inc.
CUL	Cullivan, Thoas. NY.
CUR	Curtis, harry A.
CUS	Customer Company, The, CA.
CWD	C.W. Distributors, IA.
DAB	Dabs Cigarette Company
DAC	Detroit Athletic Club, MI.
DAH	Darragh, J.G.
DAK	Drake, A.S. NY.
DAL	Dallas Cigarette Company, Inc. TX.
DAN	Danville Cigarette Company, The, VA.
DAV	Dave's Tobacco Company, NC.
DAW	Dawn Cigarettes, Inc.
DEG	Dengler, J.R.
DEL	Delux Tobacco Company, OH.
DEM	Double E.M. Company, GA.
DEN	Denobili Cigar Company, RI.
DEO	Dellaneo Cigar Company, NYC.
DEP	Deplis, F.A.
DER	Derring, Ellis, Company, NYC.
DEU	Deutsch Brothers & Graham. NYC.
DFS	DFS North America, Division of DFS Grp.
DIB	Dtbrill & Company, VA.
DIC	Dakota Indian Casino
DIE	Diesel, Henry & Company, OH.
DIL	Dill, J.G.
DKE	Duke Company, The
DLG	Garlington & Company, NYC.
DLM	Doelman, L. & Company, NY.
DLT	Dalton, M.J. PA.
DLW	Dilworth Cigar Company, PA.
DMS	D.M.S., Inc., NY.
DMZ	Dominguez Brothers, PA.
DNF	Dingfelder & Libko, NYC.
DNG	Dingman, Henry C., NYC.
DNN	Dunn, T. J. & Company, PA.
DNS	Dunnsboro Tobacco Company
DOC	Dock, Mortimer Russell
DOE	Doebelo, F.A., OH.
DOM	Dosal & Mendez Tobacco Corporation, FL.
DON	Donohue, T.N.
DOS	Dosal Tobacco Corporation, FL.
DOU	Douglas, G. Nelson
DRC	Dream Castle Tobacco Company, CA.
DRE	Dressner, D., NYC.
DRK	Drinkhouse, J. Commpany, CA.
DRL	Drucklieb Brothers
DRQ	Drucuer & Sons, Ltd. Ca.
DRU	Drummond Tobacco Company, MO.
DRY	Dreyfus Brothers, AL.
DTW	Dominion Tobacco Works
DUB	Dubec Ltd.
DUC	Duckworth Enterprises
DUD	Dudley Cheroot & Cigar Company, VA.
DUH	Dunhill, Ltd.
DUK	Duke, W. Sons & Company, NC.
DUL	Dunlop, David
DUN	Dunhill, Ltd.
DUP	Dupont, de Nemours & Company, DE.
DUR	Durham Tobacco Company, NC.
DUV	Duval Tobacco Company
DWD	Dowd, A.J. IL.
DYC	Dycyan & Company, MA.
EAC	Eastern Cooperative Wholesale, Inc.
EBC	English, Belcher & Company, VA.
ECC	Egyptian Cigarette Company, NYC.
ECK	Eckmeyer & Company, NYC.
ECT	Eastern Cigarette & Tobacco Company
ECW	Eastern Cooperative Wholesale League
EDC	Empire Distributing Company, OH.
EGC	Egyptian Crown Cigarette Company, KY.
EGD	Egyptian Deputies Cigarette Company, MA.
EGH	Egyptian Heros Cigarette Company
EGY	Egyptian Ideal Cigarette & Tobacco Works
EHR	Ehrlich, D.P, MA.
EIT	Eitel & Gas, KY.
ELC	Ellis, H. & Company, MD.
ELI	Eliot, H. Clay, NYC.
ELL	Elliott, Charles K.
ELM	Elmira Tobacco Company
ELN	Ellinger, Julius & Company, NYC.
ELP	El Paso Cigar Mfg. Company, TX.
ELR	Elmer, R. Company, NYC.
ELT	Elliott, Richard, MA.
ENB	Engelberg, A., NYC.
ENG	Englehardt, Leopold
EPM	Epstein, Morris, NY.
EPS	Epstein, J., Brothers, NYC.
EQU	Equity Cigar Company, OH.
ERB	Erb Tobacco Products
ESC	Escobal
ESH	Eshrelby, E.C. Tobacco Company
ESP	Esposito, J.G.
ESS	Ess En Cee Company, Inc.
EST	Estabrook & Eaton Company
ETC	Egyptian Tobacco Co. of America, NYC.
ETT	Ettinger & Wilson
EUR	Eureka Tobacco Company
EVE	Eve Holdings, Inc.
EVN	Evans, I.W.
EVR	Eversfield, J.C. & Company, MD.
EVT	Everette, John, PA>
EWD	Economy Wholesale Distributor, Inc., FL.
EWM	East/West Marketing Company
EXO	Exotic Tobacco Company, UT.
EXT	Export Tobacco Company
FAI	Fairfax Tobacco Company
FAL	Falk Tobacco Company, NYC. and VA.
FAM	Familiar Herb Company
FAT	Fifth Avenue Tobacco Company
FCC	First Cigarette Company, The, MA.
FACG	Faber, Coe & Gregg, NYC. and IL.
FCH	Fuchs, G. & Company, PA.
FCM	Farmer's Co-op Manufacturing Group
FCO	First Consul Cigarett Company, NYC.
FCR	Faber coe & Gregg, Inc., NJ.
FCT	Federal Cigarette & Tobacco Co. NYC.
FDC	Florida Division of Corrections Industries
FDL	F & L Products
FDM	Frank, D.M. & Company, NYC.
FDP	F&D Products, CA.
FEC	Famous Egyptian Cigarette Company
FED	Feder Brothers, OH.
FEE	Frey, E., NYC.
FEF	Feifer & Company, NYC.
FEI	Feinberg, Chas. L., NY.
FEL	Felgner, F.W. & Son, MD.
FEM	Federal Mining & Mfg. Company
FEN	Fendrich, H., IN.
FER	Fernandez, S. & Company
FEZ	Fezzan, T. & Company
FHL	Fuchs, Louis, NYC.
FID	Fidell, B.
FIK	Finkelstein, L.
FIL	Filter Cigarette Corporation, NYC.
FIS	Fischedick, H.F.
FIZ	Fitzpatrick & Draper, NY.
FLA	Flagg, John E, NYC.
FLC	Flinchbang, S.S., PA.
FLD	Field, Alexander Cigarette Co., Inc., NC.
FLH	Flemming-Hall Tobacco Company, NYC.
FLI	Flicker Company, The
FLM	Feldman, Abe. J., PA.
FLN	Flalaner, G.F, NYC.
FLO	Flora Tobacco Company, NYC.
FLS	Fairlawn Stores
FMA	Fmali Herb Company, CA.
FMI	FMA International Sales & Service, NC.
FMN	Freeman Brothers & Company, MD.
FNA	First Nation, Indian Reservation
FNH	Frank, Herman, PA.
FNK	Frankson, Adolph & Company
FQH	Fox, H. Newton & Company, PA.
FOL	Follard & Stephens
FOO	Foods, Inc. CA.
FOR	Forsyth Tobacco Products, NC.
FOS	Foster Hood and Company
FOT	Fortune Tobacco Company
FOX	Fox & Company, MD.
FPI	Federal Prison Industries
FRA	Frank, Wally Company
FRE	French Tobacco Company
FRH	French Tobaccos, Inc.
FRK	Franklin, H.O., & Company
FRN	Frank, Daniel & Company
FRO	Frohman, S. & Company, CA.
FRP	Freeport Cigar Company, IL.
FRS	Fritsch & Sons
FRU	Frankau, A.
FRY	Frey, L.C. & Company, OH.
FSC	Fischer, Max, PA.
FSH	Fisher, L. Harry, NYC.
FSJ	Fletcher, S.J.
FSM	Foster, M. & Company, NYC.
FTZ	Fitzgerald, John J.
FUH	Fuchs, G., IL.
FUR	Furstenberg, A., NYC.
FVB	Famous Value Brands, VA.
GAB	G.&B. Tobacco Company, Inc., TN.
GAG	Georgopulo, G.A. & Company, NYC.
GAL	Galba Cigarette Company
GAP	Great Atlantic & Pacific Tea Co., NJ.
GAP	A and P
GAR	Gary Tobacco Company
GAT	Gatlinburlier Tobacco Company, TN.
FAX	Gail, G.W. & Ax Tobacco Company
FCC	General Cigar Company
GDM	Goodman, R. & Sons Company, MD.
GDN	Gordon, Willis P., MA.
GEL	Gelman
GEN	Genco Marketing Company, NE.
GGF	Gail, G.F Company, IL.
GHI	Global Holding Inc., NJ.
GIA	Gianaclis, Nestor Company
GIC	Grand Island Cigar Mfg. Company, NE.
GIL	Gialanella, Cesare Distributors
GIM	Gilmore, Francis T.
GIN	Ginter, Lewis
GLA	Gladstone Tobacco Company
GLC	Gold Leaf Cigarette & Tobacco
GLE	Glencourt, Inc., CA.
GLF	Golf Cigarette Company
GLM	Glas M. & Company, OH.
GLN	Glenn, W. B.
GLO	Globe Tobacco Company, MI
GLS	Glasser Brothers, CA.
GLT	Golden Leaf Tobacco Company
GMM	Gilman & Morrison, OH.
GMN	Grossman, M., NYC.
GNK	Giannakis Cigar Company, IL.
GNO	Genio Market
GNS	Genesee Tobacco Works, NY.
GOC	Goodman Company
GOD	Goldman, H., NYC.
GOJ	Good & Johnson
GOL	Golden West Tobacco Company
GOM	Gomler, Willis P., MA.
GON	Gonzalez, Diaz
GOO	Goodwin, & Company
GOP	Gordon, Powhatan G., NYC.
GOR	Gordon, Robert A. Company, PA.
GOU	Goulston Jr., E.S., MA.
GPA	Generic Products Associates, MO.
GPA	GPA Incorporated, MO.
GPC	Generick Products Corporation, TX.
GRD	Gordon, Jacob
GRH	Goodrich, A.L., NY.
GRJ	Gredjinski, J.J., MA.
GRS	Greenstone, S.F., VA.
GRT	Green River Tobacco Company, KY.
GRU	Gershuny, N. & Company, NYC.
GRY	Gray, Arthur. NYC.
GSN	Gnosin, Vladimus F.
GSR	Gensior, A., NYC.
GTC	General Tobacco Company, IL. or KY.
GTH	G.T.H., Inc., NJ.
GTT	Guttermann, Solomon, NYC.
GUA	Guardian Tobacco Company, NYC.
GUC	Grand Union Company, The, NJ.
GUI	Guild, J.H. Company, Inc., VT.
GUM	Gumpert Brothers, PA.
GUN	Gunst, M.A. & Company, CA.
GVT	Greenwich Village Tobacco, NY.
GWD	Greenwald, M., NYC.
HAA	Haan, R.M., NYC.
HAC	Hack, Francis G.
HAD	Hadad, Alexander, NYC.
HAF	Hargraft & Sons, IL.
HAG	Harkert :& Goos, IA.
HAL	Hall's Sons, Thomas A., NYC.
HAM	Hamburger, Streng, & Company, OH.
HAP	Hall & Pierce, NY.
HAR	Hartford Project
HAS	Hasker & Marguse Manufacturing Co.
HAU	Hausman, Edward C.
HAV	Harvey's, Inc.
HCH	Hirsch, M. NY.
HCR	Heckler Tobacco Company
HDD	Haddad Brothers, NYC.
HDG	Hudgins, Joseph, NC.
HEA	Health Cigar Company, Inc.
HED	Heckler Tobacco Company
HEE	Heegaard, W.H. & Company, IL.
HEG	Helme, Geo. W. Company, NJ.
HEI	Heintzel, R.S. Manufacturing
HEL	Helme, George W. NYC.
HEM	Hemboldt, A. & M.
HEP	Helme Products, Company
HER	Herlan, NYC.
HES	Hernsheim, S. Brothers & Company, LA.
HET	Hetzel's, Inc.
HFR	Hofritz, Chas, OH.
HFT	Hefter, L., NYC.
HGH	Highlands, W.R. Ltd., NV.
HHH	Herschorn, Mack & Company, NYC.
HIC	Hickey Brothers, Inc.
HIG	Higginson, B.M., Inc., NY.
HIL	Hilton, T.H.
HIM	Himrod Manufacturing Company, NJ.
HIN	Hines, Norman
HIR	Hirsch, Ferdinand, NY.
HIT	Heitmann Brothers, OH.
HLB	Hill Brothers, NY.
HLL	Hiller, R.J., PA.
HLM	Helme Tobacco Company
HLN	Hilson Company, NYC.
HLS	Holis, M.G.
HMH	H.M.H. Publishing
HNK	Honkomp & Schmidt, MO.
HNM	Heinemann Brothers, MD.
HNN	Hontain, William E., & Company, NY.
HNS	Hines, W.F., KY.
HOB	Hoormoozi Brothers, NYC.
HOC	House of Cartier
HOE	House of Edgeworth
HOF	Hoffman, E. Company, IL.
HOG	Hogden, William and Company, NY.
HOL	Holbrook, S.G.
HON	Horner, James E., NYC.
HOO	Hood, Foster and Company
HOR	Horenstein, J.
HOS	Hood, S. & Company, NYC.
HOU	Houtain, William E. & Company, NY.
HOV	House of Vegas, Inc., VA.
HOW	Howe, Thad. H. IL.
HOZ	Horwitz, F., & Company, MD.
HPN	Hupman, J.
HPW	H.P.W. Cigarette Company
HPZ	Huperz, A.A., MI.
HRB	Herbst, C.S., Imp. Company, WI.
HRE	Heere, George E., PA.
HRP	Hartford Project, The
HRS	Harralson, Ed., GA.
HRT	Heartland Tobacco Company, KY.
HSL	Hosselman & Orto, OH.
HSN	Hansen, Julius G., PA.
HSS	Hess, S.F. & Company, NY.
HSY	Hersey, A. & Brothers, PA.
HTH	Hartman, T.H. PA.
HTM	Hartman, O.R.
HIT	Hetterman Brothers Company, KY.
HYT	Hathaway, E.A., NY.
HUD	Hudnell, Armstead B.
HUG	Hughes, Lloyd F.
HUL	Huddle, Ogden
HUP	Huston, Tom Peanut Company, OH.
HUS	Hussey Leaf Tobacco Company
HUW	Hurwitz, M., NYC.
HVC	Havana Cigar Company, TX.
HVL	Hovell, Chonpontian & Company, NYC.
HVN	Hooven, Mercantile Company, NYC.
HVY	Havemeyer, E. NY.
HYN	Hyniman, Thomas, M., NYC.
IAF	Inter-American Food, Inc., OH.
IBI	International Brands, Inc., CA.
IBS	Ibis Export Import Corporation, NYC.
ICC	Imperial Tobacco Cigarette Company, NYC.
ICT	Imperial Cigarette & Tob. Co., PA.
IDC	Illiniois Division of Correction
IDM	Ideal Marketing, PA.
IGA	Independent Grocers Alliance (I.G.A.)
IIE	Ilie, S.F. Company
IMC	International Minerals & Chemical Corp.
IMH	Imhoff, H.E., NY.
IMP	Imperial Tobacco Company
IMT	Imported Tobacco Manufacturing Co., NYC.
INC	International Cooperation Group, VA.
INE	International Enterprises
IRB	Irby, W.R. Cigar & Tobacco Co., LA.

166

ID	CIGARETTE MERCHANT
PBC	Pent Brothers, & Coleman, PA.
PBT	Patterson Brothers Tobacco Co., VA.
PCC	Piccadilly Cigarette Company (1890)
PCE	Pace, R.J., Tobacco Company, VA.
PCH	Pacholder, M.S., MD.
PCK	Pollacek, Charles, NYC.
PCM	Paper Cigarette Makers' Union, NYC.
PCN	Ponlides, C.N., NYC.
PDS	Peoples Drug Stores
PEA	Peace Tobacco Company
PEB	Penn Brothers
PEE	Peerless Tobacco Works
PEK	Peck, William, VT.
PEN	Penn Tobacco Company
PER	Perkins, Charles B. & Company, MA.
PET	Peterson Tobacco Corporation, NYC.
PEY	Peyser, Charles, NYC.
PFA	Pfaltzgraff, J.K. & Company, PA.
PFE	Pfeiffer, Charles
PFF	Pfaff, H.C., MD.
PGN	Paragon Cigar Mfg. Company, PA.
PGT	Pagter, Samual, CN.
PHI	Phillipine Tobacco Company
PHK	Phillips & King Cigar Company, CA.
PHL	Phillips, G., NYC.
PHO	Photiades, Theo Company
PIC	Piccadilly Tobacco Company, Inc.
PID	Premier International Distributing Co., MN.
PIE	Pierce, S.S. Company, MA.
PIL	Pilkerton, E.T.
PIN	Pinkerton Tobacco Company
PIT	Pinecrest Tobacco Company, CA.
PJS	Penn Janitor Supply Company, PA.
PKF	Pang, K.F. Company, NYC.
PKH	Pinkussohn, J.S. Cigarette Company, GA.
PKI	Pinki Brothers
PKN	Pilkinton, E.T., Company, VA.
PKS	Pinkus, Flora W.
PLA	Plantation Tobacco Company
PLE	Pledge Sales Company
PNC	Pinecrest, CA.
PLK	Pollak, NYC.
PLL	Phillipson, L., TX.
PLR	Plat, Rud, WI.
PLS	Palestine Tobacco Corporation
PLT	Palestine Cigarette & Tobacco Company
PLU	Palumbos Lithography & Printery, NY.
PLY	Player, John & Sons, Ltd.
PMA	Peer Marketing Associates, NJ.
PMC	Philip Morris & Company, VA.
PME	Pall Mall Electric Association
PNC	Pinecrest, CA.
PNK	Pinkus Brothers, NYC.
PNM	Pan-American Tobacco Company, Inc.
PNS	Pennsylvania Tobacco Company
PNT	Penn, F.R. Tobacco Company
POC	Ponderosa Tobacco Company, CA.
POG	Pogue, W.J., TN.
POL	Pohalski, P., NYC.
POP	Product Opinion Laboratory, VA.
POR	Porto Rican American Tobacco Co., PR.
POS	Postal Cigar Company, OH.
POU	Poulides Brothers Tobacco Co., NYC.
POY	Poynter Products
PPP	Pappas Tobacco Mfg. Company, NYC.
PRA	Pera Cigarette Company
PRC	Pierce, W.B.
PRD	Paredes, Juan Santalla
PRE	Preferred Havana Tobacco Company
PRG	Prager, M.W., NYC.
PRI	Price Cigarette Company, OH.
PRK	Perkins, George B., MA.

ID	CIGARETTE MERCHANT
PRS	Patterson, W.E., NC.
PRU	Prudential Tobacco Company
PSF	Pinkus, Fred M., NC.
PST	Pappastratos, Greece
PTB	People's Tobacco Company, LA.
PTC	Pacific Tobacco Company, OR.
PTK	Pritkin Brothers, IL.
PTO	Prieto, Manuel, NYC.
PTT	Plunkett, T.J., NYC.
PTY	Pantry, Inc, The, NC.
PUA	Pura Smoke Company, Inc.
PUE	Puerto Rico Tobacco Corp., PR.
PUL	Poulo
PUR	Purchik
QUI	Quintin & Company, Inc., CA.
RAA	R and A Adventures, NY.
RAG	Ragland, J.B. & Company, VA.
RAN	Randall-Landfield
RAP	Rapoval Tobacco Company, NYC.
RAR	Raporel Tobacco Company, NYC.
RAS	R & S Cigar Company
RAY	Ray D'Or Tobacco Company, NYC.
RBC	Robinson's California
RBF	Roth, Bruner & Feist, OH.
RBL	Rosenblum Brothers, NYC.
RBN	Robinson, A.
RBR	Robertson-Nettles Tobacco Company
RBS	Roberts, J.W. & Sons
RCC	Royal Cigarette Company
RCH	Richardson, Jr., R.P. & Co., Inc., NC.
RCP	Royal Cigarette Corporation
RDD	Richardson, Denny & Company, NC.
RDM	Redmond Tobacco Company, NC.
RDZ	Radezky, E., NYC.
REC	Red Cross Tobacco Company, LA.
RED	Redezky
REE	Reed Tobacco Company, VA.
REH	Resch, N., NYC.
REM	Rembrandt Tobacco Company
REN	Rosen, M., NYC.
REQ	Requa Manufacturing Company, Inc., NY.
RES	Reseska, Helen Maria
RET	Retailers Cigarette Company
REX	Rex Cigarette Company, VA.
REY	Remer & Brothers, PA.
RGC	Ralph's Grocery Company, CA.
RHF	Richfood, Inc., VA.
RHN	Rothensels, I.D., NY.
RIC	Rich & Company
RIE	Rieders, M.H., NYC.
RIG	Riggio Tobacco Corporation, NYC.
RIN	Riggio Tobacco Corporation of NY, Ltd.
RIP	Rippen, H.
RIT	Ritz-Carleton
RJR	R.J. Reynolds Tobacco Company, NC.
RLL	Rosell & Company, NYC.
RMB	Rush, M.B., NYC.
RMC	Richmond-Chevroot Company, The, VA.
RNM	Russian-American Tube Company
ROB	Robbins, Lee J.
ROD	Rodriguez, A., NYC.
ROE	Rosen Enterprises, Inc.
ROH	Rothchilds
ROM	Romanmoff Cigarette Company
ROS	Rose, D.E. & Company, NC.
ROT	Ross Tobacco Company, VA.
ROU	Roundup Groceries, OR.
ROV	Roever, A.T., OH.
RPH	Raphael Brothers, NYC.
RRD	Rack-Rite Distributors, PA.
RRJ	Roberts, R.J.

ID	CIGARETTE MERCHANT
RSB	Rosenberg, H., VA.
RSC	Rosenberg, Casper, NY.
RSD	Rosedor Cigarette Company, NY.
RSF	Rosenfeld, H. & Company, PA.
RSH	Rosenberg, H., PA.
RSI	Ross, G. Val, Inc., NV.
RSL	Rosenthal, S.M.
RSN	Robinson, Allan
RSR	Rossenheimer, A., CN.
RST	Rosenblatt, C.
RSW	Reynolds, S.W., PA.
RSY	Ramsey, John, NJ.
RTH	Rosenthal Brothers
RIT	Royal Turkish Tobacco Company
RTZ	Ritz Cigarette Corporation
RUH	Ruhe Brothers Company, PA.
RUL	Russell James B., Inc., NJ.
RUM	Rum & Maple Tobacco Corporation
RUN	Rum & Maple Cigarettes, Inc.
RUS	Russell, C.F., VA.
RUT	Russian Turkish Tobacco Company, NYC.
RWS	Rawson & Simpson Company, MA.
RYP	Royal Pearl Cigarette Company, NYC.
RYT	Royal Tobacco Corporation
RZH	Ritz Hotel Ltd.
SAC	Sackett, H.
SAD	Sadler, Mau. & Company, CA.
SAF	Safir Smokes
SAG	Sage Cigarettes
SAL	Salamandia, Tito
SAM	S&M Brands, Inc., VA.
SAN	Stapleton, M., NY.
SAR	Star Tobacco Corporation, VA.
SBG	Seidenberg, H., NY.
SBL	Smith & Bloodgood, DC
SCC	Standard Cigar & Cigarette Co., NYC.
SCD	Schmidt & Company
SCF	Schiffmann, R. & Company, CA.
SCH	Scheidnagel, S.B.
SCI	Sacconi, Speed, Ltd.
SCJ	Schwartz, Joseph, NYC.
SCK	Schenker, I.W., NYC.
SCM	Seneca & Mohawk Tobacco Company
SCN	Scotten, Daniel & Company, MI.
SCO	Scott Tobacco Company
SCR	Suares & Crispo
SCS	Schinasi Brothers, Inc., NYC.
SCT	Schulte
SCW	Schwartz, Peter Paul
SCZ	Schwartz, Hary B., PA.
SDL	Sidlsky, S., PA.
SDS	Seven Island Company
SEA	Steane, E.G. & Company, PA.
SEB	Seidenberg, R., NY.
SEC	Schendel, Charles & Company, NYC.
SEF	Seifert, Rudolf, IL.
SEI	Seidenberg, R.J. Company, NYC.
SEL	Select Marketing, VA.
SEM	Selim Milan
SEN	Sentinal Company
SER	Serailian, J.K.
SEV	Seven Island Company
SFL	Smoker Friendly, LLC
SFN	Santa Fe Natural Tobacco Co., NM.
SFS	Safeway Stores, Inc.
SFT	Scheffey, Lewis C. & Company, NYC.
SGC	Stone Hedge Corporation, NY.
SGL	Segal, I., NYC.
SGT	Starlight Brothers, NYC.
SHA	Spalding R.Z., NY.
SHC	Streng, Hamburger & Company, OH.

ID	CIGARETTE MERCHANT
SHD	Sherick, Daniel, NYC.
SHE	Sherman, Nat Company, NYC.
SHG	Shagreen Products
SHI	Shield, Inc., CA.
SHK	Shirk, Joseph G., PA.
SHL	Stahl, Jr., Jacob & Company, NYC.
SHM	Schein, M., NYC.
SHO	Shoemaker, N.C.
SHW	Schadow, Henry, NY.
SIE	Siegel, J.M. & D.
SIG	Sigmund Strauss
SIR	Silver Rod Sales Company
SKA	Sklamberg & Abramson, NYC.
SKI	Skillern & Sons, Inc., TX.
SKO	Smo-Ko Company, NYC., PA.
SKR	Stadeker, H.H., IL.
SKT	Strike Axe Trading Company, OK.
SLA	Slamey, Joseph A. & Company
SLD	Slade, Geo., F., MA.
SLE	Sole, Louis C. & Company, PA.
SLG	Silverburg, Charles, NYC.
SLM	Salmon Management
SLT	Schulte, NYC.
SLV	Silverstone Brothers, NYC.
SLZ	Slutzky, Isaac, NYC.
SMB	Shaw, Made By, CA.
SMH	Swinging Mothers, Inc., NYC.
SMI	Smith, Richard D.
SMJ	Smokin Joe's, NY.
SMK	Smith-Kirkpatrick & Company, NYC.
SMN	Silverman, Harris, NYC.
SMO	Smoke a Cola Cigarette Company
SMP	Simpson, Max
SMR	Simon-Riegel Cigar Company, NYC.
SMS	Smith, W.F. & Sons
SMT	Smith, C.R.
SNC	Schein's Cigar Factory, NYC.
SND	Scotten-Dillon Company, MI.
SNH	Stein, H., PA.
SNO	Snooty Cigarette Company
SNS	Stein, Samual, NYC.
SOB	Sterling Tobacco, MA.
SOD	Stoddard, L.L., CN.
SOM	Somborn, Morris, NYC.
SON	Semon, J.S., PA.
SOT	Soter, F.&E. Tobacco Corporation, NYC.
SOV	Soulbrands, Ltd.
SPA	Space, Inc.
SPC	Sullivan, Powell & Company, Ltd.
SPE	Superior Cigar Company, NY.
SPG	Sprague, Warner & Company, IL.
SPH	Stephen, W. & Son, PA.
SPO	Spiro, David Tobacco Company
SPR	Springfield Company
SPS	Speirs, Albert, IL.
SPU	Spud Cigarette Corporation, WV.
SQU	Squi, Sam
SRA	Stern, Arthur & Brothers, NY.
SRB	Surbug, John, Company
SRC	Shurfine Central Corporation, IL.
SRD	Stratford Cigarette Company
SRF	Shop Rite Food Stores, Wakefern Food
SRG	Stachelberg, M., NYC.
SRN	Stern, Jean, & Company, NYC.
SRO	Sears, Roebuck & Company
SRR	Starr & Reed, PA.
SRS	Sarna's Superette, MN.
SRT	Strand Tobacco Company
SRZ	Spaulding R.Z., NY.
SSC	Star Service Company
SSO	Sasso, E, De

ID	CIGARETTE MERCHANT
SSS	Simpson, Studwell & Swick, NYC.
SST	States Tobacco Company, VA.
SSW	Spier, Swan & Company
STA	Standard Tobacco Company, VA.
STB	Southern Tobacco Products Co., GA.
STC	Special Tobacco Company, NYC.
STD	Standard Export Cigarette Company
STE	Stade, Amos, Lowell, MA.
STF	Stanley Freres, IL.
STG	Straus, G, NYC.
STH	Smith, Thorndike & Brown Co., WI.
STI	Stickney, W.A. Cigarette Company
STJ	St. John W.W. Company
STK	Stockkebye, Peter International, Inc.
STL	Stein & Lethman, NYC.
STM	Stamaloglas, S.E., NYC.
STN	Sternbaum's Food Marts, Inc.
STO	Stowecroft Brook Distributors, MA.
STP	Stephano Brothers
STR	Sterling Tobacco Company, NYC.
STS	Straus Brothers & Company, OH.
STT	Star Thompson Tobacco Company, FL.
STU	Steuben Cigarette Company
STV	Statesville Tobacco Works, NC.
STW	Sheffield Tobacco Works
STY	Stuyvesant, Peter of N.Y., Inc.
SUB	Superior Brokerage
SUC	Sun Cigarette Company, NYC.
SUL	Sultan-Flore Tobacco Company
SUM	Supermarket General Corporation, NJ.
SUN	Sunfresh, Inc., MN.
SUP	Superiot Products Company
SUR	Superior Tobacco Company, Inc.
SUS	Sussman, D., NYC.
SUY	Surrey Ltd., John, NY.
SVB	Scruggs-Vandervoort-Barnay Co., MO.
SVM	Super Valu Stores, Inc.
SVR	Silverberg & Company, MD.
SWA	Swain, R.L. Tobacco Company, Inc., VA.
SWE	Sweet, J.D., NY.
SWH	Swisher, E. W. Cigar Company, OH.
SWI	Swisher, John
SWP	Smyth, Woodson & Payne, VA.
SWR	SWR Corporation, TN.
SWT	Swedish Tobacco Company
SWW	Stewart, W.W., PA.
SWZ	Schwarz, Max, NYC.
TAB	Tabard Cigarette Tobacco Company, Ltd.
TAI	Tobacco Alternative, Inc. NY.
TAK	Takowefsky, H.
TAN	Tanner, G.W., RI.
TAR	Taroma, NJ.
TAW	Truner, A.W., GA.
TBC	Tobacco Blending Corporation, KY.
TBR	Tobacco Brands Corporation
TCH	Tcharic, Simlah & Company
TEA	Te-Amo Geryl Company, Inc.
TEC	Turco-Egyptian Cigarette Company, NY.
TEI	Teischmann's Sons, Isaac, NYC.
TEL	Tel Aviv Tobacco Company
TEO	Teofani & Company, Inc.
TES	Teiser & Pollak, VA.
TEX	Tobacco Exporters International, Ltd.
TGM	Thompson, Geo. M., IL.
THB	Themelis Brothers Company
THC	Thomas, Cal., Cubana City Cigar Co., GA.
THE	Themalis, George & Company
THL	Temple, Hummel, Ellis Company, IN.
THM	Thomas, John N., PA.
THO	Thompson & Company
THR	Theoraripis

ID	CIGARETTE MERCHANT
THS	Theocaridis, D.
THU	Thurber Company, MA.
TIC	Teichman, Isaac, NYC.
TIN	Tint, Harry A.
TKE	Turco-Egyptian Tobacco Company, NYC.
TLL	Teller, Frank & Company, PA.
TMG	Tumbridge, William, NY.
TNC	Trade Named Cigarettes, NC.
TNG	Tango Manufacturing Company
TOB	Tobin, R.R. Tobacco Company
TOK	Tokay Cigarette Company
TOP	Topco Associates, Inc., IL.
TOR	Toro y Ca S.en, PR.
TOU	Tourist Cigarette Company, NYC.
TOW	Towne Tobacconists, Inc., NYC.
TPC	Tobacco Products Corporation, NYC.
TPE	Tobacco Products Export Company
TPR	Toprahinan, M.C.
TRC	TRC Company
TRE	Ruscarora Reservation Enterprises, NY.
TRI	Triumph Smokes, Inc., TX.
TRN	Turney, John, E.C., Ltd., LA.
TRO	Trostal, George, PA.
TRU	Turco-Russian Cigarette Company, PA.
TTT	Timayenas, T.T., MA.
TUC	Tuckett. John E. & Son
TUM	Turmac Tobacco Company, B.V.
TUR	Turco-American Tobacco Company, NYC.
TWB	Transworld Tobacco, Ltd., CA.
TWL	Transworld Tobacco, Ltd, CA.
TWR	Thorwart & Roehling, IL.
TWT	Transworld Tobacco, Ltd., DE.
UCF	United Cigarettes Factories, PA.

ID	CIGARETTE MERCHANT
UCS	United Cigar Stores
UCW	United Cigar-Whalen
UIO	Union American Cigar Company, PA.
UKT	University of Kentucky (Code 1R1)
ULL	Ullman, Lewis & Company, TX.
ULM	Ulmer, Robert & Company, NYC.
ULT	Ultratech Corporation, PA.
UNC	Universal Tobacco Company, NYC.
UNI	Union Tobacco Company, NYC.
UNN	Union News
UPT	Upper Ten Cigarette Company
URT	Urtsch & Schmitt, NYC.
USA	USA Tobacco
USJ	United States Tobacco Company of NJ.
USM	U.S.A. Cigarettes, Inc., MI.
USV	United States Tobacco Company, VA.
UTC	Universal Tobacco Company, NYC.
UTW	United Tobacco Works, NYC.
VAF	Vafiadis, Theo & Company
VAL	Vali Cigarette Company
FAW	Vaughn-Ware Tobacco Company, VA.
VCT	Virginia Carolina Tobacco Corporation
VEN	Venable, S.W. & Company, VA.
VER	Verdurin
VET	Veteran's Tobacco Company
VGN	Virginian (The) Tobacco Company, NYC.
VIC	Victory Tobacco Company, Inc., WV.
VIS	V.I. Sales, CA.
VIT	Vitsas Cigarette Company, NYC.
VLC	Value Cigarette Company, NYC.
VLL	Vallauri, V., NYC.
VLN	Vallens, Eugene & Company, NYC., IL.
VLR	Valor Tobacco Company, Inc.

ID	CIGARETTE MERCHANT
VON	Von's Grocery Company, CA.
VPC	Virginia Products Corporation
VRN	Vernon Tobacco Company
VTC	Virginia TC.
WAD	Ware, F.D. Tobacco Company, Inc., VA.
WAG	Wagner, R. & Company, MI.
WAK	Wakefern Food Corporation
WAL	Waldorf Astoria International
WAN	Wanamaker, J., Department Store, NY., PA.
AR	Ware-Kramer, VA.
WAS	Wassermann, B.
WAT	Watts, Earl Linzy
WAY	Way, E.C., IL.
WCH	Worch, Albert
WDA	Waldorf Astoria, The
WDW	Walt Disney World
WEB	Webber, George, NYC.
WEC	Weis, Carl, No. 339, NYC.
WEI	Weis, Markets, Inc., PA.
WEL	Wells, A.B.
WEN	Weiner & Gossage, Inc.
WEP	West Park Tobacco Company, VA.
WER	Werner, Paul A., Inc., NYC.
WES	Weisert, John Tobacco Company
WET	Western Tobacco Company
WFF	Western Family Foods, Inc.
WGN	Wagner, Em, IN.
WHA	Whayne, Roy C., Supply Co., KY.
WHG	Whelan, George J., NY.
WHH	Whitehall Products, Inc., NJ.
WHL	Whitlock, P., VA.
WHN	Whiteman, McNamara Tobacco Co., KY.
WHR	Wheeler, John T., NY.

ID	CIGARETTE MERCHANT
WHT	White, Mrs. Anna M.
WID	Windsor Tobacco Company
WIE	Wiedeman Company
WIG	Wigdorovitz, L., NYC.
WIK	Wicke, William Company, NYC.
WIL	Wildcraft Herbs
WIM	Wims Research Lab
WIN	Winans, R.F.
WIS	Wiseman
WIT	Witchcraft Herbs
WIX	Wix, J. & Sons
WKD	Wolkind, R., NY.
WLC	Williams, John, R. & Company, NJ.
WLF	Wolfe, W.B. Tobacco Company
WLH	Willard Hotels, DC.
WLK	Wilkins, H. & Company, MD.
WLW	Warner, L.W., NYC.
WLY	Whaley, C.F., MN.
WMB	William Brothers Tobacco Co., PA.
WMS	Williams, R.C. Company, NYC.
WNE	Winecke & Doerr, MN.
WNG	Winegarden, A., NYC.
WOD	Woodbury, E.F., ME.
WOF	Wolf, B.S., NYC.
WOH	Wohl, Peter & Company, IL.
WOL	Wolfe & Conti
WOO	Wooten, F.W.
WOR	World International Tobacco Corp., VA.
WOS	Wolff & O'Shlag, NYC.
WRC	Worcester Cigar Company, MA.
WRD	Ward, William P., NYC.
WRI	Wright, Allen H., OH.
WSC	Weis & Company, MD.

ID	CIGARETTE MERCHANT
WSF	Weisfeld, D., IL.
WSH	Walsh's, NYC.
WSM	Witsch & Schmitt, NYC.
WTA	Willoughby Taylor, PA.
WTB	World Tobac, Ltd, KY.
WTC	Winston Tobacco Company
WTH	Wortheimer Company, The, CA.
WTI	Worldwide Tobacco, Inc., USA
WTL	Whitelaw, J. & Company
WTN	Wartman, M. & Sons
WTS	Waltenspiel, T.C., UT.
WWG	Walwig & Cook, WI.
WWH	Wells-Whitehead Tobacco Company, NC.
YAH	Yahn, & McDonnell, PA.
YER	Yerby, G.W., NY.
YNC	Your Name Cigarette Company, IL.
YOR	Yorke Drug Company
YOW	Yow Yow Cigar Company, OH.
YRK	Yorkshire Drig Company, NYC.
ZAC	Zachos, S.G.
ZAF	Zafiris, A. & Company
ZAP	Zaphirio, A. & Company, IL.
ZAR	Zariffe Cigarette Company
ZEE	Zeeman, Isidor I.
ZEH	Zehr, William, NY.
ZEI	Zeiter Tobacco Company, CA.
ZER	Zerbe, T.T. & Brothers, PA.
ZET	Zesery & Triandafillou
ZIM	Zimmerman, Harris, NYC.
ZIP	Zippy/Food Bag Markets, PA.
ZUF	Zufedi, A., Cigarette Company
ZUN	Zunder, M. & Sons, CN.

Appendix C:
CIGARETTE FACTORY NUMBER LIST

The first column, Factory Number, is the number found on a package of cigarettes. An identifying factory number was required on each cigarette package for federal excise tax collection purposes from 1868 until June 1954. From June 1954 to October 1960, however, no factory number was required on packages. Since October 1960, a manufacturer's name or a permit number (such as C-30-VA or TP-42-NC or "an approved symbol") have identified the cigarette maker or vendor. The corresponding brand name appears in column five.

Even with these numbers, it is somtimes difficult to determine the identity of the cigarette maker, if it's different from the name on the pack.

The second column, Factory Years is (in most cases) my "best guess" as to the year or span of years that this factory number appeared on cigarette packages, possibly used by several different makers. These estimates are primarily based on information available from our collections, and have a margin of error of several years. The factory numbers were not required after 1955.

Column three, Maker, is the maker of the cigarette brand. Column four is the Vendor column. For example, Kroger may have been the vendor of a given pack of cigarettes, while R.J. Reynolds was the maker.

Column five, Brand Name, is the brand name on a package of cigarettes bearing the factory number listed in column one. Only a few of the many brand names made in some factories are listed. As noted previously, some brand names were made in more than one factory, hence they may be repeated under different factory numbers.

The Brand Name Years column, column six, lists a year or span of years in which cigarettes of the given name were produced at the factory in column one. In a few cases the beginning and ending years of the brand name are listed, when known. The cut-off year for factory numbers (but not "TP" or "C" numbers) is 1955, after which the factory number was no longer required.

There are obvious anomalies in my listings that require resolution, such as a merchant with two brands listed in the 1890s and one brand in the 1970s. I left out many cigarette names and information due to the lack of information. With the help of collectors—and anybody else who wants to help—I hope to get most of it sorted out. Please send pictures and information to Tobacco Barn, P.O.B. 214, Clinton Mo. 64735.

Appendix C: FACTORY NUMBERS

Factory #	Factory Yrs.	Maker	Vendor	Brand Name	Brand Years
C-1-GA	1932-1935	STB		H.D. (Happy Days)	1932-1935
F1-1KY	1952	FLH			1952
F1-NC	1912-1955	RJR		Camel	1913-date
F5-NC	1912-1918	RJR			1913-1936
TP-1-NC	1955-Date	RJR	FOR	Red Kamel	1913-1918
TP-1-NC	1955-Date	RJR	GLE	Monarch	1989-Date
TP-1-NC	1955-Date	RJR	IAF	Scotch Buy	1988-Date
TP-1-NC	1955-Date	RJR	KRO	Cost Cutter	1991-Date
TP-1-NC	1955-Date	RJR	PMA	Best Choice	1990-Date
TP-1-NC	1955-Date	RJR	SFA	Scotch Buy	1988-Date
TP-1-NC	1955-Date	RJR	TOP	Value Time	1994
TP-1-NC	1955-Date	RJR	LOR	Slim Price	1993-Date
F1-5NJ	1912				
F1-1NY	1943-1953	FLH		Sheffield	1930-1955
F1-1NY	1943-1953	FLH		Jefferson Chums	1943-1947
F1-1NY	1943-1953	FLH		81 Blended	1950
F1-1NY	1943-1953	FLH	LDC		1950
F1-1NY	1943-1953	FLH	STW		1950
F1-1NY	1943-1953	FLH	SSS		1950
F1-1NY	1943-1953	FLH	AFT	BEH No. 15	1944
F1-2NY	1943-1953	FLH	BEH	Vanity Fair	1888
F1-28NH	1878-1910	KIM		Formal	1943-1946
F1-100H	1943-1946	CAN		Director's Special	1943-1946
F1-100H	1943-1946	CAN		None Known	
F1-100H	1943-1946	CAN		Wix	
F1-VA	1895-1921	USV		Idle Hour	1920
F1-VA	1951-1955	USJ		Sano	1922-1978
F1-VA	1951-1955	USJ		Encore	1922-1972
F1-VA	1951-1955	USJ	FLH	Regent	1922-1972
F1-VA	1951-1955	USJ	RIG	Jaguar	1936-1953
C-1-VA	1951-1955	USJ	STP	None Known	1953-1964
TP-1-VA	1955-1965	USJ		Wix	
F2-NC				Caliph	1900
F2-5NJ			MON	Leroy	1890s
F2-NY	1890s	MIL		Leroy	1890s
F2-NY	1890s	MIL		P. Rainbows	1964
TP-2-PA	1964	SHE		Seniors	1964
TP-2-PA	1964	SHE		herman' 164	1964
TP-2-PA	964	SHE		Toreador Mexican	1923
F2-3TX	923-1926	MCT		Coupon	1895-1950
F3-LA	1895-1912	ATD		Wix	1885
F3-NC	1885	WIX		Milo	1895-1935
F3-2NY	1895	KHE		Duke of Durham	1881-1911
F3-VA	1870-1930	DUK		Gemini	1965
TP-3-VA	1965-Date	USJ	ADR	Friendship	992
TP-3-VA	1965-Date	USJ	BYE	Gatlin Burlier Smokie	1986
TP-3-VA	1965-Date	USJ	GST	Gatlin Bulier Smokies	1978
TP-3-VA	1965-Date	USJ	GAB	El Cuno	965
TP-3-VA	1965-Date	USJ	MEN	Econ	1987
TP-3-VA	1965-Date	USJ	RHF	Tryon	1967
TP-3-VA	1965-Date	USJ	SST	Vogue	1965-1972
TP-3-VA	1965-Date	USJ	STP	Black Gold	1986
TP-3-VA	1965-Date	USJ	SWR	West (Export)	1992
TP-3-VA	1965-Date	USJ	WEP	Shur Saving	1984
TP-3-VA	1965-Date	USJ	WFF	Generic	1987
F4-LA	1890-1911	PTB		Kotton	1910
F4-1MO	1930-1936	WES		Carmen	1931-1940
F4-NC	1939-1945	RJR		Camel	1939-1945
F4-VA		USJ			
F4-6VA				Burley Cubs	

Factory #	Factory Yrs.	Maker	Vendor	Brand Name	Brand Years
F5-NY	1925-1955	LOR			1944-1945
F5A-NY		BEH			
F5A-NY		LOR			
F5-2NY	1925-1955	BEH	AME	Pump Room	1948
F5-2NY	1925-1955	BEH	SEI	Hotel Statler, The	1953
F5-2NY		BEH	PIE	Coronation	1925
F5-2NY		KHE			1898
F7-1IL		WTC		Fems	1940
F7-MA		LAZ		Omiros	1912
F7-3MA		LAZ		Daimonios	1912
F7-NJ	1890-1955	ATD	ANR		
F7-?NJ				Trophies	1890
F7-3NJ		ATD		Mogul/Murad	1930-1955
F7-3NJ		ATD	ANR	Mogul	1943-1947
F7-3NJ		LOR		Murad	1950
F7-5NJ		LOR	ANR	Nebo	1950
F7-NY				Twelfth Night	1950
F7-2NY	1895-1925	ANR		Egyptian Deities	1950
F7-2NY	1895-1925	ANR		Murad	1944
F7-3NY	1895	ANR		London Life	1888
F7-3NY		LOR		Egyptian Deities	1943-1946
F7-3NY		LOR		Egyptian Luxury	1943-1946
F7-3NY		LOR		Egyptian Deities	
C-7-VA	1955			Marlboro	1920
F7-VA	1925-1955	CNT		Cigarette Time	1930-1934
F7-VA	1925-1955	PMC		Philip Morris	1934-1955
F7-VA	1925-1955	PMC	CRR	Craven "A"	1934-1955
F7-VA	1925-1955	PMC	DUH	Dunhill	1934-1945
F7-VA	1925-1955	PMC	NCS	Black & White	1934
F7-VA	1925-1955	PMC	PLY	Players	1938
F7-2VA	1925-1955	PMC		Havana America	1934-1955
F7-VA	1925-1955	PMC		Paul Jones	1934-1955
F7-VA	1925-1955	PMC		Cigarette Time	1934-1955
TP-7-VA	1955-Date	PMC		F&L	1990
TP-7-VA	1955-Date	PMC	BEC	Best Buy	1991
TP-7-VA	1955-Date	PMC	CMP	Generic	1992
TP-7-VA	1955-Date	PMC	CPA	Money/F&D	1991-1993
TP-7-VA	1955-Date	PMC	CUS	Basic	1990-Date
TP-7-VA	1955-Date	PMC	FVP	Royale	1895-1950
TP-7-VA	1955-Date	PMC	GAP	Generic	1988-1990
TP-7-VA	1955-Date	PMC	GEN	Premium Buy	1992
TP-7-VA	1955-Date	PMC	MCP	Test Pack	1992
F8-1GA		STH	SEL		
F8-MI	1921-1935	SND		Ramrod	1921-1939
F8-NJ	1925-1955	ANR			
F8-2NJ	1925-1955	ANR			
F8-2NJ	1925-1955	LOR			
F8-5NJ	1925-1955	ANR		Helmar	1925
F8-5NJ	1925-1955	LOR		Tiger	1925
F8-5NJ	1925-1955	LOR		Bounty	1930
F8-5NJ	1925-1955	LOR		Old Gold	1930-1953
F8-5NJ	1925-1955	LOR		Polar	1952
F10-KY	1935-1953	TBC		I Like Ike	1935
F10-KY	1935-1953	TBC	BRE	Breng's Own	1935-1940
F10-KY	1935-1953	TBC	DRC	Red Crown	1937-195?
F10-KY	1935-1953	TBC	RUM	Rum & Maple	1948-1953
F10-KY	1935-1953	TBC	JAT	John Alden	
F10-KY		TBC	SWA		
F10-2NY		COS	CON	Count Condossis	1930

Factory #	Factory Yrs.	Maker	Vendor	Brand Name	Brand Years
F11-KY	1950-1955	LOR		Kent	1953-1955
TP-11-KY	1955-Date	LOR			
C-11-KY		LOR		Golden Rule	1955-1961
F11-1MO	1927-1934	TUC		Golden Rule	1934
F11-1MO	1927-1934	TUC	LAP	Listerine	1927
F11-1MO	1927-1934	TUC	TOB	Cookie Jar	1934
F11-1MO	1934-194?	CHR		Gordon Buchanan	1934-1939
F11-1MO	1934-194?	CHR	COL	First Lady	1934-1939
F11-1MO	1934-194?	CHR	MOS	Phillips Own	1934-1939
F12-4NC		NAD		Contenttnea	1910
F12-12PA		PNS			
F12-VA	1930	CNT		Cigarette Time	1935
F12-WV	1918-1955	BLO		Wizard	1919
F12-WV	1918-1955	BLO	CHR	All Jacks	1953
F12-WV	1918-1955	BLO	DEL	Romance	1928
F13-3NY	1933	BLO	SPU	Spud	1922
F14-MA		SMK		White Spot	1933
F14-3MA		MCU		Pyramid	
F14-VA		MCU		After Dinner Special	1936
TP-14-VA	1992	WEP		Paramount (Exp.)	
TP-14-VA		SAR	CCI	Way (Exp.)	1992
F15-KY	1935	SAR	WOR	Madison Lights	1993
F15-1MO	1935	BAW	COU	DU Maurier	1939
F15-2NY		MAD		Grads	1936
F15-VA	1939	CHR			
TP-16-GA	1955-1992	WID		Kingsly	1939
TP-16-GA	1955-1992	PMC			
TP-16-GA	1955-1992	BAW		Generics	1984
TP-16-GA	1955-1992	BAW	CMP	Major Brand	1987
F17-NC	1900	BAW	GPC	GPC	1990
F17-2NY		BAW	HRT	Generics	1986
F17-VA		BAW	TEX	St. Moritz	1992
F19-3NY		ATD		El Principe De Gales	1900
F20-KY				New Knight	1897
F20-11MO	1923-1946	LES			
F20-14NY	1923-1946	FLH			
F20-VA		BLO		Menthorets	
F21-NC		ALC	CMP	Puppies	
F21-5NJ	1905	ALI	FAL	Presidential	1923
F21-5NJ	1911-1920	STT	CRT	Little Champ Clark	1940
F21-NY		HIG	NCS		
F21-2NY	1895	RED	WER	Tiger	1905
F21-2NY	1895	LOR		Zira	1911-1920
F21-VA	1920-1955	ANR		London Life	1912
F21-VA	1920-1955	OUS		Egyptian King	1895
F21-VA	1920-1955	CNT	WER	Barking Dog	1925
F21-1VA	1920-1955	CNT	FAL	London Sports	1920-1934
F21-1VA	1920-1955	CNT	CRT	Green River	1920-1934
F21-1VA	1920-1955	CNT	NCS	Black & White	1934
F22-12PA	1940-1955	PMC	WER	Marlboro Ivory Tip	1934-1953
F22-12PA	1940-1955	PEN		Kentucky Winner	1940
F22-12PA	1940-1955	PEN		Julep	1945
F22-12PA	1940-1955	WTA		Longfellow	1943
F22-12PA	1940-1955	BAD		Bright Star	1937
F22-12PA		RSD			
F22-12PA	1940-1955	ALE		Salome	1955

Brand reference table (three columns across the page). Each group has the columns: Factory #, Factory Yrs., Maker, Vendor, Brand Name, Brand Years.

Left group

Factory #	Factory Yrs.	Maker	Vendor	Brand Name	Brand Years
TP-22-VA	1989	SAR	WOR	Four Kings	1990-Date
TP-22-VA	1989	SAR	WOR	American Spirit	1989-Date
TP-22-VA	1989	SAR	CWD	Lots of Value	1994
TP-22-VA	1989	SAR	LSX	Jackpot Junction	1995
TP-22-VA	1989	SAR	KRI	Born Free	1994
TP-22-VA		SAR	PTK	McClintock	1994
TP-22-VA		SAR	SAM	Bailey's	1994
TP-22-VA		SAR	SCM	Seneca Hawk	1992
TP-22-VA	1989	SAR	STO	X (in red square)	1994
TP-22-VA	1989	SAR	WEP	West	1990
TP-22-VA	1989	SAR	KRT	Free Spirit	1995
TP-22-VA	1989	SAR	RUL	JBR	1993
TP-22-VA		SAR	MCI	Madison Box King	1994
TP-22-VA	1989	SAR	STK	McClintock King	1989
TP-22-VA	1989	SAR	WPR	Peter Stokkebye	1993
F24-KY	1917-1944	AFT		Spud	1924-1947
F24-KY	1917-1944	AFT	SWA	Pinehurst	1940
F24-KY	1917-1944	AFT	ALA	All American Imperial	1941-1944
F24-KY	1917-1944	AFT	CDG	Ardsley	1938
F24-KY	1917-1944	AFT	VIC	Blue Crown	1936
F24-KY	1917-1944	AFT	EDC	Grand Prize	1938
F24-KY	1917-1944	AFT	HED	Hed Kleer	1935
F24-KY	1917-1944	AFT	HAV	Hedkleer	1936
F24-KY	1917-1944	AFT	UCW	Ladd's Imperial	1940
F24-KY	1917-1944	AFT	PMC	Lord Mansfield	1937
F24-KY	1917-1944	AFT	DAW	Dawn	1930
F24-KY	1917-1944	AFT	FLH	Mapleton	1937-1944
F24-KY	1917-1944	AFT	FLS	Name This Cigarette	1937
F24-KY	1917-1944	AFT	PAP	Pan Am	1937
F24-KY	1917-1944	AFT	NTH	Plus Four	1936
F24-KY	1917-1944	AFT	SKI	Rebels	1936
F24-KY	1917-1944	AFT	RAS	Sandy	1937
F24-KY	1917-1944	AFT	SEF	Seven Island Club	1937
F24-KY	1917-1944	AFT	SNO	Snooty	1937
F24-KY	1917-1944	AFT	SPU	Spud	1924
F24-KY	1917-1944	AFT	HUG	Spud	1926
F24-KY	1917-1944	AFT	TOK	Tokay	1939
F24-KY	1917-1944	AFT	NRT	White Oak	1936
F24-KY	1917-1944	AFT	PLU	Zebra	1929
F24-KY	1917-1944	AFT	WTC	Winston Rounds	1940
TP-24-KY	1944-1955	PMC		Phillip Morris	1944-1953
TP-24-KY	1955	PMC		Puppies	1945
F24-14NY	1942-1946	ALC	NCO	Co-Op	1948
F24-14NY	1942-1946	AUO		Autograph	1944
F25-1MO	1875-1899				1899
F25-NC	1895	KIN		Caporal Tabac Fort	1883
F25-2NY	1880-1955	KIN		Pay Car	1895
F25-VA	1880-1955	PIN		Old Mill	1919
F25-VA	1880-1955	LAM			1911-1955
F25-2VA	1880-1955	ATD	KIN	Richmond Straight Cut	1891-1911
F25-2VA	1880-1955	ATD	ALG	Fatima	1911-1955
F26-NJ	1952-1955	SHE		MCD	1952
TP-26-2NY	1955-197?	SHE		Virginia Circles	1973
F26-2NY	1885-1910	GOO		Old Judge	1888
F27-2NY	1940-1944	CEN		White Eagle	1940-1944
F27-2NY	1942-1945	CEN		Clipper	1940-1944
C-30-NC	1955	MID		Walnut	1942-1945
F30-KY	1917-1946	ATC		Milo Violets	1955-1960
F30-NC	1917-1946	ATC		Lucky Strike	1920-1955
F30-NC	1917-1946	ATC	COC	Cocktail Hour	1933-1955
F30-NC	1917-1946	ATC	CRT	The Court	1939
F30-NC	1917-1946	ATC	EXT	Gold Flake	1938
F30-NC	1917-1946	ATC	FAL	Herbert Tarryton	1925
F30-NC	1917-1946	ATC	GIA	Royal Nestor	1919
F30-NC	1917-1946	ATC	PER	Beacon Hill	1920-1955
F30-NC	1917-1946	ATC	PLY	Players	1920
F30-NC	1917-1946	ATC	PRU	Yanks	1921

Middle group

Factory #	Factory Yrs.	Maker	Vendor	Brand Name	Brand Years
F30-NC	1917-1946	ATC	ACC	Sweet Caporal	1941
F30-NC	1917-1946	ATC	WDA	Waldorf Astoria	
F30-NC	1895-?	KIN			
TP-30-NC	1955	ATC			1960
F30-1NY	1885-1928	ATD		H.De Cabanas Y	1895
F30-2NY	1885-1928	MON	PTK	Petit Canon	1887
F30-2NY	1885-1928	ATC		Melachrino	1917
F30-2NY	1885-1928	ATC	LOM		
F30-2NY	1885-1928	ANR		Minaret	1895
F30-2NY	1885-1928	KIN		St. James	1895
F31-VA	1931	DUH		Dunhill	1931
F32-2NY		LOM			
F33-4NC	1927	PNT		Penbarry	1927
F34-2NY	1885-1945	SSS		Chukker Rounds	1955
F34-2NY	1885-1945			Milo Egyptian	1895-1940
F34-2NY	1885-1945	BOU		Egyptian Idols	1925
F34-2NY	1885-1945	GAG	STC	Vernon	1945
F34-2NY	1885-1945	BOU			1940
F35-2NY	1900-1940	COP		Drury Lane	1935
F35-2NY	1900-1940			Lepton	1910
F35-VA	1933-1955	BAW		Avalon	1933-1955
F35-VA	1933-1955	BAW	RTZ	Ritz	1933-1955
F35-VA	1933-1955	BAW		Kentucky Winners	1933
TP-35-VA	1933-1955	PNT		Lucky Strike	1940
TP-35-VA	1933-1955	BAW		Pall Mall	1937
TP-35-VA	1955	BAW		Generics	1955
TP-35-VA	1955	BAW	HRT	Generics	1955
F36-KY	1925-1955	LOR		Kentucky Kings	1925-1955
F36-KY	1955	BAW		Kool	1955
C-36-KY	1955	BAW		Kentucky Kings	1955
C-36-KY	1929-1955	BAW		Raleigh Billfold	1929
TP-36-KY	1955	DUK			
F37-3NY	1895	SWA		Hits	1895
F40-3NY	1936	GOO		Gypsy Queen	1936
F42-NC	1880-1900	CAM			1936
F42-4NC	1870-1955	CAM		Home Run	1929
F42-NC	1870-1955	ALG		Richmond Straight Cut	1911-1955
F42-NC	1870-1955	DUK	ALG	Duke's Cameo	1880-1891
F42-NC	1870-1955	ATD	DUK	Richmond Straight Cut	1870-1891
F42-4NC	1870-1955	ATD		Duke's Cameo	1870-1955
F42-4NC	1870-1955	LAM		Piedmont	1870-1955
TP-42-NC	1955	LAM	ALB	Generic	1988
TP-42-NC	1955	LAM	ALP	Econo Buy	1981-1985
TP-42-NC		LAM	ASB	Econo Buy	1985-1992
TP-42-NC		LAM	ASW	Always Save	1988
TP-42-NC		LAM	BRA	Generic	1988
TP-42-NC		LAM	CDE	Generic	1988
TP-42-NC		LAM	CER	Monticello	1984-1986
TP-42-NC		LAM	CFI	Generic	1986
TP-42-NC		LAM	CFM	C.F.M.	1983-1986
TP-42-NC		LAM	CMP	First Choice	1988
TP-42-NC		LAM	CUS	F&D	1988
TP-42-NC		LAM	DAL	Dallas	1993
TP-42-NC		LAM	EWD	Price Breaker	1989-1992
TP-42-NC		LAM	FDL	Food & Liquor	1986-1989
TP-42-NC		LAM	FDP	Food & Deli	1988
TP-42-NC		LAM	FFI	Generic	1986
TP-42-NC		LAM	FOO	Slim Price	1989
TP-42-NC		LAM	GAP	PsQ	1981
TP-42-NC		LAM	GAR	Quality	1985
TP-42-NC		LAM	GLS	Best Buy	1981-1990
TP-42-NC		LAM	GPA	Generic	1993
TP-42-NC		LAM	GPC	Epic Deluxe	1987
TP-42-NC		LAM	GPI	Eagle 20's	1993
TP-42-NC		LAM	GUC	Generic	1988
TP-42-NC		LAM	JEW	Generic	1982

Right group

Factory #	Factory Yrs.	Maker	Vendor	Brand Name	Brand Years
TP-42-NC		LAM	KRO	Cost Cutter	1981-1987
TP-42-NC		LAM	MGA	Generic	1990
TP-42-NC		LAM	MMI	Generic	1989
TP-42-NC		LAM	NBS	Better Value	1993
TP-42-NC		LAM	NOR	Miami Lights	1993
TP-42-NC		LAM	NPG	Bronson	1983-1992
TP-42-NC		LAM	PDS	Peoples	1983
TP-42-NC		LAM	PTY	Worth	1983-1988
TP-42-NC		LAM	RGC	Plain Wrap	1984
TP-42-NC		LAM	ROE	Bogart	1986
TP-42-NC		LAM	ROU	Generic	1989
TP-42-NC		LAM	RRD	Generic	1988
TP-42-NC		LAM	SFS	Scotch-Buy	1981-1987
TP-42-NC	1955	LAM	SRC	Price Saver	1985
TP-42-NC		LAM	SUM	No Frills	1986
TP-42-NC		LAM	SUN	Generic	1988
TP-42-NC		LAM	TOP	Valu Time	1980
TP-42-NC		LAM	VON	Slim Price	1983-1993
TP-42-NC		LAM	TUM	St. Moritz	1958
TP-42-NC		LAM	WEI	Generic	1987
F44-1CA	1992	CBI		USA Gold	1995
F44-1CA	1992	CBI		Maui 10's	1995
F44-2NY	1992	CBI		Sonoma	1995
F44-2NY	1992	CBI		Miami Lights	1993
F44-2NY	1992	CBI	SFN	Natural American Spirit	1994
F44-2NY	1992	CBI	USA	USA	1993
F43-FL	1963	CBI	DIC	Reno Full Flavor	1994
F44-CA	1925-1945	DOM		Competadora	1963
F44-1CA	1925-1945	HET		Dream Castle	1925-1945
F44-2NY		DRC		Dream Castle	1925-1945
F44-2NY		HOR		Lion	1941
F44-2NY		RYT		Lion	1945
F44-2NY		ZEE		Tel Aviv	1931
F45-VA	1955	LAB		Yorktown	1955-1976
F45-VA	1955	HOE		St. Moritz	1955-1970
F45-VA	1955	HOE		Centrofinos	1963
F49-KY	1910	HOE	BLT	Peter Stuyvesant	1973
F50-VA	1940-1945	AFT	STY	Jeep	1945
F51-NC	1900-1913	SWA		Champaigne	1908
F54-2NY	1945	FAL		Medley	1945
F55-6CA	1940	SSS		Ritz	1945
F56-5VA		LIR		Bare-Kat	1913
F56-6VA		WAD	WAD	Ware's Pure Virginia	1913
F57-5NJ		LOR			
F57-5NJ		ANR		King Condosis	1938
F59-2NY	1938	CON	COS	Blue Peter	1934
F59-2NY	1925-1935	CON	BLP	Blue Peter	
F59-2NY	1925-1935	CON		Pall Mall	1938-1950
F60-NC	1938-1940	ATC	ACC	The First	1933
F60-NC	1938-1955	FCC		Egyptian Oasis	1939
F62-MA	1933	RJR		Vafiades	1926
F64-NC	1938-1940	LAM		Egyptian Oasis	1921
F64-2NY	1890-1920	VAF			
F64-2NY	1890-1920	LEE		Leighton	1943-1957
F65-NY	1936-1955	LEI		Le Marber	1943-1957
F65-NY	1936-1955	LEI	SUP	McDonnell	1943-1957
F65-2NY	1936-1955	LEI	MLL	Zed	1943
F65-2NY	1936-1955	LEI	WLF	Fook Look	1936
F67-1CA	1936-1955	KOW		King's Choice	1989
F67-1CA	1938-1940	ATC		Pall Mall	1981
F67-1CA	1938-1940	PAL		1939 Exposition	1939
F72-1NY	1926	SOT		Emir, Emek	1926
F74-3NY	1915-1955	SOT		La Turka	1921
F74-3NY	1915-1955	GAG	BEN	Lady Hamilton	1945
TP-75-NY	1955	GAG	FTC	Benaderet's My Own	1972
TP-75-NY	1955	GAG	GTH	Cancer	1966
TP-75-NY		GAG	GTH	Go to Hell	1987

Cigarette brand reference table (page 172). Three column-groups read left-to-right; each group has columns: Factory #, Factory Yrs., Maker, Vendor, Brand Name, Brand Years.



Factory #	Factory Yrs.	Maker	Vendor	Brand Name	Brand Years
TP-75-NY	1955	GAG	SMI	Giggle Grass	1967
TP-75-NY	1955	GAG	PET	Peterson's	1955-1985
TP-75-NY	1955	GAG	RUL	JBR	1970
TP-75-NY	1955	GAG		Generic	1988
TP-75-NY	1955	GAG	SHE	Havana Ovals	1955-198?
TP-75-NY	1955	GAG	GAB	Choo Choo Club Cars	1980
F80-6CA		SER		London Pride	1941
TP-75-NY	1955	GAG		Gatlinburlier Smokies	1984
F81-VA	1915-1925	GUN		Gunstoria	1915
F81-VA	1915-1925	STA	GBR	Strollers	1916
F81-2VA	1915-1925	FAL	FAL	Champagne Cocktail	1915
F81-2VA	1915-1925	ATC			
F85-MI	1920-1939	SND		Ramrod	1921
F85-1MI	1920-1939	SND		Yankee Girl	1932-1939
F87-1PA		MID		Old Marines	
F88-110H		DEL		Romance	1922
F89-1MO	1922	MDY		Rose of Egypt	1913
F94-NY	1890-1955	RIG		Regent	1938-1955
F94-NY	1890-1955	RIG	CDC	Trim	1938-1955
F94-NY	1890-1955	RIG	FIL	O-NIC-O	1938-1955
F94-NY	1890-1955	RIG	SMO	Smo-Cola	1952
F94-1NY	1890-1955	RIG	CBC	Bells	1943
F94-1NY	1890-1955	RIG		Regent	1938-1955
F94-1NY	1890-1955	RIG	PIT	Cable Car	1938-1955
F94-3NY	1890-1955	VAF		Vafiades	1895
F97-NC	1927-1935	RJR		Drum	1933
F100-1MO	1870-1900	DRU		Drum	1890
F100-NH		BAI		Carolina Royales	1918
F100-2IL		PMC		Egyptian Unis	1913
F104-1IL		STF		Stanley Freres	1905
F108-1CA	1930-1935	ORI		Jewel	1930-1935
F120-3NY		TEL		Pang's Superior	1912
F122-MA	1927	PKF		Wall Street Special	1927
F123-2NY	1938	BER	TOW	Yorkshire	1938
F130-NC	1920-1955	ATC	BAG	Sweet Tip	1938-1955
F130-NC	1920-1955	ACC		Pall Mall	1920-1955
F130-NC	1920-1955	ATC		Lucky Strike	1925-1955
TP-130-NC	1920-1955	ATC		Private Stock	1993
F130-3NY		ATC	SUY	Kavalla #9	1920
F130-VA	1927-1945	ATC		Lucky Strike	1938-1945
F137-NJ	1920-1955		PIC	Piccadilly	1920-1955
F137-5NJ	1920-1955		GUA	Denictor	1920-1955
F137-5NJ	1920-1955	LIU	BND	Denictor	1920-1955
F137-5NJ	1920-1955	SAC		O-Nic-O	1920-1955
F137-5NJ	1920-1955	SAC		Sackett	1920-1955
F139-3NY	1945	RYT		S. Denicotinized	1945
F141-6CA	1916-1930	SMB		Lion	1923
F147-2NY	1895-1930	BUB	UNI	Ambra	1901
F150-5NJ	1939			Sovreign	1939
F156-2NY	1941-1945	PET		Peterson's	1939
F156-2NY	1941-1945	AUO		Demitasse	1942
F157-FL	1950	AUO		Autograph	1950
TP-161-NY	1980	STT	SCK	Champ Clark	1985
TP-165-NY	1985	SHE		Cigaretellos	1980
TP-168-NY		AND		Texas Lights	1991
TP-168-NY		TAI	TAI	Pure Full Flavor	1995
F170-NY		ACI	SUY	Pure Full Flavor	1996
F170-3NY	1943	DRQ		Kavakka No. 9	1944
F170-3NY	1943	DRQ	SUY	Walford Virginia	1946
F171-1CA	1890-1930	PET		Peterson's Turkish	
F171-1CA	1905-1925	BOL	BOL	Obak	1895-1911
F171-1CA	1905-1925	ATD	BOL	Obak	1895-1911
F174-2NY	1890-1920	ATD		Richmond Strt. Cut #1	1885-1946
F174-2NY	1890-1920	LAM	LAM	Richmond Strt. Cut	1911-1930
F174-3NY	1890-1920	SCS		Rose of Egypt	1895
F174-3NY	1890-1920	ANT		Sultan	1906
F174-3NY	1890-1920	SCS	POU	In Style	

Middle column group

Factory #	Factory Yrs.	Maker	Vendor	Brand Name	Brand Years
F179-1CA	1900-1910	MAC		Minos	1904
F179-1CA	1900-1910	MAC		Madedonia	1910
F181-CT	1905-191?	LBI		Labinger	1901
F200-1CA		JOH		Pyrgos	1910
F211-1CA	1920-1940	BEN		Chinese Girl Mild	1935
F213-1CA	1920-1940	MDV		Paramount	1920-1940
F214-NY		KRI		Broadway	
F223-1NY	1895-1915		KRI	Turkish Student	1902
F223-3NY	1890-1920		GRD	Egyptian Heroes	1905
F225-1NY	1890-1920		EGH	Egyptian Heroes	1912
F225-1NY	1890-1920	KRI	KRI	Egyptian Heroes	1906
F225-1NY				Fifth Avenue Cork Tip	
F232-1PA		KRE		Du Maurier	
F240-KY		COU		Makaroff	
F240-1PA	1915-1929	PMC	MAK	Polo	
F240-1PA	1915-1929	KHO	LAM	Polo	
F244-NY			NPL	El Ahram	
F245-2NY		KHC		Alexandra	1925
F248-3NY	1925		APO	Lords	1925
F248-3NY	1945-1948	CHR	LAN	Lords	1946
F248-3MA			LAN	Fanny	
F255-MI	1928-1938		COU	Jacob Gordon	1932
F255-3NY	1910		ART	Hamidia	1910
F263-3MA			KRI	Hamidia	
F263-NY	1923			Themalis	1923
F265-NY		HOB	HOB	Egyptian Brights	
F266-MA				Egyptian Brights	
F266-3MA	1899	THB	THB	S.S. Pierce	1899
F266-MA	1903			Wanda Turkish	1903
F266-MA	1915	MAK	MAK	Russian #25	1915
F266-3NY		DYC		Ammon	
F272-MA	1920-1935	KHR		Alma, London	1927
F279-NJ		PLT		Egyptian Arabs	1938
F279-NJ	1890-1915	KHE	KHE	Yara	
F279-5NJ			SRB	Spotlite	
F295-10H	1890-1920	SRB		Kef	1895
C-305-CA	1955		FRY	Mexican Beauties	1954
F308-2NY		COM	COM	Federal	1901
F310-1CA	1890-1920	TUR		Egyptian Heroes	
F317-2NY	1955			Condax	1955
F317-2NY	1928-1939	DRQ	DRQ	Condax	
F317-2NY	1890-1925	KRI		Condax Turkish	
F320-2NY	1890-1925	FCT		Condax	
F320-2NY	1890-1925	EGH		Ali Pasha	
F320-3NY	1904-1925	CDX	CDX	Du Maurier	
F320-3NY	1904-1925	CDX	CDX	Adonis	
F327-2NY	1904-1925	LAM	LAM	Svoboda/Freiheit	
F331-1NY				Samplers	
F331-3NY		THE		Milo	
F339-2NY	1928-1955			Beacon Hill	
F348-1CA	1900-1930		SCK	Milo	
F348-2NY	1900-1930			Egyptian Idols	
F348-2NY				Dolma	
F348-2NY	1888-1925	DRQ	DRQ	Milo Lonfellows	1936
F349-2NY	1888-1925	DRQ	DRQ	Walford Virginia	1936
F351-CA	1888-1925		ZAP	Mexican Beauties	
F351-1NY	1888-1925		POU	Zaphirio	
F355-1NY			SRD	Bagdad	1897
F355-1NY	1893-1918	SRD	SRD	Yvonne Turkish No. 5	1912
F355-1NY	1893-1918	SRD	SRD	Yvonne Turkish No. 5	1912
F355-2NY	1893-1918			Mignon No. 1	1915
F355-2NY				Sultan	1906
F358-1IL	1915	POU	BST	Boulevard	1915

Right column group

Factory #	Factory Yrs.	Maker	Vendor	Brand Name	Brand Years
F360-IL	1928-1936	GTC	GTC	Churchill Downs	1915
F360-IL	1928-1936	ZAP	ZAP	Zaphirio	1895
F363-3NY	1883	MON	MON	Khedive	
F365-2NY			POU	Pet	
F365-2NY			PET	Peterson's	1895
F393-3MA			THU	Thurber's No. 5	
F394-3NY			CON	King Condosis	1906
F400-3MA	1906		GIA	Royal Nestor	1920
F400-2NY			COT	Vita-Vim	
F401-2NY	1920			Medley	1930-1946
F404-1NY	1911-1946	SSS	FLH	Sheffield English	1930-1946
F404-1NY	1911-1946	SSS	STW	Sheffield Imperial	1930-1946
F404-2NY	1911-1946	SSS		Jaylepi No. 6	1914
F404-2NY	1911-1946	JAY		Pinkus Brothers	1918
F404-2NY	1911-1946	PNK		Chukkers	1930-1946
F404-2NY	1911-1946	SSS		Medley	1938
F404-2NY	1911-1946	SSS	DUN	My Blend	1932
F404-2NY	1911-1946	SSS	EHR	Ehrlich's	1930
F404-2NY	1911-1946	SSS	FCG	FC&G/Yellow & Blk.	1940
F404-2NY	1911-1946	SSS	GAG	My Blend (for Dunhill)	1928
F404-2NY	1911-1946	SSS	HEA	Sano	1938
F404-2NY	1911-1946	SSS	LEA	Cake Box	1938
F404-2NY	1911-1946	SSS	MOS	Charing Cross	1939
F406-2NY	1936	SSS	PIE	Virginia Blend	1932
C-407-NY	1961	SSS	REY	Reymers	1943
C-407-NY	1961	SSS	SHE	Variety Selection	1940
F407-NY	1905-1955	SSS	SWA	Royale	1936
F407-1NY	1905-1955	SSS	BRE	Chukkers	1961
F407-2NY	1905-1955	GAG	RBC	El Bar Gor IV	1961
F407-2NY	1905-1955	SHE		Havana, Sherman's	1955
F407-2NY	1905-1955	GAG	BAB	Modenique	1945
F407-2NY	1905-1955	GAG		Maders	
F407-2NY	1905-1955	GAG	HIC	The Astor	1952
TP-407-NY	1905-1955	GAG	PET	Peterson's Egyp. Spec.	1957
F410-2NY	1905-1955	GAG	NAN	Humdinger	1945
F417-28NY	1875-1905	GAG	TIN	Personal Blend	1955
F417-28NY	1875-1905	GAG	SRT	Strand	1955
F430-1PA		GAG	STR	Fairfax	1905
F435-2NY	1905-1955	GAG	WAN	London Shop	1951
F435-2NY	1905-1955	GAG	BRX	Brand "X"	1937
F439-3NY	1905-1955	BUD		Bud	1957
F456-3MA		BLY		Margarita	1876
F460-VA	1905-1955	KIM		Three Kings	1886
F460-VA	1875-1905	SRR		Starr & Reed	1906
F460-VA	1875-1905	ATC	PRU	Afternoon Egyptian	1923
F460-VA		PRU	TPC	Yanks	1919
F460-VA	1905-1955	RSD		Cabryses	1910-1955
F460-VA	1905-1955	MTR	REE	Relu	1931-1952
F460-VA	1905-1955	REE		Chelsea	1938
F460-VA	1905-1955	LAB	BDO	Bonded	1950
F460-VA		LAB	CAH	Carl Henry	1955
F460-VA		LAB	HIN	Tall Cig. for the Texan	1954
F460-VA		LAB	IGA	IGA	1955
F460-VA		LAB	LAN	Hale	1955
F460-VA		LAB	LOB	Saybrooke	1953
F460-VA		LAB	MAY	S.S. Pierce	1941
F460-VA		LAB	PIE	Little King	1948
C-460-VA	1955	LAB	RUM	Yorkshire	1953
F460-VA		LAB	SRO	Julie Marc	1955
F460-VA		LAB	SSC	Super Valu	1948
F460-VA		LAB	STN	Teofani No. 5	1954
F460-VA		LAB	SVM	Cookie Jar	1947
F460-VA		LAB	TEO	Shop Rite	1953
C-460-VA	1955	LAB	TOB	Edgeworth Expert	1955-1968
F463-3NY	1934-194?	HOE	MON	Petit Canon	
F467-1PA		WAK	JUL	F&D (Fine & Dandy)	1936-1938

Factory #	Factory Yrs.	Maker	Vendor	Brand Name	Brand Years
F467-1PA	1934-194?	ART		Fanny	1935
F469-VA	1870-1900	DAN		Souvenier	1895
F469-VA		PRU		S.S. Pierce	1945
F485-2NY	1905-1930	SCS		Natural Rounds	
F485-2NY	1905-1930	GIA		Royal Nestor	1909-1925
F485-3NY		SCS		Egyptian Prettiest	
F488-3NY		SCS			1912
F508-2NY				Egyptian Banner	1910
F512-2NY		PMC		Philip Morris	1911
				Cambridge Blend	
F535-2NY	1932-			My Best	
F535-2NY		UTC		Shepheard's	1932
F535-2NY	1928-1931	PRI		Pyramid	1930
F537-3NY		RIT		The New Lord	1936
F537-3NY	1912	RIP		Turil	1912
F546-2NY		DUN		Shepheard's	
F546-2NY		MST		Shepheard's	
F546-2NY		MST	PIE	Blightly	
F547-RI		BER		Old '76	1918
F551-2NY	1920-1935	BAB		"Go Ter Hell"	1920-1935
F551-2NY	1920-1935	BAB		Russian Embassy	1920-1935
F551-3NY	1920-1935	BAB		Batt Brothers	1920-1935
F556-2NY	1920-1926	CUI		Egyptian Mysteries	1923
F562-3NY	1889-1905	ZUF		Zufedi	1895
F562-3NY	1889-1905	PHO			
F582-3NY					
F587-2NY	1895	CRE		Amber	1895
F593-MD	1878-1900	KIN	KIN	In Style	1895
F593-MD	1878-1900	ATD		Sweet Caporal	1897
F602-3NY	1900	AEC		Sovereign	1900
F619-1NY	1909	ATD		Anglo-Egyptian #1	1909
F622-3MA	1930-1934	MAK		Fez	1932
C-622-NC	1955	LOR		Makaroff	1955-1965
TP-622-NC	1955	LOR		Murad	1955-Date
F624-PA	1942-1948	PEN		Spring	
F624-1PA	1942-1948	PEN		Harley-Davidson	1993
TP-629-NC	1996	SFN	CCO	Jumbo	1945
				Jumbo	1997
F633-2NY				Natural American Spirit	
F647-2NY		HDD		Pig & Whistle	
F647-2NY	1908-1930	HAD		Egyptian Pharaohs	1898
F649-NY		ATD		Egyptian Pharaohs	1910
F649-1NY	1808-1930	MEL		Tokio	1911
				Melachrino	1895-1960

Factory #	Factory Yrs.	Maker	Vendor	Brand Name	Brand Years
F649-1NY	1808-1930	ISM		Macedonia	
F649-1NY	1808-1930	PRU			
F649-1NY	1808-1930			Players	1911
F649-1NY	1808-1930	UNI	ATC	Emblem	1895
F649-1NY	1808-1930	BUB	ATC	Pall Mall	1906
F697-3NY		MEL	UCS	"Beau Brummell"	1912
F750-FNJ	1939-1943	CIC		Camp	1940
F750-5NJ		KAD		Cornwall	1939
F750-5NJ	1939-1943	PET		Peterson's	
F750-5NJ	1939-1943	PFE		Cornwall	1940
F750-5NJ	1939-1943	KAD	RDM	Phi Delta Theta	
F750-5NJ	1940-1942	AUO		Autograph	1942
TP-762-FL	1984	AUO		Demitasse	1984
TP-762-FL	1963	DOS		Gaditana	1963
TP-762-FL	1984	MEN	ATL	El Cuno	1982
TP-762-FL	1963	DOS	NEY	Atlantic City	
TP-762-FL	1963	MEN	RSI	New York	
TP-762-FL		MEN	SFN	Las Vegas	
F855-2NY	1905-1915	CTD		American Spirit	1912
F879-3NY	1916-1936	RSD		Sahib	1920
F916-NY	1915-1935	PEN		Moonlight No. 1	1915-1924
F916-NY	1915-1935	BLO		Salome	
F916-1NY	1915-1935	RSD		Ebonies	
F916-2NY	1915-1935	RSD	YRK	Menthoret	1932
F930-1NY		NTP		Golden Gift	1915
F936-3NY		BEH		Adsyn	
F937-3NY		LOR		Old Gold	1924
F1016-3NY		MEL		Miltiades	1927
F1048-12PA	1927	RSD			
C-1048-PA	1946-1955	LEE		Vega Havana	1945
C-1048-12PA	1955	LEE		Brookton	1958
C-1048-12PA	1955	RSD			
F1287-5NJ	1930	ITC		Afra	1930
F1532-1PA				Radio	1933
F1673-IIL		CTM		Athenian	1895
F1798-3NY	1895			Longfellow	1925
F1839-1NY	1925	IMT		Red Kamel	1908
F1867-1NY	1908	MAT		Tubarette	1903
F1867-3NY	1900-1910	MAT			
TP-1896-KY	1900-1910	ATC			
TP-1898-PA		ATC			
F1978-3NY		RSD			
F2032-1PA	1895-1955	STP		Rameses II	1895-1955

Factory #	Factory Yrs.	Maker	Vendor	Brand Name	Brand Years
F2032-1PA	1895-1955	STP	GAG	Tipt	1895-1955
F2032-1PA	1895-1955	STP	PMC	Oxford Blues	1895-1955
F2032-1PA	1895-1955	STP	PMC	Cambridge	1895-1955
F2032-1PA	1895-1955	STP	AMS	Gems	1932
TP-2032-PA	1955-1970	STP			1955-1980
F2100-2NY		GIA		Nestor	
F2109-1PA		GIA			
F2109-NY				Milo Cork Tip	1914
F2109-2NY		PMC		Cambridge	
F2109-3NY		MEL			
F2109-3NY		SCH		Schinasi Natural	1901
F2109-3NY		GIS			
F2109-3NY	1925	SCS		Schinasi Brothers	1925
F2109-3NY		GIA			
F2153-2NY	1922-1932	SCS			
F2153-2NY	1922-1932	ATC		Egyptienne Straights	1900-1930
F2153-3NY	1922-1932	MEL		Soveriegn	1900-1930
F2153-3NY	1922-1932	BUB	BUB	La Marquise	1900-1930
F2153-3NY	1922-1932	ATC		Egyptienne Straights	1903
TP-2442-PA	1980	TKE		Generic	1981
TP-2442-PA	1980	GOR	ATG	Benton	1981
TP-2442-PA	1980	GOR	CHP	Chaparral	1992
TP-2442-PA	1980	GOR	HOV	Vegas	1988
TP-2442-PA	1980	GOR	IDM	Ideal	1981
TP-2442-PA	1980	GOR	SRS	Sarra's	1983
TP-2442-PA	1980	GOR	TWB	Charro	1996
TP-2442-PA	1980	GOR	TWT	Grey Wolf	1994
TP-2442-PA	1980	GOR	VIS	Not Guilty	1995
TP-2442-PA	1980	GOR	PAM	Passport International	1991
TP-2442-PA	1980	GOR	PAS	Passport-I	1992
TP-2442-PA	1980	GOR	MLC	Buffalo Spirit	1996
TP-2442-PA	1980	GOR	CCL	Charlie's	1994
TP-2442-PA	1980	GOR	ELT	Dick Elliot	1996
TP-2442-PA	1980	GOR	CPC	Durham III	1996
TP-2442-PA	1980	GOR	TWL	Grey Wolf Lights	1996
TP-2442-PA	1980	GOR	POC	Happy Deluxe	1996
TP-2442-PA	1980	GOR	EVT	John Everette	1996
TP-2442-PA	1980	GOR	HDG	Joseph Hudgins	1996
TP-2442-PA	1980	GOR	MDD	Madison	1996
TP-2442-PA	1980	GOR	WOR	Marabou	1996
TP-2442-PA	1980	GOR	FNA	S. Signals	1996
TP-2442-PA	1980	GOR	USM	U.S.A.	1989
TP-2442-PA	1980	GOR	ZIP	Zippy/Food Bag	1984

Appendix D:
LIST OF CIGARETTE BRAND NAMES AND PRICE LIST

Many brand names have been used, dropped, and then picked up to be used again by the same or a different maker or vendor. Therefore, many brand names are listed more than once, sometimes with the same merchant.

The first column is the brand name. There are many brand names not listed due to lack of information on the type, kind, number in pack, etc. This will grow as information comes in from differant Collector's around the country.

The second column is the Series column, (S means series or stamp) which tells you the time the cigarettes were made, as follows:

• From 1879 to 1917 there is a factory number and the date printed on the stamp.
• From 1917 to 1930 there is a stamp but no series number.
• From 1931 to 1955 there is a stamp and series number.
• From 1956 to 1965 there is no stamp or series number— I called this No Stamp period.
• 1966 to 1970 are the "caution" years.
• 1971 to 1985 are the "warning" years.
• 1986 to present are the "surgeon general" years.

The third, or Manufacturer, column is either the code for the maker of the cigarette, if known, or the merchant whose name appears on the package of cigarettes, who may or may not be the maker.

The fourth column, Vendor, is the code for the merchant whose name is on the package of cigarettes if the cigarette is known to have been made by a different maker; i.e., Benson & Hedges (BEH) on a pack of Virginia Slims made by Philip Morris (PMC).

The fifth column, Year, is (in some cases) the year the brand name was copyrighted or trade marked. In other cases is simply a year in which the brand name was known to have been vended by the named merchant.

The sixth column is the number of cigarettes in the package.

There will be times when you will find a pack, box, or tin that is not listed in this price guide. Just look at the "MFG" date and go from there.

The seventh column is type of cigarettes which are defined as follows:

70's	70mm	F100R or M	filter-100mm-regular taste or menthol.
70's F	70mm, filters.	F120R or M	filter-120mm-regular taste or menthol
70's M	70mm, menthol	FKRL	filter-85mm-regular taste lights.
RKR	non-filter-85mm-regular taste.	FKRU	filter-85mm-regular taste ultra.
RKM	non-filter-85mm-menthol taste.	FKRUL	filter-85mm-regular taste ultra lights.
FKR	filter-85mm-regular taste.	R70O	non-filter-70mm-oval shape.
FQR	filter-85mm-queen size.		

The eighth column, pack kind, is the type of package the cigarettes came in, as follows:

S/P	Soft box.	W/B	Wood box
S/B	Soft and box	B/T	Box tin
R/T	Round tin	C/T	Casket
RT/T	Rectangular tin.	P/B	Plastic box
P/T	Pocket tin	FTB	Flip top box
F/T	Flat tin	CSB	Clam shell box
F/B	Flat box	SSB	Slide and shell box

The ninth column, description, gives a brief description of packs or factory numbers, if known. You may also see the following abbreviations:

CPA	Cigarette Pack Art by Chris Mullen.
SOP	BAW "Special order" packs.
C98	"C" followed by two numbers indicates brand name is listed in Connorton's Tobacco Brand Name Directory for that year, i.e., C98=Connorton's 1998, etc.
TMA	The Tobacco Merchants Association Directory of Cigarette Brands 1864-1988
USP	Underage Sale Prohibited; On all PMC packs starting in last half of 1995.
WCCS-1	Winston Cup Collector's Series #1. 5 different racing car views on 5 different Winston, Winston Select packs.
CCAS-1	Collector's Choice Americana Series (a PMC issue of 5 boxes for collectors.)
CCMS-1	Collector's Choice Medley Series (A PMC issue of 2 each of 5 menthol soft packs for collectors.)
CCMS-2	Collector's Choice Medley Series (A PMC issue of 2 each of 5 menthol soft packs for collectors.) Same as CCMS-1 except for "Underage Sale Prohibited" (USP) on packs.
CCP-A	Camel Collector's Pack—old ads (set of 10 different old ads in 4 different style packs by RJR.)
CCP-J	Camel Collector's Pack—Joe's place (Set of 5 different packs in 6 different styles by RJR.)
CCP-S	Camel/Collector's Pack—States (Set of 10 state name packs in 6 different style packs by RJR.)
CCSS-1	Collector's Choice Skyline series 1 (A PMC issue of 5 boxes for collectors.)
CCSS-2	Collector's Choice Skyline series 2 (A PMC issue of 10 full flavor "red" boxes for collectors.)
CCSS-3	Collector's Choice Skyline Series 3 (A PMC issue of 10 full flavor "red" soft packs for collectors.)
CCSS-4	Collector's Choice Skyline Series 4 (A PMC issue of 10 full flavor "red" soft packs for collectors.) Same as CCSS-3 except fot "Underage Sale Prohibited" (USP) on pack.
CCVS-1	Collector's Choice Vista 1 Series (A PMC issue of 10 light "white" boxes for collectors.)
CCVS-2	Collector's Choice Vista series 2 (A PMC issue of 10 light "white" soft packs for collectors.)
CCVS-3	Collector's Choice Vista Series 3 (A PMC issue of 10 light "white" soft packs for collectors.) Same as CCVS-2 except for "Underage Sale Prohibited" (USP) on pack.

"Trademark" indicates that a distinctive trademark pack exists even though the brand may have been vended routinely or test-marketed with another pack design. Avalon is an example, a well-known BAW brand in the 1920s and 30s that was later issued as a trademark pack. Many trademarks exist with different health warnings or minor design changes. I have not attempted to list these variations. In the case of Brown & Williamson (BAW) only trademark packs with the "square bullseye" are listed in this column. Almost every BAW "square bullseye" trademark brand name is, however, represented by a unique non-trademark pack design—some have several, such as Hallmark or High Score. Many of these are designated "special order" (SPO) packs in the "Remarks" column.

The laws governing registered trademark protection required the manufacturers to periodically place at least a few packs with the registered trademark name for sale at least once every six months or a year, to maintain the validity of the trademark. Most trademark protection packs were soft packs of relatively plain design, as compared to the more colorful commericial packs.

For example, Liggett & Myers (LAM) trademarks are plain white paper with basic black printing. R.J. Reynolds (RJR) are all blue with white print in two different styles. American Tobacco Company (ATC) trademarks are mostly solid-color packs in various colors with black print. For the past twenty or more years Philip Morris has been an exception to this practice, putting out a unique, colorful king size flip-top box for each different trademark. In 1994, however, PMC broke tradition and issued trademark-type soft packs (light, full flavor and menthol) in the Collector's Choice Series.

It is my understanding that the trademark regulations have recently been relaxed and we may see fewer trademark packs in the future. I have seen trademark packs from ATC, BAW, LAM, LOR, PMC and RJR. Larus & Brother also issued some trademark brands before they became The House of Edgeworth (HOE). I would appreciate any data on trademark packs from other companies, so they can be added to the brand name listing.

Until the 1950s the 70mm plain end cigarette was the standard; occasionally they were tipped with cork, colored paper, straw, cellophane, gold or silver, but seldom filtered. Longer 85 and 100mm cigarettes were available but were "specialty" items. Even so, one could ask for Melachrinos, for instance, in a variety of cigarette and package sizes as well as different tips. Since the 1950s king size and 100mm filters have almost become the rule—to the extent that someone asking for a "regular" pack now gets a king size filter pack.

From the 1950s until the present the better-selling brands have appeared in a startling variety of sizes, packages, flavors and configurations. Monarch, by RJR/Forsyth (now "1995" by RJR only), for instance, comes in 15 different sizes and colors of soft packs and boxes. Marlboro and Winston are just as varied. I don' t believe anyone is complaining about this since it certainly helps flesh out the old collection in a big hurry, but it does make record keeping somewhat of a hassle. In these cases, I have listed the different names and have put "All Kinds" in the Type Size and the Pack Kinds columns.

The tenth column is the (approximate) Price for Labels, Empties, and Repacks. A good repack may be worth twice as much as a label or empty.

The eleventh column represents the price for a full pack, which means it must have the original cigarettes in it. In my opinion, the cellophane should be taken off of all packs to prevent it from shrinking and destroying your pack or box.

There are obvious peculiarities in my listings which require explanation. I left out many cigarette names and descriptions do to the lack of information. With the help of you collectors—and anybody else who wants to help—I hope to eventually get most of it sorted out. Please send all information (and pictures, if possible) to Tobacco Barn, P.O. Box 214, Clinton Mo. 64735

Appendix D:

LIST OF CIGARETTE BRAND NAMES AND PRICE LIST

Codes used:

Mfg: Manufacturer;
Ven: Vendor;
YMf: Years manufactured;
#: number in pack;
Type: Type Size;
Pack: Pack Kind;

Brand Name	Series	Mfg	Ven	YMf	#	Type	Pack	Description/Remarks	Empty	Full
A	Sur-Gen	ATC			20	FKR	S/P	Trademark	$6-8	$25-35
A Handfull of Gunston	S-118	LAB	REM	1948	20	70's	S/P	F460-VA, TP-45-VA	$10-15	$40-55
A Hint of Mint	Warning	SHE		1983	20	70's	CSB	TP-161-NY brown and white	$2-4	$7-9
A Puff of Hollywood	S-102	LIC		1925	20	70's	S/P	?	$20-35	$50-65
A Salute to the Armed Forces	S-122	GAG		1952	20	70's	S/P	Consolidated-vultee	$10-15	$40-55
A Touch of Clove	Warning	SHE		1983	20	F100R	CSB	Brown cigarette	$2-4	$7-9
A Trip Kit	Caution	GAG	SMH	1967	10	FKR	S/P	1 of 10 Spoof packs	$20-25	$60-85
A One	?	ECT		1922	?	70's	?	?	$20-25	$60-85
A D' Condois	S-111	CON		1931	20	70's	S/P	F59-2NY	$15-20	$55-65
A Zaphiro	S-1910	ZAP		1912	50	70's	C/T	Also 100ct.	$30-45	$75-115
A.A.	No Series	ATC		1925	20	70's	S/P	?	$20-25	$60-85
A.F.L.	S-138	AFT		1937	20	70's	S/P	AFT was union all the way	$15-20	$55-65
A.J.G.	S-1898	HOZ		1898	10	70's	SSB	C98	$35-50	$90-115
A.O.F.L.	S-1898	FEN		1898	10	70's	SSB	C98	$35-50	$90-115
AAAAA	S-1898	ATD	DRU	1898	10	70's	P/T	C98	$35-50	$90-115
AAAHHH	Sur-Gen	LOR		1987	20	FKR	S/P	Your name cig. co	$6-8	$25-35
AAAN Advert.	S-121	GAG	YNC	1951	20	70's	S/P	C98	$20-25	$60-85
Aaron Burr	S-1898	FEN		1898	10	70's	SSB	?	$35-50	$90-115
Abdallah No. 13	S-1898	ATD	MON	1899	?	70's	?	F363-3NY	$35-50	$90-115
Abdallah No. 13	S-1898	MON		1899	?	70's	?	?	$35-50	$90-115
Abdulla Imperial	S-1901	ATD		1907	10	70's	F/B	Black w/silver trim	$35-50	$90-115
Abdulla	S-1901	ABD		1905	20	70's	F/B	?	$35-50	$90-115
Aberdeen	S-1898	HRB		1898	?	70's	?	C98	$35-50	$90-115
Aberdia	S-1898	JAE		1898	10	70's	S/P	C98	$35-50	$90-115
Ac'cent	S-122	IMC		1952	20	70's	?	?	$10-15	$40-55
Acapulco Gold	Warning	GEL		1972	20	FKR	S/P		$2-4	$7-9
Accord	Sur-gen	PMC		1995	20	FKR	S/P	Red (For Collector's)	$1-2	$6-8
Ace of Trumps	S-1879	ALG		1880	10	70's	SSB	Picture on pack	$75-100	$200-250
Acme	S-1887	MRB		1887	20	70's	S/P	C98.	$50-65	$150-190
Acme Hardware	S-121	GAG	YNC	1951	20	70's	S/P	F407-2NY	$10-15	$40-55
Act III	Warning	BAW		1975	20	FKR	S/P	White w/black letters	$2-4	$7-9
Actron	Warning	BAW		1971	20	FKR	S/P	Trademark	$6-8	$25-35
Actual	Warning	RJR		1975	20	FKR	S/P	Trademark	$6-8	$25-35
Adair	Warning	LAM		1975	?	FKR	S/P	Trademark	$6-8	$25-35
Adalinda	S-1898	KLR		1898	?	70's	S/P	C98.	$35-50	$90-135
Adam	Warning	LAM		1971	20	FKR	S/P	Brown (with man's face)	$3-5	$8-12
Adam	Warning	LAM		1972	20	FKR	S/P	Brown (riveted leather)	$3-5	$8-12
Adam	Warning	LAM		1972	20	FKR	S/P	Brown (riveted leather)	$3-5	$8-12
Adelina Patti, La	S-1898	SCK		1898	?	70's	?	C98	$35-50	$90-135
Adept	Warning	PMC		1977	20	FKR	S/P	?	$3-5	$8-12
Adlai	S-1898	OWL		1898	?	70's	?	C98	$35-50	$90-135
Adlai E.Stevenson	S-1898	OWL		1898	?	70's	S/P	C98	$35-50	$90-135

Brand Name	Series	Mfg	Ven	YMf	#	Type	Pack	Description/Remarks	Empty	Full
Admiral	S-1887	NAT		1898	10	70's	CSB	C98, Eagles Head.	$50-65	$150-190
Admiral	S-1910	UNI		1914	?	70's		?	$30-45	$75-115
Admiral Dewey	S-1887	ATD	DUK	1895	?	70's		?	$50-65	$150-190
Admiral Specials	S-1898	NAT		1898	20	70's	F/B	C98	$35-50	$90-135
Admiral, High	S-1887	NAT		1893	20	70's	F/B	Eagles head	$50-65	$150-190
Admiration	S-1901	FER		1901	?	70's		?	$35-50	$90-135
Adonis	No Series	BAB		1926	10	50's	C/B	Smallest U.S. Cig. made	$75-100	$200-250
Adsyn	S-1910	NTP		1911	10	70's	SSB	F930-1NY	$30-45	$75-115
Advance	Warning	ATC		1970	20	FKR	S/P	Red and white	$2-4	$7-9
Adventure	Warning	RJR		1983	20	FKR	S/P	Blue w/gold stripes	$2-4	$7-9
Advertising Age	S-122	GAG	YNC	1952	20	70's	S/P	F407-2NY Your name Cig.	$20-25	$60-85
Advertising Club	S-118	GAG		1948	20	70's	S/P	F407-2NY	$20-25	$60-85
Aetna	S-1898	LEO		1898	10	70's	CSB	C98	$35-50	$90-135
Affair	Warning	BTC		1970	20	FKR	S/P		$2-4	$7-9
Affaire	Warning	WIL		1980	20	FKR	S/P	Non-tobacco cigarette	$3-5	$8-12
Afra (or Afro)	Warning	ITC		1970	20	FKR	S/P	?	$2-4	$7-9
Afrodite	S-1898	STP		1898	?	70's	S/P	?	$35-50	$90-135
Afros	S-1910	STP		1912	10	70's	CSB	F2032-1PA	$35-50	$90-135
After Dinner	S-1898	GDM		1898	10	R100R	F/B	Red/ Gold seal upper ctr.	$35-50	$90-135
After Dinner Mints	Sur-Gen	SHE		1989	?	FKM	CSB	TP-161-NY	$6-8	$25-35
Afternoon	No Series	ATC	PRU	1923	20	70's	S/P	F485-2NY	$20-25	$60-85
Afternoon Egyptian	No Series	ATC	PRU	1923	10	70's	SSB	TMA	$20-25	$60-85
Afternoon Egyptian Mouthpiece	S-108	ATC	PRU	1934	20	RKR	F/B	Blue and gold trim	$15-20	$55-65
Afternoon Plain	No Series	ATC	PRU	1923	20	70's	S/P	F485-3NY	$20-25	$60-85
Afternoon Plain # 2	No Series	ATC	PRU	1923	20	70's	S/P	F485-3NY	$20-25	$60-85
Afternoon Turkish # 1	No Series	ATC	PRU	1923	20	70's	SSB	F485-3NY	$20-25	$60-85
Afternoon Turkish # 1 Cork Tip	No Series	ATC	PRU	1923	10	RKR	F/B	F485-3NY	$20-25	$60-85
Afternoon Turkish # 2	No Series	ATC	PRU	1923	20	70's	S/P	F485-3NY	$20-25	$60-85
Afternoon Turkish # 2 Cork Tip	No Series	ATC	PRU	1923	10	70's	CSB	F485-3NY	$20-25	$60-85
Afternoon Turkish # 3	No Series	ATC	PRU	1923	20	70's	CSB	F485-3NY	$20-25	$60-85
Afternoon Turkish # 3 Cork Tip	S-108	ATC	PRU	1923	20	70's	CSB	F485-3NY	$20-25	$60-85
Afterthought	S-1898	SMR		1898	20	70's	CSB	Green w/logo upper left	$35-50	$90-135
Agnes	S-1898	ECC		1898	10	70's	SSB	C98	$35-50	$90-135
Agree	Warning	BAW		1980	20	FKR	S/P	White w/blue & yellow sq.	$2-4	$7-9
Ah Kim	S-1898	BOL		1898	20	70's	S/P	C98	$35-50	$90-135
Ahead	Warning	RJR		1976	20	FKR	S/P	Trademark	$6-8	$25-35
Ahead of the times	S-1898	BCK		1898	10	70's	SSB	C98	$35-50	$90-135
Aidee	S-1901	MYR		1905	?	?	S/P	?	$35-50	$90-135
Air Corps	S-111	AFT		1937	20	FKR	S/P		$15-20	$55-65
Air Force One	Warning	LAM		1975	20	FKR	S/P	Most Mfg. Sleefes & Inserts	$15-20	$55-65

Brand Name	Series	Mfg	Ven	YMf	#	Type	Pack	Description/Remarks	Empty	Full
Air Force Two	Warning	LAM		1975	20	FKR	S/P	Most Mfg. Sleeves & Inserts	$15-20	$55-65
Air-Flow	S-111	RIG		1942	20	70's F	S/P	White/Fuller flavored	$15-20	$55-65
Air-Flow	No Series	REM		1956	20	RKR	S/P	Lt Blue w/2 clouds	$6-8	$25-35
Air-Lite	No Series	LAM		1965	20	?	?	Trademark	$6-8	$25-35
Atro-o-matic	Caution	HUD		1965	20	FKR	S/P	F24-KY	$3-5	$8-12
Airdrome	S-108	AFT		1936	20	70's	F/B	Blue w/airplane flying Rt.	$15-20	$55-65
Airline	S-111	REE	REE	1941	20	70's	SSB	Green w/airplane flying Lf.	$15-20	$55-65
Airline	S-125	LAB		1951	20	70's	SSB	Blue w/airplane flying Lf.	$10-15	$40-55
Airline	S-109	REE		1941	20	FKR	S/P	Test Market	$10-15	$40-55
Airmark	Warning	LBC		1976	20	70's	S/P	White on Black	$6-8	$25-35
Airways	Ser-Gen	BAW		1989	20	70's	S/P	?	$1-2	$6-8
Airways	S-106	BAW		1936	20	FKR	S/P	White w/picture of lady	$2-4	$6-8
Airy Fairy	S-118	RIG		1948	10	70's	S/P	Yellow w/picture of lady	$35-50	$90-135
Aladdin	S-1887	WLK		1922	20	70's	S/P	C87	$35-50	$90-135
Alamo	No Series	LAM		1960	20	70's	S/P	Trademark	$2-4	$7-9
Alamo	S-1887	GNS		1887	20	70's	SSB	C87, C98	$50-65	$150-190
Alarm	Warning	PMC		1960	20	FKR	FTB	F1-VA	$50-65	$150-190
Albemarle Pippins	S-1887	FEL		1921	20	70's	S/P	C98	$6-8	$25-35
Albert Edward	No Series	USV		1898	20	70's	S/P	Trademark	$50-65	$150-190
Albert Steinberg, Electronic Parts	S-1898	HOZ		1898	?	70's	S/P	?	$20-25	$60-85
Albion	S-121	GAG	YNC	1951	20	70's	S/P	White w/your name	$35-50	$90-135
Aldea	S-1898	AEC		1900	20	70's	S/P	F603-2NY, picture of horse	$10-15	$40-55
Alden	No Series	EPS		1923	20	70's	F/B	Denicotinized	$10-15	$40-55
Alden Park	S-118	JAT		1948	20	70's	F/T	T/B w/white label	$50-65	$150-190
Alduna	S-110	MID		1940	50	70's	F/B	Dark red w/gold trim	$50-65	$150-190
Alexandria	S-125	ATD	ECK	1955	10	70's	SSB	C87	$50-65	$150-190
Alexandria	S-1887	ECK		1895	10	70's	SSB	C87	$50-65	$150-190
Alf and Alf	S-1898	KLC		1887	10	70's	SSB	C98	$6-8	$25-35
Alhambra	S-1898	MIL		1898	10	70's	CSB	C98, F2-NY	$1-2	$6-8
Alhambra	S-1898	ANS		1898	12	70's	CSB	Same as above	$2-4	$7-9
Ali Pasha	Warning	THE		1975	20	F120R	S/P	F320-3NY	$35-50	$90-135
All American	S-1901	AFT		1907	10	FKR	F/B	May be F24-KY or F57-KY	$15-20	$55-65
All American	S-114	AFT		1916	10	70's	SSB	Red w/picture of eagle	$15-20	$55-65
All American	S-111	AFT	ALA	1942	20	70's	RKR	Red w/picture of eagle	$50-65	$150-190
All Around	S-1887	ULM		1941	24	70's	F/B	C87, C98	$15-20	$55-65
All Day	S-107	AFT		1937	20	FKR	S/P	F24-KY	$35-50	$90-135
All Jacks	S-111	CHR		1929	20	70's	S/P	Red w/pic. of all jacks	$35-50	$90-135
All Over	S-1898	CAM		1898	?	FKR	S/P	?	$1-2	$6-8
Allstar	Hazard	RTC		1988	20	70's	S/P	White w/silver stars	$60-85	$150-190
Allago	S-1901	MIL		1901	10	70's	CSB	C98, F2-NY	$60-85	$180-225
Allen & Genter	S-1883	ALG		1885	10	70's	SSB	F25-VA	$10-15	$40-55
Alligator	S-117	LAB		1946-	20	RKR	S/P	White top w/gator	$35-50	$70-95
Alma	No Series	TPC		1922	20	70's	P/T	?	$35-50	$90-135
Alma London Cig.	S-1901	KHE		1905	10	FKR	CSB	F279-5NY, red	$35-50	$90-135
Alma Mater	S-1901	BEH		1901	20	70's	CSB	?	$6-8	$25-35
Almaz	Warning	LAM		1976	20	FKR	S/P	F25-2NY	$15-20	$55-65
Aloha	S-1898	ALG		1937	20	FKM	S/P	F24-KY	$35-50	$90-135
Aloma	S-1898	ECK		1898	?	70's		C98	$1-2	$5-8
Alpha	Warning	PMC		1977	20	FKM	S/P	Trademark	$20-25	$60-85
Alpha	No Series	HOW		1898	?	70's	S/P	White w/black letters	$6-8	$25-35
Alphil	Caution	LAM		1968	20	FKR	S/P	White w/black letters	$1-2	$6-8
Alpine	Warning	PMC		1962	20	FKM	S/P	Green & white	$1-2	$6-8
Alpine	Sur-Gen	PMC		1973	20	FKM	S/P	Trademark	$15-20	$55-65
Alpine	S-108	PMC		1936	20	FKM	S/P	Picture of Mtn,	$2-4	$7-9
Alps	Warning	AFT		1968	20	FKR	FTB	Black and blue lines	$35-50	$90-135
Altares	S-1898	DMZ		1898	?	70's		?	$60-85	$180-225
Alto	Warning	SHE		1975	20	FKR	S/P	Made/for Sammy Davis Jr.	$10-15	$40-55
Alumidor	S-117	BAW		1947	20	FKR	S/P	F36-KY	$6-8	$25-35
Always Save	Sur-Gen	LAM	ASW	1988	20	FKR	S/P	Trademark	$20-25	$60-85
Aly Zaman	No Series	CUI		1926	20	70's	S/P	F556-2NY	$30-45	$75-115
Am Pm	S-1910	?		1912	10	70's	S/P	C98	$3-5	$8-12
Amaze	Caution	LAM		1968	20	FKR	S/P	White w/black letters	$2-4	$7-9
Amaze	Warning	LAM		1975	20	FKR	S/P	White w/black letters	$20-25	$60-85
Ambar	No Series	BEH		1927	10	70's	S/P	Dark beige w/gold tip	$1-2	$6-8
Ambar	Sur-Gen	BEN		1924	18	70's	CSB	F213-1CA	$15-20	$55-65
Ambar Turkish	S-1885	BEH		1945	20	70's	S/P	Picture of Mtn,	$10-15	$40-55
Ambassador	S-1887	KIN		1887	10	70's	SSB	F593-MD	$50-65	$150-190
Ambassador	Warning	PMC		1967	20	FKR	S/P	Trademark	$6-8	$25-35

Brand Name	Series	Mfg	Ven	YMf	#	Type	Pack	Description/Remarks	Empty	Full
Ambassador	S-1887	ATD	KIN	1891	20	70's	F/B	C98, F593-MD	$50-65	$150-190
Ambassador, The Duo-Blend	S-118	GAG		1948	20	70's	S/P	F407-2NY	$10-15	$40-55
Ambassador	S-1887	MON		1887	?	70's	S/P	F363-3NY	$50-65	$150-190
Amber	Caution	RJR		1970	10	FKR	S/P	Trademark	$6-8	$25-35
Amber	No Series	SMB		1926	20	70's	F/B	F141-6CA	$20-25	$60-85
Ambra	No Series	RSD		1925	20	70's	S/P	F916-1NY	$20-25	$60-85
Ambre Rouge	S-1898	WOS		1898	20	70's	SSB	C98	$35-50	$90-135
America's Emblem	S-1898	LAM		1992	20	FKR	S/P	Red, White & Blue	$1-2	$6-8
America, Taste of	Sur-Gen	ATC		1959	20	FKR	S/B	White w/3 gold bands	$6-8	$25-35
American	No Stamp	ATC		1994	20	FKR	S/P	White w/blue bands	$1-2	$6-8
American	Sur-Gen	GOR		1987	20	All Kinds	S/B	?	$2-4	$7-9
American All Star	S-1898	KAU		1898	?	FKR	S/P	C98,	$35-50	$90-135
American Babies	S-1898	ATD		1898	?	70's		C98,	$35-50	$90-135
American Beauties	Sur-Gen	SHE		1989	10	FKQ	F/B	Blue w/American flag	$2-4	$7-9
American Beauty	S-1887	ATD		1890	20	FKQ	F/B	?	$50-65	$150-190
American Beauty	S-1910	LAM		1911	20	70's	S/P	White w/picture of ship	$30-45	$75-115
American Beauty	S-122	LAM		1952	20	70's	S/P	?	$10-15	$40-55
American Belles	S-1898	WKD		1898	?	70's	S/P	C98	$35-50	$90-135
American Brand	Warning	ATC		1968	20	FKR	S/B	Gold and Red on White	$2-4	$7-9
American Brands	Warning	ATC		1968	20	FKR	S/P	Trademark	$6-8	$25-35
American Eagle	Caution	ATC		1967	20	FKR	S/P	Trademark	$35-50	$90-135
American Eagle	S-1910	GAG	YNC	1912	20	70's	S/P	Your Name Cigarette	$20-25	$60-85
American Envelope	S-121	ATC		1974	?	70's	S/P	Trademark	$6-8	$25-35
American Filters	Warning	WES		1989	20	All Kinds	FTB	Blue and white stripes	$2-4	$7-9
American Filters	Sur-Gen	HEL		1899	10	70's	S/P	Could be made by LOR	$35-50	$90-135
American Gentlemen	S-1898	FUR		1898	20	70's		C98	$35-50	$90-135
American League	Warning	ATC		1976	20	F120R	S/P	Red Rt. 3/4 White on LF.	$2-4	$7-9
American Lights	Warning	ATC		1976	20	F120M	S/P	C98	$6-8	$25-35
American Lights	Warning	ATC		1975	20	F120R	S/P	Trademark	$6-8	$25-35
American Longs	Warning	ATC		1975	20	F120M	S/P	3/4 Green on Rt. White LF.	$2-4	$7-9
American Lord	S-1898	WSM		1898	?	FKR	S/B	C98	$35-50	$90-135
American Man	S-1898	CRO		1898	?	FKR	S/P	C98	$35-50	$90-135
American Melowicks	S-110	GAG	SRT	1940	20	FKR	S/P	F407-2NY	$15-20	$55-65
American Messenger	S-1898	OBL		1912	10	70's	S/P	C98	$35-50	$90-135
American Mixture	S-1910	FAL		1912	10	70's	S/B	?	$30-45	$75-115
American Ovals	Caution	ATC		1969	20	F100R	S/P	Gold weave basket look,	$3-5	$8-12
American Premium	Export	RJR	FLD	1992	20	FKR	FTB	Gold and white	$1-2	$6-9
American Queen Box	Export	RJR		1995	20	FKR	FTB	?	$1-2	$4-5
American Spirit	Sur-Gen	SFN		1996	10	All Kinds	S/B	Indian headress & valcano	$75-100	$200-250
American Standard	S-1879	KIN		1882	10	70's	SSB	F593-MD	$35-50	$90-135
American US Hanana	S-1898	RSH		1898	20	70's	SSB	C98	$35-50	$90-135
American Wholesaler	S-121	GAG		1951	20	FKR	S/P	F407-2NY	$10-15	$40-55
American Youth	S-1898	CRO		1898	10	70's		C98	$35-50	$90-135
Ames Futuristic 5	S-121	GAG	YNC	1951	20	70's	S/P	Your name cigarette Co.	$2-4	$7,9
Amherst	Warning	RJR		1983	20	FKR	S/P	Blue w/white gold lines	$35-50	$90-135
Amidon	S-1898	SHE		1898	10	70's	CSB	C98	$1-2	$5-8
Amigos	Sur-Gen	OUS		1989	20	F100R	S/P	With Sombrero	$35-50	$90-135
Amir Dar	S-1898	GAG		1898	?	70's		C98	$35-50	$90-135
Amitie	Sur-Gen	USJ	BYE	1993	20	FKR	S/P	TP-3-VA	$1-2	$5-8
Ammon	S-104	KHR	SOB	1934	20	FKR	F/B	Black w/gold trim	$15-20	$55-65
Ammon	No Series	DUK		1924	10	RKR	RKR	F266-3MA	$20-25	$60-85
Amorita	S-1887	GAG		1887	16	70's	SSB	C87	$50-65	$150-190
Amorita	S-1910	ATD	DUK	1910	10	70's	S/P	F42-4NC (or MIL F2-NY)	$50-65	$150-190
Anchor	S-1887	WITC		1887	10	70's	SSB	Blure w/white gold lines	$30-45	$75-115
Andover	Warning	BAW		1980	10	FKR	S/P	Trademark	$6-8	$25-35
Andover	No Series	GAG		1986	18	70's	CSB	Special Order Pack	$35-50	$90-135
Andron	No Stamp	GAG		1925	10	FKR	F/B	F407-2NY	$20-25	$60-85
Andron Black & Gold	No Stamp	GAG		1959	20	FKR	S/P	TP-75-NY	$6-8	$25-35
Andron Egyptian Specials	S-124	GAG		1954	10	70's	F/B	White w/gold red stripes	$10-15	$40-55
Andron Filters 102's	Warning	GAG		1978	20	RKR	F/B	Black w/gold trim	$2-4	$7-9
Andron Special	S-123	GAG		1953	10	FKR	S/P	White w/gold red seal	$10-15	$40-55
Andron Special	Warning	GAG		1968	20	FKR	F/B	Black w/gold lines	$3-5	$8-12
Andron Variety	Caution	GAG		1967	16	RKR	F/B	Black w/gold trim (large)	$3-5	$8-12
Angel Food	S-1887	KLS		1898	10	70's	SSB	C98	$35-50	$90-135
Anglo-Egyptian # 1	S-1898	AEC		1900	10	70's	S/P	Picture of Mummy	$35-50	$90-135
Annapolis	Warning	GAG		1972	18	70's	CSB	Blue w/dk, blue trim	$6-8	$25-35
Annie's	S-1898	MHR		1898	?	70's	S/P	C98	$35-50	$90-135
Anotta	S-1898	BRC		1898	?	70's	S/P	C98	$35-50	$90-135

Left table

Brand Name	Series	Ven	Mfg	YMf	#	Type	Pack	Description/Remarks	Empty	Full
Anthos	S-103		OCC	1933	20	70's	S/P	C98	$15-20	$55-65
Anti Deluvian	S-1898		SRN	1898	10	70's	SSB	C98	$35-50	$90-135
Anti-Trust	S-1898		CLL	1898	10	70's	SSB	C98	$35-50	$90-135
Antonio Go Go	Caution	ANC	ANC	1965	20	FKR	S/P	C98	$6-8	$25-35
Anubis	S-1898		SRN	1898	10	70's	CSB	C98	$35-50	$90-135
Apache	Warning		ATC	1967	20	FKR	S/P	Trademark	$6-8	$25-35
Apex	Sur-Gen		CAM	1898	10	FKR	S/P	C98	$3-5	$8-12
Apollo Egyptian	Sur-Gen		RJR	1995	10	FKR	S/P		$30-45	$75-115
Apollo Metal Works	S-1898		CRE	1898	10	70's	SSB		$35-50	$90-135
Apollo Raleigh	S-121		GAG	1951	20	70's	S/P	Your name cigarette co.	$20-25	$60-85
Apollo	S-121	YNC	GAG	1951	20	70's	S/P	Your name cigarette co.	$2-4	$7-9
Apollo-Soyuz	Warning	YNC	PMC	1975	20	FKR	FTB	Commemorates US/USSR	$2-4	$7-9
Appeal	Warning		RJR	1976	20	FKR	S/P	Trademark	$3-5	$8-12
April	Caution		RJR	1967	20	FKR	S/P		$2-4	$7-9
Aquarius	Caution		PLA	1969	10	FKR	S/P	Also Mfg. by ARA,MAR	$30-45	$75-115
Arabesca	S-1910		ANA	1912	10	70's	F/B		$3-5	$8-12
Arabian Nights	S-101		ARB	1931	20	70's	SSB	White top blue btm.	$3-5	$8-12
Arbor	Caution		RJR	1965	20	FKR	S/P	?	$2-4	$7-9
Arcee	Warning		ATC	1970	20	FKR	S/P	?	$2-4	$7-9
Archer	Warning		BAW	1975	20	FKR	S/P	?	$2-4	$7-9
Architect	S-1898		FEN	1898	10	70's	SSB	C98	$35-50	$90-135
Arctic	Caution		ATC	1964	20	FKR	S/P	Blue w/sky	$6-8	$25-35
Arctic Lights	Warning		BAW	1979	20	FKR	S/P	Same as above	$2-4	$7-9
Arctic Lights	Warning		BAW	1979	20	FKM	S/P	Trademark	$2-4	$7-9
Arden	Caution		RJR	1964	20	FKR	S/P	Orange and yellow	$6-8	$25-35
Ardsley	Warning		LAM	1975	20	70's	S/P	Trademark	$15-20	$55-65
Argus	S-1898		MIL	10	20	70's	S/P	C98, F2-NY	$35-50	$90-135
Argyle	Sur-Gen		PMC	1992	?	FKR	SSB	White w/4 orange lines	$2-4	$7-9
Aries	Sur-Gen		PMC	1994	20	FKML	FTB	CCMS-2, Same as above	$6-8	$25-35
Aries Menthol Lights	S-112		STP	1942	20	FKML	S/P	F2032-1PA	$2-4	$7-9
Aristocrat	S-1898		MKR	1898	10	70's	SSB	C98	$15-20	$55-65
Aristocrats	No Stamp	BEN	GAG	1962	20	70's	S/P	Georgopulo	$35-50	$90-135
Aristpho No. 1	S-1901		ARI	1902	?	70's	S/P	?	$35-50	$90-135
Arizona Lights	Sur-Gen		PMC	1995	20	FKR	S/P	CCVS-2, White	$1-2	$6-8
Arizona Lights	Sur-Gen		PMC	1992	20	FKR	FTB	CCAS, White	$1-2	$6-8
Arizona Lights	Sur-Gen		PMC	1994	20	FKR	FTB	CCVS-1, White	$1-2	$6-8
Arkansaw	S-1898		THC	1898	?	70's	?	?	$35-50	$90-135
Armenia Oriental	Warning	CDG	MDH	1926	20	FKR	S/P	Also ATD	$20-25	$60-85
Armiro Superior	S-1887		MON	1887	10	70's	SSB	Khki	$15-20	$55-65
Armored Force	S-115		AFT	1941	20	70's	?	Was cig. co	$20-25	$60-85
Armour 62nd Rd. up	S-122		GAG	1952	20	70's	S/P	Was Mt. Generic at LAM	$20-25	$60-85
Armstead Brock	Warning	YNC	LAM	1898	10	FKR	S/P	C98	$35-50	$90-135
Army	S-1898		CMM	1898	20	70's	S/P	C98	$10-15	$40-55
Aroma	S-118		GAG	1948	20	FKR	S/P	F407-2NY	$10-15	$40-55
Aromatic	S-1898		ROD	1898	10	70's	F/B	C87	$50-65	$150-190
Aromatique, Dubec	S-1887		KIM	1887	10	70's	S/P	C98	$35-50	$90-135
Aronia	S-1898	ALG	ATD	1898	10	70's	CSB	C98	$35-50	$90-135
Arrow	No Series		MRN	1898	20	70's	SSB	?	$35-50	$90-135
Arthur E. Wilsong Co.	Warning		BLO	1920	20	FKR	S/P	Beige, green and gold	$20-25	$60-85
Ascot	S-121	YNC	GAG	1951	20	FKR	S/P	Same as above	$20-25	$60-85
Aspen	S-125	CNT	PMC	1954	20	FKR	S/P	C98, F2-NY	$10-15	$40-55
Aspen	Caution		LOR	1950	10	FKR	S/P	Trademark	$3-5	$8-12
Aspen	Warning		LOR	1967	20	FKR	S/P	Test Market	$3-5	$8-12
Asthmador	No Stamp		LOR	1979	20	FKM	S/P	Green and white	$15-20	$55-65
Astgnadir	S-1898		SCF	1892	12	F100M	F/B	Green, white trim	$20-25	$60-85
Astonisher	S-1898		SCF	1980	24	RKR	F/B	Same as above	$65-75	
Astor	S-1898		MEU	1898	10	70's	?	C98	$15-20	$55-65
Astor, The	Warning	PAV	PAV	1985	20	FKR	S/P	Beige, green and gold	$2-4	$7-9
Astor, The	Warning		PAV	1985	20	FKR	S/P	Same as above	$6-8	$25-35
Astron	S-121		GAG	1950	20	FKR	S/P	F407-2NY	$20-25	$60-85
Astron Ladies	Warning		LAB	1940	20	FKR	S/P	Trademark	$10-15	$40-55
Asuf	S-1901		TUR	1903	10	70's	SSB	F460-VA, F2109-3NY	$35-50	$90-135
At Ease	Caution		TUR	1967	20	FKR	S/P	Blue w/gold & red letters	$15-20	$55-65
At East	S-101		SLA	1931	20	70's	CSB	?	$2-4	$7-9
At The Foundation	Sur-Gen		ATC	1967	20	FKR	S/P	Trademark	$10-15	$40-55
ATC	S-1901		BUT	1967	20	FKR	S/P	Trademark	$6-8	$25-35
Atco	Warning		ATC	1967	20	FKR	S/P	Trademark	$6-8	$25-35
Atco	Warning		ATC	1965	20	FKR	S/P	Trademark	$6-8	$25-35

Right table

Brand Name	Series	Ven	Mfg	YMf	#	Type	Pack	Description/Remarks	Empty	Full
Atco	?		ATC	?	8	70's	P/T	F1673-1IL	$25-35	$70-95
Athenian	S-1887		CTM	1895	10	FKR	SSB	Star in box, Three types	$50-65	$150-190
Atkinsons	Sur-Gen		CHP	1988	10	70's	SSB		$2-3	$6-8
Atlantic	S-1898		KSR	1898	10	70's	SSB	C98	$35-50	$90-135
Atlantic City	Warning	ATL	DOS	1982	20	FKR	S/P	Dark red w/white band	$2-4	$7-9
Atlantis	Warning	YNC	LOR	1971	20	FKR	S/P		$2-4	$7-9
Atlas Waste Paper	Warning		GAG	1898	20	FKR	S/P	Trademark	$20-25	$60-85
Atom	S-121		LEI	1951	20	70's	S/P	Your cigarette co.	$10-15	$40-55
Attache	S-115		RJR	1945	20	RKR	F/B	Red w/white trim	$2-4	$7-9
Au Claire, Nestor Gianaclis	Warning		GIA	1967	20	FKR	S/P		$35-50	$90-135
Au-Noir	S-1898		MIL	1898	?	70's	S/P	C98, F2-NY	$35-50	$90-135
Augusta	S-1898		MRT	1898	?	70's	S/P	C98	$35-50	$90-135
Aura	Warning		LOR	1973	20	FKR	S/P		$2-4	$7-9
Austin	Caution		RJR	1963	20	FKR	S/P	Trademark	$6-8	$25-35
Austin	Warning		RJR	1967	20	FKR	S/P	Blue, w/gld, white stripes	$2-4	$7-9
Austin	Sur-Gen		RJR	1988	20	FKR	S/P	3 Multi. colors bars	$2-4	$7-9
Austin	Sur-Gen		RJR	1993	20	FKR	S/P	W/gold sun	$1-2	$4-6
Autocrat	S-1898		ATD	1898	20	All Kinds	S/B	C98	$35-50	$90-135
Autograph	S-114	GOO	AUO	1941	20	70's	S/P	F24-14NY	$15-20	$55-65
Autolite	S-1901		AUT	1903	20	70's	S/P	Self-lighting	$35-50	$90-135
Avalon	No Series		KLS	1921	30	70's	S/P	Packed 40's also	$20-25	$60-85
Avalon	S-112		BAW	1936	20	70's	S/P	White & red (with pennies)	$35-50	$90-135
Avalon	S-106		BAW	1936	20	70's	S/P	White & red (no pennies)	$15-20	$55-65
Avalon	Warning		BAW	1977	20	FKR	S/P	Red w/3 gold checks	$2-4	$7-9
Avalon	Warning		BAW	1982	20	FKR	S/P	Trademark	$6-8	$25-35
Avanore	S-113		BRC	1943	20	FKR	S/P	Blended with latakia	$15-20	$55-65
Avanti	S-1898		PMC	1987	?	FKR	S/P	C98 (Also Avanore)	$35-50	$90-135
Avila	Ser-Gen		PMC	1962	20	FKR	S/P	Trademark	$6-8	$25-35
Avoca Villa	No Stamp		KLS	1898	10	FKR	S/P	?	$2-4	$7-9
Aware	Warning		RJR	1976	20	FKR	SSB	C98	$35-50	$90-135
Axminster	S-1898		BOY	1898	?	70's	S/P	C98	$2-4	$7-9
Axton V.S.	S-114		AFT	1944	20	70's	S/P	Made on one year	$35-50	$70-95
Axton Vintage Spec.	S-120		AFT	1950	?	RKR	F/B	F24-KY, Brown w/gold trim	$10-15	$40-55
Axton's Vintage Spec	S-113		AFT	1942	20	70's	CSB	F24-KY	$15-20	$55-65
Aztecas	S-110		GOL	1931	10	70's	CSB	Dark blue, gold letters	$20-25	$60-85
B & P Egyptian	No Series		BEN	1924	?	70's	S/P	F213-1CA	$20-25	$60-85
B & W	No Series		BEN	1922	20	70's	S/P	F213-1CA	$20-25	$60-85
B & W Jacks	Warning		BAW	1959	20	FKR	S/P	Trademark	$6-8	$25-35
B V	Sur-Gen		RJR	1984	20	FKR	S/P	Different Pack than B & W	$2-4	$7-9
B&W Extra	No Stamp	FOR	RJR	1995	20	FKR	S/P	Large B V on front of pack	$1-2	$4-6
B&W Extra	Warning		BAW	1964	20	FKR	S/P	Trademark	$6-8	$25-35
B.L.	Warning		BAW	1984	20	FKR	S/P	White w/blue & yellow sq.	$2-4	$7-9
B.M.H. Inc.	S-1898		BUL	1898	10	70's	SSB	C98	$35-50	$90-135
Baby Appy	No Series	PSK	CON	1928	20	70's	S/P	Your name cig. co.	$20-25	$60-85
Baby Grand	S-1898		ULM	1898	?	70's	S/P	C98	$35-50	$90-135
Baby Pak	S-107		AFT	1937	10	70's	S/P		$15-20	$55-65
Bafrah	No Stamp		PAL	1957	20	70's	?	F72-1NY	$6-8	$25-35
Bafrah	S-1989		WNE	1887	?	70's	?		$35-50	$90-135
Bagdad	Warning	MON	ATD	1980	10	FKR	S/P	C98	$35-50	$90-135
Bagley's Sweet Tip	S-109		POU	1899	20	70's	F/B	Trademark	$20-25	$60-85
Baiaderka	S-1898		BAG	1923	10	70's	F/B	For 1939 worlds fair	$10-15	$40-55
Bailey's	S-1898			1898	20	FKR	S/P	Bl. w/lady sitting	$20-25	$60-85
Batram Egyptian	Sur-Gen		SAR	1898	?	70's	F/B	Red, green and white	$2-3	$4-6
Balance	S-1901	SAM	ATD	1905	20	FKR	S/P	Moving picture booklets,	$35-50	$90-135
Balfour	Warning		LAM	1973	20	70's	?	White w/black letters	$35-50	$90-135
Balsam	No Series		PAL	1926	20	70's	?	F72-1NY	$35-50	$90-135
Baltimore Pearls	Warning		WNE	1898	20	70's	S/P	C98	$2-4	$7-9
Banack	Warning		ATC	1980	10	FKR	S/P	Trademark	$35-50	$90-135
Bankers Club of America	S-1898		BKE	1898	?	70's	S/P	?	$6-8	$25-35
Bankers' Puffs	Warning		RJR	1973	20	FKR	S/P	Purple w/white band	$2-4	$7-9
Banner	S-117		GAG	1937	20	70's	F/B	C98	$15-20	$55-65
Banneret	S-1898		HLL	1898	?	70's	S/P	C98	$15-20	$55-65
Banquet	S-1887		BLA	1887	?	70's	?	C87, C98	$2-4	$7-9
Banquet	S-106		AFT	1936	20	FKR	S/P	F24-KY	$50-65	$150-190
Banquet	S-107		PMC	1937	10	FKR	Box	Light brown, w/lion seal	$15-20	$55-65
Bantam	S-110		SSS	1956	10	115's R	Box	Light brown, in glass cases	$6-8	$25-35
Bantam Havana	S-114		RYT	1944	?	120's R	F/B	F139-3NY	$15-20	$55-65
Banyon	Warning		BAW	1984	20	FKR	S/P	Textured, Blend cigaretos	$10-15	$40-55
								Trademark	$6-8	$25-35

Top table (Belair – Big Hit)

Brand Name	Series	Mfg	Ven	YMf	#	Type	Pack	Description/Remarks	Empty	Full
Belair	No Stamp	BAW		1963	20	FKM	S/P	1/2 white, 1/2 shaded blue	$6-8	$25-35
Belair	Caution	BAW		1967	20	FKM	S/P	1/2 white, 1/2 shaded blue	$3-5	$8-12
Belair	Warning	BAW		1977	20	FKM	S/P	1/2 white, 1/2 shaded blue	$2-4	$7-9
Belair	Sur-Gen	BAW		1991	20	All Kinds	S/P	1/2 white, 1/2 shaded blue	$1-2	$3-5
Belle Of The Orient	No Series	SCI		1926	?	70's	?	?	$20-25	$60-85
Belle Of The Orient	S-103	PAR		1933	?	70's	?	?	$15-20	$55-65
Bells	S-1910	RIG	CBC	1911	10	70's	F/B	Picture of lady on front	$15-20	$75-115
Belmont	S-113	RIG		1943	20	70's	S/P	F94-1NY	$6-8	$55-65
Benaderet Standard	No Stamp	PMC		1962	20	70's	S/P	Red, w/white diamond ctr	$25-35	$25-35
Benaderet's Harem	No Series	BEN		1923	10	70's	CSB	Purple w/gold trim	$6-8	$70-95
Beauties	S-101	BEN		1931	10	70's	CSB	Silver w/blue letters	$20-25	$60-85
Benaderet's English Style	S-106	BEN		1936	10	70's	SSB	F213-1CA, silver rounds	$20-25	$60-85
Benaderet's,	S-110	BEN		1940	10	70's	SSB	Beige w/gold letters	$20-25	$60-85
The Senator Blend	S-1910	BEH		1910	100	70's	F/B	Silver box, w/brown sq/	$35-50	$90-135
Benson & Hedges	S-1910	BEN		1913	10	70's	CSB	?	$35-50	$90-135
Majesty	No Series	BEH		1922	10	70's	F/B	Dark brown w/bronze trim	$30-45	$90-135
Benson & Hedges	S-102	BEH		1932	10	70's	F/B	Red w/gold seal	$30-45	$75-115
Tubarette	S-102	BEH		1922	10	70's	F/B		$20-25	$60-85
Benson & Hedges	S-103	BEH		1933	10	70's	F/B	Dark brown, w/gold letters	$30-45	$75-115
Garenia	S-1910	BEH		1910	50	70's	F/B		$75-115	$200-225
Old Gubek	S-107	BEH		1937	100	70's	F/B	Gray w/no 1 cork or plain	$75-115	$200-225
Benson & Hedges	S-107	BEH		1937	10	R120's	F/B	Beige	$50-65	$150-190
No 1 Plain	S-107	BEH		1927	10	70's	F/B	Silver box,beige label,	$30-45	$75-115
Benson & Hedges	S-115	BEH		1945	10	70's	F/B	Green w/#5 upper lf	$50-65	$150-190
Benson & Hedges	S-116	BEH		1946	50	F120R	F/T	Silver box w/white label	$15-20	$55-65
Turkish	S-122	BEH		1949	10	RKR	F/B	Light gold,w/gold silk tips	$65-125	$150-225
Benson & Hedges	Caution	BEH		1965	10	70's	S/P	White, white gold trim	$10-15	$40-55
Virginia Rounds	Warning	BEH		1976	20	FKR	FTB	Yellow, w/brown/red letters	$3-5	$8-12
Benson & Hedges	Sur-Gen	BEH		1995	20	FKR	FTB	F5-2NY, Cork tipped	$2-4	$7-9
Monarch	S-121	GAG	YNC	1951	20	70's	S/P	Brown woodgrain	$1-2	$3-6
Benson & Hedges	Sur-Gen	GOR		1988	20	70's	C/T	Black w/B&H in gold	$20-25	$60-85
Private Blend	No Series	BER		1927	100	70's	S/P		$1-2	$3-6
Benson & Hedges	S-1898	TEC		1898	20	FKR	S/P		$25-35	$70-95
Deluxe	Caution	RJR		1969	20	FKR	S/P	Black w/gold trim	$35-50	$90-135
Benson & Hedges	S-121	GAG	YNC	1951	20	FKR	S/P	Your name cigarette co.	$6-8	$25-35
Park Avenue	S-1898	LOR		1967	20	FKR	S/P	TP.2442-PA, star in box	$6-8	$25-35
Benson & Hedges	Caution	CUC		1898	100	70's	SSB	TP122-MA, paper label	$3-5	$8-12
Special K	Warning	PMC	PMA	1975	20	FKR	FTB	C98	$6-8	$25-35
Bentley & Gage Ins.	Warning	PMC		1977	20	FKR	FTB	Trademark	$2-4	$7-9
Benton	Sur-Gen	LAM	FOR	1981	20	All Kinds	S/B	Your name cigarette co.	$2-4	$4-6
Berberian's Special	Sur-Gen	RJR		1990	20	All Kinds	S/B	?	$1-2	$4-6
Berberin	Sur-Gen	PMC		1988	20	All Kinds	S/P	Trademark	$1-2	$4-6
Beret	Warning	PMC		1977	20	FKR	S/P	White w/yellow orange brn	$2-4	$7-9
Berghoff Beer	No Series	ROT		1928	20	70's	SSB	TP-42-NC, Mult. colors	$20-25	$60-85
Bermuda	S-1993	LAM	NBS	1993	20	FKR	S/P	TP-7-VA, Mult. colors	$1-2	$4-6
Berwick	S-1883	HAL		1883	10	70's	SSB	TP-1-NC, 3 pack changes	$75-100	$200-250
Best	S-1898	ATD		1898	10	70's	CSB	TP-7-VA	$35-50	$90-135
Best	No Series	LAM		1922	20	70's	S/P	?	$20-25	$60-85
Best Buy	S-110	CRC		1940	10	FKR	S/P	Red, w/white band	$15-20	$55-65
Best Buy	Caution	ATC		1969	20	70's	S/P	C98	$6-8	$25-35
Best Choice	S-1898	DRU		1898	10	70's	CSB	F42-NC	$35-50	$90-135
Best Value	S-1898	FEN		1898	10	70's	SSB	?	$35-50	$90-135
Beta	S-1898	MIL		1898	10	70's	SSB	Trademark	$35-50	$90-135

Bottom table (Bar One – Beggar Student)

Brand Name	Series	Mfg	Ven	YMf	#	Type	Pack	Description/Remarks	Empty	Full
Bar One	S-1883	WIX		1885	?	70's			$60-85	$180-225
Bar One	S-1917	ATC		1918	20	70's	CSB		$25-35	$70-95
Barclay	Caution	BAW		1966	20	FKR	S/P	Trademark	$6-8	$25-35
Barclay	Warning	BAW		1968	20	All Kinds	S/B	New multicel filter	$3-5	$8-12
Barclay	Sur-Gen	BAW		1977	20	All Kinds	S/B	Multicel filter	$2-4	$7-9
Barclay	Sur-Gen	WAD		1982	20	All Kinds	S/B	Ultra low tar	$2-3	$6-8
Bare-Kat	S-1910	RJR		1913	50	70's	F/B	F56-5VA	$20-45	$75-115
Bargain Buy	Sur-Gen	RJR	FOR	1992	20	All Kinds	S/P	TP-1-NC, Mult. Colors	$2-3	$6-8
Bargain King	Sur-Gen	RJR	FOR	1993	20	All Kinds	S/B	TP-1NC, Mult. Colors	$2-3	$7-9
Baridi	Warning	LAM		1976	20	70's	S/P		$2-4	$7-9
Barking Dog	S-104	PMC		1916	20	70's	S/P	Brown w/picture of dog	$30-45	$75-115
Barking Dog	S-1917	BAR		1934	20	70's	S/P	Same as above	$15-20	$55-65
Barkmahn	S-1910	BAR		1919	?	70's	S/P		$25-35	$70-95
Barkmahn Limited	S-121	BAR		1915	20	70's	S/P	Also MHN, in 1939	$30-45	$75-115
Barnes & Noble Col.	Caution	GAG	NYC	1970	20	70's	F/T	Your name cigarette co.	$20-25	$60-85
Baron	S-1887	LOR		1897	10	FKR	P/T	Orange, w/black letters	$50-65	$150-190
Baton Bros. No. 3	Warning	BBR		1976	20	FKR	S/P	?	$3-5	$8-12
Baronet	S-123	PMC		1953	20	FKR	S/P	?	$2-4	$7-9
Baronet	No Series	BRN		1920	20	FKR	S/P	?	$10-15	$40-55
Baracuda	S-1909	TUR		1966	10	FKR	S/P	Trademark	$6-8	$25-35
Barras Memoirs	S-1898	RIG		1898	?	70's	S/P	C98	$35-50	$90-135
Barrett House	S-1898	POL		1898	20	70's	S/P	C98	$35-50	$90-135
Barrington	S-1910	SRN		1913	10	70's	CSB	?	$35-50	$90-135
Bas-Blew	S-1898	BAN		1898	20	70's	S/P	C98	$2-4	$7-9
Basic	Warning	HLL		1974	20	All Kinds	S/B	TP-7-VA Mult. colors	$2-2	$6-8
Basic	Sur-Gen	PMC		1995	20	All Kinds	S/B	TP-42-NC Mult. colors	$2-4	$7-9
Basics	No Stamp	LAM	GUC	1983	20	FKR	S/P	?	$6-8	$25-35
Bat	Caution	CNC		1959	20	FKR	S/P	White w/purple angle	$30-45	$75-115
Baton	S-1909	RJR		1967	10	R100RL	F/B	Green w/Gold trim	$20-25	$60-85
Batt Bros No. 4	S-1898	BAB		1925	10	70's	F/B	Silkette	$15-20	$55-65
Batt Bros No. 6	S-1898	BAB		1923	20	70's	F/T	Pink box, Gold letters	$20-25	$60-85
Batt Bros No. 7	S-1898	BAB		1940	10	70's	S/P	Light gold, w/gold trim	$20-25	$60-85
Batt Bros No. 9	S-1909	BAB		1923	10	R100RL	F/B	Light and dark blue	$20-25	$60-85
Batt Bros No. 10	S-1909	BAB		1923	20	70's	S/P	Light and dark blue	$20-25	$60-85
Batt Bros No. 11	S-1909	BAB		1923	10	R100RL	F/B	Green w/gold trim	$20-25	$60-85
Batt Bros No. 14	S-1909	BAB		1923	10	70's	F/B	Yellow w/yellow lines	$35-50	$90-135
Batt Bros No. 35	S-1898	ICC		1898	20	FKR	S/P	C98	$35-50	$90-135
Battalion	S-1898	ATD		1898	10	70's	CSB	C98	$35-50	$90-135
Battle Axe	S-1898	PFF		1898	10	70's	CSB	C98	$35-50	$90-135
Battleship Monument	S-1901	HVC		1901	20	70's	SSB	C98	$20-25	$60-85
Battleship Texas	Caution	RJR		1967	20	FKR	S/P	White, w/large green S	$3-5	$8-12
Baxter	Warning	BAW		1972	20	FKR	S/P	Blue, w/gold stripes on top	$2-4	$7-9
Baylor	Warning	GAG	YNC	1984	20	FKR	S/P	Your name cigarette co.	$6-8	$25-35
Bayou Welding Work	No Series	BAB		1951	50	70's	F/T	F551-3NY	$20-24	$60-85
BB	S-121	RJR		1925	60	FKR	S/P	Trademark	$20-25	$60-85
Beacon	No Series	RJR		1964	20	All Kinds	S/B	TP-1-NC, Mult.colors	$6-8	$25-35
Beacon	Sur-Gen	ATC		1993	20	70's	S/P	F30-NC	$1-2	$4-6
Beacon Hill	Caution	SSS	PER	1939	20	70's	S/P	F404-2NY	$30-45	$75-115
Beacon Hill	No Stamp	DRK		1898	10	70's	CSB	C98	$15-20	$55-65
Beacon Hill	Caution	ATD		1898	20	70's	CSB	C98	$35-50	$90-135
Bear Plug	S-1898	WHG	GOO	1898	20	70's	CSB	Also 100 and F/B	$35-50	$90-135
Beats The World	S-1898	MEL	UCS	1905	20	70's	CSB	C98, F30-NY	$35-50	$90-135
Beau Brummell	S-1901	ATD		1898	10	70's	CSB	C98	$35-50	$90-135
Beau Brummell	S-1898	ATD	KIN	1921	20	70's	SSB	?	$20-25	$60-85
Beau Brummell	S-1887	FNK		1898	20	FKR	S/P	Trademark	$6-8	$25-35
Beau Ideal	S-1898	VLL		1962	20	70's	S/P	?	$50-65	$150-190
Beau Royal	No Series	PMC		1888	20	70's	S/P	Also in 20's multi. color bx.	$50-65	$150-190
Beau Sexe	No Stamp	ASH		1898	20	70's	SSB	C98	$35-50	$90-135
Beaumont	S-111	ATD		1897	10	FKR	S/P	Trademark	$20-25	$60-85
Beauty Bright	No Series	FRI	FRI	1897	20	70's	S/P	Black and yellow stripes	$2-4	$7-9
Beauty Bright Straight Cut	S-1898	NIC		1926	20	FKRL	FTB	Picture of bee	$2-4	$7-9
Beauty Brights	S-1887	RJR	MTC	1961	50	FKR	FTB	White w/gold circle	$20-25	$60-85
Beaver	No Series	RJR	MTC	1995	20	FKRL	FTB	C98	$1-2	$4-6
Bedford	No Stamp	RJR		1995	20	RKR	S/P		$20-25	$60-85
Bee	S-110	LOR		1921	20	70's	S/P		$15-20	$55-65
Bee Lights	No Series	LOR		1940	20	70's	CSB	Trademark	$35-50	$90-135
Beech-Nut	Caution	ATC		1898	10	70's	CSB	C98	$35-50	$90-135
Beech-Nut	S-1898	DRU		1898	10	70's	SSB	C98	$35-50	$90-135
Beech-Nut	S-1898	KRB		1898	10	70's	SSB	C98		
Beefsteak	S-1898	CRO		1898	?	?	?	?		
Beggar Student										

Brand Name	Series	Mfg	Ven	YMf	#	Type	Pack	Description/Remarks	Empty	Full
Big Money	Sur-Gen	PMC	CUS	1990	20	F100M	S/P	TP-7-VA,	$1-2	$4-6
Big Peter	S-1898	MLH		1898	20	70's	S/P	C98	$35-50	$90-135
Big Ten	Warning	ATC		1972	20	FKR	S/P	Trademark	$6-8	$25-35
Bijou	S-1887	RUS		1887	10	70's	SSB	C87	$50-65	$150-190
Bijou	S-1898	IRB		1898	10	70's	SSB	C98	$35-50	$90-135
Bike	S-1898	ATC		1898	10	70's	CSB	C98	$35-50	$90-135
Billups	S-122	LAB		1952	20	FKR	S/P	F460-VA, White & Red.	$10-15	$55-65
Biltmore	No Stamp	LAB		1961	20	FKR	S/P	F460-VA, White & Red.	$6-8	$25-35
Birmingham Blend	S-121	RJR		1965	20	FKR	S/P	?	$20-25	$60-85
Biscayne	No Stamp	GAG	YNC	1951	20	70's	S/P	Your name cigarette co.	$6-8	$25-35
Bistro	Warning	RJR		1965	20	FKR	S/P	Blue, w/gold stripes.	$1-2	$4-6
Bistro	S-120	LOR		1981	10	FKR	S/B	Blue and Green	$15-20	$55-65
Black	Sur-Gen	LOR		1991	20	All Kinds	S/B	Blue and Red, Mult. colors	$6-8	$25-35
Black and White	Warning	ACO		1971	20	70's	S/P	F7-VA, 1/2 black 1/2 white	$15-20	$55-65
Black &White	Warning	PMC		1984	20	FKR	S/P	Trademark	$1-2	$4-6
Black And Yellow	No Stamp	PMC		1972	20	FKR	FTB	Trademark	$10-15	$40-55
Black Beauties	S-101	FCG		1931	20	70's	S/P	Gold letters,	$2-4	$7-9
Black Carter	Sur-Gen	SHE		1989	10	FKR	CSB	?	$6-8	$25-35
Black Gold	S-120	BEH		1950	10	70's	CSB	F5-2NY, black silver top.	$35-50	$90-135
Black Knight	S-1898	MTZ		1898	10	70's	SSB	C98	$35-50	$90-135
Black Label	Warning	USJ	SWR	1984	10	FKR	S/P	Black w/picture of city	$6-8	$25-35
Black Prince	S-1898	ATD		1898	10	70's	CSB	C98	$35-50	$90-135
Black Spots	S-1898	DRY		1898	10	FKR	S/P	C98	$35-50	$90-135
Black Watch	S-1898	HOW		1965	20	FKR	FTB	Trademark	$35-50	$90-135
Blairmont Country Club, Duo-Blend	S-118	GAG		1948	20	70's	S/P	F407-2NY,	$10-15	$40-55
Blend	Warning	BAW	SWT	1975	20	FKR	S/P	F1-VA	$2-4	$7-9
Blended	S-121	RIG		1990	20	All Kinds	S/B	White and Mult. colors	$10-15	$40-55
Blend No. 618	S-121	LAB		1951	20	All Kinds	S/P	White corked tipped	$1-2	$4-6
Blends Number 99	S-1917	EST	PIE	1917	20	70's	SSB	?	$35-50	$90-135
Blighty	S-1898	GOM		1898	20	70's	SSB	F546-2NY	$25-35	$70-95
Blizzard	Warning	LNE		1898	10	70's	S/P	C98	$35-50	$90-135
Blocks of Five	S-123	ATC		1898	20	70's	CSB	C98	$35-50	$90-135
Blonde	No Stamp	BLS		1966	20	FKR	S/P	Red and white	$20-25	$60-85
Blosser's	No Series	BEH		1874	20	70's	F/B	Picture of man, non-tob.	$6-8	$25-35
Blue Box Rays	No Series	BEH		1928	10	FKR	CSB	Blue, w/gold letters.	$75-100	$200-250
Blue Buckle	No Series	BAW		1950	20	70's	CSB	F36-KY	$20-25	$60-85
Blue Horse The	No Series	SSS	GVT	1928	?	70's	?	?	$10-15	$40-55
Blue Max	Warning	ATC		1973	20	FKR	S/P	Trademark	$6-8	$25-35
Blue Peter	S-1910	BLP		1914	20	70's	All type	Also, 20's 50's 100's	$35-50	490-135
Blue Peter	S-104	COS	BLP	1934	20	70's	All type	F59-2NY, same as above	$20-25	$60-85
Blue Ribbon	S-1887	DUK		1958	20	70's	CSB	F42-NC	$60-85	$180-225
Blue Ridge	Warning	PMC		1958	20	FKR	S/P	Trademark	$6-8	$25-35
Blue Rings	S-1898	IRB		1898	20	70's	S/P	C98	$35-50	$90-135
Blue Royal	No Stamp	CLL		1898	10	70's	?	?	$6-8	$25-35
Blue Ship	No Stamp	LAM		1961	20	FKR	S/P	Trademark	$20-25	$60-85
Blush	Sur-Gen	PMC		1989	20	FKR	S/P	Blue w/green lines	$1-2	$4-6
Blues	Sur-Gen	RBN		1900	?	70's	S/P	C98	$35-50	$90-135
Board of Trade	S-121	GAG	YNC	1951	20	FKR	S/P	Your name cigarette co.	$20-25	$60-85
Bob Thompson Private Blend	Warning	LAM	ROE	1975	20	FKR	S/P	Trademark	$6-8	$25-35
Bogart	No Stamp	ROE	WHH	1964	20	FKR	S/P	Two tone gold, non-tob.	$6-8	$25-35
Bogart 100	S-1887	RJR		1887	20	FKR	S/P	Trademark	$6-8	$25-35
Bold	Warning	PMC		1983	20	F100R	?	?	$50-65	$150-190
Bon Homme	Sur-Gen	PMC		1978	20	FKR	S/P	?	$6-8	$25-35
Bon Ton	S-124	LAB		1954	20	70's	CSB	C87	$10-15	$40-55
Bon Ton	S-1887	ALG		1887	20	70's	S/P	C87	$15-25	$40-55
Bon Vivant	No Stamp	IWA		1966	20	FKR	S/P	Trademark	$6-8	$25-35
Bonanza	Caution	PMC		1968	10	FKR	S/P	?	$3-5	$8-12
Bonanza	Warning	ATC		1971	20	70's	S/P	Trademark	$6-8	$25-35
Bond Street	S-1901	PMC		1903	?	70's	?	?	$6-8	$25-35
Bond Street	Warning	PMC		1978	20	FKR	S/P	Trademark	$50-65	$150-190
Bond Street	Sur-Gen	PMC		1898	20	FKR	S/P	C98	$6-8	$25-35
Bonded	S-124	LAB	BOO	1954	20	70's	CSB	Picture of pk. front & back	$10-15	$40-55
Bonnie Lassie	S-1898	MLH		1898	10	FKR	S/B	C98 Beige w/pic of dog	$35-50	$90-135
Bonnie Brook	S-1898	KLS		1934	20	FKR	S/P	C98	$35-50	$90-135
Bonus Value	Sur-Gen	RJR	FOR	1992	20	All Kinds	S/B	Large B. V. mult. colors	$1-2	$4-6
Boo, Tijuana	Caution	GAG	SMH	1967	20	FKR	S/P	1 of 10 spoof packs	$10-15	$40-55
Boot	S-104	BAB		1934	20	70's	S/P	F551-3NY	$15-20	$55-65
Boot And Shoe	S-1898	MNC		1898	?	70's	S/P	C98	$35-50	$90-135
Born Custom Tailors	S-1898		YNC	1952	?	FKR	S/P	Your name cig. co.	$20-25	$60-85
Born Free	Warning	BAW		1972	20	FKR	S/P	Picture of dog	$2-4	$7-9
Born Free	Sur-Gen	SAR	KRI	1995	20	FKR	S/P	TP-22-VA, also FKRL's	$1-2	$2-4
Boro	Warning	PMC		1971	20	FKR	FTB	Trademark	$6-8	$25-35
Boston	S-104	TUM		1934	20	70's	F/B	Yellow w/gold seal	$20-25	$70-95
Boston Athletic Association	S-118	GAG		1948	20	FKR	S/P	White and gold	$10-15	$40-55
Both	Warning	RJR		1977	20	FKR	S/P	Trademark	$6-8	$25-35
Boulevard	S-1910	BST		1915	?	?	?	F358-1IL	$30-45	$75-115
Boultbee & Colby	No Series	BOU		1922	50	70's	F/T	F348-2NY	$35-50	$90-135
Boultbee & Colby	S-125	LOR		1955	10	70's	F/B	F407-2NY, brown on brown	$1-15	$40-55
Bounty	S-118	LOR		1948	20	70's	S/P	F8-5NJ	$10-15	$40-55
Bounty	Warning	LAB		1974	20	FKR	S/P	Trademark	$2-4	$7-9
Boutique	Warning	LAB		1975	20	70's	S/P	Blue top & bottom	$2-4	$7-9
Bradford	Warning	RJR		1988	20	FKR	S/P	Trademark	$6-8	$25-35
Brainard Steel Co.	S-121	GAG	YNC	1951	20	70's	S/P	Your name of cig.	$20-25	$60-85
Brand X	Caution	GAG		1960	20	70's	S/P	Black on white	$6-8	$25-35
Brand X	Warning	BRX	BRX	1967	20	FKR	F/B	TP-75-NY, white & black	$2-4	$7-9
Branded	Warning	LAM		1971	20	All Kinds	S/P	White w/mult. colors	$2-4	$7-9
Branded Quality	Warning	HTC		1974	20	FKML	S/P	White two green lines	$2-4	$7-9
Brandon	Caution	RJR		1961	20	FKR	S/P	White top and bottom	$1-2	$4-6
Brandon	Sur-Gen	RJR	FOR	1994	20	All Kinds	S/P	TP-1-NC, Mult. colors	$10-15	$55-65
Bravo	No Stamp	BRL		1964	20	RKR	S/P	Lettuce, non-tobacco.	$3-5	$8-12
Bravo	No Stamp	BRL		1979	20	FKR,FKM	S/P	Non-tobacco	$2-4	$7-9
Breaker	Warning	LAM		1977	20	FKR	S/P	?	$6-8	$25-35
Breeze	No Stamp			1967	20	FKR	S/P	Trademark	$6-8	$25-35
Brennig's Own	S-114	BAW		1959	20	FKM	S/P	White w/green blue waves.	$10-15	$40-55
Brentwood		TBC	BRE	1958	20	70's	S/P	White w/red letters	$2-4	$7-9
Brentwood	Sur-Gen	RJR		1988	10	70's	S/P	?	$1-2	$4-6
Brer Rabbit	Sur-Gen	RJR	FOR	1994	20	All Kinds	SSB	TP-1-NC, mult. colors	$35-50	$90-135
Brevit	S-1898	HRS		1898	10	70's	SSB	C98	$3-5	$8-12
Brewster	Caution	RJR		1967	20	FKR	S/P	Blue w/white gold lines	$6-8	$25-35
Bride	Warning	BAW		1984	20	FKR	S/P	Trademark	$35-50	$90-135
Bridge	S-1898	ATD		1898	20	70's	CSB	C98	$20-25	$60-85
Bridgette	Sur-Gen	BAB		1928	20	FKR	S/P	?	$6-8	$25-35
Brief	Sur-Gen	RJR		1989	20	FKR	S/P	Trademark	$6-8	$25-35
Brigade	Caution	RJR		1967	20	FKR	S/P	Trademark	$2-4	$7-9
Brigadier	Warning	LOR		1972	20	FKR	S/P	?	$6-8	$25-35
Briggs	Warning	LOR		1979	20	FKR	FTB	White w/red lines top	$20-25	$60-85
Bright	S-104	LOR		1930	20	70's	S/P	White and dark green	$2-4	$7-9
Bright Star	Warning	RJR		1982	20	FKM	S/P	F916-1NY	$20-25	$60-85
Brighton	Caution	RSD		1928	20	FKR	S/P	Trademark	$6-8	$25-35
Brighton Convertible	Warning	ATC		1964	20	FKR	S/P	F22-1PA, green and white	$2-4	$7-9
Brilliant	Warning	PMC		1968	20	All Kinds	S/P	F42-IPA, green and white	$6-8	$25-35
Brisk	Warning	ATC		1979	20	FKR	S/P	Phase III filter	$3-5	$8-12
Bristol	No Series	RSD		1926	20	FKR	S/P	F916-1NY	$20-25	$60-85
Bristol	Sur-Gen	ATC		1966	20	FKR	S/P	Trademark	$1-2	$4-6
Bristol	Caution	RJR		1970	20	All Kinds	S/P	White w/mult. colors	$3-5	$8-12
Brite	S-1887	PRS		1887	10	70's	SSB	Silver and red	$50-65	$150-190
Broad Ax	S-1887	ATD	DUK	1887	10	70's	SSB	C87	$35-50	$90-125
Broadleaf	No Stamp	LAM		1921	20	70's	S/P	C98	$20-25	$60-85
Broadway Full Flavor	Sur-Gen	PMC		1994	20	All Kinds	S/B	?	$1-2	$4-6
Bronco	Caution	RJR		1969	20	FKR	S/B	CCSS-2,3,4, red	$6-8	$25-35
Bronson	Warning	RSD		1983	20	FKR	S/P	Trademark	$2-4	$7-9
Bronson	Sur-Gen	LAM	NPG	1992	10	All Kinds	CSB	TP-42-MC, multi. colors	$1-2	$4-6
Bronx	No Stamp	PMC	FVB	1992	8	All Kinds	F/B	TP-7-VA, multi. colors	$15-20	$55-65
Brook Club	No Stamp	GAG		1933	20	70's	S/P	Went to South pole, w/Byrd.	$25-35	$70-95
Brookfield	Sur-Gen	RJR		1922	20	FKR	S/P	Trademark	$6-8	$25-35
Brookton	Sur-Gen	RJR		1988	20	FKR	S/P	Trademark	$10-15	$40-55
Brookwood	Warning	LEE		1958	20	RKR	S/P	Red w/unicorn	$6-8	$25-35
Brown And Gold	Warning	PMC		1979	?	70's	S/P	Produced two years	$10-15	$40-55
Brown Box & Paper	No Series	RSD		1925	20	FKM	S/P	F916-1NY	$20-25	$60-85
Brownies	S-108	BEH		1950	10	70's	S/P	Trademark	$10-15	$55-65
Bryant Park	Caution	COA		1938	8	70's	CSB	F5-2NY, brown & gold top	$15-25	$70-95
Buckhorn	S-1910	RJR		1915	20	70's	F/B	Brown w/tobacco leaf center	$35-50	$90-135
Buckingham	No Name	LAM		1923	20	FKR	S/P	Blue w/white & gold lines	$30-45	$75-115
Buckingham	S-105	BAG		1935	20	70's	P/T	Picture of flowers	$20-25	$60-85
Buckingham	S-110	PMC		1934	20	70's	S/P	Picture of building	$15-20	$55-65
Buckingham		ATC		1934	20	70's	S/P	Yellow w/picture of factory	$20-25	$60-85

Left table

Brand Name	Series	Mfg	Ven	YMf	#	Type	Pack	Description/Remarks	Empty	Full
Bucks	Sur-Gen	PMC		1990	20	FKR	S/P	Also FKRL, red & white, gold ltr.	$2-4	$7-9
Bud Plain End	S-1910	BUD		1913	10	70's	F/B	F410-2NY	$35-50	$90-135
Buffalo Athletic Club	S-125	GAG		1948	10	FKRL	F/B	White w/gold circle	$3-5	$8-12
Buffalo Spirit	Sur-Gen	GOR		1990	20	FKR	S/P	White buffalo	$3-5	$8-12
Buffalo Spirit	Warning	SHE		1975	20	FKR	CSB	White buffalo	$25-35	$70-95
Bug	No Stamp	ATD	GOO	1928	20	70's	P/T	TP-26-NJ	$35-50	$90-135
Buglar	S-1898	ATC		1898	10	70's	SSB	F36-KY, blue and white	$3-5	$8-12
Bull Dog	Caution	ATC		1966	20	FKR	S/P	C98	$2-4	$7-9
Bull Durham	Warning	ATC		1978	20	FKR	S/P	Silver w/dark brown circle	$35-50	$90-135
Bull Durham	Sur-Gen	ATC		1990	20	FKRL	S/P	Red w/silver trim	$35-50	$90-135
Bull Durham	S-1898	FRJ		1898	20	70's	S/P	Red w/orange trim	$35-50	$90-135
Bull Terrier	S-1898	FCH		1898	10	70's	SSB	C98	$35-50	$55-65
Bullets	Caution	LOR		1967	20	FKR	SSB	C98	$3-5	$90-135
Burbank	S-1898	BAW		1933	20	FKR	S/P	White w/knight on horse	$20-25	$55-65
Burleigh	Sur-Gen	GAG		1988	20	FKR	S/P	TP-75-NY, White, w/picture	$10-15	$40-55
Bush For President	No Stamp	SCW		1961	20	RKR	S/P	TP-75-NY, white & red	$6-8	$25-35
Butties	No Stamp	BAB		1944	20	FKR	S/P	?	$10-15	$40-55
Buy Your Own	S-114	BAB		1944	20	FKR	CSB	?	$1-2	$4-6
Buy Your Own	Sur-Gen	SER		1995	20	All Kinds	FTB	F80-6CA	$15-20	$55-65
Buy Your Own #18	S-111	SER		1941	20	FKR	S/P	White w/blue yellow square	$2-4	$7-9
Buz	Warning	BAW		1974	20	FKR	S/P	White w/blue letters	$10-15	$40-55
By Seralian	S1898	SRB		1898	20	70's	S/P	C98	$35-50	$90-135
B. W. Jacks	No Stamp	ATC		1922	20	FKR	S/B	Blue and gold	$20-25	$60-85
C. J. Farwell Co.	Warning	LAM		1976	20	FKR	S/P	C98	$2-4	$7-9
Caballero	S-1887	KHV		1898	20	70's	S/P	C87	$35-50	$90-135
Cabanas	No Stamp	KIM		1887	20	70's	S/P	?	$75-100	$150-190
Cabaret	S-123	RIG	PIT	1953	20	FKR	S/P	F94-1NY	$35-50	$90-135
Cabinets	S-1879	DUK		1871	20	70's	S/P	F42-NC	$35-50	$90-135
Cable	S-1887	ATD	DUK	1890	20	70's	S/P	F42-NC	$20-25	$40-55
Cable Car	S-1883	ATD		1886	20	70's	S/P	?	$75-100	$200-250
Cablegram	S-1910	CAD		1915	10	FKR	F/B	Reef top & bottom	$50-65	$150-190
Cablegram	No Stamp	KHO		1925	20	FKR	F/B	Picture of pillars	$60-85	$180-225
Cadet	S-1883	MON		1885	20	70's	S/P	Picture of camel van	$20-25	$60-85
Cado	No Stamp	ATC		1922	20	70's	SSB	Picture of camel van	$50-65	$150-190
Café-Noir	S-1898	ATD	MON	1899	20	70's	S/P	C98, F363-3NY	$35-50	$90-135
Cairo	S-1910	SSS	LEA	1898	20	70's	S/P	?	$35-50	$90-135
Cairo	Warning	LAB		1971	20	FKR	S/P	Blue, w/gold stripes on top	$35-50	$90-135
Cairo No. 27A	Warning	RJR		1973	20	FKR	F/B	Golden gate expo.	$35-50	$90-135
Cake Box	S-109	BEN		1939	20	FKR	S/P	Brown, w/light brown letters	$35-50	$90-135
Calgary Treble Gold	Sur-Gen	BAW		1972	20	FKR	S/B	CCSA, CCVS-2, CCVS-3	$2-4	$7-9
Caliber	Warning	PMC		1992	20	FKR	S/B	F2-5NJ, C98	$35-50	$90-135
California	No Stamp	MON		1898	20	70's	S/P	F7-3NY	$35-50	$90-135
California	S-1901	ANR		1902	20	FKR	S/P	?	$35-50	$90-135
California Lights	Caution	RJR		1967	20	FKR	S/P	White and yellow	$15-20	$55-65
Caliph	Caution	CAB		1934	20	FKR	S/P	White, vertical blue stripes	$15-20	$55-65
Calumet	No Stamp	RJR		1955	20	FKR	S/P	White and yellow	$6-8	$25-35
Camber-Rubies	Caution	LAB		1966	20	FKR	S/P	White and blue	$3-5	$8-12
Cambridge	No Stamp	ATC		1966	20	All Kinds	S/B	?	$15-20	$55-65
Cambridge	Caution	PMC		1972	20	All Kinds	S/B	White and yellow	$6-8	$25-35
Cambridge	Warning	PMC		1991	20	70's	S/P	White and blue	$6-8	$25-35
Cambridge	Sur-Gen	PMC		1991	20	70's	S/P	F456-3MA	$6-8	$25-35
Cambyses	S-1901	MTR		1906	20	70's	S/P	?	$2-4	$8-12
Cambyses		CMB		1908	?	70's		?	$35-50	$90-135
Camel	S-1910	RJR		1913	20	FKR	S/P	F1-NC, many other plants	$35-50	$90-135
Camel	S-1910	RJR		1913	20	FKR	S/P	Same as above	$35-50	$90-135
Camel	S-1910	RJR		1913	10	70's	SSB	F1-NC, F1-1NC, F1-5NC	$35-75	$180-225
Camel	S-103	RJR		1933	10	FKR	S/P	F1-NC, F1-1NC, F1-5NC	$15-20	$55-65
Camel Asst. Tins	Warning	RJR		1955	10	FKR	S/P	Gold foil pack??	$6-8	$25-35
Camel Talls	No Stamp	RJR		1966	20	FKR	S/P	Brown, red stripes	$6-8	$25-35
Camel 75th	Sur-Gen	RJR		1988	20	FKR	S/P	Test Marketed, 1966-68	$10-15	$40-55
Camel "99"	Sur-Gen	RJR		1991	20	FKR	S/P	Classic camel scene	$6-8	$25-35
Camel	Caution	RJR		1966	20	FKR	S/P	Green bottom white top	$6-8	$25-35
Camel	Caution	RJR		1967	20	FKR	S/P	White standard pack	$60-85	$180-225
Camel	Warning	RJR		1971	20	FKR	S/P	Trademark	$6-8	$25-35
Camel	Sur-Gen	RJR		1977	20	FKR	S/P	Came w/light brown angle	$50-65	$150-190
Camel	Sur-Gen	RJR		1988	20	FKR	S/P	Joe on pack	$50-65	$150-190
Camel	Sur-Gen	RJR		1991	20	FKR	S/P	99 on front of box	$50-65	$150-190
Camel	Sur-Gen	RJR		1994	20	FKR	S/P	10 States pack collection	$6-8	$25-35
Cameo	Sur-Gen	RJR		1995	10	70's	SSB	Old ads on pack	$35-50	$90-135
Cameo	S-1887	VGN	DLG	1895	10	70's		Light gray, w/lady in center		
Cameo Duke's	S-1878	DUK		1888	10	70's	SSB	Duke & sons & co. on brm.		

Right table

Brand Name	Series	Mfg	Ven	YMf	#	Type	Pack	Description/Remarks	Empty	Full
Cameo Duke's	S-1887	ATD	DUK	1890	10	70's	SSB	F42-NC	$50-65	$150-190
Cameo Duke's	S-1887	CRN		1889	?	70's	?	?	$35-50	$90-135
Cameron's Entire										
Cameron's Gold Medal Straight Cut	S-1887	CAM		1889	?	70's	S/P	?	$50-65	$150-190
Camile	No Series	DON		1924	20	70's	S/P	?	$20-25	$65-85
Camouflage	Sur-Gen	LAM		1990	20	FKR	S/P	?	$1-2	$4-6
Camp Claiborne	S-111	AFT		1941	20	70's	S/P	Khaki (Army seal), LA	$20-25	$60-85
Camp Cork Tip	S-1901	ZUF		1905	50	70's	RT/T	F562-3NY	$35-50	$90-135
Camp David	Warning	LAM		1976	20	FKR	S/P	Various makers	$25-35	$75-95
Camp Shelby	S-111	AFT		1941	20	70's	S/P	Khaki (Army seal), Miss.	$20-25	$60-85
Camp Wheeler	S-111	AFT		1941	20	70's	S/P	Khaki (Army seal) Georgia	$20-25	$60-85
Campon Co. Inc	S-121	GAG		1951	20	70's	S/P	Your name cig. co.	$15-20	$55-65
Campus	S-1901	CPS	YNC	1906	?	70's	?	?	$35-50	$90-135
Canal	S-1910	MAH		1914	20	FKR	S/P	?	$30-45	$75-115
Cancer	Caution	BAW		1966	20	FKR	S/P	Black w/white letters	$3-5	$8-12
Canvas Back	S-1883	GOO		1883	10	70's	SSB	C86	$60-85	$180-225
Canyon	Caution	RJR		1965	20	FKR	S/P	White w/large green band	$3-5	$8-12
Canyon	No Series	LAM	LIG	1993	20	FKR	S/P	White	$1-2	$4-6
Capital	Sur-Gen	USV		1921	20	FKR	S/P	F1-VA	$20-25	$60-85
Capitol	Warning	RJR		1966	20	FKR	S/P	Trademark	$6-8	$25-35
Caporal	S-1879	KIN	KIN	1869	?	70's	S/P	F593-MD	$75-100	$200-250
Caporal	S-1879	ATD		1891	?	70's	?	C98, F593-MD	$50-65	$150-190
Caporal Tabac Fort	S-1879	KIN		1880	?	70's	?	F25-NC	$75-100	$200-250
Capri	Caution	LTC		1955	20	FKR	F/B	Black, w/yellow pink lines	$6-8	$25-35
Capri	Warning	BAW		1967	20	FKR	S/P	Green on left and right	$3-5	$8-12
Capri 110's	Sur-gen	BAW		1975	20	FKM	S/P	Trademark	$6-8	$25-35
Capstan	No Series	BAW		1989	20	All Kinds	FTB	Muli. colors	$1-2	$4-6
Captain Kidd	S-1898	LEI		1956	10	70's	CSB	C98	$6-8	$25-35
Captain Wright's	S-1898	MLH		1898	?	70's	?	Blue gold white trim	$35-50	$90-135
Captain Wright's	S-1901	ATD		1908	20	70's	R/T	F:00-1MO	$60-85	$180-225
Captain's Choice	S-1883	DRU		1883	50	70's	SSB	Gold, Multi. colors	$60-85	$180-225
Caravan	No Series	EST	PIE	1926	10	70's	S/P	Also 100's, Multi. colors	$25-35	$70-95
Cardinal	No Series	EST	PIE	1926	50	70's	RT/T	White, w/black letters	$30-45	$75-115
Career	S-1910	RTT		1914	20	FKR	S/P	Beige w/picture of Caravan	$30-45	$75-115
Caress	Sur-Gen	RJR	PMA	1992	20	All Kinds	S/P	TP-1NC, White blue stripes	$1-2	$4-6
Carioca Rums	No Stamp	RJR		1959	20	FKR	S/P	Trademark	$6-8	$25-35
Carl Henry	S-1887	MON		1887	20	70's	S/P	F363-3NY	$50-65	$150-190
Carl Henry	S-107	BUM		1936	20	70's	S/P	Rum Flavored	$15-20	$55-65
Carl Henry	S-114	LIU	CAH	1926	20	70's	S/P	F137-5NY	$20-25	$60-85
Carlotina	S-103	LAB	CAH	1933	20	70's	S/P	Most nicotine removed	$15-20	$55-65
Carlton	Warning	LAB		1951	20	FKR	S/P	Mild-pleasant-satisfying	$10-15	$40-55
Carlton	S-121	RIC		1921	20	FKR	S/P	?	$20-25	$60-85
Carlton	No Series	BAB-	GAG	1929	20	FKR	S/P	Red & white	$20-25	$60-85
Carlton	No Series	LOR		1954	20	FKR	S/P	W/air stream filter	$6-8	$25-35
Carlton Club Egyptiennes	No Stamp	ATC		1967	20	All Kinds	S/P	Multi. colors	$3-5	$8-12
Carlyle	Caution	ATC		1974	20	All Kinds	S/B	Multi. colors, (also slims)	$2-4	$7-9
Carmen	Sur-Gen	ATC		1985	20	All Kinds	S/B	Mouthpiece, exclusive cig.	$1-2	$4-6
Carmen	S-1898	ANR		1900	10	70's	SSB	Pinnacle of Perfection	$35-50	$90-135
Carnival	S-124	REM		1954	20	70's	SSB	Black or gray, w/lady	$10-15	$40-55
Carolina Brights	S-1898	ETC		1898	20	70's	SSB	Trademark	$35-50	$90-135
Carolina Gold	S-104	WES		1929	20	FKR	S/P	Trademark	$20-25	$60-85
Carriage Trade	Warning	PMC		1971	20	FKR	FTB	C87	$6-8	$25-35
Carriage Trade	Warning	PMC		1968	20	FKR	FTB	Multi. colors on white	$35-50	$90-135
Carriage Trade	S-1898	WWH		1898	10	F100R	FTB	C460-VA. & F460-VA	$35-50	$90-135
Carson	Sur-Gen	PMC		1991	10	F100M	S/P	Red, w/white band	$10-15	$40-55
Carte Blanche	Caution	USJ	STP	1964	20	FKR	S/P	Trademark	$6-8	$25-35
Cartier Vendome	No Stamp	LAB		?	20	FKR	CSB	Trademark	$6-8	$25-35
Cascade	S-1887	LAB	RUM	1954	20	FKR	F/B	TP-3-NY	$60-85	$180-225
Casino	Caution	BAW		1971	20	FKQ	F/B	F363-3NY, Monopol	$6-8	$25-35
Casino Superior 25A	Warning	TWR		1980	20	70's	?	Beige, w/gold trim	$50-65	$150-190
Casinos	S-1887	SHE		1895	?	70's	?	Trademark	$50-65	$150-190
Casion Gold Tip	S-1887	MON		1898	20	FKR	S/P	?	$50-65	$150-190
Castle	Caution	ATC		1969	20	FKM	S/P	Green on white	$6-8	$25-35
Catamount	S-1898	BAW	W1K	1898	10	70's	SSB	C98	$35-50	$90-135

(Left table)

Brand Name	Series	Mfg	Ven	YMf	#	Type	Pack	Description/Remarks	Empty	Full
Catareba	S-1910	HEI		1915	20	70's	S/P	?	$30-45	$75-115
Catarrh	S-1887	CNT		1887	?	70's	?	?	$50-65	$150-190
Catch On	S-1898	LNS		1898	10	70's	SSB	C98	$35-50	$90-135
Cavalcade	S-108	AFT		1939	20	70's	S/P	F24-KY	$15-20	$55-65
Cavalcade	S-109	SWA		1949	20	RKR	S/P	White, w/man riding horse	$10-15	$40-55
Cavalier	S-124	RJR		1950	100	RKR	R/T	F1-NC, white & red,	$50-65	$180-225
Cavalier	S-122	RJR		1950	20	RKR	S/B	Also 50's, white and red	$1-2	$4-6
Cavalier Ovals	Sur-Gen	RJR	FOR	1992	20	All Kinds	S/B	TP-2-NC, Multi. colors	$2-4	$7-9
Cavalier	Sur-Gen	RJR		1976	20	FKR	S/P	Blue, w/white gold stripes	$1-2	$4-6
CB	Sur-Gen	SAR	CBY	1997	20	FKR	FTB	TP-22-VA	$2-4	$7-9
CBY	S-122	GAG		1952	20	70's	S/P	By Raybill Inc.	$10-15	$40-55
CCC Highway Inc.	No Series	GAG		1920	20	70's	SSB	?	$25-35	$60-85
Celebre	Caution	?		1925	20	70's	S/P	F407-2NY	$6-8	$25-35
Cement Mixer	No Series	ATC		1964	20	FKR	S/P	Trademark	$10-15	$40-55
Centaur	Caution	SWA		1945	20	70's	S/P	F1-VA	$3-5	$8-12
Center Ring	S-115	FLA		1945	20	FKR	S/P	White, w/blue & gold sq.	$3-5	$8-12
Centrofinos	Warning	LOR		1967	20	FKR	S/P	Orange & gold	$10-15	$40-55
Century	Caution	LOR		1968	20	FKR	S/P	Yellow, w/black letters	$1-2	$4-6
Century	Warning	LOR		1968	20	F100R	F/B	Silver, w/black letters	$2-4	$7-9
Centennial Assoc.	Sur-Gen	GAG		1955	25	All Kinds	S/B	White, w/gray C. A.	$6-8	$25-35
Century 25's	S-125	RJR		1987	25	70's	CSB	Multi. color	$1-2	$4-6
Century City U.S.A.	Sur-Gen	SHE		1991	10	F100R	CSB	TP-161-NY, Gold	$1-2	$4-6
Cerise No. 2	S-1910	CRR		1916	20	70's	S/P	?	$30-45	$75-115
C.F.M.	Warning	LAM		1983	20	All Kinds	S/P	TP-42-NC, Multi. colors	$2-4	$7-9
Chad	Warning	LAM		1976	20	FKR	S/P	?	$6-8	$25-35
Chalet	Warning	RJR		1975	20	FKR	S/P	Trademark	$2-4	$7-9
Chalice	No Series	USV		1921	20	FKR	S/P	F1-VA	$20-25	$60-85
Challenge	Warning	BAW		1970	20	FKR	S/P	White, w/blue & gold sq.	$2-4	$7-9
Champ Clark	S-121	STT		1950	20	70's	S/P	F30-NY, F30-NJ	$10-15	$40-55
Champagne Cocktail	S-1917	ATC	FAL	1917	20	70's	S/P	C87,	$60-85	$180-225
Champion	S-1883	PAC		1886	15	70's	SSB	F26-2NY	$2-4	$7-9
Champions	S-1879	GOO		1880	10	70's	CSB	CPA, Page 27	$6-8	$25-35
Chancellor	S-1883	ATD	GOO	1895	20	70's	S/P	TP-75-NY	$2-4	$7-9
Chanel	Warning	GAG		1978	20	FKR	F/B	Trademark	$2-4	$7-9
Change	Warning	LAM		1975	20	FKR	S/P	Trademark	$2-4	$7-9
Change-up	No Stamp	ATC		1971	20	FKR	S/P	Trademark	$6-8	$25-35
Chaparral	Sur-Gen	GOR	CHP	1990	20	70's	S/P	Multi. colors (3 types)	$1-2	$4-6
Chaparral	Warning	BAW		1980	20	FKR	S/P	White, w/blue yellow sq.	$2-4	$7-9
Chaps	Caution	PMC		1961	20	FKR	S/P	?	$2-4	$7-9
Character	Caution	ATC		1964	20	FKR	S/P	Trademark	$6-8	$25-35
Charcoal	S-109	TBC		1939	20	70's	S/P	F404-NY	$1-2	$4-6
Charing Cross	Sur-Gen	BAW		1979	20	FKR	F/B	TP-2442-PA, Boot & rope	$2-4	$7-9
Charleston	Sur-Gen	GOR	TWB	1996	20	FKR	F/B	TP-1-NC, Multi. colors	$1-2	$4-6
Charo	Warning	FOR		1997	20	FKR	S/P	C98	$15-20	$55-65
Charter	S-1887	ATD	KIM	1895	10	70's	S/P	White w/3 red angle's	$50-65	$15-190
Charter Oak	S-1887	BAW		1975	20	FKR	S/P	C87	$2-4	$7-9
Chasers	No Series	REE		1887	24	70's	S/P	C87	$50-65	$150-190
Cheer Up	S-113	KIM		1887	?	70's	S/P	Red circle on white	$20-25	$60-85
Chelsea	Sur-Gen	REE	REE	1924	20	70's	S/P	F460-VA	$15-20	$55-65
Chelsea	Caution	LAB		1943	20	FKR	S/P	F460-VA,	$10-15	$40-55
Chelsea Sportswear	S-109	RJR		1964	20	All Kinds	S/B	F460-VA, Multi. colors	$6-8	$25-35
Chemist Club	Sur-Gen	BAW		1989	20	70's	S/P	F407-2NY	$10-15	$40-55
Cherettes	Warning	TBC		1955	10	70's	F/B	F-407-2NY	$10-15	$40-55
Chesapeake	S-125	BAW		1955	?	70's	SSB	C98	$35-50	$90-135
Chester	No Series	MIL		1898	20	All Kinds	S/B	?	$6-8	$25-35
Chester Kings	Caution	LAM		1964	20	70's	S/P	?	$3-5	$8-12
Chesterfield	S-1873	DRU	DRU	1873	?	70's	F/T	Also R/T; F/T; F/B	$95-175	$250-350
Chesterfield	S-1887	ATD		1893	?	70's	S/P	F25-VA	$60-85	$180-225
Chesterfield	S-1911	LAM		1911-	50	FKR	SSB	F42-NC	$15-45	$90-135
Chesterfield Designer	S-102	LAM		1932	12	FKR	4-PKS	Designer packs	$15-25	$60-85
Chesterfield 101	Caution	LAM		1968	20	F101R	S/P	Yellow, w/picture of sailboat	$10-15	$40-55
Chesterfield 101	Warning	LAM		1964	20	F101R	S/P	Dark red, w/gold letters	$10-15	$40-55
Chesterfield 101	Warning	LAM		1980	20	F101R	S/P	Chesterfield logo,	$6-8	$25-35
Chesterfield (picture)	Warning	LAM		1981	20	F101R	S/P	Packs w/pictures on packs	$10-15	$40-55
Chesterfield	Warning	LAM		1968	20	FKR, FKM	S/P	Packs w/pictures on packs	$10-15	$40-55
Chesterfield	Warning	LAM		1985	20	FKR	S/P	C98	$1-2	$8-12
Chesterfield	Sur-Gen	LAM		1990	20	All Kinds	S/B	Drawing of 1920s on back	$3-5	$4-6
Chesterfield	No Stamp	LAM		1898	20	70's	SSB	Any Packs made after 1990	$35-50	$90-135
Chevalier	No Stamp	PMC		1958	10	70's	SSB	C98, F2-NY	$6-8	$25-35
Chevron	No Stamp	BAW		1962	20	FKR	S/P	?	$6-8	$25-35

(Right table)

Brand Name	Series	Mfg	Ven	YMf	#	Type	Pack	Description/Remarks	Empty	Full
Chic	S-105	SWA		1935	20	70's	S/P	?	$15-20	$55-65
Chicago Athletic Association	S-113	BEH		1943	?	70's	S/P	F5-2NY, Cork or plain tips	$10-15	$40-55
Chicago Club	S-118	GAG		1948	?	70's	S/P	F407-2NY	$10-15	$40-55
Chicago Record	S-1898	CHL		1898	?	70's		C98	$35-50	$90-135
Chicago Smoke	S-1898	CLS		1898	10	70's	SSB	C98. White w/picture of cig.	$35-50	$90-135
Chicago Spy	S-1883	CRO		1898	?	70's		C87, F42-NC	$50-65	$180-225
Chief	S-1887	DUK		1898	?	70's		C98, F25-VA	$1-2	$4-6
Chief	S-1887	ATD	ALG	1891	?	70's		C87, F42-NC	$2-4	$7-9
Chieftain	S-1887	DUK		1898	?	70's		C87, F42-NC	$1-2	$4-6
Chips	Warning	SHE		1982	20	70's		Multi. colors	$10-15	$40-55
Chiropractor	S-1917	CRD		1917	10	FQR	CSB		$2-4	$7-9
Choice	Warning	BAW		1974	20	70's	S/P	Trademark	$25-35	$70-95
Choo Choo Club Cars	Warning	GAG	GAB	1980	18	FKR	F/B	TP-75-NY	$3-5	$8-12
Chukker	S-102	SSS		1932	50	RKR	F/B	White,w/red band upper left	$25-35	$70-95
Chukker Ovals	S-102	SSS		1932	20	FKR	S/P	Black and white	$25-35	$70-95
Chukker Ovals	S-116	FLH		1946	20	70's	CSB	F1-1NY	$15-20	$55-65
Chukker Rounds	S-125	SSS		1940	20	70's	S/P	F404-NY	$15-20	$55-65
Chukker Rounds	S-107	USJ		1936	20	70's	S/P	F34-2NY, red w/white circle	$15-20	$40-55
Chums, Jefferson	S-115	FLH		1945	20	70's	S/P	F1-1NY	$15-20	$40-55
Churchill	S-110	CHU		1940	20	70's	S/P	English blend	$15-20	$40-55
Churchill Kings	S-110	GEN	CHU	1940	20	RKR	S/P	F11-1MO, Red and black	$15-20	$55-65
Churchill Downs No's	No Series	HAR		1921	20	RKR	S/B	All numbers	$15-20	$55-65
Cigarette	Warning	LAM		1975	20	All Kinds	S/B	White w/multi. colors	$2-4	$7-9
Cigarette Club	S-1887	ECK		1887	?	70's	S/P	C87	$35-50	$90-135
Cigarette Time	S-104	PMC	CNT	1934	20	FKR	S/P	F7-VA	$25-35	$70-95
Cigarettes	Warning	SHE		1982	20	70's	F/B	TP-161-NY	$2-4	$7-9
Cigettes	S-1879	BLC		1879	20	70's	F/B	The original generic	$75-100	$200-250
Ciguf	No Series	WRI		1926	10	F100RQ		?	$20-25	$60-85
Cimarron	Caution	GAG		1964	20	70's	S/P	?	$3-5	$8-12
Cimarron	S-110	RJR		1970	20	70's	S/P	?	$1-2	$4-6
Cinclair	Caution	RJR	FOR	1993	20	70's	S/P	TP-1-NC	$1-2	$4-6
Cindy	S-110	LAD		1940	20	All Kinds	S/P		$15-20	$55-65
Cinnamon	S-109	SWA		1935	20	RKR	S/B	Yellow, black band	$15-20	$55-65
Circle	No Series	?		1925	20	70's	S/P	Non-tobacco	$20-25	$60-85
Citadel	S-1887	DUK		1887	?	70's	S/P	F42-NC	$50-65	$150-190
Citation	No Stamp	PMC		1968	20	All Kinds	S/B	White, w/4 green bands	$6-8	$25-35
Citation	Warning	RJR		1975	20	FKR	FTB	Blue w/white gold lines	$6-8	$25-35
City 100's	Sur-Gen	RJR	GAR	1981	20	All Kinds	S/P	Multi. colors on white	$1-2	$4-6
City Brights	Sur-Gen	RJR	FOR	1993	20	F100R	FTB	Picture of skyscraper	$1-2	$4-6
City Lights	Sur-Gen	RJR	MTC	1995	20	F100RUL	S/P	Blue w/white gold lines	$2-4	$7-9
City of Stamford	S-1898	SHE		1974	20	FKR	S/P	Dark blue, white gold lines	$1-2	$4-6
City Press	Warning	SLE		1973	20	FKR	S/P	White w/orange paw	$2-4	$7-9
City Treasury	S-1898	HOF		1981	20	70's	S/P	C98	$35-50	$90-135
Claim	Caution	CRO		1898	20	FKR	S/P	C98	$35-50	$90-135
Class	Warning	RJR		1975	20	FKR	S/P	Trademark	$6-8	$25-35
Class "A"	Caution	LAM	GAR	1968	20	All Kinds	S/P	TP-42-NC	$2-4	$7-9
Class "A"	Sur-Gen	LAM		1987	20	All Kinds	S/P	TP-42-NC	$1-2	$4-6
Classic	Sur-Gen	LAM		1990	20	FKR	S/P	Trademark	$6-8	$25-35
Classic	Warning	RJR		1975	20	FKR	CSB	TP-161-NY	$1-2	$4-6
Clear	Sur-Gen	SHE		1993	20	FKR	S/P	Lite blue w/black letters	$2-4	$7-9
Clemson Tigers	Warning	LOR		1981	20	FKR	S/P	White w/orange paw	$2-4	$7-9
Clemson Tigers 81	Warning	LAM		1981	20	70's	S/P	C98	$2-4	$8-12
Cleopatra	S-1898	ATD	KIN	1898	?	70's	S/P	C98	$35-50	$90-135
Clipper	S-111	CEN		1941	20	FKR	S/P	F27-2NY	$15-20	$55-65
Clipper	S-114	CEN		1941	20	FKR	F/B	F27-2NY, White and red	$30-45	$75-115
Close	Warning	LAM	ALG	1911	20	70's	S/P	F25-VA	$6-8	$25-35
Cloth of Gold	S-1887	KIM		1887	?	70's	S/P	Trademark	$50-65	$150-190
Cloud Club	No Stamp	RJR		1976	20	FKR	S/P	Renamed in Old Gold	$6-8	$25-35
Clove	Caution	JER		1960	20	FKR	S/P	F36-KY, Brown, w/gold trim	$15-20	$55-65
Clovelly	S-105	BAW		1935	20	70's	S/P	F36-KY, white & red	$20-25	$60-85
Clovis	S-103	BAW		1930	20	70's	S/P	Trademark	$15-20	$55-65
Clown	Sur-Gen	LAM		1990	20	FKR	S/P	F24-KY	$50-65	$150-190
Club	S-108	AFT		1920	20	70's	S/P	C87	$60-85	$180-225
Cocarettes	S-1887	ATD	ECK	1895	10	70's	S/P	C87	$25-35	$55-65
Cocktail Hour	S-1883	CBA		1884	20	70's	SSB	Non-Tob. (Cocoa bean) cig.	$15-20	$55-65
Coffee Tone	S-104	FAL	COC	1934	10	70's	S/P	F30-NJ	$25-35	$70-95
Coffee Tone	S-1917	FLH	CBR	1919	20	70's	F/B	F1-1NY, Two tone brown	$15-20	$55-65
Coffin Nail	S-1898	LSW		1898	?	70's	S/P	C98	$35-50	$90-135

Left table

Brand Name	Series	Mfg	Ven	YMf	#	Type	Pack	Description/Remarks	Empty	Full
Coins	Warning	BAW		1985	20	FKR	S/P	Red, w/gold letters	$2-4	$7-9
Coins	Warning	BAW		1985	20	RKRL	S/P	Cream w/red letters	$2-4	$7-9
Cola	Warning	ATC		1970	20	FKR	S/P	Trademark	$6-8	$25-35
Cold	Caution	ATC		1968	20	FKR	S/P	Trademark	$6-8	$25-35
Cold Harbor	No Stamp	ATC		1966	20	FKM	S/P	Dark green, water drop,	$6-8	$25-35
Coldstream	Caution	ATC		1965	20	FKR	S/P	Trademark	$6-8	$25-35
Collegian	Caution	PMC		1967	20	FKR	FTB	Trademark	$6-8	$25-35
Collory's	S-101	RSD	WLH	1929	20	70's	S/P	F916-1NY	$20-25	$60-85
Colonel Adams	Sur-Gen	GAG		1997	20	FKR	S/P	Pink, party colors	$1-2	$4-6
Colonial	S-108	FRA		1938	20	FKR	S/P	Red w/picture of officer	$15-20	$55-65
Colony	S-1887	ATD		1890	?	70's	S/P	?	$50-65	$150-190
Colony	Caution	LAB		1954	20	RKR	S/P	F460-VA	$10-15	$40-55
Colorado	Warning	ATC		1964	20	All Kinds	S/B	Man wagon/horses	$3-5	$8-12
Colt	Warning	PMC		1968	20	FKR	FTB	Trademark	$2-4	$7-9
Columbia	S-118	GAG		1979	20	FKR	S/P	White w/picture of horseshoe	$10-15	$40-55
Columbia	Caution	LAG		1948	20	FKR	S/P	F407-2NY	$10-15	$40-55
Columbus	S-1879	CNT		1967	?	70's	S/P	?	$75-100	$200-250
Column	Caution	RJR		1878	20	FKR	S/P	Also by ATC in 1911	$6-8	$25-35
Columbia University / Clvb	S-125	?		1966	10	70's	CSB	F407-NY	$6-8	$25-35
Comanche	Sur-Gen	LAM	CHN	1955	20	FKR	S/P	White w/picture	$1-2	$7-9
Combo	Caution	CON		1986	20	FKR	S/P	Trademark	$6-8	$25-35
Combo	Warning	MON		1967	20	70's	FTB	Trademark	$6-8	$25-35
Commander	Warning	PMC		1973	20	FKR	S/P	Trademark	$6-8	$25-35
Commander	No Series	PMC		1909	20	70's	S/P	?	$30-45	$75-115
Commander	S-104	BEH		1929	20	70's	S/P	F5-2NY	$20-25	$60-85
Comme IL Faut	No Stamp	AFT		1931	20	70's	S/P	F24-KY	$15-20	$55-65
Commonwealth	No Series	PMC		1959	20	FKR	FTB	Trademark	$6-8	$25-35
Compac	Caution	BED		1870	?	70's	S/P	A suitable or proper smoke	$95-150	$225-300
Competidora	S-103	ACC		1933	20	70's	S/P	?	$15-20	$55-65
Competidora	Caution	ATC		1961	20	FKR	S/P	White, w/large black letters	$6-8	$25-35
Computer Systems / Roy C. Whayne Co.	No Stamp	DOM		1965	20	FKM	S/P	Dark green into light green	$6-8	$25-35
Concept	Sur-Gen	DOS		1963	20	All Kinds	S/P	TP-43-FL, White, gold trim	$6-8	$25-35
Concert	Warning	GLC		1979	20	All Kinds	S/P	TP-43-FL	$2-4	$7-9
Concord	S-118	TBC		1975	20	FKR	S/P	Dark blue, w/gold seal	$10-15	$40-55
Concord	Warning	RJR		1948	?	70's	S/P	F10-KY	$2-4	$7-9
Concord	S-1998	SCK		1970	20	FKR	S/P	?	$6-8	$25-35
Condax Very Mild	S-1901	KRI		1902	?	70's	S/P	F225-1NY	$35-50	$90-135
Condax Turkish	No Stamp	PMC		1962	20	70's	S/P	Trademark	$6-8	$25-35
Condax	Sur-Gen	PMC		1985	10	70's	S/P	Twist for flavor control	$60-85	$180-225
Condax Straw Tips Original	S-1901	CDX		1903	10	70's	CSB	F320-1NY, self closing top	$50-65	$180-225
Condax Turkish Original	S-1901	CDX		1905	10	70's	CSB	F320-3NY	$60-85	$180-225
No. One	S-1901	CDX		1904	50	FKR	CSB	F320-1NY,	$50-65	$180-225
Condossis	No Series	CDX		1928	10	FKR	CSB	F320-1NY,	$20-25	$60-85
Congress	S-103	CDX		1930	?	70's	S/P	F10-2NY	$15-20	$55-65
Consols Dark Havana	S-1898	CON		1898	20	FKR	S/P	C98, F363-3NY	$35-50	$90-135
Consols Medium Havana	S-1883	CTC		1872	10	70's	SSB	Light brown, wood grain	$60-85	$180-225
Constitution	S-1872	CTC		1872	10	70's	SSB	?	$50-65	$180-225
Contempo	S-1917	COP		1919	?	70's	?	?	$25-35	$70-95
Contentnea	Warning	PMC		1975	20	FKR	CSB	F12-4NC	$6-8	$25-35
Contessa	S-1910	NAD		1910	20	70's	S/P	White diamond on red	$30-45	$75-115
Contessa	Warning	PMC		1971	20	FKR	FTB	2 red angles on white	$2-4	$7-9
Continental	Warning	PMC		1976	20	FKR	S/P	F21-VA	$10-15	$40-55
Continental	Caution	ATC		1954	20	FKR	S/P	Trademark	$10-15	$40-55
Contopoulo Specials	No Stamp	LOR		1968	20	FKR	S/P	?	$10-15	$40-55
Controlled Profile	Sur-Gen	ATC		1916	20	70's	S/P	?	$30-45	$75-115
Convoy	S-1910	PMC		1936	20	70's	S/P	F11-MO	$15-20	$55-65
Cook Appliances, Inc.	Caution	COP		1968	20	FKR	S/P	?	$15-20	$55-65
Cookie Jar	S-108	TUC		1936	20	70's	S/P	Semi in the sun	$2-4	$7-9
Cookie Jar	Warning	LAM		1976	20	FKR	S/P	F407-NY	$10-15	$40-55
Co-op	S-121	TUC	YNC	1951	20	70's	S/P	F460-VA, yellow (aromatic)	$10-15	$40-55
Cooperator, The	S-118	TUC		1947	20	RKR	S/P	F460-VA, red w/white band	$10-15	$40-55
Cop	S-125	LAB	TOB	1932	10	70's	CSB	F24-14NY,white and brown	$10-15	$40-55
Copley	S-115	ALC	NCO	1948	20	70's	S/P	?	$15-20	$55-65
Cordoba	S-113	ECW		1943	50	70's	F/B	?	$6-8	$25-35
Corkers	S-125	KOH		1955	20	FKR	S/P	Trademark	$30-45	$75-115

Right table

Brand Name	Series	Mfg	Ven	YMf	#	Type	Pack	Description/Remarks	Empty	Full
Cornell Club Of N.Y.	S-118	GAG		1948	20	70's	S/P	F407-2NY	$10-15	$40-55
Cornwall	S-110	KAD	PFE	1940	20	70's	S/P	F750-5NJ, british blend	$15-20	$55-65
Coronation	S-115	MAK	PIE	1935	20	70's	CSB	F266-3MA	$15-25	$55-65
Coronation	S-102	BEH	PIE	1930	50	70's	F/T	F5-NY	$60-85	$180-225
Coronation	S-122	RIG	PIE	1952	20	70's	SSB	F94-1NY	$10-15	$40-55
Coronation 1953	No Stamp	?		1953	50	70's	C/T	Queen Elizabeth	$35-50	$90-135
Coronet	S-1887	JON		1887	50	70's	F/T	C87	$95-145	$225-275
Coronet	No Series	LAM		1928	20	70's	S/P	F42-4NC	$20-25	$60-85
Coronet	S-104	BAW		1962	20	RKRFF	S/P	Gold w/2 black crowns	$6-8	$25-35
Coronia	No Stamp	BOR		1934	20	70's	S/P		$15-20	$55-65
Corsica	Warning	LAB		1975	20	FKR	S/P	Blue w/white band	$2-4	$7-9
Cort	S-110	RIG		1940	20	RKR	S/P	F94-1NY, white w/gold crest	$15-20	$55-65
Cort	S-125	RIG		1955	20	RKR	S/P	F94-1NY, white w/3 lions	$10-15	$40-55
Cosmos	S-1910	KRI		1914	20	70's	S/P	F225-1NY,	$30-45	$75-115
Cosmos Club	S-118	GAG		1948	20	70's	S/P	F407-2NY	$10-15	$40-55
Cost Cutter	Warning	LAM	KRO	1981	20	All Kinds	S/P	TP42-NC	$1-2	$4-6
Cost Cutter	Sur-Gen	RJR	IAF	1988	20	All Kinds	S/P	TP-1-NC	$3-5	$8-12
Cotton Exchange	S-1887	IRB		1891	?	70's	?	C98	$50-65	$150-190
Cottontail	S-1901	ATD	PTB	1911	?	70's	?		$30-45	$75-115
Cougar	Caution	BAW		1969	20	FKR	S/P	Trademark	$6-8	$25-35
Count Condossis	S-102	CON		1932	20	FKR	S/P	Trademark	$15-20	$55-65
Count Tolstoi	S-1887	SCK		1890	20	70's	S/P	C98	$50-65	$150-190
Countess	S-123	PMC	CNT	1953	20	70's	S/P	F21-VA	$10-15	$40-55
Country	Warning	PMC		1971	20	FKR	S/P	?	$2-4	$7-9
Country Doctor	S-1883	PMC		1964	20	70's	S/P	?	$6-8	$25-35
Coupon	No Stamp	IRB		1883	?	70's	S/P	?	$60-85	$180-225
Coupon	S-1917	LAM		1911	20	70's	S/P	Yellow w/indian chief	$20-25	$60-85
Coupon	No Series	LAM		1928	10	70's	SSB	F42-NC,	$25-35	$70-95
Courier	Caution	RJR		1950	20	FKR	S/B	Trademark	$1-2	$4-6
Courtier	Sur-Gen	RJR	FOR	1967	20	FKR	S/P	TP1-NC	$1-2	$4-6
Covington	Sur-Gen	LAM		1976	20	All Kinds	S/P	Multi. colors on white	$6-8	$25-35
Cowboy	Warning	PMC		1993	20	70's	S/P	Trademark	$6-8	$25-35
C.P.C.A.	Warning	LAM		1972	20	FKR	FTB	4 Red stars on white	$6-8	$25-35
C.P.C.A.	Warning	LAM		?	20	FKR	S/P	?	$6-8	$25-35
Craven A	S-1910	ATC		1982	20	70's	S/P	Durham II, 2 green angles	$35-50	$90-135
Craven A	S-120	PMC		1910	10	70's	SSB	F7-VA, white circle on red	$15-20	$55-65
Craven A	S-124	PMC		1950	20	70's F	S/P	F7-VA, white circle on red	$15-20	$55-65
Creme De Menthe	Warning	LAM		1976	20	FKM	S/P	Green and white	$2-4	$7-9
Crescent City	S-1879	HES		1879	10	70's	SSB	C87, pure Virginia tob.	$95-150	$250-300
Crest	S-123	LAB		1953	20	70's	SSB	F460-VA	$15-20	$55-65
Crimps	S-1879	LAM		1879	10	70's	SSB	F25-1MO	$75-100	$200-250
Crimson Coach	S-102	CRC		1932	20	70's	S/P	Picture of horses, pulling	$15-20	$55-60
Cripple Creek	S-1898	WSM		1898	20	70's	SSB	C98	$35-50	$90-135
Crocodile	No Series	MEL		1923	?	70's	F/B	F1016-3NY	$20-25	$60-85
Cross Country	S-1898	ATD	KIN	1898	20	70's	S/P	C98, F30-NY	$35-50	$90-135
Cross-Cut (Turkish Cross-Cut)	S-1887	ATD	DUK	1890	?	F100R	FTB	C98, F42-4NC	$75-100	$200-250
Cross-Cut (Turkish Cross-Cut)	S-1883	DUK		1880	10	All Kinds	S/B		$95-150	$250-325
Cross-Cut Polo Team	S-1887	DUK		1887	10	70's	SSB	F42-NC	$75-125	$200-250
Crossword	S-1917	PBT		1920	?	70's	?	F42-4NC	$50-65	$150-190
Crown	S-108	BEH		1938	20	FKR	S/P	F5-2NY	$25-35	$70-95
Crown	Warning	LAM		1975	20	70's	S/P	TP-42-NC	$2-4	$7-9
Crown Gold	S-110	BEH		1940	20	FKR	FTB	F5-2NY, for ladies	$15-20	$55-65
Crown Gold, Turkish	S-115	BEH		1945	10	70's	S/P	F5-2NY, gray and white	$15-20	$55-65
Crown Jewel	S-1883	ATD	KIM	1886	20	60,s	CSH	?	$60-85	$180-225
Crown Point	No Stamp	LOR		1966	20	FKR	S/P	F407-2NY	$6-8	$25-35
Crowns	Sur-Gen	ATC		1991	20	F100R	FTB	Crowns on red	$6-8	$25-35
C R S T	Sur-Gen	ATC		1994	20	All Kinds	S/B	TP-130-NC, multi. colors	$95-150	$250-325
Cruise	Warning	GAG		1994	20	FKR	S/P	F407-2NY, white w/rooster	$2-4	$7-9
Crusader	S-111	BAW		1974	20	FKR	S/P	F407-2NY	$20-25	$60-85
Cuban Dainties	Warning	USV		1921	20	70's	S/P	F1-VA	$15-20	$55-65
Cubeb, Marshall's	S-102	SSS		1932	10	70's	CSB	F407-2NY	$15-20	$55-65
Cluberg Asbestos	S-1917	CCC		1911	38	70's	F/B	All tobacco, handmade	$75-100	$200-250
Cycle	No Series	HON	YNC	1880	20	70's	S/P	White letters on blue	$10-15	$40-55
Cycle	S-1887	GAG		1951	10	FKR	S/P	F407-2NY	$50-65	$150-190
Cycle	S-1910	LAM		1911	10	70's	SSB	F42-NC	$40-55	$150-190
Cyclone	S-122	BAT		1928	?	70's	S/P	Yellow w/red blue lines,	$10-15	$40-55
Corkers	S-1879	DUK		1884	?	70's	?	C87, F42-NC	$50-65	$150-190

Left table:

Brand Name	Series	Mfg	Ven	YMf	#	Type	Pack	Description/Remarks	Empty	Full
Cypsy Queen	S-1887	GDC		1888	20	70's	F/B	Lady inside Q	$60-85	$180-225
Czar	Sur-Gen	PMC		1987	20	FKR	S/P	Trademark	$10-15	$25-35
D. D. Richardson	S-123	GAG		1953	20	70's	S/P	F7-3MA	$30-45	$75-115
Daimonios	S-1910	LAZ		1912	10	70's	SSB	?	$35-50	$90-135
Dainties	S-1879	ATD	ALG	1891	?	70's	?	C98, F25-VA	$60-85	$180-225
Daisies	S-1901	KHE		1905	?	70's	?	?	$6-8	$25-35
Daisy Queen	S-1883	KIM		1884	20	70's	?	C87	$35-50	$90-135
Dakota	No Stamp	STP		1964	20	FKR	S/P	White w/blue band	$6-8	$25-35
Dakota	Warning	ATC		1971	20	FKR	S/P	Trademark	$60-85	$180-225
Dakata	Sur-Gen	GOO		1990	20	All Kinds	S/B	Multi. colors	$1-2	$4-6
Dale	Warning	RJR		1964	20	FKR	S/P	Trademark	$6-8	$25-35
Dalilas	S-102	BEN		1930	20	70's	S/P	F213-1CA	$15-20	$55-65
Dallas	Warning	LAM	DAL	1978	20	FKRSL	FTB	TP-42-NC	$2-4	$7-9
Dalton	No Stamp	BAW		1966	20	FKR	S/P	Red w/white band	$6-8	$25-35
Damgood	S-1898	DAK		1898	?	70's	?	C98	$35-50	$90-135
Danbury	S-102	RJR		1962	20	FKR	S/P	Trademark	$6-8	$25-35
Danube	No Stamp	LAM		1976	20	FKR	S/P	Trademark	$6-8	$25-35
Danville	No Stamp	LOR		1959	20	FKR	S/P	Gold horse on red	$6-8	$25-35
Dark Horse	S-108	GAG		1938	20	70's	SSB	F407-2NY	$15-20	$55-65
Darkies	S-115	BAB		1942	10	70's	S/P	F551-3NY	$20-25	$60-85
Dash	Warning	ATC		1973	20	FKR	S/P	Trademark	$6-8	$25-35
Date	No Stamp	RBR		1962	20	FKR	S/P	?	$1-2	$4-6
Dave's	Sur-Gen	PMC		1994	20	FKR	S/P	TP-7-VA, also FKRL,	$20-25	$60-85
Dawn	S-102	AFT	DAV	1930	10	70's	S/P	F24-KY	$6-8	$25-35
Dawn	S-102	AFT	DAW	1930	100	70's	R/T	F24-KY	$35-50	$90-135
Dawn	Warning	RJR	DAW	1975	20	F120R	S/P	Test Market	$30-45	$75-115
Dawson	Warning	LOR		1971	20	FKR	S/P	Trademark	$3-5	$8-12
Daytona	Sur-Gen	BAW		1988	20	FKR	S/P	Trademark	$3-5	$8-12
De Mauduit	S-1910	ANR		1910	20	70's	S/P	F7-3NY	$6-8	$25-35
De Menthe	No Series	GAG		1954	18	70's	SSB	Multi. colors on white	$30-45	$75-115
Death (Imports)	S-116	BAB		1925	20	70's	S/P	F139-3NY	$4-6	$7-9
Deauville	No Series	RYT		1946	10	70's	S/P	Black w/skull	$10-15	$40-55
Debs	S-110	LOR		1939	20	70's	S/P	F5-2NY	$15-20	$55-65
Decade	Sur-Gen	BEH		1976	?	All Kinds	S/P	Beige w/large "D" in square	$3-5	$8-12
Decoro	S-1898	LAM		1898	?	70's	?	C98, F2-NY	$35-50	$90-135
Def	S-1910	TUR		1910	20	70's	S/P	Also 20s,F7-3NY,F7-2NY,	$30-45	$75-115
Defender	Caution	LOR		1967	20	FKR	S/P	F57-5NJ	$3-5	$8-12
Deities, Egyptian	S-108	LOR		1911	10	70's	F/B	Trademark	$35-50	$90-135
Deities Mayfair Blend	S-1910	LOR		1938	20	70's	S/P	F7-3NY	$15-20	$55-65
Delancey	Sur-Gen	BAW		1989	20	FKR	S/P	Multi. colors on white	$6-8	$25-35
Delegate	S-1910	RJR		1910	10	70's	SSB	F139-3NY	$30-45	$75-115
Delhi	No Series	ANR		1910	20	70's	S/P	C89	$4-6	$7-9
Delicados (Imports)	No Series	GAG		1954	18	70's	S/P	Multi. colors on white	$20-25	$60-85
Delice	S-116	BAB		1925	20	70's	S/P	White and red	$10-15	$40-55
Delight	Warning	RYT		1946	10	70's	S/P	?	$35-50	$90-135
Delphine	S-1898	HUS		1900	20	70's	?	F156-2NY	$6-8	$25-35
Delta	Warning	PAV		1985	20	FKR	S/P	F137-5NJ	$35-50	$90-135
Dementhe	No Stamp	CNW		1961	20	FKM	S/P	?	$15-20	$55-65
Demi Tasse	S-102	FAL	AUO	1942	20	FKR	CSB	Dark green, white & gold stripes	$20-25	$60-85
Denictor	S-115	GUA		1974	?	70's	?	Trademark	$2-4	$7-9
Denim	Warning	LOR		1972	20	FKR	S/P	White w/3 tone 1/2 moon on lid	$6-8	$25-35
Dennison	Caution	LOR		1967	20	FKR	S/P	Green w/white trim	$3-5	$8-12
Denver	S-103	RJR		1973	20	FKR	FTB	C98	$3-5	$8-12
Derby	S-1883	KIN		1885	20	70's	S/P	F213-1CA	$6-8	$25-35
Dereszke	Sur-Gen	GOR	ELT	1996	20	FKR	S/P	Brown w/white gold stripes	$65-85	$180-225
Desert Chief	Warning	RJR		1974	20	FKR	S/P	Test market	$2-4	$7-9
Desert King	No Stamp	KIN		1957	20	FKR	S/P	C87, C98	$15-20	$55-65
Deuce	S-1898	PMC		1898	10	70's	?	F916-1NY	$35-50	$90-135
Devon	S-1898	CRO		1898	20	70's	SSB	Trademark	$35-50	$90-135
Diamant	Warning	WIK		1930	20	FKR	S/P	Durham III, 3 types	$2-4	$7-9
Diana	S-102	BEN		1973	20	70's	S/P	Blue & red packs	$6-8	$25-35
Dick Elliott	Warning	LAM		1962	20	FKR	S/P	?	$2-4	$7-9
Dickens & Grant	S-1879	ECK		1882	?	70's	?	?	$6-8	$25-35
Digest	S-103	RSD		1932	20	70's	?	?	$20-25	$60-85
Digital Air Control	No Stamp	PMC		1938	10	70's	?	?	$2-4	$7-9
Dilbear	No Series	GLC		1926	5	70's	F/B	?	$6-8	$25-35
Dimension	Warning	LAM		1975	20	FKR	S/P	Trademark	$3-5	$8-12

Right table:

Brand Name	Series	Mfg	Ven	YMf	#	Type	Pack	Description/Remarks	Empty	Full
Diosa	S-1898	MIL		1898	10	70's	CSB	C98,F2-NY	$35-50	$90-135
Diplomat	S-125	NAC		1955	20	RKR	S/P	White w/blue letters	$10-15	$40-55
Director's Choice	Sur-Gen	RJR	FOR	1993	20	All Kinds	S/B	Multi. colors on white	$2-1	$4-6
Director's Special	S-115	CAN		1942	20	70's	S/P	?	$15-20	$55-65
Disney World, Walt	Warning	GAG		1971	20	70's	CSB	F1-10-OH	$2-4	$7-9
Disque Steel Product	S-121	GAG	YNC	1951	20	80's	CSB	Virginia ovals	$10-15	$40-55
Dividend	S-1898	ATD	DRU	1898	?	70's	?	F407-2NY	$35-50	$90-135
Dixie	S-1887	ATD	ALG	1891	?	70's	?	C98, F25-VA, also flat 50's	$50-65	$150-190
Dogs Head	S-1883	GOO		1892	20	70's	SSB	F26-2NY	$60-65	$180-225
Dogs Head	S-1887	KIN		1887	?	70's	?	F593-MD, also mfg. by LAM	$50-65	$150-190
Dogfight	No Series	USV		1921	20	70's	S/P	F1-VA	$30-35	$90-135
Dolf Gordon	S-1898	MRT		1898	?	70's	?	C98	$35-50	$90-135
Dolly	No Series	?		1920	?	70's	?	?	$25-35	$70-95
Dolma London Cig.	S-1901	SRB		1904	10	70's	CSB	F348-3NY, RED	$35-50	$90-135
Dolphin	No Stamp	PMC		1961	20	FKR	FTB	Red and white	$15-20	$55-65
Domino	S-109	LAB		1931	20	70's	S/P	F460-VA, red and white	$75-100	$200-250
Domino	S-103	LAB		1933	50	70's	F/T	F460-VA, also R/T & 100's	$10-15	$40-55
Domino	S-123	LAB		1953	20	70's	F/B	F460-VA, red and white	$6-8	$25-35
Don Carlos	No Stamp	USJ	LAB	1959	20	RKR	S/P	107-CP2-1, 108-CP2-1, red	$35-50	$90-135
Donosa	S-1898	FRP		1898	?	70's	?	C98, F2-NY	$35-50	$90-135
Dorado	No Stamp	MIL		1898	20	RKR	S/P	Trademark	$2-4	$7-9
Dorado	Warning	LAM		1962	20	RKR	S/P	Brown woodgrain	$3-5	$8-12
Doral	No Stamp	LAM		1977	20	FKR	S/P	Brown and Beige on white	$2-4	$7-9
Doral II	Caution	RJR		1967	20	All Kinds	S/P	Brown and orange	$1-2	$4-6
Doral	Warning	RJR		1978	20	70's	S/B	Multi. colors	$10-15	$40-55
Dorchester	Warning	RJR		1983	20	All Kinds	S/B	Multi. colors	$10-15	$40-55
Doria Pamphilis	S-121	BAW		1950	20	70's	S/P	Trademark	$10-15	$40-55
Doric	S-119	STP		1949	20	70's	S/P	C98, F363-3NY	$35-50	$90-135
Dorset	S-123	LAB		1953	?	70's	S/P	F460-VA	$2-4	$7-9
Dot	S-1901	BEN	KIF	1907	?	70's	S/P	F213-1CA	$35-50	$90-135
Double Eight	Caution	ATC		1968	20	FKR	SSB	F213-1CA	$6-8	$25-35
Double Star	S-107	KIN		1898	15	70's	F/T	Black w/white stripes, 88mm	$35-50	$75-90
Doublets	S-125	AFT		1937	10	70's	S/B	C98, F30-OH	$10-15	$40-55
Dover	No Stamp	BAW		1955	20	FKR	S/B	F24-KY, 5 colors	$6-8	$25-35
Dover	Caution	BAW		1962	20	FKR	S/B	White w/blue letters	$10-15	$40-55
Dover Longs	No Stamp	BAW		1967	20	F100R	S/B	Red and gold	$2-4	$7-9
Downtown Athletic	S-118	GAG		1948	20	70's	SSB	F407-2NY	$30-45	$75-115
Downtown	Warning	PMC		1976	20	FKRL	FTB	Medicinal cigarette	$60-85	$180-225
Dr. Shiffmann's	No Stamp	SCF		1910	20	70's	SSB	Self lighting cigarette	$10-15	$40-55
Dr. Scotts	S-1883	PME		1883	10	70's	S/P	White w/picture of duck	$2-4	$7-9
Drake	S-119	RIG		1946	20	70's	S/P	White w/picture of duck	$10-15	$40-55
Dream Castle	Warning	HOE	RIG	1973	20	FKR	F/B	White w/picture of castle	$2-4	$7-9
Dream Castle	S-106	TBC	DRC	1936	20	70's	F/B	F10-KY	$15-20	$55-65
Dream Land	S-115	TBC	DRC	1936	20	70's	S/P	C98	$20-25	$60-85
Dromedary	S-1898	NAT		1898	20	70's	?	Trademark	$35-50	$90-135
Drug Specialties Inc.	Warning	RJR		1975	20	FKR	S/B	Trademark	$3-5	$8-12
Drum	S-121	GAG	YNC	1951	10	70's	F/B	F407-NY	$10-15	$55-65
Du Barry	S-1879	DRU		1879	?	70's	?	F100-1MO	$75-100	$200-250
Dukakis/President	No Series	RSD		1926	10	70's	F/B	F916-1NY	$20-25	$60-85
Duke	Sur-Gen	GAG		1988	20	RKR	S/P	Beige w/red letters	$30-45	$75-115
Duke	No Stamp	DUK		1876	20	70's	S/B	Trademark	$25-35	$70-95
Duke Blue Devils	Warning	LAM		1956	20	FKR	F/B	Blue on white	$10-15	$40-55
Duke of Durham	S-1887	DUK		1881	10	70's	SSB	Red w/silver lines	$6-8	$25-35
Duke of Durham	S-1898	ATD	DUK	1890	20	70's	?	C87, F42-NC	$50-65	$200-275
Duke of Durham	Caution	LAM		1956	20	70's	S/P	C98	$6-8	$25-35
Duke of York	S-1883	KHV		1895	50	70's	S/P	White w/blue stripes	$60-85	$180-225
Duke's Best	S-1883	DUK		1884	?	70's	F/TIN	F348-2NY	$95-175	$195-295
Duke's Preferred Stk.	S-1883	DUK		1886	?	70's	SSB	F42-NC	$65-85	$180-225
Dumont	Warning	HOE		1973	20	FKR	S/P	TP-45-VA	$75-100	$200-250

185

Table 1 (left section):

Brand Name	Series	Mfg	Ven	YMf	#	Type	Pack	Description/Remarks	Empty	Full
Dunbar	S-1910	GAG	DUN	1910	10	70's	SSB	F407-2NY, hand-rolled	$60-85	$180-225
Duncan Scotch Cut	Caution	LOR		1965	20	FKR	S/P	Red on white	$6-8	$25-35
Dunhill London	No Series	CNT	TEX	1925	20	70's	S/P		$25-35	$70-95
Dunhill	S-108	PMC		1938	50	70's	S/B	F21-VA	$15-20	$55-65
Dunhill	S-138	PMC		1938	20	70's	F/T	Light blue	$35-50	$90-135
Dunhill, Palace Blend	S-124	PMC		1952	20	70's	S/B	F7-VA, Multi colors	$10-15	$40-55
Dunhill	Warning	PMC		1980	All Kinds	RKR	S/P	TP-42-NY, Multi colors	$2-4	$7-9
Dunmore	Sur-Gen	RJR		1988	20	FKR	S/P	Trademark	$6-8	$25-35
Duo-Blend	S-115	GAG		1926	20	70's	S/P	F407-NY	$20-25	$60-85
Duo-Blend	S-118	GAG		1948	18	FKR	F/B	F407-2NY, white w/red seal	$35-50	$90-135
Duplex	S-1898	BUL		1898	10	70's	SSB	C98	$3-5	$8-12
Durango	Warning	LOR		1975	20	FKR	S/P	Lite blue w/black letters	$35-50	$90-135
Durbar No. 3	S-110	ANR		1902	10	FKR	S/P	F535-2NY	$60-85	$180-225
Durham	S-1883	BLA		1883	20	70's	F/B	White, w/picture in red circle	$3-5	$15-25
Durham III	Sur-Gen	GOR	CPC	1996	20	FKR	F/T	3 types, red, green, blue	$75-100	$200-250
Durmmond	S-1898	DRU		1898	10	FKR	S/P	Silver w/black triangle	$2-4	$7-9
Dutch Blend	Sur-Gen	ATC		1990	20	FKR	S/P	Trademark	$2-4	$7-9
Dutch Bowl	S-1898	ATC		1988	20	FKR	S/P	Trademark	$6-8	$25-35
Dutch Crown	Caution	ATC		1964	?	FKR	S/P	Trademark	$35-50	$90-135
Dutch Jake	S-1898	THM		1898	20	70's	?	C98	$2-4	$7-9
Dutch Mix	S-1898	ATC		1986	20	FKR	S/P	Trademark	$2-4	$7-9
Dutch Pipe	Sur-Gen	ATC		1989	20	FKR	S/P	Trademark	$50-65	$150-190
Dutch Treat	S-1883	ATC		1990	20	70's	S/P	C87, F42-NC	$35-50	$90-135
Dutchess	S-1898	DUK	DUK	1886	20	70's	S/P	C98, F42-4NC	$30-45	$75-115
Dutchess	S-1917	ROB		1918	10	FKR	F/B	Padded red box	$15-20	$55-65
Dutchess, Salaambo	S-102	DUV		1932	20	70's	S/P	?	$30-45	$75-115
Duval	Caution	RJR		1967	20	FKR	S/P	Blue w/white gold lines top	$3-5	$8-12
Duval	S-1917	MCN		1919	20	70's	S/P	Blue w/white gold lines top	$25-35	$70-95
Dynamite	Warning	RJR		1987	20	FKR	S/P	?	$3-5	$8-12
Dynasty	S-103	VCT		1933	20	70's	S/P	?	$15-25	$55-65
Eagle	Sur-Gen	GNO		1990	20	70's	S/P	Multi colors	$1-2	$4-6
Eagle 20	Warning	LAM		1976	20	FKR	S/P	Red w/white eagle and 20	$6-8	$15-25
Eagle 20	Sur-Gen	LAM	GPA	1993	20	FKR	S/P	TP-42-NC, Multi color	$1-2	$4-6
Eagle Bird	S-1898	IRB	ALP	1898	20	70's	SSB	C98	$35-50	$90-135
Eagle Bird	S-1917	BAT		1920	10	70's	S/P	Made in N.Y. and England	$30-45	$75-115
Eagles	Warning	LAM		1975	20	FKR	S/P	Trademark	$6-8	$25-35
Early American	S-107	ATC		1898	20	FKR	S/P	Trademark	$15-25	$55-65
Early Virginia	S-121	SWA	YNC	1935	20	70's	S/P	Picture of gate w/red brick	$20-25	$60-85
Eastern Dream	S-102	MIR		1930	20	70's	S/P	?	$35-50	$90-135
Eastern Lights	S-1898	PIT		1898	20	70's	S/B	C98	$15-20	$55-65
Easy	Warning	LOR		1974	20	FKR	S/P	F916-1NY	$15-20	$55-65
Ebonies	S-102	RSD		1932	20	FKR	S/P	Trademark	$6-8	$25-35
Echelon	Warning	RJR		1975	20	FKR	S/P	C98	$35-50	$90-135
Echo	S-1898	MIL		1939	20	70's	S/P	Red w/white trim	$15-20	$55-65
Echo	S-109	LEI	LEE	1995	20	FKR	F/B	Also FKM	$6-8	$25-35
Eclipse	Sur-Gen	RJR		1996	20	FKR	FTB	With gold bird & Qtr. moon	$2-4	$7-9
Eclipse	Warning	KHC	RHF	1981	20	FKR	FTB	TP-3-VA	$2-4	$7-9
Econ	Sur-Gen	GAG		1898	20	70's	S/P	TP-42-NC	$35-50	$90-135
Econo Buy	Warning	USJ		1984	20	FKR	S/P	C98	$6-8	$25-35
Edanwol	Warning	LAM	ALP	1981	20	FKR	F/B	C98	$35-50	$90-135
Edenia	S-1898	BRC		1898	10	70's	F/B	F407-NY	$10-15	$40-55
Edgar Balshaw	S-121	SLV		1951	20	70's	S/P	TP-45-VA	$15-20	$55-65
Edgeworth	S-110	GAG		1940	20	70's	S/P	TP-45-VA, Multi colors	$35-50	$90-135
Edgeworth Export	Caution	LAB		1968	20	FKR	S/B	C98	$2-4	$7-9
Edison	S-1898	LAB		1898	20	70's	S/P	C98	$35-50	$90-135
Edison	Warning	KSR		1980	20	FKR	FTB	C98	$95-200	$325-475
EF 11	S-102	LOR		1932	20	FKR	S/P	Trademark	$25-45	$90-135
Egmont	S-1860	FEN		1860	20	70's	S/P	C98	$35-50	$90-135
Egyptian	S-1883	THA		1885	20	70's	S/P	F2032-1PA, Multi colors	$35-50	$90-135
Egyptian 1444"	S-105	MON		1935	10	70's	F/B	F439-2NY	$50-65	$150-190
Egyptian	S-1898	STP		1898	10	70's	CSB	Non-Plus ultra No.1	$30-45	$75-115
Egyptian Arabs No. 2	S-1901	ECK		1901	20	70's	F/B	TP-3-VA	$50-65	$150-190
Egyptian Arabs No. 3	S-1898	SRB		1898	10	70's	F/B	F439-2NY, F279-5NJ	$30-45	$75-115
Egyptian Aroma	S-1909	SRB		1909	10	70's	CSB	C98	$10-15	$40-55
Egyptian Banner	S-1909	STM		1898	20	70's	F/B	F508-NY	$30-45	$75-115
Egyptian Beauties	S-1887	POU		1910	10	70's	P/T	C97, F363-3NY	$6-8	$15-25
Egyptian Belles	S-1898	MON		1895	20	70's	S/P	?	$3-5	$8-12
Egyptian Brights	No Series	KHO		1925	10	70's	SSB	C97, F363-3NY	$20-30	$60-85
Egyptian Cadets	S-1901	LOW		1901	10	70's	CSB	?	$35-50	$90-135
Egyptian Chief	S-1898	NTW		1900	10	70's	P/T	2 towers w/picture of chief	$35-50	$90-135

Table 2 (right section):

Brand Name	Series	Mfg	Ven	YMf	#	Type	Pack	Description/Remarks	Empty	Full
Egyptian Club	S-1898	SCS		1898	10	70's	CSB	C98	$35-50	$90-135
Egyptian Date	?	LOR		?	100	70's	F/T	Mouthpiece	$35-50	$90-135
Egyptian Deities	S-1901	ATD	ANR	1905	20	70's	CSB	F7-3NY, Multi. colors	$60-95	$180-225
Egyptian Deities	S-1901	LOR	ANR	1911	10	70's	P/T	F7-3NY, no. 3"	$35-50	$90-135
Egyptian Delight	S-1901	KHE		1905	10	70's	?	Plain end	$35-50	$90-135
Egyptian Deputies	S-1898	EGD		1898	?	70's	?	C98	$35-50	$90-135
Egyptian Deputy	S-1898	EGD		1898	?	70's	?	C98	$35-50	$90-135
Egyptian Elegantes, Longfellows	S-109			1939	20	70's	S/P		$20-25	$60-85
Egyptian Emblems	S-1901	PEN		1901	10	70's	CSB	F22-12PA	$35-50	$90-135
Egyptian Fancies	S-1901	AHR		1902	10	70's	CSB	F7-3NY, Multi. colors	$35-50	$90-135
Egyptian Flowers	S-1898	ATD	KIN	1898	?	70's	?	?	$35-50	$90-135
Egyptian Heroes	S-1917	DIL		1917	10	70's	F/B	Picture of 2 pyrmids	$25-35	$70-95
Egyptian Heroes	S-1898	KRI		1899	?	70's	?	F225-1NY	$35-50	$90-135
Egyptian Ibis	S-1901	BUB	ATD	1906	20	70's	?	F649-1NY	$35-50	$90-135
Egyptian Kings No. 2	S-1910	OUS		1910	10	70's	SSB	Picture of man inside reef	$30-45	$75-115
Egyptian Lotus	S-1898	IRB		1898	10	70's	P/T	Picture of lady smoking	$35-50	$90-135
Egyptian Luxury	S-1903	ANR		1898	10	70's	F/B	F7-3NY	$30-45	$75-115
Egyptian Merits	S-1910	ZAP		1912	20	70's	CSB	F360-IL	$30-45	$75-115
Egyptian Mysteries	No Series	CUI		1923	10	70's	SSB	F556-2NY	$20-25	$60-85
Egyptian Oasis	S-1910	LAM		1913	?	70's	?	F171-1CA, F64-NY	$30-45	$75-115
Egyptian Pharaohs	S-1898	HDD	SCS	1894	10	70's	?	F647-2NY	$35-50	$90-135
Egyptian Prettiest	S-110	SCS		1898	50	70's	F/T	Also 100's	$50-65	$150-190
Egyptian Princess	S-1887	ATC		1930	20	70's	F/B	F30-NC	$30-45	$75-115
Egyptian Queen	S-1889	SRN		1916	10	70's	?	F74-3NY	$50-65	$150-190
Egyptian Silko	S-1887	SOT		1896	10	70's	SSB	C98	$35-50	$90-135
Egyptian Unis	S-1898	ATD		1900	20	70's	?	Looks like bricks	$25-35	$60-85
Egyptian Standard	No Series	PMC		1923	10	FKR	S/P	F100-2NY	$35-50	$90-135
Egyptienne	S-1898	BEN		1898	10	70's	S/P	F213-1CA	$25-35	$60-85
Egyptienne 39A	S-1898	ATD		1898	20	70's	S/P	?	$35-50	$90-135
Egyptienne Elegante	No Series	TWR		1927	20	70's	S/P	C98	$25-35	$60-85
Egyptienne Luxury	S-1903	RSD		1898	20	70's	S/P	F7-3NY	$35-50	$90-135
Egyptienne Straights	S-1901	TKE	BUB	1903	20	70's	F/B	F2153-3NY	$35-50	$90-135
Egyptienne Straights	S-1901	TKE	BUB	1943	10	70's	CSB	F30-NC, light blue gold lion	$10-15	$40-55
Egyptienne Straights	S-113	ATD	BUB	1907	50	70's	F/T	Also 100's, F30-NC	$75-100	$200-250
Ehano	No Stamp	PMC		1962	20	FKR	S/P		$6-8	$25-35
Ehrlich's	S-114	SSS	EHR	1944	20	FKR	S/P	F404-2NY	$10-15	$40-55
Ehrlich's Blend	S-118	GAG	EHR	1948	20	FKR	S/P	F407-2NY	$10-15	$40-55
Eianaclis	No Series	NEW		1927	20	70's	S/P	?	$20-25	$60-85
Eighth Wonder	S-1898	MEU		1898	20	70's	S/P	C98	$35-50	$90-135
Eightieth (both)	Warning	RJR		1983	10	FKR	SSB	80th anniversary of Camel, Kamel, Reyno and Osman Louisiana world expo.	$35-50	$90-135
"84"	Warning	MEU	LDG	1984	20	FKR	S/P	F1-1NY, cork tip	$10-15	$40-55
Eightyone, 81 Blend	S-120	FLH		1950	20	70's	S/P	F10-KY	$10-15	$40-55
Eisenhower for President	S-122	TBC		1952	20	70's	S/P	F1-VA	$15-20	$55-65
EJS (E. J. S.)	No Series	USV		1921	20	70's	S/P	F244-NY	$20-25	$60-85
El Ahram	S-1898	KHC		1900	?	70's	S/P	C-407-NY	$6-8	$25-35
El Bar Gor IV	No Stamp	GAG	BRE	1961	20	FKR	S/P	TP-3-NC	$6-8	$25-35
El Cuno	Caution	USJ	MEN	1961	20	FKR	S/P	Also F100R, TP-762-FL	$2-4	$7-9
El Cuno	Warning	MEN		1979	20	FKR	S/P	Packed for Frank Sinatra	$20-25	$60-85
El Dago	Warning	SHE		1975	20	FKR	S/P		$30-45	$75-115
El Kab	S-1910	ITC		1910	20	70's	S/P	C87	$50-65	$150-190
El Mahdi	S-1901	KIM		1886	10	70's	S/P	F17-2NY	$6-8	$25-35
El Principe De Gales	No Stamp	ATD		1908	20	FKR	SSB	Brown on white?	$3-5	$8-12
El Toro	Warning	USJ		1956	20	FKR	S/P	Blue w/white gold lines	$3-5	$8-12
Electric	Warning	RJR		1976	20	FKR	S/P	Black and gold	$50-65	$150-190
Eli Cutter	Warning	BAW		1984	20	FKR	FTB	Red & gold, Black & Gold	$50-65	$150-190
Eli Cutter	Sur-Gen	BAW		1987	20	FKR	S/B	C87, F42-NC	$30-45	$75-115
Elite	S-1887	DUK		1887	?	70's	S/P	C98	$10-15	$40-55
Ellicot	S-1898	SEB		1898	20	FKR	S/P	Picture of Elvis	$30-45	$75-115
Elvis	Warning	LAM		1977	20	FKR	CSB	F551-3NY, gold top	$6-8	$25-35
Embassy	S-1910	ATC		1911	10	70's	S/P	F8-5NJ	$50-65	$150-190
Embassy #35	No Series	BAB		1928	20	70's	S/P	F8-5NJ, (micropore paper)	$30-45	$75-115
Embassy	S-121	LOR		1947	20	R100R	CSB	CCMS-1, trombone/sax	$15-25	$55-65
Embassy	S-117	LOR		1947	20	RKR	S/P	CCMS-2, trombone/sax	$3-5	$8-12
Emblem	Sur-Gen	PMC		1994	20	FKML	P/T	F649-1NY	$30-45	$75-115
Embra	Sur-Gen	PRU		1996	10	F100R	SSB	Also F100M	$6-8	$25-35
Emek	No Stamp	RJR		1969	20	70's	FTB	F72-1NY, brown and gold	$20-25	$60-85
		PAL		1926	20	70's	CSB	Also F100M		

Top table

Brand Name	Series	Mfg	Ven	YMf	#	Type	Pack	Description/Remarks	Empty	Full
Free	Warning	IBI		1979	20	FKR-FKMS	P	2 Varieties, non-tobacco	$6-8	$15-25
Free	Warning	IBI		1984	20	FKR-FKMS	P	2 Varieties, non-tobacco	$2-4	$8-12
Free	Sur-Gen	PMC		1994	20	FKRFF	FTB	Trademark, CCSS-2, red 94	$6-8	$25-35
Free	Sur-Gen	PMC		1995	20	FKRFF	S/P	Trademark, CCSS-3, red 95	$6-8	$25-35
Free	Sur-Gen	PMC		1996	20	FKRFF	S/P	Trademark, CCSS-4, red 96	$6-8	$25-35
Free Spirit	Sur-Gen	SAR	KRT	1995	20	FKRFF	S/P	TP-22-VA, eagle on red	$1-2	$4-6
Freemont	Warning	BAW		1981	20	FKR	S/P	Trademark	$6-8	$25-35
Freeport	Sur-Gen	PMC		1992	20	FKR	FTB	Trademark, CCAS, white 92	$6-8	$25-35
Freeport	Sur-Gen	PMC		1994	20	FKR	S/P	Trademark CCAS-3, white	$6-8	$25-35
Freeport	Sur-Gen	PMC		1995	20	FKR	S/P	Trademark CCVS-2 white	$6-8	$25-35
Freeport	Sur-Gen	PMC		1996	20	FKR	S/P	Trademark CCVS-3 white	$6-8	$15-25
Freiheit/Svoboda	S-1887	SCK		1890	20	70's	F/B	F339-2NY	$50-65	$150-190
Fresh	Caution	ATC		1980	20	FKR	S/P	Trademark	$3-5	$8-12
Fresh Convertible	Caution	ATC		1969	20	F100R	S/P	White w/gold pinstripes	$2-4	$7-9
Frisco	Warning	LOR		1974	20	All Kinds	S/P	?	$6-8	$25-35
Frontier	Warning	LAM		1969	20	RKR	S/P	Trademark, red on white	$6-8	$25-35
Frost	Caution	ATC		1961	20	RKR	S/P	Trademark, green on white	$6-8	$25-35
Frost w/ 3 Y Filter	Caution	ATC		1961	20	F100M	S/P	Green w/white stripes	$2-4	$7-9
Full Dress Straight	S-1869	KIN	KIN	1969	?	70's	?	F593-MD	$95-175	$250-450
Full Dress Straight	S-1887	ATD		1887	?	70's	?	F593-MD	$50-65	$150-190
Full Flavor	Warning	SFD	GTC	1982	20	All Kinds	S/P	TP-7-VA, Multi. colors	$1-2	$3-4
Full House	S-104	BAW		1928	20	70's	F/B	F36-KY	$20-25	$60-85
G-D	Warning	RJR		1965	20	FKR	S/P	Trademark	$6-8	$25-35
GAG Generic	S-1898	GAG		1981	20	70's	S/P	White w/black letters	$2-4	$7-9
Galano, El	S-1898	MIL		1898	?	70's	?	F2-NY	$35-50	$90-135
Galante	S-1898	MIL		1898	?	70's	?	?	$3-5	$3-4
Galaxy	Caution	PMC		1960	20	FKR	F/B	White gold on red	$2-4	$7-9
Galaxy	Warning	PMC		1971	20	FKR	S/P	White gold on red	$20-25	$60-85
Galba	No Series	GAL		1924	20	All Kinds	S/P	?	$10-15	$40-55
Galileo	No Stamp	ALV		1949	20	RKR	S/P	Blue and white	$3-5	$8-10
Gallito	Caution	PMC		1957	20	RKR	S/P	Blue and white	$3-5	$8-10
Galoises Caporal	Caution	PMC		1966	20	70's	S/P	F5-2NY, purple	$20-25	$60-85
Galoises Disque Bleu	No Series	BEH		1964	20	70's F	CSB	F537-3NY	$25-35	$70-95
Gardenia	No Series	PMC		1922	20	70's	S/P	?	$30-45	$75-115
Garibaldi	S-1917	RTT		1919	20	70's	S/P	?	$6-8	$25-35
Garrison	S-1910	BEY		1911	20	70's	S/P	?	$6-8	$25-35
Garrison	Warning	BAW		1984	20	FKR	S/P	Trademark	$3-5	$8-12
Gateway	Caution	DEG		1965	20	FKR	S/P	TP75-NY	$6-8	$25-35
Gatlin-Burlier, Smokies Naturals	Warning	GAG	GAB	1981	20	FKR-FKMS	P	Trademark	$3-5	$15-25
Gatsby	Warning	BAW		1975	20	FKR	S/P	Trademark	$6-8	$90-135
Gauloises Desque Bl.	Caution	PMC		1966	20	70's	S/P	Blue w/black letters	$35-50	$90-135
Gay American	S-1898	WSM		1898	20	70's	S/P	C98	$3-5	$8-12
Gaylord	Caution	PMC	BEH	1963	20	RKR	S/P	C98	$35-50	$90-135
Gem	S-1898	FEN		1898	?	70's	?	Picture of man smoking billfold type box	$95-175	$250-350
Gem, Mild Richmond	S-1879	ALG	GIN	1879	10	70's	SSB	C98	$20-25	$60-85
Gemini	Caution	USJ	ADR	1968	20	FKR	F/B	White w/black band	$85-150	$200-325
Gems	S-110	STP		1930	20	70's	F/T	F2032-1PA, mico-filter	$10-15	$40-55
Gems	S-114	STP		1930	20	FKR	F/B	White-red, w/generals cap	$15-20	$55-65
Gems	S-122	STP		1952	20	FKR	F/B	Gold world on white	$35-50	$90-135
General	No Stamp	HKC	LTD	1959	10	70's	S/P	C98, F2-NY	$6-8	$25-35
General Dynamics	S-125	MIL		1955	20	All Kinds	S/P	TP-7-VA, multi. colors	$6-8	$25-35
General Macco	S-1898	PMC		1898	20	FKR	S/P	Trademark	$15-20	$90-135
Generals	Sur-Gen	PMC	FVB	1993	20	FKR	S/P	Trademark	$6-8	$25-35
Generation	Warning	LAM		1977	20	FKR	S/P	Trademark	$6-8	$25-35
Genesis	Warning	LAM		1976	20	FKR	S/P	Black letters on white	$15-20	$55-65
Geneva	Warning	BAW		1982	20	FKR	S/P	Red on white	$15-20	$90-135
Genteel	S-1873	CNT		1873	?	70's	?	Red w/GI in white	$95-175	$250-325
Genuine	Warning	RJR		1975	20	FKR	S/P	Trademark	$6-8	$25-35
Georgia Girl	Warning	LAM		1974	20	FKR	S/P	Trademark	$2-4	$7-9
Georgy-Girl	Warning	LAM		1975	20	FKR	S/P	Trademark	$6-8	$25-35
Georgia Teck	S-110	?		1940	20	FKR	S/P	Trademark	$6-8	$25-35
GI Joe	Caution	ATD		1911	20	FKR	S/P	Red w/GI in white	$15-20	$55-65
Gibson Girl	S-1910	GAG	SMH	1967	?	FKR	S/P	1 of 10 "spoof" packs	$30-45	$75-115
Giggle Grass, Mother	Caution	GAG		1914	?	FKR	S/P	?	$30-45	$75-115
Gilmore	S-1910	GIM		1902	20	70's	SSB	F4-LA	$35-50	$90-135
Gemime	S-1901	PTB		1928	10	70's	S/P	F213-1CA	$20-25	$60-85
Glacier Bay	No Series	BEN		1970	20	FKR	S/P	Trademark	$6-8	$25-35

Bottom table

Brand Name	Series	Mfg	Ven	YMf	#	Type	Pack	Description/Remarks	Empty	Full
Filter	Warning	LAM	LIG	1988	20	All Kinds	S/P	TP-42-NC, black on white	$2-4	$7-9
Filtip	S-105	TUC	CHR	1935	20	70's	S/P	F1-1MO, trademark	$10-15	$55-65
Filtip	S-120	BAW		1950	20	70's	?	F-36-KY black on white	$10-15	$40-55
Final Decree	S-1898	KLS		1898	?	70's	?	C98	$35-50	$90-135
Financier	S-1898	VLN		1898	20	70's	S/P	C98	$35-50	$90-135
Fincastle	S-118	BAW		1948	20	FKR	S/P	F36-KY, trademark	$15-20	$55-65
Fire & Ice	Warning	LAM		1971	20	70's	?	?	$2-4	$7-9
Fire Cracker	S-1883	CNT		1883	20	FKR	S/P	Trademark, TP-42-NC	$60-85	$180-225
First Choice	Warning	LAM	CMP	1976	20	FKR	S/P	TP-1-NC	$6-8	$15-25
First Choice	Sur-Gen	RJR	FOR	1993	20	All Kinds	S/P	TP-1-NC	$1-2	$4-6
First Class	Sur-Gen	RJR	FOR	1996	20	All Kinds	S/P	TP-1-NC	$1-2	$4-6
First Consul	S-1898	BLE		1898	20	70's	S/P	C98	$35-50	$90-135
First Lady	S-109	TUC	COL	1939	20	70's	S/P	F11-1MO, 2 pack design	$15-20	$55-65
First Nighter	S-114	CAN		1943	20	70's	S/P	F1-1OOH,	$50-65	$150-190
First Pick	S-1887	DUK		1898	20	70's	S/P	C87	$35-50	$90-135
First Prize	S-1898	NAT		1898	20	70's	S/P	C98	$10-15	$55-65
First The	S-103	FCC		1933	20	70's	S/P	F62-MA	$10-15	$40-55
Fish & Co.	S-122	GAG	YNC	1952	20	70's	S/P	F407-2NY	$10-15	$40-55
Fisher Price Inc.	S-121	GAG	YNC	1951	20	70's	S/P	F407-2NY	$50-65	$150-190
Five For Five	S-1883	FEL		1886	?	70's	?	C87, C89	$35-50	$90-135
Five Forty Three	S-1898	MIL		1898	20	70's	?	C98, F2-NY	$25-35	$75-115
Five Star	S-101	STP		1931	20	RKO	CSB	F2032-1PA	$15-20	$40-55
Five Star	S-125	BAW		1955	20	RKO	CSB	F2032-1PA	$3-5	$8-12
Five Star	No Stamp	BAW		1968	20	RKO	CSB	?	$2-4	$7-9
Flair	Caution	GAG		1954	20	FKR	S/P	F21-VA	$10-15	$40-55
Flair	Warning	GAG	YNC	1951	20	70's	?	F407-2NY	$10-15	$40-55
Flair	S-124	OGD		1949	20	70's	?	?	$15-20	$55-65
Flame Tip	S-121	LAM	GAR	1981	20	All Kinds	S/P	Multi. colors on white	$2-4	$7-9
Flameel Tarpaulins	S-119	AFT		1936	20	RFR	S/P	F24-KY	$15-20	$40-55
Flamingo	Sur-Gen	PMC		1944	20	FKR	S/P	F24-KY	$10-15	$40-55
Flavor	S-122	PMC		1974	20	FKR	FTB	Red, black green on white	$15-20	$55-65
Fleetwood	Warning	FLH	FOR	1938	20	70's	S/P	?	$2-4	$7-9
Fleetwood	S-108	MON	FDL	1885	20	FKR	S/P	C87, C98, F363-3NY	$60-85	$180-225
Fleming	S-1883	FLI		1906	20	FKR	S/P	F2032-1PA	$35-50	$90-135
Fleur De TabacSultan	S-1901	RJR		1970	20	FKR	S/P	?	$6-8	$25-35
Flicker	Caution	BAW		1970	20	FKR	FTB	Trademark	$6-8	$25-35
Fling	Caution	ELM		1951	20	FKR	S/P	Trademark	$10-15	$40-55
Flint	S-121	FDC		1986	20	70's	S/P	Orange on white	$2-4	$8-12
Flips	S-104	CNN		1898	?	70's	?	C98	$35-50	$90-135
Florida Division of Corrections	S-1898	PEY		1898	?	70's	?	C98	$35-50	$90-135
Florida Picking	S-1898	FLM		1898	?	70's	?	C98	$35-50	$90-135
Florida Plantations	S-122	LAM		1952	20	70's	?	Trademark	$6-8	$25-35
Flying Jap	Warning	BAW		1974	20	FKR	S/P	Red square	$6-8	$25-35
FM	Sur-Gen	RJR		1988	20	70's	S/P	Trademark	$1-2	$3-6
Focus	Warning	LAM	FKP	1981	20	All Kinds	S/P	Multi. colors	$2-4	$7-9
Focus	Sur-Gen	LAM	FDL	1981	20	All Kinds	S/P	TP-42-NC, Multi. colors	$15-20	$55-65
Focus	Warning	KOW		1941	20	FKR	S/P	F67-1CA	$6-8	$25-35
F&D	S-111	LAM		1976	20	FKR	S/P	Trademark	$6-8	$25-35
F&L	Caution	ATC		1968	20	70's	S/P	Trademark, red and white	$15-20	$55-65
Fook Look	Warning	CAN		1942	20	FKR	S/P	F1-10-OH	$3-5	$8-12
Forecast	No Series	RJR		1960	20	FKR	S/P	Trademark, blue and white	$20-25	$60-85
Forest	No Series	PMC		1968	20	70's	SSB	Blue band center on white	$20-25	$60-85
Formal	S-111	AFT		1942	20	FKR	S/P	F24-KY, khaki, army seal	$6-8	$25-35
Forsyth	Caution	BAW		1928	20	FKR	S/P	F36-KY	$6-8	$25-35
Fort Leonard Wood	S-1898	IRB		1898	20	70's	?	C98	$35-50	$90-135
Fort Union	Warning	RJR		1973	20	FKR	S/P	Trademark	$6-8	$25-35
Fortuna	Warning	RJR		1974	20	FKR	S/P	Trademark	$2-4	$7-9
Fortuna	S-108	AFT		1938	20	FKR	S/P	F24-KY	$15-20	$55-65
Fortune	No Series	SFT		1898	10	70's	SSB	C89	$35-50	$90-135
Four Roses	Caution	ATC		1971	20	FKR	S/P	Trademark	$6-8	$25-35
Four Tracks	Warning	LOR		1982	?	FKR	S/P	Trademark	$6-8	$25-35
Four Winds	S-108	?	STP	1934	20	70's	?	?	$6-8	$25-35
Foxy	S-1901			1911	20	FKR	S/P	Trademark	$6-8	$25-35
Franco	S-1901	GOR		1984	20	FKR	S/P	TP-2442-PA, star in box	$2-4	$7-9
Frank's Lien-on Bar	Warning	STP		1955	20	FTB	FTB	TP2032-PA	$10-15	$40-55
Frappe	S-125	USJ		1970	10	FKM	S/P	TP-3-VA, green blue square	$3-5	$8-12
Frappe	Warning	LOR		1934	20	70's	?	?	$15-20	$55-65

Table (left column)

Brand Name	Series	Mfg	Ven	YMf	#	Type	Pack	Description/Remarks	Empty	Full
Glen	Warning	LOR		1972	20	FKR	S/P	Trademark	$6-8	$25-35
Glendale	Caution	RJR	AFT	1964	20	FKR	S/P	Trademark	$6-8	$25-35
Glenmore	S-107	AFT	GTH	1937	20	70's	S/P	Picture of land scape	$20-25	$55-65
Glenaire	Caution	ATC	GTH	1971	20	FKR	S/P	Trademark	$6-8	$25-35
Globe	Caution	RJR		1967	20	FKR	S/P	Trademark	$6-8	$25-35
Gloriette	No Series	MKT		1923	20	70's	S/P	?	$20-25	$60-85
Glory	Sur-Gen	TAI		1996	20	FKR	S/P	TP-168-NY, two kinds	$2-4	$7-9
Go	S-1917	BAW		1920	20	FKR	S/P	Picture of signal light	$25-35	$70-95
Go Ter Hell And Buy Your Own	S-110	BAB	GTH	1931	10	FKR	S/P	Green w/black letters	$20-25	$60-85
Go To Hell	Sur-Gen	GAG	GTH	1987	20	FKR	S/P	TP-165-NY, TP-75-NY	$1-2	$4-6
Gods Of The Nile	S-1910	LOR		1911	?	70's	S/P	?	$30-45	$75-115
Gold	Caution	PMC		1965	20	F100R	S/P	Trademark	$6-8	$25-35
Gold And Black	S-125	GAG		1955	20	70's	S/P	TP-75-NY, black and gold	$10-15	$55-65
Gold And Brown	No Series	RSD		1924	20	70's	S/P	Brown on white	$20-25	$60-85
Gold And White	S-1887	RSD		1924	20	FKR	S/P	F916-1NY	$20-25	$60-85
Gold Club	S-1898	HSS		1898	?	70's	?	C98	$35-50	$90-135
Auction Bridge	Warning	RJR		1985	20	FKR	S/P	Trademark	$6-8	$25-35
Gold Dollar	S-1883	ALG		1885	?	70's	?	F25-VA	$60-85	$180-225
Gold Falcon	Warning	LAM		1972	20	FKR	S/P	Brown and white	$2-4	$7-9
Gold Flake	No Series	ATC	EXT	1925	100	70's	F/T	Red on yellow	$75-100	$185-250
Gold Indian	S-1898	NAT		1898	?	70's	?	C98	$35-50	$90-135
Gold Leaf	S-1887	BRB		1890	?	70's	?	C98	$35-50	$90-135
Gold Leaf	Sur-Gen	LAM		1976	20	FKR	S/P	Gold on brown	$6-8	$25-35
Gold Leaf	S-1887	CAM		1890	20	FKR	S/P	Picture of medal	$75-110	$180-225
Gold Medal Straight	S-1898	KNA		1900	20	70's	S/P	?	$35-50	$90-135
Gold Seal	Caution	RJR		1967	20	FKR	S/P	Trademark	$6-8	$25-35
Gold Stripe	S-123	BEH		1953	20	70's	?	C98	$35-50	$90-135
Gold Tip	Sur-Gen	RJR		1993	20	FKM	FTB	White/green 2 kinds	$1-2	$4-6
Gold Salem	S-1879	MRB		1877	?	70's	?	C87	$50-65	$150-190
Golden Age	Warning	LAB		1974	20	FKR	S/P	White band on dark blue	$2-4	$7-9
Golden Band	S-1883	BLA		1885	?	70's	?	C87, F363-3NY	$50-65	$150-190
Golden Crest	S-1898	MON		1898	20	FKR	S/P	C98, F363-3NY	$35-50	$90-135
Golden Delight	Warning	LOR		1980	20	FKR	S/P	Black letters on white	$2-4	$7-9
Golden Dragon	Warning	LAM		1975	20	FKR	S/P	Trademark	$6-8	$15-25
Golden Eagle	S-1901	?		1904	20	70's	?	Trademark	$35-50	$90-135
Golden Falcon	Caution	LAM		1972	20	FKR	S/P	Brown and white	$2-4	$8-12
Golden Flavors	No Stamp	STL		1980	20	FKR	S/P	5 different flavors, non-tob	$6-8	$15-25
Golden Gate	S-102	BEN		1931	20	70's	S/P	F213-1CA	$15-20	$55-65
Golden Gate, World's Fair 1939	S-109	?		1939	20	70's	S/P	World's fair 1939	$20-30	$60-85
Golden Gift	S-102	RSD	YRK	1932	20	70's M	S/P	A golden gift	$25-35	$70-95
Golden Lane	S-108	LAN		1938	20	70's	S/P	F244-2NY	$15-20	$55-65
Golden Leaf	No Series	GLC		1937	?	70's	?	C98	$20-25	$60-85
Golden Lights	Warning	LOR		1978	20	All Kinds	S/P	Gold w/multi. colors	$2-4	$7-9
Golden Lion	S-119	USJ	FLH	1949	20	FKR	S/P	?	$10-15	$40-55
Golden Lion	Warning	PMC		1974	10	FKR	FTB	Trademark	$2-4	$7-9
Golden Ones	Warning	BAW		1980	20	FKRULT	S/P	?	$2-4	$7-9
Golden Pheasant	S-1898	NAT		1898	?	70's	?	C98	$35-50	$150-190
Golden Rods	S-1887	DAN		1887	?	70's	?	C87	$50-65	$150-190
Golden Rule	S-1887	TUC	CHR	1887	?	70's	?	C98	$50-65	$150-190
Golden Rule	S-107	TUC		1934	20	70's	?	Blue letters on white	$20-25	$60-85
Golden Slipper	No Series	TUC		1886	?	70's	?	C87	$60-85	$180-225
Golden State	S-110	WDA	CHR	1935	20	FKR	S/P	Gold and white	$15-20	$55-65
Golden State	S-1898	MID		1939	20	70's	?	C87	$15-20	$55-65
Golden Times	S-108	MLH	CHR	1952	20	RKR	S/P	Dark red on white	$50-65	$150-190
Golden Virginia	S-1898	BAW		1938	20	70's	S/P	Waldorf-Astoria hotels,	$30-45	$75-115
Golden Whiffs	Warning	GLF		1925	?	70's	?	?	$65-145	$225-325
Goldmark	Warning	BAW		1981	20	FKR	S/B	C98	$35-50	$90-135
Golf	S-1883	LAM		1888	10	70's	S/P	Trademark	$20-25	$60-85
Good Form	S-1887	CNT		1873	?	70's	?	C98, F25-1MO	$50-65	$150-190
Good Luck	S-107	AFT		1937	20	RKR	S/P	F24-KY	$15-20	$55-65
Good Things	S-125	LAM		1955	20	FKR	S/P	Millevent cig. paper	$10-15	$40-55
Goodwill	S-110	BAW		1955	20	RKR	S/P	?	$1-2	$4-6
GOR Generic	Sur-Gen	GOR		1988	20	All Kinds	S/P	Multi. colors	$6-8	$25-35
Gordon	No Stamp	LOR		1965	20	FKR	S/P	Trademark	$6-8	$25-35
Gordon Buchannan	S-113	TUC	CHR	1932	20	70's	S/P	Gold on dark gold	$25-35	$70-95
Gordon Buchanan	S-120	TUC	CHR	1932	20	70's	S/P	F11-1MO, gold and red	$15-20	$55-65

Table (right column)

Brand Name	Series	Mfg	Ven	YMf	#	Type	Pack	Description/Remarks	Empty	Full
Go to Hell and Buy Your Own	S-101	BAB	GTH	1931	10	70's	F/B	F551-3NY	$20-30	$60-85
Go To Hell	Sur-Gen	GAG	GTH	1987	20	FKR	S/P	TP-165-NY, TP-75-NY	$2-4	$7-9
GPC Approved	Warning	LAM		1980	20	All Kinds	S/B	TP-42-NC, multi. colors	$3-5	$8-12
GPC Approved (2)	Warning	BAW		1987	20	All Kinds	S/P	TP-16-GA, multi. colors	$2-4	$7-9
GPC Approved (3-4)	Sur-Gen	BAW	BAW	1989	20	All Kinds	S/P	TP-16-GA, multi. colors	$1-2	$4-6
Grads	S-109	MAD	BAW	1939	20	FKR	S/P	F15-KY	$15-20	$55-65
Grand Canyon	Sur-gen	SWA		1996	20	FKR	S/B	?	$15-20	$55-65
Grand Cental	S-112	MOT		1942	20	70's	?	?	$15-20	$55-65
Grand Dad	S-1887			1898	?	70's	?	C98	$35-50	$90-135
Grand Duke	S-1887	KIM		1887	?	70's	?	C87	$50-65	$150-190
Grand Imperiales,	S-114	BOL		1943	10	70's	SSB	F171-1CA	$50-65	$150-190
Grand Prix	Sur-Gen	AFT		1988	20	FKR	S/P	Trademark	$10-15	$40-55
Grand Prix	Sur-Gen	LAM		1994	20	FKR	S/P	Multi. colors, checker	$6-8	$25-35
Grand Prize	S-109	AFT	EDC	1938	20	70's	S/P	Red ribbon on white	$1-2	$4-6
Grand Slam Auction Bridge	No Series			1926	10	70's	CSB	F551-3NY	$35-45	$70-95
Grand Trunk	S-1898	SCN		1898	?	70's	?	C98	$35-50	$60-85
Grand Central Motors	S-121	GAG	YNC	1951	20	70's	F/B	F407-2NY	$20-25	$60-85
Grandee	S-106	AFT		1936	20	70's	S/P	F24-KY	$15-20	$55-65
Grandeur	S-103	SSS		1942	20	70's	?	?	$15-20	$55-65
Grandeurs	S-103	SSS		1932	20	70's	?	F404-2NY	$20-25	$60-85
Granny Goose Foods	S-121	GAG	YNC	1951	20	70's	F/B	F407-2NY	$50-65	$150-190
Granville	S-1883	GNS		1886	?	70's	?	C87	$50-65	$150-190
Greased Lighting	S-1898	POG		1898	?	70's	?	C98	$6-8	$25-35
Great Lengths	Warning	RJR		1976	20	FKR	S/P	Trademark	$35-50	$90-135
Great Metropolis	S-1898	FDM		1898	?	70's	?	C98	$35-50	$90-135
Great Smoker	S-1898	HAG		1898	?	70's	?	C98	$35-50	$90-135
Greater Columbus	S-1898	MBW		1898	?	70's	?	C98	$35-50	$90-135
Greater New York	S-1898	CUC		1898	?	70's	?	C98	$35-50	$90-135
Green Canoe	S-103	VPC		1930	50	FKR	SSB	Picture lady in canoe	$45-55	$150-190
Green Garter	S-1898	MTZ		1898	?	70's	?	C98	$6-8	$25-35
Green Light	Warning	RJR		1976	20	FKR	S/P	Trademark	$6-8	$25-35
Green Mist	Warning	BAW		1975	20	FKR	S/P	Trademark	$35-50	$90-135
Green Mountain	No Stamp	GUI		1932	20	FKM	SSB	Medicinal cigarette	$2-4	$8-12
Green River	S-110	CNT	GRT	1940	20	70's	S/P	F21-VA	$6-8	$15-25
Greenland	S-102	RSD		1932	20	FKR	S/P	Trademark	$35-50	$90-135
Greenland's Clover	Warning	PMC		1971	20	FKR	FTB	F916-1NY	$6-8	$15-25
Greenleaf	S-118	VER		1949	20	70's	S/P	Trademark	$6-8	$15-25
Greenock	No Stamp	ATC		1964	20	FKR	S/P	Trademark	$6-8	$25-35
Greenwich	No Stamp	PMC		1973	20	FKR	FTB	Trademark	$25-35	$70-95
Greenwood	Sur-Gen	ATC		1964	20	FKR	S/P	Trademark	$15-20	$55-65
Grenadier	No Stamp	BAW		1964	20	RKR	S/P	Trademark	$15-20	$55-65
Gresham	S-1898	LAM		1898	20	70's	S/P	C98	$20-25	$60-85
Gray Goose	Sur-Gen	GOR	TWL	1996	20	FKR	S/P	C98	$2-4	$7-9
Gray Wolf	S-102	BEH		1930	20	70's	S/P	TP-2442-PA, Ind. casino	$10-15	$40-55
Greya	S-101	FRA		1931	20	70's	S/P	F5-2NY	$20-25	$60-85
Greybrook	S-108	BAW		1938	20	70's	S/P	?	$2-4	$7-9
Greyhound	Sur-Gen	PMC		1987	20	FKR	FTB	C-36-KY, F36-KY	$35-50	$55-65
Grays	S-1887	PMC	CUS	1988	20	70's	?	?	$50-65	$150-190
Gridlock	No Stamp	DUC	DUC	1964	20	FKR	FTB	TP-7-VA, multi. colors	$50-65	$150-190
Grim Reapers	No Stamp	LAM		1976	20	FKR	S/P	Trademark	$20-25	$60-85
Grin	S-112	BEH		1959	20	70's	S/P	F5-3NY	$60-85	$180-225
Guardian	No Stamp	SHE		1922	20	70's	S/P	Trademark	$15-20	$55-65
Gubek No 1	No Series	GAG		1988	?	70's F	P/T	Trademark	$15-20	$55-65
Guerneville, Ca.	Sur-Gen	GAG	NYC	1951	20	70's	CSB	Picture cig. upper right	$10-15	$40-55
Guiberson Corp.	S-121	LAM		1974	?	70's	F/B	Picture of lady in center	$30-45	$75-115
Gulf	Warning	SAR		1994	20	All Kinds	S/B	f407-F-NY	$65-145	$225-325
Gunsmoke (1)	Sur-Gen	SAR		1995	20	FKR	S/P	Pictures of cowboys/girls	$35-50	$90-135
Gunsmoke (2)	S-1883	GUN		1880	20	70's	F/B	Multi. colors	$20-25	$60-85
Gunstoria	Warning	GUS		1976	20	FKR	S/B	White label	$1-2	$4-6
Gusto	Warning	RJR		1975	20	70's	F/B	Picture of smoke shop	$75-100	$200-250
Gypsy Casanova	S-1887	GOO		1887	?	70's	P/T	Picture of smoke shop	$10-15	$25-35
Gypsy Queen	S-121	GAG	YNC	1951	10	70's	F/B	Gypsy cig. upper right	$30-45	$75-115
H Z 30 Westward Ho	S-1917	ATC		1917	?	70's	?	Picture of lady in center	$75-100	$200-250
H. De Cabanas Y	Warning	LAM		1975	20	FKR	S/P	F30-2NY	$20-25	$60-85
H 6	S-1898	MNC		1898	?	70's	?	Black letters on white	$25-35	$70-95
Haberdasher	S-1883	CHA		1884	10	60's	C/B	Red, w/mirror inside	$95-225	$325-425

189

Table (continued — Hale through Heritage)

Brand Name	Series	Mfg	Ven	YMf	#	Type	Pack	Description/Remarks	Empty	Full
Hale	S-121	LAB		1952	20	70's	SSB	Chlorophyll filter	$20-25	$60-85
Half And Half	No Stamp	ATC		1954	20	FKR	S/P	Red & white, pipe tob.	$6-8	$25-35
Half Past Seven	S-1898	SWH	CNT	1898	?	70's	?	C98	$35-50	$90-135
Hallmark	No Stamp	PMC		1956	20	RKR	S/P	F21-VA	$6-8	$25-35
Hallmark	No Stamp	BAW		1965	20	FKR	S/P	F21-VA	$6-8	$25-35
Hallmark	Warning	BAW		1977	20	FKR	S/P	Trademark	$2-4	$7-9
Halves	S-1868	KIN		1868	?	70's	?	Brown and gold	$95-175	$250-375
Hamidia	No Series	HOB		1923	10	FKR	SSB	Half latakia - half bright	$25-35	$70-95
Hampshire	Warning	RJR		1967	20	FKR	S/P	F263-3MA,F263-2NY,	$25-35	$25-35
Handsome Dan	S-1887	PMC		1893	10	FKR	S/P	Trademark	$75-100	$200-275
Handsome Dan	No Series	PMC		1958	20	70's	S/P	?	$6-8	$25-35
Happy Days For You	S-103	STB		1933	8	70's	SSB	White diamond on red	$20-25	$55-65
Happy Hit	S-105	ATC		1935	10	70's	S/P	C-1-1GA, union made	$20-25	$55-65
Happy Life	S-1917	SUR		1919	10	70's	SSB	F30-NC, white on red	$30-45	$75-115
Happy Smoke	Sur-Gen	SHE		1993	?	FKR	CSB	Red on white label	$2-4	$7-9
Happy St. Patrick's	S-102	BEN		1930	?	70's	?	Green Cigarette	$20-25	$60-85
Harem Beauties	Sur-Gen	LAM		1988	20	FKR	S/P	F213-1CA	$20-25	$60-85
Harley	Sur-Gen	LAM		1988	20	FKR	S/P	Trademark	$6-8	$25-35
Harley-Davidson	No Stamp	LAM		1965	20	All Kinds	S/B	Gold on black	$10-15	$40-55
Harmony	Warning	?		1967	20	FKR	S/F	Trademark	$6-8	$25-35
Harriel's Dream	?	GAG		1951	?	70's	?	F407-2NY	$15-20	$90-135
Harry Stephens	S-118	GAG		1948	20	70's	S/P	F460-VA	$10-15	$40-55
Harry Tint	S-1901	LBI		1901	10	70's	S/P	F407-2NY	$35-50	$90-135
Hartford Canoe Club	S-118	HPW		1923	10	70's	F/B	Black letters on white	$10-15	$40-55
Hartford Turkish	S-118	GAG		1948	10	70's	F/B	F407-2NY, gold-circle	$20-25	$60-85
Harvard Club	S-121	GAG	YNC	1951	20	70's	S/P	F407-2NY	$20-25	$60-85
Harvard Club Boston	S-121	GAG	YNC	1951	?	70's	S/P	F407-2NY	$20-25	$60-85
Harvey L. Casebeer	S-108	ADT	KIN	1919	10	70's	F/B	Pink on black	$75-150	$200-250
Harvey Place	S-1910	ATC		1938	20	70's	S/F	F30-NC, pink on black	$20-25	$60-85
Hassan	S-1898	WLK		1886	?	70's	?	C87	$50-65	$150-190
Hassan	S-1910	PRE		1916	?	70's	?	?	$30-45	$75-115
Havana	S-102	RSD		1930	20	FKR	F/B	F916-1NY, white on brown	$15-20	$55-65
Havana Queens	No Stamp	SHE	LEI	1956	?	FKR	S/P	Brown band on white	$6-8	$25-35
Havana Vega	Caution	LEE		1968	20	70's	CSB	Brown on white	$3-5	$8-12
Havana Oval	Warning	LOR		1970	20	FKR	S/P	Trademark	$6-8	$25-35
Hawk	S-1898	LOR		1898	?	70's	?	F460-VA	$15-20	$90-135
Hawkshaw	S-1898	KLS		1898	?	70's	?	C98	$35-50	$90-135
Hayward	S-108	LAB		1938	20	70's	S/P	C98	$15-20	$55-65
Hazle Nut	S-1898	MNC		1898	?	70's	?	C98	$35-50	$90-135
H B	Warning	SUR	RUM	1978	20	FKR	S/P	Yellow, red on white	$2-4	$7-9
H D	S-103	AFT		1933	8	70's	SSB	Black, red and white	$15-20	$55-65
Head Play	S-121	GAG	YNC	1951	5	70's	SSB	11.5 in. long, class B	$50-65	$150-190
Head Light	S-1898	CAM		1898	?	70's	?	C98	$35-50	$90-135
Health Guard	S-125	CAM	ANR	1975	20	70's	S/P	Gold on dark brown	$10-15	$40-55
Heaven	S-1910	AJM	ANR	1911	50	70's	F/T	Gold on moon	$50-65	$180-225
Hebe De La Reine	S-1883	FEL		1885	?	70's	F/B	F8-5NJ	$15-20	$55-65
Hed Kleer	S-105	AFT	HED	1935	20	70's	S/P	F24-KY	$35-45	$75-115
Hedjas	S-1917	SUR		1919	20	70's	?	Stamp coll.'s as Hejaz	$15-20	$55-65
Heffler Co. Inc.	S-121	GAG	YNC	1951	20	70's	S/P	F407-2NY	$20-25	$60-85
Helene Curtis	S-121	GAG	YNC	1951	20	70's	S/P	F407-2NY	$20-25	$60-85
Helmar	S-1901	LOR	ANR	1907	20	70's	S/P	Name was Ramleh	$35-50	$90-135
Helmet Box 20	S-1910	LOR	ANR	1913	20	70's	S/P	C98	$35-50	$90-135
Helmet Box 20	No Series	LOR	ANR	1898	50	70's	F/T	Gold on black	$60-85	$180-225
Helmet Box	S-117	ANR		1947	20	FKR	F/B	F8-5NJ	$15-20	$55-65
Helmet Box	Caution	ATD		1958	?	70's	F/B	C98	$3-5	$8-12
Henley	S-113	BEH		1943	20	70's	S/P	F5-2NY	$15-20	$55-65
Henrico	Warning	LAB		1969	20	FKR	S/P	Trademark,	$20-25	$60-85
Henry Clay	No Series	HCR		1926	20	70's	?	?	$35-50	$90-135
Heral Cork Tip	S-1901	TUR		1901	?	70's	CSB	?	$30-45	$75-115
Herald	Warning	STP		1931	8	70's	F/B	F2052-1PA	$2-4	$7-9
Heraldry	Warning	BAW		1989	20	FKR	S/P	Wine color	$6-8	$25-35
Herald	Warning	ATC		1975	20	FKR	S/P	Trademark	$2-4	$7-9
Herbert Tareyton	S-1913	FAL		1913	20	70's	S/P	F649-1NY	$35-50	$90-135
Herbert Tareyton	No Series	ATC		1929	50	70's	F/T	Also 100 tins, white	$95-150	$225-300
Herbert Tareyton	S-105	ATC		1935	20	70's	S/P	F30-NC	$15-20	$55-65
Herbert Tareyton	S-124	ATC		1954	20	70's	S/P	White w/cigarette	$10-15	$40-55
Hebert Tareyton	No Stamp	ATC		1960	20	RKR	S/P	White w/blue stripes	$6-8	$25-35
Here	Warning	RJR		1975	20	FKR	FTB	Trademark,	$6-8	$25-35
Heritage	Warning	PMC		1971	?	FKR	F100R	Southland blended	$6-8	$25-35
Heritage	Sur-Gen	LOR		1990	20	All Kinds	S/P	Red, white, and blue	$2-4	$7-9

Table (continued — H1 # 18 through House Blend)

Brand Name	Series	Mfg	Ven	YMf	#	Type	Pack	Description/Remarks	Empty	Full
H1 # 18	Caution	SHE		1966	20	FKR	CSB	Blue on white brown	$6-8	$25-35
Hi-Fi	No Stamp	PMC		1957	20	FKR	FTB	Trademark	$6-8	$25-35
Hi-Lite	Warning	PMC		1976	20	F100R	FTB	Also FKR, White on bl.	$2-4	$7-9
Hiawatha	S-1887	HSS		1887	?	70's	?	C87, also C98	$50-65	$150-190
Hickory Nut	S-1898	MNC		1898	?	70's	?	C98	$35-50	$90-135
High Admiral	S-1883	NAT		1884	10	70's	SSB	F1222-3NY	$95-175	$250-375
High Art	S-1883	DUK		1884	?	70's	?	C87, F42.-NC	$50-65	$150-190
High Cough	S-1898	RSW		1898	?	70's	?	C98	$35-50	$90-135
High Fashion Turkish	S-1898	WSF		1898	?	70's	?	C98	$35-50	$90-135
High Flyer	No Series	BAT		1922	20	70's	S/P	Picture of couple	$20-25	$60-85
High Grade	S-1883	KIM		1870	15	70's	SSB	?	$95-175	$225-350
High Hat	S-1898	WAG		1900	?	70's	?	C87	$50-65	$150-190
High Life	S-1870	MRB		1870	?	FKR	?	C87	$95-175	$250-375
High Official	S-1898	FEN		1898	?	FKR	?	C98	$35-50	$90-135
High Score	S-1909	?		1910	20	FKR	?	?	$30-45	$75-115
High Score	S-120	BAW		1950	20	70's-RKR	S/P	Black lettes on white	$10-15	$40-55
High Time	Caution	LOR		1966	20	FKR	S/P	Trademark	$6-8	$25-35
Highrise	Warning	ATC		1971	20	FKR	S/P	Trademark	$6-8	$25-35
Highway	Sur-Gen	RJR		1992	20	All Kinds	S/P	Multi, colors on white	$1-2	$4-6
Hill-Chase Steel	S-121	GAG	YNC	1951	20	FKR	CSB	F407-2NY	$20-25	$60-85
Hilton	No Stamp	BAW		1959	20	FKR	S/P	Trademark	$6-8	$25-35
Himrod Medicinal	S-1889	HIM		1869	?	70's	SSB	For hay fever	$75-100	$200-275
Hindoo	S-1898	HSS		1898	?	70's	?	C98	$35-50	$90-135
Hindu	S-1898	PTB		1900	10	70's	?	F4-LA	$10-15	$40-55
His Majesty's	S-1910	BEH		1913	10	FKR	S/B	Picture of king Geo. V	$10-15	$40-55
Hit Parade	S-125	ATC		1955	20	FKR	S/P	White on red	$20-25	$60-85
Hits	S-106	SWA		1936	20	70's	S/P	F40.-NC, red on white	$20-25	$60-85
Hodnett Agency, Inc.	S-121	GAG		1951	20	70's	CSB	F407-2NY	$35-50	$90-135
Hoffner Rayon Co.	S-121	GAG	YNC	1951	20	70's	S/P	F407-2NY	$35-50	$90-135
Hogan's Kid	S-1898	PHL		1898	?	70's	?	C98	$35-50	$90-135
Hogshead Wides	Sur-Gen	RJR		1995	20	FKR	FTB	Test Market Austin Tx.	$3-5	$8-12
Hold To	S-1898	HTT		1898	?	FKR	?	?	$30-45	$75-115
Hole In One Golf	No Series	BAB		1928	10	RKR-FKR	P/T	F407-2NY, F551-3NY	$20-25	$60-85
Holiday	S-123	LAB		1948	20	RKR-FKR	S/P	F460-VA, varicolors	$10-15	$40-55
Holly Fork	No Stamp	LAB		1964	20	70's	?	F460-VA, red on white	$6-8	$25-35
Hollywood	S-107	AFT		1937	20	70's	?	F24-KY	$15-20	$55-65
Hollywood	S-107	BAW		1959	20	70's	S/P	?	$15-20	$55-65
Hollywood	Sur-Gen	STU		1959	20	FKR	S/P	?	$1-2	$7-9
Hollywood Lights	No Series	SHE		1989	20	FKR	S/P	Red glitter star	$20-25	$60-85
Hollywood Rounds	No Series	LIC		1926	20	70's	CSB	C98, F2-NY	$20-25	$60-85
Homado	S-1883	MIL		1886	20	70's	CSB	C87,	$60-85	$180-225
Home Run	S-1901	ATD	IRB	1906	20	70's	S/P	Green and white	$30-45	$75-115
Home Run	S-114	LAM		1944	20	70's	S/P	F42-NC, green and white	$10-15	$40-55
Home Run	No Stamp	LAM		1958	?	70's	S/P	Name logo on both sides	$6-8	$25-35
Honest	Sur-Gen	ATC		1988	20	FKR	S/P	Trademark	$6-8	$25-35
Honest Labor	S-1898	HPZ		1898	?	70's	S/P	?	$35-50	$90-135
Honey Clover	S-102	AMR		1932	20	70's	?	?	$15-20	$55-65
Honey Comb	S-106	AFT		1936	20	70's	?	F24-KY	$15-20	$55-65
Honey Dew	S-1898	NAT		1898	?	70's	?	C98	$35-50	$90-135
Honey Dew Varsity	S-108	DRQ		1935	20	70's	S/P	F340-1CA,	$15-20	$55-65
Honey Moon	S-1898	MIL		1898	?	70's	?	F2-NY	$35-50	$90-135
Honey Rose	Warning	EWM	FAM	1978	20	FKR	S/P	Green on gold	$2-4	$7-9
Honeycomb	Caution	ATC		1972	20	RKR	S/P	?	$6-8	$25-35
Hong Kong Hash	Sur-Gen	GAG	SMH	1967	20	FKR	S/P	Black on white	$10-15	$40-55
Hoormoos	No Series	HOB		1921	?	70's	S/P	F404-2NY, gold on black	$20-25	$60-85
Hoosier Hustler	S-1898	MCV		1898	?	70's	?	F5-2NY, virginia rounds	$35-50	$90-135
Hoover Elec. Motors	S-121	GAG	YNC	1951	20	70's	S/P	F407-2NY	$20-25	$60-85
Hope Lumber Co.	S-121	GAG	YNC	1951	20	70's	CSB	F407-2NY	$20-25	$60-85
Hopewell	No Stamp	PMC		1961	?	FKR	FTB	Trademark	$35-50	$90-135
Horizon	S-1898	FLC		1951	20	70's	S/P	C98	$35-50	$90-135
Horizon	Sur-Gen	RJR		1990	20	FKR	FTB	Multi. colors on white	$6-8	$25-35
Horse Guards	S-1901	BUB		1904	20	70's	S/P	F649.1NY	$2-4	$7-9
Horse Shit	No Stamp	DHO		145	?	70's	S/P	Light gray	$35-50	$90-135
Horse Shoe	S-115	PJS		1962	20	70's	S/P	Try one you moocher	$15-20	$55-65
Hotel Astor	No Stamp	FIS		1872	?	70's	S/P	Also mfg by CNT	$15-20	$55-65
Hotel St. Regis	S-106	RCP		1936	20	70's	S/P	Black on white	$6-8	$25-35
Hotel Statler	S-113	SSS		1948	20	70's	S/P	F404-2NY, gold on black	$10-15	$40-55
Hotel Taft	S-107	BEH	SEI	1937	20	70's	S/P	F5-2NY, virginia rounds	$15-20	$55-65
House Blend	S-125	GAG		1955	10	FKR	S/P	F407-2NY	$15-20	$55-65
House Blend	Sur-Gen	RJR		1997	20	FKR-Ls	FTB	TP-1-NC	$1-2	$4-6

Left Table

Brand Name	Series	Mfg	Ven	YMf	#	Type	Pack	Description/Remarks	Empty	Full
House of Lords	S-1901	MIL		1901	10	70's	CSB	Paper made of tob.	$35-50	$90-135
HP Milds	No Stamp	WTB	HRP	1964	20	RKR	S/P		$10-15	$40-55
H. P. W.	S-1917	HPW		1919	20	70's		F407-2NY	$25-35	$70-95
Huber Homes	S-121	GAG	YNC	1951	10	70's	CSB	F407-2NY	$20-35	$60-85
Hubert Kaub & Co.	S-121	GAG	YNC	1951	20	70's	CSB	C98	$20-25	$60-85
Huchy Kuchy	S-1898	PGN		1898	20	70's	S/P	Trademark	$35-50	$90-135
Hud	No Stamp	RJR		1959	20	FKR	S/P	F407-2NY	$6-8	$25-35
Hudson	No Stamp	STU		1959	20	FKR	S/P	F24-KY	$6-8	$25-35
Humdinger	S-122	GAG	NAN	1952	20	70's	S/P	F407-2NY	$10-15	$40-55
Hummer	S-107	AFT		1937	20	70's		?	$15-20	$55-65
Humphreys-Godwin	S-122	GAG	YNC	1952	10	70's	S/P	Trademark	$20-25	$60-85
Humps	S-118	JAM		1948	20	70's	SSB		$10-15	$40-55
Hunter	S-138	MHT		1938	20	70's	S/P		$6-8	$25-35
Huntington	Sur-Gen	RJR		1995	20	FKR	S/P	F10-KY	$10-15	$75-115
Hussar	S-1910	PMC		1910	20	FKR	S/P	F10-KY, white on red	$35-50	$90-135
Hyde Park	S-111	LAB	MAL	1941	20	FKR	S/P	No with bonus credits	$2-4	$7-9
Hydro	S-122	TBC		1952	20	70's	S/P	C98	$35-50	$90-135
I Go Pogo	S-112	LAB		1942	4	70's	S/P	Star in box	$35-50	$90-135
I Like Ike	S-1898	HSS		1898	?	70's	S/P	F1-VA	$35-50	$90-135
I Shall Return	S-1187	ATD		1895	20	FKR		F649-1NY	$50-65	$150-190
I. C. U.	S-1910	BUB	ATD	1915	50	70's	B/T	Trademark	$75-100	$200-250
Ibis	Caution	ATC		1969	20	FKM	S/P	Also F100M, grn./white	$2-4	$25-35
Ibis	Warning	ATC		1973	20	F100M	S/P	Also FKM	$2-4	$7-9
Iceberg	Sur-Gen	RJR	MTC	1996	20	FKR	FTB	TP-1-NC, also FKRL	$1-2	$4-6
Iceberg 10	S-101	WOL		1946	20	70's			$10-15	$40-55
Iceberg 100	Warning	GOR	IDM	1984	20	FKR	S/P		$2-4	$7-9
Icebox	No Stamp	USV		1903	20	70's		F1-VA	$35-50	$90-135
Idea	S-1901	RIG		1960	10	70's	SSB	Trademark	$6-8	$25-35
Idial	Caution	LAB	IGA	1967	20	RKR-FKMS	S/P	Red and green on white	$6-8	$25-35
Idle Hour	S-1887	FTZ		1965	20	FKR		?	$6-8	$25-35
Idlewild	Warning	RJR		1978	20	FKR	SSB	?	$6-8	$25-35
IGA	Caution	LOR		1968	20	70's		Picture of indians	$20-25	$60-85
Immunity	No Stamp	LAM		1930	20	RKR	S/P	F21-VA	$10-15	$40-55
Impact	Warning	PMC	CNT	1956	100	70's	B/T	F916-1NY	$50-65	$150-190
Impala	S-103	RSD		1932	100	70's	S/P	Trademark	$75-100	$200-250
Imperial	S-1879	ALG		1882	10	70's	B/T	F25-VA	$95-150	$225-300
Imperial	S-1910	RSD		1914	10	R110's	S/P	F1-1NY	$30-45	$75-115
Imperial Crown No 15	No Stamp	RSD		1929	10	R110's	CSB	F1-1NY	$25-35	$70-95
Imperial Pet	S-1887	BOL		1896	10	70's	SSB	Many kinds from 1888	$50-65	$150-190
Imperial Russian	S-101	LAM		1931	20	70's	SSB	Black letters on green	$20-25	$60-85
Imperial Russian	S-1917	LAM		1919	20	70's	S/P	White and gold on bl.	$6-8	$70-95
Imperiales	Warning	RJR		1973	20	FKR	FKR	Picture of lady	$35-50	$90-135
Imperiales	S-1887	CRE		1892	20	70's	SSB	F104-2NY	$35-50	$90-135
Imperials	S-125	?		1955	20	70's	S/P	Picture of indian girl	$10-15	$40-55
In	No Stamp	MCW		1927	20	70's		?	$20-25	$60-85
In Style	No Series	ATD		1900	20	70's		?	$35-50	$90-135
India House	Warning	USJ	SKT	1974	20	4 Kinds	S/P	TP-2-VA	$2-4	$7-9
Indian Girl	S-125	MRB		1887	20	70's	S/P	C87	$50-65	$150-190
Indian Head	Warning	RJR		1975	20	FKR	S/P	Trademark	$6-8	$25-35
Indian Smoke	S-1898	LUC		1986	20	70's		C98	$6-8	$25-35
Infants	Sur-Gen	ATC		1917	?	70's	FKR	Trademark	$6-8	$25-35
Innovation	S-1917	TPC		1917	20	70's	S/P	C98	$25-35	$70-95
Insurgent Queen	S-125	REM		1955	20	FKM	S/P	Trademark	$10-15	$40-55
Intercontinental	S-1887	BOL		1887	20	70's	S/P	C98	$35-50	$90-135
Intermission	S-1898	HLN		1898	20	70's		Trademark	$35-50	$90-135
International Passport	S-1898	THL		1898	20	70's		C98	$35-50	$90-135
Intimate Friends	Warning	RJR		1880	20	FKR	S/P	Man on horse	$2-4	$7-9
Investigate	S-1910	JOC		1910	100	70's	SSB	Made in Buffalo NY	$35-50	$90-135
Invincibles	S-1879	?		1938	20	70's	F/T	F35-VA	$15-20	$55-65
I.Q.	No Stamp	BAW	SWA	1964	20	RKR	SSB	Also S/P; SSB is unusual	$6-8	$25-35
Irby's Best	No Series	IRB		1898	20	70's	S/P	Trademark	$6-8	$25-35
Irequois	S-1898	HSS		1898	20	70's		C98	$6-8	$25-35
Iris	S-1910	ZAF		1910	20	70's		Gold on yellow	$30-45	$75-115
Irish Mint	Warning	LAM		1976	20	FKM	S/P	F916-1NY,	$10-15	$40-55
Iron Duke	S-121	GAG	YNC	1951	20	FKR		Trademark	$20-25	$60-85
Iroquois Special	Sur-Gen	RJR		1995	20	FKR	S/P		$75-100	$200-250
Irresistible	S-1898	ATW		1898	20	70's			$75-100	$200-250
Island Longs	S-108	HRB		1938	10	F101R	SSB		$15-20	$55-65
Ivanhoe	Caution	BRI		1968	10	FKR	S/P	Trademark	$6-8	$25-35
Ivanoff Gold	Sur-Gen	ATC		1989	20	70's	S/P	Trademark	$6-8	$25-35
Ivanoff Russian	S-102	RSD		1925	10	70's	CSB	C98	$25-35	$70-95
Ivanoff Russian	S-1901	RSD		1901	10	70's	CSB	F916-1NY,	$35-50	$90-135

Right Table

Brand Name	Series	Mfg	Ven	YMf	#	Type	Pack	Description/Remarks	Empty	Full
Ivory	S-1910	BWS		1916	20	70's	FTB	Trademark	$30-45	$75-115
Ivory Tipped	Warning	PMC		1974	20	FKR		?	$6-8	$25-35
J' Al Dit	No Series	DRQ		1925	20	70's	S/P	F170-3NY, F351-1CA	$20-25	$60-85
J. Lauritzen Lines	S-120	GAG		1950	20	70's	S/P	Passenger Liners	$20-25	$60-85
Jack & Charlie's 21	S-125	GAG		1948	10	70's	S/FB	F407-2NY	$10-15	$40-55
Jack Rose	S-1909	ATC		1898	10	70's	S/P	F229-6VA	$50-65	$150-190
Jackpot Junction	Sur-Gen	SAR	LSZ	1994	?	FKR & L's	S/P	TP-22-VA	$2-4	$7-9
Jacks	Sur-Gen	RJR	FOR	1992	20	All Kinds	S/B	Picture of jacks	$1-2	$3-5
Jacob Gordon Egyptian	S-1901	RJR		1988	20	70's		Trademark	$6-8	$25-35
Jade	Sur-Gen	KRI	GRD	1905	10	70's	SSB	F225-1NY, F255-3NY	$35-50	$90-135
Jaguar	Sur-Gen	LAM		1993	20	F100M	S/P	Also F100ML, grn. on grn	$1-2	$4-6
Jaguar Longs	Sur-Gen	LAM		1952	20	FKR	F/B	TP-2032-PA	$20-25	$60-85
James Cafe	Caution	STP		1970	20	FKR	S/P	C-1-VA	$3-5	$8-12
James Clark	Caution	USJ	STP	1951	20	FKR	S/P	F407-2NY	$20-25	$60-85
Jameson's Irish	S-121	GAG	YNC	1955	?	70's	S/P		$10-15	$60-85
Jamestown	S-125	FLH		1961	10	70's	F/B	Trademark	$6-8	$25-35
Japanese	S-114	RJR		1911	20	FKR	S/P	F1-1NY	$20-25	$25-35
Jasmine Slims	No Stamp	LAM		1993	20	70's	FTB	Also F100ML,F100RL,	$30-45	$75-115
Jay Freeman Co.	Sur-Gen	GAG	YNC	1951	20	70's	S/P	F407-2NY	$10-15	$40-55
JBR	S-1910	JAY	JBR	1914	20	70's		Also R/T TP-75-NY	$20-25	$60-85
Jean Nicot	Warning	STP		1975	10	FKR	F/T	F2032-PA	$6-8	$25-35
Jeep	S-121	STP		1951	20	70's	S/P	F50-VA	$10-15	$40-55
Jefferson Chums	S-125	SWA		1941	10	70's	F/B	F1-1NY	$15-20	$55-65
Jennings, LTD	S-115	FLH		1945	10	70's	S/P	F556-2NY	$15-20	$55-65
Jenny Lind	No Series	CUI		1925	?	70's	F/B	C98	$20-25	$60-85
Jersey Blue	S-1870	BED		1870	20	70's	S/P	C98	$95-175	$275-350
Jet	Caution	RSY		1898	20	70's	S/P	Red band on white	$35-50	$90-135
Jewel	Caution	SOU		1933	20	FKR	S/P		$15-20	$90-135
Jezebel Amber	S-103	TEL	OCC	1955	10	70's	F/B	F407-2NY	$20-25	$55-65
Jezebel Gardenia	S-125	GAG		1992	20	70's	F/B	Perfumed	$1-2	$55-65
Jigger	Sur-Gen	AND		1898	?	70's	S/P	C98	$35-50	$7-9
Jim Bowie	S-1898	MLH		1898	20	FKR		C98	$1-2	$90-135
Jin Jian	S-1898	BOW		1988	20	70's	S/P	TP-75-NY	$1-2	$90-135
JM	Sur-Gen	GOR		1996	20	FKR	S/P	TP-2442-PA	$50-65	$4-6
Jockey Club	S-1887	MON		1887	?	70's	S/P	C87, C98, F363-3NY	$20-25	$150-190
Jockey Club	S-110	GAG		1940	20	70's	CSB	F407-2NY	$20-35	$60-85
Joe H. Brady	S-121	GAG	YNC	1951	20	70's	CSB	F407-2NY	$15-20	$60-85
Joe Smith	S-121	TBC		1956	20	70's	S/P	F30-KY	$20-25	$70-95
John Alden	S-120	GOR	JAT	1947	20	70's	S/P	F10-KY	$15-20	$55-65
John Everette	Sur-Gen	GOR	EVT	1944	20	FKR	F/B	Durham III	$2-4	$7-9
John Metaxas	S-121	GNK		1935	20	FKR	S/P	F407-2NY	$20-25	$60-85
John Middleton	S-105	LAB	MID	1938	20	70's	S/P	F407-2NY	$15-20	$55-65
John Surrey's Havana	S-114	TBC	SUY	1938	10	70's	F/B	F460-VA	$15-20	$55-65
John Wannamaker	S-125	GAG		1950	20	70's	F/B	F407-2NY	$20-25	$55-65
John Wayne	Warning	LAM		1982	20	F100M	S/P	Picture of John Wayne	$50-65	$150-190
Johnnie Walker	S-108	FAL		1911	20	70's	S/P	Red on yellow	$30-45	$75-115
Johnnie Walker Pearl	S-125	ATC		1938	?	70's	S/P	Red on yellow, pearl tip	$15-20	$55-65
Johnny	S-103	?		1933	20	70's	S/P	C98	$35-50	$90-135
Jolly May	S-1898	KAU		1898	20	70's	S/P		$50-65	$150-190
Jordana Palestine	No Series	PAT		1924	10	70's	F/B	?	$20-25	$60-85
Joseph Hudgins	No Series	GOR	HDG	1996	20	FKR	S/P	(Durham III), 3 types	$2-4	$7-9
Juba	Ser-Gen	CDR		1898	?	FKR	S/P	C98	$35-50	$90-135
Jubilee	S-1898	ATD	KIM	1898	20	70's	S/P	C98	$35-50	$90-135
Jubilee	No Stamp	RJR		1965	20	FKR	S/P	Trademark	$6-8	$25-35
Jubilee Lights	Warning	SHE		1975	20	FQR		TP-161-NY	$20-25	$60-85
Judge	S-1898	ATD	GOO	1898	20	70's	S/P	C98	$2-4	$7-9
Julep	No Series	PEN		1928	20	FKR	S/P	F22-12PA, hint of mint	$35-50	$90-135
Julep, Mint	No Stamp	BAW		1958	20	FKR	S/P	Green on white, 2 types	$20-25	$60-85
Julie Marc	No Stamp	LAB	STN	1898	?	70's	S/P	F460-VA, Green on white	$6-8	$25-35
Jumbo	S-1910	PEN		1915	20	70's	S/P	F624-1PA	$30-45	$75-115
Jumbo	S-115	LAB	REE	1945	50	R185's	F/B	F624-1PA	$60-85	$180-225
Jumbo	S-121	GAG	YNC	1951	20	FKR	S/P	F407-2NY	$20-25	$60-85
Jumbo's	Sur-Gen	RJR		1995	20	FKR	S/P	TP-1-NC	$2-4	$4-6
Junalaska	S-1879	ATW		1883	20	70's	CSB	C98	$75-100	$200-250
Junean Park	S-1898	HRB		1898	20	70's	S/P	Trademark	$6-8	$15-25
Junior	No Stamp	HAU		1963	20	RKR		Trademark	$6-8	$25-35
Jupiter	No Stamp	RJR		1965	10	FKR	S/P	Trademark	$35-50	$90-135
Just My Style	S-1898	KSR		1898	?	70's		C98	$6-8	
Just Right	S-1898	CAM		1898	20	70's		C98	$35-50	$90-135

Cigarette pack price guide — alphabetical index (continued). Columns: Brand Name · Series · Mfg · Ven · YMf · # · Type · Pack · Description/Remarks · Empty · Full

Brand Name	Series	Mfg	Ven	YMf	#	Type	Pack	Description/Remarks	Empty	Full
Justrite	No Series	WCH		1921	20	70's		?	$20-25	$60-85
K. G. L.	Caution	LOR		1968	20	FKR	S/P	Trademark	$6-8	$25-35
K 2	S-1901	PMC		1969	20	FKR	S/P	?	$3-5	$8-12
Kadee	S-1901	CHR		1906	20	70's	S/P	?	$35-50	$90-135
Kaiser's Special Beer	S-121	GAG	YNC	1951	10	70's	F/B	F407-2NY	$20-25	$60-85
Kaiser's Strength	S-1910	PPP		1915	20	70's	S/P	Green and white	$35-50	$90-135
Kanciana	S-1898	MRT		1898	20	70's		C98	$35-50	$90-135
Kangaroo	S-106	AFT		1936	20	70's		Later TM BY PMC	$15-20	$55-65
Karam	No Series	ASL		1925	20	70's		?	$20-25	$60-85
Karam Egyptian	S-1901	ASL		1908	10	70's	SSB	?	$35-50	$90-135
Karnak	S-1910	ATD		1910	10	70's	SSB	Man's head, w/bird cap	$35-50	$90-135
Kavalla No. 9	S-1917	ATC	SUY	1920	20	70's	CSB	F130-3NY	$25-35	$70-95
Kay	S-1898	FCH		1898	?	70's	?	C98	$35-50	$90-135
Keen	S-1898	FCH		1898	20	70's	SSB	C98	$35-50	$90-135
Kef	S-1901	TUR		1904	10	70's	SSB	Lady looking at castle	$15-20	$55-65
Keg	S-105	LAB		1935	20	FKR	S/P	F460-VA	$6-8	$25-35
Kelly	Warning	RJR		1986	20	FKR	S/P	Trademark	$1-2	$7-9
Kemal	S-1910	?		1911	20	70's		?	$30-45	$75-115
Kendall Boiler Co.	S-120	GAG	BAM	1950	20	FKR	S/P	F407-2NY	$20-25	$60-85
Keno	S-1898	IRB		1898	20	70's		C98	$35-50	$90-135
Kensington	Warning	BAW		1984	20	FKR	S/P	Trademark	$6-8	$25-35
Kensitas	S-1910	WIX		1911	20	70's	F/B	F649-1NY	$30-45	$75-115
Kensitas Standard	S-115	ATC		1920	20	70's	F/T	Picture of man w/tray	$25-35	$70-95
Kent	S-102	ATC		1930	50	70's	S/P	F8-5NJ	$85-145	$250-350
Kent Deluxe Length	No Stamp	LOR		1952	20	70's F	S/B	W/mic filter	$10-15	$40-55
Kent Golden Lights	Warning	LOR		1970	20	F100R	S/B	W/mic filter	$3-5	$8-12
Kent Golden Lights	S-1898	LOR		1984	20	All Kinds	S/B	Multi. colors	$1-2	$3-6
Kent III	Sur-Gen	LOR		1992	20	2 Types	S/B	Multi. colors	$3-5	$8-12
Kent III	Warning	LOR		1978	20	FKRUL	S/B	White and silver	$1-2	$3-6
Kent International	Sur-Gen	LOR		1992	20	FKRUL	FTB	Also F100RL, White	$1-2	$-6
Kentucky Club	S-1898	PEN		1994	20	70's	S/P	?	$10-15	$40-55
Kentucky Colonel	S-122	PMC		1979	20	FKR	S/P	?	$2-4	$7-9
Kentucky Governor	Warning	TEI		1898	20	70's	?	F36-KY	$35-50	$90-135
Kentucky Kings	S-104	BAW		1934	20	70's	S/P	Tobacco filter,	$15-20	$55-65
Kentucky Kings	No Stamp	BAW		1956	20	FKR	S/B	?	$6-8	$25-35
Kentucky Picaninnies	S-1898	CAM		1898	20	70's	S/P	C98	$35-50	$90-135
Kentucky Slims	Warning	PMC		1974	20	FKR	S/P	Trademark	$6-8	$25-35
Kentucky Twins	S-104	BAW		1934	20	70's	S/P	F36-KY	$15-20	$55-65
Kentucky Winners	S-102	Pen		1932	50	70's	F/T	Horse running to right	$85-145	$200-275
Kentucky Winners	S-104	BAW		1934	20	70's	S/P	3 different type	$15-20	$55-65
Kettle Drum	S-1898	BRB		1898	?	70's	?	C98	$35-50	$90-135
Kewenlyk	S-1883	ECK		1886	20	70's	?	C87	$50-65	$150-190
Kewpie	S-121	GAG	YNC	1952	20	70's	F/B	F407-2NY	$20-25	$60-85
Key West Buds	S-1898	RSH		1898	25	FKR-FKMFTB	?	?	$35-50	$90-135
Key West Egyptian Blend No. 10	S-108	KWC		1938	50	70's	F/T	?	$85-145	$200-275
Khakies	S-123	ALC		1943	20	70's	S/P	F20-14NY	$15-20	$55-65
Khedival	S-1887	KHE		1895	20	70's		F348-2NY	$50-65	$150-190
Khedive	S-1883	MON	MON	1886	20	70's		C87, C98,	$60-85	$180-225
Khedive	S-102	ATD		1899	20	70's	CSB	F363-3NY	$35-50	$90-135
Kickum	Sur-Gen	RAA		1994	20	FKR	S/P	White on blue	$2-4	$7-9
Kieffer Club Clothes	S-122	GAG	YNC	1972	20	FKR	F/B	F407-2NY	$6-8	$25-35
Kim	Warning	BAW		1971	20	FKR	S/P	Trademark	$2-4	$7-8
Kim Slims	Sur-Gen	BAW		1987	20	70's	F/B	Yellow w/ orange wave	$6-8	$25-35
Kimball	Caution	LOR		1967	20	FKR	S/P	Trademark	$2-4	$7-9
Kimball's Straight Cut	S-1879	KIM		1882	10	70's	SSB	C98	$75-100	$200-250
Kin Key West	S-1898	KSR		1898	20	70's	?	C98	$35-50	$90-135
Kincaid	Warning	BAW		1981	20	FKR	S/P	Trademark	$6-8	$25-35
King	Caution	USJ		1968	20	FKR	S/P	Black on white	$3-5	$8-12
King Bee	S-1883	CNT		1883	20	70's		?	$60-85	$180-225
King Condossis	S-102	CON		1931	20	70's	CSB	F59-2NY	$15-20	$55-65
King Falcon	Warning	LAM		1972	20	FKR	S/P	?	$2-4	$7-9
King Kid	S-1898	HTT		1898	?	70's		C98	$35-50	$90-135
King LEAH	S-1898	COJ		1898	20	70's		?	$35-50	$90-135
King of Kings	S-122	ARM		1952	20	FKR	F/B	Black & white on gold	$10-15	$40-55
King Penn	S-1917	LAM		1920	20	70's	?	?	$20-25	$60-85
King Pin	S-1917	LAM		1920	10	70's		?	$20-25	$60-85
King Sano	S-123	LNI		1953	20	All Kinds	S/P	Gold & green on white	$10-15	$40-55
King Sano	Caution	USJ		1966	20	FKR-FKMS/P		Light green on white	$3-5	$8-12
King Seti	S-1901	CTK		1902	20	70's		?	$20-25	$60-85
King Size	S-1901	BUB	ATD	1908	20	FKR-FKMS/P	F/B	F649-1NY	$6-8	$25-35
King Size	Warning	USA		1971	20	FKR-FKMS/P	S/P	Blue/green on white	$2-4	$8-12
King Stratton	S-1898	FEN		1929	20	70's	SSB	C98	$35-50	$90-135
King Choice	No Series	?		1906	10	70's	S/P	F67-1CA	$20-25	$60-85
King Gold	S-1901	GIA		1898	10	70's	SSB	F2100-2NY	$35-50	$90-135
Kings Own	S-1898	WIK		1995	20	70's		C98	$35-50	$90-135
Kings Row	Sur-Gen	RJR		1886	20	FKR	S/P	Trademark	$6-8	$25-35
Kings	S-1883	GLO		1886	20	70's		Trademark	$6-8	$25-35
Kings Way	No Stamp	BAW		1958	20	RKR	S/P	2 tone brn & white	$15-20	$55-65
Kingsley	S-110	WID		1939	20	FKR	F/B	Brown on yellow	$35-50	$90-135
Kingsport	Sur-Gen	LAM		1993	20	All Kinds	S/P	Multi. colors	$1-2	$7-9
Kinney Bros. Straight	Sur-Gen	ATD	KIN	1898	10	70's	SSB	F30-NY	$35-50	$90-135
Kinney Bros. Straight / Full Dress	S-1910	ATC		1911	10	70's	SSB	F30-NY	$30-45	$75-115
Kisko	S-1898	CUC		1898	20	70's	S/P	?	$35-50	$55-65
Kismet	No Series	KIS		1925	20	70's	S/P	?	$20-25	$60-85
Kiss Me	S-1917	KMC		1919	20	FKR	CSB	Picture of red lips	$25-35	$70-95
Kiss of Death	S-1898	BLK		1964	20	70's	S/P	Red on white	$6-8	$25-35
Klondike	S-1898	SOM		1898	20	70's		C98	$35-50	$90-135
Knickerbocker Club	S-1910	KNI		1914	50	70's	R/T	Red and gold on white	$60-85	$180-225
Knickerbocker Club	S-125	?		1955	10	70's	F/B	Red/gold on white	$10-15	$40-55
Knight	S-1898	ATD		1898	20	70's	S/P	C98	$35-50	$90-135
Knights Of Columbus	Warning	AFS		1985	20	70's	S/P	Dark red w/blue trim	$25-35	$70-95
Knightsbridge	S-1887	KIM		1887	20	FKR	S/P	C87	$2-4	$7-9
Knock About	S-125	STP		1955	20	RKR	S/P	F2032-PA	$6-8	$25-35
Knockout	No Series	WET		1923	10	70's	SSP	F36-KY	$1-2	$3-6
Kohar	S-103	BAW		1933	50	70's	S/P	Penguin on back	$35-50	$90-135
Kool	S-105	BAW		1933	20	70's	S/B	4 line verses, w/willie	$20-25	$60-85
Kool	S-125	BAW		1955	20	70's	S/B	2 line verses, w/willie	$20-25	$60-85
Kool	No Stamp	BAW		1956	20	FKR	S/B	Green and white	$10-15	$40-55
Kool	Caution	BAW		1967	10	FK/100's	S/B	Green and white	$10-15	$40-55
Kool	Warning	BAW		1970	20	All Kinds	S/B	Test market	$3-5	$8-12
Kool Naturals	Warning	BAW		1985	20	All Kinds	S/B	Multi. colors of green	$6-8	$25-35
Kool	Sur-Gen	BAW		1975	20	All Kinds	S/B	Multi. colors	$2-4	$7-9
Kotton	S-1898	PTB		1900	20	70's	CSB	F4-LA	$6-8	$25-35
Kozy	S-1898	MIL		1898	10	70's	SSB	F2-NY	$35-50	$90-135
Kraft Chemical Co.	S-121	GAG	YNC	1951	20	70's	S/P	F407-2NY	$6-8	$25-35
Kremling	S-1901	GSN		1907	20	70's	S/P	F407-2NY	$15-20	$55-65
Kuss Machine Tool	S-121	GAG	YNC	1951	10	70's	S/P	F42-NC	$85-145	$200-275
Kuzri	S-1901	RIP		1904	10	70's		Packs w/picture's	$15-20	$55-65
L & M	S-123	LAM		1953	20	70'sF	S/P	4 pks of 10, sld as unit	$35-50	$90-135
L & M (Designer pks)	Caution	LAM		1968	10	FKR	S/P	Multi. colors	$50-65	$150-190
L & M	Warning	LAM		1968	20	FK/100's	S/B	Multi. colors	$35-50	$90-135
L & M	Caution	LAM		1967	20	All Kinds	S/B	Red and white	$10-15	$40-55
L & M	Warning	LAM		1975	20	All Kinds	S/B	Red and white	$10-15	$40-55
L & M	Sur-Gen	LAM	LIG	1987	30	F100RL	S/B	Light and dark brown	$10-15	$40-55
L. T. Brown	Warning	LOR		1985	20	F120R/M	S/P	Trademark	$2-4	$7-9
L. T. D.	Warning	LOR		1975	20	FKR	S/P	C98	$6-8	$25-35
La Amalia	S-1898	MLH		1898	20	70's		Before airport was built	$35-50	$90-135
La Banquet	S-1898	HOU		1898	20	70's		F2153-3NY	$35-50	$90-135
LA International	S-1901	KGB	BUB	1904	10	70's	SSB	?	$35-50	$90-135
LA Marquise	S-114	ATD		1943	20	70's	F/B	F80-6CA	$10-15	$40-55
LA Petite Box	S-106	ATC		1936	20	70's	S/P	F74-2NY	$25-35	$70-95
La Turka	No Series	SOT		1912	20	70's	S/P	F24-KY	$35-50	$90-135
LA Yerba Habana	S-1910	BEH		1940	20	FKR	S/P	Trademark	$15-20	$55-65
Ladd's Imperial	S-110	AFT	UCW	1940	20	70's	S/P	?	$15-20	$75-115
Ladies	Caution	MON	MON	1899	20	70's		F363-3NY	$60-65	$150-190
Ladies Cig. No. 14	S-1898	ATD		1899	20	70's	C/B	F363-3NY	$60-85	$180-225
Ladies Egyptian	S-1910	THS		1913	20	70's		Padded red box	$30-45	$75-115
Ladies Salaambo	S-1910	ROM		1915	10	70's		C98, F2-NY	$60-85	$180-225
Ladrone	S-1898	MIL		1898	20	70's		C98	$35-50	$90-135
Lady Churchill	No Series	ACG		1923	20	70's		?	$35-50	$90-135
Lady Hamilton	S-1910	SOT		1919	20	70's	S/P	Picture of lady	$10-15	$40-55
Lady Hamilton	S-110	SOT		1919	20	70's	S/P	Same as above	$20-25	$60-85
Lady Nic tuts	No Series	LNI		1923	10	70's	SSB	?	$25-35	$70-95
LAM generic	S-123	LAM		1983	20	All Kinds	S/P	For Multi. stores	$25-35	$70-95
Lambs	S-1898	LML		1898	10	70's	SSB	Gold on white	$35-50	$90-135

192

Left Table

Brand Name	Series	Mfg	Ven	YMf	#	Type	Pack	Description/Remarks	Empty	Full
Lancaster	S-105	?		1935	20	70's	S/P	?	$15-20	$55-65
Laramie	No Stamp	BAW		1969	20	FKR	S/P	Trademark	$6-8	$25-35
Larchmont	Caution	RJR		1966	20	FKR	S/P	Trademark	$3-5	$25-35
Laredo	Caution	BAW		1968	20	FKR	S/B	Brown on white	$3-5	$8-12
Lariet	Warning	ATC		1971	20	FKR	S/P	Trademark	$6-8	$25-35
Lark	No Stamp	LAM		1963	20	FKR	S/P	White stripes on red	$3-5	$8-12
Lark	Caution	LAM		1969	20	All Kinds	S/P	Multi. colors	$3-5	$8-12
Lark II	Warning	LAM		1977	20	FKR	S/P	Red stripes on white	$1-2	$4-7
Lark	Sur-Gen	LAM		1985	20	All Kinds	S/P	Multi. colors	$3-5	$8-12
Las Vegas	Warning	BRO		1969	20	FKRL	?	Red on white	$3-5	$8-12
Las Vegas	Warning	DOS	RSI	1983	20	3 types	?	C98	$3-5	$8-12
Lasfal	S-1898	MKR		1898	20	70's	?	?	$2-4	$7-9
Latest English	S-1898	ATD	KIN	1898	10	70's	SSB	C98, F30-NY	$6-8	$25-35
Latest Turkish	S-1887	ATD	KIN	1891	20	70's	CSB	F593-MD	$35-50	$90-135
Lauixiana Perique	S-1887	ATD	HES	1896	50	70's	SSB	Gold on black	$50-65	$150-190
Laurens	S-1901	BUB	ATD	1903	20	70's	SSB	F649-1NY	$35-50	$90-135
Lausanne	Caution	PMC		1969	20	FKR	FTB	Trademark	$6-8	$25-35
Lawson	Warning	BAW		1981	20	FKR	S/P	Trademark	$6-8	$25-35
LDL	Warning	LOR		1975	20	FKR	S/P	Black on white	$2-4	$7-9
Le Delice	No Series	BAB		1925	10	70's	SSB	F551-3NY	$20-25	$60-85
Lee	Warning	BAW		1972	20	FKR	S/P	Trademark, also RJR	$6-8	$25-35
Le Marber	S-115	LEI	SUB	1945	10	R160's	F/B	F65-2NY	$30-45	$75-115
Le Marber, Jr.	S-109	LEI	SUB	1939	20	70's	F/B	F65-2NY	$25-35	$70-95
Le Marber, Yahn	No Stamp	YAH		1960	20	FKR	FTB	F65-1NY,	$6-8	$25-35
Le Roy	S-1879	MIL		1883	50	70's	F/B	F2-NY	$95-175	$225-375
Leader	Warning	RJR		1975	20	FKR	S/P	Trademark	$6-8	$25-35
Leadway	S-108	AFT		1938	20	70's	S/P	F24-KY	$15-20	$55-65
Leaf	Caution	LAM		1966	20	FKR	FTB	Green on white	$3-5	$8-12
Leaf Stix	Warning	LAM		1976	20	FKR	S/P	Trademark	$6-8	$25-35
Lcar	Warning	BAW		1970	20	FKM	S/P	Trademark	$6-8	$25-35
Leeds	No Stamp	ATC		1964	20	FKR	S/P	?	$6-8	$25-35
Legacy	Warning	LAM		1975	20	FKR	S/P	Trademark	$6-8	$25-35
Legend	Sur-Gen	RJR	FOR	1993	20	All Kinds	S/P	Multi. colors	$6-8	$25-35
Lehman & Zehr Co.	S-121	GAG	YNC	1898	?	70's	S/B	F407-2NY	$20-25	$60-85
Leighton	S-109	LEI	LEE	1936	20	70's-RKR	F/B	F65-2NY	$25-35	$70-95
Leighton	S-1910	LAB	LEI	1948	?	RKR	S/P	F460-VA, dark blue	$10-15	$40-55
Leisure	Warning	SLA		1939	20	FKR	S/P	Trademark	$15-20	$55-65
Lem	Caution	ATC		1966	20	70's	S/P	Trademark	$6-8	$25-35
Lementhol	No Stamp	RJR		1974	?	FKR	F/B	J.E.K.'s campaign	$30-45	$75-115
Lemac	S-1887	MON		1887	?	FKR	S/P	C87, C98, F363-3NY	$50-65	$150-190
Lemon Cooler	Warning	LOR		1974	20	FKR	S/P	Orange gray on white	$6-8	$25-35
Lemon Ice	Warning	RJR		1974	20	FKR	S/P	Trademark	$6-8	$25-35
Lemon Longs	Warning	SNJ		1997	20	All Kinds	S/P	Multi. colors	$1-2	$3-6
Lemon Twist	Warning	LAB		1954	20	FKR	S/P	F460-PA	$10-15	$40-55
Lemon Up	Warning	LAM		1981	20	FKR	S/P	Red and white	$2-4	$7-9
Lemonaid	No Series	ATC		1973	20	FKR	S/P	C98	$6-8	$25-35
Lenox	S-1898	PCH		1898	?	70's	?	Trademark	$35-50	$90-135
Leopard	Warning	BAW		1974	20	FKR	FTB	Trademark	$6-8	$25-35
Lepton	S-1910	COP	DUK	1910	?	70's	E/T	Picture of man on left	$30-45	$75-115
Leroy	No Series	MIM		1925	20	70's	?	Trademark	$20-25	$60-85
Less	Warning	RJR		1974	20	FKR	S/P	Trademark	$6-8	$25-35
Let's Back Jack	No Stamp	GAG	YNC	1960	?	FKR	?	Trademark	$15-20	$75-115
Levant	S-1887	SHE		1887	20	70's	S/P	C87, C98, F363-3NY	$50-65	$150-190
Level	Warning	LOR		1974	20	FKR	S/P	Trademark	$6-8	$25-35
Levi's	Warning	RJR		1974	20	FKR	S/P	Trademark	$6-8	$25-35
Lewiston	Sur-Gen	SNJ		1997	?	FKR	S/P	?	$1-2	$3-6
Lexington	Warning	LAB		1954	20	All Kinds	S/P	Multi. colors	$10-15	$40-55
Lexington	Warning	LAM		1981	20	FKR	FTB	Trademark	$2-4	$7-9
Lib	Warning	ATC		1973	20	FKR	S/P	C98	$6-8	$25-35
Liberty	S-1887	ATD	DUK	1890	?	FKR	S/P	Trademark	$6-8	$25-35
Liberty Place	S-1898	ALM		1898	20	FKR	S/P	Trademark	$25-35	$70-95
Liberty Tool Co.	?	COP		1898	?	FKR	?	F407-2NY	$20-25	$60-85
Libra	Warning	LAM	GAG	1951	20	70's	F/B	C98	$20-25	$60-85
Lickter's Hollywood	No Stamp	LIC		1926	20	FKR	S/P	?	$6-8	$25-35
Lido	Sur-Gen	SNJ		1957	20	FKR	FTB	C98, F2-NY	$6-8	$25-35
Lieutenant General	S-1898	MIL		1898	20	FKR	S/P	Life inside circle	$35-50	$90-135
Life	S-1917	PBT		1920	20	70's	S/P	F35-VA, F36-KY	$25-35	$70-95
Life	S-123	BAW		1948	10	RKR-FKR	S/P	Millicel	$10-15	$40-55
Life	Caution	BAW		1963	20	FKR	?	?	$3-5	$8-12
Life	Warning	BAW		1977	20	F100R	S/P	Black on white	$2-4	$7-9

Right Table

Brand Name	Series	Mfg	Ven	YMf	#	Type	Pack	Description/Remarks	Empty	Full
Life Guard	S-105	BAW		1935	20	70's	S/P	F36-KY	$15-20	$55-65
Ligget	No Stamp	LAM		1960	20	FKR	S/P	?	$6-8	$25-35
Ligget Winners	Sur-Gen	LAM		1991	20	F100R	S/P	Sales conference	$6-8	$25-35
Light	Warning	PMC		1974	20	FKR	S/P	Black and white	$2-4	$7-9
Light	Sur-Gen	SHE		1993	20	FKR	CSB	TP-161-NY, black	$2-4	$4-6
Light The Ice	Sur-Gen	LAM		1972	20	FKR	S/P	Trademark	$6-8	$25-35
Like	Caution	ATC		1967	20	FKR	S/P	Trademark	$6-8	$25-35
Liliputians	S-1898	MON		1898	?	70's	?	C98	$35-50	$90-135
Limehouse	Warning	ATC		1972	20	FKR	S/P	Trademark	$6-8	$25-35
Limelight	Caution	LOR	PMC	1964	20	FKR	FTB	Trademark	$6-8	$25-35
Limelite	Caution	PMC		1969	20	FKR	S/P	Trademark	$6-8	$25-35
Limit	Warning	LOR		1973	20	FKR	S/P	?	$2-4	$7-9
Limited Edition	Caution	PMC		1967	20	FKR	S/P	Trademark	$6-8	$25-35
Limited Mail	S-1898	RBL		1898	?	70's	?	C98	$35-50	$90-135
Lincoln	S-1898	KSR		1898	20	70's	?	C98	$35-50	$90-135
Lincoln Desk Co.	S-121	GAG	YNC	1898	?	70's	?	F407-2NY	$20-25	$60-85
Lindsey	Warning	RJR		1980	20	FKR	S/P	Trademark	$6-8	$25-35
Linfield	Warning	BAW		1982	20	FKR	S/P	Trademark	$6-8	$25-35
Linger	Warning	RJR		1975	20	FKR	S/P	Trademark	$6-8	$25-35
Lion	S-1917	MLK		1919	20	70's	S/P	Picture of lion	$25-35	$70-95
Lion	No Series	RYT		1928	?	70's	S/P	Rd stripes, war paper	$20-25	$60-85
Lion	Warning	ATC		1973	20	FKR	S/P	Trademark	$6-8	$25-35
Liso	S-1898	LTL		1898	12	70's	?	C98	$35-50	$90-135
Listerine	S-104	TUC	LAP	1927	20	70's	?	F11-1MO	$20-25	$60-85
Little Beauties, Our	S-1877	ALG		1877	?	70's	?	F25-VA	$50-65	$225-325
Little Brown Jug	S-1887	HES		1887	?	70's	?	C87, Pat. mouthpiece	$2-4	$150-190
Little Buddy	Warning	PMC		1971	20	FKR	FTB	?	$2-4	$7-9
Little Cricket	S-1898	EQU		1898	?	70's	S/P	C98	$35-50	$90-135
Little Croakers	S-1898	HNS		1898	?	70's	S/P	C98	$35-50	$90-135
Little King	S-123	LAB	RUN	1953	20	FKR	S/P	F460-VA	$6-8	$25-35
Little Sweetheart	S-1883	AMC		1886	10	70's	CSB	Picture of lady	$60-85	$180-225
Lloyds	S-108	AFT		1938	20	70's	S/P	F24-KY	$15-20	$55-65
Loco Weed	Caution	GAG	SMH	1967	20	FKR	S/P	1 of 10 "spoof" packs	$10-15	$40-55
Loew's	S-1910	BOT		1913	?	70's	?	?	$30-45	$75-115
Loggs	Warning	BAW		1972	20	FKR	FTB	Trademark	$6-8	$25-35
Logic	Caution	PMC		1972	20	FKR	S/P	Trademark	$6-8	$25-35
London Gold Tip	S-1901	SRB		1901	?	70's	?	F439-2NY	$35-50	$90-135
London Life	S-1887	ANR		1892	20	70's	?	F7-3NY, F21-NY	$50-65	$150-190
London Life Cork Tip	S-1901	ANR		1902	10	70's	?	F7-3NY, cork	$35-50	$90-135
London Lords	Caution	BRI		1968	20	FKR	SSB	Gold leaf on dark red	$6-8	$8-12
London No. 1	Warning	SUP		1972	20	R101R	F/B	Gold on red	$2-4	$7-9
London No. 1	S-1909	BEH		1910	100	F100R	R/T	F75-2NY	$75-100	$200-250
London Plain End	S-1887	KHE		1896	50	70's	F/B	F279-5NY	$50-65	$150-190
London Pride	S-111	SER		1941	10	70's	SSB	F80-6CA	$15-20	$55-65
Lone Eagle	S-101	CLL		1930	20	70's	SSB	F30-NC, Trademark	$15-20	$55-65
Lone Fisherman	S-1875	CLL		1875	?	70's	?	?	$95-175	$275-350
Lone Jack	S-1883	LOJ		1886	?	70's	?	C87	$60-85	$180-225
Lone Jack	Warning	RJR		1975	20	FKR	S/P	Trademark	$6-8	$25-35
Lone Jack Straight	S-1898	CLL		1898	?	70's	?	C98	$35-50	$90-135
Lone Star	S-1887	SWP		1887	20	70's	?	C87	$60-85	$180-225
Lone Star	No Stamp	PMC		1961	20	FKR	S/P	Trademark	$6-8	$25-35
Loner	Warning	RJR		1973	20	FKR	S/P	Trademark	$6-8	$25-35
Long	S-105	ATC	WER	1931	25	70's	FTB	2 tone red	$15-20	$55-65
Long Beach Lights	Sur-Gen	PMC		1992	20	FKR	S/P	Trademark, CCVS	$6-8	$25-35
Long Beach Lights	Sur-Gen	PMC		1994	20	FKR	S/P	Trademark, CCVS-1	$6-8	$25-35
Long Beach Lights	Sur-Gen	PMC		1995	20	FKR	S/P	Trademark, CCVS-2	$6-8	$25-35
Long Beach Lights	Sur-Gen	PMC		1997	20	FKR	S/P	Trademark, CCVS-3	$6-8	$25-35
Long Brown	Warning	ATC		1974	20	FKR	S/P	Trademark	$6-8	$25-35
Long Green	Warning	RJR		1974	20	FKR	S/P	Trademark	$6-8	$25-35
Long Jack	Warning	ATC		1967	?	FKR	S/P	F22-12PA	$6-8	$25-35
Long Johns	Caution	ATC		1967	20	FKR	S/P	F25-1MO	$3-5	$8-12
Long Johns	Warning	ATC		1975	20	F120M	S/P	6 green lines	$2-4	$7-9
Long Ten	Sur-Gen	ATC		1989	20	F120R	S/P	6 red lines	$6-8	$25-35
Long Tow	Warning	ATC		1973	20	FKR	S/P	Trademark	$6-8	$25-35
Long Twins	Warning	ATC		1972	20	FKR	S/P	Trademark	$6-8	$25-35
Long View	Caution	ALE		1955	20	FKR	S/P	Trademark	$6-8	$25-35
Long Voyage	S-1887	LAM		1889	?	70's	S/P	F22-12PA	$6-8	$25-35
Longfellow Petites	S-115	RSD		1930	20	RKR	SSB	F25-1MO	$25-35	$70-95
Longfellow	No Series	LAM		1930	50	RKR	FTB	F1798-3NY	$10-15	$40-55
Longfellow	S-115	RSD		1930	20	RKR	R/T	F916-1NY,	$15-20	$55-65
Longfellow	S-113	PEN	WTA	1943	20	F120R	F/B	F22-12PA, orange	$50-75	$150-190

Brand Name	Series	Mfg	Ven	YMf	#	Type	Pack	Description/Remarks	Empty	Full
Longfellow Twins	S-110	PEN		1945	20	F120R	F/B	F22-12PA, orange	$10-15	$40-55
Longjohns	Sur-Gen	ATC		1994	20	F120R	S/P	Trademark	$6-8	$25-35
Longmeadow	Caution	ATC		1964	20	RFR	S/P	Trademark	$6-8	$25-35
Longway	Warning	RJR		1973	20	FKR	S/P	Trademark	$6-8	$25-35
Loose	Warning	LOR		1974	20	FKR	S/P	Trademark	$6-8	$25-35
Lorain Power Shovels	S-121	GAG	YNC	1951	20	70's	F/B	F407-2NY	$20-25	$60-85
Lord Baltimore	No Series	?		1920	10	70's	S/P		$35-50	$70-95
Lord London	S-106	AFT		1936	20	70's	CSB	F24-KY	$15-20	$55-65
Lord Mansfield	S-107	AFT		1937	20	70's	F/B	F24-KY	$15-20	$55-65
Lord Mansfield	Caution	PMC		1968	20	FKR	FTB	Trademark	$6-8	$25-35
Lord Nelson	S-1917	SOT		1919	20	70's	S/P		$25-35	$70-95
Lord Salisbury	S-1898	WIK		1898	?	70's	?	C98	$35-50	$90-135
Lord Salisbury	S-1889	ANR		1905	50	70's	SSB	F7-3NY	$30-45	$75-115
Lord Salisbury	S-1901	ATC		1910	15	70's	S/P	F2153-3NY	$15-20	$55-65
Lord Salisbury	S-105	ATC		1935	20	70's	F/B	F30-NC	$6-8	$25-35
Lords	Warning	ATC		1974	20	FKR	S/P	F248-2NY	$20-25	$60-85
Lorillard	S-122	LAB	LAN	1921	20	70's	CSB	F460-VA	$15-20	$55-65
Lords	No Series	LAB	LAN	1957	20	70's	CSB	F460-VA	$6-8	$25-35
LSD	Caution	LOR		1955	20	FKR	S/P	Blue gold on white	$15-20	$40-55
LTC	Warning	ATC		1971	20	FKR	S/P	C98	$35-50	$90-135
LTD	Caution	GAG		1971	20	70's	S/P		$35-50	$90-135
Luckies	Warning	ATC		1982	20	FKR	S/P	F223-1NY	$30-45	$60-75
Lucky Charm	S-125	LAM		1925	20	FKR	S/P	Trademark	$6-8	$25-35
Lucky Eight	Warning	ATC		1971	20	FKR	S/P	F407-2NY	$6-8	$25-35
Lucky Eleven	Warning	ATC		1971	20	FKR	S/P	F5-2NY	$15-20	$55-65
Lucky Lady	S-106	AFT		1936	20	70's	S/P		$30-45	$75-115
Lucky Lindy	No Series	LUB		1929	20	70's	F/B		$30-45	$75-115
Lucky Seven	Warning	ATC		1971	20	FKR	S/P	F460-VA	$15-20	$55-65
Lucky Strike green	S-1917	ATC		1916	20	70's	S/P	Trademark	$30-45	$75-115
Lucky Strike green	No Series	ATC		1920	50	70's	R/T	F30-KY, also 100 in	$60-85	$180-225
Lucky Strike green	No Series	ATC		1920	50	70's	F/T	F130-NC	$95-175	$225-325
Lucky Strike green	S-102	ATC		1930	50	70's	F/T	F130-VA	$65-125	$150-225
Lucky Strike gold	No Series	ATC		1938	50	70's	F/T	F30-2NY, flat fiftys	$50-65	$150-190
Lucky Strike white	No Series	ATC		1925	50	70's	F/T	Silver w/gold leaves	$65-125	$150-225
Lucky Strike blue	S-113	ATC		1943	20	70's	F/B	White w/red circle	$65-125	$150-225
Lucky Strike	S-105	ATC		1970	20	70's	F/B	Blue w/red circle	$30-45	$75-115
Lucky Strike	S-125	ATC		1943	20	70's	S/P	Blue line sq. on red	$6-8	$25-35
Lucky Strike	No Stamp	ATC		1956	20	70's	S/P	Standard w/war stamp	$20-25	$60-75
Lucky Ten	Caution	ATC		1967	20	FKR	S/P	Standard	$3-5	$3-5
Lucky 100	S-121	ATC		1951	50	All Kinds	S/B	Multi. colors on white	$3-5	$8-12
Lucky Ten & Ten	Caution	ATC		1967	20	All Kinds	S/B	Multi. colors on white	$2-4	$7-9
Luke	Warning	ATC		1971	20	All Kinds	S/B	Multi. colors on white	$1-2	$3-5
Luper Freight Lines	S-121	ATC		1970	20	FKR	S/P	Red and white	$6-8	$25-35
Lusanne	Caution	LOR		1967	20	FKR	S/P	Red and white	$6-8	$25-35
LUV	Warning	GAG		1971	20	FKR	S/B	1/2 men. 1/2 reg	$3-5	$8-12
Luxury Row	S-121	PMC	YNC	1951	20	FKR-FKM	S/P	F407-2NY	$20-25	$60-85
Lyme	Caution	ATC		1969	20	FKR	S/P	Blue line sq. on red	$3-5	$8-12
Lynbrook	S-1898	RHN		1961	?	70's	?	Trademark	$6-8	$25-35
Lyric	Warning	BAW		1970	20	70's	S/P	C98	$35-50	$90-135
M. M.	S-1898	IRB		1898	?	70's	?		$35-50	$90-135
M. M.	No Stamp	LAM		1898	20	All Kinds	S/B	Trademark	$25-35	$75-115
MAAT	No Series	MMP		1922	20	FKR	F/B	White trim on white	$25-35	$70-95
Macco	S-125	MAT		1955	20	70's	F/B	Red letters on white	$10-15	$40-55
Macedonia	S-1910	MIL		1912	20	70's	S/P	?	$30-45	$60-85
Macedonia	S-1898	MAC		1898	?	70's	?	C98	$35-50	$90-135
Made For Me	S-1901	ATC		1904	100	70's	S/P	F179-1CA	$95-175	$225-325
Made In U.S.A.	S-109	GAL		1939	20	FKR	F/B	F30-NC	$15-20	$60-85
Maders	No Series	LAB		1926	20	FKR	S/P	?	$2-4	$7-9

Brand Name	Series	Mfg	Ven	YMf	#	Type	Pack	Description/Remarks	Empty	Full
Madison	Sur-Gen	SAR	MCI	1995	10	FKR	S/P	TP-22-VA	$1-2	$4-6
Madison	Sur-Gen	GOR	MDD	1996	10	FKR	S/P	TP-2442-PA	$1-2	$4-6
Maestro	No Series	MIL		1898	?	70's	?	C98, F2-NY	$35-50	$90-135
Magi	Sur-Gen	FCG		1920	?	70's	S/P	?	$25-35	$70-95
Magna	Sur-Gen	RJR		1987	20	70's	S/P	Red and gray	$3-5	$8-12
Magnet	No Series	MCE		1925	20	70's	S/P	Picture of horseshoe	$20-25	$60-85
Magneto Ignition Co.	No Series	GAG	YNC	1951	20	70's	F/B	F407-2NY	$20-25	$60-85
Magnolia	S-1887	SMS		1951	20	70's	S/P	F5-2NY	$50-65	$150-190
Magnolia	S-115	BEH		1945	10	70's	S/P	Gold	$30-45	$90-135
Mah Mall Ladies Size	S-102	PIE		1931	100	70's	CSB	Also 10 pk, 50 pk,	$75-125	$200-225
Mah Mall No. 1 3 5 7	S-102	PIE		1931	100	70's	F/T	Gold	$75-125	$200-225
Mahdine	S-1898	KHV		1898	?	70's	F/T/R/T	C98	$35-50	$90-135
Mahnola	S-1898	MHN		1900	100	70's	C/T/R/T	C98	$75-125	$200-225
Mahogany	S-1898	MNC		1898	?	70's	S/P	C98	$35-50	$90-135
Main Street	S-115	SWA		1945	20	70's	S/B	F50-VA	$10-15	$40-55
Major Brands	Sur-Gen	SAR		1995	20	All Kinds	S/B	Multi. colors	$1-2	$3-6
Madaroff Russian	S-1901	MAK		1908	10	70's	S/P	F266-3MQ	$50-65	$150-190
Makaroff	S-106	KHO		1938	20	70's	S/B	F266-MA	$15-20	$55-65
Makaroff Russian No	S-104	MAK		1930	20	70's	SSB	F266-MA	$35-50	$60-85
Make Or Break	S-1883	KIM		1886	?	70's	?		$35-50	$180-225
Malaga	S-1898	RSW		1898	?	70's	?	C87	$60-85	$90-135
Malibu	Sur-Gen	ATC		1987	20	All Kinds	S/P	C98	$35-50	$90-135
Malibu Thins	Caution	ATC		1967	20	F100R	FTB	Multi. colors	$6-8	$60-85
Malik	S-1898	MIL		1898	?	70's	S/P	Trademark	$35-50	$55-65
Mallard	S-114	LAB		1944	20	FKR	S/P	F460-VA, TP-45-VA	$10-15	$40-55
Mallard	Warning	HOE	RIG	1973	20	70's	S/P	Picture of 2 men	$3-5	$8-12
Malta Amber	No Series	NSS		1924	20	70's	S/P		$20-25	$60-85
Mammoth	S-1898	DLM		1898	?	70's	S/P	C98	$35-50	$90-135
Mamonna	S-1898	MIL		1898	?	70's	S/P	C98, F2-NY	$6-8	$25-35
Manchester	Sur-Gen	RJR		1987	20	70's	S/P	Gold/white lines	$6-8	$25-35
Manchester	S-1898	RJR	FOR	1994	20	70's	S/P	TP-1-NC	$1-2	$3-6
Maple	S-1898	MNC		1898	?	70's	S/P	C98	$35-50	$90-135
Mapleton	S-110	AFT	FLH	1937	20	FKR	S/P	F24-KY	$15-20	$60-85
Mapleton	S-123	USJ	FLH	1953	20	FKR	S/P	F1-VA	$15-20	$55-65
Marathon	S-106	AFT		1936	20	70's	S/P	F24-KY	$15-20	$55-65
Marcovitch Rd. White	Sur-Gen	PMC		1986	20	FKR	S/P	F24-KY	$6-8	$25-35
Mardi Gras	Caution	PMC		1967	20	FKR	FTB	Trademark	$6-8	$25-35
Mariana	Sur-Gen	SHE		1989	10	FQR	CSB	TP-161-NY	$2-4	$7-9
Mariani	S-1898	LNE		1898	20	70's	S/P	C98	$35-50	$90-135
Marijuana	Warning	FEN		1898	20	70's	S/P		$6-8	$25-35
Marine	No Stamp	ATC		1976	10	FKR	F/B	Trademark	$6-8	$25-35
Marine One Comp.	Warning	PMC		1961	20	FKR	S/P	Trademark	$6-8	$25-35
Mariner	No Stamp	?		1961	20	70's	S/P	All major Mfg.	$6-8	$25-35
Marion Power Shovel	No Stamp	PMC		1960	20	FKR	FTB	Trademark	$6-8	$60-85
Marius	S-121	GAG	YNC	1951	20	70's	F/B	F40-7-2NY	$20-25	$60-85
Mark Ten	S-108	IYC		1938	20	FKR	S/B	F1278-5NJ	$15-20	$55-65
Mark V II	Warning	PMC		1980	20	FKR	FTB	Trademark	$3-5	$8-12
Marken	Caution	PMC		1969	20	FKR	FTB		$6-8	$25-35
Marlboro	No Series	ATC		1908	20	70's	S/P		$35-50	$90-135
Markham	Sur-Gen	RJR		1974	20	FKR	S/P	Trademark	$1-2	$3-5
Marlboro	Warning	BAW		1992	20	All Kinds	S/P	C98	$6-8	$25-35
Marlboro	S-108	PMC		1938	10	RKR	CSB	Picture of lady	$35-50	$55-65
Marlboro	S-114	YOR		1936	20	70's	S/P	Olive gold on white	$15-25	$55-65
Marlborough	S-108	AFT		1931	20	RKR	S/P	Orange and white	$15-20	$55-65
Marquee	S-125	STP		1935	50	70's	F/T	Orange on white	$20-25	$60-85
Marquette	No Stamp	USJ	STP	1960	20	RKR-FKR	S/P	Also RKR,FKR,FKM	$95-150	$250-325
Marshall's Cubeb	Warning	LAM		1982	20	F70s-70's	S/P		$2-4	$7-8
Martini	No Stamp	BAW		1959	20	FKR	S/P	Picture of turtle	$6-8	$25-35
Marvels	S-114	YOR		1936	20	70's	S/P	Multi. colors	$15-25	$55-65
Marvels	S-108	AFT		1931	20	RKR	S/P	Trademark	$15-20	$55-65
Maryland Tarpins	No Stamp	STP		1955	20	FKR	S/P	TP-3-VA	$2-4	$7-8
Mary Long	No Stamp	BAW		1959	20	FKR	S/P	F407-2NY	$6-8	$25-35

Brand Name	Series	Ven	Mfg	YMf	#	Type	Pack	Description/Remarks	Empty	Full
Mary Powell	S-1898		BLB	1898	20	70's	S/P	C98	$35-50	$90-135
Mary Wanna	Caution	SMH	GAG	1967	20	FKR	S/P	1 of 10 "spoof" packs	$20-25	$60-85
Maryland	No Series		ATC	1967	20	FKM	S/P	Also F100R, F100M	$6-8	$25-35
Maryland Doux	No Series		PKI	1922	10	70's	SSB		$60-85	$180-225
Mascot	S-1883		ALG	1882	20	70's	S/P	F25-VA	$75-100	$200-275
Masher, The	S-1879		MTK	1923	10	70's	S/P	Brown wood grain	$6-8	$25-35
Master's Own	No Stamp		LAM	1964	20	70's	S/P	Trademark	$6-8	$25-35
Masterpiece	Warning		BAW	1982	20	FKR	SSB	C98	$6-8	$25-35
Masterson	S-1898		PCE	1898	20	FKR	SSB	F25-VA	$6-8	$25-35
Mastiff	S-1898		ALG	1885	10	70's	SSB	F213-1CA	$60-85	$180-225
Matchless	S-1883		BEN	1890	10	70's	FTB	F593-MD,	$25-35	$70-95
Matchless	S-102		KIN	?	10	70's	S/P		$50-65	$150-190
Matinee	S-1887		MTK	1887	20	70's	S/P	Trademark?	$25-35	$70-95
Matoaka	S-1917	DEP	PMC	1919	20	FKR	SSB	C87	$6-8	$25-35
Maure Moyen	Warning		SWP	1886	20	70's	S/P	Coral and silver	$50-65	$150-190
Matsuri	S-1883		?	1883	20	70's	SSB	Coral on white	$35-50	$90-135
Maud Miller	S-1901		CBI	1901	20	70's	SSB	C98, F2-NY	$1-2	$4-6
Maui	Sur-Gen		CBI	1974	20	FKR	S/P	C87, C98	$2-4	$7-8
Maui	Sur-Gen		MIL	1995	20	FKR	S/P	F25-VA	$6-8	$25-35
Maumin	S-1898		ECK	1898	10	F100R	S/B	Man on horse	$6-8	$25-35
Maureo	S-1887		MAU	1887	20	70's	S/P	Horse on red/white	$2-4	$7-8
Maverick	S-1901		?	1908	20	FKR	S/B	Red/brown stripes	$1-2	$3-5
Maverick	Warning		LOR	1959	20	FKR	S/P	Gold on black	$2-4	$8-12
Maverick	Warning		LOR	1971	20	F100R	S/P	Trademark	$6-8	$25-35
Max	Warning		LOR	1978	20	All Kinds	S/B	White gold stripes	$2-4	$8-12
Max Slim	Warning		LOR	1997	20	F120R-M	S/B	Brown on beige	$2-4	$7-9
Maxim	Caution	YNC	LOR	1975	20	F120RL	FTB	Trademark	$6-8	$25-35
May Flower	S-1898		RJR	1983	20	FKR	S/P	C98	$35-50	$90-135
Mayfair	S-106		BAG	1966	20	70's	S/P	F24-KY	$15-20	$55-65
Mayfield	Warning		PMC	1936	20	FKM	FTB	Trademark	$15-20	$55-65
Mayflower	No Series		LAM	1958	20	70's	S/P	F407-2NY	$15-20	$55-65
Mayflower, The	S-108	STK	GAG	1938	20	70's	CSB	Yellow ship on white	$10-15	$40-55
Mayo's Cut Plug	S-125		SHE	1955	10	70's	CSB	F407-2NY, red pack	$15-20	$55-65
Maytag	Caution		SHE	1969	20	70's	CSB	TP-22-VA	$15-20	$55-65
Maytime	S-121		LEI	1984	20	FKR	FTB	TP-161-NY, 3 types	$50-65	$150-190
MCD Doubles	No Stamp	MLL	NAT	1943	20	70's	CSB	TP-161-NY, 3 types	$3-5	$8-12
MCD	Warning		ATD	1898	20	FKR	CSB	F65-2NY	$3-5	$8-12
McDonnell	S-114		ANR	1911	20	70's	S/P	C98	$15-20	$55-65
McFadden's Kid	S-1898	KIN	ATC	1919	24	70's	FTB	Picture of McGovern	$35-50	$90-135
McGovern	Warning		MEL	1972	20	FKR	F/B	F30-2NY	$35-50	$90-135
Mecca	S-1887		GAG	1891	20	70's	S/P	F30-NC	$35-50	$90-135
Mecca	S-105		ATC	1911	10	70's	SSB	F30-NC	$30-45	$75-115
Mecca	S-115		ATC	1911	10	70's	S/P	C98	$35-50	$90-135
Mechanic's Joy	S-1898		HSS	1919	20	70's	S/P	Multi. colors	$35-50	$90-135
Medallion	S-1898		HVL	1898	20	70's	S/P	Trademark	$35-50	$90-135
Medallion	Sur-Gen		LAM	1959	20	FKR	S/P	F54-2NY, "aromatic"	$1-2	$3-5
Medion	Warning		LAM	1898	20	70's	All Kinds	Red letters on dk gray	$15-20	$55-65
Medley	S-109		SSS	1939	20	70's	S/P	Trademark	$10-15	$40-55
Medley	S-125		USJ	1946	10	70's	CSB	F649-1NY	$6-8	$25-35
Medley	Warning	FLH	PMC	1973	10	FKR	FTB	Also 100's, 50's	$60-85	$180-225
Melachrino	S-1883		MEL	1884	20	70's	F/B	F30-NC	$75-100	$200-250
Melachrino	S-1910		ATC	1911	20	70's	R/T	C98, F2-NY	$35-50	$90-135
Melachrino No.4	S-1917		MEL	1919	20	70's	F/B-F/T	F10-KY	$35-50	$90-135
Melachrino Original	No Stamp		ATC	1959	20	All Kinds	S/P	F407-2NY	$35-50	$90-135
Melodies	S-1898		MIL	1898	20	70's	S/P	F407-2NY	$35-50	$90-135
Melody	S-108	FLH	TBC	1938	20	70's	S/P	C87	$35-50	$90-135
Melowicks	S-111		GAG	1941	20	70's	S/P	?	$6-8	$25-35
Melowicks, Club Size	S-113		GAG	1943	10	70's	CSB	Picture of man in ctr.	$15-20	$55-65
Melrose	S-1883		MRB	1883	20	70's	S/P	F24-KY	$60-85	$180-225
Memashi	S-1901	SUY	KHC	1906	10	70's	S/P	Green and white	$35-50	$90-135
Menashi No. 2	S-1901	SRT	MCH	1905	10	70's	S/P	F20-11MO,	$35-50	$90-135
Menelek Extra Egyptian	S-108	FOR	MCC	1900	20	70's	S/P	F916-1NY	$35-50	$90-135
Menthols	Sur-gen		AFT	1995	20	RKR	S/P		$1-2	$4-6
Menthols	S-108		BLO	1938	20	70's	S/P		$20-25	$60-85
Menthorets	No Series		RSD	1927	20	All Kinds	S/P		$10-15	$40-55
Menthorettes					20	70's	S/P		$20-25	$60-85

Brand Name	Series	Mfg	Ven	YMf	#	Type	Pack	Description/Remarks	Empty	Full
Mentor	Caution	LAM		1969	20	FKR	S/P	Trademark	$6-8	$25-35
Merchants Club	S-118	GAG		1948	20	70's	S/P	F407-2NY	$10-15	$40-55
Mercury	S-109	STP		1938	20	RKR	S/P	F2032-1PA	$15-20	$55-65
Meridian	Sur-Gen	LAM		1993	20	70's	S/P	Red sq. on white	$1-2	$4-6
Merit	S-106	AFT		1936	20	70's	S/P	F24-KY	$15-20	$55-65
Merit	Warning	PMC		1975	20	FKR-FKM S/B		Brn and grn on white	$2-4	$7-9
Merit	Sur-Gen	PMC		1989	20	All Kinds	S/B	Multi. colors	$1-2	$3-6
Mermaid	Warning	ATC		1966	20	FKM	S/P	Trademark	$6-8	$25-35
Mermaid	Warning	ATC		1967	20	F100M	S/P	Picture of mermaid	$3-5	$8-12
Mesa	Caution	ATC		1969	20	FKR	S/P	Trademark	$6-8	$25-35
Message	No Series	BAG		1922	20	70's	S/P	?	$20-25	$60-85
Medal Products Mfg.	S-121	GAG	YNC	1951	20	70's	F/B	F407-2NY	$20-25	$60-85
Metar	Warning	LAM		1975	20	FKR	S/P	Trademark	$6-8	$25-35
Metere	Warning	RJR		1976	20	FKR	S/P	Trademark	$6-8	$25-35
Metric	Warning	RJR		1976	20	FKR	S/P	Trademark	$6-8	$25-35
Metro	Sur-Gen	RJR	MTC	1995	?	F100R	FTB	Also lights, fancy box	$1-2	$3-5
Metro Slims	S-1898	RJR		1995	20	FKR	S/P	C98	$35-50	$90-135
Metropole	No Series	JOB		1898	?	70's	S/P	F170-3NY	$20-25	$60-85
Mexican Beauties	S-1898	DRQ		1928	20	70's	S/P	C98	$35-50	$90-135
Mexican Onyx	S-1898	FCH		1898	?	70's	S/P	C98	$35-50	$90-135
MGM Grand-Reno	Warning	SHE		1978	20	FKR	FTB	MGM lion on box	$3-5	$8-12
Miami	Sur-Gen	CBI		1993	?	FKRL	S/P	TP-42-KY	$1-2	$3-6
Mickey	No Stamp	LAB	NOR	1962	20	FKR	S/P	Red on white	$6-8	$25-35
Middleton	S-125	JMI		1955	?	FKR	F/B	Gold and white	$2-4	$7-8
Mignon	S-1898	PCN		1898	20	70's	S/P	C98	$1-2	$3-5
Mignon Egyptian	S-1887	POU		1897	50	70's	F/T	Tin w/paper label	$6-8	$25-35
Mignon Egyptian	S-114	POU		1944	100	70's	C/T-R/T	Also F/T, also 50's	$3-5	$8-12
Mignon No. 1	No Series	POU		1923	20	70's	F/B	F355-2NY	$2-4	$7-9
Milo Mon Caprice	S-1909	SRB		1910	20	70's	CSB	?	$6-8	$25-35
Mild Black Tobacco	No Series	DOM		1965	10	FKR	S/P	C98	$35-50	$90-135
Mild Richmond Gem	S-1879	ALG		1882	10	70's	SSB	TP-43-FL	$75-100	$200-250
Mild Richmond Gem	S-1887	ATD	ALG	1891	10	FKR	F/B	F25-VA, rice paper	$50-65	$150-190
Mill Hill	Warning	ATC		1971	20	FKR	F/T	F25-VA, rice paper	$15-20	$55-65
Millbank	Warning	BAW		1948	50	FKR	S/P	Black letters on white	$20-25	$60-85
Millbank	Warning	BAW		1948	20	FKR	S/P	F36-KY	$6-8	$25-35
Millbrook	Caution	ATC		1978	?	FKR	S/P	Trademark	$20-25	$60-85
Millhill	S-1887	KHE		1896	20	70's	S/P	Slant red bands on dark blue	$3-5	$8-12
Milo	S-1901	MEL		1905	10	70's	CSB	F279-5NY	$35-50	$90-135
Milo	S-1910	SRB		1912	10	70's	SSB	F1026-3NY	$50-65	$150-190
Milo Egyptian Plain	S-107	ATC		1930	10	70's	F/B	Possible import	$35-50	$90-135
Milo Egyptian	No Series	MIM		1924	20	FKR	CSB	F649-1NY	$15-20	$55-65
Milo Violets	S-1887	MIL		1898	20	FKR	S/P	F30-NC, also 20's	$20-25	$60-85
Miltiades Egyptian	S-1910	ANR		1890	?	FKR	S/P	F1016-3NY	$50-65	$150-190
Mimosa	S-1901	ATC		1911	20	FKR	F/B	F2-NY	$30-45	$75-115
Minaret	S-1887	ATC		1902	?	FKR	F/B	Quarter moon w/star	$6-8	$25-35
Minaret	S-1910	PTB		1976	20	FKR	F/B	Pillrd building	$6-8	$25-35
Mine	Warning	RJR		1968	20	FKR	F/B	F4-LA	$15-20	$55-65
Miner's Extra	Caution	ATC		1967	20	FKR	S/P	Trademark	$6-8	$25-35
Miner's Extra Long	Caution	ATC		1901	20	FKR	F/T	Trademark	$6-8	$25-35
Minit	S-1901	PTB		1936	?	70's	S/P	F4-LA	$6-8	$25-35
Mino	S-106	MAC		1993	20	70's	?	F179-1CA	$30-45	$75-115
Minos	Sur-Gen	SHE		1958	20	80's	CSB	TP-161-NY	$15-20	$55-65
Mint	No Stamp	BAW		1954	?	FKR	S/P	Green or white 2 types	$75-100	$200-225
Mint Julep	Warning	GOV		1977	20	FKR	S/P	Black on white	$6-8	$25-35
Minneapolis Athl-Club	S-124	RJR		1898	?	FKR	S/P	Trademark	$75-100	$200-250
Minthol	Warning	MBW		1979	20	FKR	S/P	C98	$35-50	$90-135
Minus	Warning	RJR		1898	20	FKR	S/P	Trademark	$35-50	$90-135
Minute Mann	S-1898	CBS		1899	?	70's	S/P	Trademark	$10-15	$40-55
Mirage	Warning	PMC		1972	20	FKR	S/P	Trademark	$6-8	$25-35
Miss Charmion's	S-1887	ATC		1974	10	FKR	FTB	Trademark	$20-25	$60-85
Mistletoe	Sur-Gen	ATC		1991	20	FKR	S/P	Green or white on white	$3-5	$8-12
Misty	S-1898	CAM		1898	20	FKR	S/P	Multi. colors	$35-50	$90-135
Mixtop	Warning	PMC		1974	20	70's	S/P	C98	$35-50	$90-135
Miyako	S-1898	HSS		1898	?	70's	S/P	Red on light brown	$15-20	$55-65
Mo-Ko	S-118	CLO		1948	20	RKR	S/P	?	$1-2	$4-6
Moby Dick	Caution	PMC		1967	20	FKR	FTB	Trademark	$20-25	$60-85
Mode, La	S-1898	MIL		1898	?	70's	?	C98, F2-NY	$35-50	$90-135

195

(Table continued — Brands Mt. Menthol through Nevada)

Brand Name	Series	Ven	Mfg	YMf	#	Type	Pack	Description/Remarks	Empty	Full
Mt. Menthol	Caution		RJR	1970	20	FKM	S/P	Trademark	$6-8	$25-35
Mr. Mint	Caution		RJR	1968	20	FKR	S/P	Trademark	$6-8	$25-35
Mr. Slims	Warning		PMC	1970	20	FKR	FTB	Trademark	$6-8	$25-35
Mr. Spearmint	Caution		RJR	1968	20	FKR	S/P	Trademark	$6-8	$25-35
Ms	Warning		PMC	1972	20	70's-FKR	S/B	Trademark	$6-8	$25-35
Mt. Neboh	S-1898		PCK	1898	?	70's	?	C98	$35-50	$90-135
Mule	S-1917		LIN	1918	?	70's	?		$25-35	$70-95
Multifilter	Caution	BEH	PMC	1967	20	FKR	P/B	Red on Brown	$6-8	$25-35
Multifilter	Warning	ANR	PMC	1973	20	FKR-FKMS/P		Multi. colors	$2-4	$7-8
Murad	Caution		PMC	1967	20	70's	?	F7-2NY	$60-85	$90-135
Murad	S-1901		ATD	1905	?	70's	?	Also R/T, and 100 ct.	$95-175	$250-325
Murad	S-1901		ANR	1904	50	70's	F/T-C/T	F57-5NJ, F8-5NJ	$50-85	$200-250
Murad	S-1910		ANR	1911	10	70's	SSB	F7-3NY	$30-45	$75-115
Murad	S-1901		ANR	1905	10	70's	CSB	F7-3NY	$30-45	$75-115
Muratti's	Warning		LOR	1971	20	70's	SSB	F8-5NJ, C-622-NC	$2-4	$7-9
Murray Hill	S-1917		MUT	1919	?	70's	S/P		$15-20	$55-65
Music	S-108		AFT	1936	20	70's	?	F24-KY	$50-65	$150-190
Musketeer	S-1887		LAM	1891	?	70's	S/P	F25-1MO	$15-20	$55-65
Mustang	S-106		AFT	1936	20	FKR	S/P	F24-KY	$6-8	$25-35
Mustang	Warning		BAW	1984	20	All Kinds	S/P	Trademark	$1-2	$3-6
My Blend	Sur-Gen	FOR	RJR	1994	10	70's	W/B	Multi. colors on white	$35-50	$90-135
My Blend	S-110	DUN	GAG	1940	?	70's	?	Black letters on brown	$15-20	$55-65
My Daily Smoke	S-125		GAG	1955	20	70's	?	C98	$35-50	$90-135
My Own Blend	S-1898		HNN	1898	20	FKR	CSB	TP-75-NY	$2-4	$7-9
My Selection	Warning	VEN	GAG	1975	10	70's	?	Multi. colors	$50-65	$150-190
My Uncle Toby	S-1887		GON	1889	?	70's	?	Paperwrap, cig pack	$75-100	$200-275
Mysteries, Egyptian	S-1879		BAA	1880	20	70's	F/B	F556-2NY,	$20-25	$60-85
N. B.	No Series		CUI	1923	?	70's	?		$3-5	$8-12
N S	S-1898		MIL	1898	40	R100R	F/B	Black letters on white	$20-25	$60-85
N. Brezner & Co.	Warning		SHE	1975	20	FKR	S/P	F407-2NY	$20-25	$60-85
N.Y. Athletic Club	S-120	BAM	GAG	1950	20	FKR	F/B	TP-75-NY	$6-8	$25-35
Nabob	Caution		GAG	1968	?	70's	?	C98	$2-4	$7-9
Nacional	S-1898		PCH	1898	20	FKR	FTB	Red blue on white	$60-85	$180-225
Nacs 21st Convention	Warning		PMC	1974	20	FKR	S/P	NACS-Nat. Assos. stores	$35-50	$90-135
Nadine	Sur-Gen		LAM	1981	10	70's	?	F363-3NY	$6-8	$25-35
Naishapur	S-1901		MON	1902	20	70's	?		$35-50	$90-135
Name this Cigarette	S-1910		ORT	1910	20	70's	S/P	F24-KY	$50-65	$150-190
Nan	S-107	FLS	AFT	1937	20	70's	?	F74-2NY	$20-25	$60-85
Nantucket	No Series		SOT	1924	20	FKR	S/P	Trademark	$20-25	$60-85
Nantucket	Warning		BAW	1974	20	70's	?	White w/whale	$6-8	$25-35
Napoleons	S-1883		BAW	1984	10	70's	?	F25-VA, half & half	$2-4	$7-9
Nardac	S-1883		ALG	1884	20	70's	S/P	C98	$60-85	$180-225
Nashville	S-1898		BRC	1898	20	FKR	S/P	Trademark	$35-50	$90-135
Nassau	Warning		RJR	1971	20	FKR	S/P	Trademark	$6-8	$25-35
Nation's Pride	Caution		SCN	1966	?	70's	?	C98	$35-50	$90-135
National	S-1898		PAC	1898	20	70's	F/B	F407-2NY, Detroit, Ml.	$50-65	$150-190
National Plated	S-121	YNC	GAG	1951	?	70's	S/P	Picture of capital	$20-25	$60-85
Nationals	No Series		NTC	1887	10	70's	SSB	C98, F30-NY,	$20-25	$60-85
Native	S-1898	KIN	ATD	1898	?	70's	?	F439-2NY	$35-50	$90-135
Nat Sherman	No Stamp		SHE	1961	60	RKR	CT	Pink on brown	$35-50	$75-115
Natural, Schinasi Bro	Warning		SHE	1884	20	70's	SSB	Black on orange	$95-175	$275-350
Natural, Rounds	S-1883	SCS	SCS	1930	15	70's	CSB	F7-5NJ, cork tip	$30-45	$75-115
Natural, Schinasi Bro	S-102	SCS	ATC	1942	10	70's	?	C98	$30-45	$75-115
Natural	S-112		ATC	1948	20	RKR	S/P	F30-NC	$20-25	$60-85
Naturals, Salaambo	S-118	LIE	LEE	1994	20	All Kinds	S/B	F30-NC	$15-20	$60-85
Natural Ameican Sp.	Sur-Gen		CBI	1915	10	70's	SSB	TP-42-KY	$1-2	$3-5
Naturecell	S-1910		ROM	1970	20	FKR	SP	Trademark	$30-45	$75-115
Navy (Gail & Ax)	Warning		ATC	1988	20	FKR	S/P	Trademark	$6-8	$25-35
Navy Blue	Sur-Gen		ATC	1925	?	70's	?	Picture ships wheels	$20-25	$60-85
Nazima	No Series	?	VAW	1910	20	FKR	?	Blue on white	$20-25	$60-85
N. C. S. U. Wolf Pk.	Warning		LAM	1982	20	FKR	SP	F439-2NY	$35-50	$90-135
Nebo	Sur-Gen		SRB	1899	?	70's	?	Black on white	$10-15	$40-55
Nebo	S-1898		LOR	1911	10	70's	S/P	F7-5NJ, cork tip	$35-50	$90-135
Nebraska Hummer	S-1910		MEY	1898	?	70's	?	C98	$50-65	$150-190
Nectar	S-1898		?	1898	100	70's	R/T		$35-50	$90-135
Nestor	S-1898		GIA	1894	10	70's	F/B	F2100-2NY	$60-85	$180-225
Nestor Egyptian	S-1887		GIA	1898	10	70's	F/B	Red letters, gold crest	$60-85	$180-225
Nestor Gianachis	S-1898		GIA	1898	10	70's	P/T	Also F/T 50's	$35-50	$90-135
Neuvo	S-1898		LAM	1968	20	FKR	S/P	Black letters on white	$35-50	$90-135
Nevada	Warning		PMC	1968	20	FKR	FTB	Trademark	$6-8	$25-35

(Table — Brands Model through Mt. M)

Brand Name	Series	Ven	Mfg	YMf	#	Type	Pack	Description/Remarks	Empty	Full
Model	S-1887		FEL	1887	?	70's	C/T	C87, C89	$50-65	$150-190
Moderates	Caution		PMC	1968	20	FKR	FTB	Trademark	$6-8	$25-35
Modereator	Warning		PMC	1968	20	FKR	FTM	Trademark	$6-8	$25-35
Modernique	No Series	BAB	BAB	1921	10	70's	F/B	Redwood box	$60-85	$180-225
Modernique	S-125		GAG	1955	50	R100R	F/B	Redwood box	$50-65	$150-190
Modernique Pastelle	S-125		GAG	1955	20	RKR	S/P	TP-75-NY	$10-15	$40-55
Mogno, El	No Stamp		KHH	1898	?	RKR	S/P	C98	$6-8	$25-35
Mogul	S-1898		ATD	1892	10	70's	C/T	F7-3NY, single layer	$60-85	$90-135
Mogul	S-1901	ANR	ATD	1905	50	70's	S/P	F7-3NY	$35-50	$180-225
Mon Caprice, Milo	S-1910		LOR	1911	10	70's	CSB	F57-5NJ, double layer	$75-145	$200-250
Mon Plaisir	S-1910		SRB	1886	10	70's	C/T		$50-65	$150-190
Mona Lisa	S-1883		MON	1910	10	70's	CSB		$30-45	$75-115
Monaco	S-1910		VRN	1914	20	70's	S/P	C87	$30-45	$75-115
Monaco	No Stamp	CNT	PMC	1959	20	RKR	S/P	F21-VA	$6-8	$25-35
Monarch	Sur-Gen	FOR	RJR	1992	20	All Kinds	S/B	Multi. colors	$1-2	$3-5
Monarch	S-1883		MNR	1886	?	70's	?	C87	$50-65	$150-190
Monarchs	Sur-Gen	FOR	RJR	1992	20	All Kinds	S/B	Multi. colors	$15-20	$55-65
Money	S-111		BEH	1941	20	70's	S/P	F5-2NY	$15-20	$55-65
Monitor	No Stamp	BEC	PMC	1990	20	FKML	S/P	TP-7-NC	$6-8	$25-35
Monitor	Warning		RJR	1964	20	FKR	S/P	Blue band on white	$30-45	$75-115
Mono	S-1898		GOU	1898	?	70's	S/P	Blue	$2-4	$7-9
Monogram	Warning		RJR	1976	20	FKR	S/P	C98, turkish blend	$35-50	$90-135
Monolite	No Series		BEH	1921	20	70's	S/P		$20-25	$60-85
Monopole Turkish	S-1901		AUT	1903	10	70's	P/T	Self-lighting	$75-100	$200-250
Monroe	S-1883		MON	1885	10	70's	S/P	F363-3NY	$10-15	$40-55
Montana	S-122		MON	1952	20	70's	S/P	F1-1NY	$2-4	$7-9
Montauk	Warning		BAW	1971	20	FKR	S/P	Trademark	$6-8	$25-35
Montclair	S-1898		MIL	1898	20	70's	S/P	C98	$35-50	$90-135
Montclair	Sur-Gen		ATC	1961	20	FKM	S/P	Trademark,	$6-8	$25-35
Montclair	Warning		ATC	1970	20	FKM	S/B	White on blue	$3-5	$8-12
Montclair	Sur-Gen		ATC	1989	20	All Kinds	S/B	Multi. colors on blue	$1-2	$3-6
Monte Carlo	Warning		LOR	1974	20	FKR	S/P	Yellow gold on white	$2-4	$7-9
Montecristo	Sur-Gen		PMC	1988	20	FKR	S/P	Multi. colors on white	$6-8	$25-35
Montego	Sur-Gen		LAM	1994	20	All Kinds	S/P	Multi. colors	$1-2	$3-6
Montera	Warning		PMC	1971	20	FKR	FTB	Orange on white	$2-4	$7-9
Monterey	Sur-Gen		PMC	1992	20	FKRL	S/P	White, CCAS	$6-8	$25-35
Monterey	Sur-Gen		PMC	1994	20	FKRL	S/P	White, CCVS-1	$6-8	$25-35
Monterey	Sur-Gen		PMC	1995	20	FKRL	S/P	White, CCVS-2	$6-8	$25-35
Monterey	Sur-GEn		PMC	1997	20	FKRL	S/P	White, CCVS-3	$6-8	$25-35
Monticello	S-109		MNT	1939	20	70's	S/P	?	$15-20	$55-65
Monument Square	Warning	CER	LAM	1984	20	All Kinds	S/P	Multi. colors on white	$1-2	$3-6
Moonlight No. 1 Specials Turkish	S-1898		PFF	1898	?	70's	?	C98	$35-50	$90-135
Mora	No Series	CTD	CTD	1926	100	70's	C/T	F879-3NY	$95-175	$275-350
Moraiti	S-1898		RSW	1898	?	70's	S/P	C98	$35-50	$90-135
Moran	No Series		MOR	1923	20	FKR	FTB	Trademark	$6-8	$25-35
Moran	Warning		BAW	1984	20	FKR	S/P	Gold stripes on red	$6-8	$25-35
More	Caution		RJR	1974	20	F120R-M	S/B	Multi. colors	$3-5	$8-12
More	Warning		RJR	1983	20	F120R-M	S/B	Multi. colors	$2-4	$7-9
Morey's Best	Sur-Gen		LAM	1987	20	All Kinds	S/P	Multi. colors on white	$1-2	$3-6
Morgan	Caution		LAM	1970	20	FKR	S/P	Orange on white	$6-8	$25-35
Mortisco Cork Tip	Sur-Gen	SMH	PMC	1992	20	FKR	S/P	White, CCAS	$6-8	$25-35
Moritsette	Sur-Gen		PMC	1995	10	FKR	S/P	Also plain tip	$6-8	$25-35
Moritsfield	Sur-Gen		PMC	1910	20	70's	S/P		$6-8	$25-35
Morning Mail	No Series		MOR	1923	20	70's	S/P		$15-20	$55-65
Morningstar	S-1883		KIM	1885	20	70's	S/P	C87	$50-65	$150-190
Moscows	S-1865	TWL	GOR	1996	?	70's	BOX	Would bring thousands	$95-175	?
Moses Cleveland	S-1898		BED	1898	20	70's	S/P	C98	$35-50	$90-135
Moslem	S-1917		MNB	1920	20	70's	S/P		$25-35	$70-95
Most	Warning		RJR	1974	20	FKR	S/P	Trademark	$6-8	$25-35
Most Extraordinary	S-1898		ANR	1899	20	70's	S/P	1 of 10 "spoof" packs	$35-50	$90-135
Mother's Giggle Grass	Caution	GAG	GAG	1967	20	FKR	S/P	Picture of couple	$35-50	$90-135
Motor	S-108		ATD	1913	10	70's	S/P	F25-1MO	$20-25	$60-85
Motorcycle	S-1898		WAY	1897	20	70's	S/P	C98	$35-50	$90-135
Mt. Apple	Caution		RJR	1968	20	FKR	S/P	Trademark	$6-8	$25-35
Mt. Cherry	Caution		RJR	1968	20	FKR	S/P	Trademark	$6-8	$25-35
Mt. Flavor	Caution		RJR	1969	20	FKR	S/P	Trademark	$6-8	$25-35
Mt. Lime	Caution		LAM	1968	20	FKR	S/P	Trademark	$3-5	$8-12
Mt. M	Caution		RJR	1968	20	FKR	S/P	Trademark	$6-8	$25-35

The catalog continues alphabetically. The lower (left) table runs New Field → Northern Lights; the upper (right) table runs Northwind → Old Time.

Brand Name	Series	Mfg	Ven	YMf	#	Type	Pack	Description/Remarks	Empty	Full
New Field	Caution	ATC		1964	20	FKR	S/P	Trademark	$6-8	$25-35
New French	S-1901	BUB	ATD	1906	20	70's	?	F649-1NY	$35-50	$90-135
New Jersey & You	Sur-Gen	SHE		1995	10	70's	CSB	White/blue box	$1-2	$3-6
New Knight	S-1887	ATD		1897	10	F100R	SSB	F17-2VA	$50-65	$150-190
New Leaf	Caution	PMC		1970	20	70's	S/P	Green on white	$3-5	$8-12
New Light	S-1901	ATD		1905	10	FKR	SSB	Cig. or little cigar	$35-50	$90-135
New Look	Caution	BAW		1967	20	FKR	S/P	Trademark	$6-8	$25-35
New Vanity Fair	S-1883	KIM		1885	?	70's	?	C87	$50-65	$150-190
New Woman	S-1898	GLO		1933	20	70's	?	C98	$35-50	$90-135
New World	S-103	CTD		1948	20	70's	S/P	F879-3NY	$15-20	$55-65
New York Athletic Club	S-118	GAG		1955	10	70's	F/B	F407-2NY	$20-25	$60-85
New York City Lights	S-125	SHE		1984	10	FQR	F/B	Gold letters on blue	$6-8	$25-35
New York Standard	S-1883	KIN		1948	20	70's	SSB	F593-MD	$60-85	$180-225
New York Yacht Club	S-118	GAG		1978	20	70's	F/B	F407-2NY	$15-20	$55-65
New York, N.Y.	Warning	DOS	NEY	1978	20	FKR	S/B		$2-4	$7-9
New Yorker	S-107	DNS	AUL	1937	20	FKR	S/P	Gold on white	$20-25	$55-65
New Yorker	Warning	PMC		1972	20	FKR	S/P	Blue on white	$2-4	$7-9
New Yorker	Sur-Gen	PMC		1992	20	FKRL	FTB	Gray, CCSS-1	$6-8	$25-35
New Yorker	Sur-Gen	PMC		1994	20	FKRFF	FTB	Red, CCSS-2	$6-8	$25-35
New Yorker	Sur-Gen	PMC		1995	20	FKRFF	FTB	Red, CCSS-3	$6-8	$25-35
New Yorker	Caution	ATC		1996	20	FKRFF	S/P	Red, CCSS-4	$6-8	$25-35
Newfield	S-1898	FCH		1964	?	70's	S/P	Trademark	$35-50	$90-135
Newfoundland	Sur-Gen	LAM		1898	?	70's	?	C98	$6-8	$25-35
Newhan	Warning	PMC	NTI	1991	20	FKR	S/P	Trademark	$10-15	$25-35
Newmarket	No Stamp	LOR		1956	20	FKM	S/P	TP-622-NC	$3-5	$8-12
Newport	Caution	LOR		1967	20	All Kinds	S/B	All kinds of mint flavor	$2-4	$7-9
Newport	Warning	LOR		1974	20	All Kinds	S/B	All kinds of mint flavor	$3-5	$8-12
Newport	Warning	LOR		1978	20	All Kinds	S/B	First non-filter	$1-2	$3-6
Newport	Sur-Gen	LOR		1985	20	70's	?	Includes "ice", slims	$35-50	$90-135
Newport	S-1898	MON		1898	?	70's	S/P	C98	$35-50	$90-135
Newport Golf Club	S-1898	MON		1898	?	70's	?	C98, F363-3NY	$6-8	$25-35
Newport Specials	Warning	LOR		1974	20	All Kinds	S/P	Multi. colors on white	$1-2	$4-6
News	Sur-Gen	PMC		1989	20	FKR	S/P	Trademark	$6-8	$25-35
Next De-Nic	Warning	BAW		1978	20	FKR	S/P	Trademark	$2-4	$7-9
Niagara	Warning	BAW		1978	20	FKR	S/P	Green on white	$15-20	$55-65
Niagara No. 10	S-111	LAB		1939	20	70's	S/B	C98	$35-50	$90-135
Nickel Threes	S-120	MLH		1898	20	70's	S/P	Has a cigarette cards	$35-50	$90-135
Nickel-In	S-102	NCK		1898	20	70's	S/P	C98	$60-85	$180-225
Nickel-Plate	No Series	?		1885	20	70's	?	C98	$6-8	$25-35
Nicoless	S-118	RJR		1975	20	FKR	S/P	Trademark	$2-4	$7-9
Nicosan	Warning	RJR		1975	20	FKR	S/P	Red on white	$15-20	$40-55
Night Lights	Warning	RJR		1974	20	FKR	S/P	Trademark	$25-35	$70-95
Nile	No Series	FAT		1922	20	70's	CSB	?	$20-25	$55-65
Nine O Three, 903	S-118	BAW		1948	20	FKR	S/P	F36-KY	$10-15	$40-55
Ninety Nine	No Stamp	LAB		1960	20	FKR	S/P	F460-VA, chocolate	$35-50	$90-135
Nix	S-1898	SHE		1968	20	FKR	S/P	Trademark	$6-8	$25-35
Nixon, Win With	Caution	RJR	FOR	1972	20	FKR	S/P	Picture of Nixon	$35-50	$90-135
Nixon	Warning	SHE		1945	20	FKR	F/B	No picture, rd white/bl.	$25-35	$70-95
No	S-115	BLN		1980	20	FKR	S/P	Don McNeill's bkf. club	$10-15	$55-65
No Frills	Warning	LAM	SUM	1980	20	All Kinds	S/P	Red, blue on white	$2-4	$7-9
No Name	S-120	BAW		1950	20	70's	S/P	Black letters on white	$10-15	$40-55
No. 1	S-102	BEH		1932	20	FKR	S/P	F5-2NY, also cork tip	$15-20	$55-65
No. 15	S-105	BEH		1898	10	70's	CSB	F5-2NY, F1-2NY	$25-35	$70-95
Nob Hill	No Series	LAB		1960	20	FKR	S/P	F460-VA	$6-8	$25-35
Noble Cadet	S-1898	OBL		1898	20	70's	S/P	C98	$35-50	$90-135
Nobless	S-1883	KIM		1886	20	70's	S/P	C98	$35-50	$90-135
Nomad	S-1898	WHN		1898	20	FKR	S/P	Trademark	$6-8	$25-35
Nomad	Caution	RJR	MTC	1968	20	FKR	S/P	Black on white	$3-5	$8-12
Non Filter	Warning	ECK		1885	20	All Kinds	S/P	C87, C98	$50-65	$150-190
Non Plus ultra	S-1883	ATC		1976	20	70's	S/P	Trademark	$6-8	$25-35
None	No Series	ATC		1976	20	FKR	S/P	Trademark	$6-8	$25-35
Norfolk	Warning	BAW		1971	20	FKR	S/P	Picture of Ram	$20-25	$60-85
Normandy	Warning	LAM		1972	20	FKR	S/P	Green on white	$20-25	$60-85
North Carolina	Warning	USJ		1923	20	FKR	S/P	TP-1-NC, also FKRL	$1-2	$3-6
North Pole	No Series	RJR		1995	10	70's	CSB	Trademark	$6-8	$25-35
North Star	Sur-Gen	PMC		1960	20	FKR	S/P	Gold on blue	$2-4	$7-9
North Wind	No Stamp	RJR		1976	20	FKR	S/P	By and for inmates	$6-8	$25-35
Northern Lights	Warning	MSC		1986	20	FKR	S/P	Trademark	$6-8	$25-35
Northern Lights	Sur-Gen	PMC		1980	20	FKR	FTB	Trademark	$15-20	$55-65

Brand Name	Series	Mfg	Ven	YMf	#	Type	Pack	Description/Remarks	Empty	Full
Northwind	Warning	PMC		1980	20	FKR	S/P	Also F100R, bl./grn	$2-4	$7-9
Not Guilty	Sur-Gen	GOR	VIS	1996	20	95mm	S/P	O.J. Trial	$25-35	$225-325
Notara No. 2	S-1898	HAS		1898	20		R/T	Also in R/T 100's	$75-145	$225-325
Nova	Caution	ATC		1967	20	FKR	S/P	Trademark	$6-8	$25-35
Novelty	No Series	BEN		1928	20	70's	S/P	F213-1CA	$6-8	$60-85
Novo	Warning	ATC		1967	20	FKR	S/P	Trademark	$2-4	$7-9
Now	Sur-Gen	RJR		1992	20	All Kinds	S/B	Multi. colors on silver	$1-2	$3-6
Now	Warning	RJR		1977	10	All Kinds	S/B	Multi. colors	$6-8	$25-35
Nuance	Sur-Gen	PMC		1898	20	FKR	S/P	Trademark	$35-50	$90-135
Nubia	Warning	PER		1975	20	70's	SSB	F348-2NY	$20-25	$40-55
Nuevo	S-1898	LAM		1898	20	FKR	S/P	Trademark	$10-15	$25-35
Nugget	S-121	JAR		1907	10	70's	CSB	Red & white on gold	$3-5	$8-12
Number 1, Turkish	S-1901	BEH		1907	10	70's	CSB	Also 20's, 50's, 100's	$10-15	$40-55
Number 15 Turkish	S-1901	BEH		1903	10	70's	?	White, minaret on cover	$6-8	$25-35
Nylak	S-1901	AUT		1924	20	70's	S/B	White, "Denicotinized"	$30-45	$75-115
O-Nic-O	No Series	LIU		1953	20	70's	S/P		$6-8	$25-35
O-Nic-O	S-114	LIU	FIL	1965	20	70's	S/B	F137-4NJ	$35-50	$90-135
O-Nic-O	S-125	STP		1950	20	70's	S/P	Red diamond on white	$50-65	$90-135
O.K.	Warning	LOR		1979	20	FKR	S/P	Trademark	$30-45	$75-115
O.G.	S-125	LAM		1913	20	70's	S/B		$6-8	$25-35
Oasis	S-1910	HAL		1955	20	FKM	S/B	Green and white	$35-50	$90-135
Oasis, Egyptian	S-1910	LAM		1913	10	70's	F/B	F64-2NY, F171-1CA	$50-65	$90-135
Obak	S-1898	BOL	LAM	1898	12	70's	S/P	F171-1CA	$35-50	$150-190
Obak	Warning	LAM		1977	12	FKR	CSB	F171-1CA, red on blue	$60-85	$150-190
Obelisk	S-1898	MON		1898	?	70's	?	Re-issue	$75-100	$250-350
October.	Caution	ATC		1898	20	70's	S/P	C98, F363-3NY	$35-50	$90-135
Oklahoma	No Series	AFT		1967	20	70's	S/P	Trademark	$95-150	$250-325
Old 76	S-1898	CLR		1898	10	70's	SSB	F24-KY	$75-100	$200-250
Old 76	S-1917	BER		1918	10	70's	CSB	White gold on purple	$20-25	$60-85
Old Ax	S-1898	FEN		1898	10	70's	SSB	F547-RJ, class b,	$75-125	$225-325
Old Colonial	S-1887	DRU		1887	10	70's	F/B	F100-1MO	$95-150	$250-375
Old Dominion	S-1883	ALG		1886	10	70's	CSB	F25-VA	$95-225	$250-450
Old Egypt Cork Tip	S-1910	ATD	GOO	1898	?	70's	?	Two ladies looking Rt.	$25-35	$70-95
Old Friend	S-1898	KIM		1898	10	70's	?	C98	$30-45	$75-115
Old Gold	S-1883	ATD	DUK	1884	10	70's	SSB	Green on white	$60-85	$180-225
Old Gold	S-1887	LOR		1895	20	70's	S/B	Green and white	$10-15	$40-55
Old Gold	No Series	LOR		1923	20	70's	S/P	F8-5NJ	$6-8	$25-35
Old Gold	No Series	LOR		1923	20	70's	S/P	Also F/T, gold & yellow	$3-5	$8-12
Old Gold	S-113	LOR		1923	50	70's	P/T-R/T	Valvet bx., gld. on gld.	$10-15	$40-55
Old Gold	S-117	LOR		1943	50	70's	F/B	Backgammon Game	$25-35	$70-95
Old Gold	S-102	LOR		1932	50	70's	F/T	Gold/yellow, freedom	$60-85	$150-190
Old Gold	S-125	LOR		1955	10	70's	S/P	Treasure of them all	$75-100	$175-250
Old Gold	No Stamp	LOR		1958	10	FKR	SSB	Light brown on gold	$60-85	$150-190
Old Gold Spin Filter	No Stamp	LOR		1958	10	FKR	S/P	Gold and yellow	$35-50	$90-135
Old Gold	Caution	LOR		1967	20	All Kinds	S/B	C-11-KY, First filter	$10-15	$40-55
Old Gold Straights	Warning	LOR		1971	20	70's-RKR	S/P	New spin filter inside rd.	$6-8	$25-35
Old Gold Straights	Sur-Gen	LOR		1985	20	70's-RKR	S/P	F25-VA	$3-5	$7-9
Old Gubek No. 1	No Stamp	BEH		1957	10	70's	CSB	Multi. colors	$2-4	$8-12
Old Gubek No. 1	Caution	BEH		1967	20	70's	S/P	Multi. colors	$1-2	$3-6
Old Harry	No Series	SCN		1922	40	70's	S/P	Gold dollar on white	$10-15	$40-55
Old Hickory	S-1898	PAC		1898	20	70's	S/P	C622-NC, gld dollar	$25-35	$70-95
Old Joker	S-1883	ATD	GOO	1886	?	70's	?	F5-2NY	$75-125	$175-250
Old Judge	S-1887	GOO		1887	20	70's	SSB	C98	$35-50	$90-135
Old Kentucky	No Series	BAW		1926	10	70's	S/P	F26-2NY	$50-65	$150-190
Old Mac	No Series	TUR		1923	20	70's	S/P	Orange on green	$50-75	$150-190
Old Marines	S-1887	MID		1950	20	70's	SSB	F87-1PA	$20-25	$60-85
Old Mill	S-1910	ATD		1890	10	70's	S/P	F42-NC	$10-15	$40-55
Old Mill	No Series	LAM		1911	20	70's	S/P	F25-VA, picture of mill	$60-85	$180-225
Old North State	S-107	BAW		1926	20	70's	S/P	15 cents straight	$20-25	$60-85
Old Paduke	S-121	AFT		1937	100	70's	S/P	F24-KY	$15-20	$40-55
Old Plantation	S-1898	FPI		1951	20	70's	S/P	C98	$20-25	$60-85
Old Pop Smith	S-121	ZUN		1898	?	70's	?	C87, F25-VA	$15-20	$60-85
Old Rip	S-1883	ALG		1885	?	70's	?	C98	$35-50	$90-135
Old Rover	S-1898	MLH		1898	20	70's	S/P	C98	$60-85	$180-225
Old Time	S-108	AFT		1937	20	70's	S/P	F24-KY	$15-20	$55-65

Brand Name	Series	Mfg	Ven	YMf	#	Type	Pack	Description/Remarks	Empty	Full
Oliver King	No Series	MLD		1927	20	70's	S/P	F30-NC	$20-25	$60-85
Omar	S-1901	ATD		1902	50	70's	F/T-R/T	F30-NC	$75-145	$225-325
Omar	S-108	ATC		1911	?	70's	S/P	TP-75-NY	$20-25	$20-25
Omar Khayyam	No Stamp	GAG		1957	10	70's	SSB	Also turkish no. 2	$6-8	$25-35
Omiros Egyptian	S-1910	LAZ		1912	10	70's	S/P	Also FKR	$30-45	$75-115
Omni Luxury	Warning	LAM		1983	20	F100R	F100R	Also F100R	$2-4	$7-9
Omni 30's	Sur-Gen	LAM		1993	30	F100M	S/P	TP-161-NY, 2 types	$6-8	$25-35
One Sixty Four (164)	Caution	SHE		1968	20	160mm	S/P	Also 20's and 24's	$3-5	$8-12
One-Eleven (111)	S-1901	ATD		1903	15	70's	S/P	F30-NC, w/coupons	$35-50	$90-135
One-Eleven (111)	S-1901	ATC		1926	20	70's	S/P	W/coupons	$20-25	$60-85
One-O-One (101)	Caution	LAM		1970	20	F101R	S/P	W/coupons	$6-8	$25-35
One-O-One (101)	Caution	LAM		1967	20	F101R	S/P	W/coupons pic. sailboat	$6-8	$25-35
One Forty Three	S-102	LAM		1898	20	70's	SSB	Red letters on white	$2-4	$7-9
Opera Puffs	S-1898	ATD	ALG	1898	10	70's	S/P	F25-VA, amber tipped	$35-50	$90-135
OPT	Warning	RJR		1967	20	FKR	S/P	Trademark	$6-8	$25-35
Option	Warning	RJR		1969	20	FKR	S/P	Trademark	$6-8	$25-35
Orange Blossom	S-105	DRQ		1935	?	FKR	S/P	F170-2NY	$15-20	$55-65
Orator	S-1898	MIL		1898	20	70's	SSB	F2-NY	$35-50	$90-135
Orient Cork Tip	S-1901	KHE		1905	20	70's	S/P	F279-5NY	$35-50	$90-135
Oriental	S-1883	KIM		1885	?	70's	F/B	C87, C98	$50-65	$150-190
Original American Spirit	Sur-Gen	DOS	SFN	1991	20	FKR-FKM	S/P	TP-762-FL	$1-2	$3-6
Orleans	S-103	RIT		1933	10	70's	CSB	?	$15-20	$55-65
Ormuz	S-1910	RJR		1913	20	FKR	S/P	F1-5NY	$30-45	$75-115
Osman	Warning	GLC		1985	10	FKR	F/B	Trademark	$15-20	$55-65
Osman	S-102	ANR		1932	?	70's	S/P	F7-1NY	$35-50	$90-135
Oteen	S-1910	MRX		1912	20	70's	SSB	C98	$6-8	$25-35
Otez	S-1898	SFT		1898	20	70's	S/P	C98	$35-50	$90-135
Our Fanny	S-1898	ALG		1898	?	70's	CSB	C87, Amber tip oval	$35-50	$90-135
Our Flower	S-1879	MIL		1881	10	70's	F/B	F2-NY	$75-125	$200-275
Our Little Beauties	S-1898	GAG		1898	20	70's	S/P	F407-2NY	$20-25	$60-85
Our Winchester	S-121	BEH		1951	20	FKR	R/T	F5-2NY, cork tip	$15-20	$55-65
Outlet Supply Co.	S-108	BEH		1938	20	FKR	F/T	Trademark	$6-8	$25-35
Oval Tip	S-1917	ATC	YNC	1918	20	70's	F/B	TP-161-NY	$1-2	$3-6
Oval Virginia	No Series	SHE		1990	10	70's	S/P	F2032-1PA	$75-125	$200-275
Overton	Sur-Gen	PMC		1902	20	FKR	R/T	C98	$75-150	$225-300
Owl Shop	S-1901	RJR		1913	20	70's	F/T	Also 20 and 100 count	$35-50	$90-135
Oxford	No Series	PMC		1898	100	70's	S/P	C98	$60-85	$180-225
Oxford Blues	S-1910	PAG		1894	20	FKR	F/B	TP-42-NC, Multi. colors	$35-50	$90-135
Oxford Club	S-1898	CCC		1919	20	FKR	F/B	Penn. Athl. Club	$10-15	$40-55
Oxford Turkish	S-1887	FRI		1898	20	FKR	F/B	Trademark	$25-35	$70-95
P & A	Warning	ATC	GAP	1964	10	FKR	S/P	Trademark	$10-15	$70-95
P.A.C.	Caution	TUR		1890	20	70's	F/B	Gold on red	$6-8	$25-35
Pace	Sur-Gen	BUB	FOR	1899	10	70's	F/B	Beware of counterfeits	$75-100	$200-275
Pacer	Caution	ATD	ATD	1900	10	70's	F/B	Gold on red	$75-100	$200-275
Pacific	No Stamp	ATD		1906	20	FKR	S/P	White on red	$95-175	$225-325
Page Boy	No Series	ATD		1922	100	All Kinds	S/P	Trademark	$75-100	$200-275
Pageant	Sur-Gen	ATC		1930	20	All Kinds	S/B	White & red, xmas	$95-175	$225-275
Paget & Paget	Caution	ATC		1930	20	FKR	C/T	Also 10 count	$20-25	$60-85
Page Inhalers	No Series	ATC		1939	10	RKR	S/P	Start/classic red	$95-185	$450-650
Pal's	No Series	ATC		1985	20	All Kinds	S/B	White on red	$20-25	$60-85
Palisades	S-1917	ATC		1898	20	70's	S/P	Multi. colors	$15-20	$55-65
Pall Mall	S-1898	ATC		1966	20	All Kinds	S/B	Multi. colors	$10-15	$40-55
Pall Mall	S-1887	ATC		1955	20	All Kinds	S/B	Multi. colors	$6-8	$25-35
Pall Mall	S-1898	ATC		1959	20	RKR-FKR	S/B	Multi. sold to BAW	$3-5	$8-12
Pall Mall London	S-1901	ATD		1970	20	70's	S/B	Trademark	$2-4	$7-9
Pall Mall Rounds	No Series	ATC		1985	20	All Kinds	S/P	C98	$1-2	$3-6
Pall Mall Blend	No Series	ATC		1898	20	FKR	S/B	Trademark	$6-8	$25-35
Pall Mall Georges	S-125	ATC		1966	20	FKR	S/P	Trademark	$35-50	$90-135
Pall Mall	S-108	ATC		1966	20	70's	S/P	Trademark	$6-8	$25-35
Pall Mall	No Series	ATC		1898	?	FKR	S/P	Trademark	$15-20	$55-65
Palladium	S-1898	IRB		1966	20	FKR	S/P	Trademark	$15-20	$55-65
Palma	No Stamp	COB		1966	20	FKR	S/P	Trademark	$30-45	$75-115
Palmer	Warning	ATC		1937	20	FKR	S/P	Trademark	$15-20	$55-65
Palo Alto	S-107	AFT	PAP	1937	20	FKR	S/P	F24-KY, "lip savers"		
Pan Am	S-1910	PMC		1913	20	70's	S/P	F21-VA	$30-45	$75-115

Brand Name	Series	Mfg	Ven	YMf	#	Type	Pack	Description/Remarks	Empty	Full
Pan Am	Caution	PMC		1968	20	FKR	FTB	Trademark	$6-8	$25-35
Pan American	S-1898	MOT		1898	?	70's	?	C98	$35-50	$90-135
Panalette	S-1898	DLW		1898	?	70's	?	C98	$35-50	$90-135
Pang's Superior	S-1910	PKF		1912	10	70's	F/B	F120-2NY	$30-45	$75-115
Pansies	S-1898	MON		1898	10	70's	SSB	C98, F363-3NY	$35-50	$90-135
Paons	No Series	BAB		1929	54mm	54mm	C/B	Cedar box	$30-45	$75-115
Pappas'	S-1910	PPP		1915	10	70's	SSB	Corked tipped	$6-8	$25-35
Par 5	Caution	PMC		1967	20	70's	S/P	F213-1CA	$20-25	$60-85
Paramount Mellow	S-103	BEN		1933	16	70's	S/P		$1-2	$4-6
Paris	Sur-Gen	GOR		1996	20	FKR	S/P	TP-2442-PA	$3-5	$8-12
Park Drive	Sur-Gen	PMC		1992	20	FKRL	FTB	Trademark, CCSS-1	$3-5	$8-12
Park Drive	Sur-Gen	PMC		1994	20	FKRFL	FTB	Trademark, CCSS-2	$3-5	$8-12
Park Drive	Sur-Gen	PMC		1995	20	FKRL	S/P	Trademark, CCSS-3	$3-5	$8-12
Park Drive	Sur-Gen	PMC		1996	20	FKRL	S/P	Trademark, CCSS-4	$6-8	$25-35
Parkway	No Stamp	LAM		1962	20	70's	S/P	Trademark	$6-8	$25-35
Parliament	S-102	BEH		1930	50	FKR	F/T	Blue on white	$15-20	$55-65
Parliament	S-102	BEH		1931	20	70's	S/P	Blue on white	$10-15	$40-55
Parliament	S-123	BEH		1953	20	FKR	S/P	Blue V on white	$6-8	$25-35
Parliament	No Stamp	PMC	BEH	1958	20	FKR	SSB	Blue V on white	$2-4	$7-9
Parlor Match	Warning	PMC	BEH	1978	20	All Kinds	S/B	C98	$50-65	$150-190
Parnassus	S-1898	RSW		1898	10	70's	SSB	C98	$35-50	$90-135
Parnell	Warning	KAR		1972	20	FKR	S/P	Trademark	$6-8	$25-35
Parrot	S-102	LOR	REE	1932	20	FKR	S/P	Picture of Parrot	$15-20	$55-65
Passport	No Stamp	ATC		1965	20	FKR	S/P	Trademark	$6-8	$25-35
Passport International	Sur-Gen	GOR		1991	20	All Kinds	S/P	Multi. colors	$2-4	$4-6
Past & Present	Warning	PMC		1976	10	FKR	F/B	Also Queen size	$6-8	$25-35
Pastelle	S-1898	SHE		1954	20	70's	?	C98	$10-15	$40-55
Patent Process	S-1898	FEN		1898	?	70's	S/P	F2032-1PA	$35-50	$90-135
Patrician Rounds	S-123	STP		1953	20	70's	S/P	C87	$10-15	$40-55
Patriot	S-1898	KSR		1898	20	70's	CSB	F21-VA	$35-50	$90-135
Patti	S-1879	GUN		1887	20	70's	S/P	Also F100R	$50-65	$150-190
Paul Jones	No Series	CNT		1927	20	FKR	S/P	F407-2NY	$2-4	$7-9
Paul Revere Extra	S-1887	HOE		1973	10	FKR	F/B	White on green	$20-25	$60-85
Paul Stich	Warning	GAG	YNC	1951	20	FKM	P/P	F25-VA	$10-15	$40-55
Paxton	S-151	PIN		1963	20	70's	S/P	Trademark	$20-25	$60-85
Pay Car	No Stamp	PIN		1917	20	70's	SSB	F85/MI, also F/B	$20-25	$60-85
Paycar	S-1917	LAM		1925	10	70's	S/P	Trademark	$10-15	$40-55
Peace	No Series	SWA		1944	20	FKR	S/P	C98	$10-15	$40-55
Peachy	S-114	LAM		1920	20	70's	SSB	C98, F2-NY	$10-15	$40-55
Peak	No Series	SND	PDS	1967	20	FKR	S/P	F42-NC	$6-8	$25-35
Pearl Caroline	Caution	ATC		1887	20	FKR	S/P	Trademark	$50-65	$150-190
Pebble	S-1887	KLS		1887	20	FKR	S/P	Trademark	$35-50	$90-135
Pedro	S-1879	MIL		1881	10	70's	SSB	Bl. letters on yellow	$6-8	$25-35
Peerless	Caution	DUK		1967	20	70's	S/P	F36-KY	$20-25	$60-85
Pelham	Caution	ATC		1939	20	70's	S/P	Trademark	$10-15	$40-55
Penbarry	No Stamp	LAM		1927	20	70's	S/P	F25-VA	$20-25	$60-85
Penguin	S-102	PNT		1929	10	70's	S/P	C98	$6-8	$25-35
Pennant	No Stamp	BAW		1965	20	FKR	S/P	Trademark	$20-25	$60-85
Pensa-Cola	S-1917	RJR		1944	10	FKR	P/P	TP-42-NC	$10-15	$40-58
Peoples	No Series	SWA		1983	20	70's	S/P	F25-VA, also 10's	$10-15	$40-55
Pepsinettes	Warning	LAM		1889	?	70's	SSB	F25-VA	$2-4	$7-9
Perc	S-1898	MNB		1966	20	FKR	S/P	F-363-3NY	$35-50	$90-135
Perfect Blend	Caution	PMC		1994	10	FKR	S/P	F407-2NY	$6-8	$25-35
Perfection	Sur-Gen	LAM	SRC	1912	10	FKR	S/P	F25-VA	$1-2	$7-9
Perfection	S-1910	LAM		1938	20	70's	SSB	F25-2VA, straight cut	$30-45	$75-115
Persian	S-1898	LAM		1886	20	70's	S/P	Gold and black	$60-85	$180-225
Personal Blend	S-125	MON		1955	10	70's	S/P	Founded New York	$10-15	$40-55
Pet	S-1898	TIN		1898	20	70's	S/P	Trademark	$50-65	$150-190
Pet Ponies	S-1887	ATD	ALG	1891	20	70's	SSN	TP-42-NC	$50-65	$150-190
Peter Jackson	Warning	ATD	ALG	1984	20	FKR	SSN	F750-5NJ	$2-4	$7-9
Peter Stuyvesant	S-119	BAW		1957	20	FKR	FTB	F407-2NY	$15-20	$55-65
Peterson's	Sur-Gen	RIG	SRC	1953	20	FKR	S/B	Yellow on red	$10-15	$40-55
Peterson's Vintage	S-125	PET		1937	20	FKR	S/P	Trademark	$15-20	$55-65
Petit Amour	S-119	GAG		1939	20	70's	S/P	Purple, white/red bx.	$6-8	$25-35
Petroff	S-125	GAG	BAB	1953	20	70's	F/B		$20-25	$60-85
Peyton	S-107	ADT		1937	10	70's	F/B		$30-45	$75-115
Phantom	S-115	GAG		1945	20	RFR	FTB			
Philip Morris	Sur-Gen	PMC		1966	20	FKR	FTB			
English Blend	No Stamp	LEE	LEI	1940	20	70's	CSB	F21-VA		

198

Left table

Brand Name	Series	Mfg	Ven	YMf	#	Type	Pack	Description/Remarks	Empty	Full
Philip Morris English Blend	S-103	PMC		1933	50	70's	R/T	F7-VA, special		$180-225
Philip Morris Special Blend	S-118	PMC		1948	20	70's	S/P	Brn. red & white pk.	$10-15	$40-55
Special Blend	S-150	PMC		1950	50	70's	R/T	F7-VA	$50-65	$180-225
Philip Morris Special Blend	No Series	PMC		1923	20	70's	P/T/F/T	Many different, pks	$60-145	$225-375
Philip Morris	S-125	PMC		1955	20	70's	S/P	F24-KY	$10-15	$55-65
Philip Morris	No Stamp	PMC		1958	20	70's	S/P	W/london w. 60	$6-8	$35-45
Philip Morris Banquet	S-1910	PMC		1910	10	R135mm CSB		Red/white no stripes	$50-65	$150-190
Commander	No Stamp	PMC		1963	20	FKR	S/P	Red and white	$6-8	$35-55
Philip Morris	Caution	PMC		1967	20	FKR	P/P	Red w/brown plastic	$10-15	$40-55
Philip Morris International	Warning	PMC		1973	20	All Kinds	S/P	Multi. colors	$2-4	$7-9
Philip Morris Call	No Stamp	PMC		1963	20	70's	S/P	Trademark	$6-8	$25-35
Phillip's Own	S-118	PMC		1948	20	FKR	S/P	F10-KY	$10-15	$40-55
Phoenix	Warning	BAW		1975	20	FKR	S/P	Also FKR,FKM	$2-4	$7-9
Phoenix	Warning	BAW		1975	20	F120's	S/P	Also FKR,FKM	$6-8	$25-35
Picas	Warning	PMC		1977	20	FKR	S/P	Trademark	$6-8	$25-35
Picayune	S-1910	LAM		1911	20	70's	S/P	Name/logo, both sides	$30-45	$75-115
Picayune	No Stamp	LAM		1920	20	70's	S/P	F137-5NJ, gold on red	$30-45	$40-55
Piccadilly	S-121	SAC	PIC	1958	20	70's	F/B	F137-5NJ, gold on red	$25-45	$75-115
Piccadilly	S-124	RIG	PIC	1954	20	70's	SSB	F94-NY	$25-45	$55-75
Picobac	S-120	BAW		1950	10	70's	S/P	FC36-KY	$15-20	$55-65
Piedmont	S-1898	ATD		1893	10	70's	SSB	Blue on white	$60-85	$180-225
Piedmont	S-1910	LAM		1911	10	70's	SSB	Blue on white	$30-45	$75-135
Piedmont	S-102	LAM		1941	50	70's	F/T-ER/T	Blue on white	$75-155	$250-375
Piedmont	No Stamp	LAM		1929	20	70's	SSB	F25-VA	$20-25	$60-85
Pielroja	S-103	?	MTC	1958	20	FKR	S/P	Logo both sides	$6-8	$25-35
Pilot	Sur-Gen	RJR	FOR	1996	20	FKR	S/P	Multi. colors	$1-2	$3-5
Pimlico	No Stamp	ATC		1964	10	FKR	S/P	Trademark	$6-8	$25-35
Pin Head	S-1883	DUK		1884	10	70's	R/T	F42-NC,	$85-165	$250-375
Pinch	No Stamp	ATC		1965	20	FKR	S/P	Trademark	$30-45	$75-115
Pinehurst	S-111	AFT	SWA	1930	20	FKR	F/B	F24-KY	$15-20	$55-65
Pinhead	S-1879	DUK		1882	50	70's	SSB	One of Duke's first	$95-175	$275-375
Pinnacle 3X	Warning	ATC		1970	20	FKR	S/P	Light gray on white	$3-5	$8-12
Plain No. 15	S-105	BEH		1935	10	FKR	CSB	F5-2NY	$20-25	$60-85
Planet	Sur-Gen	RJR		1996	20	FKR	FTB	TP-1-NC, also FKRL	$1-2	$3-5
Platinum	Warning	BAW	CHP	1980	20	FKR	FTB	Multi. colors	$6-8	$25-35
Plato	S-108	PIE		1938	50	FKR	R/T	F25-VA	$85-165	$250-375
Players	S-1917	PMC		1920	20	FKR	F/B	Multi. colors	$30-45	$75-115
Players	No Series	ATC		1926	20	FKR	CSB	Multi. colors	$25-35	$70-95
Players Navy Cut	S-108	PMC		1938	20	70's	SSB	Multi. colors	$15-20	$55-65
Players Navy Cut Medium	S-138	PMC		1938	50	70's	F/T	Dark blue, logo left	$95-165	$250-325
Medium	Warning	PMC		1975	20	FKR	FTB	Picture upper left	$6-8	$25-35
Players Select	Warning	PMC		1983	20	FKR	FTB	Gold on black	$2-4	$7-9
Plus	Warning	ATC		1934	20	FKR	FTB	Trademark	$6-8	$25-35
Plus Four	Sur-Gen	RJR	MTC	1995	10	FKR	SSB	Picture of golfer	$6-8	$25-35
Plymouth	S-104	AFT	NTH	1936	20	FKR	S/P	Light gray on white	$15-20	$55-65
PM Blues	S-121	GOR	YNC	1951	20	FKM	S/P	Picture of ship	$6-8	$25-35
PM Blues	Warning	PMC		1987	20	FKM	S/P	Trademark	$1-2	$4-6
PM Browns	Sur-Gen	BAW		1975	20	FKR	S/P	Also F100's 2 types	$6-8	$25-35
Pocahontas	Warning	ATC		1971	20	FKR	R/T	C86	$60-85	$180-225
POT	S-1883	HES		1883	?	70's	S/P	Trademark	$6-8	$25-35
Point	Caution	PMC		1976	20	FKR	S/P	Trademark	$6-8	$25-35
Pointer	Caution	RJR		1967	20	FKR	S/P	Trademark	$6-8	$25-35
Polar	S-104	LOR		1934	20	FKR	S/P	Green, blue top	$15-20	$55-65
Politix	Sur-Gen	RJR		1995	10	FKR	F/B	TP-1-NC	$2-4	$4-6
Polo	S-108	AFT		1936	20	FKR	R/T	F24-KY	$50-65	$150-190
Pom Pon	Warning	BAW		1975	20	70's	S/P	White	$15-20	$55-65
Ponies	Sur-Gen	PMC		1983	20	All Kinds	S/B	Gold on black,	$2-4	$7-9
Porpbkrs	Sur-Gen	PMC		1992	20	FKRFF	S/B	CCSS-1-2-3-4	$6-8	$25-35
Port Royal	Warning	ATC		1971	20	All Kinds	S/P	Picture of Queen	$1-2	$3-5
Portsmouth	Warning	PMC		1963	10	FKR	S/P	TP-2-PA	$2-4	$7-9
Preferred Stock	S-1901	ATD		1905	20	70's	F/B	Man on elephant	$20-25	$60-85
Premier	S-1887	ATD	DUK	1890	50	70's R/T-F/T		F36-KY, F35-VA,	$75-100	$175-225
Premier	Sur-Gen	RJR		1987	20	70's	S/P	Billfold pack	$20-25	$60-85
Premium	Warning	SHE		1976	20	F100R	FTB	TP-26-NJ	$2-4	$7-9

Right table

Brand Name	Series	Mfg	Ven	YMf	#	Type	Pack	Description/Remarks	Empty	Full
Premium Buy	Sur-Gen	PMC	MCP	1992	20	All Kinds	S/P	Multi. colors	$1-2	$4-6
President	S-122	TBC		1952	20	70's	S/P	Mt. Rushmore	$15-20	$55-65
Presidential	S-115	ACM		1945	20	70's	S/P	Wartime paper	$10-15	$40-55
Presidential Seal, Etc.	Caution	LAM		1960	20	F100R	S/B	Sleeves for all makes	$20-25	$60-85
Preston	Caution	RJR		1964	20	FKR	S/P	Trademark	$6-8	$25-35
Price Breaker	Warning	LAM	EWD	1982	20	70's	S/P	Red on white	$2-4	$7-9
Price Saver	Sur-Gen	LAM	SRC	1985	20	All Kinds	S/P	Multi. colors	$2-4	$7-9
Pricemaster	Sur-Gen	LAM	SRC	1985	20	All Kinds	S/P	TP-1-NC	$1-2	$4-6
Pride of Washington	S-1898	KLR		1898	?	70's		C98	$35-50	$90-135
Prime	S-1898	ATC		1992	20	All Kinds	S/B	Several variety's	$1-2	$4-6
Prince Albert	Caution	HEL		1900	?	70's	?	Excelled by none	$35-50	$90-135
Prince Albert	S-102	RJR		1965	20	FKR	S/P	Test Market	$3-5	$8-12
Prince Condossis	S-102	CON	COS	1931	20	70's	CSB	Orange on gray	$20-25	$60-85
Prince Consort	S-123	RIG		1953	20	RKR	S/P	F94-NY	$10-15	$40-55
Prince Hamlet	S-1909	TRC		1910	10	70's	CSB	Red padded top	$35-50	$90-135
Princess	S-102	BAB		1930	20	70's	S/B	F551-3NY,F407-2NY	$15-20	$55-65
Princess Lillian	S-1887	MON		1894	10	70's	F/B	F363-2NY	$50-65	$150-190
Princess Pat	No Series	FCT		1927	100	70's	F/T	?	$95-155	$250-325
Princeton	S-125	GAG		1955	10	70's	S/P	Black on orange	$6-8	$25-35
Princeton	Caution	PMC		1969	20	70's	S/P	Trademark	$20-25	$60-85
Princeton Club	S-125	GAG		1955	20	70's	S/P	F407-2NY	$20-25	$60-85
Private Black	S-123	BEH		1953	10	70's	S/P	F5-2NY	$10-15	$40-55
Private Blend	S-119	BEH		1949	20	70's	S/B	Blk letters on white	$10-15	$40-55
Private Stock	S-125	STS		1955	20	70's	S/P	Multi. colors	$10-15	$40-55
Private Stock	Sur-Gen	STS		1992	10	All Kinds	S/B	Gold tip, leatherette	$60-85	$180-225
Prize Cup Mini.	S-1909			1909	20	FKR	S/B	Trademark	$6-8	$25-35
Pro	Warning	LAM		1976	20	FKR	FTB	Trademark	$6-8	$25-35
Profile	Caution	PMC		1968	20	FKR	F/B	Black letters on white	$3-5	$8-12
Project 7	Caution	LAM		1967	20	FKR	F/B	Two tone green	$2-4	$7-9
Proof	Warning	BAW		1976	20	FKR	S/P	Trademark	$6-8	$25-35
Prudence	Warning	RJR		1976	20	FKR	S/P	(P) pipe (T) tobacco	$6-8	$25-35
P.T.	Caution	USJ	MPT	1976	20	FKR	S/P	Trademark	$6-8	$25-35
Pup	Sur-Gen	RJR		1988	20	70's	S/P	C98	$35-50	$90-135
Puck And Judge	S-106	HOZ		1898	?	70's	S/P	Gold on red	$20-25	$60-85
Puff Slenderline	S-106	BAU		1934	20	70's	F/B	Brown on brown	$20-25	$60-85
Puffies	No Series	ALC		1928	20	FKR	SSB	C86, F42-NC	$60-85	$180-225
Pug	S-118	BEH	AME	1948	10	FKR	S/B	Picture of ladey	$20-25	$55-65
Pump Room	S-115	ALC		1945	20	FKR	F/B	Wood grain	$20-25	$60-85
Puppies	Sur-Gen	TAI		1995	20	FKR	S/P	2 Variety' s	$1-2	$4-6
Pure	S-1898	ATD	KIN	1898	10	FKR	S/P	C98, F30-NY	$35-50	$90-135
Pure Perique	S-123	SSP		1953	20	RKR	F/B	White on red	$10-15	$40-55
Pure Virginia	No Stamp	GIA		1964	20	FKR	F/B	Gold Plastic	$10-15	$40-55
Puritan	S-1883	SMB		1906	20	70's	SSB	C86, C89	$50-65	$150-190
Purity	S-102	PAC		1883	20	70's	SSB	Dark gray	$20-25	$60-85
Pyramid	S-102	DRQ		1930	12	70's	S/P	Multi. colors	$1-2	$3-5
Pyrgos No. 1	S-1910	LAM		1910	10	All Kinds	CSB	Also 12 ct., red/gold	$35-50	$90-135
QC	Sur-Gen	LAM		1988	20	All Kinds	S/P	Multi. colors on white	$1-2	$3-5
Quaker	S-1898	PCH		1898	20	70's	R/T	C98	$35-50	$90-135
Qualite Fine	S-102	BEH		1932	20	FKR	S/P	F5-2NY	$75-145	$225-325
Quality	Warning	LAM	GAR	1981	20	FKR	F/B	Multi. colors	$1-2	$3-5
Queen Bell	Sur-Gen	LAM	LAM	1988	20	All Kinds	S/P	Multi. colors	$15-20	$55-65
Queen Bess	S-121	?		1951	20	70's	S/P	Picture of lady	$10-15	$40-55
Queen City Club	S-118	BAW		1948	20	FKR	F/B	Picture of Queen	$10-15	$40-55
Queen Victoria	No Series	GAG		1925	10	FKR	W/B	F407-2NY	$25-35	$70-95
Queens Gold	No Stamp	GIA		1906	20	FKR	S/P	Wood box	$50-64	$90-135
Quest	Caution	LAM		1969	20	FKR	SSB	F2100-2NY	$6-8	$25-35
Quickies	Warning	RJR		1975	20	FKR	S/P	Trademark	$6-8	$25-35
R 1	S-102	LAB		1966	20	FKR	F/B	Trademark	$3-5	$8-12
Racquet & Tennis	S-125	GAG		1955	10	70's	S/P	Brown on orange	$20-25	$60-85
Racquet Club	S-102	GAG		1930	20	70's	S/P	F407-2NY	$85-175	$250-375
Radio	S-103	?		1933	20	70's	S/P	F407-2NY	$15-20	$55-65
Raffles	Warning	PMC		1983	20	FKR	S/P	F1532-1PA	$2-4	$7-9
Raffles	Sur-Gen	PMC		1992	20	All Kinds	S/B	Gold on black,	$6-8	$25-35
Rainbow	Sur-Gen	PMC		1987	10	FKRFF	S/B	CCSS-1-2-3-4	$1-2	$3-5
Rainbows	Warning	PMC	LIG	1973	20	All Kinds	S/P	Multi. colors	$6-8	$25-35
Rajah	S-1901	SHE		1905	10	70's	F/B	Man on elephant	$35-50	$90-135
Raleigh	S-102	ATD		1928	50	70's R/T-F/T		F36-KY, F35-VA,	$75-150	$225-350
Raleigh	No Series	BAW		1928	20	70's	S/P	Billfold pack	$20-25	$60-85
Raleigh	S-102	BAW		1930	20	70's	S/P	F36-KY, "Ivory tip"	$20-25	$60-85

Left table

Brand Name	Series	Mfg	Ven	YMf	#	Type	Pack	Description/Remarks	Empty	Full
Raleigh Tipped 903	S-114	BAW		1944	20	70's	S/P	War bond ad on pk.	$25-35	$70-95
Raleigh 903	S-118	BAW		1948	20	70's	S/P	903 in shield, tipped	$20-25	$60-85
Raleigh Tipped	S-123	BAW		1953	20	RKR	S/P	F36-KY, F35-VA	$10-15	$40-55
Raleigh	No Stamp	BAW		1957	20	FKR	S/P	Picture of Raleigh	$6-8	$25-35
Raleigh	Caution	BAW		1967	20	RKR-FKR	S/P	Red/gold stripes	$3-5	$8-12
Raleigh	Warning	BAW		1975	20	All Kinds	S/P	Multi. colors	$2-4	$7-9
Raleigh	Sur-Gen	BAW		1990	20	All Kinds	S/B	Multi. colors	$1-2	$3-5
Rameses Aristocat	S-1887	STP		1895	20	70's	S/B		$6-50	$25-190
Rameses	S-112	STP		1942	20	70's	S/P	F2032-1PA	$15-20	$55-65
Rameses II	S-1887	STP		1895	10	70's	CSB	Also 20 count	$6-50	$25-190
Rameses II	S-102	STP		1930	50	70's	F/T	Also 100ct & R/T	$65-145	$225-325
Ramleh	S-1901	EGY		1902	10	70's	F/B	Also 20ct.	$35-50	$90-135
Ramly	S-1901	MTR		1901	20	70's	F/B	F456-3MA	$15-20	$55-65
Ramona	S-106	AFT		1936	20	70's	S/P	F24-KY	$6-8	$25-35
Ramrod	No Series	SND		1921	20	FKR	S/P	Picture of cig.	$1-2	$3-5
Ran	Caution	LOR		1970	20	FKR	S/P	Trademark	$6-8	$25-35
Raven	Sur-gen	CBI	SKI	1995	20	FKR	FTB	White letters on black	$3-5	$7-9
Ray	Warning	PMC		1967	10	FKR	S/B	Trademark	$2-4	$7-9
Rays	No Series	BEH		1928	10	70's	S/P	Gold letters on blue	$20-25	$60-85
Real	Warning	RJR		1977	20	FKR-FKMS	S/P	Red on white	$3-5	$8-12
Reason	Warning	RJR		1975	20	FKR	S/P	Trademark	$2-4	$7-9
Rebel	Warning	LOR		1971	20	FKR	S/P	Also F100R	$6-8	$25-35
Rebels	S-107	AFT	SKI	1937	20	FKR	FTB	White, battle scene	$10-15	$40-55
Recon	Caution	ATC		1970	20	FKR	S/P	Trademark	$6-8	$25-35
Recruit, The	S-1889	ELC	ELC	1888	10	70's	SSB	Flat hat on soldier	$60-85	$180-225
Recruit, The	S-1889	ATD	ELC	1894	10	70's	SSB	High hat on soldier	$50-65	$150-190
Red Circle	S-125	LAB		1955	20	70's	S/P	F460-VA, red on white	$10-15	$40-55
Red Crown	S-110	TBC	DRC	1940	20	70's	S/P	F10-KY, "war paper"	$15-20	$55-65
Red Express Lts.	Sur-Gen	PMC		1994	20	FKR	S/B	CCVS-1-2-3-4	$6-8	$25-35
Red Kamel	S-1901	IMT		1908	10	RKR	SSB	F1839-3NY,	$35-50	$90-135
Red Kamel	S-1901	TRU		1913	10	70's	CSB	F1-5NC,F1-NC, F97-NC	$30-45	$75-115
Red Line	Caution	ATC		1970	20	FKR	S/P	Trademark	$20-25	$60-85
Red Sun	S-1898	PTB		1900	10	70's	F/B	F4-LA	$35-50	$90-135
Red Sun	Warning	LAM		1973	20	FKR	S/P	Red sun on blk/orange	$2-4	$7-9
Red Sun	Warning	ATC		1976	20	FKR	S/P	Trademark	$6-8	$25-35
Redford	No Series	LOR		1970	20	FKR	S/P	Test market	$6-8	$25-35
Redsdale	S-108	LAB		1938	20	FKR	S/P	F460-VA	$20-25	$60-85
Reefers	Warning	GAG	SMH	1968	20	FKR	SSB	1 of 10 spoof pack	$6-8	$25-35
Regal	Warning	ATC		1974	20	FKR	S/P	Trademark	$6-8	$25-35
Regard	Warning	LAM		1972	10	FKR	S/P	Trademark	$6-8	$25-35
Regatta	Warning	LAM		1890	20	70's	SSB	F25-1MO	$50-65	$150-190
Regent	Warning	RJR		1967	20	FKR	S/P	Trademark	$6-8	$25-35
Regent	S-107	RIG		1937	20	FKR	F/B	Dark red on gray	$15-20	$55-65
Relu	S-125	RIG		1955	20	RKR	FTB	C94-NY, also F/T	$30-45	$75-115
Rembrandt	S-1910	REE		1912	20	70's	S/P	Red on white	$6-8	$25-35
Remuda	No Stamp	RIG		1957	20	FKR	CSB	F94-NY	$15-20	$55-65
Reno	Warning	ATC		1971	20	FKR	S/P	Trademark	$6-8	$25-35
Requa's Cubeb	Sur-Gen	SAR		1994	20	FKR	S/B	Red on white	$2-4	$7-9
Reserve	S-1887	REQ		1891	12	70's	S/P	?	$50-65	$150-190
Respond	Warning	RJR		1976	20	FKR	S/P	Trademark	$6-8	$25-35
Revelation	Warning	LAM		1975	20	FKR	S/P	Trademark	$6-8	$25-35
Reward	No Series	CNT		1923	20	All Kinds	S/P	Mild and mellow	$20-25	$60-85
Rex	S-1910	ATC		1968	20	All Kinds	S/P	Two torches 1 left 1 right	$6-8	$25-35
Rexland	Warning	LAM		1983	20	FKR	SSB	Trademark	$6-8	$25-35
Reymers	Warning	BAW		1971	20	FKR	S/P	F404-2NY	$15-20	$55-65
Reyno	S-1910	SSS	REY	1913	10	70's	S/B	F1-5NC, blue on white	$35-50	$90-135
Reynolds	S-103	RJR		1933	20	RKR	SSB	White on green	$6-8	$25-35
Rialto Vanities	No Stamp	RJR		1957	20	FKM	S/P	Trademark	$15-20	$55-65
Ricardo	Sur-Gen	BAB		1973	20	FKR	F/B	Gold on white	$2-4	$7-9
Rich	Warning	BAW		1975	20	FKR	S/P	White on blue	$6-8	$25-35
Richfield	Warning	LOR		1977	20	All Kinds	S/P	Multi colors on white	$2-4	$7-9
Richland	Sur-Gen	BAW		1983	20	All Kinds	S/P	Trademark	$2-4	$7-9
Richmond	Warning	ATC		1971	20	FKR	S/P	Also 25ct. & F100R	$6-8	$25-35
Richmond Club	S-1879	CAM		1883	10	70's	SSB	Trademark	$75-165	$225-375
Richmond High Class	S-1898	RTC		1898	20	70's	S/P	?	$50-65	$150-190
Richmond Preferred	S-108	PMC		1913	20	FKR	F/B	Green on green	$10-15	$40-55
Richmond Straight Cut	Warning	LAM		1973	20	FKR	FTB	Trademark	$6-8	$25-35
No 1	S-1910	LAM	ALG	1911	50	70's	R/T-F/T	F25-2VA	$75-150	$225-300

Right table

Brand Name	Series	Mfg	Ven	YMf	#	Type	Pack	Description/Remarks	Empty	Full
Richmond Straight Cut	S-108	LAM	ALG	1930	20	70's	F/B	Green on beige	$20-25	$60-85
No 1	No Stamp	ATC		1964	20	FKR	S/P	Trademark	$6-8	$25-35
Ridgefield	Warning	ATC		1975	20	FKR	S/P	Trademark, also R120R	$6-8	$25-35
Right	S-114	AUO		1945	20	FKR	S/P		$10-15	$40-55
Rinek Rope	Caution	RJR		1967	20	FKR	S/P	Trademark	$6-8	$25-35
Ring	S-1883	SWP		1886	?	70's	?	C98	$35-50	$90-135
Rink	S-1883	ROS		1883	20	70's	SSB		$50-65	$150-190
Rio Grande	S-106	AFT		1936	20	70's	S/P	F24-KY	$15-20	$55-65
Rio Rita	S-110	LIR		1940	100	70's	W/B	F55-6CA, wooden box	$75-175	$325-425
Ritz	S-110	BAW	RTX	1940	20	70's	S/P	F35-VA, red and white	$15-20	$40-55
Ritz	Sur-Gen			1993	10	F100R	FTB	2 variety's	$2-4	$4-6
Ritz Luxury Box	S-105	PUE		1935	20	70's	S/P	Wood grain, war paper	$15-20	$55-65
Rivalo	No Stamp	ATC		1959	20	70's	S/P	Blue gold on white	$6-8	$25-35
Riviera	Sur-Gen		CNT	1991	20	FKM	S/P	Green on white	$1-2	$4-6
Riviera	S-1917	MLK		1919	20	All Kinds	S/B		$25-35	$70-95
Rivoli	Caution	RJR		1964	20	FKR	S/P	Trademark	$6-8	$25-35
RJR	S-1898	IRB		1898	?	70's	?	C98	$35-50	$90-135
Roadster	No Stamp	PMC		1961	20	70's	S/P	White diamond on red	$6-8	$25-35
Roanoke	No Stamp	PMC		1961	20	FKR	FTB	Trademark,	$6-8	$25-35
Roanoke	Sur-Gen	PMC		1959	20	FKR	S/P	F21-VA	$6-8	$25-35
Rob Roy	Warning	ATC		1971	20	RKR	S/P	Trademark, also 120's	$10-15	$40-55
Rocket 10	S-115	SWA		1945	20	70's	S/P	F50-VA	$20-25	$60-85
Roger	No Series	DEL		1928	20	70's	F/B	Picture of couple	$60-85	$180-225
Romance	S-1887	ROS		1887	10	70's	S/P	Pink circle on white	$20-25	$60-85
Rose	No Series	SOT		1924	20	70's	S/P	F74-3NY	$30-45	$75-115
Rose	S-1910	MDY		1914	20	70's	F/B	Picture of lady sitting	$20-25	$60-85
Rose Of Egypt	No Series	ATC		1925	20	70's	F/B	F174-3NY	$50-65	$150-190
Rose Of Egypt	S-1883	SCS		1896	10	70's	SSB	F174-1NY	$35-50	$75-115
Rose Of Egypt Egyptian	S-1883	SCS		1896	10	70's	SSB		$50-65	$150-190
Rose Tip Specials, Themelis	S-1910	THB		1914	20	70's	CSB	Picture of a rose	$35-50	$75-115
Rosedor	No Series	RSD		1924	20	70's	S/P	F916-1NY	$20-25	$60-85
Rothschilds Tx.	Warning	GAG	SWA	1980	20	FKR	S/P	TP-75-NY	$2-4	$7-9
Rough & Ready	S-108	AFT		1937	20	70's	S/P	F24-KY	$35-50	$90-135
Roulette	No Series	USJ		1922	20	70's	S/P		$6-8	$25-35
Roulette Ovals	No Series	BEN		1926	10	100?mm	R/B	Rect. box	$25-35	$70-95
Rounds	No Series	ATC		1926	?	70's	CSB	F213-1CA	$20-25	$60-85
Roundup	Warning	ATC		1971	20	FKR	S/P	F24-KY, red and white	$15-20	$55-65
Roy	S-107	AFT		1937	20	70's	S/P	F7-VA, red and white	$10-15	$40-55
Roy	S-115	PMC		1945	20	70's	S/P	F139-3NY	$15-20	$55-65
Royal	Warning	RYT		1935	20	70's	FTB		$15-20	$55-65
Royal Ascot	S-105	ASC		1901	10	70's	CSB		$35-50	$90-135
Royal Nestor	S-1901	SCS		1904	20	70's	S/P	F2153-2NY,	$35-50	$75-115
Royal Puck	S-1909	GIA		1915	20	70's	CSB	F485-3NY,F2109-3NY	$50-65	$150-190
Royal Sweets	S-1868	BED		1868	?	70's	?	An early one	$95-225	$325-500
Royale	S-1883	NAT		1883	20	70's	S/P	F404-2NY	$60-85	$180-225
Royalty	S-110	SSS	SWA	1940	20	70's	S/P	F916-1NY	$15-20	$55-65
Royce	No Series	RSD		1924	?	70's	S/P	F24-KY	$20-25	$60-85
Roycroft	Warning	BAW		1982	20	FKR	S/P	Silver on white	$6-8	$25-35
R S	S-106	AFT		1936	20	70's	S/P	Pink and black	$15-20	$40-55
Ruby Queens	S-125	BAW		1955	10	70's	S/P	Blends 97 or 53	$10-15	$40-55
Rum And Maple	No Series	BAW		1926	20	70's	SSB	Blend 53 "Original"	$20-25	$60-85
Rum And Maple	S-107	TBC	RUM	1937	20	70's	S/P	Red and white	$15-20	$55-65
Russian	S-125	LAB	RUM	1953	20	70's	S/P	F22-2NY	$10-15	$40-55
Russian Blend	S-115	LAB	RUM	1960	20	FKR	S/P	F916-1NY	$15-20	$55-65
Russian Crown	S-102	BEH		1932	20	70's	F/B	F916-1NY	$15-20	$55-65
Russian Embassy	S-104	RSD		1909	?	70's	S/P	F551-3NY	$35-50	$90-135
Russian No. 3	S-103	BAB		1934	10	R120mm	CSB	F5-2NY, several no's	$20-25	$60-85
Russian No. 5	S-110	BEH		1932	10	R95mm	CSB	F5-2NY, green	$15-20	$55-65
S Signals	Sur-Gen	BEH		1940	10	R120mm	CSB	Black on white	$10-15	$40-55
S. C.	S-125	GOR	FNA	1993	12	70's	SSB	Slide box	$20-25	$60-85
S.S. Pierce Virginia	S-1910	ATC		1912	20	70's	SSB	F404-2NY	$20-25	$60-85
S.S. Pierce English	S-109	SSS	PIE	1939	20	70's	F/B	Orange on white	$45-65	$90-135
S. S. Pierce's	S-101	PIE		1931	50	70's	R/T	Trademark	$10-15	$40-55
Sable	S-120	LAB	PIE	1950	20	70's	S/P	Trademark	$15-20	$55-65
Sabrina	Warning	BAW		1981	20	FKR	S/P	Trademark	$6-8	$25-35
Sachett No.2	No Series	LAM		1968	20	70's	S/P	Virginia blend	$20-25	$60-85
Safari	No Stamp	ATC		1957	20	F100R	S/P	Lion on front	$6-8	$25-35

Left table:

Brand Name	Series	Mfg	Ven	YMf	#	Type	Pack	Description/Remarks	Empty	Full
Safir	No Stamp	LAB		1963	20	FKR	S/P	C460-VA	$6-8	$25-35
Sahara	S-1887	CHA		1893	100	70's	C/T	Also R/t	$75-100	$200-275
Sahara	Caution	LOR		1969	20	FKR	S/P	Trademark	$25-35	$225-375
St. James	S-1879	KIN		1873	20	70's		C87, F593-MD	$95-175	$60-375
St. James Court	Warning	BAW		1984	20	All Kinds	S/B	Multi-colors on bronze	$2-4	$7-9
Salaambo Dutchess	S-1917	ROB		1918	10	55mm	P/B	Red padded box	$60-85	$180-225
Salem	No Stamp	RJR		1956	20	FKM	S/P	Green on white	$6-8	$25-35
Salem Premium Length	No Stamp	RJR		1963	20	FKMPL	S/P	Also 100's, grn on white	$3-5	$8-12
Salem Lights	Warning	RJR		1970	20	FKMPL	S/P	Also 100's, no pine trees	$2-4	$7-9
Salem	Warning	RJR		1984	20	FKM	FTB	Green on green	$2-4	$7-9
Salome Ideal	Sur-Gen	RSD		1985	20	All Kinds	S/B	Multi: shades of green	$1-2	$3-6
Salome Ideal	S-107	PEN		1924	10	70's	CSB	F22-5PA, F27-12PA	$25-35	$70-95
Samaris	S-1901	KHE		1903	10	70's	S/P	F22-12PA, gold and red	$25-35	$55-65
Sample	S-108	LAB		1938	10	70's	?	F279-5NY	$35-50	$90-135
San Bernardo	S-1898	FCH		1898	?	70's	?	F460-VA, light green	$15-20	$55-65
Sancho	No Stamp	WLK		1887	20	FKR	F/B	Wooden box	$75-100	$200-250
Sandhurst	S-1887	ATC		1964	20	FKR	S/P	Trademark	$6-8	$25-35
Sandy	S-107	AFT	RAS	1937	20	70's	S/P	Orange, white picture	$15-20	$55-65
Sane	Caution	ATC		1968	20	FKR	S/P	Trademark	$6-8	$25-35
Sano	No Series	SSS	HEA	1924	20	70's	S/P	F404-2NY	$20-25	$60-85
Sano	S-114	FLH		1944	20	70's	S/P	F1-1NY, Original	$10-15	$55-65
Sano	S-123	FLH		1953	20	70's	S/P	F1-1NY, Less nicotine	$10-15	$40-55
Sano	S-125	USJ		1955	20	FKR	S/P	F1-1NY	$10-15	$25-35
Sans Souci	S1898	MIL		1898	?	70's	S/P	C98, F2-NY	$35-50	$90-135
Saratoga	No Stamp	PMC		1960	20	FKR	FTB	Trademark	$6-8	$25-35
Saratoga	Warning	BAW		1962	20	FKR	P/B	Rd/white, plastic pack	$2-4	$7-9
Saratoga	Sur-Gen	BAW		1976	20	F120R	FTB	Also F120M	$1-2	$3-6
Sarna's U.S.A.	Sur-Gen	GOR	SRS	1996	20	F100R	S/P	TP2442-PA, star in box	$2-4	$7-9
Satin	Warning	LOR		1982	20	F100R	S/P	Also F100M	$2-4	$7-9
Satin Straight Cut	S-1887	KIM		1887	20	FKR	S/P	Satin-like bag 10+ cfrs.	$75-100	$200-275
Saturn	Warning	LAM		1975	20	FKR	S/P	Trademark	$6-8	$25-35
Saturnette Egytian	S-1910	DER		1913	10	70's	CSB	Possible import	$35-50	$90-135
Savannah	Warning	BAW		1976	20	F100R	S/P	Picture of city on water	$2-4	$7-9
Savannah Slim	Sur-Gen	BAW		1987	20	F100RL	FTB	Also F100ML	$1-2	$3-6
Save	Caution	ATC		1968	20	70's	?	Trademark	$6-8	$25-35
Save, Always	Sur-Gen	LAM	ASW	1988	20	All Kinds	S/P	Multi: colors on white	$15-20	$55-65
Saver's Choice	Sur-Gen	LAM	SRC	1980	20	All Kinds	S/P	Multi: colors on white	$35-50	$75-115
Savvy	Sur-Gen	LAM		1964	20	FKR	S/P	3 different types	$2-4	$7-9
Saxton	No Stamp	ATC		1964	20	FKR	S/P	F460-VA	$6-8	$25-35
Saybrooke	Warning	LAB		1941	20	FKR	S/P	C98	$15-20	$55-65
Scaferlati	S-1898	MON		1898	?	70's	?	Possible import	$35-50	$90-135
Schinasi Bros Natural	S-1910	SCS		1913	10	70's	CSB	F485-3NY,	$35-50	$75-115
Schinasi Bros Natural	S-1915	ATC		1915	100	70's	F/TC/T	Also R/T 50's, F30-NC	$95-175	$225-350
Schinasi Bros Natural	S-112	ATC	SCS	1942	20	70's	CSB	F30-NC, outer purple	$15-20	$55-65
Scotch Buy	Warning	LAM	SFS	1981	20	All Kinds	S/P	Made for Safeway	$1-2	$3-6
Scots	Warning	RJR		1976	20	FKR	S/P	Trademark	$6-8	$25-35
Scotty	S-102	SCO		1931	20	70's	S/P	F11-MO	$20-25	$60-85
Scout	S-107	LOR		1964	20	FKR	S/P	Trademark	$6-8	$25-35
Seafield	No Stamp	ATC		1964	20	FKR	S/P	Red on white	$6-8	$25-35
Sebring	Sur-Gen	ATC		1970	20	FKR	S/P	Multi: colors	$6-8	$25-35
Sedona	No Stamp	RJR	FOR	1994	20	FKR	FTB	TP-1-NC	$2-1	$3-6
1776	S-1910	RJR	MTC	1995	10	70's	SSB	F2-NY, also box of 50	$2-1	$3-6
Select Society	S-1887	MIL		1899	10	70's	FTB	F213-CA	$60-85	$180-225
Senator Blend	S-108	BEN		1938	20	70's	S/P	Multi: Colors	$15-20	$25-35
Seneca Hawk	Sur-Gen	SAR	SCM	1992	20	All Kinds	S/P	F8-5NJ, red and white	$1-2	$3-6
Sensation	S-108	LOR		1938	20	70's	S/P	Trademark	$15-20	$55-65
Sensible	Warning	RJR		1986	20	FKR	FTB	F460-VA, brown	$6-8	$25-35
Sentry	Caution	NOT		1970	20	FRK	S/P	Non-tobacco	$3-5	$8-12
Seralian	S-111	SER		1941	20	70's	S/P	Trademark	$15-20	$55-65
Serene	S-1910	FAL		1912	50	70's	R/T	?	$15-20	$55-65
Seven Eleven	Sur-Gen	RJR		1990	20	FKR-FKMFTB	S/P	Red band, 5 gold stars	$6-8	$180-225
Seven Island Club	Warning	MIL		1976	20	70's	S/P	Blk 7 on red or green	$2-4	$7-9
Seven Seven Seven	S-107	AFT		1937	20	70's	S/P	F24-KY	$6-8	$25-35
Seven (7)	Sur-Gen	LAM	SEV	1991	20	FKR	FTB	CCMS-1-2, red	$1-2	$3-6
Seven-Teen-Sixty	S-105	LOR		1935	10	70's	S/P	F7-5NJ	$15-20	$55-65
Seventy 70	Sur-Gen	PAV		1976	20	70's	S/P		$2-4	$7-9
Seville	Warning	PMC		1994	20	FKR	S/P		$6-8	$25-35
SF	Sur-Gen	LAM	SFL	1996	20	All Kinds	S/P	TP42-NC	$1-2	$3-6

Right table:

Brand Name	Series	Mfg	Ven	YMf	#	Type	Pack	Description/Remarks	Empty	Full
SG	No Stamp	BAW		1959	20	FKR	S/P	Gold white on red	$6-8	$25-35
Shamba	Warning	RJR		1973	20	FKR	S/P	Trademark	$6-8	$25-35
Sheffield English 5	S-102	HEA		1930	20	70's	F/B	Brown on white	$20-25	$60-85
Sheffield English 5	S-116	FLH		1946	20	70's	F/B	Also F/B, brown/white	$10-15	$40-55
Sheffield Imperial	S-122	SSS	FLH	1952	20	70's	F/B	Beige, Ovals	$10-15	$25-35
Shenandoah	Caution	PMC		1966	20	70's	S/P	Trademark	$6-8	$25-35
Shenandoah	Sur-Gen	PMC	FVB	1993	20	All Kinds	S/P	TP-7-VA, multi. colors	$1-2	$3-6
Shepheard's	S-102	MST		1931	100	70's	F/T-R/T	F546-2NY	$75-100	$200-275
Sherman's	S-119	SHE		1949	20	70's	S/P	Gold on white	$15-20	$55-65
Sherman's Havana	S-122	SHE		1952	20	70's	R100R	F65-1NY	$10-15	$40-55
Sherman's Pastelle	S-124	SHE		1954	20	70's	CSB	Also 85mm	$10-15	$40-55
Sherman's Cigarettellos	No Stamp	SHE		1958	20	RKR	S/P	White on black	$6-8	$25-35
Sherman's Havana	Caution	SHE		1968	20	70's	CSB	White on black	$3-5	$8-12
Sherman's Alto	Warning	SHE		1975	20	FKR	F/B	Pk for Sammy Davis Jr.	$35-50	$90-135
Sherman's El Dago	Warning	SHE		1975	20	FKR	F/B	Pk for Frank Sinatra	$35-50	$90-135
Sherman's, Lets Back Jack	No Stamp	SHE		1960	20	FKR	F/B	Pk. for John F. Kennedy	$35-50	$90-135
Sherman's 164	Caution	SHE		1968	10	R164mm	F/B	TP161-NY, multi. colors	$15-20	$55-65
Double Long	Warning	SHE		1971	10	FQR	F/B	Variety of colors/shapes	$2-4	$7-9
Sherman's	No Stamp	SHE		1985	10	FKR	F/B	Variety of color/shapes	$1-2	$3-6
Sherman's	Sur-Gen	SHE		1993	20	Sur-Gen	S/P	Multi: colors	$1-2	$3-6
Shield	Sur-Gen	PMC	GPA	1995	20	Sur-Gen	S/P	Trademark	$6-8	$25-35
Shikari	Warning	ATC		1935	20	70's	S/P	Also 85mm, red on white	$15-20	$55-65
Shirley	S-105	LAB	REE	1887	20	70's	S/P	C86, C87, C98	$75-100	$200-250
Shoo Fly	S-1887	FEL		1898	?	70's	S/P	W/the dollar $ign,	$35-50	$90-135
Shop Girl	S-1898	IMH		1960	20	FKR	S/P	TP45-VA, red on white	$6-8	$25-35
Shop-Rite	No Stamp	LAB	WAK	1964	20	FKR	S/P	Trademark	$6-8	$25-35
Shorty	Sur-Gen	SHO		1994	20	FKR	S/P	TP-42-NC, multi colors	$1-2	$3-6
Shur Fine	Sur-Gen	LAM	SRC	1994	20	All Kinds	S/P	TP-1-NC, multi colors	$6-8	$25-35
Shur Saving	Caution	RJR	TOP	1994	20	FKML	S/P	CCMS-1-2	$6-8	$25-35
Sienna	Caution	PMC		1968	20	70's	S/P	Aqua	$3-5	$8-12
Sign ($ign)	S-104	BAW		1934	?	70's	R/B	W/the dollar $ign,	$15-20	$55-65
Signal	Warning	GAG		1970	20	FKR	S/P	Trademark	$6-8	$25-35
Signaline	Warning	ATC		1970	20	FKR	S/P	Trademark	$1-2	$3-6
Signature	Sur-Gen	RJR		1995	20	All Kinds	S/P	Multi: colors on white	$15-20	$55-65
Signia	S-111	AUT	FOR	1941	20	70's	F/B	Gold red on white	$35-50	$90-135
Signor, El	S-1898	MYO		1898	?	70's	S/P	F36-KY, black on white	$20-25	$55-65
Silhouette	No Series	LOR		1928	20	70's	S/P	Trademark	$6-8	$25-35
Silhouette	Warning	LOR		1974	20	FKR	S/P	Trademark	$2-4	$7-9
Silk	Warning	BAH	RUL	1975	20	RKR	S/P	3 types from England	$15-20	$55-65
Silk Cut	Warning	BAH		1973	20	70's	R/B	F5-2NY	$35-50	$75-115
Silk Tips	S-108	BEH		1938	20	70's	S/P	Pack looks like brick wall	$75-100	$200-250
Silko	S-1898	ATD		1899	20	70's	S/P	Silver and green	$2-4	$4-6
Silva	Caution	ATC		1967	20	70's	S/P	C98	$35-50	$90-135
Silva Thin	Sur-Gen	ATC		1973	20	All Kinds	S/P	Trademark	$3-5	$8-12
Silver	Warning	BUL		1958	20	FKR	S/P	TP-75-NY, multi. colors	$6-8	$25-35
Silver Brown Rounds	No Stamp	GAG		1975	20	FKR	S/P	White letters on yellow	$6-8	$25-35
Silver City Deluxe	Warning	STJ		1962	20	FKR	S/P	Trademark	$6-8	$25-35
Silver Eagles	No Stamp	RAG		1927	20	70's	S/P	F2032-1PA	$20-25	$60-85
Silver Horse	No Series	?		1898	20	FKR	FTB	Trademark	$2-1	$3-6
Silver King	S-1898	JNS		1898	?	70's	S/P	C98	$35-50	$90-135
Silver Knight	Sur-Gen	MVR		1989	20	FKR	CSB	Trademark	$6-8	$25-35
Silver Slims	Warning	AFT		1971	20	FKR	S/P	Black letters on white	$10-15	$40-55
Silverline	Sur-Gen	LAM		1950	20	All Kinds	S/P	Multi: colors on white	$1-2	$3-6
Sincere	S-120	BAW		1991	20	FKR	S/P	Trademark	$20-25	$60-85
Sincerely Yours	S-151	LAM		1970	20	FKR	S/P	C98	$35-50	$90-135
Sinclair Oils	Warning	GAG	YNC	1970	20	FKR	S/P	Red on white	$3-5	$8-12
Singles	No Stamp	ATC		1909	?	70's	S/P	Gold letters on white	$20-25	$60-85
Sinjin	S-1909	STJ		1909	20	70's	S/P		$6-8	$25-35
Sixty Six	No Stamp	RAG		1959	20	FKR	S/P		$20-25	$60-85
Sixty Wall Tower	S-105	JNS		1935	20	70's	S/P		$50-65	$150-190
Skarabel No. 1	S-1901	MVR		1903	20	70's	S/P		$35-50	$90-135
Skeet	S-107	AFT		1936	20	FKM	S/P	Picture of man shooting	$35-50	$90-135
Ski	Warning	PMC		1974	20	FKM	S/P	Trademark	$15-20	$55-65
Skis	No Stamp	USJ	FLH	1940	20	FKM	S/P	Picture of man sking	$15-20	$55-65
Skis	Warning	ATC		1961	20	FKM	S/P	Picture of man sking	$15-20	$55-65
Skyscraper	No Stamp	ATC		1975	20	FKR	S/P	Trademark	$6-8	$25-35
Sledge	Warning	LAM		1940	10	FKR	F/B	F23-1MO	$95-165	$225-325
Slim Price	Sur-Gen	RJR	FOR	1993	20	FKR	S/P	TP-1-NC	$1-2	$3-6
Slims	Caution	SHE		1968	20	FQR	CSB	TP-26-NJ, TP-65-NY	$3-5	$8-12

Left table (Brand Name S–Sp):

Brand Name	Series	Mfg	Ven	YMf	#	Type	Pack	Description/Remarks	Empty	Full
Smiles	No Series	STP		1923	20	70's	S/P	F2032-1PA	$20-25	$60-85
Smiles	S-108	STP		1938	50	70's	F/T	F2032-2PA	$75-100	$200-225
Smith	Warning	LOR		1974	20	FKR	S/P	Trademark	$6-8	$25-35
Smo Cola	S-112	RIG	SMO	1952	20	RKR	S/P	F94-NY	$10-15	$40-55
Smoke First	Warning	LAM		1967	20	FKR	S/P	Black letters on white	$3-5	$8-12
Smoke Pot	Caution	GAG	SMH	1967	20	FKR	S/P	1 of 10 "spoof" packs	$10-15	$40-55
Smoke Weed	Caution	GAG	SMH	1967	20	FKR	S/P	1 of 10 "spoof" packs	$10-15	$40-55
Smokes, Quality	Sur-Gen	RJR	FOR	1992	20	All Kinds	S/P	Multi. colors	$1-2	$3-6
Smyrna	S-1879	MON		1875	10	70's	S/P	F363-3NY	$75-100	$200-250
Snaggs	S-110	HEA		1940	20	70's	S/P	Denicotinized cigarette	$15-20	$55-65
Snooty	S-107	AFT		1937	20	70's	S/P	F24-KY, Dude and lady	$20-25	$60-85
Snowball	S-103	CNT	WER	1933	20	70's	S/P	F21-VA,	$20-25	$60-85
Snowman	No Stamp	?		1958	?	70's	?	Green band on white	$6-8	$25-35
Social Puff	S-1898	CAM		1898	?	70's	?	C98	$35-50	$90-135
Society Smoke	S-1898	MIL		1898	20	FKR	S/P	Trademark	$35-50	$90-135
Solo	Warning	RJR		1982	20	FKR	F/B	Trademark	$6-8	$25-35
Solution	Warning	BAW		1973	20	FKR	S/P	Multi. colors, mountains	$6-8	$25-35
Sonoma	Sur-Gen	CBI		1995	20	All Kinds	S/P	C87	$1-2	$3-6
Soudan	S-1898	SRB		1899	20	70's	S/P	F439-2NY	$50-65	$150-190
Source	Warning	RJR		1976	20	FKR	S/P	Trademark	$6-8	$25-35
Southern	S-1887	RUS		1887	?	70's	?	C86, C98	$35-50	$90-135
Southern Lights	Sur-Gen	IDC		1985	20	FKR	S/P	White gold stripes	$6-8	$25-35
Southern Lights	Caution		KIN	1967	20	FKR	S/P	4 engine airplane	$35-50	$90-135
Southgate	S-105	LAB	REE	1935	20	70's	F/B	C87	$15-20	$55-65
Southland	S-122	GAG	YNC	1952	10	70's	S/P	Orange on yellow	$20-25	$60-85
Southwest Supply Co	S-1887	DAN		1887	20	70's	SSB	F30-NC, several varieties	$30-45	$75-115
Souvenier	S-1910	ATC		1914	20	70's	SSB	Orange on yellow	$65-145	$180-225
Sovereign	S-1901	ATD	KIN	1901	50	70's	R/T	White diamond on red	$10-15	$40-55
Sovereign	S-110	ATC		1950	20	70's	CSB	Trademark	$6-8	$25-35
Sovereigns	Caution	PMC		1965	20	70's	SSB		$6-8	$25-35
Spa	No Stamp	STP	SPA	1898	20	70's	?		$10-15	$40-55
Space	S-1898	FEN		1898	20	70's	?	Picture of space ship	$35-50	$90-135
Spanish Chief	S-104	DRQ		1934	20	FKR	S/P	C98	$15-20	$55-65
Spanish Senorita	S-1898	KSR		1898	?	70's	?	C98	$15-20	$90-135
Spanish Snakes	S-1898	CAM		1898	20	70's	S/P	Green & white	$60-85	$180-225
Spanish Triplets	Caution	ATC		1966	20	FKR	S/P		$35-50	$90-135
Spearmint Blend	Sur-Gen	ATC		1993	10	All Kinds	FTB		$6-8	$25-35
Special 10's	S-1898	ATD	KIN	1898	10	FKR	S/P	10's on red and green	$1-2	$3-6
Special Cut	S-1887	ATD	KIN	1891	?	70's	S/P	C98, F30-NY	$35-50	$90-135
Special Cut	S-1887	ATD		1898	20	70's	S/P	C98, F593-MD	$35-50	$90-135
Special Favours	Warning	PMC	BEH	1972	10	70's	CSB	Trademark	$35-50	$90-135
Special Label	S-1887	RTT		1898	20	70's	SSB	C98, F30-NY	$50-65	$150-190
Special Royal	S-1898	ATD	KIN	1898	10	70's	SSB	F430-1VA	$35-50	$90-135
Special Virginia	S-102	DRQ		1932	20	70's	F/B	TP-42-NC	$15-20	$55-65
Special Salaambo	S-1910	ROM		1915	10	70's	?	F593-MD	$30-45	75-115
Specially	No Stamp	RGR		1980	20	FKR	?	Trademark	$2-4	$7-9
Spectators	Warning	KIN		1973	10	FKR	S/P	Small profit quick returns	$2-4	$7-9
Spectrum 10	S-1898	ATC		1898	10	70's	S/P		$6-8	$25-35
Spirit	Warning	BAW		1971	20	FKR	S/P		$6-8	$25-35
Spirit	Warning	BAW		1978	20	FKR	F/B		$2-4	$7-9
Spokes	Warning	RJR		1978	20	FKM	S/P		$6-8	$25-35
Sport	Warning	ATD		1898	20	FKR	S/P		$35-50	$90-135
Sport	S-1887	ATD	KIN	1891	?	70's	S/P		$1-2	$3-6
Sporting Extra	S-1898	PMC	BEH	1898	20	70's	S/P		$35-50	$90-135
Sports	S-102	DRQ		1932	50	70's	F/T		$35-50	$150-190
Sporlite	S-110	KIN		1940	20	FKM	S/P		$25-35	$70-95
S.P.Q.R.	S-124	COM		1954	20	FKM	S/P		$60-85	$180-225
Spree	S-108	BEH		1939	10	70's	SSB	Trademark	$6-8	$25-35
Spring	Warning	RJR		1970	20	70'sM	S/P	Green stripes on white	$3-5	$8-12
Spring	Caution	LOR		1967	20	FKML	S/P	Green and white	$2-4	$7-9
Spring Lemon	Sur-Gen	LOR		1989	20	FKR	S/P	Multi. colors on white	$2-4	$7-9
Spring Air	No Series	SSS		1948	10	70's	F/B	Gold letters on white	$6-8	$25-35
Sprint	Warning	BAW		1984	20	70's	S/P	White on yellow	$2-4	$7-9
Spud	No Series	RJR		1922	20	70'sM	S/P	Green on white	$35-50	$90-135
Spud	Caution	BLO	SPU	1926	20	70'sM	S/P	With Hughes name on it	$6-8	$25-35
Spud	No Series	ATD	HUG	1932	50	70'sM	F/T	Green trim on white	$35-50	$90-135
Spud Imperial	S-102	AFT		1940	20	FKM	S/P	F24-KY, Silver	$1-2	$3-6
Spud Filter	No Stamp	PMC		1956	10	70's	SSB	Green orange on white	$6-8	$25-35
Spur	S-1910	LAM		1911	10	70's	S/P	Also flat 50's tin	$60-85	$180-225
Spur	S-109	LAM		1939	20	FKR	S/P	Picture of horse	$35-50	$90-135
Spuyten Duyvil	No Series	ATC		1964	20	FKR	S/P	Trademark	$6-8	$25-35

Right table (Brand Name St–Super):

Brand Name	Series	Mfg	Ven	YMf	#	Type	Pack	Description/Remarks	Empty	Full
St. James	S-1873	KIN	KIN	1873	10	70's	SSB	Multi. color Kinney Bros	$95-150	$225-325
St. James	S-1887	ATD	KIN	1891	?	70's	S/P	C98, F593-MD	$35-50	$90-135
St. James 1/2	S-1887	BAW		1977	20	70's	F/B	White w/diag. stripes	$2-4	$7-9
St. James Court	Warning	ATD	KIN	1891	20	70's	S/B	F593-MD, also 20ct. box	$65-85	$150-225
St. Moritz	Warning	HOE		1974	20	All Kinds	S/B	Copper	$2-4	$7-9
St. Moritz	Sur-Gen	TEX		1995	20	F100M	S/P	F-in red, M-in green	$2-4	$7-9
St. Petersburg	S-1865	BED		1865	?	70's	?	Gold trim on green	$1-2	$3-6
Stage III	Warning	LAM		1975	20	F100RLL	S/P	Lataka & bright tob.	$95-190	$350-500
Stampede	Warning	RJR		1975	20	FKR	S/P	Trademark	$6-8	$25-35
Standard Egyptian	No Stamp	BEN		1923	10	70's	S/P	Trademark	$25-35	$70-95
Standard, Benaderet	S-107	BEN		1937	10	70's	CSB	F213-1CA	$20-25	$60-85
Stanley Freres	S-107	STF		1905	?	70's	CSB	F213-1CA	$20-25	$60-85
Staple	S-1901	AFT		1900?	?	70's	?	F104-1IL	$6-8	$25-35
Star	S-1898	LAM		1898	10	70's	SSB	This is the earliest AFT	$35-50	$90-135
Star Service	S-125	LAB	SSC	1955	10	70's	S/P	Multi. Design	$35-50	$90-135
Starr & Reed	S-1901	SRR		1906	10	70's	CSB	F460-VA, three stars	$15-20	$55-65
Stars And Stripes	S-1901	DTW		1905	10	70's	CSB	F430-1PA	$35-50	$90-135
Statesman	No Stamp	PMC		1961	10	70's	SSB	Stripes on slant, & stars	$6-8	$25-35
Stella	S-115	SLA		1945	20	70's	FTB	Bl. red orange on white	$10-15	$40-55
Stephania, Sweet	S-1879	COH		1879	10	FKR	?	Glass tipped	$95-175	$225-300
Stephano	S-114	STP		1924	20	RKR	F/B	Muti. color trim on red	$25-35	$70-95
Stephano Hellenic	S-107	STP		1924	20	RKR	F/B	F2032-1PA, cork tip	$25-35	$70-95
Sterling	Sur-Gen	RJR		1990	20	All Kinds	S/B	Metallic and stripes	$1-2	$3-6
Steuben	S-122	STU		1959	20	70's	S/P	Blue and white	$6-8	$25-35
Stevenson For	S-120	TBC		1952	10	70's	S/P	Picture of Stevenson	$35-50	$90-135
Still Harbor	S-120	FPI		1950	10	70's	SSB	C87	$15-20	$55-65
Stock Exchange	Warning	GAG		1972	20	FKR	S/P	TP-75-NY	$2-4	$7-9
Stockton	Caution	LOR		1966	20	FKR	S/P	By and for convicts	$6-8	$25-35
Stockton	Sur-Gen	RJR	FOR	1995	20	All Kinds	S/P	F30-NC	$1-2	$3-6
Stop	No Stamp	MOL		1959	20	FKR	SSB	Multi. colors on white	$6-8	$25-35
Straight Cut	S-1872			1872	5	70's	F/B	Black and white stripes	$95-175	$225-300
Straight Cut	S-107	BEH		1937	20	70's	CSB	F593-MD	$20-25	$60-85
Straight Virginia	S-111	SSS		1941	20	FKR	S/P	F5-2NY	$15-20	$55-65
Straight Web	S-1887	PAC		1898	20	70's	S/P	C86, C89	$60-85	$180-225
Strata III	Warning	LAM		1975	20	FKR	S/P	Trademark	$6-8	$25-35
Stratford	S-113	FLH		1945	20	70's	S/P	Bridge over river	$10-15	$40-55
Stratford	S-125	USJ		1955	20	RKR	S/P	Black red letters on white	$10-15	$40-55
Stratford	No Stamp	USJ	FLH	1961	20	RKR	S/P	Black red letters on white	$6-8	$25-35
Straw Tubes	No Series	BEN		1928	20	70's	S/P	F213-1CA	$20-25	$60-85
Stride	Warning	LAM		1975	20	FKR	S/P	Multi. colors on silver	$3-5	$8-12
Strollers	S-107	TPC		1922	15	70's	S/P	White and green	$20-25	$200-275
Students' Solace	No Series	ATC		1975	15	FKR	S/P	F30-NC	$15-20	$55-65
Style	Warning	CAM		1937	20	70's	SSB	C98	$35-50	$90-135
Style	Sur-Gen	PMC		1992	20	FKR	FTB	Trademark	$1-2	$3-6
Sub-Rosa	S-107	LOR		1885	10	70's	S/B	Also F100ML	$60-85	$180-225
Sublime	S-1898	MIL		1898	10	70's	S/P	Red letters on white	$35-50	$90-135
Suede	Warning	BAW		1975	20	FKR	S/P	C98, F2-NY	$6-8	$25-35
Suedes	Warning	ATD		1975	20	FKR	S/P	Trademark	$6-8	$25-35
Sugar Leaf	S-1898	ATC		1898	20	All Kinds	S/P	2 Types test marketed	$35-50	$90-135
Sugarbush	Sur-Gen	RJR		1974	20	FKR	FTB		$6-8	$25-35
Sultan	S-107	MON		1886	?	70's	F/B	Trademark	$95-145	$250-325
Sultans	S-1910	LAM		1914	20	70's	S/P	Red on light brown	$30-45	$75-115
Sultans	S-1887	KIN		1890	10	70's	S/P	F64-NY	$60-85	$180-225
Summit	S-102	BEN		1930	20	70's	SSB	Enameled ends	$20-25	$60-85
Summit	S-123	COU		1952	20	70'sF	S/P	F213-1CA	$10-15	$40-55
Summit	Warning	PMC		1993	20	70's	S/P		$6-8	$25-35
Sun	Sur-Gen	ATC		1896	?	70's	?	White diamond on red	$1-2	$3-6
Sun Flower	S-107	LAM		1936	20	FKR	S/P	TP-130-NC	$50-65	$150-190
Sunbelt	Warning	AFT		1976	20	FKR	S/P	F25-1MO	$6-8	$25-35
Sundance	Sur-Gen	RJR		1971	20	FKR	S/P	F24-KY	$6-8	$25-35
Sunland	Sur-Gen	RJR		1992	20	All Kinds	S/P	Multi. colors	$1-2	$3-6
Sunny South	Caution	PMC		1969	20	FKR	FTB	Trademark	$6-8	$25-35
Sunrich	Warning	ALG		1887	?	70's	?	C86, C87, F25-VA	$60-85	$180-225
Sunshine	S-1887	RJR		1890	10	70's	S/P		$60-85	$180-225
Sunshine	No Stamp	DUK		1890	10	70's	SSB	F42-NC	$75-100	$175-250
Super C	S-105	LAM	PIN	1935	10	70's	S/P	F42-NC, yellow on red	$15-20	$55-65
Super Lemon	Warning	ATC		1974	20	FKR	S/P	Trademark	$6-8	$25-35

Brand Name	Series	Mfg	Ven	YMf	#	Type	Pack	Description/Remarks	Empty	Full
Super M	Warning	ATC		1974	20	FKR	S/P	Trademark	$6-8	$25-35
Super M	Warning	ATC		1974	20	F100M	S/P	Blue and silver pack	$2-4	$7-9
Super Valu	No Stamp	LAB		1962	20	RKR	S/P	White w/yellow stripes	$6-8	$25-35
Super Virginia	S-107	BEH		1930	50	70's	F/T	Red paper label	$50-65	$150-190
Supreme	S-1898	MIL		1898	?	70's	?	F2-NY	$35-50	$90-135
Sure	Warning	LOR		1975	20	FKR	S/P	Trademark	$6-8	$25-35
Sure Winner	S-108	AFT		1936	20	70's	S/P	F24-KY	$15-20	$55-65
Surprise	Warning	LOR		1885	10	70's	F/B	Trademark	$60-85	$180-225
Surrey	S-1883	FLA		1972	20	FKR	S/P	Four Different Varieties	$60-85	$180-225
Sussini's Caporal	S-1883	SCH		1884	10	70's	SSB	C98	$35-50	$90-135
Sutoca	S-1898	STG		1898	?	70's	?	Trademark	$6-8	$25-35
Sutton	No Stamp	ATC		1964	20	FKR	S/P	F339-2NY, "freedom"	$60-85	$180-225
Svoboda/Freiheit	S-1887	SCK		1890	10	70's	SSB	Picture of lady	$30-45	$75-115
Svoboda Prudential	S-1910	ATD		1910	10	70's	F/B	F50-VA	$15-20	$55-65
Swain's Virginia	S-108	SWA		1938	20	70's	S/P	Trademark	$6-8	$25-35
Swanee	No Stamp	PLA		1965	20	FKR	S/P	F30-NC,	$15-20	$55-65
Sweepstakes	S-120	ATC		1936	20	70's	S/P	Sweet, coarse, shaggy	$95-200	$325-500
Sweet Caporal	S-1887	ATD	KIN	1891	10	70's	F/B	Most sold/all others	$50-65	$150-190
Sweet Caporal	S-102	ATD		1930	50	70's	F/T-R/T	Many different kinds,	$50-65	$150-190
Sweet Caporal	S-105	ATC		1911	20	70's	S/P	Best seller 1911-1969	$2-20	$6-55
Sweet Caporal	No Stamp	ATC		1965	20	70's	S/P	Test market brand	$10-15	$40-55
Sweet Moments	S-1887	LAM		1893	10	70's	F/T	F25-1MO	$35-50	$90-135
Swell Ellen	S-1898	SDS		1898	?	70's	?	C98	$35-50	$90-135
Sylvan	No Stamp	RJR		1964	20	FKR	S/P	Trademark	$6-8	$25-35
System III	Warning	LAM		1975	20	FKR	S/P	Trademark	$6-8	$25-35
T.T. Natural Turkish	S-1901	MTR		1901	10	70's	F/B	F456-3MA	$60-85	$180-225
Tahiti	No Stamp	BAW		1972	20	FKR	S/P	Trademark	$6-8	$25-35
Tall	Warning	ATC		1975	20	F120R	S/P	Black and white	$2-4	$7-9
Tall Cig, For Texan	No Stamp	LAB	HIN	1957	20	FKR	S/P	C460-VA	$15-20	$55-65
Tally-Ho	S-1910	LOR		1911	20	70's	F/B	F57-5NJ, orange on white	$50-65	$150-190
Tandem	Caution	ATC		1969	20	FKR	S/P	Trademark	$15-20	$55-65
Tangier	S-125	?	ANR	1969	20	FKR	S/P	Gold trim on black	$6-8	$25-35
Tango	Caution	LIS		1963	20	FKR	S/P	Trademark	$6-8	$25-35
Taper Off	No Stamp	LUC		1898	?	70's	?	?	$6-8	$25-35
Tara	Caution	ATC		1969	20	FKR	S/P	?	$6-8	$25-35
Tareyton	No Stamp	RJR		1958	20	FKR	S/B	Two red stripes on white	$6-8	$25-35
Tareyton	Warning	ATC		1967	20	FKR	S/P	Red stripes on white	$3-5	$8-12
Tareyton	Warning	ATC		1975	10	All Kinds	S/P	Grn or red stripes	$2-4	$7-9
Tareyton	Sur-Gen	ATC		1993	20	All Kinds	S/P	Duel red stripes on white	$1-2	$3-6
Target	S-102	BAW		1930	20	70's	S/P	Trademark	$20-25	$60-85
Target	S-104	BAW		1930	20	70's	S/P	F36-KY	$25-35	$70-95
Tartan	S-1901	AFT		1936	20	70's	S/P	F24-KY	$15-20	$55-65
Tasha Turkish	Caution	GAG	SMH	1906	10	70's	F/B	Also CSB	$15-20	$55-65
Taste	Warning	TAI	TRE	1994	20	FKR	S/P	Test market	$35-50	$90-135
Taste Of America	Sur-Gen	EST		1993	20	All Kinds	S/P	TP42-NC, red on white	$1-2	$3-6
Tastemaker	Warning	BEA		1971	20	FKR	S/P	Trademark	$6-8	$25-35
Tavern	No Series	LAB	REE	1925	10	70's	CSB	Blue gold on green	$20-25	$60-85
Tea Sticks	Caution	GAG	SMH	1939	20	70's	S/P	4 horse and carriage	$15-20	$55-65
Teka Extra	No Series	TAI	TRE	1936	20	FKR	S/P	1 of 10 "spoof" packs	$25-35	$70-95
Tel-Aviv	S-1901	HOR		1906	10	70's	F/B	?	$1-2	$3-6
Telescope	S-109	LUC		1898	?	70's	?	?	$15-20	$55-65
Temple Bar	S-1887	GOO		1887	20	70's	?	C98	$35-50	$90-135
Ten Minute	No Stamp	MRB		1963	20	FKR	S/P	C87, F26-2NY	$50-65	$150-190
Ten Strike	Warning	ATC		1972	20	FKR	S/P	Trademark	$6-8	$25-35
Tennyson	No Stamp	RJR		1959	20	FKR	S/P	With Actifilter	$6-8	$25-35
Tennyson	Caution	ATC		1967	20	FKR	S/P	Multi. colors on white	$3-5	$8-12
Tent	S-1887	LAM		1887	20	70's	?	Trademark	$50-65	$150-190
Teofani No. 5	S-1910	LAB	TEO	1915	20	70's	S/P	Red black on white	$30-45	$75-115
Texas	Sur-Gen	AND		1995	20	FKR	S/P	TP-165-NY	$20-25	$60-85
The "Greys"	Caution	BEH		1882	10	70's	S/P	Black letters on green	$15-20	$55-65
The "Masher(S")"	S-1879	ALG		1933	20	70's	F/T	F25-VA	$95-175	$225-300
The First	S-1910	FCT		1910	10	70's	SSB	F62-MA	$15-20	$55-65
The Home	Warning	RJR		1976	?	70's	?	Trademark	$6-8	$25-35
The Lady	No Stamp	RJR		1979	20	FKR	S/P	C98, F2-NY	$50-65	$150-190
The Lark	S-1898	MIL		1898	?	70's	?	Multi. colors	$1-2	$3-6

Brand Name	Series	Mfg	Ven	YMf	#	Type	Pack	Description/Remarks	Empty	Full
The New John Alden	S-122	TBC	JAT	1952	20	70's	S/P	F10-KY	$10-15	$40-55
The Taste	S-1887	HES		1887	?	70's	?	C86, C87, mouthpiece	$50-65	$150-190
The Union Club	S-1887	ATD	KIN	1891	?	70's	?	F593-MD	$50-65	$150-190
These	Caution	PLA		1969	20	FKR	S/P	Test market	$3-5	$8-12
Think	Warning	RJR		1976	20	FKR	S/P	Trademark	$6-8	$25-35
Thirtyfifth Division	S-112	AFT		1942	20	70's	S/P	F24-KY, blue crosshairs	$15-20	$60-85
Thirtyfourth Division	S-112	AFT		1942	20	70's	S/P	White black red emblem	$15-20	$60-85
Thirtythird Division	S-112	AFT		1942	20	70's	S/P	Yellow cross on black	$15-20	$60-85
Thirtysecond Division	S-112	AFT		1942	20	70's	S/P	Red arrow on front/back	$15-20	$60-85
Three Castles, The	No Series	UNI		1926	20	70's	F/B	Was three kings before	$25-35	$70-95
Three Cities, The	Warning	UNI		1983	20	FKR	SSB	Import from England	$2-4	$7-9
Three Feathers	S-1879	CBL		1880	10	70's	?		$75-100	$200-250
Three Flowers	S-1898	ATD		1898	?	70's	?	C98	$35-50	$90-135
Three Kings	S-1898	GLM		1898	?	70's	?	C98	$35-50	$90-135
Three Kings	S-1887	ATD		1895	20	70's	F/B	Three kings on red	$50-65	$150-190
Three Kings	S-1910	UNI		1910	20	70's	S/P	Crowned cork tip	$30-45	$75-115
Three Musketeers	S-108	ATD		1938	20	70's	S/P	Three kings on green	$15-20	$55-65
Three Stars	S-1898	BLE		1898	?	70's	?	C98	$35-50	$90-135
Three Three Three	S-102	ISM		1932	20	70's	S/P	F649-1NY	$15-20	$55-65
Three-Seven-Two	Warning	SHE		1973	10	164mm	F/B	Blue logo on white	$3-5	$8-12
Thrills	Warning	?		1972	20	FKR	S/P	Blue band on white	$2-4	$7-9
Tiger	S-107	AFT		1936	20	70's	S/P	F21-5NJ	$20-25	$60-85
Tiger	S-1910	RED		1895	20	70's	F/B	F7-3NY, picture of Tiger	$50-65	$150-190
Tijuana Boo	Caution	GAG	SMH	1915	?	70's	?	1 of 10 "spoof" packs	$30-45	$75-115
Tilburg	No Stamp	ATC		1967	20	FKR	S/P	Test market	$20-25	$60-85
Time	S-102	CNT		1965	20	FKR	S/P	Pic. of pack of cigarette	$20-25	$60-85
Time Out	Caution	LOR		1930	20	70's	FTB	Orange band on white	$3-5	$8-12
Tipperary	Caution	PMC		1968	20	FKR	S/P	Trademark	$6-8	$25-35
Tipperary	S-106	LOR		1967	20	FKR	S/P	F24-KY	$15-20	$55-65
Tipt	S-102	AFT		1936	20	RKR	S/P	Tipped cig-mild	$6-8	$25-35
Titleist	Warning	STP		1974	20	FKR	S/P	Trademark	$15-20	$55-65
TJ Fats	Warning	ATC		1976	20	FKR	S/P	Trademark	$6-8	$25-35
TLC	Warning	ATC		1987	20	FKR	S/P	Trademark	$6-8	$25-35
Tobacco Horn	S-1887	LOJ		1975	?	70's	?	C86, C98	$6-8	$25-35
Tobacco Road	Warning	RJR		1887	20	FKR	S/P	Trademark	$50-65	$150-190
Tobats	S-107	BBC		1976	20	FKR	S/P	White circle on yellow	$6-8	$25-35
Today	Warning	BAW		1937	20	70's	S/P	Blue on white	$15-20	$55-65
Tokay	Caution	AFT	TOK	1970	20	FKR	S/P	F24-KY, bunch of grapes	$3-5	$8-12
Tokio	S-1901	ATD		1936	20	70's	FTB	Red band on white	$15-20	$55-65
Tolstoi	S-1898	ATC		1901	20	70's	F/B	F30-NC, russian cigarette	$35-50	$90-135
Tolstoi	S-108	ATC		1900	10	70's	SSB	Single layer of cigarette	$50-65	$150-190
Tolv Ratt	S-118	LAB		1936	10	70's	SSB	Three red band/white	$20-25	$60-85
Toppers	No Series	REE	REE	1945	20	70's	S/P	F460-VA	$10-15	$40-55
Toppers	No Series	LAB		1920	20	70's	S/P	F460-VA, black and white	$25-35	$70-95
Toreador Mexican	Caution	MCT		1935	20	FKR	FTB	Trademark	$20-25	$60-75
Toro Y Ca S.en	S-1887	TOR		1923	20	70's	S/P	F2-3TX	$15-20	$55-65
Total	Warning	LAM		1936	20	FKR	S/P	Girl blowing horn	$60-85	$180-225
Tourney	Sur-Gen	LAM		1975	20	All Kinds	S/P	Multi. colors on white	$2-4	$7-9
Tourney Slims	Sur-Gen	LAM		1989	20	All Kinds	S/P	Multi. colors on white	$2-4	$7-9
Town Talk	S-1883	DUK		1993	10	70's	SSB	Multi. colors on white	$1-2	$3-6
Townsend	Warning	BAW		1885	20	FKR	S/P	F42-NC	$60-85	$180-225
Trace	Warning	BAW		1981	20	FKR	S/P	Trademark	$6-8	$25-35
Trade	S-1887	FEL		1976	20	70's	S/P	Trademark	$6-8	$25-35
Trading Post	Warning	RJR		1887	?	70's	?	C86, C87, C98	$75-100	$200-275
Trafalgar	No Stamp	ATC		1973	20	FKR	S/P	Trademark	$6-8	$25-35
Tramps	Warning	BAW		1964	20	FKR	S/P	Charlie Chaplin	$3-5	$8-12
Tramps	Warning	BAW		1974	20	FKR-FKMS	S/P	Charlie Chaplin	$3-5	$8-12
Tramps 110s	Warning	BAW		1977	20	FKR-FKMS	S/P	E. Kelly, Red Skelton	$25-35	$70-95
Trek	No Series	REE		1978	20	F110R	S/P	F460-VA	$15-20	$55-65
Tremont	Warning	ATC		1974	20	FKR	S/P	Trademark	$20-25	$60-75
Trend	S-1887	ATD	KIM	1895	?	70's	?	C98	$50-65	$150-190
Tri-Brand	Sur-Gen	RJR	FOR	1994	20	All Kinds	S/P	Multi. colors	$1-2	$3-6

Cigarette brand catalog — continued (alphabetical listing).

Brand Name	Series	Mfg	Ven	YMf	#	Type	Pack	Description/Remarks	Empty	Full
Tribune	Caution	ATC		1969	20	FKR	S/P	Trademark	$6-8	$25-35
Trident	Warning	BAW		1970	20	FKR	S/P	Test market	$2-4	$7-9
Trim	No Stamp	RIG	CDC	1960	20	RKR	FTB	reducing aid-cig.	$15-20	$55-65
Trim	Caution	RJR		1966	20	FKR	S/P	?	$6-8	$25-35
Trinidad Diego	Caution	LAB	BLT	1965	20	RKR	S/P	TP-45-VA, white	$6-8	$25-35
Trinidad Diego	Warning	DOS		1979	20	FKR	S/P	TP-762-FL white and red	$2-4	$7-9
Trio	Warning	RJR		1980	20	FKR	S/P	Trademark	$6-8	$25-35
Triple Extract		DUK		1887	10	FKR	SSB	Trademark	$60-85	$150-190
Triplex	Caution	ATC		1971	20	FKR	S/P	F42-NC	$6-8	$25-35
Triumph	No Stamp	TRI		1985	20	FKR-FKM	S/P	No nicotine, no warning	$2-4	$7-9
Triumph	Warning	LOR		1980	20	FKM	S/P	Brown and gold on white	$2-4	$7-9
Triumph	Warning	LOR		1980	20	FKM	S/B	Green gold & white	$6-8	$25-35
True.	Caution	LOR		1966	20	All Kinds	S/B	Blue orange on white	$2-4	$7-9
True.	Warning	LOR		1974	20	All Kinds	S/B	Multi. colors	$1-2	$3-6
True.	Sur-Gen	LOR		1992	10	All Kinds	S/B	Multi. colors	$1-2	$3-5
True Union		PTB		1902	10	70's	S/P	F4-LA	$35-50	$90-135
Tryon	Caution	USJ	SST	1967	20	FKR-FKM	S/P	TP-3-VA, 2+ versions	$3-5	$8-12
Tubarette		MAT		1913	100	70's	S/P	Also sample box 10	$75-100	$200-250
Tune	Warning	RJR		1976	20	70's	F/B	Trademark	$6-8	$25-35
Turc Fort	S-1887	MON		1898	?	70's	?	?	$50-65	$150-190
Turf Club	S-1887	HYN		1895	20	FKR	S/P	?	$50-65	$150-190
Turk	Warning	RJR		1973	20	FKR	S/P	C98, F363-3NY	$6-8	$25-35
Turkey Red	S-1901	ATD	ANR	1905	20	FKR	CSB	Trademark	$35-50	$90-135
Turkey Red	S-1910	LOR		1911	10	FKR	CSB	F7-3NY	$20-45	$75-115
Turkish	S-122	SHE		1952	100mm	FKR	CSB	F7-5NJ	$15-20	$55-65
Turkish Crown Gold	S-1901	BEH		1945	10	60mm	CSB	F5-2NY, gray and white	$15-20	$55-65
Turkish Delight	S-1901	KHE		1904	10	70's	CSB	Gold seal on dark red	$35-50	$90-135
Turkish Gold	S-121	BEH		1953	10	70's	CSB	Wide slide box	$15-20	$55-65
Turkish Guards	S-1901	CRE		1901	20	70's	CSB	Also 20, 50, 100's	$1-2	$3-5
Turkish No. 1	S-1901	BEH		1907	20	70's	CSB	?	$6-8	$25-35
Turkish No 15	S-1901	BEH		1907	20	70's	CSB	Minaret on cover	$6-8	$25-35
Turkish Whiffs	S-1901	BEH		1907	10	70's	CSB	Straw mouthpiece	$6-8	$25-35
Turkish, Condax	S-105	CDX		1905	10	70's	CSB	Brown or white cig.	$3-5	$8-12
Turkish, Sherman's	S-1910	SHE		1966	20	FQR	CSB	Brown or white cig.	$30-45	$75-115
Turret Crown	A-1901	BER		1901	?	60mm, ?	CSB	F320-1NY, F320-3NY	$30-45	$75-115
Twelfth Night	Caution	SHE		1967	20	70's	CSB	F547-RI	$15-20	$55-65
Twenty Aces		SWA		1938	20	FKR	S/P	TP-161-NY, also 100mm	$6-8	$25-35
Twenty Dollar Bill	No Stamp	DFS		1976	20	F100R	FTB	C98	$35-50	$90-135
Twenty Grand	S-101	AFT		1931	20	70's	S/B	Ad. Money to burn	$2-4	$7-9
Twenty Turks	Caution	BRI		1968	20	F101R	SSB	5 different pks, Horse	$1-2	$3-5
Twist	Warning	ATC		1977	20	F100M	S/P	Unusual SSB	$20-25	$60-85
Twist Lemon Menthol	Warning	ATC		1973	20	70's	F/B	Trademark	$6-8	$25-35
Two Lions	No Stamp	LAB		1956	10	70's	SSB	Green on yellow	$10-15	$40-55
Tycoon Kings	S-122	GAG		1952	20	FKR	S/P	F460-VA, 2 lions on red	$10-15	$40-55
Tyler	Warning	BAW		1982	20	FKR	F/B	F2032-1PA	$6-8	$25-35
U-Tote'm	Sur-Gen	GOR	USM	1988	10	FKRL	S/P	TP2442-PA, also FKML	$2-4	$7-9
U.S.A.	S-1898	GOD		1898	?	70's	?	C98	$35-50	$90-135
U.S. Mail	S-1910	LOR	ANR	1910	20	70's	S/P	F7-3NY, also 20ct.	$35-50	$90-135
Ulissa Egyptian	Sur-Gen	RJR	FOR	1995	20	All Kinds	S/P	Multi. colors on white	$1-2	$3-5
Ultra	Sur-Gen	AMB		1994	20	All Kinds	S/B	Multi. colors on white	$1-2	$3-5
Ultra Buy	Warning	LOR		1982	20	FKR	S/P	Trademark	$6-8	$25-35
Umph	Warning	LAM		1982	20	FKR	S/P	1982 Champions	$10-15	$40-55
U. N. C. Tarheels	Warning	JAC		1882	20	FKR	S/P	Man lighting cigarette	$65-85	$180-225
Unicum Match-less	Sur-Gen	GAG		1952	10	F100M	CSB	?	$95-175	$225-300
Union Club	S-122	GAG		1952	20	70's	S/P	C98	$10-15	$40-55
Union Club Turkish	S-1898	ATD	KIN	1898	10	FKR	S/P	F30-NY	$6-8	$25-35
Union Club, The	S-1887	KIN		1890	10	70's	F/B	F593-MD	$50-65	$150-190
Union League Club	S-105	GAG	STC	1935	20	70's	SSB	F407-2NY, F34-2NY	$75-100	$200-250
Unis, Egyptian	S-108	PMC		1908	20	70's	F/B	Name in circle, 2 people	$15-20	$55-65
United Nations	S-121	GAG		1951	10	FKR	F/B	Gold letters on white	$10-15	$40-55
Uptown	Sur-Gen	RJR		1990	20	FKR-FKM	S/B	Gold letters on white	$2-4	$7-9
USA	Sur-Gen	CBI	USA	1993	20	FKR	S/P	4 Types	$2-4	$7-9
USA Gold	Sur-Gen	CBI		1995	20	All Kinds	S/P	10+ types Frankfort Ky.	$1-2	$3-5
US Government	Warning	LAM		1984	20	All Kinds	S/p	7+ types, different area's	$10-15	$40-55
US 1	Warning	DMS		1996	20	All Kinds	S/B	Red white and blue	$1-2	$3-5
V.S.O.P.	Warning	BAW		1971	20	FKR	S/P	Trademark	$6-8	$25-35
Vafiadis	S-1887	VAF		1895	?	70's	?	Also made by LAM	$60-65	$180-225
Vafiadis	S-1910	LAM		1916	10	70's	SSB	Also 100ct. F/T	$65-125	$175-225
Valentine	Sur-Gen	SAR		1994	20	70's	SSB	White lip print	$1-2	$3-5
Valentino	No Series	CTY		1923	20	70's	SSB	?	$20-25	$60-85
Vali	S-1910	VAL		1910	10	FKR	CSB	Gold on red	$35-50	$90-135
Valiant	No Stamp	BAW		1963	20	FKR	S/P	White on red, w/eagle	$15-20	$55-65
Valor	Warning	LEE	LEI	1941	20	70's	CSB	TP-42-NC	$2-4	$7-9
Valu Time	Sur-Gen	LAM	TOP	1980	20	FKR	S/P	TP-1-NC	$1-2	$3-5
Valu Time	Sur-Gen	RJR	TOP	1994	20	All Kinds	S/P	TP-1-NC	$1-2	$3-5
Value & Quality	Sur-Gen	RJR	FOR	1990	20	All Kinds	S/P	TP-1-NC	$1-2	$3-5
Value Buy	Sur-Gen	RJR	FOR	1993	20	All Kinds	S/P	TP-1-NC	$1-2	$3-5
Value Pride	Sur-Gen	RJR	FOR	1994	20	All Kinds	S/P	TP-1-NC	$1-2	$3-5
Value Save	Sur-Gen	BAW		1958	20	FKR	S/P	Red and white, 5+ types	$6-8	$25-35
Vanguard	No Stamp	KIM		1975	?	FKR	S/P	Maroon on red on white	$2-4	$7-9
Vanity Fair	S-1873	ATC		1873	20	FKR	FTB	C86, C87	$95-150	$225-300
Vanity Fair	No Stamp	RJR		1957	20	FKR	S/P	Blue letters on white	$6-8	$25-35
Vantage	Caution	RJR		1964	20	All Kinds	S/P	Multi. colors on white	$3-5	$8-12
Vantage	Sur-Gen	RJR		1967	20	All Kinds	S/B	Multi. colors on white	$3-5	$8-12
Vantage	Sur-Gen	RJR		1970	20	All Kinds	S/P	Multi. colors	$2-4	$7-9
Variety Selection	S-123	SHE		1985	10	100mm	CSB	Multi. colors	$1-2	$3-5
Varsity Honey Dew	S-106	DRQ		1936	20	70's	S/P	Havana, Turkish, USA	$10-15	$40-55
Vega Havana	No Stamp	LEE	HOV	1962	20	FKR	S/P	F340-1CA	$15-20	$55-65
Vegas	Warning	GOR		1982	20	FKR	S/P	Brown, "plantation size"	$1-2	$3-5
Vello	Sur-Gen	LAM		1975	20	FKR	S/P	TP2442-PA, 3 types	$6-8	$25-35
Vello	Warning	LAM		1964	20	FKR	S/P	Trademark	$2-4	$7-9
Velvet	Warning	LAM		1985	20	FKR	S/P	Red/marn on white	$6-8	$25-35
Ventura	No Stamp	BAW		1968	20	FKR	S/P	2 tone beige	$3-5	$8-12
Venture	Caution	PMC		1968	20	FKR	S/P	sky tips	$6-8	$25-35
Venture	Warning	CSC		1982	20	FKR	S/P	Trademark	$6-8	$25-35
Venus	Warning	RJR		1969	20	FKR	S/P	Trademark	$6-8	$25-35
Vermont Maple	S-120	TUC	CHR	1950	?	FKR	S/P	Trademark	$10-15	$40-55
Vernon	S-107	GAG		1937	100	70's	R/T	F11-1MO, man w/buckets	$75-100	$200-250
Vernon	S-105	GAG	STC	1940	20	70's	S/P	F407-2NY	$15-20	$55-65
Vernon Oval	S-110	GAG		1940	20	70's	F/B	F34-2NY, deep blue pink	$15-20	$55-65
Verve	Caution	ATC		1968	20	FKR	S/P	Gold trim on blue	$6-8	$25-35
Veteran	S-1887	KIN		1890	?	70's	?	Trademark	$95-175	$225-300
Viceroy	Warning	BAW		1971	50	FKR	F/T	F593-MD	$75-100	$200-225
Viceroy	S-106	MES		1935	50	70's	F/T-R/T	Red white and blue	$15-20	$55-65
Viceroy	S-118	TBC		1948	10	70's	F/B	Many different designs	$3-5	$8-12
Viceroy	S-109	ALG		1939	20	FKR	FTB	Red white and blue	$2-4	$7-9
Villa	Warning	PMC	PIE	1971	20	FKR	S/P	Multi. colors on white	$20-25	$60-85
Virgin Queen	S-1883	MLH		1886	10	FKR	S/P	Multi. colors	$6-8	$25-35
Virginia Blend	S-118	SSS		1939	10	F100R	FTB	Large gray V, blue ltrs	$6-8	$25-35
Virginia Brights	S-109	ALG		1879	20	FKR	FTB	Trademark	$60-85	$180-225
Virginia Circles	Caution	SHE	BEH	1966	20	FQR	CSB	Picture of lady	$10-15	$40-55
Virginia Diamonds	S-1910	ATD		1912	20	70's	S/P	Gold crest on blue	$75-100	$200-250
Virginia Extra	S-103	MAN		1933	20	70's	S/P	F404-2NY	$6-8	$25-35
Virginia Fads	S-1917	BEH		1918	10	FKR	S/B	F25-VA,	$65-85	$180-225
Virginia Ovals	Warning	GAG		1971	50	FKR	S/P	Brown on white	$65-85	$180-225
Virginia Ovals	S-112	BEH		1982	50	70's	F/T	C98	$3-5	$8-12
Virginia Plain End	S-102	BEH		1931	50	70's	F/T/R/T	Plain and cork tip	$2-4	$7-9
Virginia Rounds	S-102	BEH		1931	20	F100R	FTB	Black/red on white	$1-2	$4-6
Virginia Rounds	Caution	PMC	BEH	1968	20	All Kinds	FTB	Also F100M, stripes	$15-20	$55-65
Virginia Slims	Warning	PMC	BEH	1975	20	All Kinds	FTB	Multi. colors on stripes	$35-50	$90-135
Virginia Slims	S-108	SWA	BEH	1992	20	70's	S/P	Multi. colors on stripes	$2-4	$7-9
Virginia Sweets	S-1898	MLH		1898	?	70's	?	F50-VA	$35-50	$90-135
Virginia Twisters	Sur-Gen	SAR	SGC	1997	20	FKR	S/P	C98	$2-4	$7-9
Virginians	Caution	LAM		1970	20	FKR	S/P	TP-22-VA	$2-4	$7-9
Virgo								Test market		

Brand Name	Series	Mfg	Ven	YMf	#	Type	Pack	Description/Remarks	Empty	Full
Visa	Warning	PMC		1975	20	FKR	FTB	Trademark	$6-8	$25-35
Viscount	S-125	LAB		1955	20	RKR	F/B	F630-VA, brown on white	$10-15	$40-55
Vision	Warning	BAW		1975	20	FKR	S/P	Trademark	$6-8	$25-35
Visor	S-120	LAB		1950	20	70's	S/P	F460-VA, red and white	$10-15	$40-55
Vista	No-Stamp	RJR		1964	20	FKR	S/P	Trademark	$6-8	$25-35
Vita	Warning	BAW		1969	20	FKR	FTB	Trademark	$6-8	$25-35
Vogue	Caution	USJ	STP	1970	20	FKR	S/P	TP-3-VA, black gold top	$3-5	$8-12
Vow	Warning	RJR		1975	20	FKR	SSB	Trademark	$6-8	$25-35
Wakefield	No Stamp	PMC		1964	20	FKR	S/P	Trademark	$6-8	$25-35
Waldorf-Astoria	S-115	GAG		1935	10	70's	CSB	Also 20ct.	$20-25	$60-85
Waldorf-Astoria	S-125	GAG		1955	20	70's	S/P	Black and silver	$10-15	$40-55
Waldorf-Astoria	S-125	GAG		1955	50	70's	F/T	Also 100ct.	$60-85	$180-225
Walford	S-103	DRQ		1928	20	70's	S/P	F170-3NY	$15-20	$90-135
Walford Blues	S-102	DRQ		1928	10	70's	S/P	Hand rolled	$25-35	$90-135
Walford Virginia	S-106	DRQ		1936	10	70's	S/P	Hand rolled, blue eagle	$25-35	$90-135
Wall Street Special	No Series	BER		1927	20	70's	F/B	F122-MA	$15-20	$55-65
Walnut	S-108	ATC	MID	1938	10	70's	S/P	Green on white	$15-20	$55-65
Walnut Aromatic	S-110	ATC	MID	1940	20	70's	S/P	F30-NC,	$15-20	$55-65
Walsh's	S-102	WSH		1932	20	70's	S/P	F266-MA	$35-50	$90-135
Wanda Turkish	S-1901	DYC		1905	10	70's	CSB	F266-MA	$60-85	$180-225
Wanda Turkish	S-1901	DYC		1905	100	70's	F/T	Test market	$25-35	$70-95
Warwick	Caution	LOR		1967	20	FKR	S/P	Picture of water lily	$6-8	$25-35
Water Lily	S-1917	FCT		1920	20	70's	S/P	Trademark	$6-8	$25-35
Waterfall	Caution	ATC		1965	20	FKR	S/P	Trademark	$6-8	$25-35
Waterford	Caution	ATC		1965	20	FKR	S/P	Water bubble in tip	$15-20	$90-135
Waterford Water Tip	S-111	BEH		1941	20	70's	S/P	F5-2NY	$6-8	$25-35
Watermark	Warning	LAM		1976	20	FKR	S/P	Trademark	$2-4	$4-6
Wave	Sur-Gen	LAM		1987	20	FKR	S/P	Blue on white	$6-8	$25-35
Wave	Caution	ATC		1966	20	FKR	S/P	Trademark	$20-25	$60-85
Waverly	Caution	GAG		1967	20	FKR	FTB	1 of 10 "spoof" packs	$20-25	$60-85
Weed, Smoke	Caution		SMH	1940	5	70's	F/B	Blue letter on coral	$20-25	$60-85
Welcome James A. Farley	S-110	GAG	SMH	1940	5	70's	F/B	Metal box	$75-100	$200-250
Wellington	S-1898	TUC	CHR	1900	100	70's	R/T	White on red	$2-4	$7-9
Wellscroft Specials	Sur-Gen	PAV		1989	20	All Kinds	FTB	Brit. Auction listing	$6-8	$25-35
West	S-102	PMC		1932	20	FKR	F/T	Green bands on white	$20-25	$90-135
West Point	No Stamp	ATC		1960	20	FKR	FTB	Trademark	$10-15	$40-55
West Wind	No Stamp	ATC		1964	20	FKR	S/P	C98, F2-NY	$35-50	$90-135
Westchester Fives	S-1898	MIL	REE	1955	?	70's	?	Trademark	$10-15	$40-55
Westren 20	S-107	BAW		1932	20	70's	S/P	20 inside star	$35-50	$90-135
Whiff's, Turkish	S-1901	RJR		1901	10	FKR	SSB	?	$15-20	$55-65
Whisper	Warning	RJR		1976	20	FKR	S/P	Trademark	$15-20	$55-65
White Eagle	S-111	CEN		1941	20	FKR	S/P	Large white eagle on red	$6-8	$25-35
White House Special	S-1898	MON		1898	10	70's	SSB	F363-3NY	$15-20	$90-135
White Leaf	Caution	ATC		1966	20	FKR	S/P	Test market, Wichita Ks.	$35-50	$90-135
White Leaf	S-110	ATC		1967	20	FKR	S/P	F24-KY	$15-20	$55-65
White Oak	No Series	AFT	NRT	1936	20	FKR	S/P	White rabbit on blue	$20-25	$60-85
White Rabbit	Warning	USJ		1921	20	70's	S/P	No frills but honest value	$6-8	$25-35
White Rolls	S-107	REE		1935	?	FKR	S/P	3 Cigs, gold tip on white	$6-8	$25-35
Whitehall	S-102	LAB		1932	20	FKR	S/P	F13-3NY, F13-2NY	$60-85	$180-225
Whitefield	S-106	SMK		1936	20	FKR	S/P	Extra fine quality	$35-50	$90-135
Whitney	Sur-Gen	TUC	CHR	1982	20	FKR	S/P	Trademark	$6-8	$25-35
Wide Awake	S-1887	DAM		1887	?	70's	?	C98	$25-35	$55-65
Widow Jones	S-1898	KAU		1898	20	FKR	S/P	Trademark	$6-8	$25-35
Wild Life	No Stamp	LAM		1974	?	70's	?	Trademark	$60-85	$180-225
Williamsburg	Warning	PMC		1960	20	FKR	FTB	Trademark	$35-50	$90-135
Winchester	S-100	BAW		1930	20	FKR	S/P	Black letters on white	$6-8	$25-35
Winchester	Warning	RJR		1970	20	FKR	S/P	Trademark	$25-35	$55-65
Winchester	Warning	RJR		1974	20	FKR-FKMS	S/P	Test market one year	$6-8	$25-35
Wind Miller	S-1898	HAS		1898	?	FKR	S/P	C98	$35-50	$90-135
Windham	Warning	LAM		1982	20	FKR	S/P	Trademark	$6-8	$25-35

Brand Name	Series	Mfg	Ven	YMf	#	Type	Pack	Description/Remarks	Empty	Full
Windsor	No Series	LOR		1926	20	RKR	F/B	Bl. Gold letters on beige	$20-25	$60-85
Windsor Castle Fags	S-1917	LOR		1918	24	70's	S/P	4 and 20 smokes	$60-85	$180-225
Windsor Hall	S-102			1932	20	70's	S/P	F57-5NJ, "The Utmost"	$20-25	$60-85
Winfield	Warning	TUM		1976	20	FKR	S/P	Test market	$3-5	$8-12
Wingate	Warning	BAW		1975	20	FKR	S/P	Trademark	$6-8	$25-35
Wings	No Series	BAW		1929	20	FKR	S/P	85mm in 1940, first pack	$20-25	$60-85
Wings	No Stamp	BAW		1966	20	FKR	S/P	F35-VA, many varieties	$6-15	$25-55
Winner's Crown	S-102	RSD		1932	20	FKR	S/P	F916-1NY	$15-20	$55-65
Winners	S-112	PEN		1942	20	FKR	S/P	F22-12NY	$10-15	$40-55
Winnie	Warning	RJR		1975	20	FKR	S/P	Trademark	$6-8	$25-35
Winston	S-109	WTC		1939	20	70's	F/B	Red gold lines on blue	$20-25	$60-85
Winston	S-124	RJR		1954	20	FKR	S/P	F1-NC, red and white	$10-15	$55-65
Winston	No Stamp	RJR		1956	20	FKR	S/P	Red and white	$6-8	$25-35
Winston	Caution	RJR		1967	20	FKR-FKMS	S/B	Multi. colors	$3-5	$8-12
Winston	Warning	RJR		1970	20	All Kinds	S/P	Multi. colors	$2-4	$7-9
Winston Cup	Sur-Gen	RJR		1995	20	FKR	S/P	Series 1, 5 different pks	$3-5	$8-12
Winston 40th Anniversary	Sur-Gen	RJR		1994	20	FKR	S/P	Mylar cover	$3-5	$8-12
Winston Rounds	S-110	AFT	WTC	1940	20	FKR	S/P?	F24-KY	$20-25	$60-85
Wint-A-Green	S-121	RIG	ELL	1951	10	RKR	S/P	3 leaves on white	$10-15	$40-55
Wise	Warning	ATC		1975	20	FKR	S/P	Trademark	$6-8	$25-35
Wooden Kimona Nails	No Series	BAB		1923	10	70's	F/B	Blk/white checker board	$25-35	$60-85
World Cup	Sur-Gen	LAM		1993	20	FKR	S/P	Trademark	$6-8	$25-35
World's Fair (1982)	Warning	LAM		1982	20	F100R	S/P	Knoxville Tn. rd/white	$6-8	$25-35
Worth	Warning	RJR	PTY	1983	20	All Kinds	S/P	TP-42-NC, multi. colors	$1-2	$3-6
Wrangler	Warning	RJR		1973	20	FKR	S/P	Trademark	$6-8	$25-35
Wyndham	Warning	LAM		1983	20	FKR	S/P	Trademark	$6-8	$25-35
X	Sur-Gen	SAR	STO	1994	20	FKM	FTB	An X for your collection	$1-2	$3-6
XLs	Caution	PMC		1967	20	FKR	S/P	White diamond on red	$6-8	$25-35
XLs	Warning	PMC		1975	20	FKR	FTB	Orange band on white	$2-4	$7-9
Xtra-Mild	S-125	GAG	EHR	1955	20	70's	S/P	F407-2NY	$10-15	$40-55
Yahn & McDonnell	S-123	LEI	YAH	1953	20	70's	S/P	2 different packs	$10-15	$25-35
Yale	S-1883	KIM		1885	?	70's	?		$95-175	$225-325
Yale Club	S-118	GAG		1948	10	70's	F/B	C86, C89	$20-25	$60-85
Yankee Girl	No Series	SND		1921	20	FKR	S/P	Blue gold C Y, on white	$20-25	$60-85
Yardley	No Series	PMC		1958	20	FKR	F/B	Orange band on white	$6-8	$25-35
Yellow and Black	No Series	SSS	FCG	1928	20	FKR	S/P	Yellow and black stripes	$20-25	$40-55
York	S-125	LAB		1955	20	FKR	S/P	F460-VA	$10-15	$25-35
York Imperial Size	No Stamp	LOR		1961	20	FKR	S/P	TP622-NC, white on red	$6-8	$25-35
York Imperial	Caution	LOR		1965	20	F100R	S/P	Red on white	$2-4	$7-9
Yorkshire	S-108	TOW		1938	20	70's	CSB	F123-2NY, picture of ship	$15-20	$55-65
Yorkshire	S-122	LAB		1974	20	FKR	S/P	F460-VA	$10-15	$40-55
Yorktown	Caution	JTC	SRO	1967	20	FKR-FKMS	S/P	Red/green on white	$6-8	$25-35
Yours	No Series	LAB	REE	1927	20	70's	S/P	Red on white	$20-25	$60-85
Yours	Warning	LAM		1983	20	All Kinds	S/P	TP-42-NC, multi. colors	$2-4	$7-9
YSL	Sur-Gen	LAM		1985	20	All Kinds	S/P	TP-42-NC, multi. colors	$1-2	$3-5
Yukon	No Series	RJR		1990	20	F100R	FTB	Red and green	$2-4	$7-9
Yukon Club	No Stamp	LAB		1959	20	FKR	S/P	F460-VA, green on white	$6-8	$25-35
Yum Yum	No Stamp	LAB		1960	20	FKM	S/P	Menthol cool, coupon	$6-8	$25-35
Yvonne Turkish No 5	No Series	MER		1922	10	70's	F/B	Yellow red on white	$30-45	$70-95
Zack	Warning	SRD		1915	20	FKR	F/B	F355-2NY	$10-15	$40-55
Zapata	Warning	LOR		1974	20	70's	S/B	Looks like blue jeans	$20-25	$60-85
Zebra	S-102	RJR		1929	20	70's	S/P	Trademark	$15-20	$55-65
Zed	S-106	AFT		1970	20	FKR	S/P	F24-KY, picture of zebra	$15-20	$55-65
Zephyr	No Stamp	LEI	WLF	1962	20	FKR	S/P	F64-2NY	$6-8	$25-35
Zephyr	Warning	AFT		1975	20	FKR	F/B	F24-KY, Gull or Train	$15-20	$55-65
Zero	Warning	PMC		1975	20	FKR	S/P	Trademark	$2-4	$7-9
Zipper	S-114	BAW		1940	20	70's	CSB	F36-KY	$35-50	$90-135
Zippy	No Stamp	GOR	ZIP	1984	10	70's	S/P	TP-2442-PA, food market	$2-4	$7-9
Zira	S-1909	LOR		1911	20	70's	CSB	F21-5NJ	$35-50	$90-135
Zubelda	S-1910	LOR		1911	20	70's	S/P	Picture of lady in center	$30-45	$75-115
Zufedi	S-1910	ZUF		1915	10	70's	CSB	F562-2NY	$30-45	$75-115

Appendix E:
SAMPLES

This is an alphabetical listing of some of the unique samples I have in my collection. I have hundreds of Air lines and private corporations from the U.S. and Foreign countries. They are usually packs from major cigarette manufacturers with stickers on the back or the front. I put them all together in Row l. The columns are arranged like Appendix D. Many samples I have do not have the tax stamp on them, but some do. I don't know if it was required to have a tax stamps on samples or not.

Appendix E: SAMPLES

Codes used: Mfg: Manufacturer; YMf: Years manufactured; #: number in pack; Type: Type Size; Pack: Pack Kind;

Brand Name	Series	Mfg	YMf	#	Type	Pack	Description/Remarks	Empty	Full
Airline & Corp	All	All	All	All	All Kinds	All	Multi. colors, and multi brands	$10-15	$40-55
Alpine	None	PMC	1956	6	FKM	FTB	White and blue, w/white mtn	$10-15	$25-35
Barclay	Warning	BAW	1976	10	FKM-FKR	S/B	Beige/green and Beige/brown	$3-5	$7-9
Barclay	Sur-Gen	BAW	1985	10	All Kinds	S/P	Multi. colors on beige	$2-4	$5-8
Belair	None	BAW	1959	4	FKR	FTB	White left, slant blue w/clouds right	$10-15	$25-35
Benson&Hedges	None	BEH	1959	5	FKR	FTB	Gold, w/black crest, blk. letters	$10-15	$25-35
Benson&Hedges	None	BEH	1960	5	F100RL	UF,TB	White w/gold crest & red letters	$6-8	$8-12
Benson&Hedges	Caution	BEH	1967	4	F100R-M	FTB	Green or gold w/park ave on pack	$3-5	$7-9
Benson&Hedges	Warning	BEH	1970	4-6	All Kinds	FTB	Multi. colors on gold and green	$2-4	$4-6
Benson&Hedges	Sur-Gen	BEH	1985	6	All Kinds	FTB	Multi. colors on gold and green	$3-5	$7-9
Bistro	Warning	LOR	1981	4	FKR-FKM	FTB	Dk. blue, w. pic. person smoking	$10-15	$25-35
Breeze	None	BAW	1959	4	FKM	FTB	White w/3tone waves lower bottom	$3-5	$7-9
Bright	Warning	RJR	1976	10	F100-FKMS	P	White w/dark green/silver bands	$3-5	$7-9
Brookwood	Warning	RJR	1970	4	FKM	FTB	Dark green w/3tone lt green	$2-4	$4-6
Bucks	Sur-Gen	PMC	1994	6	FKR-L	F/B	Red/white, w/2 gld. lines, pic., buck	$3-5	$7-9
Cambridge	Warning	PMC	1978	4-6	All Kinds	FTB	Also F/B, white w/ gold seal	$10-15	$25-35
Camel	None	RJR	1940	3	70's	F/B	Old design, (K-Ration)	$30-45	$70-95
Camel	None	RJR	S-110	4	70's	FTB	Old design, blue letters	$15-20	$40-55
Camel	Warning	RJR	1964	4	FKR	FTB	Brown w/red band, pic. of camel	$15-20	$25-35
Camel	Warning	RJR	1978	4	FKR	FTB	White w/slant black	$3-5	$7-9
Carlton	Warning	RJR	1974	12	All Kinds	FTB	White w/standard design	$10-15	$25-35
Cavalier	None	ATC	1957	4	FKR	FTB	Red and White, w/black letters	$10-15	$25-35
Chesterfield	None	LAM	1911	4	RKR	FTB	W. w/picture of Cavalier, (mild)	$35-50	$90-135
Chesterfield	None	LAM	1940!	9	70's	SSB	Beige, beige and green letters	$60-85	$180-225
Chesterfield	None	LAM	1940	4	70's	SQ/B	Ox is sq. Beige, w/green letters	$15-20	$40-55
Chesterfield	Caution	LAM	1964	4	FKR	FTB	White, w/gold crest	$3-5	$7-9
Curtis Hotel	Warning	LAM	1970	4	70's	FTB	Gold leaf looking w/seal center	$15-20	$40-55
Doral II		?	1950!	4	FKR	FTB	Red w/man and woman on horse	$6-8	$25-35
Dunhill	Warning	RJR	1976	4	FKR-FKM	FTB	Multi. colors on beige	$15-20	$40-55
Dunhill	None	PMC	1976	4	F100R	FTB	White w/crest top ctr	$3-5	$7-9
Embassy	Caution	PMC	1965	5	FKR	FTB	3/4 red top, white circle, 8 stars	$15-20	$40-55
Eve	Warning	LOR	1975	2	RKR	SSB	White w/red band, w/white letters	$6-8	$8-12
Fleetwood	Warning	AFT	1944	3	70's	SSB	Brown w/dark brown letters	$3-5	$7-9
Galaxy	None	PMC	1960	4	FKR	FTB	White w/band upper center	$20-25	$55-65
Golden Lights	Warning	LOR	1978	4	F100R	FTB	White w/crest ctr	$3-5	$7-9
Gunston	None	LOR	?	12	RJR	S/P	Beige w/gold letters	$15-20	$40-55
Hit Parade	None	ATC	1955	4-5	FKR	FTB	Red, w/white circle	$15-20	$40-55
Iceberg	None	ATC	1967	4	FKM	FTB	Green, w/white stripes	$6-8	$8-12
Iceberg 10	None	ATC	1967	4	FKM	FTB	Green, w/white stripes	$6-8	$8-12
JSP	None	JPT	1977	3	FKR	FTB	Also 10 count, Black, w/gold ltrs.	$3-5	$7-9
Kent	None	LOR	1955	4-5	70's F	FTB	White, w/Micronite filter	$15-20	$40-55
Kent	S-125	LOR	1955	4	FKR	FTB	Non Micronite filter	$3-5	$7-9
Kent Golden Lts.	Warning	LOR	1976	4	All Kinds	FTB	Multi. colors on gold and silver	$3-5	$7-9
Kent III	Warning	LOR	1976	4	FKR	FTB	White w/blue trim, gold band	$3-5	$7-9
Kentucky Kings	None	BAW	1964	4	TOB. FKR	FTB	Brown & white circle, red letters	$6-8	$8-12
Kool	Warning	BAW	1970's	10	All Kinds	S/P	White and green	$3-4	$7-9
Kool	Warning	BAW	1958	4-6	FKR	FTB	Man & woman walking	$10-15	$25-35
L&M	None	LAM	1967	4	All Kinds	FTB	Multi. colors on red and white	$6-8	$8-12
L&M	Warning	LAM	1976	4	FKR-FKM	FTB	Red and green on white	$3-4	$7-9
Lark	None	LAM	1976	4	FKR	FTB	White w/gold band top	$15-20	$25-35
Life	None	BAW	1957	4	FKR	FTB	White w/gold band top	$10-15	$40-55
Lucky Strike	None	ATC	1940!	9	70's	S/B	Square Box, beige w/green letters	$60-85	$180-225
Lucky Strike	Green	ATC	1940'S	3	70's	SSB	Green w/red circle	$25-35	$60-85
Lucky Strike	S-120	ATC	1950	3	70's	SSB	White, w/black, green, red circle	$15-20	$40-55

Brand Name	Series	Mfg	YMf	#	Type	Pack	Description/Remarks	Empty	Full
Lucky Strike	None	ATC	1957	4-5	70's	FTB	Red and white	$10-15	$25-35
Lucky Strike	Warning	ATC	1970	4	F100R	FTB	Red and white	$3-5	$7-9
Lucky 100's	Warning	ATC	1967	4	F100R	FTB	1/2 White, 1/2 Red	$10-15	$25-35
Max	Warning	LOR	1975	4	F120R-M	FTB	Gold lines on blue and green	$3-5	$7-9
Marlboro	None	PMC	1954	3-4	FKR	FTB	Red and white	$15-20	$40-55
Marlboro	None	PMC	1963	5-6	FKR	FTB	Red and white	$8-12	$25-35
Marlboro	Warning	PMC	1976	10	All Kinds	S/B	Multi. colors$3-5	$4-6	$8-12
Maryland	Sur-Gen	PMC	1985	10	All Kinds	S/B	Multi. colors$2-4	$3-5	$4-6
Merit	Warning	ATC	1976	4-6	All Kinds	FTB	Multi. colors on white	$6-8	$8-12
Mild Seven	None	?	1960	5	FKR	FTB	White, w/gold letters	$10-15	$25-35
More	Warning	RJR	1981	10	F100R-M	S/P	Green and gold lines on red/beige	$3-5	$7-9
Newport	None	LOR	1960	4	FKM	FTB	Blue, w/white letters	$6-8	$8-12
Newport	Caution	LOR	1967	4	FKM	FTB	Blue, w/white letters	$3-5	$7-9
Newport	Warning	LOR	1976	6	All Kinds	S/B	Also 10cts. Multi. colors	$6-8	$8-12
Newport	Warning	LOR	1983	6	FKR	FTB	3/4 red, 1/4 white	$2-4	$4-6
Northwind	Sur-Gen	LOR	1985	10	All Kinds	S/P	Multi. colors on white	$10-15	$25-35
Old Gold	Warning	PMC	1980	6	FKR-100's	FTB	White w/3tone blue, (cool-no men.)	$25-35	$60-85
Old Gold	None	LOR	1930's	2	70's	SSB	Yellow, w/lge. red and gold letters	$20-25	$55-65
Old Gold	S-111	LOR	1941	7	P/T	Pull Tab	w/dark gold dollars	$15-20	$40-55
Old Gold	S-121	LOR	1950's	5	70's	SSB	Yellow, w/gold dollars	$10-15	$25-35
Old Gold	Caution	LOR	1960	4	FKR	FTB	White w/gold V OG in V	$3-5	$7-9
Pall Mall	S-109	ATC	1939	5	RKR	F/S	White on red	$25-35	$60-85
Pall Mall	S-124	ATC	1954	4	RKR	F/B	White on red	$15-20	$40-55
Pall Mall	None	ATC	1958	4	RKR	FTB	White on red	$10-15	$25-35
Pall Mall	Caution	ATC	1967	4-5	All Kinds	FTB	Multi. colors	$3-5	$7-9
Parliment	Warning	BAH	1970's	4	F100R-L's	FTB	Two tone blue	$3-5	$7-9
Philip Morris	1913-54	PMC	?	2	70's	SSB	Brown w/yellow letters	$30-45	$75-115
Philip Morris	1913-54	PMC	1950	2	70's	SSB	Brown w/yellow ltrs.(15 cent) cig.	$50-65	$150-190
Philip Morris	S-120	PMC	1955	4	70's	SSB	Brn. and yellow, picture of Johnny	$25-35	$60-85
Philip Morris	S-125	PMC	1955	4	F/B		Brown and yellow	$10-15	$25-35
Philip Morris	S-125	PMC	1958	4	F/B		Brown and yellow	$15-20	$40-55
Players	None	PMC	1950!	10	70's	FTB	Looks like plastic color	$15-20	$40-55
Players	None	PMC	1976	6	70's	SSB	White top/bottom, w/blue band	$3-5	$7-9
Raleigh	Warning	PMC	1976	6	FKR	FTB	Black w/gold letters	$25-35	$60-85
Raleigh	Warning	BAW	1935	5	F100R-M	FTB	White w/lg. pic. of Raleigh in ctr.	$10-15	$25-35
Real	S-105	BAW	1964	6	RKR	S/P	Two red sq w/tob. leaf	$3-5	$7-9
Salem	None	RJR	1956	4	FKR	FTB	Green and white	$15-20	$40-55
Salem	Caution	RJR	1967	4	FKM	FTB	Green and white	$10-15	$25-35
Sano	Warning	RJR	1976	4-6	All Kinds	B/S	colors of green, white, silver	$3-5	$7-9
Saratoga	Warning	UST	1952	4	70's	F/B	White, w/red seal lower center	$20-25	$55-65
Satin	Warning	RJR	1976	4	F120R-M	FTB	Brown and gold, w/gold letters	$6-8	$8-12
Sensation	S-108	LOR	1976	4	F100R-M	FTB	Light green, gold letters	$15-20	$40-55
Silva	None	ATC	1938	2	70's	SSB	Beige, w/red circle, name in circle	$10-15	$25-35
Stuyvesant	None	?	1976	4	F100R-M	FTB	colors, on silver and green	$6-8	$8-12
Tareyton	Caution	ATC	1958	4	F100R	FTB	White, w/two red stripes	$15-20	$40-55
Tareyton	None	ATC	1964	10	F100R	FTB	White, w/two red bands on right	$3-5	$7-9
Tareyton	Warning	ATC	1976	4-5	All Kinds	FTB	colors on white	$10-15	$25-35
Tempo	None	ATC	1963	4	FKR	FTB	White, w/red gold circle	$3-5	$7-9
Triumph	Warning	LOR	1979	4	FKR	FTB	White, w/2 tone brn & grn. to point	$3-5	$7-9
True	Warning	LOR	1976	4	All Kinds	FTB	Multi. colors on white	$6-8	$8-12
Twist	Warning	ATC	1979	4	F100M	FTB	Yellow, w/green letters	$3-5	$7-9
Vantage	None	RJR	1976	4	FKR	FTB	colors on white	$3-5	$7-9
Viceroy	Warning	BAW	1958	4	FKR	FTB	White, w/red band down center	$6-8	$8-12
Viceroy	None	BAW	1967	4	FKR	FTB	Also 10ct., F100R, blue, w/shield	$3-5	$7-9
Viceroy Rich L's	None	BEH	1976	4-6	All Kinds	FTB	Multi. colors	$15-20	$40-55
Virginia Slims	Warning	RJR	1954	4	FKR	FTB	White on red, w/crown	$10-15	$25-35
Winston	None	RJR	1958	4	FKR	FTB	White on red, w/crown	$6-8	$8-12
Winston	Caution	RJR	1967	4	FKR	FTB	White on red, w/crown	$3-5	$7-9
Winston	Warning	RJR	1976	4	FKR	FTB	White on red, w/crown	$3-5	$7-9
York	None	LOR	1962	4	FKR	FTB	Imperial size, red and white	$15-20	$40-55